FINE ART REPRODUCTIONS OF OLD & MODERN MASTERS

A COMPREHENSIVE ILLUSTRATED CATALOG OF ART THROUGH THE AGES

NEW YORK GRAPHIC SOCIETY, LTD.
GREENWICH, CONNECTICUT, U.S.A.
NEW YORK · CHICAGO · DALLAS

A CHARTWELL COMPANY

NEW YORK GRAPHIC SOCIETY LTD.

Main Office:

P.O. Box 1469
Greenwich, Connecticut 06830
(203) 661-2400

Branch Offices:

200 Lexington Avenue, Rm. 809
New York, New York 10016
(212) 679-4840

1256 Merchandise Mart
Chicago, Illinois 60654
(312) 644-5755

9004 World Trade Center
Dallas, Texas 75258
(214) 742-7126

International Standard Book Number 0-8212-1121-8
Library of Congress Catalog Card Number 79-93410

Copyright © 1980 New York Graphic Society Ltd.
All rights reserved.

Printed in the United States, 1980

Reprinted 1984

INTRODUCTION

The urge to create works of art seems always to have been with us. Wherever we find traces of human life, even in the remotest past, we are likely to discover images fashioned by the hand of man. And wherever we find the remains of his dwelling place, we have learned to expect the walls to be decorated in one way or another. This unbroken chain of art reaches back through countless empires to the dawn of painting. And the history of art from that distant moment is one of the most fascinating and rewarding of the learned sciences.

In its own way this catalog of *Fine Art Reproductions: Old and Modern Masters* offers a modest glimpse of art history, as the reader will soon discover in turning its pages. All the principal schools are included. Beginning with examples of Egyptian, Assyrian, and Classic art, then Early Christian and Byzantine, the catalog continues through Duccio and the Early Renaissance Italians, the High Renaissance and Baroque periods in Europe, and into the later 18th and 19th century developments that paved the way for modern painting in France and elsewhere—in which the collection is particularly rich. The list of the 19th and 20th century French and American artists represented in the catalog, in many cases by a generous selection of works, reads like a *Who's Who* of modern art.

Although our catalog was intended originally as a sales aid, it has grown over the years—as our own inventory of prints has grown—into the largest selection of illustrations in color of fine paintings ever published in a single book. The New York Graphic Society, too, has grown with the times; and its growth reflects both an ever-increasing interest in art and recent developments in fine color printing which have been made during the last few decades.

About 150 years ago the process of lithography was adapted to commercial use. Now, with ultra modern photographic and electronic aids, the printer is the virtual master of color process reproduction. Thus we are able to publish replicas of original paintings, particularly modern works and watercolors, that almost defy detection.

Although large color reproductions have more than one use, the commonest by far is for home decoration. The 20th century home owner shares a desire with the cave man of long ago and the Renaissance prince to decorate the walls of his dwelling with pictures. There are also other uses of perhaps a more serious sort for the color print. Schools and colleges, libraries and museums are able to accumulate reference collections of great value. Indeed, one of the largest groups of users of our catalog is to be found among these institutions.

This catalog is more than just a record of prints available or even the wide catholicity of public taste in art. It reflects a constant bond between our publishing program and its primary supporters—the many officials of museums and other art organizations, the individual artists and their families, and the collectors. Without their kindness and cooperation our prints could not be published and to them we owe our immense gratitude and thanks. Last but not least, a vote of thanks is due our printers in America and abroad for their constant assistance in maintaining always the most exacting standards in their work and providing us with reproductions of the highest quality.

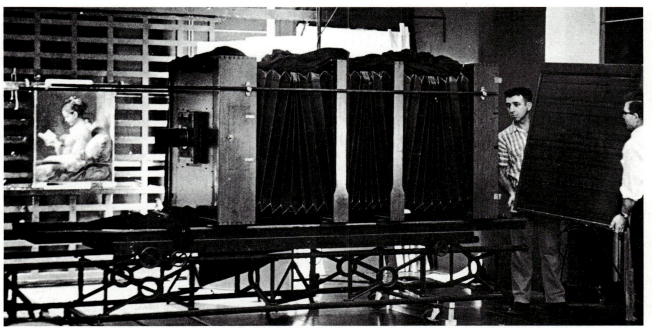

The above photograph shows photographic technologists at the National Gallery, Washington, D.C. making color collotype separation plates in the precise size of the intended reproduction. The color collotype process requires a reverse camera image which is used to produce a correct picture image on the press. After the 30 x 40 inch plates are exposed and developed, they are inspected and then compared to the original painting. This is the first step in the long carefully controlled process of creating a faithful reproduction.

A BRIEF HISTORY OF

REPRODUCTIONS

It is difficult to realize that the wide variety of color reproductions available to us is a comparatively recent development, brought about by the perfection of modern photographic and printing methods and the growth of fine art publishing. The importance of these developments may be understood in terms of the individual's limited opportunities to enjoy the visual arts in the past. Throughout the Middle Ages, only the most highly privileged persons—popes, kings and princes—actually owned paintings. Others found artistic satisfaction in the churches, where paintings, stained-glass windows, tapestries, sculpture, and jeweled altars offered a rich display. The great cathedrals and the parish churches commissioned works of art and so became the centers of the community's intellectual and artistic life.

During the Renaissance, a new wealthy middle class emerged, and its members desired paintings of their own. At first they commissioned religious paintings for their private chapels or portraits of themselves and members of their families, but soon the artists began to paint other subjects. Landscapes and allegories were popular, and, later, scenes from everyday life. In periods of great middle-class prosperity, as in seventeenth-century Holland, such households boasted a painting in almost every room.

An even wider, less affluent, audience remained to be satisfied and wood and copper-plate engraving began increasingly to fill this need. The art of wood engraving had been practiced before the fifteenth century and became less expensive with the replacement of parchment by paper. Copperplate engraving soon followed, offering a greater delicacy and refinement of technique. Often reproductions resulted in certain changes, but if the engraver had sufficient artistic sensitivity and manual dexterity, he managed to convey not only the subject matter, but also the subtleties of the original painting in his black-and-white rendering. It was necessary, however, for him to refrain from contributing any of his own concept or style. This required great self-restraint. Nevertheless, engravings would generally reflect some of the individuality of the engravers.

Engravings had a widespread effect. Martin Schongauer's plates were frequently copied or adapted; Durer's engravings were famed throughout Europe, and inspired many imitators even as late as the eighteenth century. In the early sixteenth century Marcantonio Raimondi and a whole circle of engravers copied the works of Raphael, Michelangelo, Titian, and others, and were thus largely responsible for these artists' influence on the painters of their age and of later generations.

The large number of reproductions printed in the mid-sixteenth and early seventeenth centuries is clear evidence of their growing popularity, and many engravers began to specialize in this field. Rubens himself, realizing

that good engravings helped to gain wider recognition for an artist's work, set up a workshop for the reproduction of his own paintings. Subsequently, new but still limited, techniques such as mezzotint and aquatint were introduced in an attempt to reproduce color and some of these reproductions were so beautifully executed that they are themselves considered works of art.

In the eighteenth and nineteenth centuries the printing of reproductions became an established trade, managed either by the engravers or by their publishers. Customers were attracted in various ways: through Paris exhibitions, the Leipzig and Frankfurt fairs, the book trade, magazines and itinerant vendors. Many buyers were artists and art students, since in those days of limited travel and much smaller and less accessible collections, reproductions were often the only means of studying the great masters. Goethe's record of his efforts to build a collection will suffice to show the importance of these prints to the scholar and the instructive value that was attributed to them. During the second half of the nineteenth century photo-mechanical processes began to supersede previous techniques. However, the new processes still did not reproduce the exact colors of the original painting. To us this is almost a fatal shortcoming, for color in painting is not merely added decoration. Color and its tones and treatment themselves create space, light and form in a painting, and are all important to defining the mood and emotional quality of a work of art. The artist's palette and his handling of it are as individual as his craftsmanship and sense of composition. It is only recently that the perfection of special cameras, film, and methods of developing have made possible precise reproduction of the color and texture of a painting.

The sensitivity of the engraver's eye and the skill of his hand have been replaced by lithography and gravure, in which the human factor is limited to supervision and control of the equipment used. Personal interpretation is excluded; now the demand is for duplication of the original painting with the greatest possible fidelity.

Color reproductions in the form of books or of prints have now brought the world of painting to millions who would never be able to own an original or visit a major museum. They have made possible an entirely new approach to art. Every individual can now view works of great art in terms of the private world of his own ideas and experiences. He may choose those reproductions which particularly appeal to him and which will add to his life an extra dimension of beauty and simple pleasure. Opportunities for study and appreciation have also been enlarged, as the art of all ages and of all countries is now accessible to everyone. Our age has the special privilege of enjoying a wide and varied inheritance, which is bound to have its effect on our own art and that of future generations.

CONTENTS

IMPORTANT NOTE

Ordering

Since all New York Graphic Society print orders are processed according to stock numbers as well as Artist and Subject Title, please be sure to include this information in your orders.

To make your selections easier, you should be aware that the first digit of the stock number refers to the size of the print (based on the larger dimension, either height or width). This also applies to certain three digit stock numbers which appear in the catalog . . . (for example number 497 is a print in the up-to-16-inch category).

Size (up to)	Stock Number
5 inches	1001 – 1999
8 inches	2000 – 2999
12 inches	3000 – 3999
16 inches	4000 – 4999
20 inches	5000 – 5999
24 inches	6000 – 6999
30 inches	7000 – 7999
34 inches	8000 – 8999
Larger Prints	9000 – 9999

Prices

A separate price list accompanies this catalogue and reflects the latest information on New York Graphic Society print costs.

CLASSIFIED SUBJECT MATTER INDEX

Wang Yuan-chi *(Chinese, 1642-1715)*
PAVILION WITH DISTANT MOUNTAIN
Alice Boney Collection, New York
5691 - 14″x17″ (35x43 cm)

Wang Yuan-chi
PHILOSOPHER'S RETREAT
Alice Boney Collection, New York
5692 - 14″x17″ (35x43 cm)

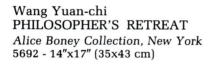

Wang Yuan-chi
SNOWSCAPE
Alice Boney Collection, New York
5694 - 14″x17″ (35x43 cm)

Wang Yuan-chi
THE SACRED POND
Alice Boney Collection, New York
5693 - 14″x17″ (35x43 cm)

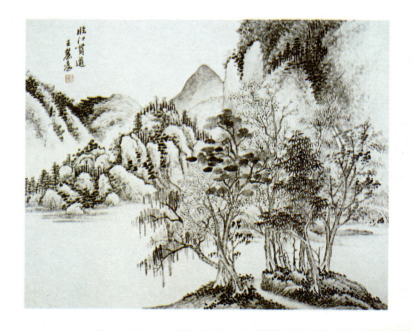

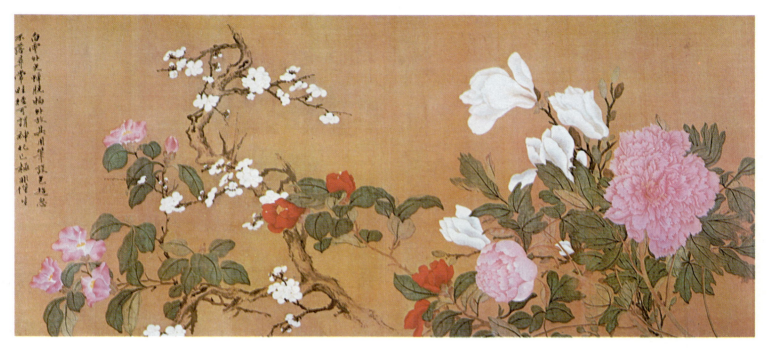

Yun Shou-p'ing *(Chinese, 1633-1690)*
CAMELIAS, PLUM BLOSSOMS,
PEONIES AND MAGNOLIA
(DETAIL, "One Hundred Flowers")
Collection of Mr. John M. Crawford, Jr., New York
8111 - 15½"x34" (39x86 cm)

Yun Shou-p'ing
ROSES AND IRIS
Collection of Mr. John M. Crawford, Jr., New York
5663 - 16"x16" (40x40 cm)

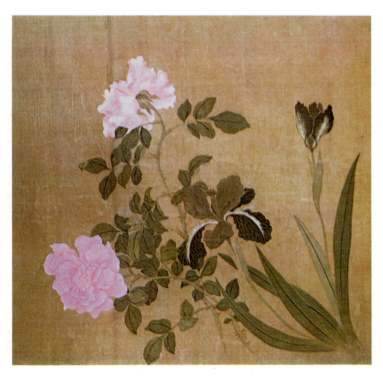

Yun Shou-p'ing
CHERRY BLOSSOMS AND WILD ROSES
Collection of Mr. John M. Crawford, Jr., New York
5664 - 16"x16" (40x40 cm)

9

T'ang Yin *(Chinese, 1470-1523)*
DRUNKEN FISHERMAN BY A REED BANK
(From a Hanging Scroll)
Collection of Mr. John M. Crawford, Jr., New York
7198 - 28½"x14½" (71x37 cm)

Maruyama Okyo *(Japanese, 1733-1795)*
GEESE IN FLIGHT
Courtesy of the Alice Boney Gallery, New York
7516 - 28"x28¼" (71x71 cm)

T'ang Ti *(Chinese, 1296-c. 1364)*
PAVILION OF PRINCE T'ENG
Collection of Mr. John M. Crawford, Jr., New York
7088 - 9⅞"x30" (25x76 cm)

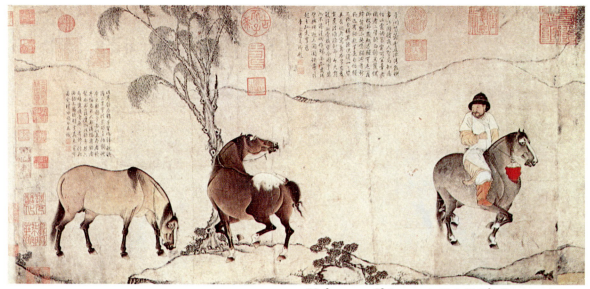

Unknown Chinese Artist *(14th Century)*
THREE HORSES
(Detail of Handscroll)
Collection of Mr. John M. Crawford, Jr., New York
8112 - 16″x32″ (40x81 cm)

Lang Shih-Ning *(Giusseppe Castiglione)*
Born: Milan, Italy, 1688; Died: Peking, China, 1766)
EIGHT IMPERIAL HORSES
Alice Boney Collection, New York
9305 - 18″x34″ (45x86 cm)

Yeh-lu Ch'u-ts'ai *(Chinese 1190-1244)*
CALLIGRAPHY, A SEVEN WORD POEM
(Detail of Handscroll)
Collection of Mr. John M. Crawford, Jr., New York
7197 - 14½″x30″ (37x76 cm)

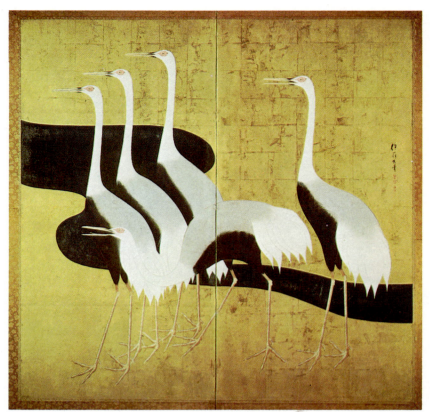

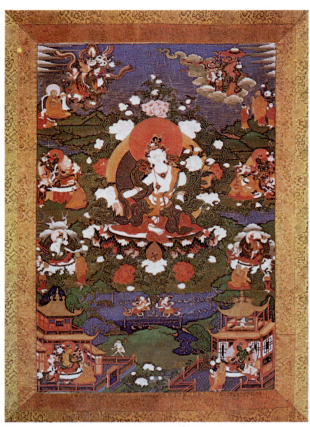

Unknown Tibetan Artist *(18th Century)*
BODHISATTVA AND OTHER DEITIES
Collection of Mead Art Museum, Amherst College
7298 - 28"x20" (71x50 cm)

Sakai Hoitsu *(Japanese-Tokugawa Period, 1761-1828)*
CRANES
Worcester Art Museum
9069 - 27¼"x27¼" (69x69 cm)
5515 - 14½"x14½" (37x37 cm)

Shen Ch'uan
FLOWERS AND BIRDS, *c. 1758*
Nelson Gallery-Atkins Museum
Kansas City, Missouri
8686 - 34"x14" (86x36 cm)

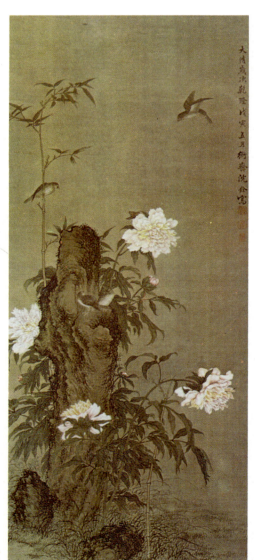

Sakai Hoitsu
PAULOWNIAS AND CHRYSANTHEMUMS
The Cleveland Museum of Art
8101—28"× 28¼" (71× 72 cm)
5503 - 14½"x14¼" (37x37 cm)

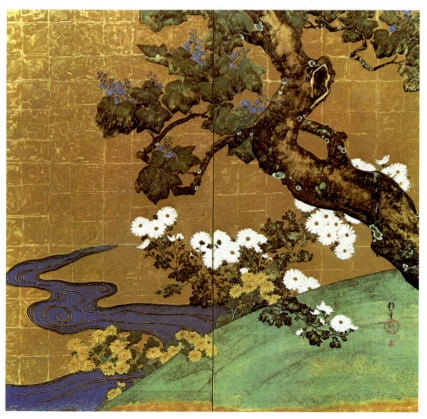

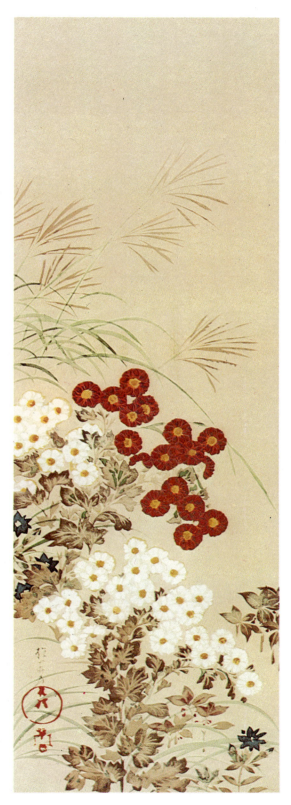

Sakai Hoitsu
CHRYSANTHEMUMS
Museum of Fine Arts, Boston
7293 - 29½"x10" (75x25 cm)

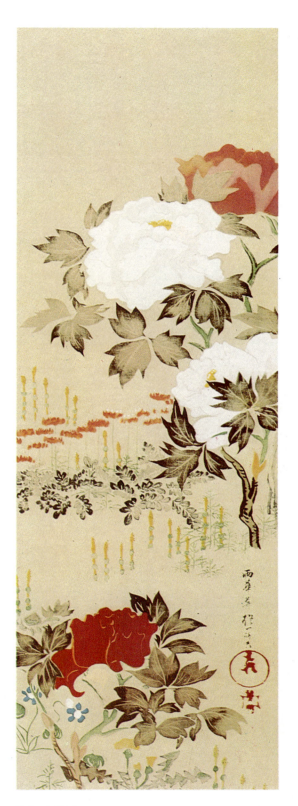

Sakai Hoitsu
PEONIES AND CHRYSANTHEMUMS
Museum of Fine Arts, Boston
7294 - 29½"x10" (75x25 cm)

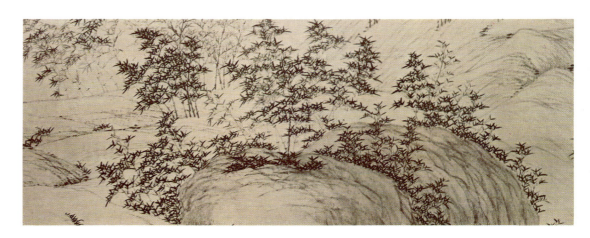

Sung K'o *(Chinese 1327 - 1387)*
MYRIAD BAMBOO
Freer Gallery of Art, Washington, D.C.
9021 - 14¾"×38" (37×96 cm)

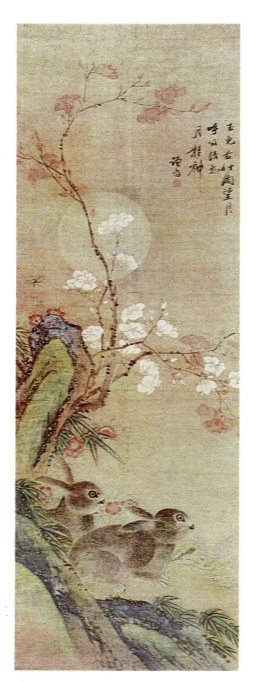

Cho Tai Eok *(Korean, 1675-1728)*
TWO HARES IN MOONLIGHT
Philadelphia Museum of Art
8255 - 34"×11½" (86×29 cm)

Sakai Hoitsu
(Japanese, 1761-1828) Edo Period
AUTUMN FLOWERS AND MOON
Freer Gallery of Art, Washington, D.C.
8025 - 32¾"×11½" (83×29 cm)

Sakai Hoitsu
IRIS AND MANDARIN DUCKS
Dallas Museum of Fine Arts
8098 - 34"×14" (84×36 cm)

Chin Nung *(Chinese, 1687-1764)*
STILL LIFE—PEAR, APPLE, LOTUS POTS
Private Collection
4625—11″ × 9¼″ (28× 23 cm)

Chin Nung
STILL LIFE—WINTER MELON, EGGPLANT, TURNIPS
Private Collection
4626—11″ × 9¼″ (28× 23 cm)

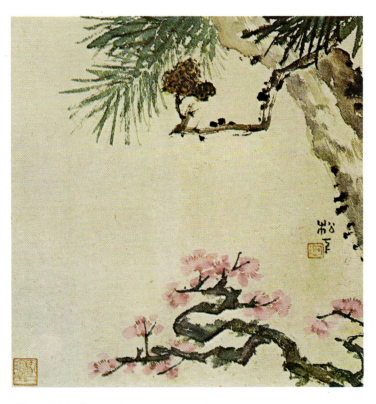

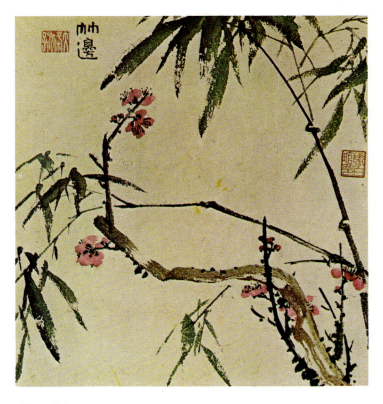

Tao-chi *(Chinese, 1641-c. 1720)*
PLUM BLOSSOMS—UNDER THE PINE
Private Collection
4628—11¼″ × 10¼″ (28× 26 cm)

Tao-chi
PLUM BLOSSOMS—BY THE SIDE OF BAMBOOS
Private Collection
4627—11¼″ × 10¼″ (28× 26 cm)

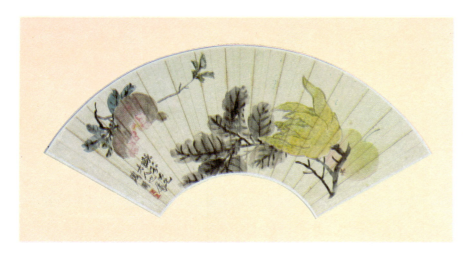

Tsung-Pai Chow *(Chinese, 1820-c. 1875)*
THE POMEGRANATE
Private Collection
5923—13½″ × 24½″ (34 × 62 cm)

Tzu-Hsiang Chang *(Chinese-Ching Dynasty, 1803-1886)*
APRIL BLOSSOMS
Private Collection
5920—13½″ × 24½″ (34 × 62 cm)

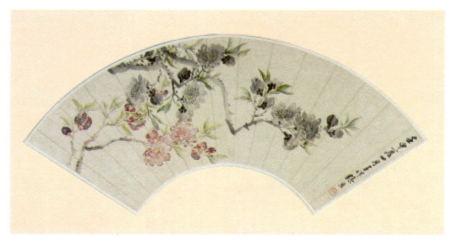

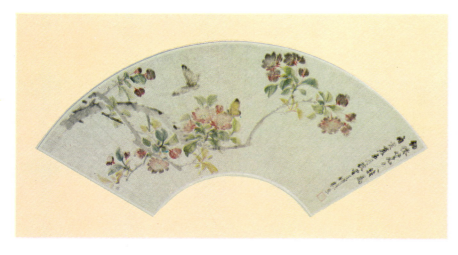

Tzu-Hsiang Chang
MAY BLOSSOMS
Private Collection
5922—13½″ × 24½″ (34 × 62 cm)

Tzu-Hsiang Chang
THE IRIS
Private Collection
5921—13½″ × 24½″ (34 × 62 cm)

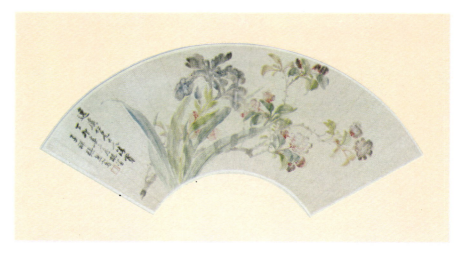

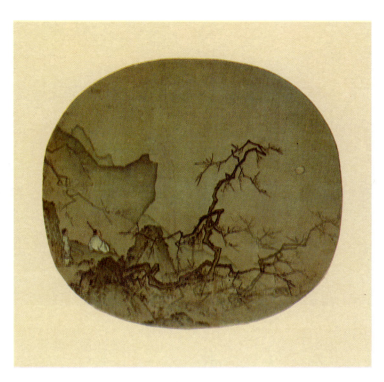

Ma Yüan *(Chinese, late 12th to 13th Century)*
PLUM BLOSSOMS BY MOONLIGHT
Private Collection
4518—14″× 14″ (35× 35 cm)

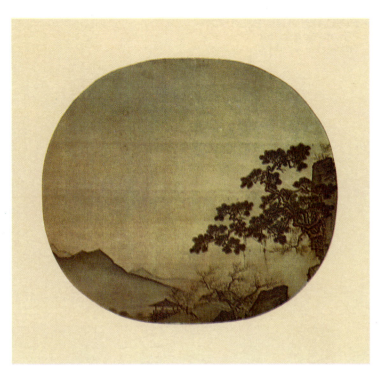

Anonymous Chinese *(13th Century)*
EVENING IN THE SPRING HILLS
Private Collection
4517—14″× 14″ (35× 35 cm)

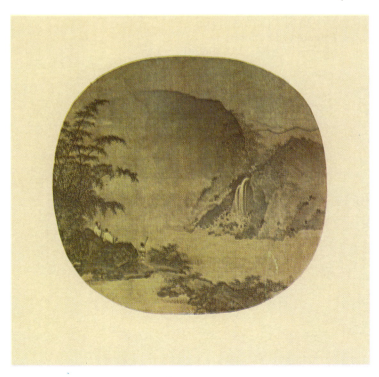

Anonymous Chinese *(12th Century)*
GENTLEMEN GAZING AT A WATERFALL
Private Collection
4519—14″× 14″ (35× 35 cm)

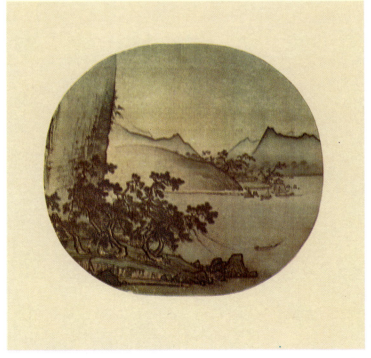

Anonymous Chinese *(13th Century)*
BOATS MOORED IN WIND AND RAIN
Private Collection
4516—14″× 14″ (35× 35 cm)

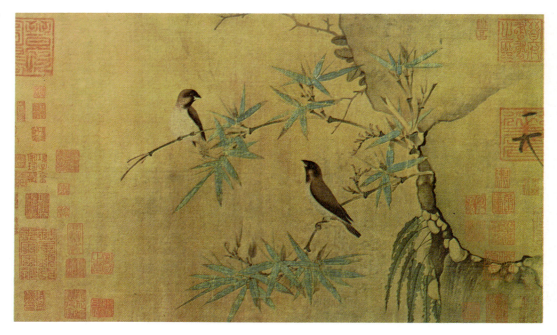

Hui-Tsung *(Chinese-Sung Dynasty Emperor, 1080-1135)*
FINCHES AND BAMBOO
Private Collection
5019—11″× 18″ (28× 46 cm)

Tong-Yang Lee *(Chinese-Ming Dynasty, 1447-1516)*
YU YEN TING, c. 1490
Private Collection
9041—10″× 37″ (25× 94 cm)

Attributed to Kano Motonobu *(Japanese, 1456-1559)*
FLOWERS AND BIRDS IN A SPRING LANDSCAPE
The Cleveland Museum of Art
8102 - 30″x24″ (76x61 cm)
5516 - 18½″x14½″ (47x37 cm)

Unknown Korean Artist (*Li Dynasty, 17th Century*)
PUPPY CARRYING A PHEASANT FEATHER
Philadelphia Museum of Art
5359 - 14"x17" (35x43 cm)

Unknown Japanese Artist (*14th Century*)
CHIGO DAISHI, THE PRIEST
KOBO DAISHI AS A CHILD
The Art Institute of Chicago
8672 - 34"x19" (86x48 cm)
4201 - 14"x11" (35x27 cm) (detail)

Kano Tannyu (*Japanese, 1602-1674*)
SUMMER PALACE
Private Collection
7295 - 20½"x28" (52x71 cm)

19

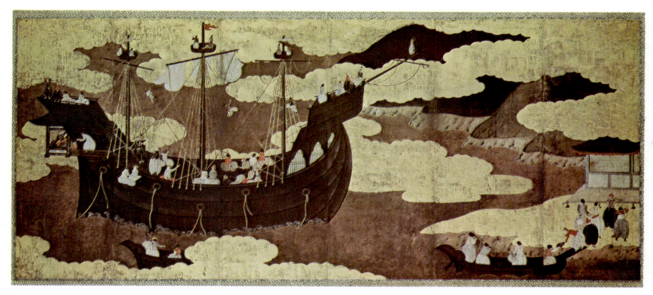

Unknown Japanese Artist (*Early 17th Century*)
PORTUGUESE SHIP ENTERING A JAPANESE HARBOR
(1st of pair of six-fold Japanese screens), Rijksmuseum, Amsterdam
9634 - 19"x42" (48x106 cm)

Fukaye Roshū (*Japanese, 1699-1757*)
**THE PASS THROUGH
THE MOUNTAINS (MOUNT UTSU)**
The Cleveland Museum of Art
John L. Severance Fund
9674 - 20¼"x40¼" (51x103 cm)

Unknown Japanese Artist (*Early 17th Century*)
PORTUGUESE VISITORS ARRIVING IN JAPAN
(2nd of pair of six-fold Japanese screens), Rijksmuseum, Amsterdam
9635 - 19"x42" (48x106 cm)

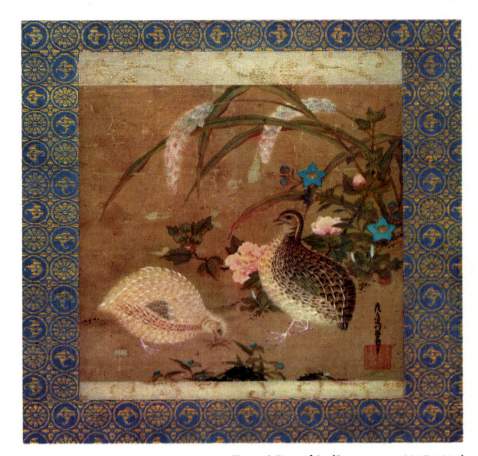

Tosa Mitsuoki, (Japanese, 1617-1691)
QUAILS AND FLOWERS
Museum of Asiatic Art
Rijksmuseum, Amsterdam
5096 - 16"x16" (40x40 cm)

Japanese, 18th Century
RED AND WHITE POPPIES
Freer Gallery of Art, Washington, D.C.
7665 - 29¾"x12" (76x30 cm)

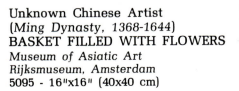

Unknown Chinese Artist
(*Ming Dynasty, 1368-1644*)
BASKET FILLED WITH FLOWERS
Museum of Asiatic Art
Rijksmuseum, Amsterdam
5095 - 16"x16" (40x40 cm)

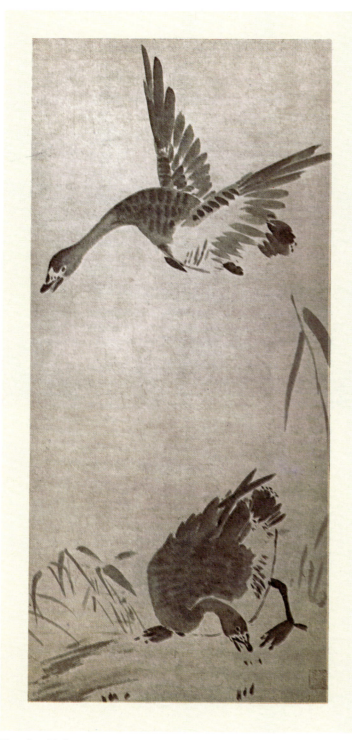

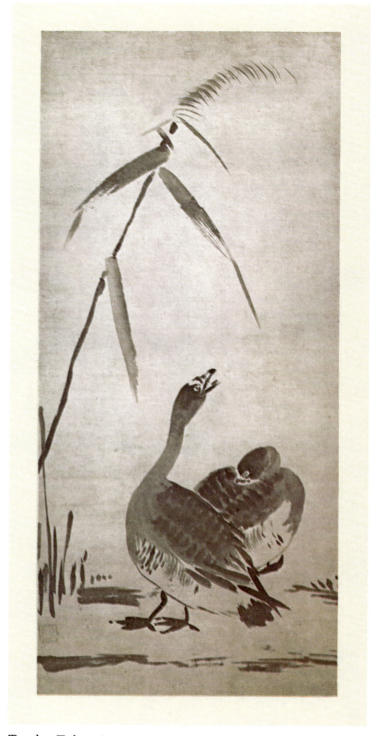

Tesshu Tokusai (*Japanese, circa 1342-1366*)
REEDS AND GEESE—IN FLIGHT
Virginia Museum of Fine Arts, Richmond
8048 - 30¼"x15" (77x38 cm)

Tesshu Tokusai
REEDS AND GEESE—AT REST
Virginia Museum of Fine Arts, Richmond
8049 - 30¼"x15" (77x38 cm)

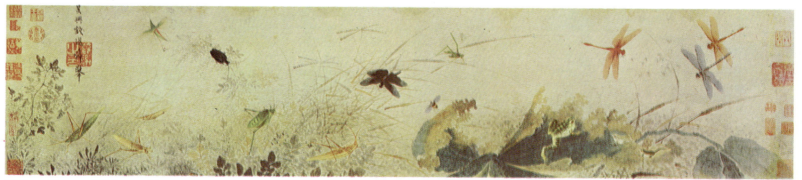

Ch'ien Hsuan (*Chinese-Yuan Dynasty, 1236-1368*)
EARLY AUTUMN
Detroit Institute of Arts
8850 - 8"×36" (20×91 cm)

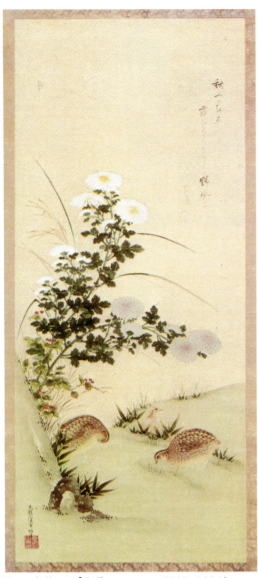

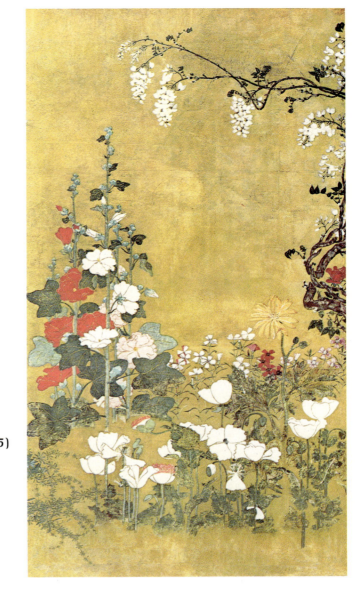

Watanabe Shiko
(Japanese, 1683-1755)
FLOWERS
Freer Gallery of Art,
Washington, D.C.
8367 - 33″×17¾″
(84×45 cm)
5521 - 18″x9½″
(46x24 cm)

Tosa Mitsuoki *(Japanese, 1617-1691)*
CHRYSANTHEMUM AND QUAIL
Virginia Museum of Fine Arts, Richmond
8022 - 34″x14¾″ (86x38 cm)

Ogata Korin *(Japanese, 1658-1716)*
CRANES
Freer Gallery of Art, Washington, D.C.
9059 - 17¼″×39″ (44×99 cm)

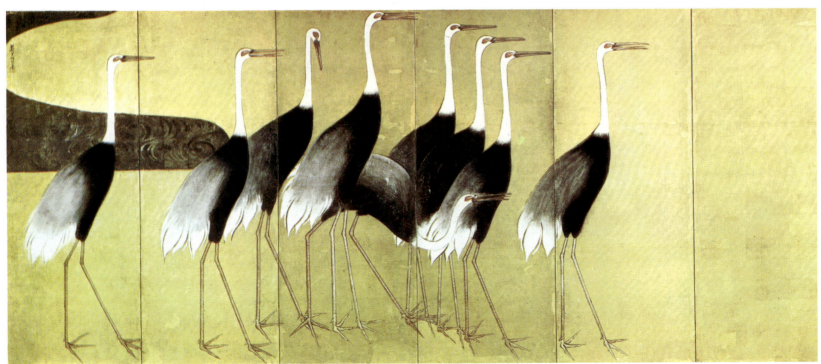

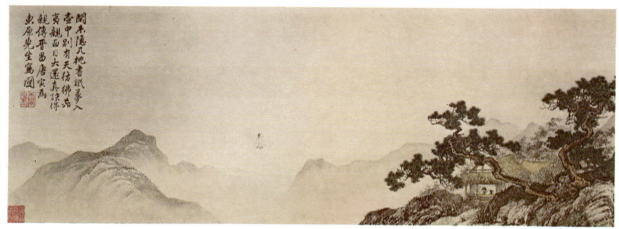

T'ang Yin (*Chinese, 1470-1523*)
DREAMING OF IMMORTALITY . . .
Freer Gallery of Art, Washington, D.C.
9020 - 14¾"×38" (37×96 cm)

Unknown Chinese Artist (*Yuan Dynasty, 1260-1368*)
TRIBUTE HORSES
Indianapolis Museum of Art
Gift of J. W. Alsdorf
5358 - 14"x16½" (35x41 cm)

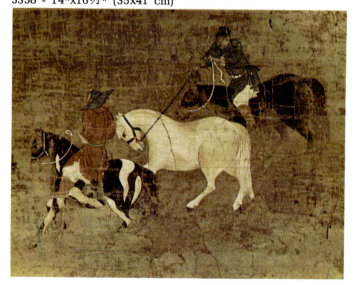

Ikeda Koson (*Japanese, 1802-1867*) Edo Period
CYPRESS TRESS
Private Collection
8854 - 31½"x33" (80x84 cm)

Attributed to Han-Kan (*Chinese, VIII Century*)
TARTARS BRINGING A TRIBUTE OF HORSES
Freer Gallery of Art, Washington, D.C.
9281 - 12¼"x40" (31x101 cm)

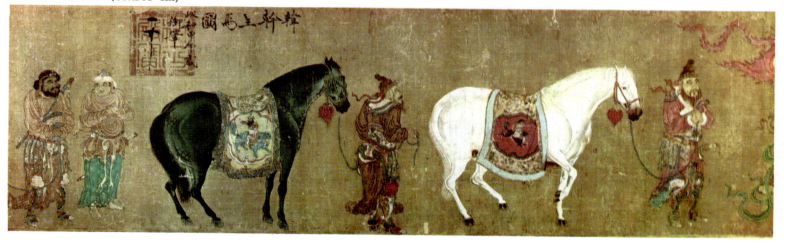

Shiou-Ping Liao *(Chinese, 1936)*
IT'S SPRING AGAIN
Private Collection
8857 - 30"×22½" (76×57 cm)

Kenzo Okada *(Japanese, 1905-)*
EVENTAILS, *1958*
7993 - 22"x27½" (56x70 cm)
Selected by an International Jury at the
XXIXth Biennale of Venice, 1958

Yoshishige Saito *(Japanese, 1905-)*
PAINTING "E," *1958*
Private Collection
7045 - 24"x19" (61 x48 cm)
Selected by the International Art
Critics Association, 1959

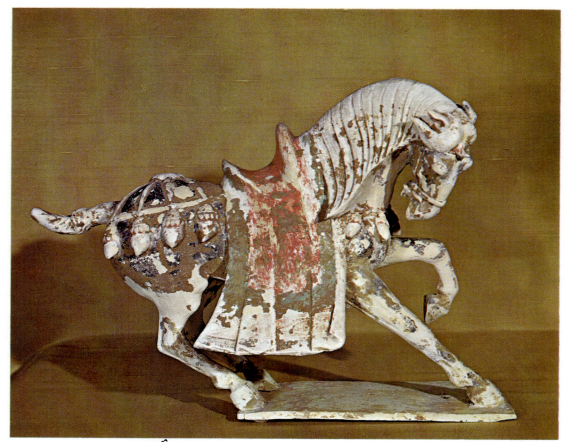

Chinese, T'ang Period 618-906 A.D.
PRANCING HORSE
Fogg Art Museum, Harvard University, Cambridge, Mass.
7300 - 21x27¾" (53x70 cm)

Chinese, T'ang Period
POTTERY FIGURE OF A SADDLED HORSE
The Art Institute of Chicago
Russell Tyson Collection
7301 - 20"x27¾" (53x70 cm)

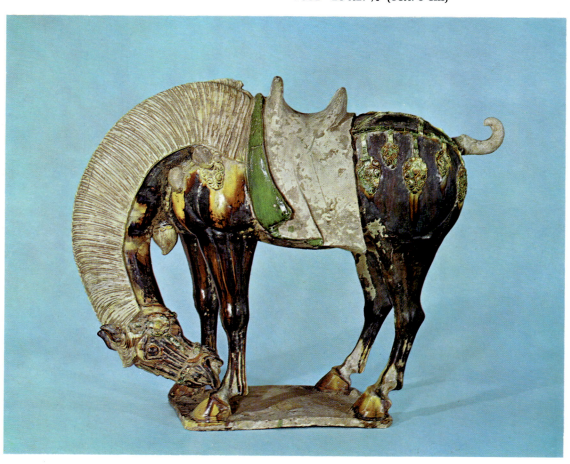

Tseng-Ying Pang
MOUNTAIN ASCENT
Private Collection
4623 - 16"x12" (40x30 cm)

Tseng-Ying Pang
THE LUXURIANCE OF PINE, *1967*
Private Collection
8964 - 31½"x30" (80x76 cm)

Tseng-Ying Pang
CORAL AND BLUE
Private Collection
4624 - 16"x12" (40x30 cm)

Tseng-Ying Pang
FRAGMENT OF AUTUMN
Private Collection
4621 - 12"x16" (30x40 cm)

Tseng-Ying Pang (*Chinese, 1916- *)
STIRRING LEAVES
Private Collection
4622 - 12"x16" (30x40 cm)

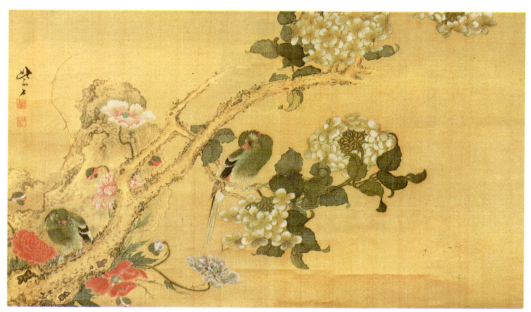

So Shiseki
PARAKEETS AND HYDRANGEA
Private Collection
5025 - 13¹¹⁄₁₆″x22¾″ (35x58 cm)

Tseng-Ying Pang
MOUNTAIN IN THE MIST, *1966*
Private Collection
8264 - 34½″x15″ (86x38 cm)

Tseng-Ying Pang
LONE TREE, *1966*
Private Collection
8263 - 34½″x15″ (86x38)

So Ryu
THE FLOWER CART
Private Collection
8684 - 17½"x34" (44x86 cm)
5514 - 9"x18" (23x46 cm)

Tseng-Ying Pang
COLD CLOUDS AND WEATHERED TREES
Private Collection
9643 - 36"x27" (91x68 cm)

Hui Chi Mau (*Chinese, 1922- *)
ORIENTAL AUTUMN
Private Collection
7952 - 20"×29¾" (51×76 cm)
5499 - 12"x18" (30.4x45.5 cm)

Henry Wo Yue-kee (*Chinese, 1927-*
TWO TIGERS
Collection of the Artist
9066 - 22¼"×36" (57×91 cm)
5508 - 11"x18" (28x46 cm)

Hui Chi Mau
GRAPES AND SONGBIRD
Private Collection
5607 - 20¾"x18" (53x46 cm)

Hui Chi Mau
PEONIES AND BUTTERFLIES
Private Collection
5608 - 20¾"x18" (53x46 cm)

Hui Chi Mau
SQUASH AND LADYBUG
Private Collection
5609 - 20¾"x18" (53x46 cm)

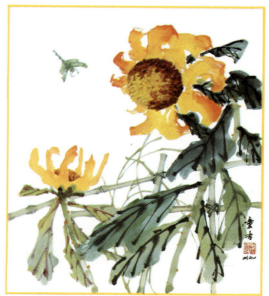

Hui Chi Mau
SUNFLOWERS AND DRAGONFLY
Private Collection
5610 - 20¾"x18" (53x46 cm)

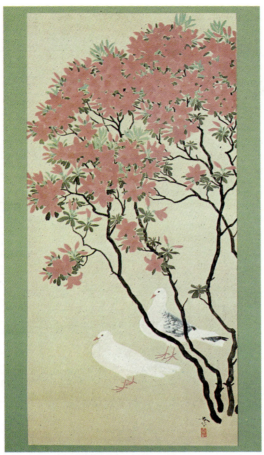

Shunso Hishida *(Japanese, 1874-1911)*
AZALEA AND PIGEONS
6939 - 23½″x12½″ (60x32 cm)

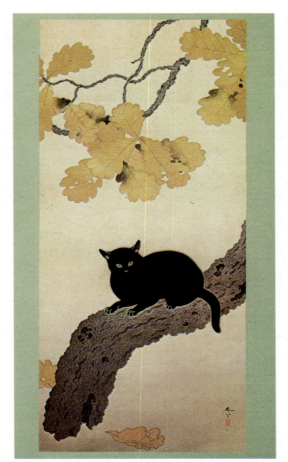

Shunso Hishida
BLACK CAT
6940 - 23½″x12½″ (60x32 cm)

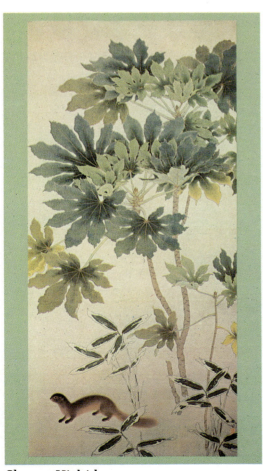

Shunso Hishida
MID-AUTUMN
6942 - 23½″x12½″ (60x32 cm)

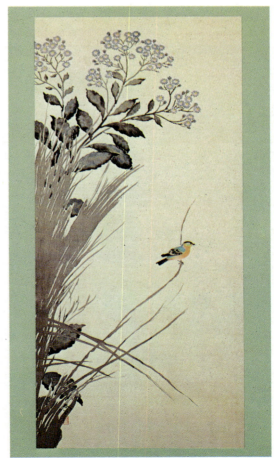

Shunso Hishida
SPRING
6941 - 23½″x12½″ (60x32 cm)

C. Chandler Ross (American, 1888-1952)
ORIENTAL SIMPLICITY
6878 - 20"x24" (50x60 cm)

Hovsep Pushman (Armenian, 1877-1966)
WHEN AUTUMN IS HERE
University Art Gallery
College of Fine Arts, University of Illinois
6611 - 22½"x15½" (57x39 cm)

Molly Guion (Contemporary American)
JADE AND CHINA
6796 - 24"x20" (60x50 cm)

Molly Guion
ROSE GODDESS
6794 - 24"x20" (60x50 cm)

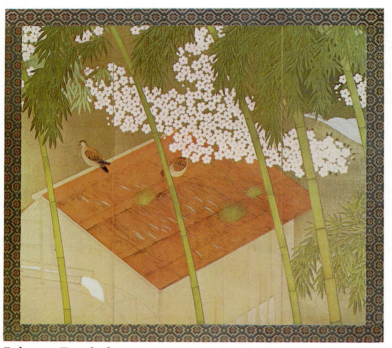

Bakusen Tsuchida *(Japanese, 1887-1936)*
CHERRY BLOSSOMS AND PIGEONS
5912 - 15"x16½" (38x42 cm)

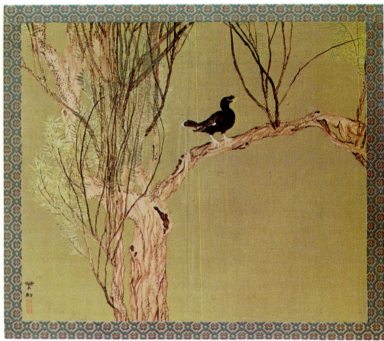

Shiko Imamura *(Japanese, 1880-1916)*
MAGPIE ON A PURPLE WILLOW
5913 - 15"x16½" (38x42 cm)

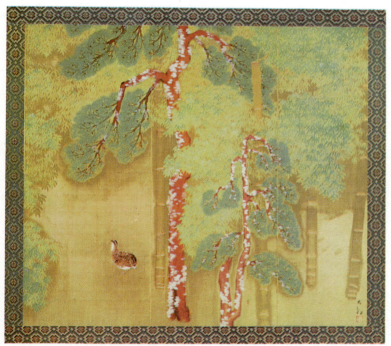

Taikan Yokoyama *(Japanese, 1867-1958)*
PINE TREES AND A QUAIL
5914 - 15"x16½" (38x42 cm)

Kanzan Shimomura *(Japanese, 1873-1930)*
WHITE FOX
5915 - 15"x16½" (38x42 cm)

Henry Wo Yue-kee
LOTUS IN THE RAIN
Private Collection
7076 - 20"x32" (51x81 cm)

Hsien-Min Yang *(Contemporary Chinese)*
PANDAS AT PLAY
Private Collection
5556 - 16"x20" (41x51 cm)

Hui Chi Mau
FINCHES AND ROSES
Private Collection
5687—24"× 12" (16× 30 cm)

Hui Chi Mau
MANY SEASONS
Private Collection
7348 - 20"x30" (51x76 cm)

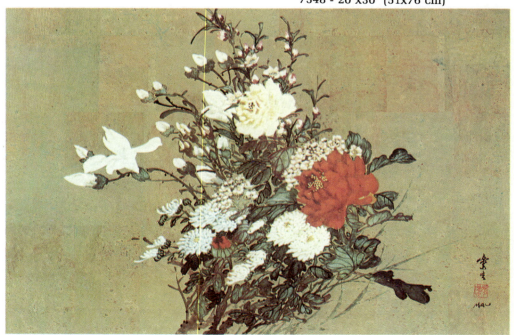

Barbara Nechis *(Contemporary American)*
FLOWER FANTASY
Private Collection
6376 - 15"x22" (38x56 cm)

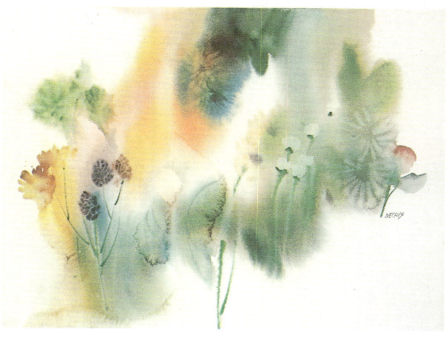

Barbara Nechis
SUMMER SILHOUETTE
Private Collection
6377 - 15"x22" (38x56 cm)

Hui Chi Mau
AZALEAS AND BUTTERFLIES
Private Collection
5686—24"×12" (61×30 cm)

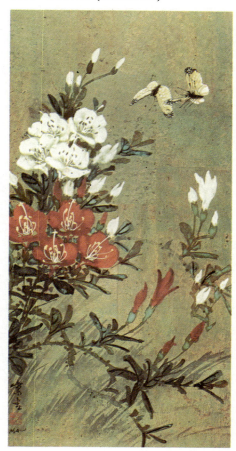

Hui Chi Mau
ROSES IN THE WIND
Private Collection
7349 - 20"x30" (51x76 cm)

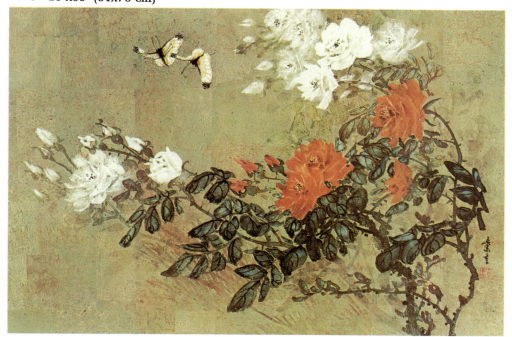

Yasu Eguchi *(Japanese, 1938-)*
COUNTERPOINT
Private Collection
7347 - 22"x30" (55x76 cm)

Tadashi Asoma *(Japanese, 1923-*
LILY POND IN SUMMER
Private Collection
8103 - 28"x28" (71x71 cm)

Michael Rossi *(Contemporary American)*
AUTUMN MIRAGE
Private Collection
7754 - 20⅝"x30" (52x76 cm)

Michael Rossi
KYUSHU, 1978
Private Collection
7755 - 20⅝"x30" (52x76 cm)

UNITED NATIONS EDUCATIONAL, SCIENTIFIC and CULTURAL ORGANIZATION REPRODUCTIONS

U.N.E.S.C.O. states that the purpose of this series is "designed to bring within the reach of artists, teachers, students and the wide art-loving public the finest quality color reproductions of masterpieces of art which hitherto have been known to a too limited few."

Single plates are uniformly priced at _____ each. Average picture is about 14" × 11" (35×28 cm). Paper size is standard 18¾" × 13¼" (47.6×33.7 cm).

INDIA, Paintings from Ajanta Caves

1585 - INDIA

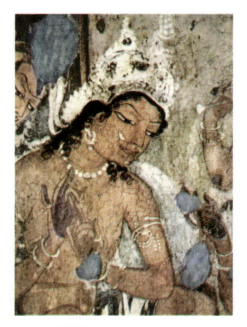

1582 - INDIA

1584 - INDIA

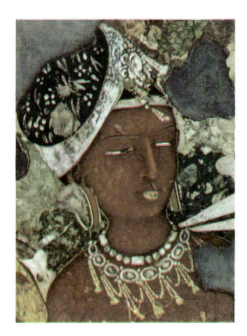

1587 - INDIA

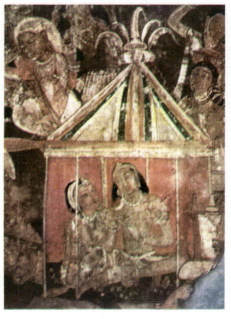

1586 - INDIA

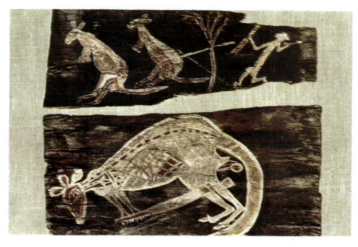

1506 - AUSTRALIA

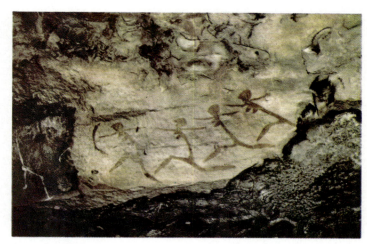

1499 - AUSTRALIA

AUSTRALIA, Aboriginal Paintings—Arnhem Land

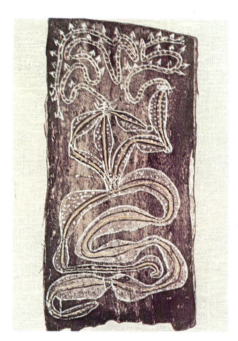

1501 - AUSTRALIA

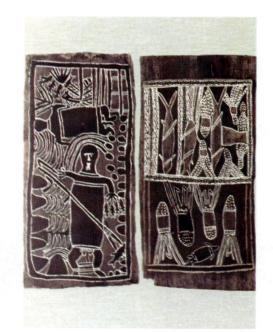

1503 - AUSTRALIA

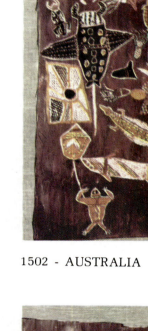

1502 - AUSTRALIA

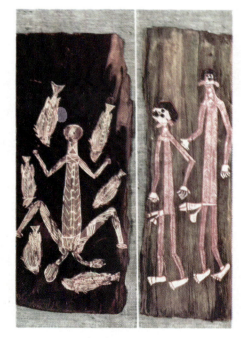

1504 - AUSTRALIA

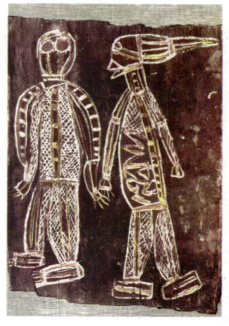

1505 - AUSTRALIA

1523 - EGYPT

1527 - EGYPT

1529 - EGYPT

EGYPT, Paintings from Tombs and Temples

1533 - EGYPT

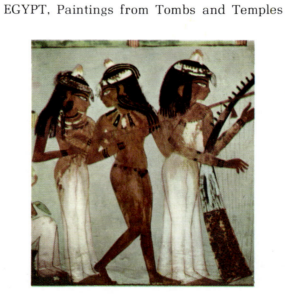

1532 - EGYPT

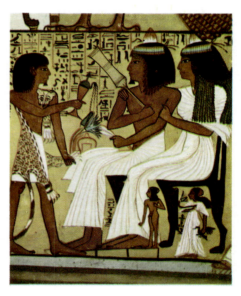

1534 - EGYPT

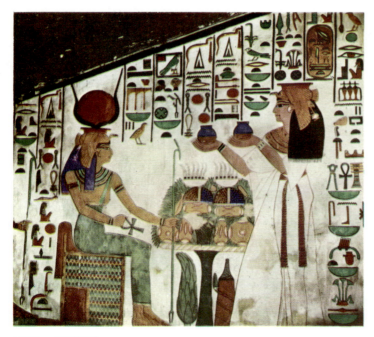

1525 - EGYPT

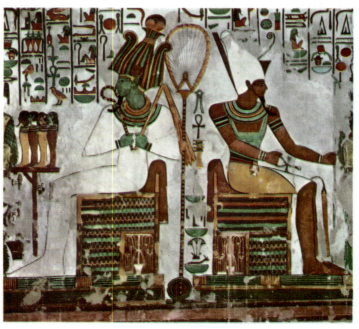

1526 - EGYPT

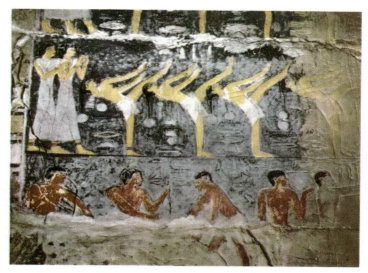

1524 - EGYPT

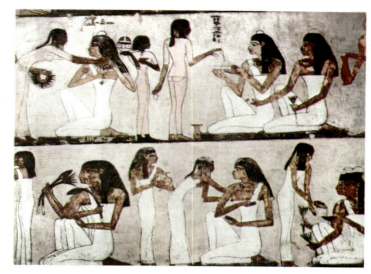

1528 - EGYPT

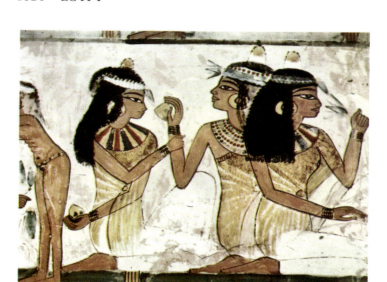

1530 - EGYPT

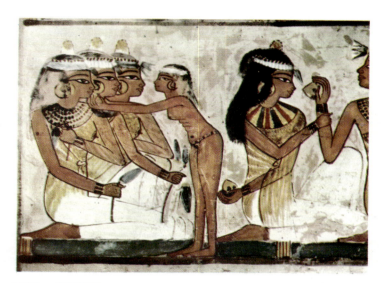

1531 - EGYPT

CEYLON, Paintings from Temple, Shrine and Rock

1515 - CEYLON

1514 - CEYLON

1516 - CEYLON

1616 - TUNISIA

1617 - TUNISIA

TUNISIA, Ancient Mosaics

1613 - TUNISIA

1619 - TUNISIA

1612 - TUNISIA

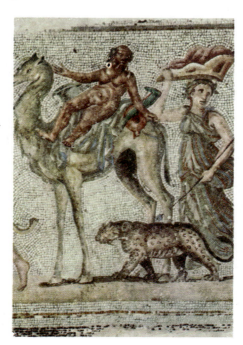

1615 - TUNISIA

1614 - TUNISIA

1618 - TUNISIA

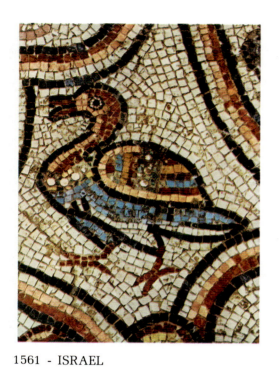

ISRAEL, Ancient Mosaics

1561 - ISRAEL

1566 - ISRAEL

1565 - ISRAEL

1555 - ISRAEL

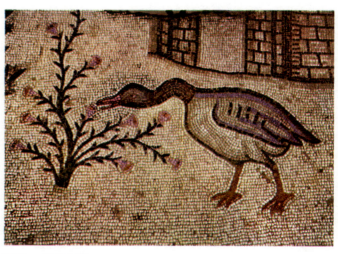

1560 - ISRAEL

1553 - ISRAEL

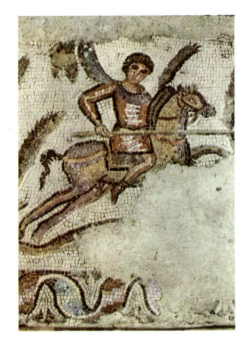

1556 - ISRAEL

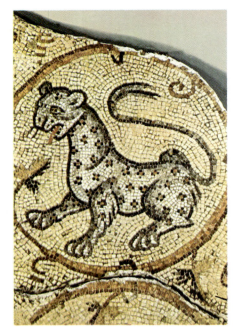

1563 - ISRAEL

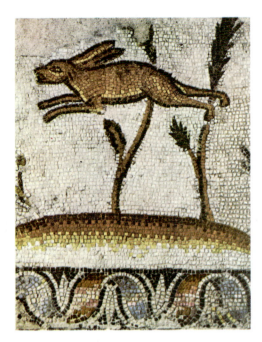

1557 - ISRAEL

1562 - ISRAEL

1552 - ISRAEL

1558 - ISRAEL

1559 - ISRAEL

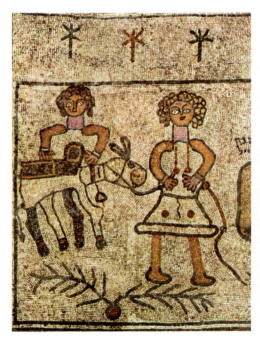

1554 - ISRAEL

1537 - ETHIOPIA

1536 - ETHIOPIA

ETHOPIA, Illuminated Manuscripts

1609 - SPAIN

1610 - SPAIN

SPAIN, Romanesque Paintings

1608 - SPAIN

1611 - SPAIN

1607 - SPAIN

1631 - YUGOSLAVIA

1632 - YUGOSLAVIA

YUGOSLAVIA, Mediaeval Frescoes

1633 - YUGOSLAVIA

1634 - YUGOSLAVIA

1630 - YUGOSLAVIA

1627 - YUGOSLAVIA

1628 - YUGOSLAVIA

1629 - YUGOSLAVIA

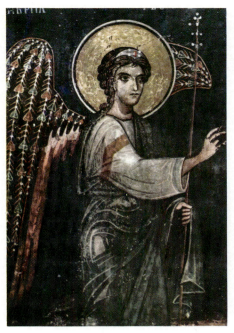

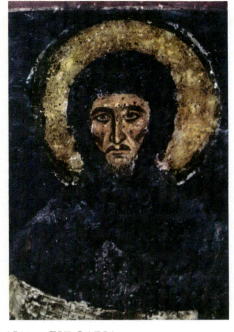

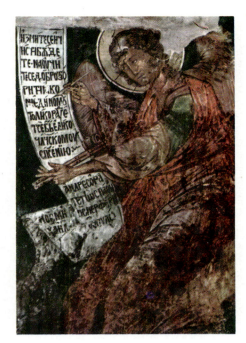

1509 - BULGARIA

1511 - BULGARIA

1513 - BULGARIA

BULGARIA, Mediaeval Wall Paintings

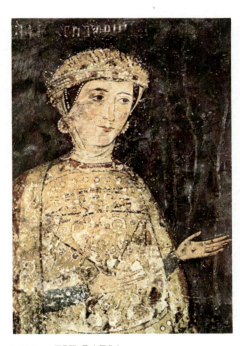

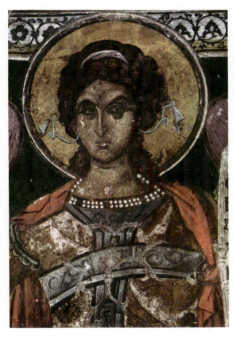

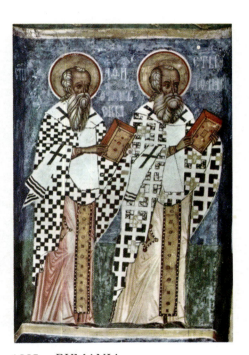

1510 - BULGARIA

1512 - BULGARIA

1605 - RUMANIA

RUMANIA, Painted Churches of Moldavia

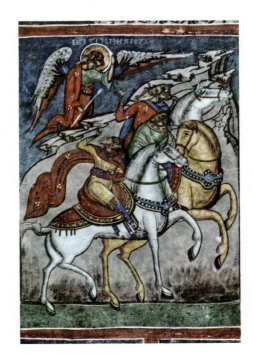

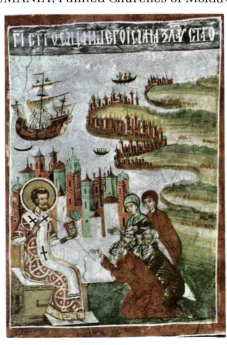

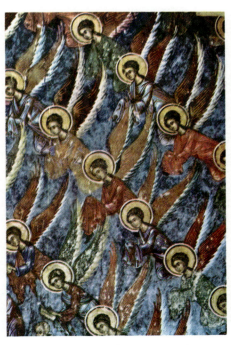

1603 - RUMANIA

1606 - RUMANIA

1604 - RUMANIA

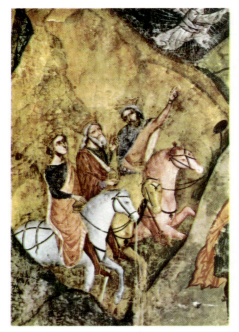

1519 - CYPRUS

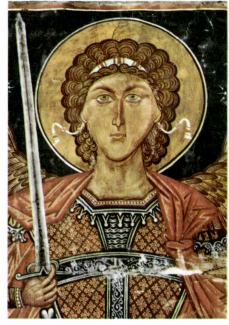

1520 - CYPRUS

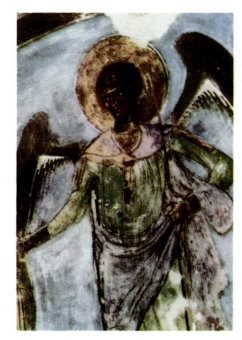

1518 - CYPRUS

1517 - CYPRUS

1542 - GREECE

GREECE, Byzantine Mosaics

1540 - GREECE

1538 - GREECE

1541 - GREECE

1508 - AUSTRIA

1507 - AUSTRIA

AUSTRIA, Mediaeval Wall Paintings

1597 - POLAND

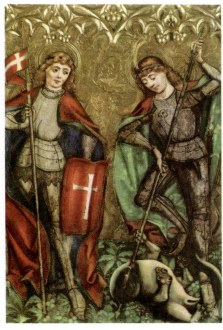

1601 - POLAND

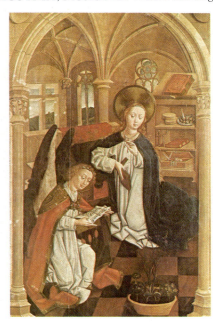

1602 - POLAND

POLAND, Painting of the Fifteenth Century

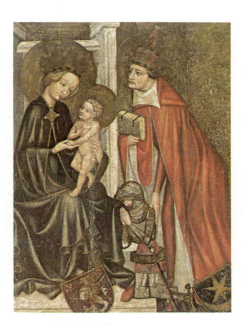

1596 - POLAND

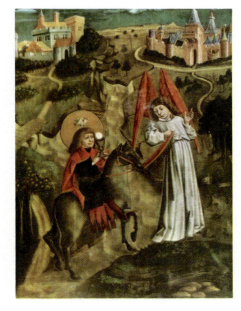

1599 - POLAND

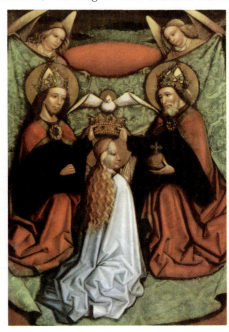

1598 - POLAND

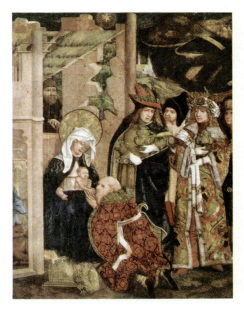

1600 - POLAND

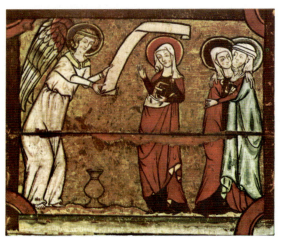

1594 - NORWAY

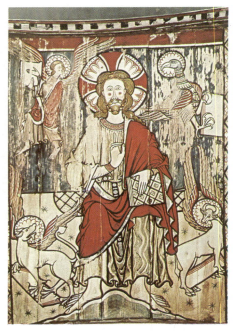

1588 - NORWAY

1591 - NORWAY

NORWAY, Paintings from Stave Churches

1590 - NORWAY

1595 - NORWAY

1592 - NORWAY

1593 - NORWAY

1589 - NORWAY

1647 - U.S.S.R

1637 - U.S.S.R.

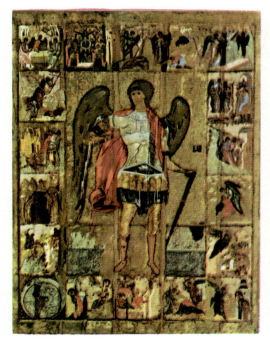

1640 - U.S.S.R.

U.S.S.R., Early Russian Icons

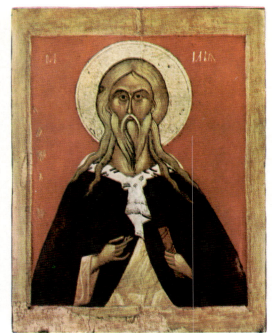

1644 - U.S.S.R.

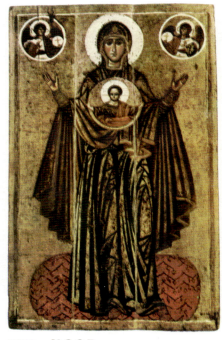

1641 - U.S.S.R

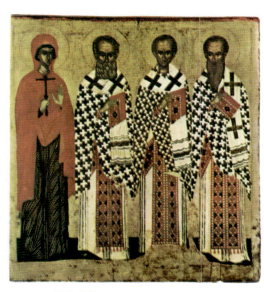

1635 - U.S.S.R

1646 - U.S.S.R.

1639 - U.S.S.R.

1642 - U.S.S.R.

51

1636 - U.S.S.R.

1650 - U.S.S.R.

1648 - U.S.S.R.

1645 - U.S.S.R.

1643 - U.S.S.R.

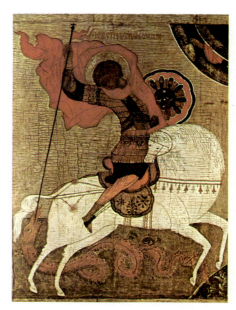

1638 - U.S.S.R.

CZECHOSLOVAKIA, Romanesque and Gothic Illuminated Manuscripts

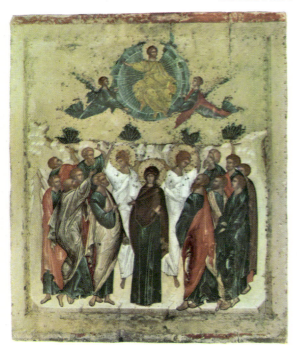

1649 - U.S.S.R.

1522 - CZECHOSLOVAKIA

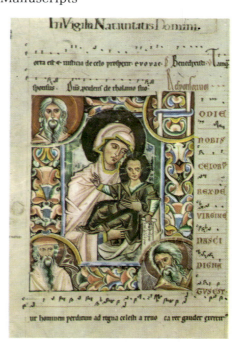

1521 - CZECHOSLOVAKIA

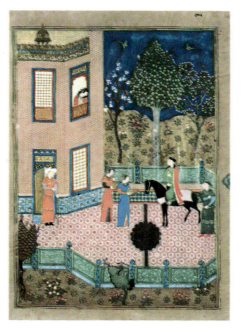

1544 - IRAN

1543 - IRAN

1545 - IRAN

IRAN, Persian Miniatures

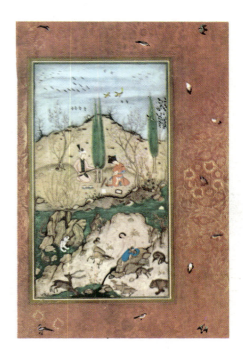

1546 - IRAN

1547 - IRAN

1551 - IRAN

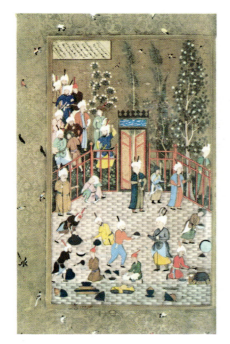

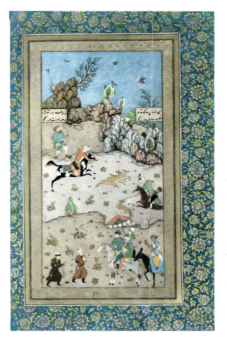

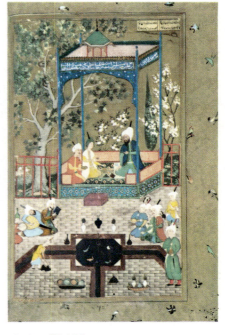

1550 - IRAN

1548 - IRAN

1549 - IRAN

1621 - TURKEY

1620 - TURKEY

1626 - TURKEY

TURKEY, Ancient Miniatures

1622 - TURKEY

1624 - TURKEY

1623 - TURKEY

1625 - TURKEY

1568 - JAPAN

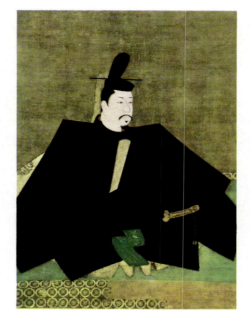

1576 - JAPAN

JAPAN, Ancient Buddhist Paintings

1569 - JAPAN

1572 - JAPAN

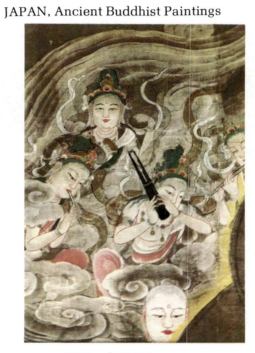

1574 - JAPAN

1573 - JAPAN

1570 - JAPAN

1571 - JAPAN

1575 - JAPAN

1578 - JAPAN

1580 - JAPAN

1581 - JAPAN

1577 - JAPAN

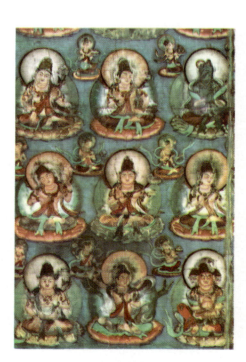

1567 - JAPAN

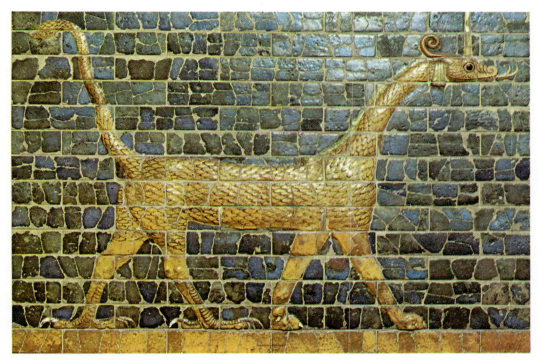

Babylonian, Reign of Nebuchadnezzar II, 604-562 B.C.
THE DRAGON OF BEL-MARDUK *(Detail from the Ishtar Gate)*
The Detroit Institute of Arts
Gift of the Founders Society, General Membership Fund, 1931
7482 - 20"x29¾" (52x76 cm)

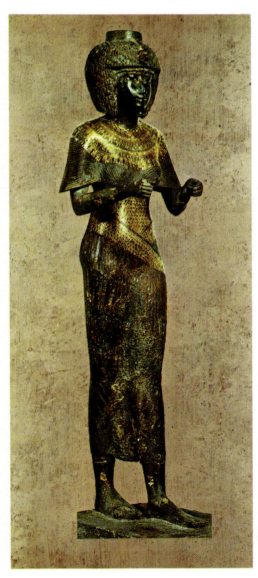

Egyptian, XXII Dynasty, *950-c. 730 B.C.*
QUEEN KAROMANA, WIFE OF
THELETH II
Louvre Museum, Paris
9630 - 37¼"x16" (94x40 cm)

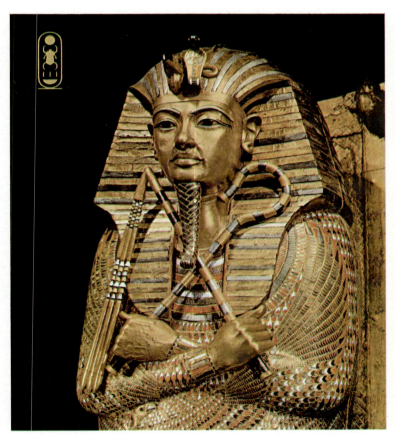

Egyptian, XVIII Dynasty, *14th Century B.C.*
GOLDEN EFFIGY OF KING TUTANKHAMEN
Cairo Museum
6836 - 21½"x18¾" (54x47 cm)

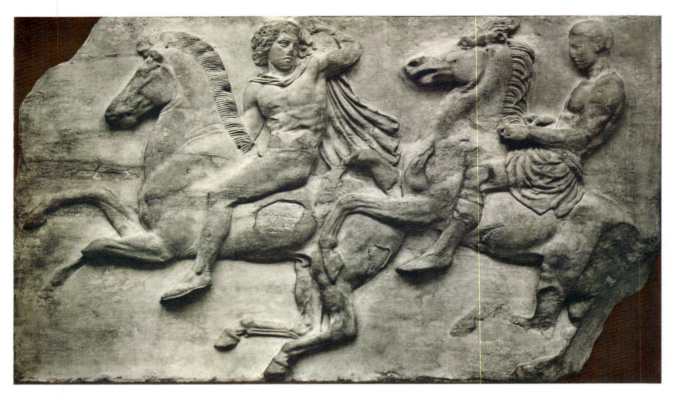

Greek, Parthenon West Frieze *(Elgin Marbles)*, c. 440 B.C.
HORSEMEN IN THE PANATHENAIC PROCESSION
The British Museum, London
9546 - 20¾"x35½" (52x90 cm)

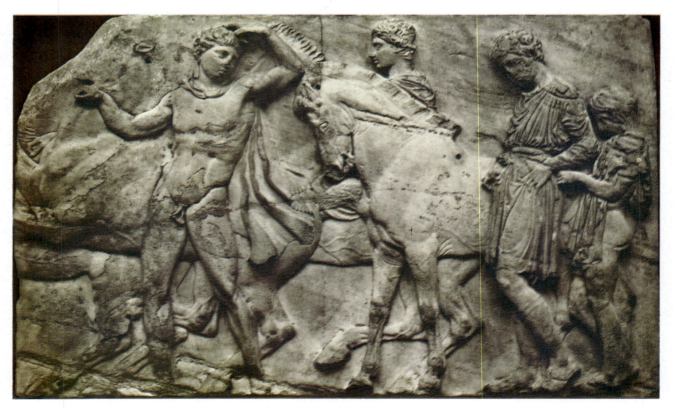

Greek, Parthenon North Frieze *(Elgin Marbles)*, c. 440 B.C.
HORSEMEN PREPARING FOR THE PANATHENAIC PROCESSION
The British Museum, London
9545 - 21½"x35½" (54x90 cm)

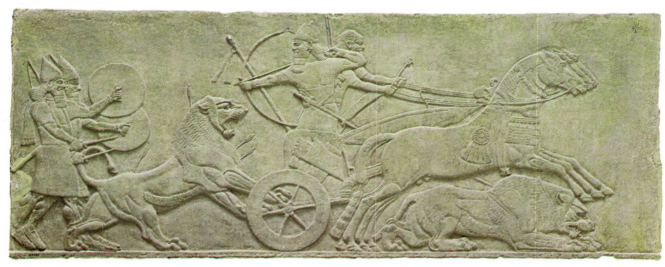

Assyrian, Ashurnasirpal II, *883-859 B.C.*
THE KING IN HIS CHARIOT HUNTING LIONS
The British Museum, London
9550 - 15"x38" (38x96 cm)

Assyrian, Ashurnasirpal II, *883-859 B.C.*
ASSYRIAN CHARIOTS OVERTHROWING THE ENEMY'S CHARIOTS,
ACCOMPANIED BY FOOT SOLDIERS
The British Museum, London
9551 - 14¾"x37¾" (37x96 cm)

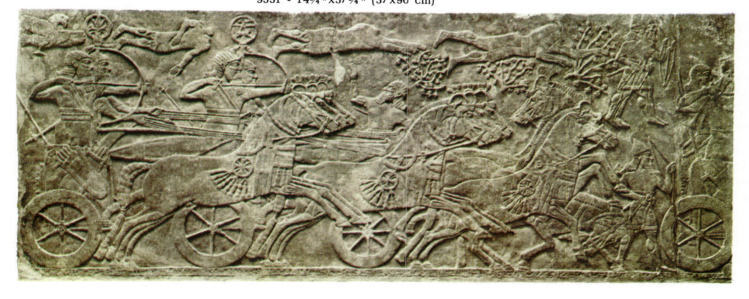

Etruscan, *c.510 B.C.*
FRESCO WITH HORSES
Tomb of the Barons, Tarquinia
8013 - 9"x32¾" (23x83 cm)

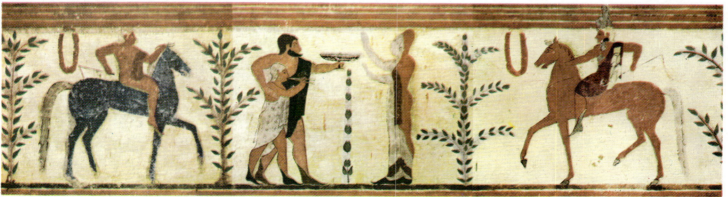

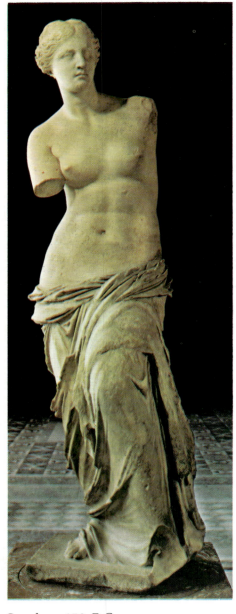

Etruscan, *Early VI Century B.C.*
RED-FIGURED CRATER
Villa Giulia Museum, Rome
4416 - 14¾″x11″ (37x28 cm)

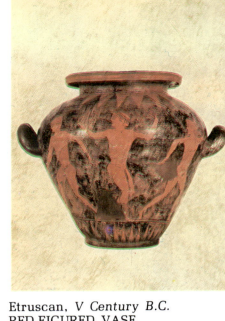

Etruscan, *V Century B.C.*
RED-FIGURED VASE
Villa Giulia Museum, Rome
4415 - 14¾″x11″ (37x28 cm)

Greek, *c.150 B.C.*
VENUS DE MILO (APHRODITE OF MELOS)
Louvre Museum, Paris
9570 - 37½″x13½″ (95x34 cm)

Etruscan, *c.540-530 B.C.*
AMPHORA WITH BLACK FIGURES
Staatliche Antikensammlungen, Munich
4413 - 14¾″x11″ (37x28 cm)

Etruscan, *Early IV Century B.C.*
BLACK-FIGURED AMPHORA
National Museum, Parma
4414 - 14¾″x11″ (37x28 cm)

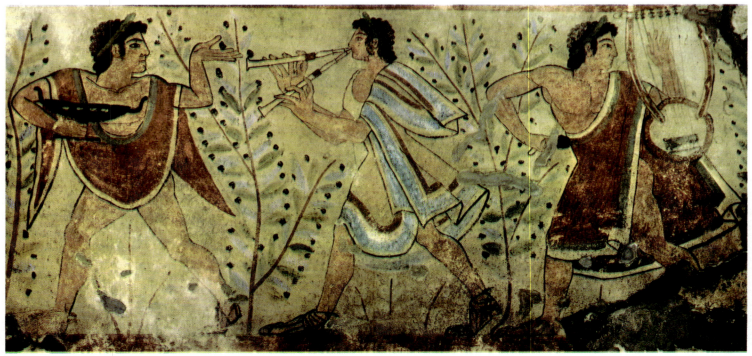

Etruscan, c. 475 B.C. MUSICIANS
Tomb of the Leopards, Tarquinia
8014 - 15″x30½″ (38x77 cm)

Luca della Robbia *(Italian, c.1400-1482)*
MADONNA WITH THE LILIES, *c.1480*
Museum of Fine Arts, Boston
5395 - 20″x15¾″ (51x40 cm)

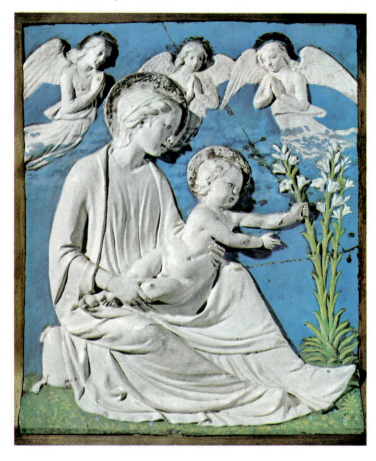

Stefano di Giovanni Sassetta *(Italian, c.1392-1450)*
SAINT ANTHONY LEAVING HIS MONASTERY, **c.1440**
National Gallery of Art, Washington, D.C.
Samuel H. Kress Collection
5117 - 18½″x13¾″ (47x35 cm)

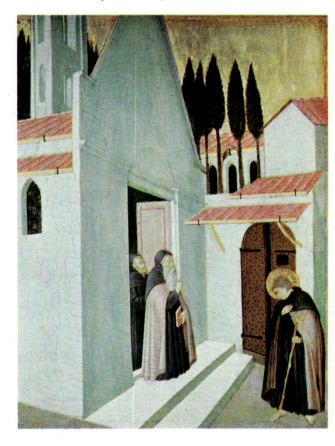

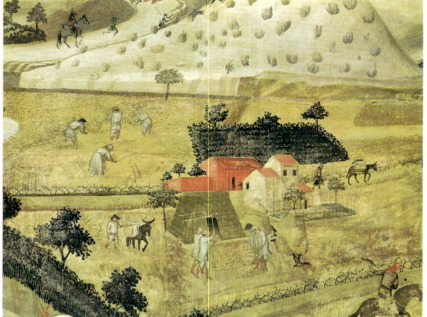

Ambrogio Lorenzetti *(Italian, c.1300-c.1348)*
THE EFFECT OF GOOD GOVERNMENT
IN THE COUNTRY, *c.1338*
(Detail from Allegories of Good and Evil Government)
Public Palace, Siena
7628 - 23¾"x30" (60x76 cm)

Fra Angelico (Giovanni da Fiesole) *(Italian, 1387-1455)*
THE MADONNA OF HUMILITY, c.1440
National Gallery of Art, Washington, D.C.
Mellon Collection
6324 - 24¾"x18½" (63x47 cm)

Byzantine School *(XIII Century)*
ENTHRONED MADONNA AND CHILD
National Gallery of Art, Washington, D.C.
Mellon Collection
7092 - 28"x17" (71x43 cm)

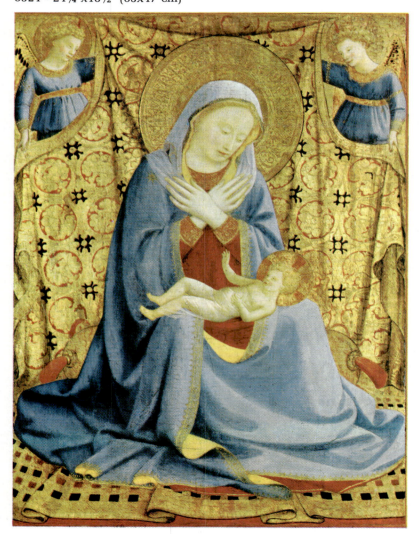

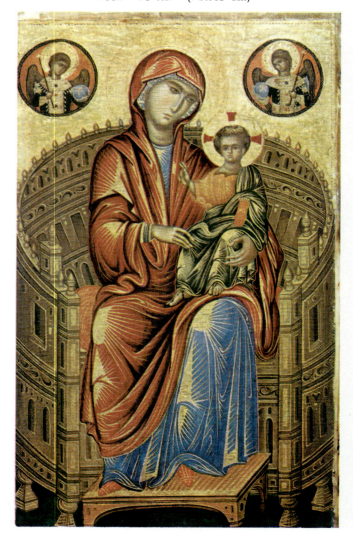

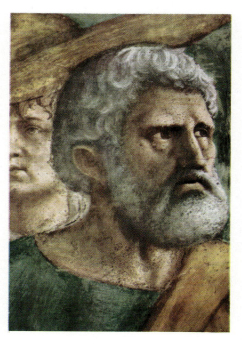

1651 - MASACCIO

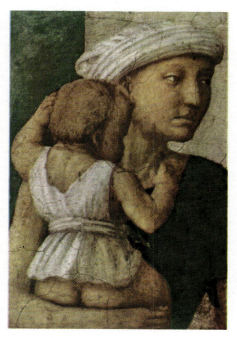

1654 - MASACCIO

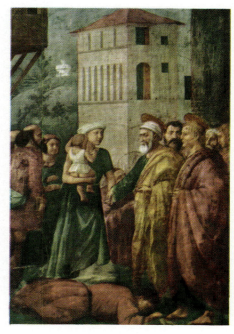

1653 - MASACCIO

MASACCIO, Frescoes in Florence
UNESCO World Art Series single plates
(Details from "The Tribute Money")
Average picture size 14"x11" (35x28 cm)

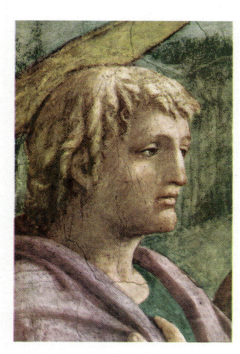

1652 - MASACCIO

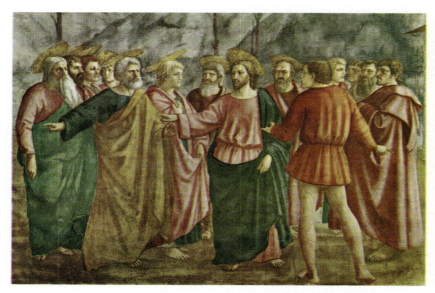

Masaccio (Tommaso Guido) *(Italian, 1401-1428)*
THE TRIBUTE MONEY *(detail),* c.1425
Brancacci Chapel, Florence
6085 - 15"x22" (38x56 cm)

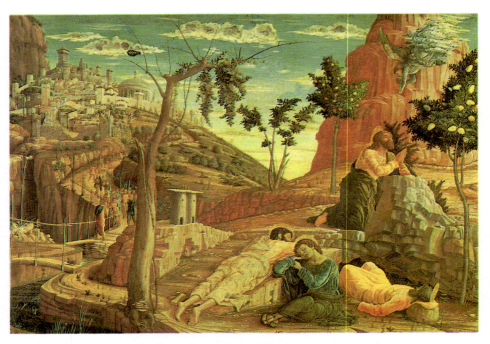

Andrea Mantegna *(Italian, 1431-1506)*
CHRIST IN THE GARDEN OF OLIVES
Musée des Beaux-Arts, Tours
7863 - 20″x28″ (51x71 cm)

Giovanni Bellini
MADONNA AND CHILD IN A LANDSCAPE, c.1500
National Gallery of Art, Washington, D.C.
Samuel H. Kress Collection
6497 - 24″x18½″ (61x47 cm)

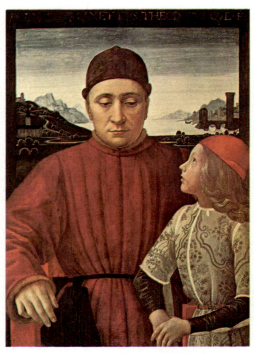

Domenico del Ghirlandaio *(Italian, 1449-1494)*
FRANCESCO SASSETTA AND
HIS SON TEODORO, 1472
The Metropolitan Museum of Art, New York
The Jules Bache Collection
644 - 22″x16″ (57x40 cm)

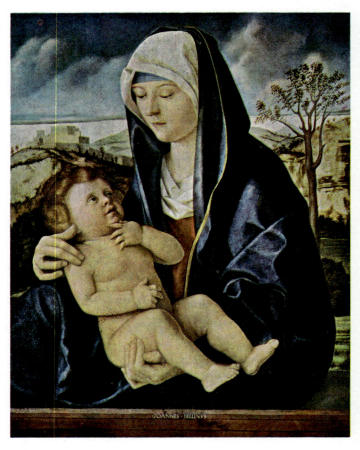

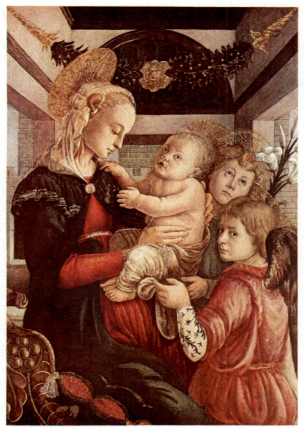

Sandro Botticelli
MADONNA AND CHILD WITH ANGELS, c.1465
National Gallery of Art, Washington, D.C.
Samuel H. Kress Collection
8045 - 30½"x20½"(77x52 cm)

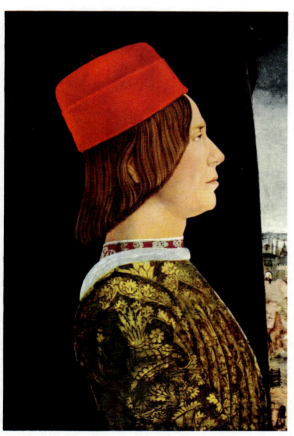

Ercole Roberti *(Italian, 1456-1496)*
GIOVANNI II BENTIVOGLIO, c. 1480
National Gallery of Art, Washington, D.C.
Samuel H. Kress Collection
514 - 21"x14½" (53x37 cm)

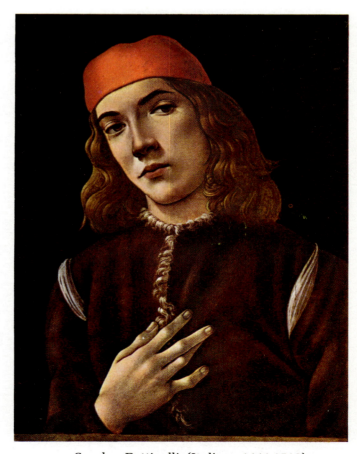

Sandro Botticelli *(Italian, 1444-1510)*
PORTRAIT OF A YOUTH, c. 1483-1484
National Gallery of Art, Washington, D.C.
Mellon Collection
422 - 15½"x12" (39x30 cm)

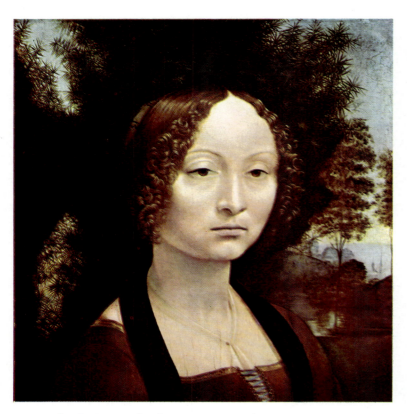

Leonardo da Vinci (Italian, 1452-1519)
GINEVRA DE'BENCI, c.1480
National Gallery of Art, Washington, D.C.
4506 - 15"x14¼" (38x35 cm)

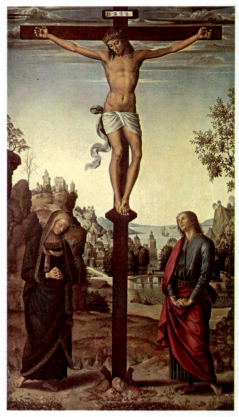

Pietro Perugino (Italian, 1446-1523)
THE CRUCIFIXION WITH
THE VIRGIN AND ST. JOHN, c.1485
National Gallery of Art, Washington, D.C.
Mellon Collection
6719 - 24"x13" (61x33 cm)

Leonardo da Vinci
THE VIRGIN AND CHILD WITH ST. ANNE
AND JOHN THE BAPTIST, c. 1499
National Gallery, London
7331 - 29¾"x22" (75x56 cm)

Leonardo da Vinci
MONA LISA, *1503*
Louvre Museum, Paris
5217 - 18½"x12¾" (47x32 cm)
3275 - 10"x6½" (25x16 cm)

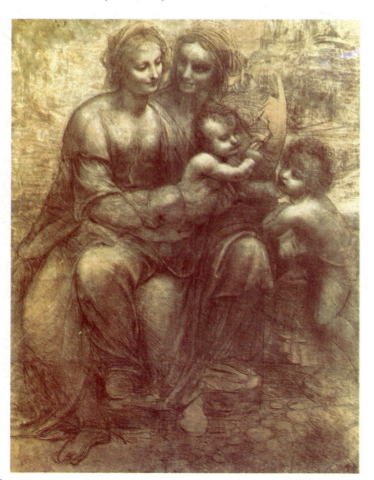

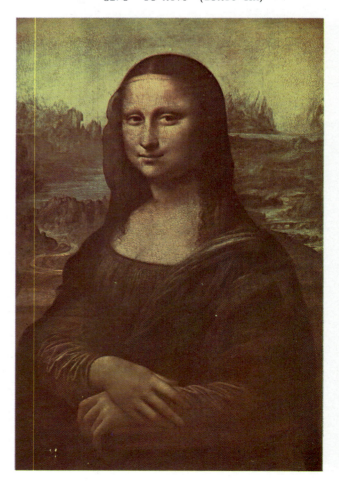

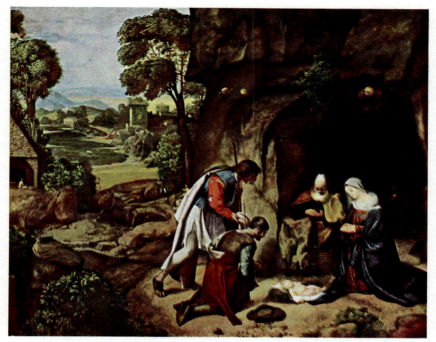

Giorgione (Giorgio da Castelfranco) (Italian, 1478-1510)
THE ADORATION OF THE SHEPHERDS, c.1510
National Gallery of Art, Washington, D.C.
Samuel H. Kress Collection
748 - 24¼"x30" (61x76 cm)

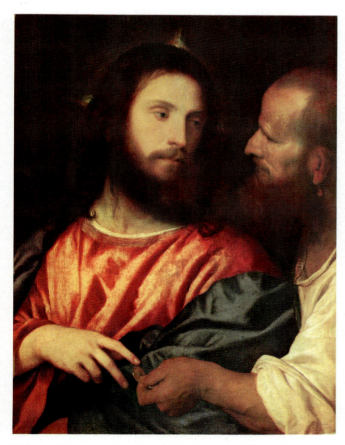

Titian (Tiziano Vecellio) (Italian, 1477-1576)
THE TRIBUTE MONEY, 1514
Staatliche Gemäldesammlungen, Dresden
7089 - 26"x19½" (66x49 cm)
5225 - 18½"x13¾" (47x35 cm)

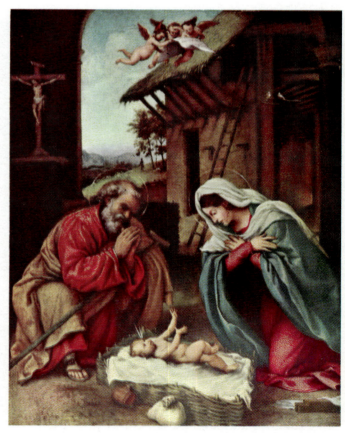

Lorenzo Lotto (Italian, 1480-1556)
THE NATIVITY, 1523
National Gallery of Art, Washington, D.C.
Samuel H. Kress Collection
5491 - 17¾"x13½" (45x34 cm)

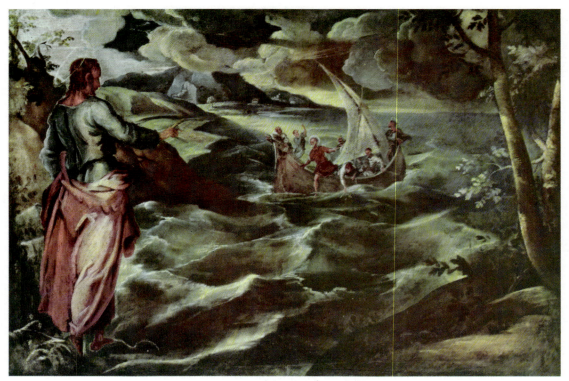

Jacopo Tintoretto *(Italian, 1518-1594)*
CHRIST AT THE SEA OF GALILEE, c.1562
National Gallery of Art, Washington, D.C.
Samuel H. Kress Collection
858 - 21¼"x31" (54x78 cm)

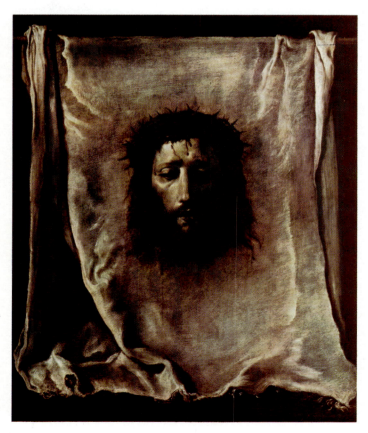

Domenico Feti *(Italian, 1589-1624)*
THE VEIL OF VERONICA, c.1613-21
National Gallery of Art, Washington, D.C.
Samuel H. Kress Collection
5396 - 24"x19¾" (61x50 cm)

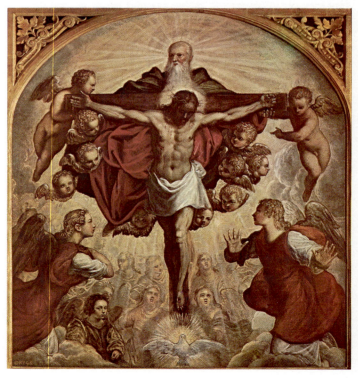

Jacopo Tintoretto
THE TRINITY ADORED BY THE HEAVENLY CHOIR
Columbia Museum of Art, Columbia, S.C.
Samuel H. Kress Collection
5252 - 20"x18¼" (50x46 cm)

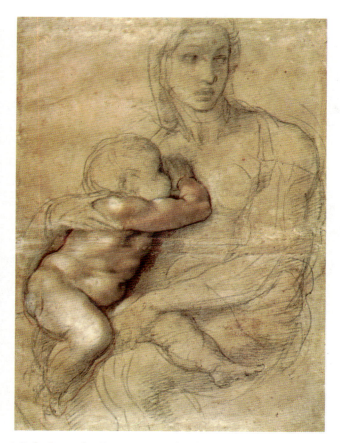

Michelangelo Buonarroti *(Italian, 1475-1564)*
MADONNA AND CHILD, *c.1512*
Casa Buonarroti, Florence
6390 - 21¼"x15½" (54x39 cm)

Michelangelo Buonarroti
EPIPHANY, *c.1550*
The British Museum, London
The Malcolm Collection
6391 - 21¼"x15½" (54x36 cm)

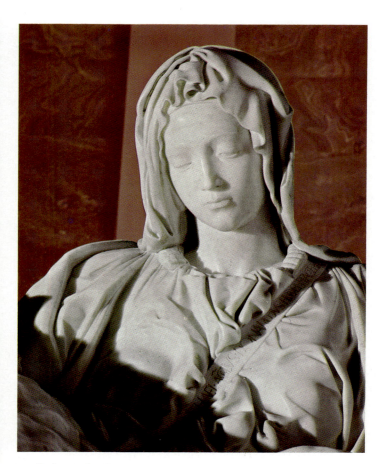

Michelangelo Buonarroti
MATER DOLOROSA *(Detail from "Pieta")*
St. Peter's, Rome
5116 - 20"x16" (51x41 cm)

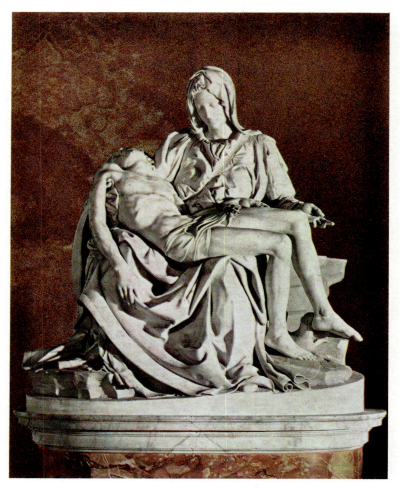

Michelangelo Buonarroti
PIETA, 1498-99
St. Peter's, Rome
7096 - 28"x22" (71x56 cm)
4096 - 14"x11" (35x28 cm)

69

Dosso Dossi *(Italian, 1479-1541)*
CIRCE AND HER LOVERS IN A LANDSCAPE, *c.* 1514
National Gallery of Art, Washington, D.C.
Samuel H. Kress Collection
861 - 23″×31½″ (58×80 cm)

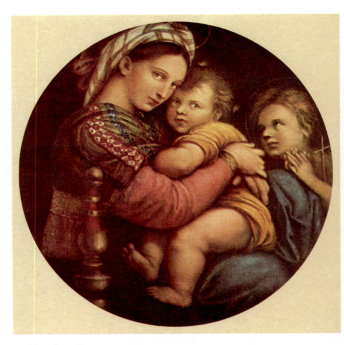

Raphael (Raffaello Sanzio) *(Italian, 1483-1520)*
MADONNA DELLA SEDIA, 1510-12
Pitti Palace, Florence
6398 - 22¼″x17¾″ (56x45 cm)

Raphael
MADONNA DELLA SEDIA, 1510-12
Pitti Palace, Florence
7398 - 24½″x24½″ background (62x62 cm)
 (24″ circle)

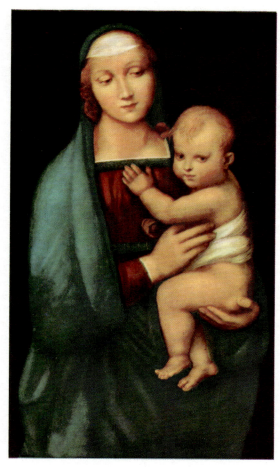

Raphael
MADONNA DEL GRANDUCA, *1504-05*
Pitti Palace, Florence
6737 - 24"x13¾" (61x35 cm)
3090 - 10"x5¾" (25x14 cm)

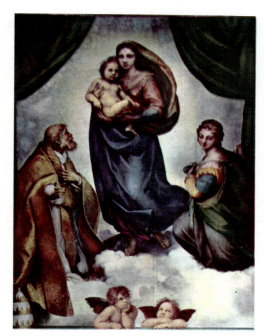

Raphael
SISTINE MADONNA, *1515-1519*
Staatliche Gemaldesammlungen, Dresden
6091 - 24"x17¾" (61x45 cm)
5222 - 21"x15½" (53x39 cm)

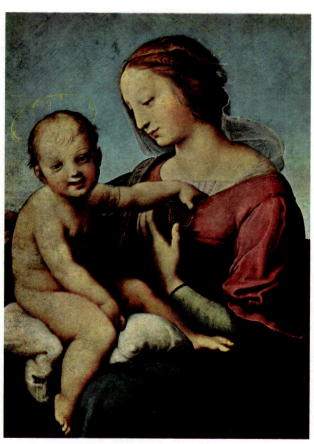

Raphael
NICCOLINI-COWPER MADONNA, *1508*
National Gallery of Art, Washington, D.C.
Mellon Collection
6718 - 24"x16½" (61x42 cm)

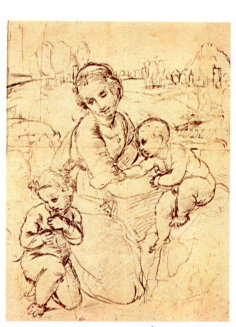

Raphael
THE VIRGIN WITH THE CHILD
AND ST. JOHN
Uffizi Gallery, Florence
4157 - 14½" x10½" (36x26 cm)

Tuscan, *Early 15th Century*
ANIMALS AND GROUPS OF ANIMALS
3642 - 9"x6¾" (22x17 cm)

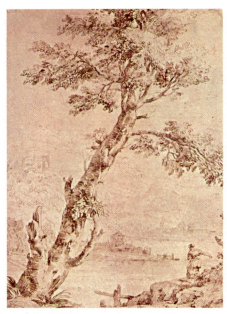

Marco Ricci *(Italian, 1676-1730)*
RIVERSIDE SCENE WITH LARGE TREE
3641 - 12"x8½" (30x21 cm)

Paolo Veronese *(Italian, 1530-1588)*
PASTORAL LANDSCAPE
WITH FLOCK AND SHEPHERDESS
3643 - 6½"x9¾" (16x24 cm)

Alessio De Marchis *(Italian, 1684-1752)*
RIVERSIDE SCENE WITH A HERD OF COWS
3635 - 6"x9¾" (15x24 cm)

Francesco Guardi *(Italian, 1712-1793)*
THE GRAND CANAL BEYOND RIALTO
3637 - 10"x9½" (25x24 cm)

Gian Paolo Panini *(Italian, 1691-1765)*
PORTICO WITH DOUBLE IONIC COLUMNS
3640 - 12"x8½" (30x21 cm)

Annibale Carracci *(Italian, 1560-1609)*
NUDE STUDY OF A YOUNG MAN
3630 - 8¼"x9¾" (21x24 cm)

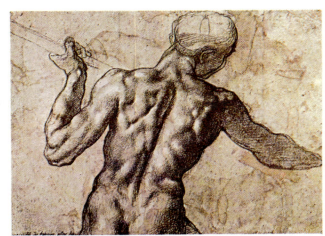

Michelangelo Buonarroti *(Italian, 1475-1564)*
MALE NUDE, BACK VIEW
3639 - 7¼"x9¾" (18x24 cm)

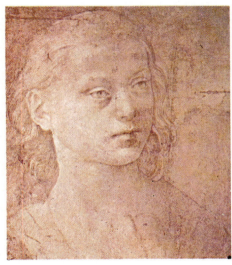

Lorenzo di Credi
(Italian, 1456 / 59-1537)
BOY'S HEAD
3633 - 7¾"x6½" (19x16 cm)

Guercino (G.F. Barbieri)
ST. DOMENICUS KNEELING
BEFORE MADONNA AND CHILD
3638 - 10½"x8" (26x20 cm)

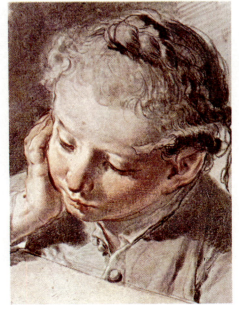

Ubaldo Gandolfi *(Italian, 1728-1781)*
A BOY'S HEAD
3636 - 11¼"x8" (28x20 cm)

Lorenzo Costa *(Italian, 1459/60-1535)*
PORTRAIT OF A MAN
3631 - 11½"x8¼" (29x21 cm)

Pietro da Cortona *(Italian, 1596-1669)*
YOUNG WOMAN'S HEAD
3632 - 11"x8¼" (28x21 cm)

Leonardo da Vinci
WOMAN IN PROFILE
Uffizi Gallery, Florence
4160 - 14½"x10¼" (36x26 cm)

Leonardo da Vinci
(Italian, 1452-1519)
APOSTLE
3634 - 5½"x4¼" (14x10 cm)

Donato Creti (Italian, 1671-1749)
THE ASTRONOMERS
The Art Institute of Chicago
3038 - 7½"x10" (19x25 cm)

Guercino (G. F. Barbieri) (Italian, 1591-1666)
SUSANNA AND THE ELDERS
Ambrosiana Gallery, Milan
4162 - 11½"x10½" (29x26 cm)

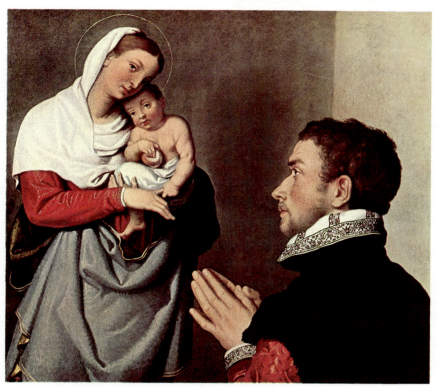

Giovanni Battista Moroni *(Italian, 1525-1578)*
A GENTLEMAN IN ADORATION BEFORE THE MADONNA, c.1560
National Gallery of Art, Washington, D.C.
Samuel H. Kress Collection
623 - 20"x21¾" (51x55 cm)

Bronzino
PORTRAIT OF A YOUNG MAN, *late 1530's*
The Metropolitan Museum of Art, New York
The H. O. Havemeyer Collection
9823 - 37¾"x29½" (96x75 cm)
7813 - 26"x20" (66x51 cm)
4823 - 14"x10¾" (35x27 cm)

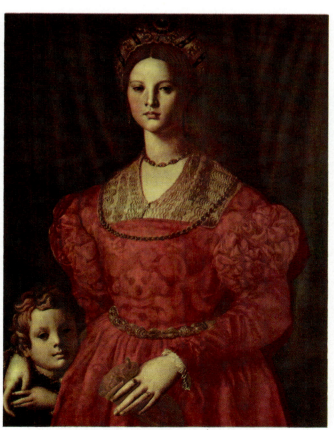

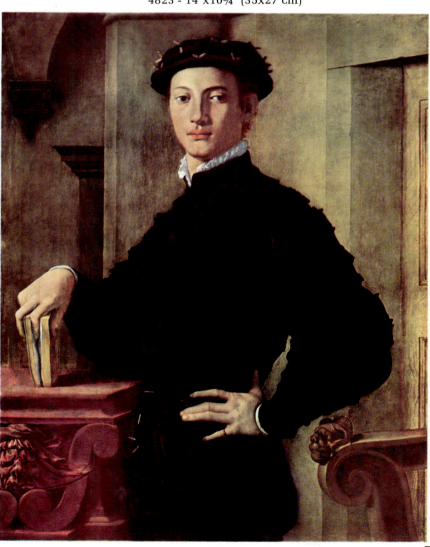

Bronzino (Angelo de Cosimo ~~Fiori~~) *(Italian, 1503-1572)*
A YOUNG WOMAN AND ~~HER~~ LITTLE BOY, c. 1540
National Gallery of Art, Washington, D.C.
Widener Collection
7524 - 27¾"x21¼" (70x54 cm)

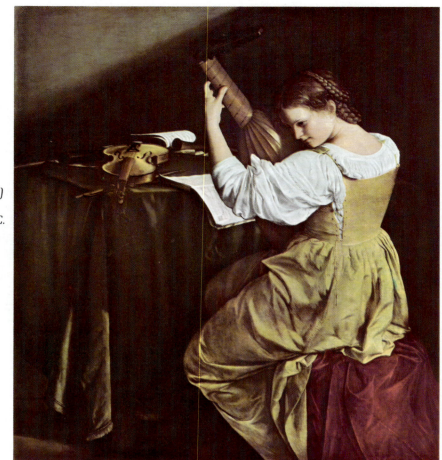

Orazio Gentileschi *(Italian, 1565-1638)*
THE LUTE PLAYER, c.1626
National Gallery of Art, Washington, D.C.
Gift of Mrs. Mellon Bruce
7395 - 26″x23¼″ (66x59 cm)

Orazio Gentileschi
YOUNG WOMAN WITH A VIOLIN, 1612
The Detroit Institute of Arts
7875 - 23½″x28″ (59x71 cm)

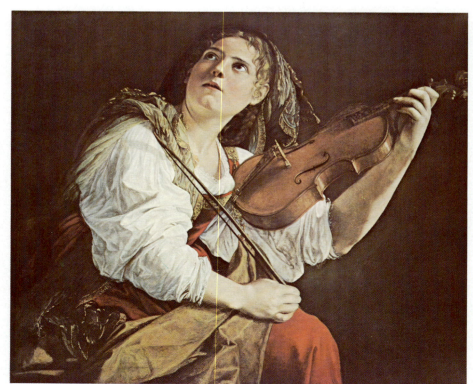

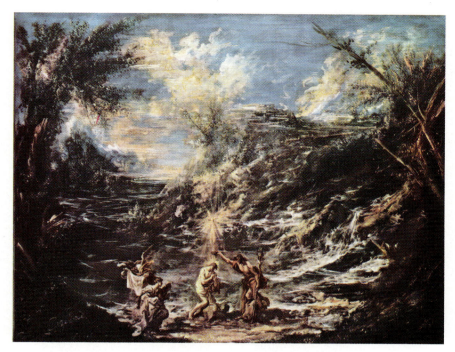

Alessandro Magnasco (*Italian, 1677-1749*)
THE BAPTISM OF CHRIST, c.1740
National Gallery of Art, Washington, D.C.
Samuel H. Kress Collection
747 - 24"x30" (61x76 cm)

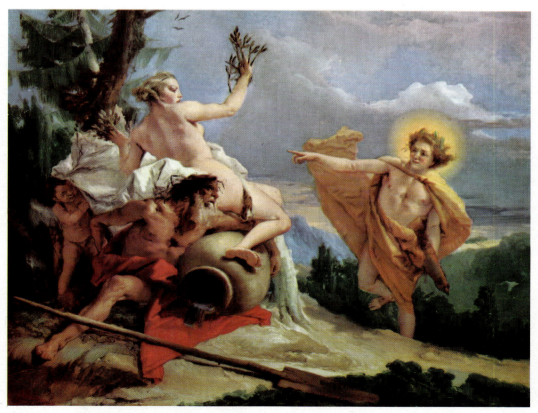

Giovanni Battista Tiepolo (*Italian, 1696-1770*)
APOLLO PURSUING DAPHNE, c.1765
National Gallery of Art. Washington, D.C.
Samuel H. Kress Collection
801 - 23½"x30" (60x76 cm)

3662 - Jewel Case

3661 - Agate Cup

3663 - Red Jasper

3672 - Jasper Vase

3670 - Gold Flask

3668 - Cup with Hercules

3669 - Ewer

3667 - Silver Gilt Ewer

3673 - Lapis Lazuli Vase

3666 - Venus and Cupid

3665 - Cosimo II de'Medici

3671 - Rock Crystal

3664 - Tiberius

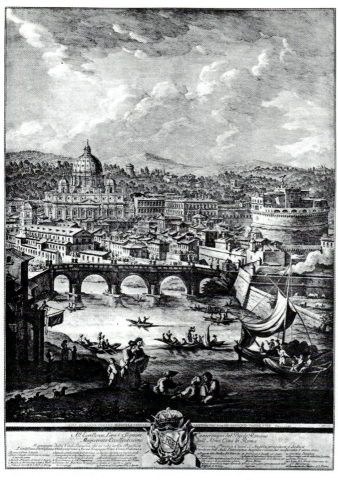

9568 - VIEW OF ROME WITH TIBER BRIDGE, 1765

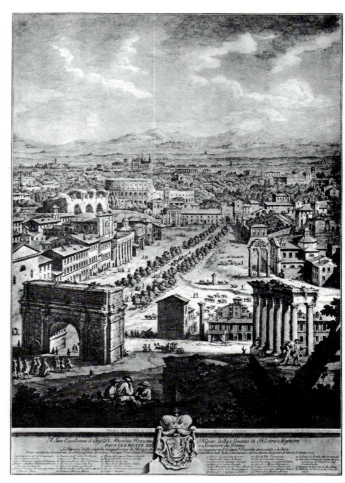

9567 - RUINS OF ANCIENT ROME, 1765

Giuseppe Vasi (*Italian, 1710-1782*)
Hand printed engravings with platemark
Private Collection
All four subjects 35½"x24½" (90x62 cm)

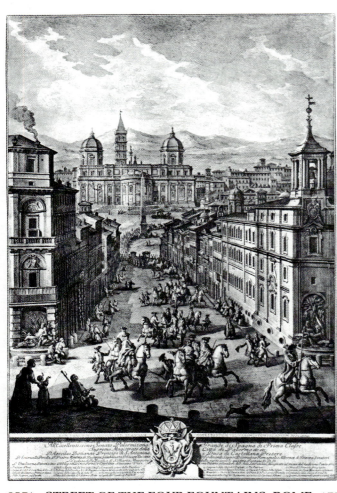

9571 - STREET OF THE FOUR FOUNTAINS, ROME, 1771

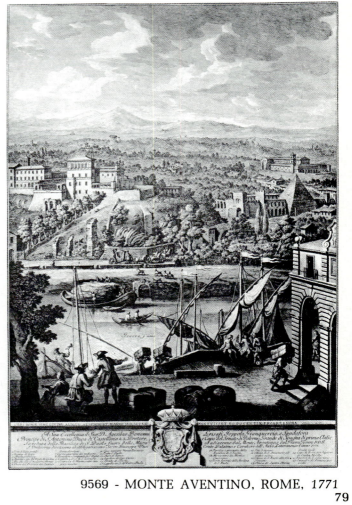

9569 - MONTE AVENTINO, ROME, 1771

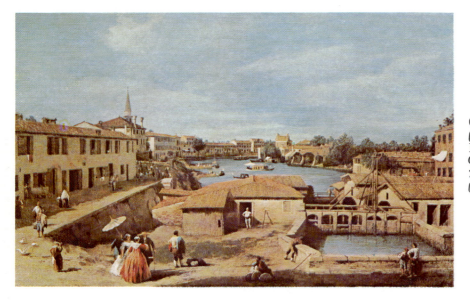

Canaletto (Giovanni Antonio Canale)
(Italian, 1697-1768)
LE CHIUSE DEL DOLO
Oxford Ashmolean Museum
7865 - 18"x27½" (45x69 cm)
(For sale in U.S.A. only)

Canaletto
THE TERRACE, c.1745
The Art Institute of Chicago
Gift of Mrs. Clive Runnels
6095 - 18¾"x22¾" (47x58 cm)

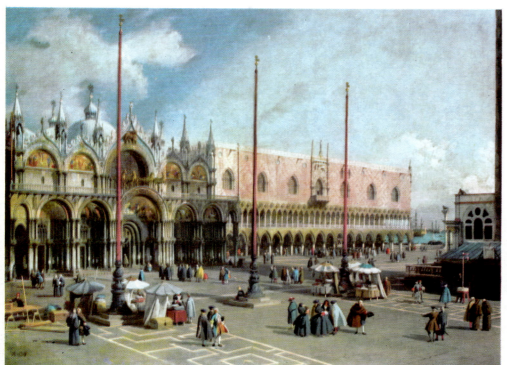

Canaletto
THE SQUARE OF ST. MARK, c.1740
National Gallery of Art, Washington, D.C.
Gift of Mrs. Barbara Hutton
489 - 10¼"x14" (26x35 cm)

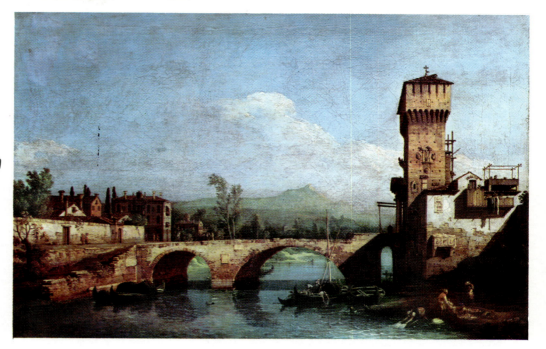

Bernardo Bellotto (Italian, 1720-1780)
BRIDGE OVER THE BRENTA
Thyssen-Bornemisza Collection, Lugano
7332 - 18¾"x28¼" (47x71 cm)

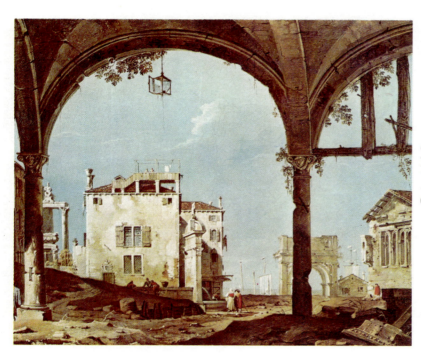

Canaletto
PORTICO WITH LANTERN, c.1745
The Art Institute of Chicago
Gift of Mrs. Clive Runnels
6094 - 18¾"x22¾" (47x58 cm)

Canaletto
THE QUAY OF THE PIAZZETTA, c.1740
National Gallery of Art, Washington, D.C.
Gift of Mrs. Barbara Hutton
990 - 26¾"x36" (68x91 cm)
490 - 10¼"x14" (26x35 cm)

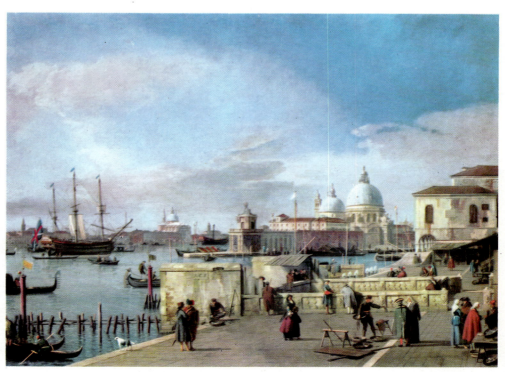

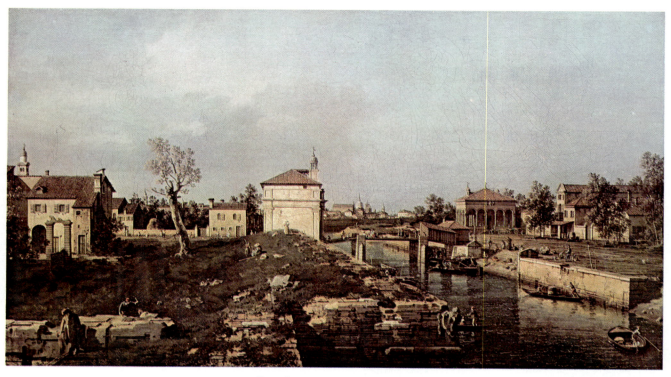

Canaletto
THE PORTELLO AND THE BRENTA CANAL AT PADUA, c.1735-40
National Gallery of Art, Washington, D.C.
Samuel H. Kress Collection
9087 - 22¾"x40" (57x101 cm)

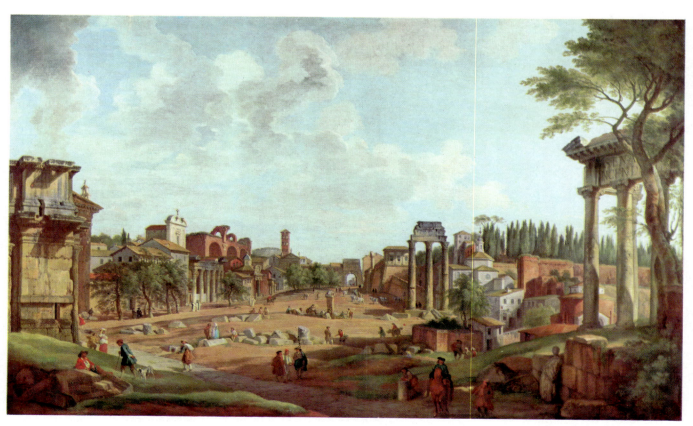

Giovanni Paolo Panini (Italian, 1692-1764)
VIEW OF THE ROMAN FORUM, 1747
The Walters Art Gallery, Baltimore
9541 - 24½"x40" (62x101 cm)

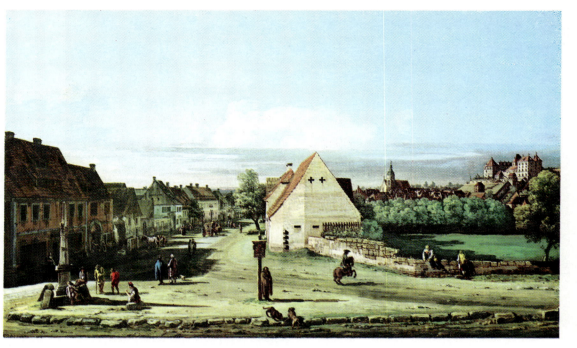

Bernardo Bellotto
VIEW OF PIRNA WITH THE
FORTRESS OF SONNENSCHEIN, *1752*
Art Institute of Chicago
Clyde M. Carr Fund
8276 - 19"x31" (48x79 cm)

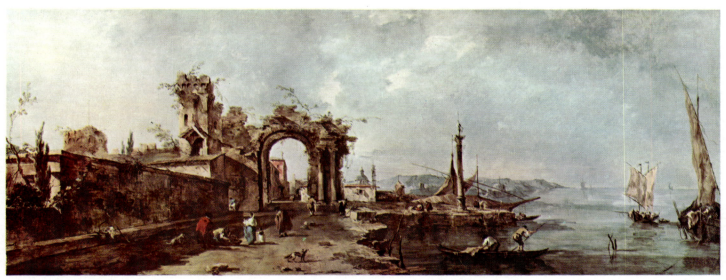

Francesco Guardi *(Italian, 1712-1793)*
FANTASTIC LANDSCAPE, c.1760
(From the Castello di Colloredo, Udine)
The Metropolitan Museum of Art, New York
9088 - 15½"x40" (39x100 cm)

Bernardo Bellotto
THE CASTLE OF NYMPHENBURG, *1761*
National Gallery of Art, Washington, D.C.
Samuel H. Kress Collection
9090 - 20½"x35¾" (52x91 cm)

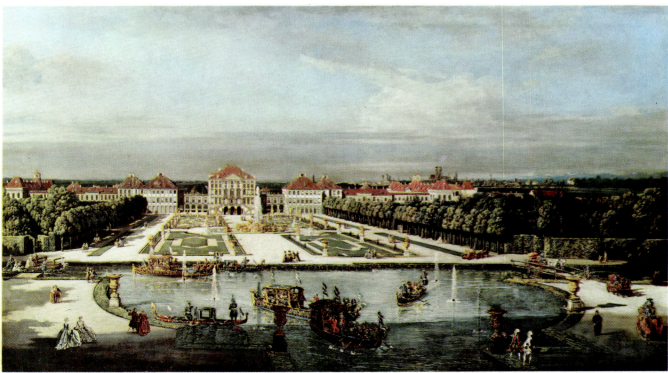

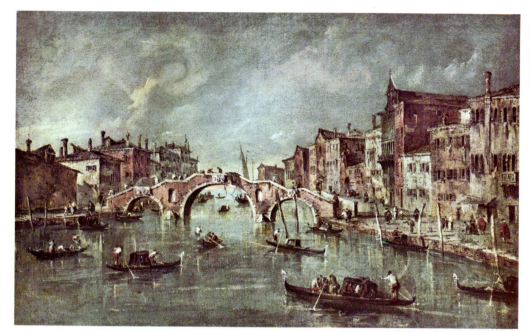

Francesco Guardi
VIEW ON THE CANNAREGGIO, c.1770
National Gallery of Art, Washington, D.C.
Samuel H. Kress Collection
770 - 16"x24¾" (41x63 cm)

Adolf Friedrich Harper *(German, 1725-1806)*
ITALIAN LANDSCAPE, *1799*
National-Galerie, Berlin
9650 - 25½"x40" (64x101 cm)

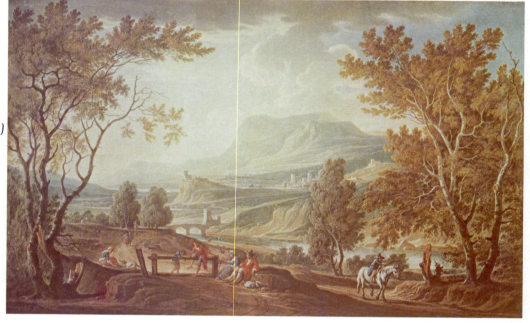

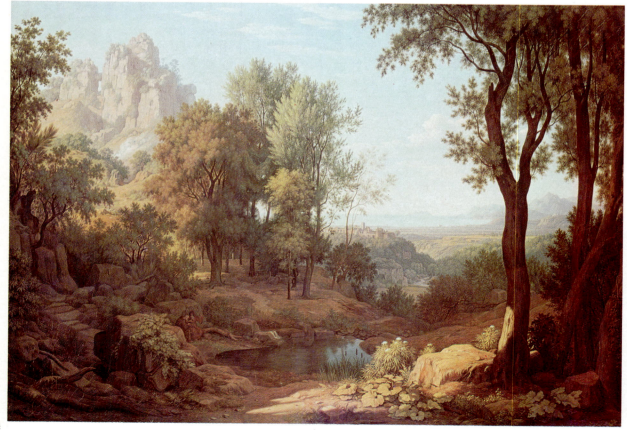

Johann Martin von Rohden
(German, 1778-1868)
MIDDAY, *1829*
Staatliche Kunstsammlungen Kassel
Neue Galerie
8107—24"×33½" (61×85 cm)

84

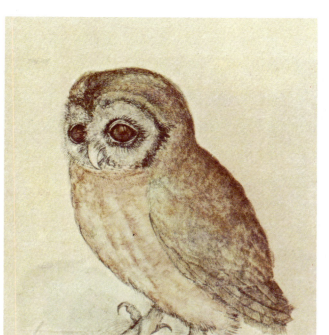

Albrecht Dürer
THE LITTLE OWL, 1508
3740—7½″ × 5½″ (18 × 13 cm)

Matthias Grünewald (German, 1475/80-1528)
THE CRUCIFIXION, 1505-10
National Gallery of Art, Washington, D.C.
Samuel H. Kress Collection
7260 - 24″x18″ (61x45 cm)

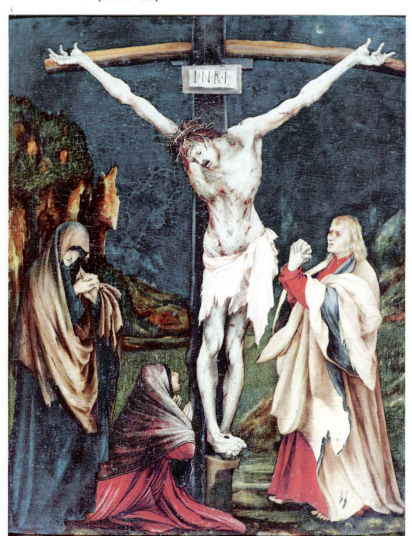

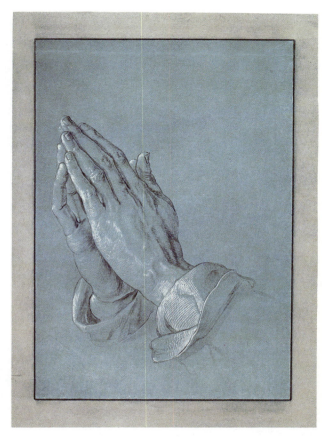

Albrecht Dürer (German, 1471-1528)
PRAYING HANDS, 1508-09
Albertina, Vienna
4049 - 11½″x8″ (29x20 cm)
2049 - 6½″x4½″ (16x11 cm)

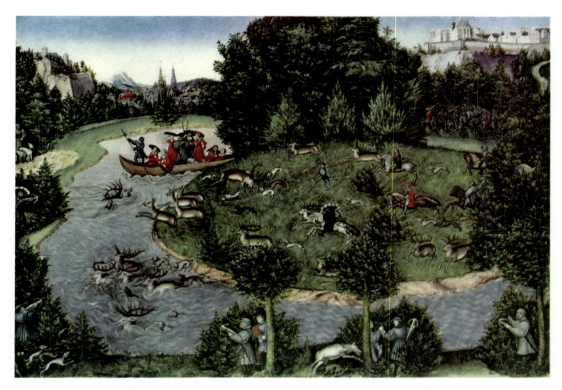

Lukas Cranach, the Elder (German, 1472-1553)
THE STAG HUNT, 1529
Kunsthistorisches Museum, Vienna
8748 - 22½"x32" (57x81 cm)

Hans Holbein (German, 1497-1543)
SIR THOMAS MORE, 1527
The Frick Collection, New York
708 - 29"x23" (73x58 cm)

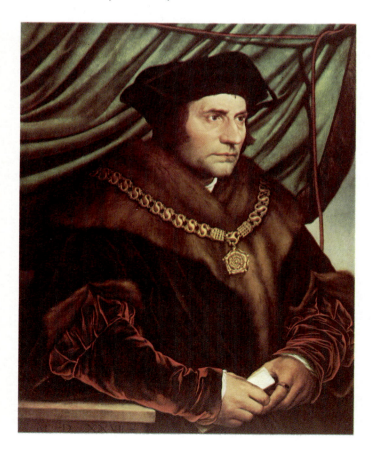

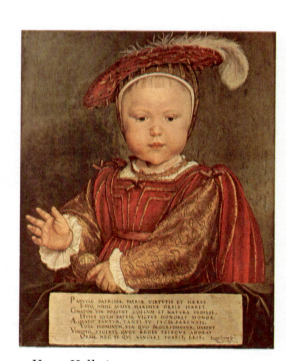

Hans Holbein
EDWARD VI AS A CHILD, 1538
National Gallery of Art, Washington, D.C.
Mellon Collection
6343 - 22"x17" (55x43 cm)

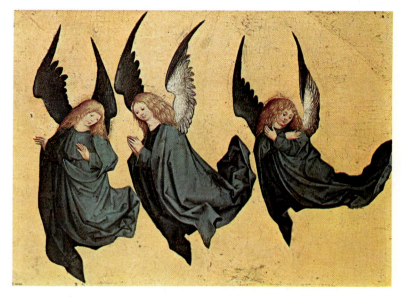

Meister des Hausbuches *(German, 1460-1490)*
THREE HOVERING ANGELS, *undated*
Kunstmuseum, Basel
4024 - 11¾"x15" (30x38 cm)

Jan van Eyck *(Flemish, 1380/1400-1441)*
THE ANNUNCIATION, *c.1435-40*
National Gallery of Art, Washington, D.C.
Mellon Collection
7663 - 26"x9¾" (66x25 cm)

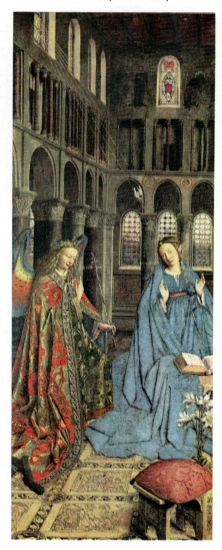

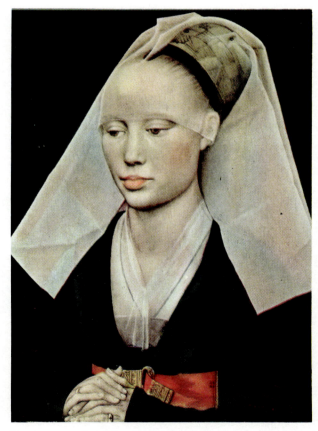

Rogier van der Weyden *(Flemish 1399/1400-1464)*
PORTRAIT OF A LADY *c.1455*
National Gallery of Art, Washington, D.C.
Mellon Collection
445 - 13¾"x9¾" (35x24 cm)

Hans Memling
MADONNA AND CHILD WITH ANGELS, *c.1480*
National Gallery of Art, Washington, D.C.
Mellon Collection
5251 - 20"x16" (50x40 cm)

Hans Memling *(Flemish, 1432-1494)*
PORTRAIT OF A YOUNG MAN
Lehman Collection, New York
479 - 15"x10¾" (38x27 cm)

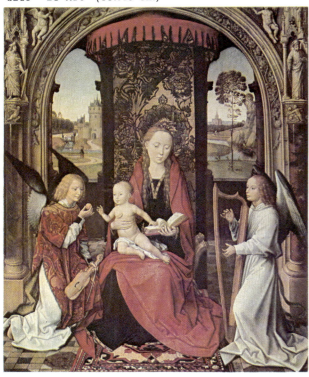

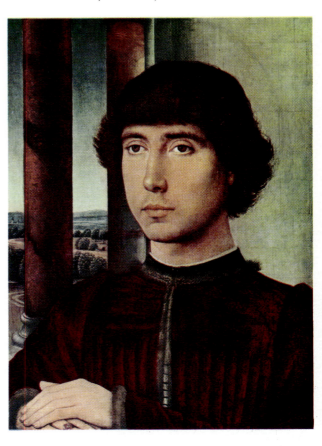

Gerard David *(Flemish, 1460-1523)*
THE REST ON THE FLIGHT INTO EGYPT, *c.1510*
National Gallery of Art, Washington, D.C.
Mellon Collection
5253 - 18"x18" (45x45 cm)

Hendrick Goltzius *(Dutch, 1558-1616)*
GROUP OF TREES IN A WOOD
Kunsthalle, Hamburg
3248 - 11"x8" (27x20 cm)

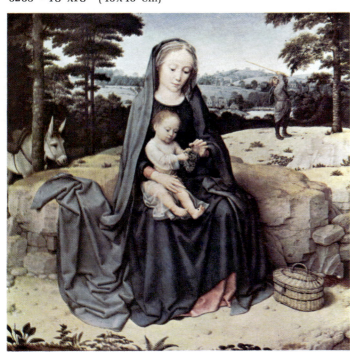

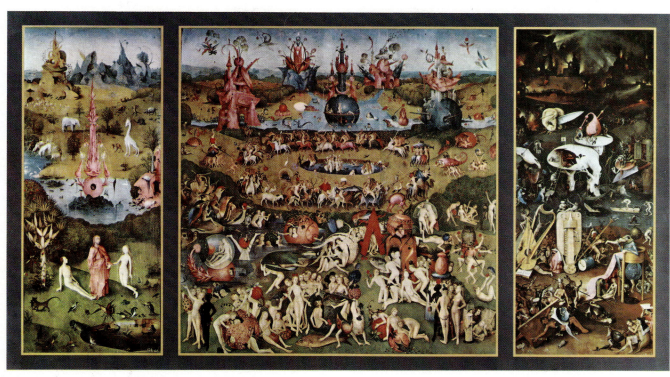

Hieronymus Bosch *(Flemish, 1460-1516)*
THE GARDEN OF DELIGHTS, c. 1480
Prado Museum, Madrid
9910 - three panels on one sheet
 23½"x41¾" (59x106 cm)

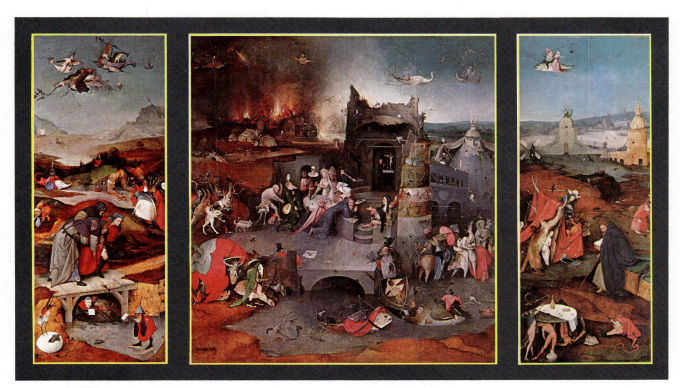

Hieronymus Bosch
THE TEMPTATION OF SAINT ANTHONY, c. 1500
Museu Nacional de Arte Antiga, Lisbon
9054 - three panels on one sheet
 24"x42" (60x106 cm)

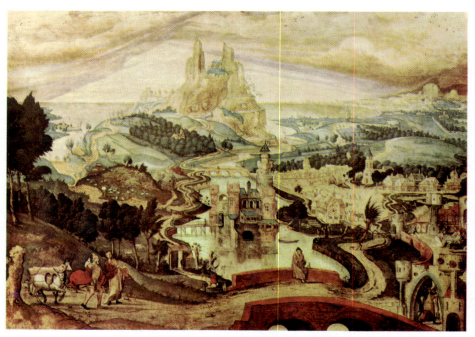

Cornelis Massys *(Flemish, 1508-1575)*
THE ARRIVAL IN BETHLEHEM, *1543*
The Metropolitan Museum of Art, New York
7832 - 21"x29½" (53x75 cm)
6832 - 15½"x22" (39x55 cm)

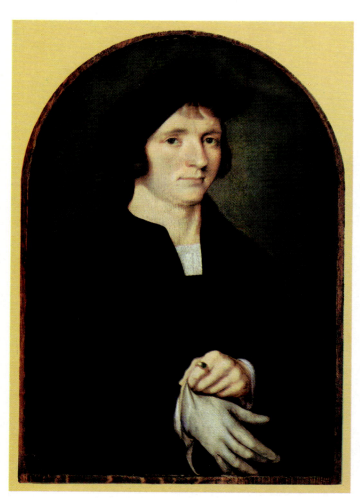

Joos van Cleve *(Flemish, active 1511-1540 / 1)*
JORIS W. VEZELER, *c. 1520*
National Gallery of Art, Washington, D.C.
Andrew W. Mellon Gift
6658 - 23¾"x16¾" (60x42 cm)

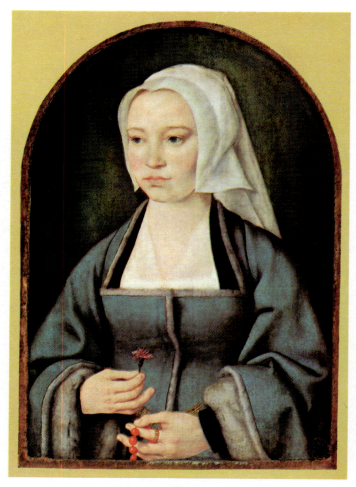

Joos van Cleve
MARGARETHA BOGHE,
WIFE OF JORIS W. VEZELER, c.1520
National Gallery of Art, Washington, D.C.
Andrew W. Mellon Gift
6657 - 23½"x17" (59x43 cm)

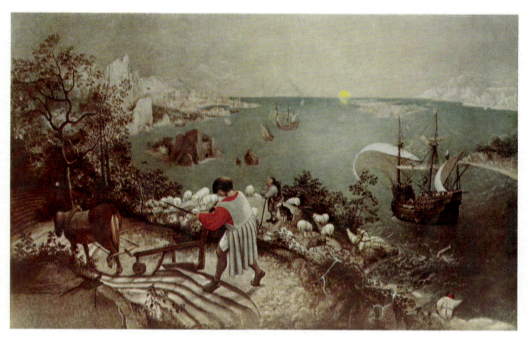

Pieter Brueghel, the Elder *(Flemish, 1525-1569)*
THE FALL OF ICARUS, *c.1555*
Royal Museum, Brussels
4754 - 11″x14″ (28x35 cm)

Pieter Brueghel, the Elder
THE HARVESTERS, *1565*
The Metropolitan Museum of Art, New York
4755 - 11″x14″ (28x35 cm)

(For sale in U.S.A. only)

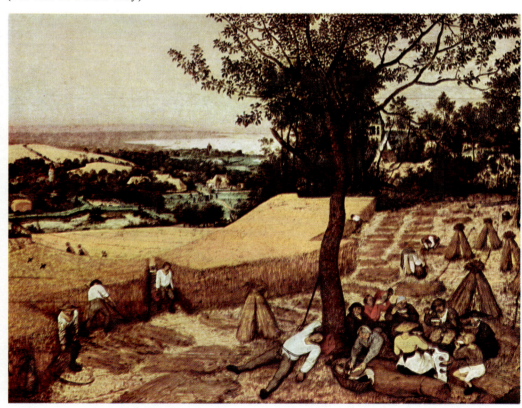

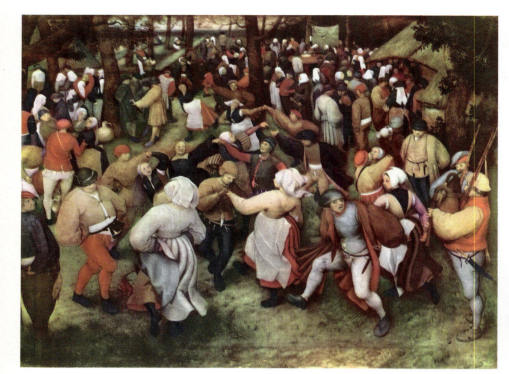

Pieter Brueghel, the Elder
THE WEDDING DANCE, *1566*
The Detroit Institute of Arts
4312 - 10½"x14" (26x35 cm)

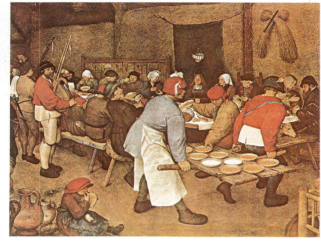

Pieter Brueghel, the Elder
VILLAGE WEDDING, *c.1560*
Kunsthistorisches Museum, Vienna
4752 - 11"x14" (28x35 cm)

5277 - 15"x21½" (38x54 cm)

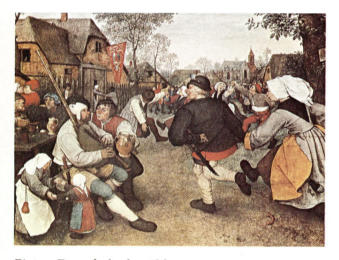

Pieter Brueghel, the Elder
PEASANTS' DANCE, *c.1560*
Kunsthistorisches Museum, Vienna
4753 - 11"x14" (28x35 cm)

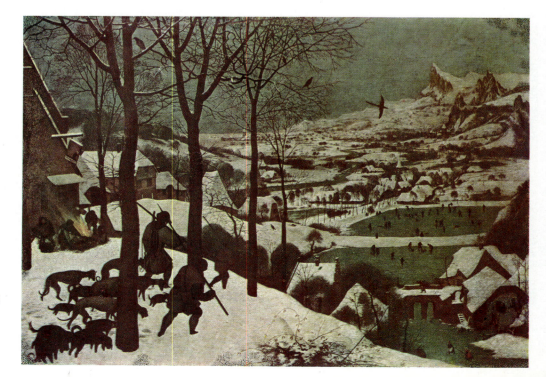

Pieter Brueghel, the Elder
WINTER—HUNTERS IN THE SNOW, *1565*
Kunsthistorisches Museum, Vienna
9999 - 31¼"x43¾" (79x111 cm)
4756 - 11"x14" (28x35 cm)

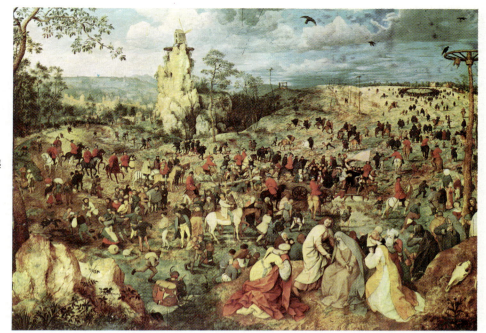

Pieter Brueghel, the Elder
THE PROCESSION TO CALVARY, 1564
Kunsthistorisches Museum, Vienna
7095 - 20"x28" (51x71 cm)

Jan Brueghel de Velours *(Flemish, 1568-1625)*
MAY DAY FROLIC
Private Collection
5938 - 15¾"x22" (40x55 cm)

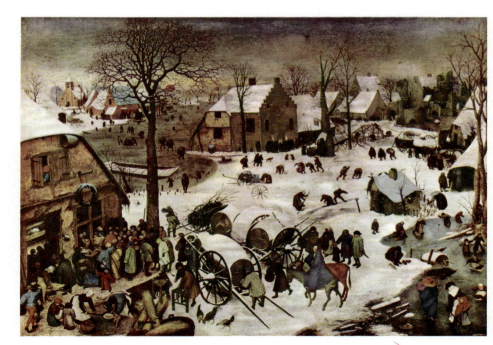

Pieter Brueghel, the Elder
WINTER IN FLANDERS, 1566
(The Census at Bethlehem)
Royal Museum, Brussels
4751 - 11"x14" (28x35 cm)

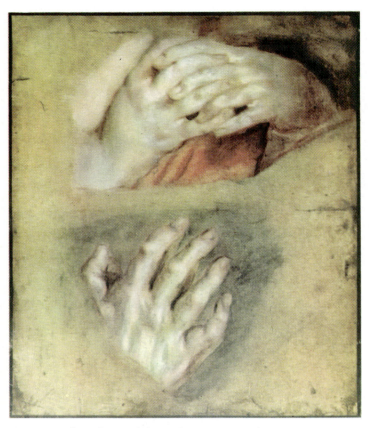

Peter Paul Rubens *(Flemish, 1577-1640)*
PRAYING HANDS
Private Collection

4114 - *(upper detail)* 10"x15" (25x38 cm)
4115 - *(lower detail)* 10"x15" (25x38 cm)

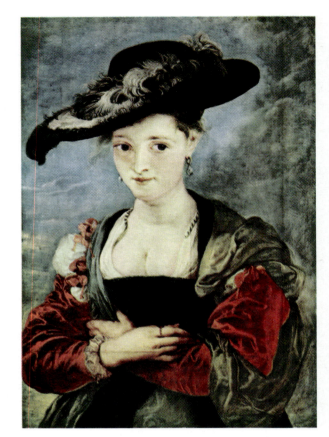

Peter Paul Rubens
LE CHAPEAU DE PAILLE, c.1620
National Gallery, London
5219 - 18"x12½" (46x32 cm)

Peter Paul Rubens
VIRGIN AND CHILD WITH FORGET-ME-NOTS
Royal Museum, Brussels
650 - 21"x15½" (53x39 cm)

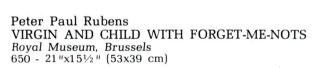

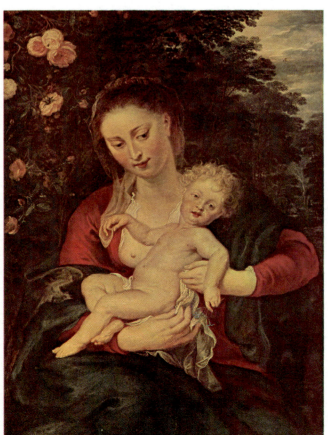

Johannes Verspronk *(Dutch, 1597-1662)*
PORTRAIT OF A YOUNG GIRL, 1641
Rijksmuseum, Amsterdam
5362 - 20"x15¾" (51x40 cm)

94

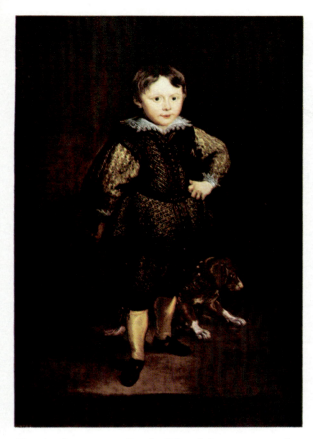

Sir Anthony van Dyck *(Flemish, 1599-1641)*
FILIPPO CATTANEO, SON OF MARCHESA
ELENA GRIMALDI, 1623
*National Gallery of Art, Washington, D.C.
Widener Collection*
6494 - 24"x16½" (61x42 cm)

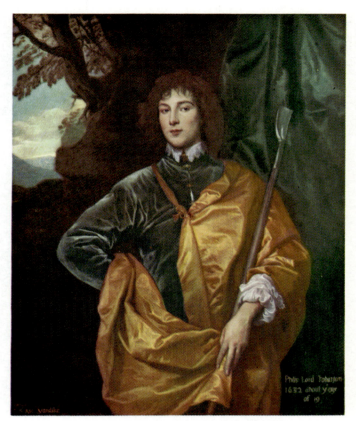

Sir Anthony van Dyck
PHILIP, LORD WHARTON, 1632
*National Gallery of Art, Washington, D.C.
Mellon Collection*
7282 - 27¼"x22¼" (70x56 cm)

Franz Hals *(Dutch, 1580-1666)*
BOY WITH FLUTE
Former State Museum, Berlin-Dahlem
8719 - 24¼"x21¼" (62x54 cm)

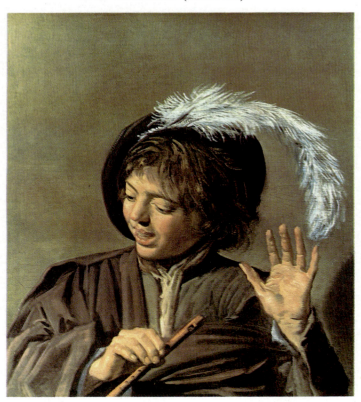

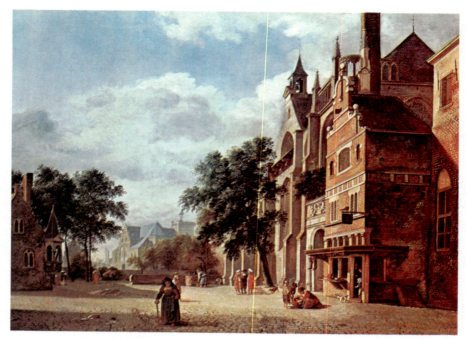

Jan van der Heyden *(Dutch, 1637-1712)*
SQUARE IN UTRECHT, *1670*
Mr. Norton Simon, Los Angeles
6348 - 17½"x23½" (44x60 cm)

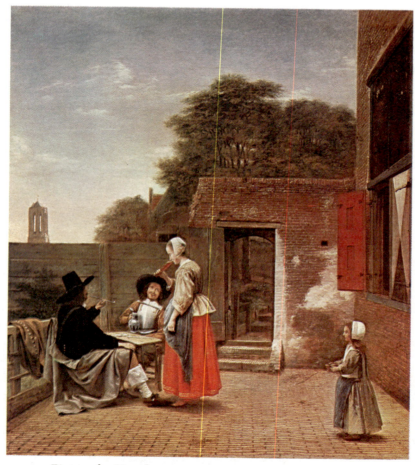

Pieter de Hooch
A DUTCH COURTYARD, c.*1660*
National Gallery of Art, Washington, D.C.
Mellon Collection
536 - 19½"x16¾" (49x42 cm)

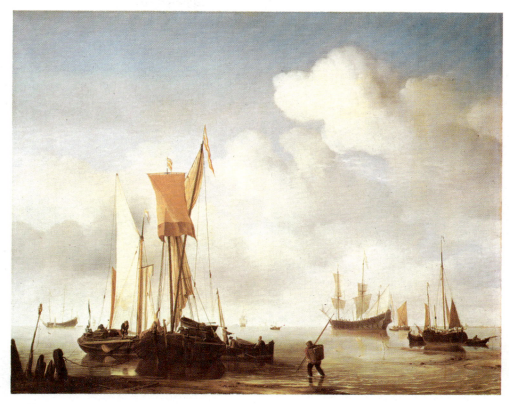

Willem van de Velde *(Dutch, 1633-1707)*
FISHING BOATS OFFSHORE IN A CALM
Museum of Fine Arts, Springfield, Mass.
8862 - 26¼″×32″ (66×81 cm)

Simon de Vlieger *(Dutch, 1601-1652)*
MARINE
Kunsthalle Bremen
9301 - $40 x40″ (66x101 cm)

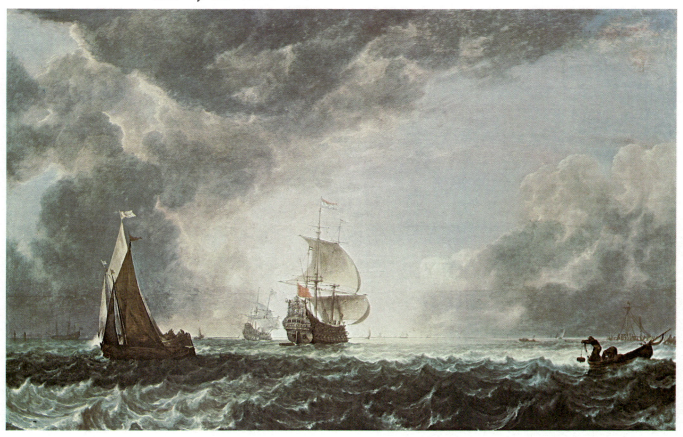

Jan Vermeer
GIRL INTERRUPTED AT HER MUSIC, 1655-60
The Frick Collection, New York
5645 - 15¼″x17¼″ (39x43 cm)

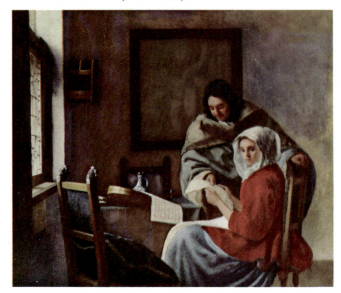

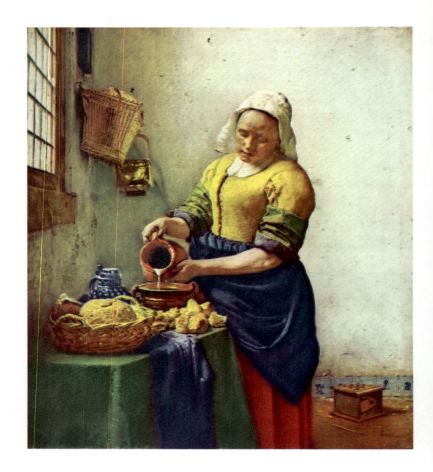

Jan Vermeer
THE MILKMAID, c.1656
Rijksmuseum, Amsterdam
565 - 18″x16″ (46x41 cm)

Jan Vermeer
YOUNG WOMAN WITH A WATER JUG, 1658-60
The Metropolitan Museum of Art, New York
5255 - 18″x16″ (46x41 cm)

Jan Vermeer
GIRL WITH TURBAN, 1660
Mauritshuis, The Hague, Holland
5785 - 19″x15½″ (48x39 cm)

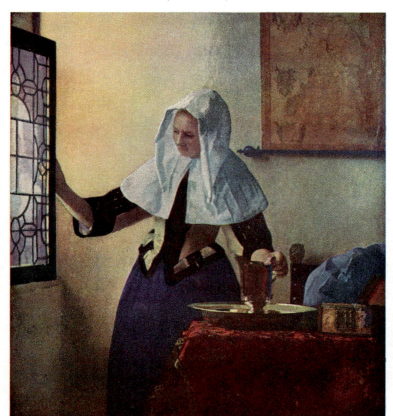

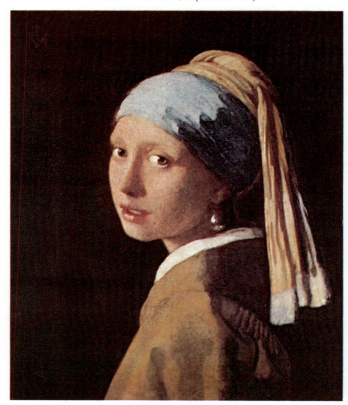

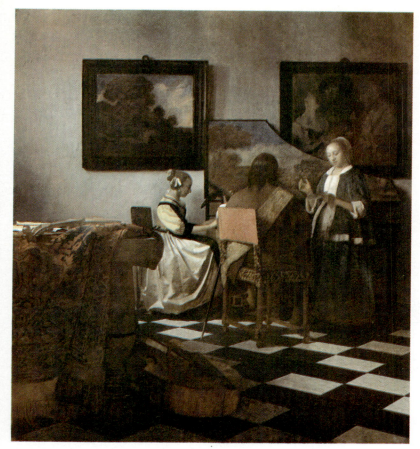

Jan Vermeer (Dutch, 1632-1675)
THE CONCERT, 1662
Isabella Stewart Gardner Museum, Boston
786 - 27"x24¼" (68x61 cm)

Jan Vermeer
A WOMAN WEIGHING GOLD, c.1657
National Gallery of Art, Washington, D.C.
Widener Collection
5254 - 16¼"x14½" (41x37 cm)

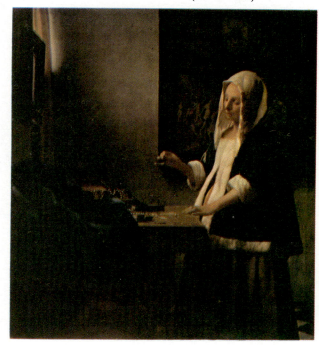

Jan Vermeer
THE ARTIST'S STUDIO, 1665
Kunsthistorisches Museum, Vienna
8749 - 31¼"x25¾" (79x65 cm)

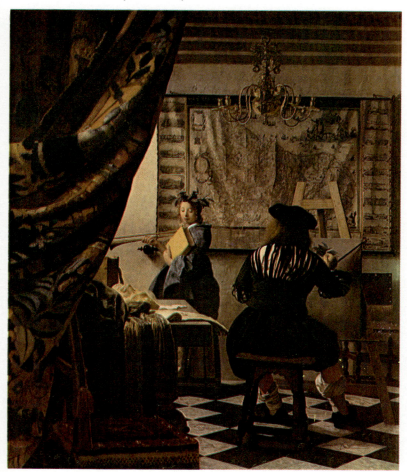

Jan Vermeer
THE LACEMAKER, c.1660
National Gallery of Art, Washington, D.C.
Mellon Collection
5641 - 17½"x15½" (44x39 cm)

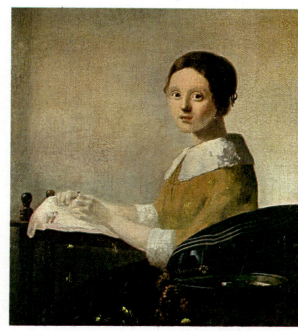

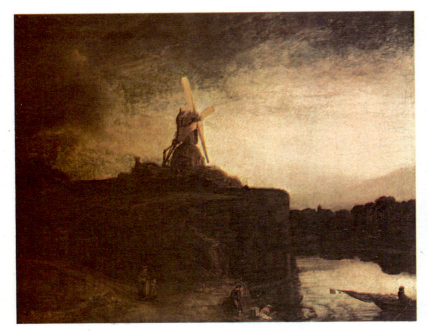

Rembrandt Harmensz van Rijn *(Dutch, 1606-1669)*
THE MILL, c.1650
National Gallery of Art, Washington, D.C.
Widener Collection
792 - 24¾"x30" (63x76 cm)

Rembrandt
THE ARTIST'S SON, TITUS, 1655
The Metropolitan Museum of Art. New York
7296 - 30½"x22¾" (77x58 cm)
4297 - 14"x10¼" (35x26 cm)

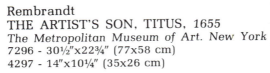

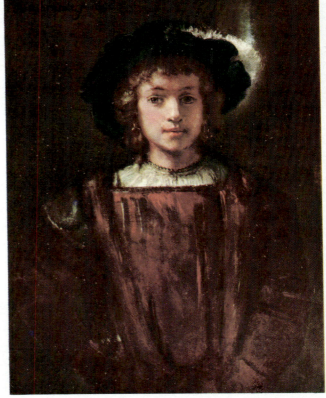

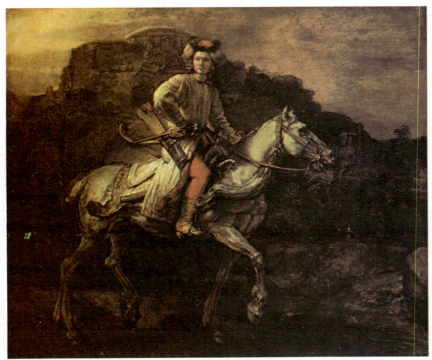

Rembrandt
THE POLISH RIDER, c.1655
The Frick Collection, New York
703 - 25"x29¼" (63x74 cm)
403 - 11¾"x14" (30x35 cm)

Rembrandt
YOUNG GIRL AT A WINDOW, 1645
College Gallery, Dulwich, London
5230 - 18½"x16" (47x40 cm)

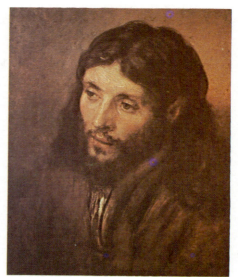

Rembrandt
HEAD OF CHRIST
Staatliche Museen, Preussischer Kulturbesitz
Gemaldegalerie Berlin (West)
3247 - 10"x8" (25x20 cm)

Rembrandt
THE APOSTLE PAUL, c.1657
National Gallery of Art, Washington, D.C.
Widener Collection
7652 - 26"x20" (66x50 cm)

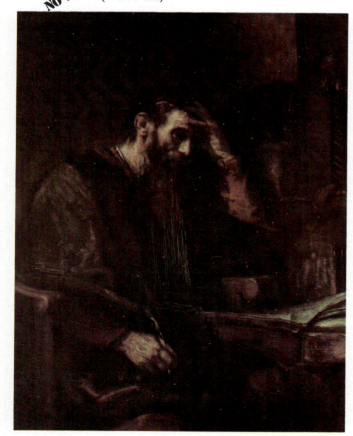

Rembrandt
PORTRAIT OF THE ARTIST'S SON TITUS, *undated*
The Norton Simon Collection
7664 - 25¼"x21¼" (64x54 cm)
4220 - 14"x11¾" (35x30 cm)

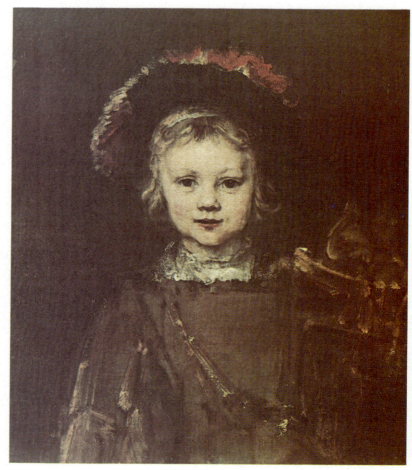

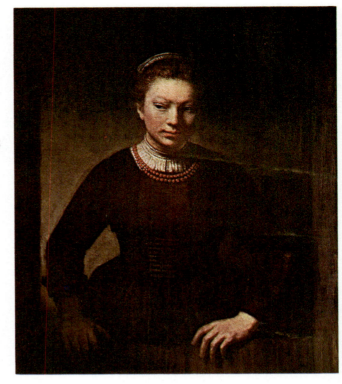

Rembrandt
YOUNG GIRL AT AN OPEN HALF DOOR, 1645
The Art Institute of Chicago
7651 - 26"x22" (66x56 cm)
4651 - 14"x11¾" (35x30 cm)
3525 - 9½"x8" (24x20 cm)

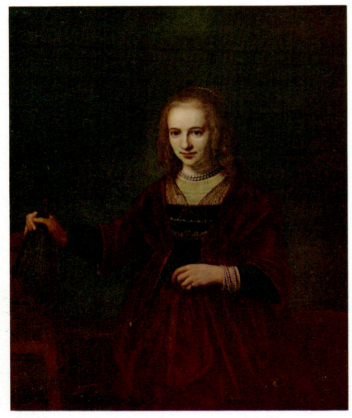

Rembrandt
PORTRAIT OF THE ADMIRAL'S WIFE, 1643
The Metropolitan Museum of Art, New York
The H. O. Havemeyer Collection
9834 - 36½"x29½" (92x75 cm)

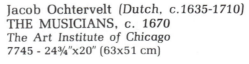

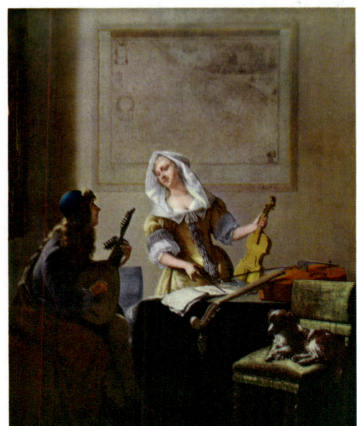

Jacob Ochtervelt *(Dutch, c.1635-1710)*
THE MUSICIANS, c. 1670
The Art Institute of Chicago
7745 - 24¾"x20" (63x51 cm)

Rembrandt
MASTERS OF THE CLOTH GUILD, *1661-62*
Rijksmuseum, Amsterdam
7483 - 20¼"x29¾" (51x75 cm)

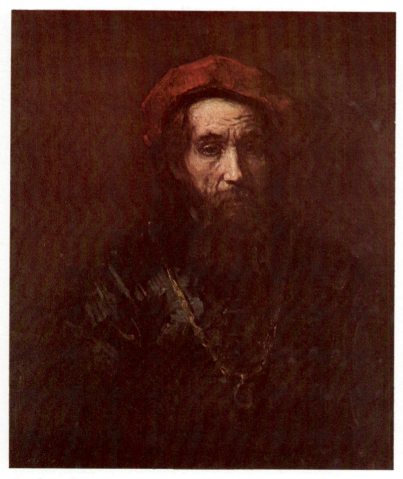

Rembrandt
PORTRAIT OF A RABBI, *1657*
California Palace of Legion of Honor, San Francisco
Mildred Anna Williams Fund, 1948
7809 - 28"x23" (71x58 cm)

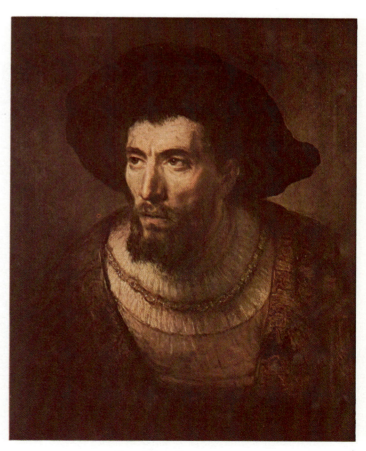

Rembrandt
THE PHILOSOPHER, c.1650
National Gallery of Art, Washington, D.C.
Widener Collection
6621 - 24"x18¾" (61x47 cm)

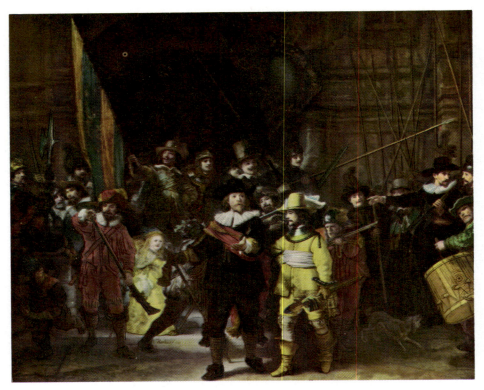

Rembrandt
THE NIGHT WATCH, 1642
Rijksmuseum, Amsterdam
7660 - 23"x27¾" (58x70 cm)

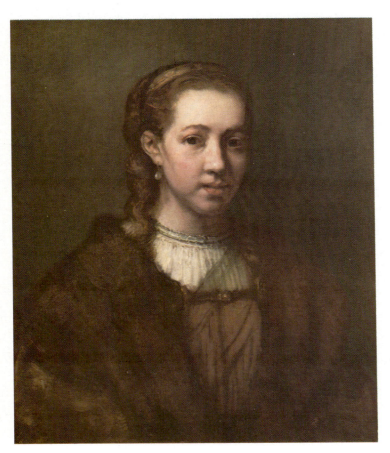

Rembrandt
HENDRIKJE STOFFELS, c.1652-54
Mrs. Norton Simon, Los Angeles
6863 - 26"x21½" (66x54 cm)

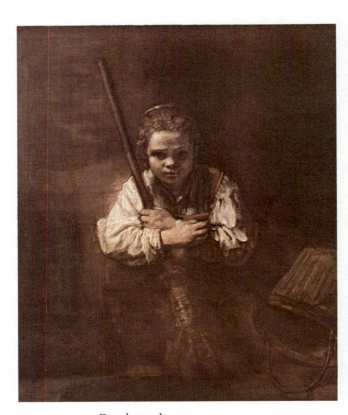

Rembrandt
A GIRL WITH A BROOM, 1651
National Gallery of Art, Washington, D.C.
Mellon Collection
7662 - 26"x22" (66x56 cm)

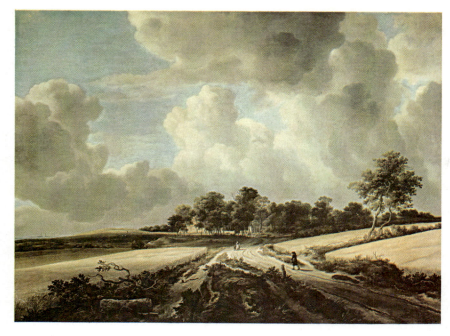

Jacob I. van Ruisdael *(Dutch, 1628-1682)*
WHEATFIELDS, *undated*
The Metropolitan Museum of Art, New York
738 - 22¾"x29¾" (58x75 cm)

Jacob I. van Ruisdael
LANDSCAPE WITH A FOOTBRIDGE, *1652*
The Frick Collection, New York
900 - 23¾"x36½" (60x93 cm)

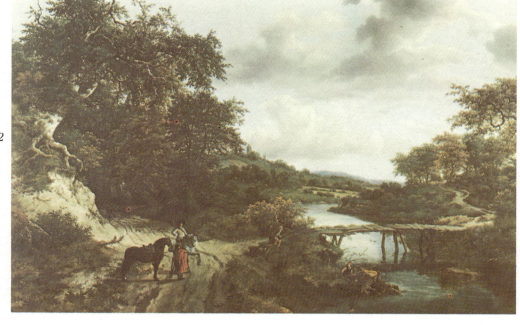

Aelbert Cuyp *(Dutch, 1620-1691)*
THE VALKHOF AT NIJMEGEN, c. 1656-60
Indianapolis Museum of Art
7986 - 20¼"x30½" (51x77 cm)

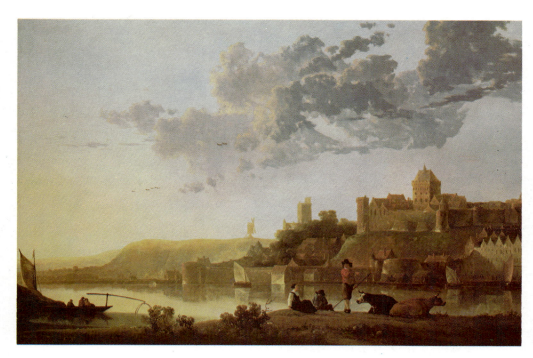

Meindert Hobbema
A VIEW ON A HIGH ROAD, 1665
National Gallery of Art, Washington, D.C.
Mellon Collection
967 - 25¾"x35¾" (65x91 cm)

Meindert Hobbema *(Dutch, 1638-1709)*
LANDSCAPE, WOODED ROAD, 1662
Philadelphia Museum of Art
William L. Elkins Collection
9845 - 29"x35¾" (73x91 cm)

Francesco Guardi *(Italian, 1712-1793)*
FLOWERS, *undated*
Rijksmuseum, Amsterdam
7481 - 21¼"x30¾" (54x78 cm)

J. M. van Nikkelen *(Dutch, born c. 1690)*
JUNE BLOSSOMS
Akademie der Bildenden Künste, Vienna
5767 - 20"x16" (51x40 cm)

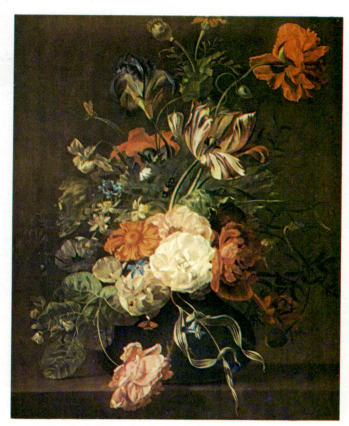

Rachel Ruysch *(Dutch, 1664-1750)*
IN FULL BLOOM
Akademie der Bildenden Künste, Vienna
5768 - 20"x16" (51x40 cm)

Jan van Huysum *(Dutch, 1682-1749)*
GARDENER'S GIFT
Akademie der Bildenden Künste, Vienna
5765 - 20"x16" (51x40 cm)

Jan van Huysum
GARDEN GAIETY
Akademie der Bildenden Künste, Vienna
5766 - 20"x16" (51x40 cm)

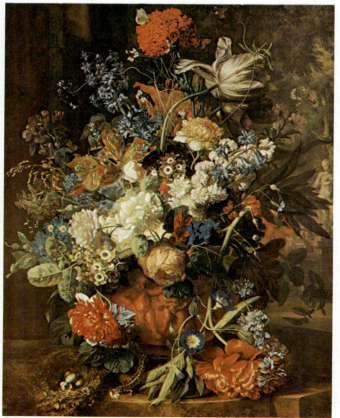

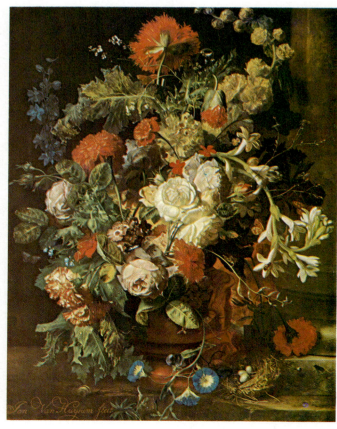

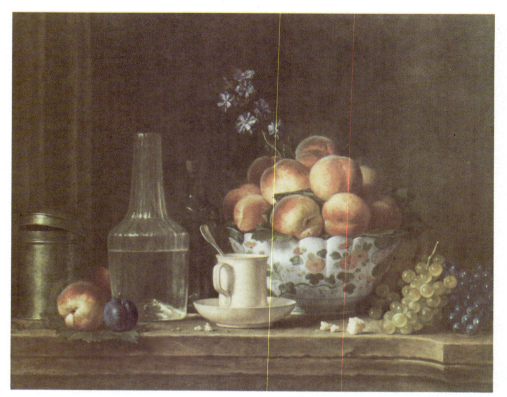

Henri-Horace Roland de la Porte (French, 1724-1793)
STILL LIFE, c.1765
Norton Simon, Inc. Museum of Art
6357 - 20"x24½" (51x62 cm)
5526 - 14½"x17½" (37x45 cm)

Jan Brueghel de Velours (*Flemish, 1568-1625*)
STILL LIFE OF FLOWERS, undated
The Detroit Institute of Arts
8535 - 33"x26¼" (84x67 cm)

Willem Kalf (*Dutch, 1622-1693*)
STILL LIFE, 1665
National Gallery of Art, Washington, D.C.
7485 - 26"x21½" (66x55 cm)

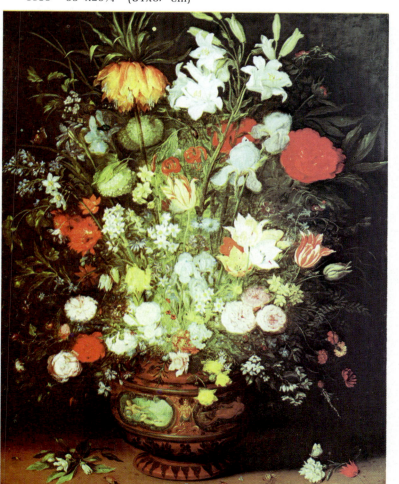

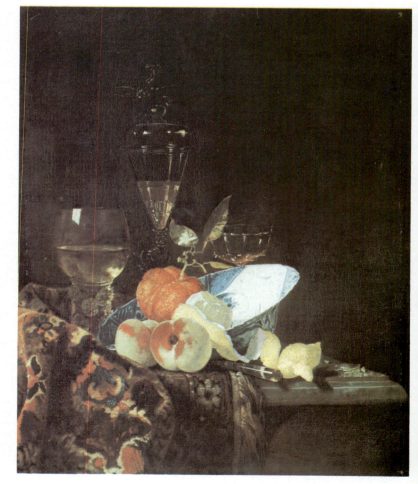

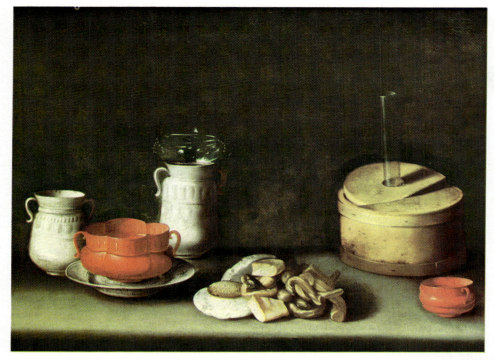

Attributed to:
Juan van der Hamen *(Spanish, 1596-1631)*
STILL LIFE, *undated*
Thyssen-Bornemisza Collection, Lugano
8280 - 23¾ "x31¾ " (60x81 cm)

Jean-Baptiste Siméon Chardin *(French, 1699-1779)*
A BOWL OF PLUMS, *undated*
The Phillips Collection, Washington, D.C.
640 - 16"x20½ " (40x52 cm)

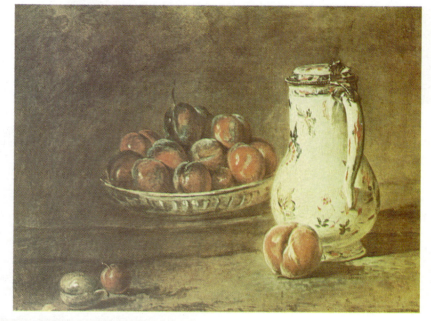

Attributed to: Juan van der Hamen
STILL LIFE: FLOWERS AND FRUIT
The Art Institute of Chicago
4189 - 10¼"x13¼" (26x35 cm)
(detail)

Jean-Baptiste Monnoyer
A FLOWER PIECE
Chrysler Museum at Norfolk
8109 - 31″x24¼″ (79x62 cm)

Louise Moillon (*French, 1610-1696*)
STILL LIFE WITH CHERRIES,
STRAWBERRIES AND GOOSEBERRIES
The Norton Simon Foundation
5554 - 14″×21¼″ (36×54 cm)

Jan Davidsz de Heem (*Dutch, 1606-1684*)
STILL LIFE WITH HAM, LOBSTER AND FRUIT, c.1656
Boymans-van Beuningen Museum, Rotterdam
8961 - 22″x31¼″ (56x79 cm)

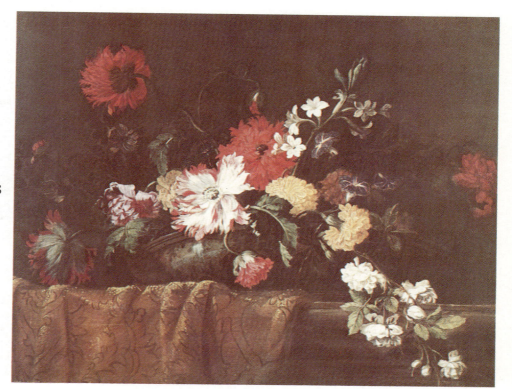

Jean-Baptiste Monnoyer (French, 1634-1699)
FLOWER PIECE, POPPIES AND MARIGOLDS
Norton Simon, Inc. Museum of Art, Pasadena
7872 - 24″x30″ (61x76 cm)

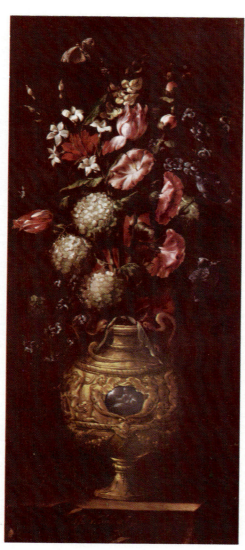

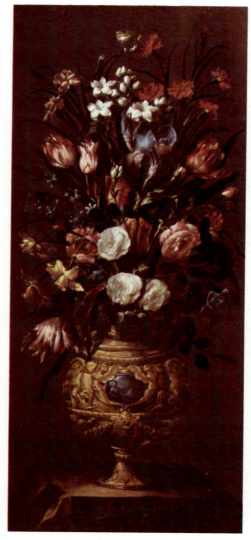

Juan de Arellano (Spanish, 1614-1676)
HYDRANGEAS WITH TULIPS, 1664
Rockoxhuis Museum, Antwerp
9641 - 36″x15¾″ (91x40 cm)

Juan de Arellano
ROSES WITH BLUE IRIS, 1664
Rockoxhuis Museum, Antwerp
9642 - 36″x15¾″ (91x40 cm)

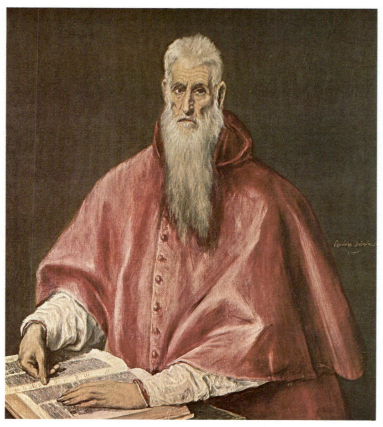

El Greco (Domenico Theotocopuli) (1541-1614, active Spain)
ST. JEROME, *1590*
The Frick Collection, New York
734 - 28½"x24½" (72x62 cm)

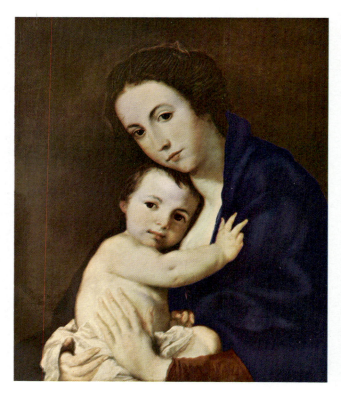

Jusepe de Ribera (Spanish, 1588-1652)
MADONNA AND CHILD, 1648, dated 1626
Philadelphia Museum of Art
William L. Elkins Collection
6841 - 24"x20" (60x50 cm)

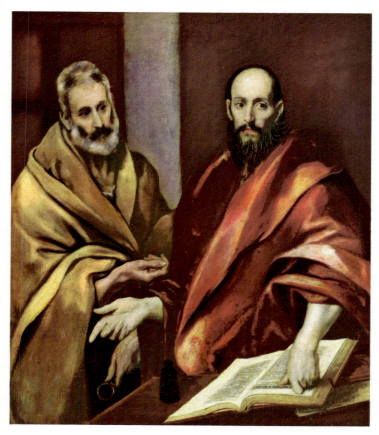

El` Greco
THE APOSTLES PETER AND PAUL, *1614*
Hermitage State Museum, Leningrad
7048 - 26"x22" (66x56 cm)

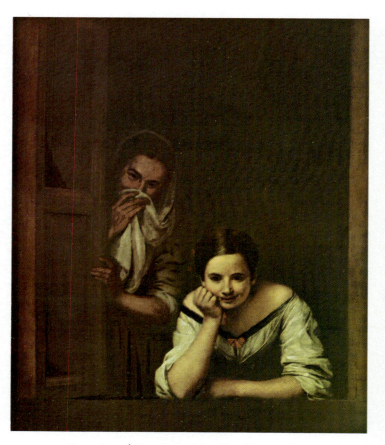

Bartolomé Esteban Murillo (Spanish, 1617-1682)
A GIRL AND HER DUENNA, *c. 1670*
National Gallery of Art, Washington, D.C.
Widener Collection
780 - 29"x24¼" (73x61 cm)

El Greco
VIEW OF TOLEDO, 1609
The Metropolitan Museum of Art, New York
The H.O. Havemeyer Collection
769 - 28"x24¾" (71x63 cm)

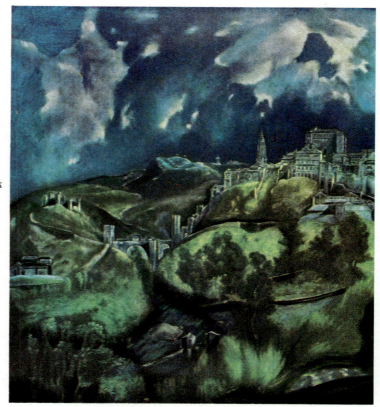

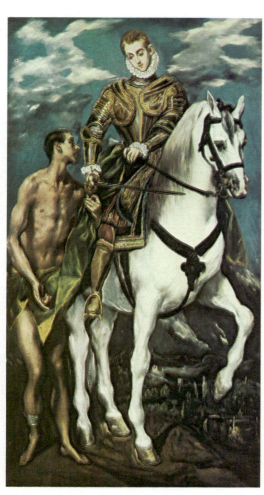

El Greco
ST. MARTIN AND THE BEGGAR, 1597-99
National Gallery of Art, Washington, D.C.
Widener Collection
6260 - 24"x12½" (61 x 30 cm)

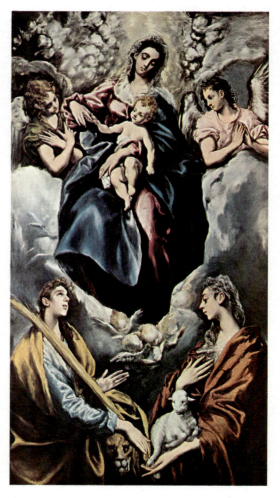

El Greco
THE VIRGIN WITH ST. JAMES
AND ST. TECLA, 1597-99
National Gallery of Art, Washington, D.C.
Widener Collection
6496 - 24"x12½" (61 x 30 cm)

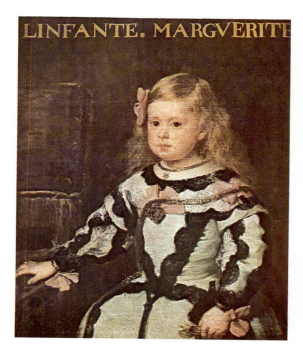

Velázquez
INFANTA MARGARITA THERESA, *1653*
Louvre Museum, Paris
5224 - 15¾"x13" (40x33 cm)

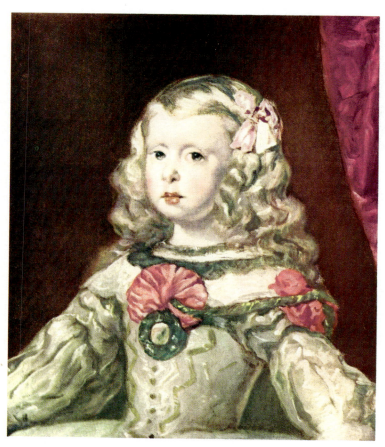

Diego Rodriguez de Silva y Velázquez (Spanish, *1599-1660*)
THE INFANTA MARGARITA, c. *1657*
The Fine Arts Society of San Diego
651 - 21"x17¾" (53x45 cm)
3175 - 11"x9¼" (28x23 cm)

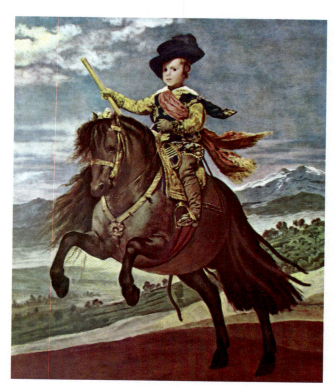

Velázquez
PRINCE BALTHASAR CARLOS, *1635-1636*
Prado Museum, Madrid
5241 - 23½"x19½" (59x49 cm)

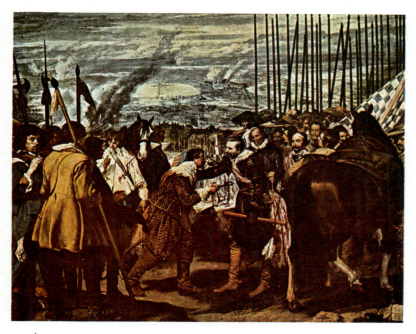

Velázquez
THE SURRENDER OF BREDA, c.1647
Prado Museum, Madrid
5240 - 15"x18" (38x45 cm)

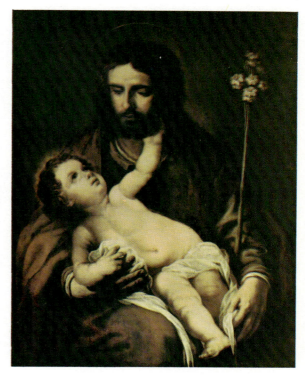

Francisco Meneses Osorio *(Spanish, 1630-1695)*
ST. JOSEPH AND THE CHRIST CHILD, *undated*
The Baltimore Museum of Art
6271 - 24"x18¼" (61x46 cm)

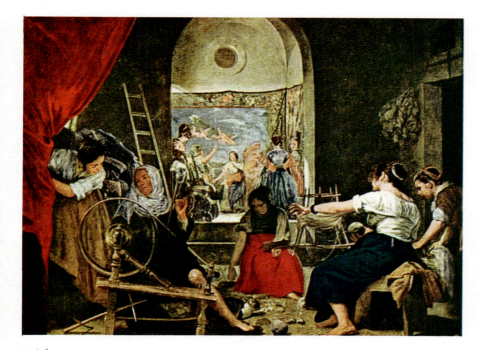

Velázquez
THE TAPESTRY WEAVERS, *1657-59*
Prado Museum, Madrid
5243 - 13¾"x18¼" (35x46 cm)

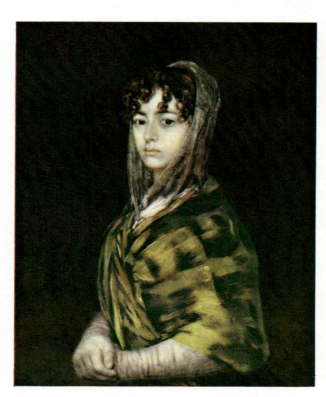

Francisco de Goya *(Spanish, 1746-1828)*
SENORA SABASA GARCIA, c.1814
National Gallery of Art, Washington, D.C.
Mellon Collection
5626 - 20"x15¾" (50x40 cm)

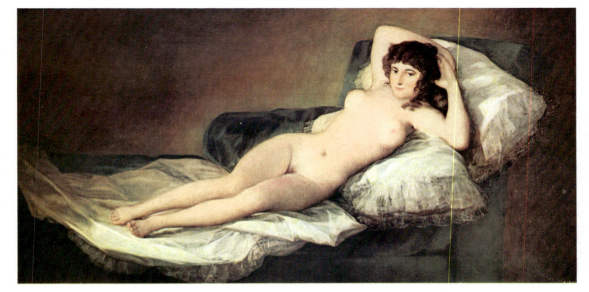

Francisco de Goya
THE NUDE MAJA, c.1796-98
Prado Museum, Madrid
8262 - 16"x32" (41x81 cm)

Francisco de Goya
MAYPOLE, 1816-18
National Galerie, Berlin
8962 - 24"x30½" (61x77 cm)

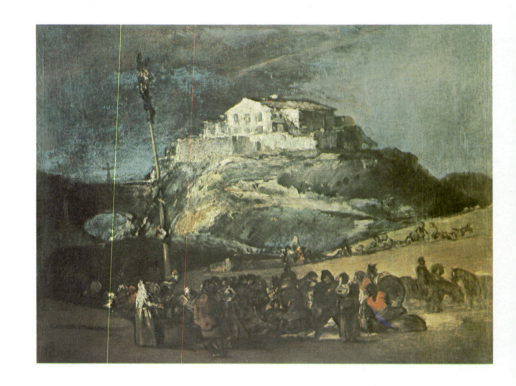

Francisco de Goya
GOSSIPING WOMEN, 1787-91
Wadsworth Atheneum, Hartford, Connecticut
9833 - 16"x40" (41x101 cm)

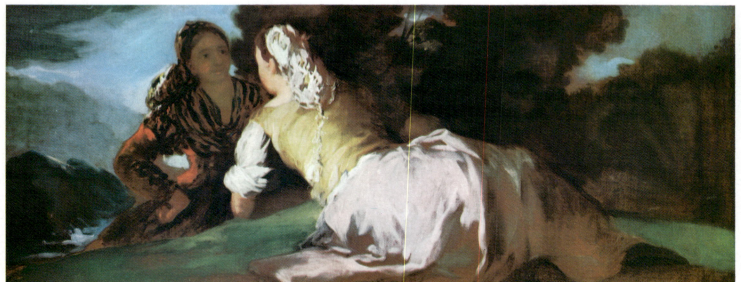

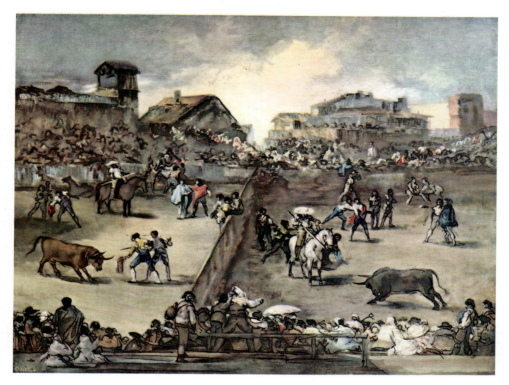

Francisco de Goya
THE BULLFIGHT, *1810-15*
The Metropolitan Museum of Art, New York
6294 - 18¾"x24¼" (47x61 cm)

Francisco de Goya
DON MANUEL OSORIO DE ZUNIGA, *1784*
The Metropolitan Museum of Art, New York
The Jules S. Bache Collection
715 - 30"x22¾" (76x58 cm)
5400 - 19½"x15" (49x38 cm)
4400 - 14"x10¾" (35x27 cm)
3507 - 12½"x9¼" (32x23 cm)

Francisco de Goya
THE WATER CARRIER, *c.1812*
Mr. Norton Simon, Los Angeles
6347 - 21¾"x15¾" (55x40 cm)

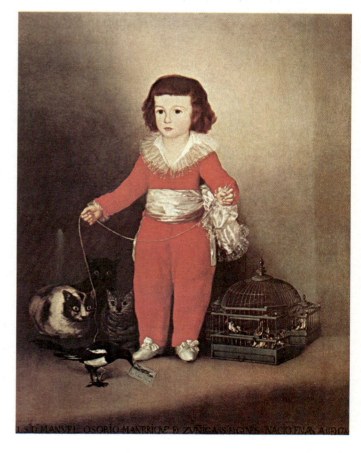

Sir Joshua Reynolds *(British, 1723-1792)*
THE AGE OF INNOCENCE, *1788*
Tate Gallery, London
5201 - 20″x16½″ (51x42 cm)

Sir Joshua Reynolds
LADY ELIZABETH DELME AND HER
CHILDREN, *c. 1780*
National Gallery of Art, Washington, D.C.
Mellon Collection
8260 - 30¾″x19″ (78x48 cm)

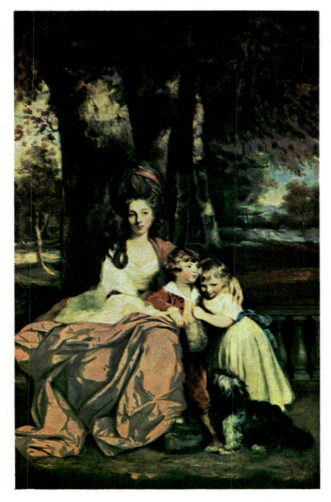

Sir Joshua Reynolds
THE INFANT SAMUEL AT PRAYER, *1777*
National Gallery, London
6852 - 24″x19¾″ (61x50 cm)
4338 - 14″x10″ (35x25 cm)
3144 - 10″x8″ (25x20 cm)

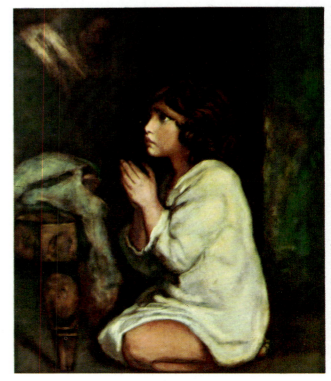

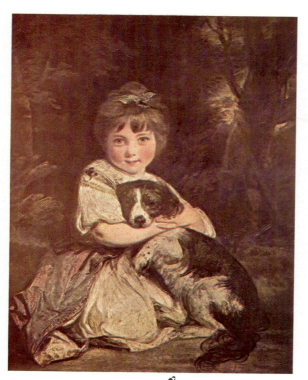

Sir Joshua Reynolds
PORTRAIT OF MISS BOWLES, 1775
Wallace Collection, London
5216 - 16½"x12½" (42x32 cm)

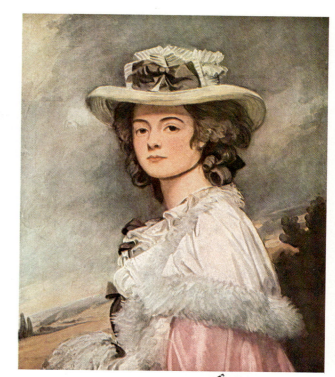

George Romney (British, 1734-1802)
MRS. DAVENPORT, 1782-84
National Gallery of Art, Washington, D.C.
Mellon Collection
509 - 19½"x16" (49x40 cm)

Sir Joshua Reynolds
LADY BETTY HAMILTON, 1758
National Gallery of Art. Washington, D.C.
Widener Collection
8834 - 31"x22" (79x56 cm)
6495 - 23½"x16¾" (60x42 cm)
5264 - 18"x12¾" (46x32 cm)
4264 - 14"x10" (35x25 cm)

George Romney
MISS WILLOUGHBY, 1781-83
National Gallery of Art, Washington, D.C.

3494 - 11"x8½" (28x21 cm)

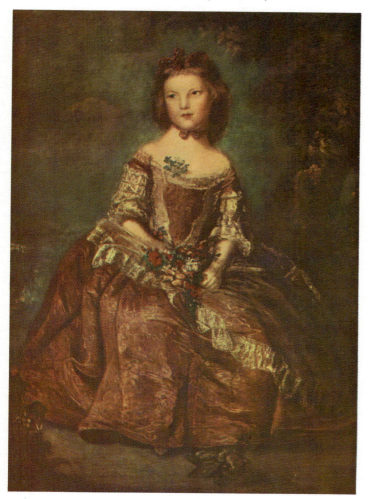

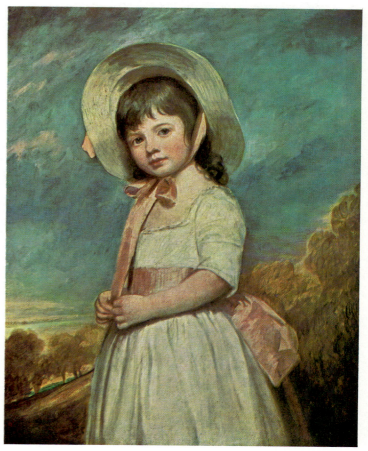

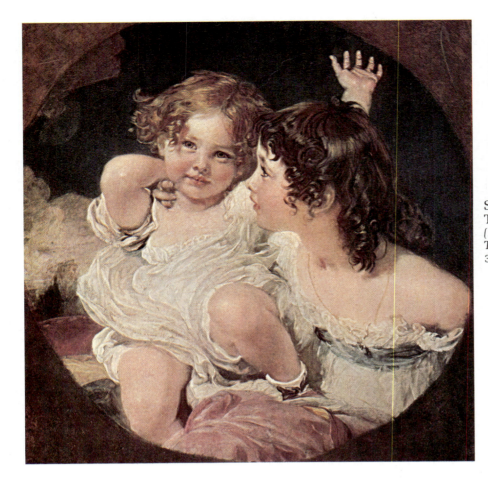

Sir Thomas Lawrence *(British, 1769-1830)*
THE CALMADY CHILDREN, *1823*
(Emily and Laura Anne Calmady)
The Metropolitan Museum of Art, New York
3128 - 9″ circle (23 cm circle)

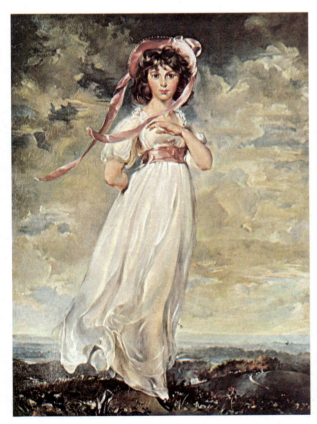

Sir Thomas Lawrence
PINKIE, *1794*
Henry E. Huntington Library and Art Gallery, Pasadena
8657 - 30¾″x22¼″ (78x58 cm)
6339 - 24″x17¼″ (61x44 cm)
5266 - 18″x12¾″ (45x32 cm)
4341 - 14″x10″ (35x25 cm)
3141 - 11¾″x8¼″ (30x21 cm)

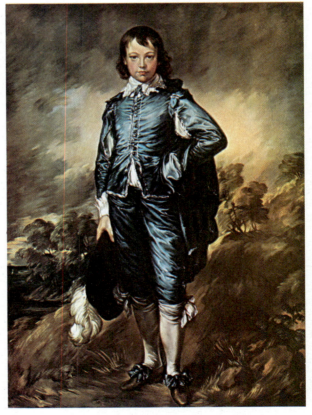

Thomas Gainsborough *(British, 1727-1788)*
THE BLUE BOY, *1770*
Henry E. Huntington Library and Art Gallery, Pasadena

5265 - 18″x13″ (45x33 cm)
4342 - 14″x10″ (35x25 cm)
3142 - 11¾″x8½″ (30x21 cm)

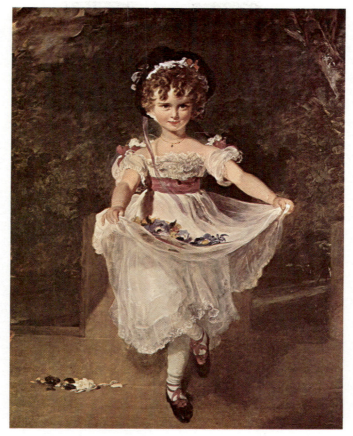

Sir Thomas Lawrence
MISS MURRAY, c.1825-27
The Iveagh Bequest, Kenwood, England
7528 - 28″x21½″ (71x54 cm)
4528 - 14″x11″ (35x28 cm)

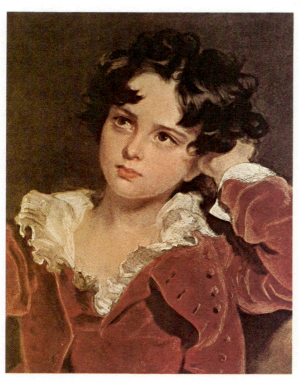

Sir Thomas Lawrence
MASTER LAMBTON (detail)
Collection of the Earl of Durham
4531 - 14″x11″ (35x28 cm)

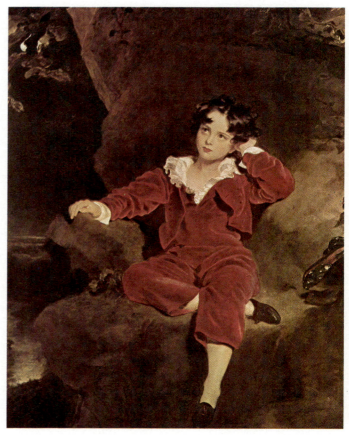

Sir Thomas Lawrence
MASTER LAMBTON, 1824-25
Collection of the Earl of Durham
4529 - 14″x11″ (35x28 cm)

Sir Henry Raeburn *(British, 1756-1823)*
THE REVEREND ROBERT WALKER
SKATING ON DUDDINGSTON LOCH
National Gallery of Scotland
6933 - 24¼"x20¼" (62x52 cm)

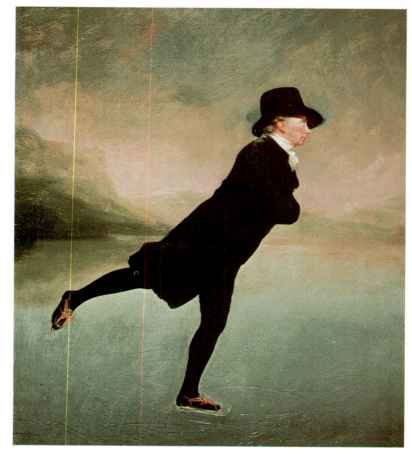

Arthur W. Devis *(British, 1763-1822)*
MASTER SIMPSON, *c.1810*
Private Collection

4337 - 14"x11¼" (35x28 cm)
3337 - 11"x8½" (28x21 cm)
3197 - 10"x8¼" (25x21 cm)

Sir Thomas Lawrence
LADY TEMPLETON AND HER SON, *c. 1801*
National Gallery of Art, Washington, D.C.
Mellon Collection
8259 - 31"x21½" (79x54 cm)

122

Thomas Gainsborough *(British, 1727-1788)*
THE MARKET CART
Tate Gallery, London
6444 - 25¼″x21″ (64x53 cm)

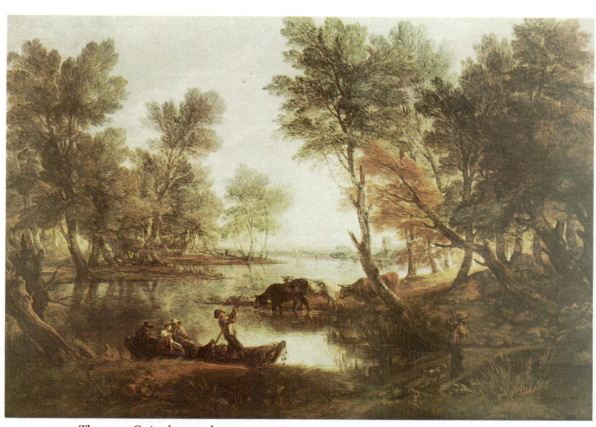

Thomas Gainsborough
VIEW NEAR KING'S BROMLEY-ON-TRENT, STAFFORDSHIRE, *1770-74*
Philadelphia Museum of Art
William L. Elkins Collection
9848 - 25½″x35¾″ (65x91 cm)

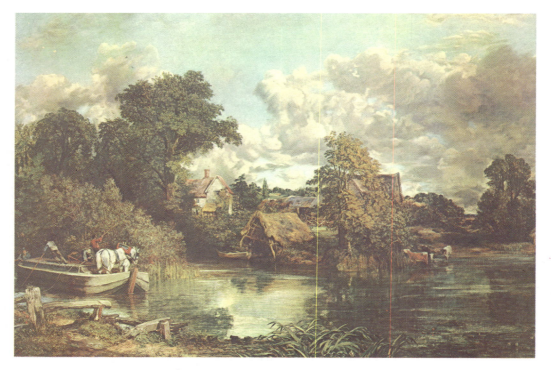

John Constable *(British, 1776-1837)*
THE WHITE HORSE, *1819*
The Frick Collection, New York
929 - 25"x36" (63x91 cm)
730 - 18"x26" (45x66 cm)
5527 - 12¾"x18" (32x46 cm)

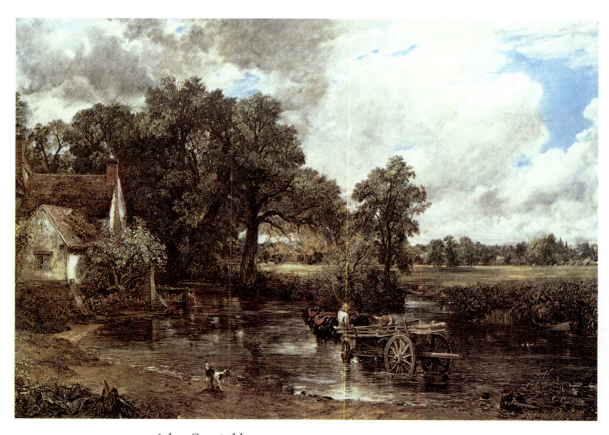

John Constable
THE HAY WAIN, *1821*
National Gallery, London
5211 - 12½"x18¼" (32x46 cm.)
1732026 - 18¼"x26" *(For sale in U.S.A. only)*
1932810 - 27¼"x38¾" *(For sale in U.S.A. only)*

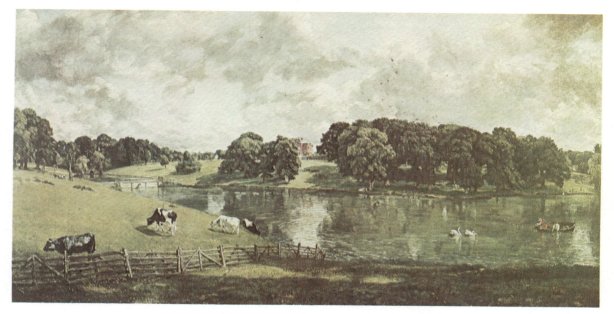

John Constable
WIVENHOE PARK, ESSEX, *1816*
National Gallery of Art, Washington, D.C.
Widener Collection
9258 - 19½"x36" (49x91 cm)

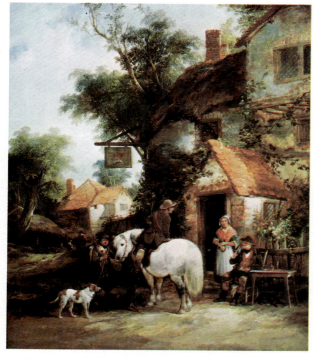

William Shayer (*English, Early 19th Century*)
FIGURES OUTSIDE AN INN
7916 - 28"×23" (71×58 cm)
5528 - 17¼"x14½" (44x37 cm)

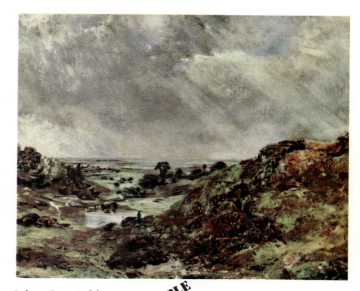

John Constable
VIEW AT HAMPSTEAD HEATH, *1827*
The Victoria and Albert Museum, London
4343 - 10¾" x13" (27x33 cm)

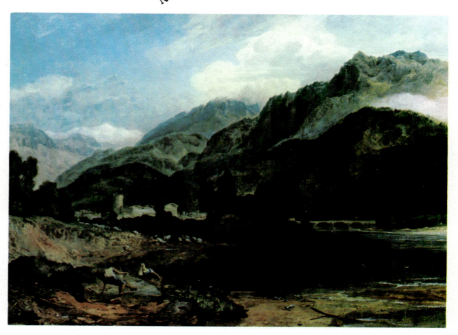

Joseph M. W. Turner
BONNEVILLE, SAVOY, *c.1812*
John G. Johnson Collection, Philadelphia
9086 - 26"x34¼" (66x87 cm)

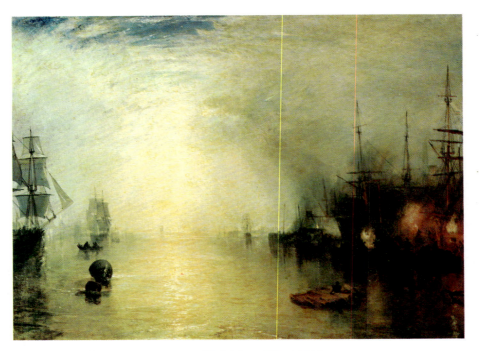

Joseph M. W. Turner (British, 1775-1851)
KEELMEN HEAVING IN COALS BY MOONLIGHT, c.1835
National Gallery of Art, Washington, D.C.
Widener Collection
9549 - 27"x36" (68x91 cm)

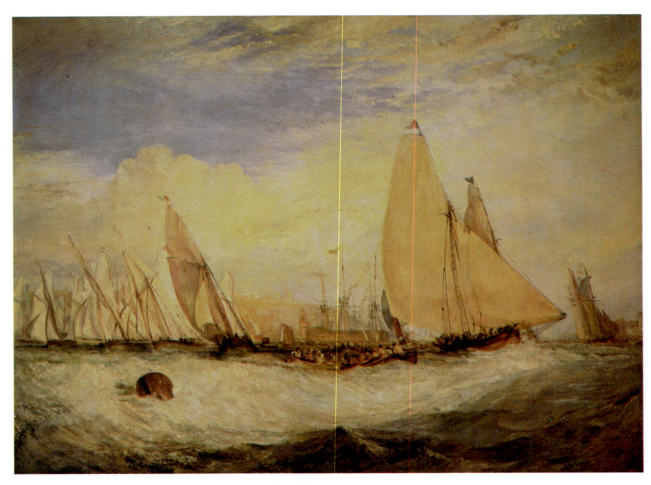

Joseph Mallord William Turner
EAST COWES CASTLE, THE SEAT OF J. NASH, ESQ.
THE REGATTA BEATING TO WINDWARD, 1828
Indianapolis Museum of Art
8105 - 24"x32" (61x81 cm)

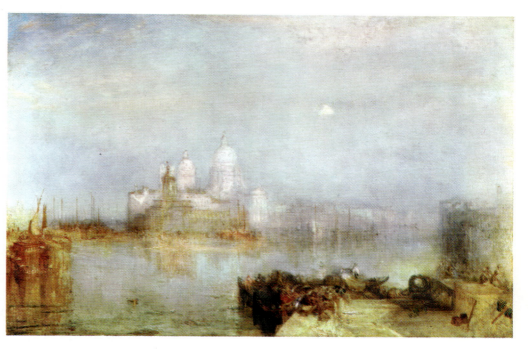

Joseph M. W. Turner
THE DOGANA AND SANTA MARIA
DELLA SALUTE, VENICE, *c.1843*
National Gallery of Art, Washington, D.C.
9838 - 23"x36" (58x91 cm)
5507 - 11¼"x18" (29x46 cm)

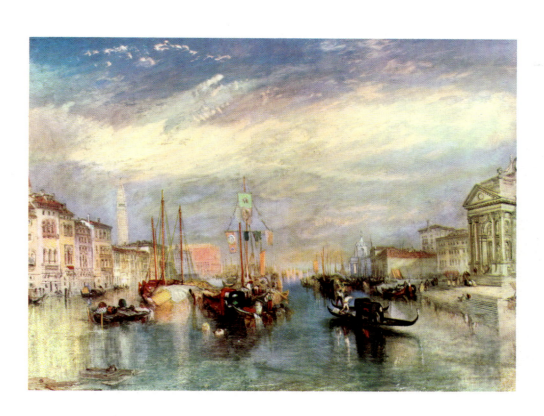

Joseph M. W. Turner
THE GRAND CANAL, VENICE, *1839*
The Metropolitan Museum of Art, New York
9837 - 29½"x39¼" (75x100 cm)

J.F. Herring, Sr. *(British, 1795-1865)*
HUNTING SCENES

FULL CRY
6743 - 13"x20½" (33x52 cm)
3743 - 6½"x11" (16x28 cm)

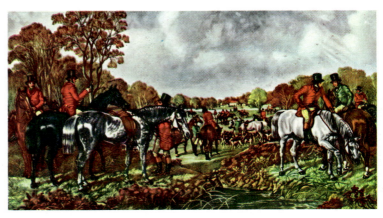

THE MEET
8741 - 17½"x30½" (44x77 cm)
6741 - 13"x20½" (33x52 cm)
3741 - 6½"x11" (16x28 cm)

F. M. Bennett
THE HUNT BREAKFAST
8396 - 22"x32" (56x81 cm)

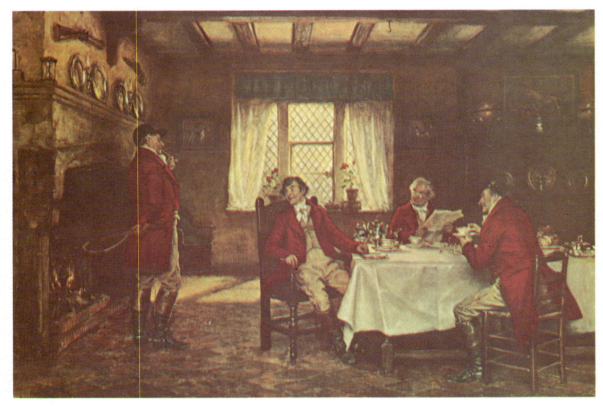

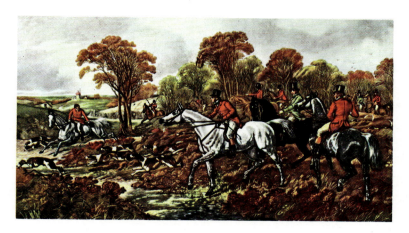

J.F. Herring, Sr. *(British, 1795-1865)*
HUNTING SCENES
Series: 3741 - 4; 6741 - 4; 8741 - 4

BREAKING COVER
8742 - 17½"x30½" (44x77 cm)
6742 - 13"x20½" (33x52 cm)
3742 - 6½"x11" (16x28 cm)

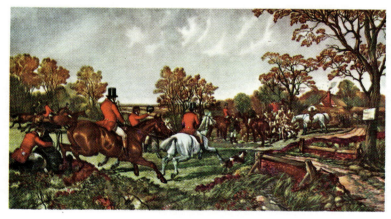

END OF HUNT

6744 - 13"x20½" (33x52 cm)
3744 - 6½"x11" (16x28 cm)

George Morland *(British, 1763-1804)*
THE END OF THE HUNT, *c.1794*
National Gallery of Art, Washington, D.C.
Widener Collection
8745 - 23½"x31" (59x78 cm)

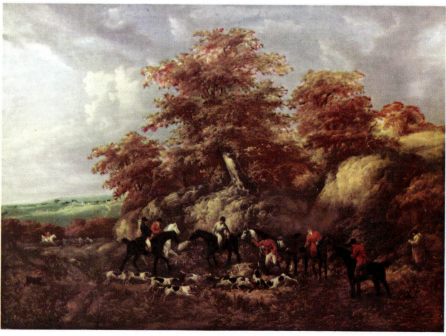

Benjamin Williams Leader *(British, 1831-1923)*
RIVER LLUGWY, NEAR CAPEL CURIG, NORTH WALES
Private Collection
7478 - 20″x30″ (51x76 cm)

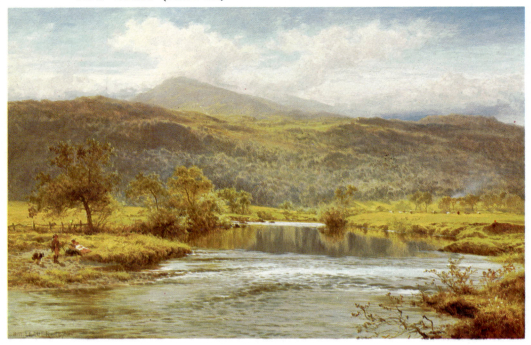

Colin Hunter *(British, 1841/42-1904)*
A SAWMILL ON THE RIVER SNAKE, *1889*
Private Collection
9652 - 40″x30″ (101x76 cm)

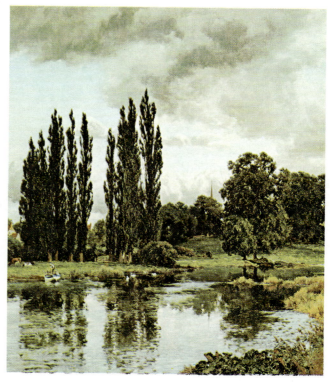

Alfred Parsons
BREDON-ON-THE-AVON, 1913 (detail)
The Corcoran Gallery of Art, Washington, D.C.
6467 - 24"x20" (61x50 cm)
5524 - 17¼"x14½" (44x37 cm)

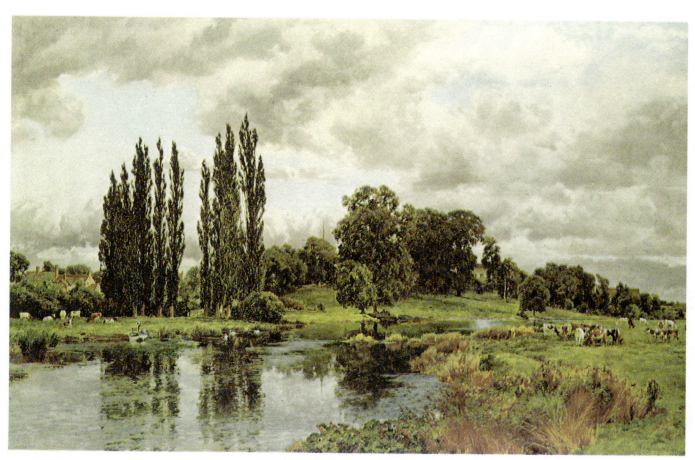

Alfred Parsons *(British, 1847-1920)*
BREDON-ON-THE-AVON, 1913
The Corcoran Gallery of Art, Washington, D.C.
9278 - 24"x36" (61x91 cm)
6245 - 16"x24" (40x60 cm)

Benjamin Williams Leader
THE WAY TO THE VILLAGE CHURCH
7243 - 17¾"x27" (45x68 cm)

(All 3 subjects illustrated are
hand engraved etchings, printed
and colored by hand.)

Benjamin Williams Leader
THE GLEAM BEFORE THE STORM
7245 - 18¼"x27½" (46x69 cm)

Benjamin Williams Leader
BY MEAD AND STREAM
7244 - 17"x28½" (43x72 cm)

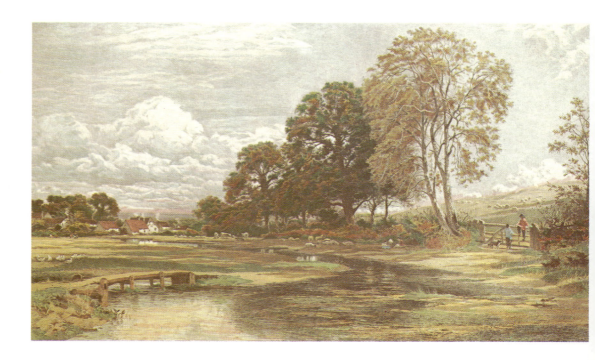

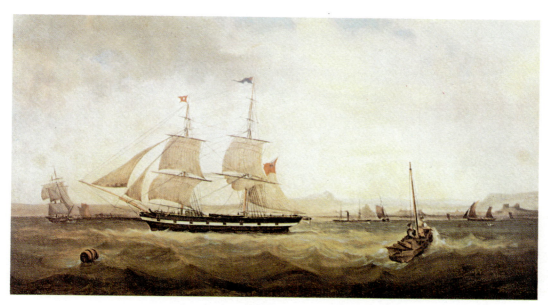

R.B. Spencer *(English, 19th Century)*
LEAVING PORT
Collection of Robert Baskowitz, Jr.
8398 - 16¾"x30" (42x76 cm)

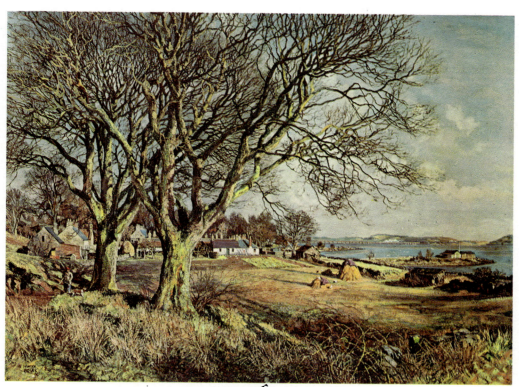

J. McIntosh Patrick, R.S.A. *(British, 1907-)*
AUTUMN IDYLL *(The Tay from Kingoodie)*
Private Collection
9005 - 27"x36" (68x91 cm)

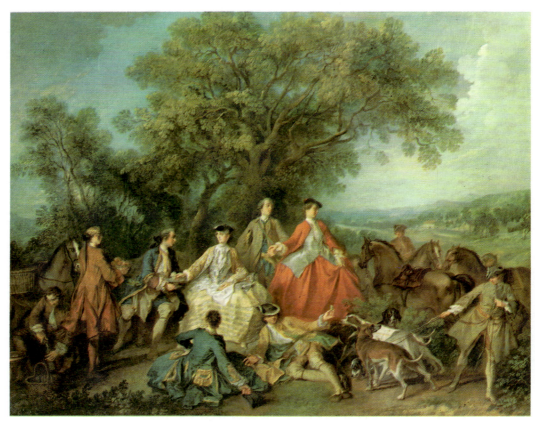

Nicolas Lancret (French, 1690-1743)
THE PICNIC AFTER THE HUNT, c.1740
National Gallery of Art, Washington, D.C.
Samuel H. Kress Collection
7264 - 23½"x29" (59x74 cm)

Jean Etienne Liotard (Swiss, 1702-1789)
THE PAINTER'S NIECE, MLLE. LAVERGNE, 1746
Staatliche Gemäldesammlungen, Dresden
5000 - 20"x15¾" (51x40 cm)

Adolf von Menzel (German, 1815-1905)
THE ROUND TABLE, 1850
National Gallery, Berlin
6930 - 24"x20¼" (61x51 cm)

Nicolas Poussin (French, 1594-1665)
HOLY FAMILY ON THE STEPS, 1648
National Gallery of Art, Washington, D.C.
Samuel H. Kress Collection
7276 - 19¼"x28" (49x71 cm)

François Clouet (French, 1522-1572)
PORTRAIT OF A COURT LADY, c.1570
The Art Institute of Chicago
4022 - 15½"x11¼" (39x28 cm)

Nicolas Poussin
THE ASSUMPTION OF THE VIRGIN, 1626-27
National Gallery of Art, Washington, D.C.
Gift of Mrs. Mellon Bruce
7476 - 26"x18¾" (66x47 cm)

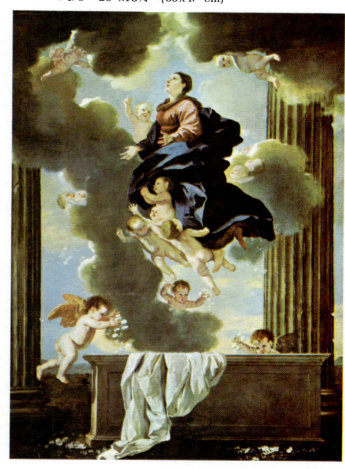

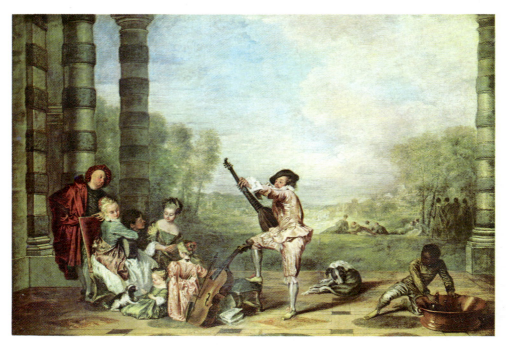

Jean Antoine Watteau *(French, 1684-1721)*
THE CONCERT, 1716
The Wallace Collection, London
7100 - 19¼"x28" (49x71 cm)

Georges de la Tour *(French, 1593-1652)*
GIRL HOLDING A CANDLE, *c.1640*
The Detroit Institute of Arts
6349 - 22½"x17½" (57x44 cm)

Jean-Baptiste Greuze *(French, 1725-1805)*
THE WOOL WINDER, *1758-59*
The Frick Collection, New York
542 - 20¼"x16½" (51x41 cm)

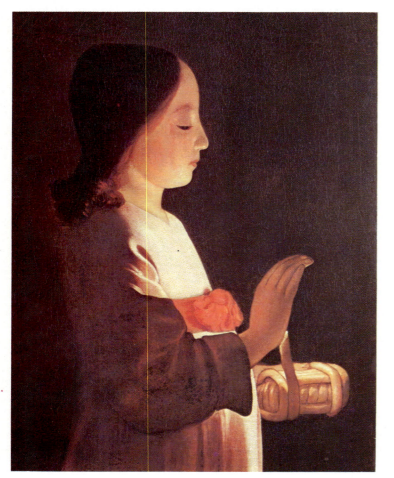

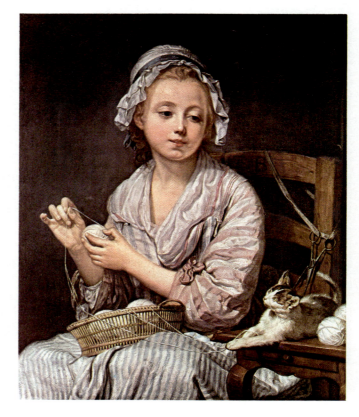

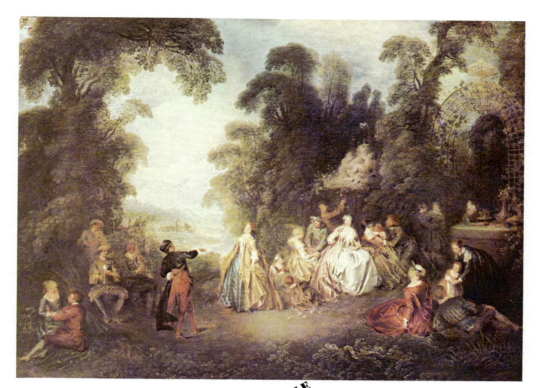

Jean-Baptiste Pater (French, 1695-1736)
THE DANCE, undated
Worcester Art Museum
8665 - 25"x33" (63x86 cm)

NO LONGER AVAILABLE

Jean-Honoré Fragonard (French, 1732-1806)
A GAME OF HOT COCKLES, 1767-73
National Gallery of Art, Washington, D.C.
Samuel H. Kress Collection
4929 - 14"x10¾" (35x27 cm)

Jean-Honoré Fragonard
A GAME OF HORSE AND RIDER, 1767-73
National Gallery of Art, Washington, D.C.
Samuel H. Kress Collection
4928 - 14"x10¾" (35x27 cm)

Hubert Robert *(French, 1733-1808)*
TERRACE OF THE CHATEAU DE MARLY, c.1777
Nelson Gallery and Atkins Museum, Kansas City, Missouri
9045 - 24½"x36" (62x91 cm)

Jean-Honoré Fragonard
A YOUNG GIRL READING, *1776*
National Gallery of Art, Washington, D.C.
Gift of Mrs. Mellon Bruce in memory of
her father Andrew W. Mellon
6725 - 25¾"x20¼" (65x51 cm)
4725 - 14"x11" (35x28 cm)

Jean-Honoré Fragonard
OATH OF LOVE
3140 - 12"x10" (30x25 cm)

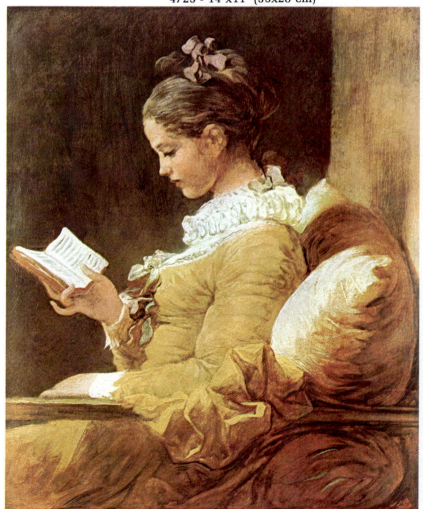

Jean-Honoré Fragonard
THE GOOD MOTHER
3139 - 11¾"x10" (30x25 cm)

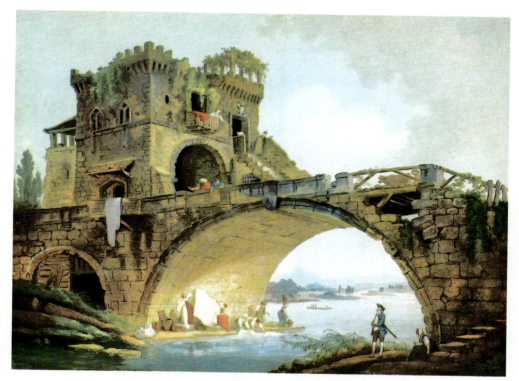

Hubert Robert
THE OLD BRIDGE, c.1775
National Gallery of Art, Washington, D.C.
Samuel H. Kress Collection
902 - 26¾"x35¾" (68x91 cm)

Hubert Robert
THE TERRACE, 1794
The Baltimore Museum of Art

4270 - 14"x10" (35x25 cm)

Hubert Robert
THE ROMAN GARDEN, 1794
The Baltimore Museum of Art
7269 - 28"x20" (71x50 cm)
4269 - 14"x10" (35x25 cm)

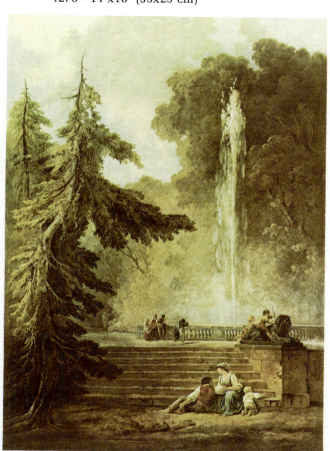

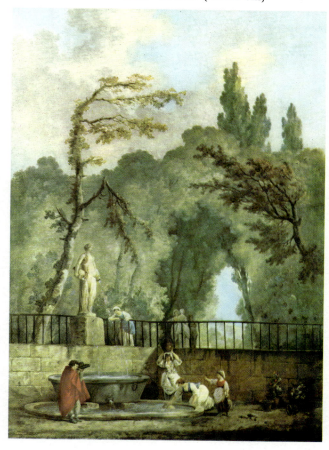

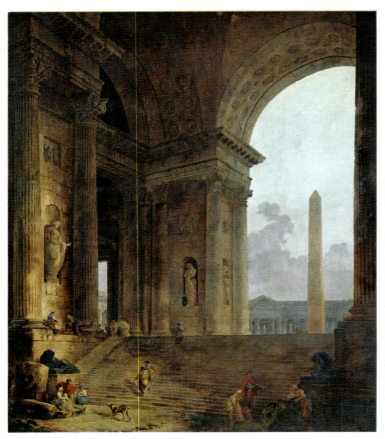

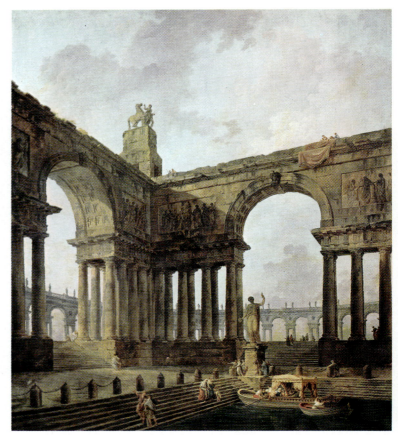

Hubert Robert
THE OBELISK, *1787*
The Art Institute of Chicago
7460 - 28"x24¼" (71x61 cm)
4460 - 14"x12" (35x30 cm)

Hubert Robert
THE LANDING, *1788*
The Art Institute of Chicago
7461 - 28"x24¼" (71x61 cm)
4461 - 14"x12" (35x30 cm)

Hubert Robert
THE FOUNTAINS, *1787-88*
The Art Institute of Chicago
7259 - 28"x24¼" (71x61 cm)
4259 - 14"x12" (35x30 cm)

Hubert Robert
OLD TEMPLE, *1787*
The Art Institute of Chicago
7258 - 28"x24¼" (71x61 cm)
4258 - 14"x12" (35x30 cm)

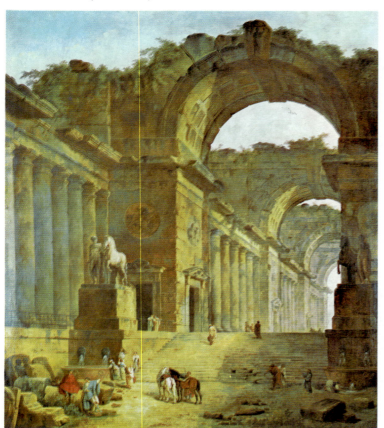

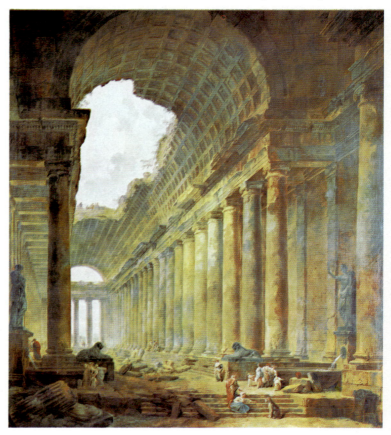

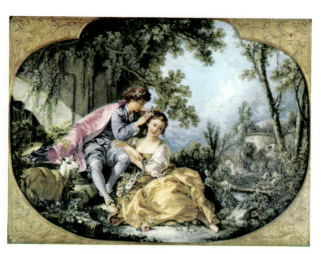

François Boucher (French, 1703-1770)
SPRING, 1755
The Frick Collection, New York
697 - 16¼″x21″ (41x53 cm)
497 - 10½″x14″ (28x35 cm)

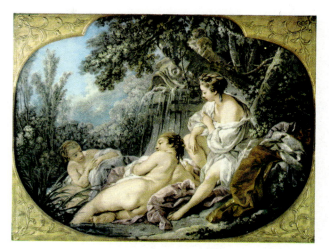

François Boucher
SUMMER, 1755
The Frick Collection, New York
699 - 16¼″x21″ (41x53 cm)
499 - 10½″x14″ (28x35 cm)

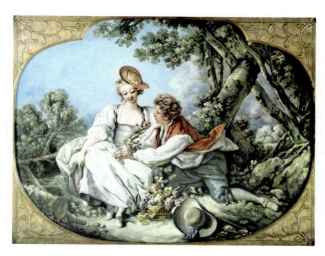

François Boucher
AUTUMN, 1755
The Frick Collection, New York
696 - 16¼″x21″ (41x53 cm)
496 - 10½″x14″ (28x35 cm)

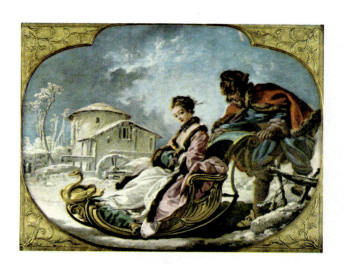

François Boucher
WINTER, 1755
The Frick Collection, New York

498 - 10½″x14″ (28x35 cm)

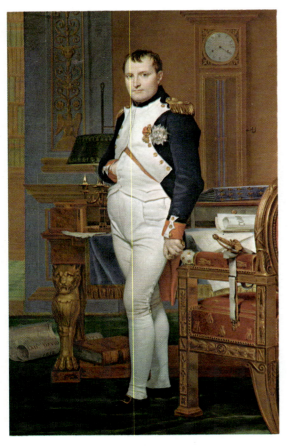

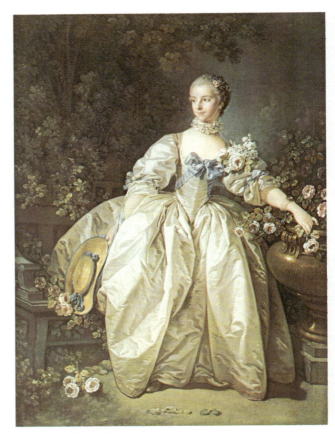

Jacques Louis David (French, 1748-1825)
NAPOLEON IN HIS STUDY, 1812
National Gallery of Art, Washington, D.C.
Samuel H. Kress Collection
4630 - 14"x8½" (35x21 cm)

François Boucher
MADAME BERGERET, 1746
National Gallery of Art, Washington, D.C.
Samuel H. Kress Collection
802 - 30"x22" (76x56 cm)

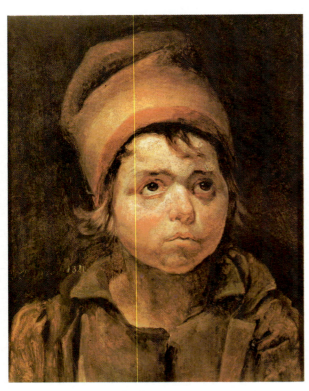

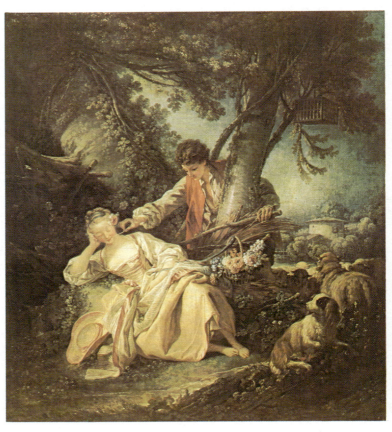

Théodore Géricault (French, 1791-1824)
ENGLISH BOY, 1821
The Norton Simon Collection
5685 - 18"x14" (46x35 cm)

François Boucher
THE SLEEPING SHEPHERDESS, 1750
The Metropolitan Museum of Art, New York
The Jules S. Bache Collection
7292 - 28"x25¼" (71x64 cm)

Jean Auguste Dominique Ingres
PORTRAIT OF CHARLES GOUNOD, *1841*
The Art Institute of Chicago
3037 - 11¾"x9" (30x23 cm)

Francisco de Goya *(Spanish, 1746-1828)*
BE CAREFUL WITH THAT STEP, *1810-19*
The Art Institute of Chicago
3047 - 12"x8" (30x20 cm)

Jean Auguste Dominique Ingres
PORTRAIT OF MME. CHARLES GOUNOD, *1855*
The Art Institute of Chicago
3036 - 11¾"x9" (30x23 cm)

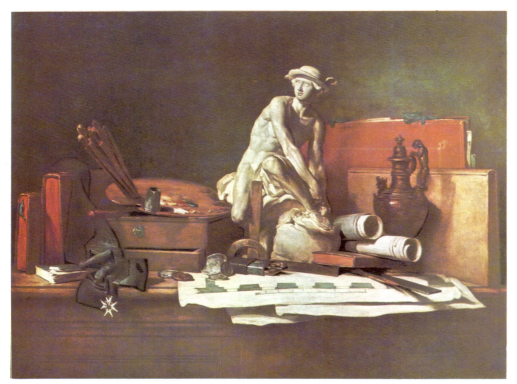

Jean-Baptiste Siméon Chardin (French, 1699-1779)
THE ATTRIBUTES OF THE ARTS, 1766
The Minneapolis Institute of Arts
8295 - 24¾"x32" (63x81 cm)

Jean-Baptiste Siméon Chardin
THE KITCHEN MAID, c.1738
National Gallery of Art, Washington, D.C.
Samuel H. Kress Collection
5100 - 17¾"x14¼" (45x36 cm)

Jean-Baptiste Siméon Chardin
THE BLESSING, 1744
Hermitage State Museum, Leningrad
5099 - 20"x15½" (51x39 cm)

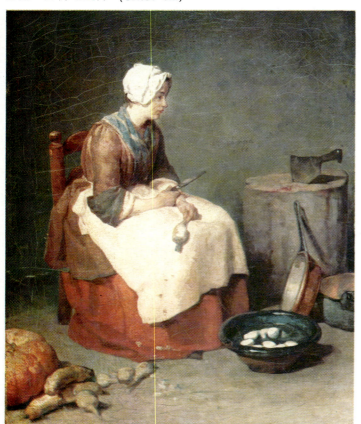

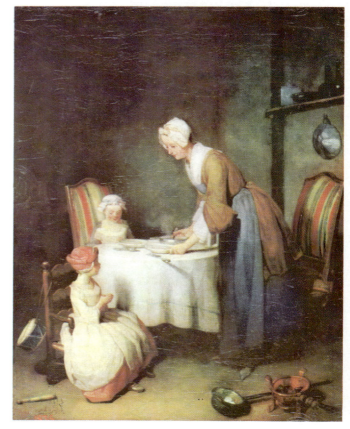

Honoré Daumier
JUGGLERS AT REST, 1870
Mr. Norton Simon, Los Angeles
7226 - 20"x24¾" (50x63 cm)

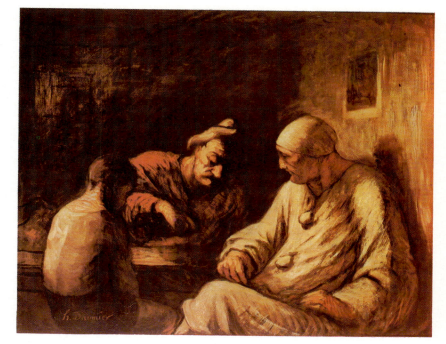

Honoré Daumier (French, 1808-1879)
THE THIRD-CLASS CARRIAGE, 1860
The Metropolitan Museum of Art, New York
The H. O. Havemeyer Collection
6007 - 16"x22" (40x55 cm)

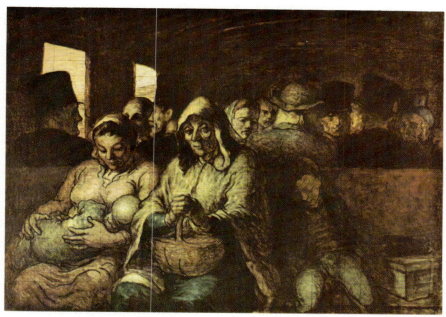

Honoré Daumier
THREE LAWYERS, *undated*
The Phillips Collection, Washington, D.C.
478 - 15½"x12¼" (39x31 cm)

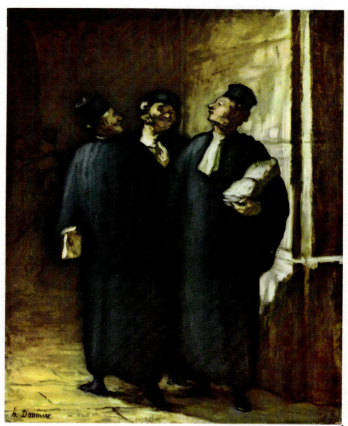

3432 - OH! DOCTOR . . .

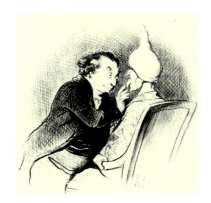

3430 - A HAPPY DISCOVERY

Honoré Daumier
FOUR MEDICAL SKETCHES
3430-33 approx. 6″x7″ (15x17 cm)

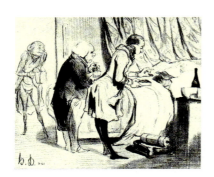

3431 - THE LAST TRY

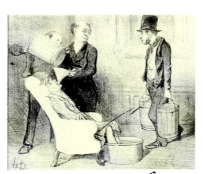

3433 - THE WATER CURE

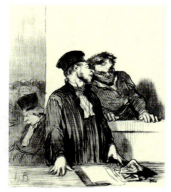

3404 - PLEAD NOT GUILTY

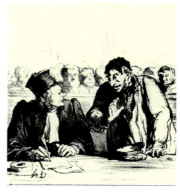

3405 - SO GOES HIS STORY

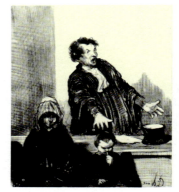

3406 - THIS SAINTLY WOMAN

Honoré Daumier
SIX LEGAL SKETCHES
3404-09 approx. 9″x8″ (22x20 cm)

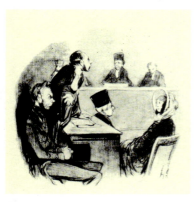

3407 - SUCH A DEVOTED
HUSBAND

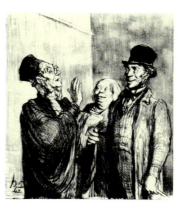

3408 - A SURE CASE

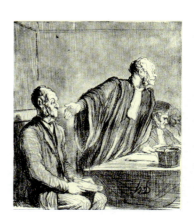

3409 - A RESPECTED CITIZEN

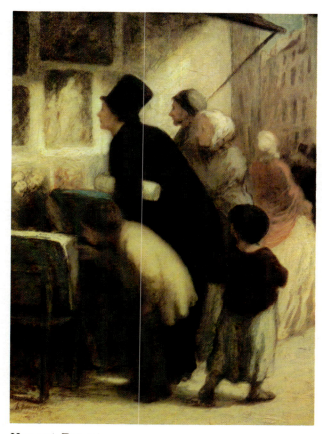

Honoré Daumier
PASSERS-BY IN FRONT OF A PRINT SHOP, c.1860
Collection of Mr. and Mrs. Leigh B. Block
4073 - 13"x9½" (33x24 cm)

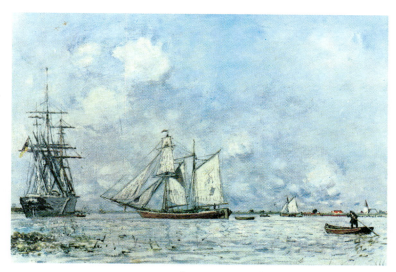

Johan Jongkind *(Dutch, 1819-1891)*
THE RIVER MEUSE, 1866
Havre Museum
5310 - 14¼"x20" (36x51 cm)

Jean-Jacques dit John Chalon *(Swiss, 1778-1854)*
LA FORGE DE LA CORRATERIE, 1829
Musée d'Art et d'Histoire, Genéve
6813 - 26"x20¹⁄₁₆" (65x51 cm)

Jean Baptiste Camille Corot *(French, 1796-1875)*
LAGO DI GARDA
*Private Collection on loan to the
San Diego Museum of Art*
6037 - 26"x20½" (66x52 cm)

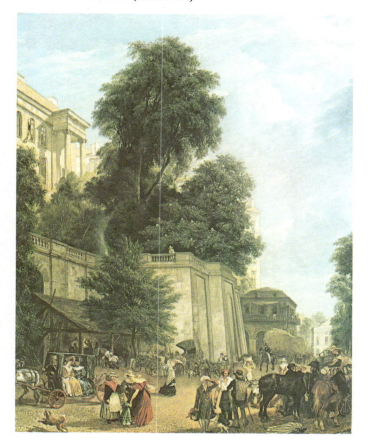

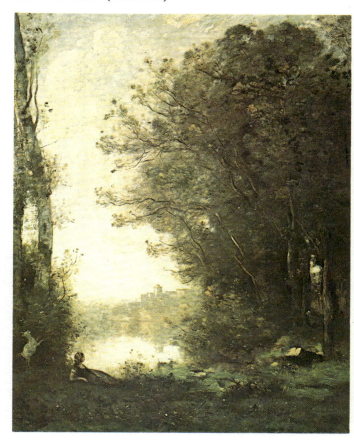

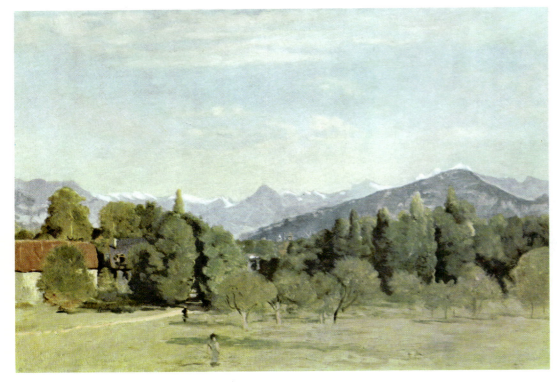

Jean-Baptiste Camille Corot
LANDSCAPE NEAR GENEVA, 1841
Museum of Art and History, Geneva
5257 - 12½″x18″ (31x45 cm)

Jean-Baptiste Camille Corot *(French, 1796-1875)*
VILLE D'AVRAY, *c.1867-70*
National Gallery of Art, Washington, D.C.
Gift of Count Cecil Pecci-Blunt
7058 - 19″x25″ (48x63 cm)
5529 - 13½″x18″ (34x46 cm)

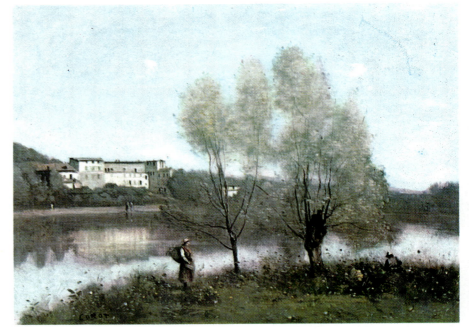

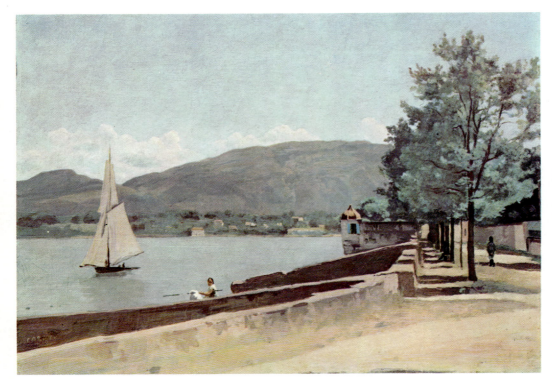

Jean-Baptiste Camille Corot
QUAI DES PAQUIS, GENEVA, 1841
Museum of Art and History, Geneva
5256 - 12½″x18″ (31x45 cm)

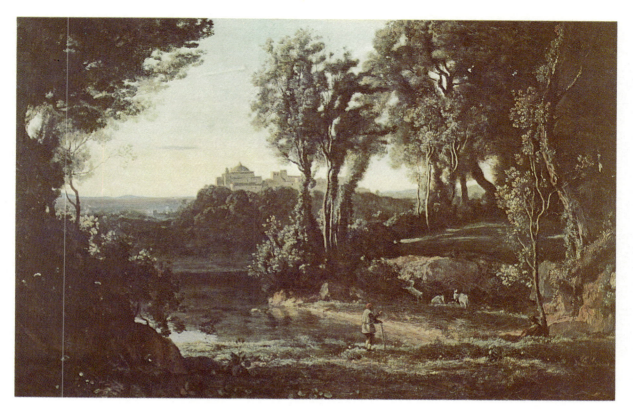

Jean-Baptiste Camille Corot
SITE D'ITALIE, *1839*
The Norton Simon Collection
8283 - 21"x32" (53x81 cm)

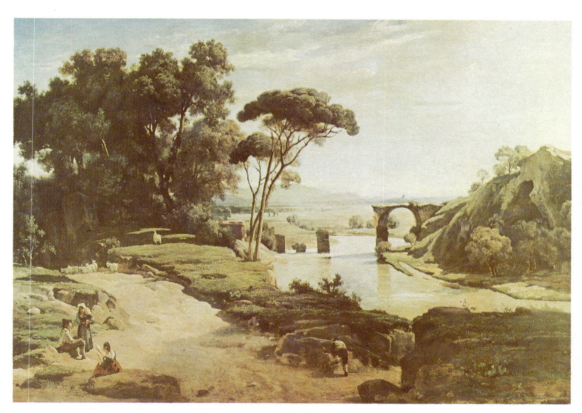

Jean-Baptiste Camille Corot
THE BRIDGE OF NARNI, *1865-70*
National Gallery of Canada, Ottawa
966 - 25½"x35¾" (64x91 cm)
666 - 16"x24" (40x61 cm)

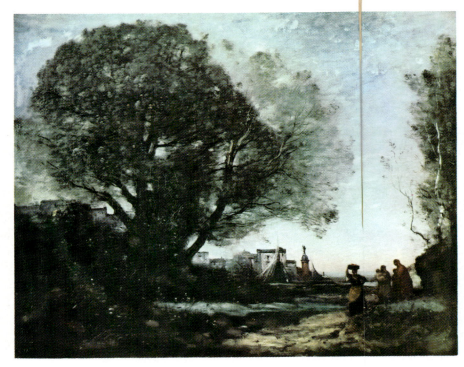

Jean-Baptiste Camille Corot
REMEMBRANCE OF TERRACINA, 1864
The Corcoran Gallery of Art, Washington, D.C.
W. A. Clark Collection
8024 - 25½"x31½" (65x80 cm)
4222 - 10¾"x13½" (27x34 cm)

Henri Joseph Harpignies *(French, 1819-1916)*
A FARMHOUSE, *undated*
The Norton Simon Foundation, Los Angeles
4074 - 10½"x16" (26x40 cm)

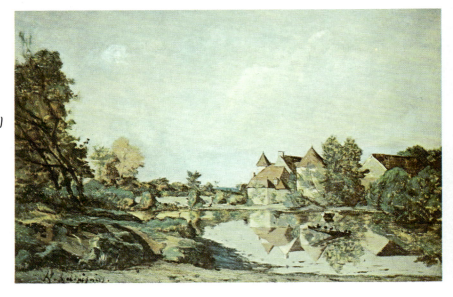

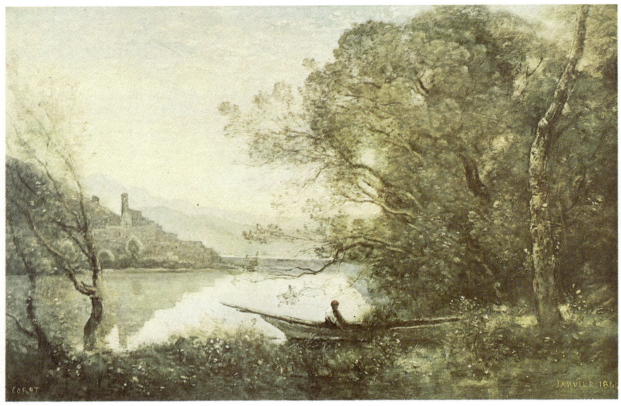

Jean-Baptiste Camille Corot
LE LAC DE TERNI, 1861
The Corcoran Gallery of Art
Washington, D.C.
9663 - 24"x35¾" (61x91 cm)
4221 - 10¾"x16" (27x40 cm)

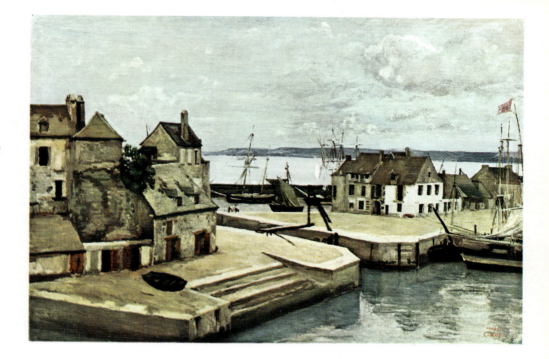

Jean-Baptiste Camille Corot
HOUSES AT HONFLEUR, *1830*
Private Collection
7007 - 17½"x25¼" (44x64 cm)

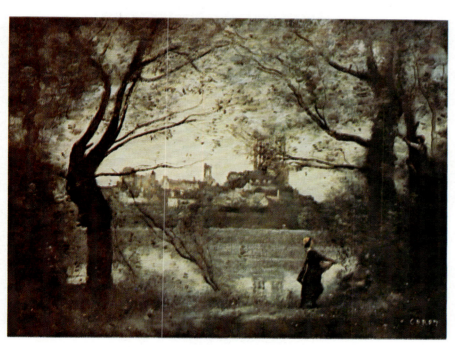

Jean-Baptiste Camille Corot
VIEW OF MANTES
Musee des Beaux Arts, Reims
6872 - 20¾"x27½" (52x69 cm)
(For sale in U.S.A. only)

Jean-Baptiste Camille Corot
VIEW NEAR VOLTERRA, *1838*
National Gallery of Art, Washington, D.C.
Chester Dale Collection
707 x30" (55x76 cm)

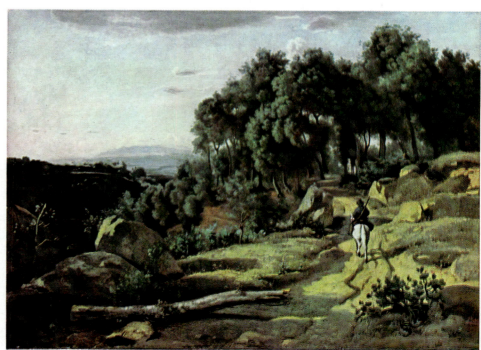

151

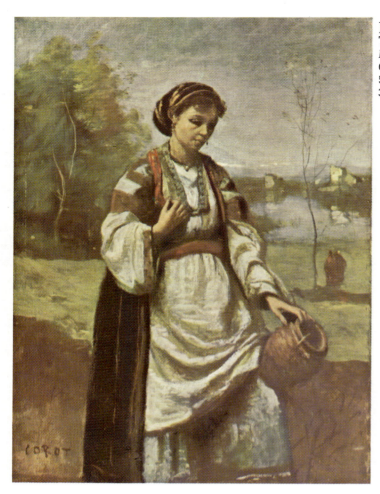

Jean-Baptiste Camille Corot
THE GYPSY GIRL AT THE FOUNTAIN, *1865-70*
Philadelphia Museum of Art
George W. Elkins Collection
5847 - 20"x15" (50x38 cm)
3847 - 10¼"x7½" (26x19 cm)

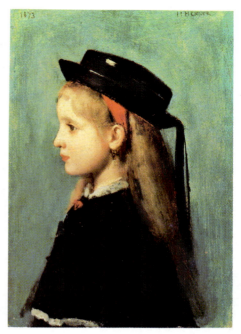

Jean-Jacques Henner (French, 1829-1905)
ALSATIAN GIRL, *1873*
National Gallery of Art, Washington, D.C.
Chester Dale Collection
3048 - 10¾"x7¼" (27x18 cm)

Jean-Baptiste Camille Corot
THE FOREST OF COUBRON, *1872*
(Le Retour au Logis)
National Gallery of Art, Washington, D.C.
Widener Collection
7255 - 29½"x24" (75x61 cm)

Henri Joseph Harpignies
LANDSCAPE AT SUNDOWN *(detail), 1897*
Private Collection
8967 - 36"x28" (91x71 cm)

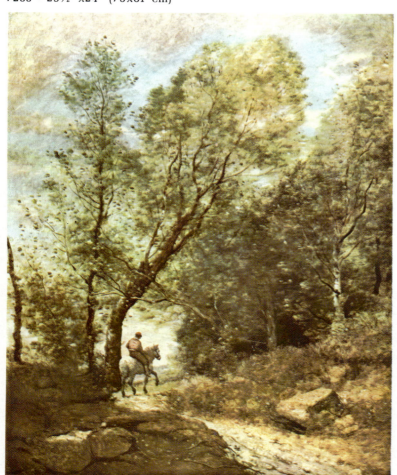

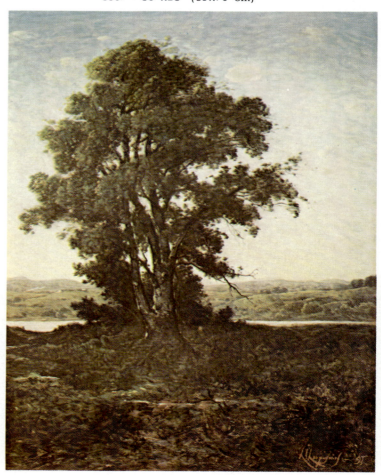

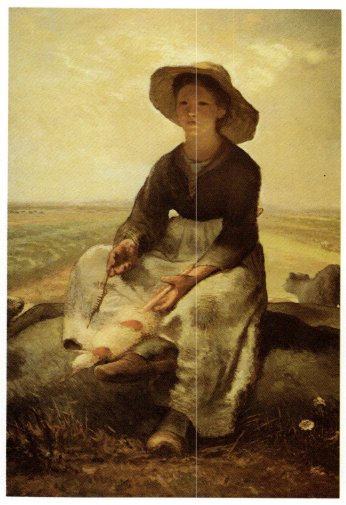

Jean François Millet
YOUNG SHEPHERDESS
Museum of Fine Arts, Boston
6932 - 24"x16½" (61x42 cm)

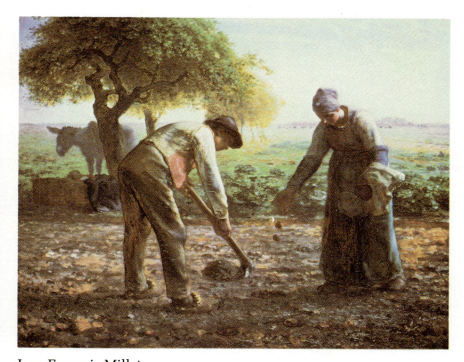

Jean François Millet
PLANTING POTATOES
Shaw Collection, Museum of Fine Arts, Boston
6509 - 20"x24⅜" (51x61½ cm)

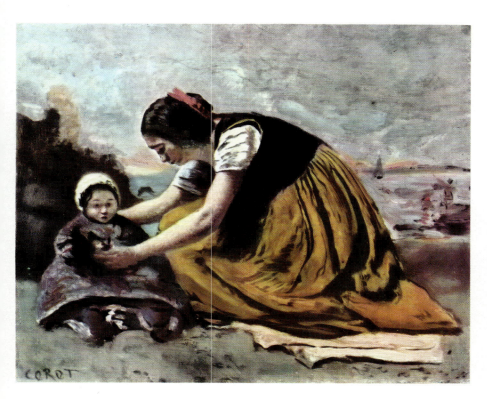

Jean-Baptiste Camille Corot
MOTHER AND CHILD ON THE BEACH, *1860-70*
Philadelphia Museum of Art
John G. Johnson Collection
591 - 14½"x18" (36x45 cm)

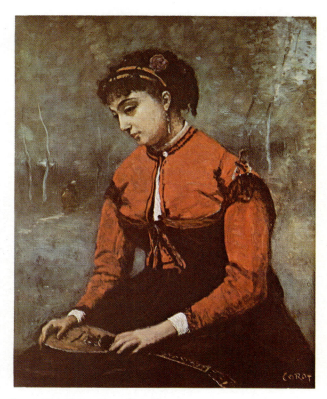

Jean-Baptiste Camille Corot
YOUNG WOMAN IN RED
WITH MANDOLIN, *c.1868-70*
Mrs. Norton Simon, Los Angeles
5360 - 18"x14¼" (46x36 cm)

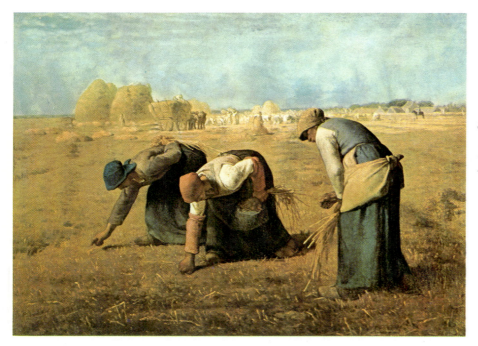

Jean François Millet (French, 1814-1875)
THE GLEANERS, 1857
Louvre Museum, Paris
6498 - 17½"x23½" (44x59 cm)
4498 - 10½"x14" (26x35 cm)

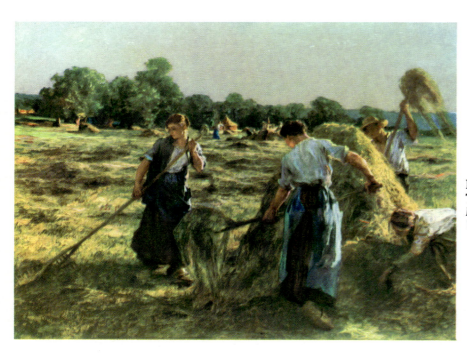

Léon Augustin L'Hermitte (French, 1844-1925)
THE HAYMAKING
Private Collection
7925 - 18½"x24¾" (47x62 cm)

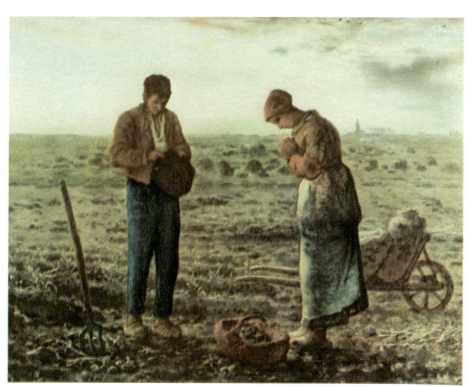

Jean François Millet
THE ANGELUS, 1859
Louvre Museum, Paris
6499 - 20"x24" (50x60 cm)
4499 - 11"x14" (28x35 cm)

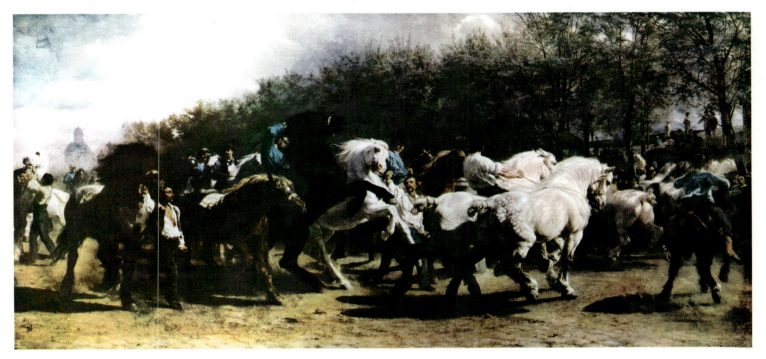

Rosa Bonheur (French, 1822-1899)
THE HORSE FAIR, 1853-5
The Metropolitan Museum of Art, New York
9014 - 17"x36" (43x91 cm)
178 - 5¼"x11" (14x28 cm)

Jules Breton (French, 1827-1906)
THE SONG OF THE LARK, 1884
The Art Institute of Chicago
Henry Field Memorial Collection

4190 - 14½"x11" (36x28 cm)

Pierre Outin (French, 1840-1899)
THE TOAST
7498 - 27¾"x22¾" (70x57 cm)

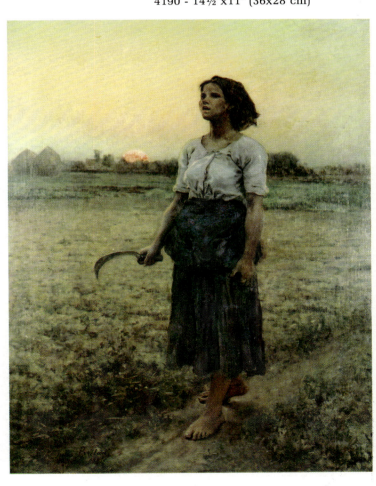

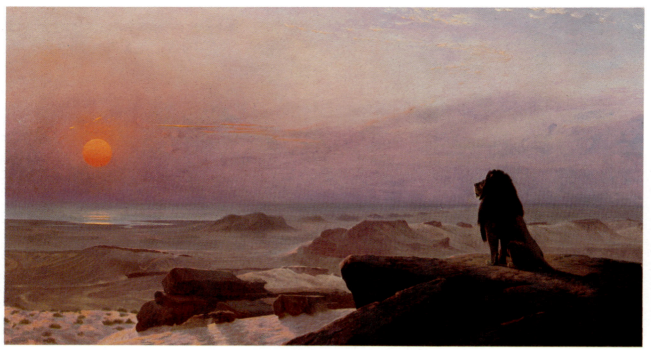

Jean-Léon Gérôme *(French, 1824-1904)*
THE TWO MAJESTIES, 1883
Milwaukee Art Center, Layton Art Collection
7982 - 16¼"x30" (41x76 cm)

Paul Chabas *(French, 1869-1937)*
SEPTEMBER MORN, *c. 1912*
The Metropolitan Museum of Art, New York
7728 - 21"x28" (52x71 cm)
4728 - 11"x14½" (28x37 cm)

Eugène Louis Boudin
THE BEACH AT VILLERVILLE, *1864*
National Gallery of Art, Washington, D.C.
Chester Dale Collection
9289 - 17¾"x30" (45x76 cm)

Gustave Courbet
THE TRELLIS, *1863*
The Toledo Museum of Art
725 - 24"x29¾" (61x75 cm)

Gustave Courbet
BEACH AT ETRETAT, *c.1869*
National Gallery of Art, Washington, D.C.
Chester Dale Collection
9284 - 24¼"x36" (61x91 cm)

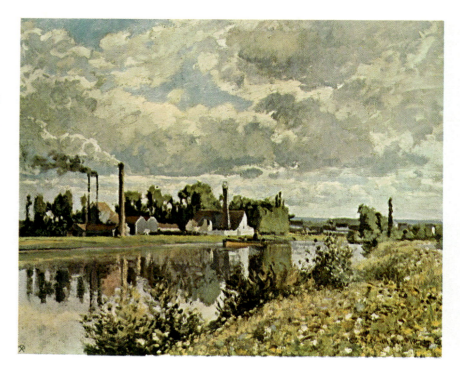

Camille Pissarro (French, 1831-1903)
THE OISE NEAR PONTOISE, 1873
Sterling and Francine Clark Art Institute
Williamstown, Massachusetts
528 - 16¼"x19¾" (41x50 cm)

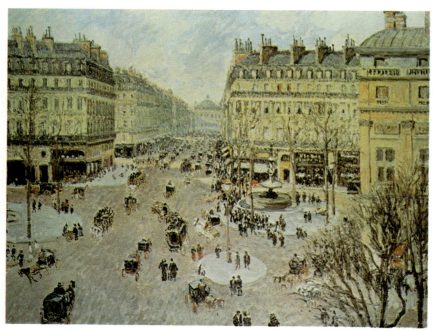

Camille Pissarro
PLACE DU THEATRE FRANCAIS,
SOLEIL D'APRES-MIDI EN HIVER, *1898*
Mr. Norton Simon, Los Angeles
7871 - 24"x30" (61x76 cm)

Camille Pissarro
BORDS DE L'EAU A PONTOISE, *1872*
Mrs. Norton Simon, Los Angeles
8265 - 21¾"x35¾" (55x91 cm)

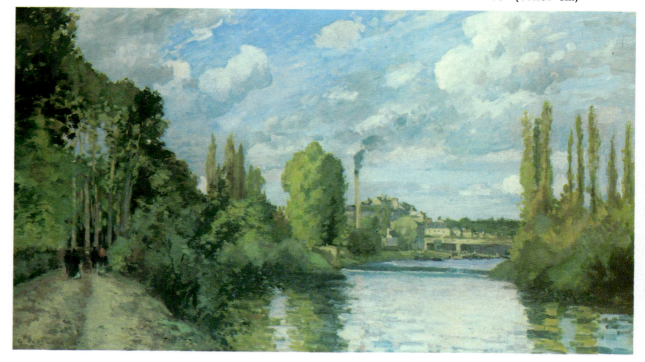

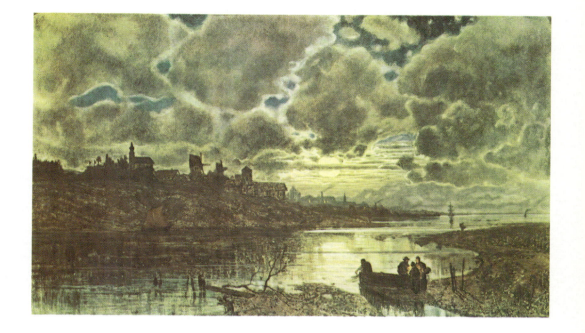

Karl Heffner *(German, 1849-1925)*
MOON GLOW
Private Collection
6018 - 17"x28" (43x71 cm)

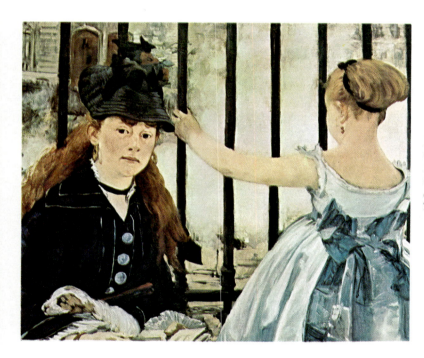

Edouard Manet *(French, 1832-1883)*
GARE SAINT-LAZARE, *1873*
National Gallery of Art, Washington, D.C.
Gift of Horace Havemeyer in memory
of his mother Louisine W. Havemeyer
7081 - 22½"x28" (57x71 cm)

Edouard Manet
GUITAR AND SOMBRERO
Calvet Museum, Avignon
7810 - 17½"x28" (45x71 cm)

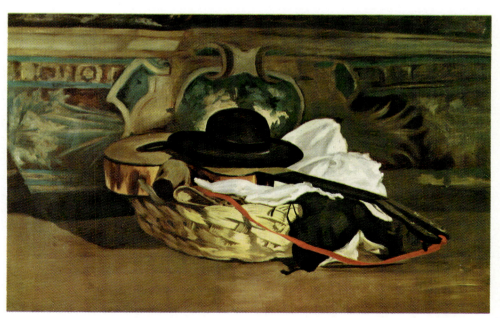

159

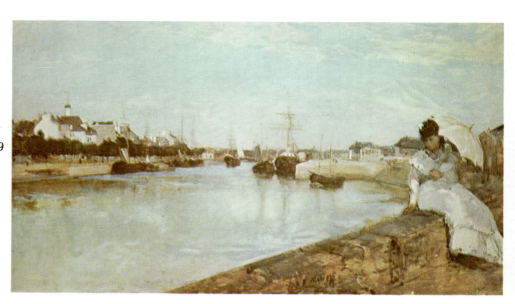

Berthe Morisot (French, 1841-1895)
HARBOR AT LORIENT
(WITH THE ARTIST'S SISTER EDMA), 1869
National Gallery of Art, Washington, D.C.
Mellon Collection
7968 - 16¾"x28" (42x71 cm)

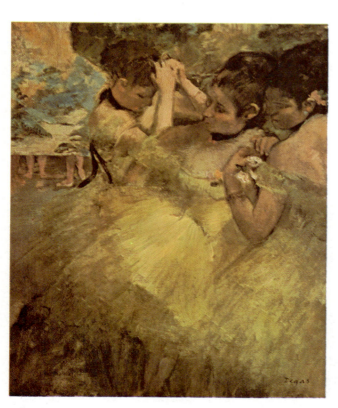

Edgar Degas
DANCERS PREPARING FOR THE BALLET, c.1878-80
The Art Institute of Chicago
7829 - 28"x23" (72x58 cm)

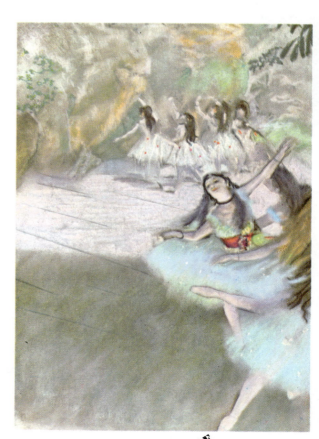

Edgar Degas (French, 1834-1917)
BALLET GIRLS ON THE STAGE, c. 1880
The Art Institute of Chicago
6762 - 22"x15½" (55x39 cm)

Edgar Degas
PORTRAIT OF RENE de GAS, *1855*
The Art Institute of Chicago
4086 - 13″x10½″ (33x27 cm)

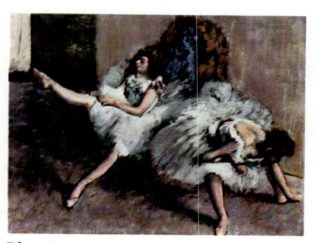

Edgar Degas
BEFORE THE BALLET *(detail), 1888*
National Gallery of Art, Washington, D.C.
Widener Collection
4019 - 11″x14″ (28x35 cm)

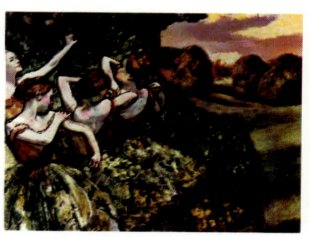

Edgar Degas
FOUR DANCERS, *c.1899*
National Gallery of Art, Washington, D.C.
Chester Dale Collection
4017 - 11″x14″ (28x35 cm)

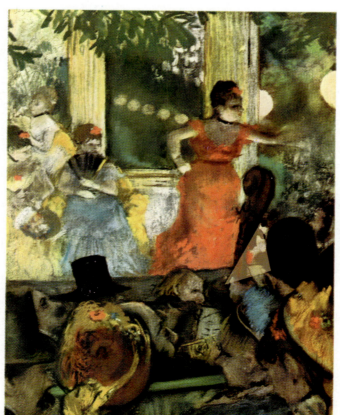

Edgar Degas
THE CABARET
Lyon Museum, France
4021 - 14″x10½″ (35x26 cm)

NO LONGER AVAILABLE

Edgar Degas
PINK AND GREEN, 1890
The Metropolitan Museum of Art, New York
6549 - 23½"x21½" (60x55 cm)

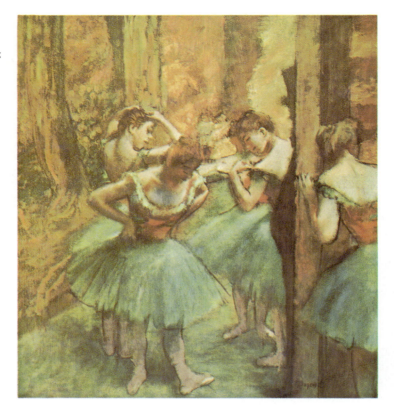

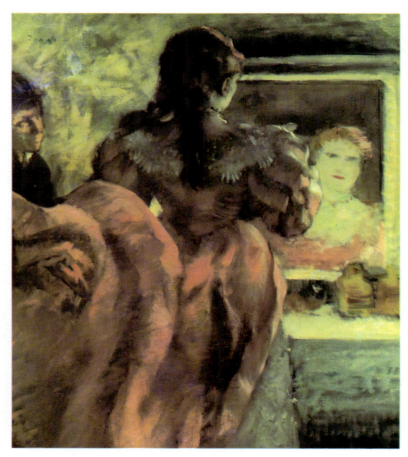

Edgar Degas
L'ACTRICE DANS SA LOGE, 1878
Mr. Norton Simon, Los Angeles
8266 - 30"x26½" (76x67 cm)

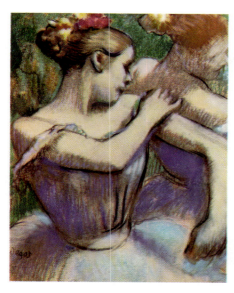

Edgar Degas
DANCERS IN THE WINGS, c.1890
The Art Institute of Chicago
5727 - 17"x13" (43x33 cm)

Edgar Degas
VIOLINIST SEATED, STUDY, c.1877-78
The Metropolitan Museum of Art, New York
5101 - 15"x11½" (38x29 cm)

Edgar Degas
DANCERS AT THE BAR, c.1888
The Phillips Collection, Washington, D.C.
8267 - 31"x23¼" (79x59 cm)

Edgar Degas
THE BALLET CLASS, c.1880
Philadelphia Museum of Art
7843 - 27½"x26" (71x66 cm)

163

Edgar Degas
LA DANSEUSE AU BOUQUET, 1878
Rhode Island School of Design
Museum of Art, Providence
4837 - 11"x14" (27x35 cm)

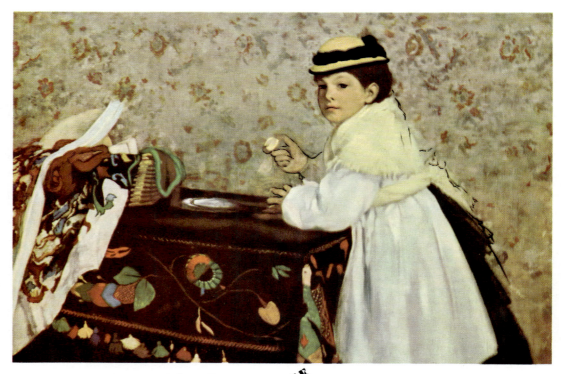

Edgar Degas
MADEMOISELLE VALPINÇON, 1869
The Minneapolis Institute of Arts
7279 - 19"x28" (48x71 cm)

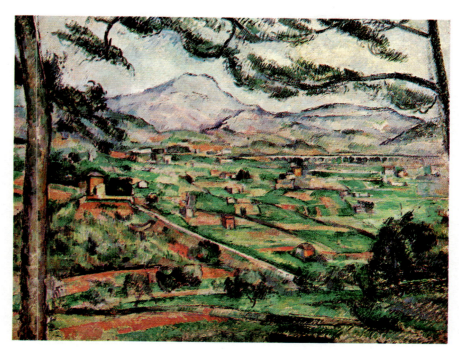

Paul Cézanne
MONTAGNE STE.-VICTOIRE, 1886-88
The Phillips Collection, Washington, D.C.
7864 - 23¼"x28½" (56x72 cm)

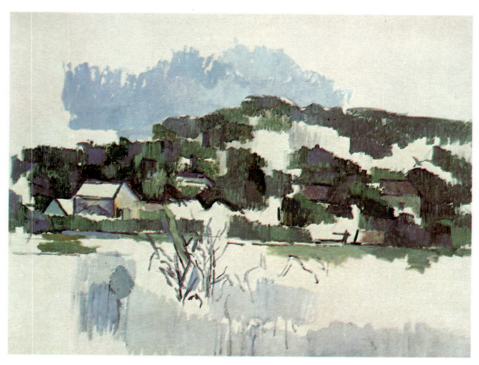

Paul Cézanne
HOUSES ON THE HILL, 1900-06
Marion Koogler McNay Art Institute, San Antonio, Texas
8965 - 23"x30" (58x76 cm)

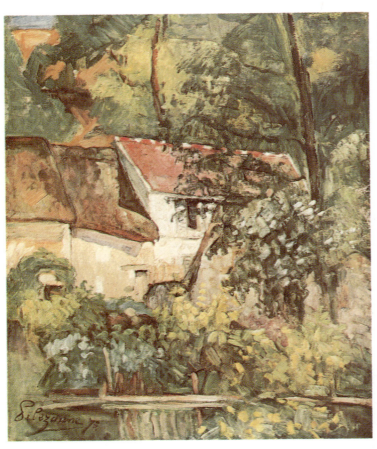

Paul Cézanne
HOUSE OF PERE LACROIX, 1873
National Gallery of Art, Washington, D.C.
Chester Dale Collection
6823 - 24"x19½" (61x50 cm)

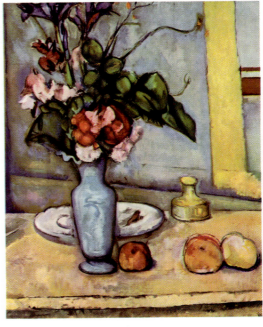

Paul Cézanne
THE BLUE VASE, *1883-87*
Louvre Museum, Paris
5926 - 20"x15½" (50x40 cm)

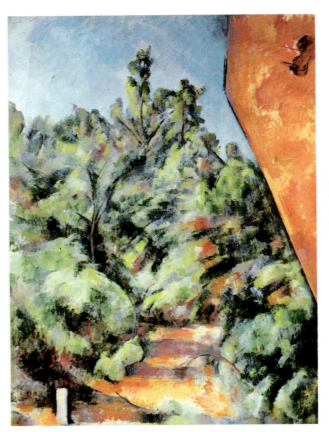

Paul Cézanne
THE RED ROCK, *1895-99*
Musée de l'Orangerie, Paris
7575 - 28"x20½" (71x52 cm)

Paul Cézanne
VASE OF FLOWERS, c.1876
National Gallery of Art, Washington, D.C.
Chester Dale Collection
7833 - 28"x23" (71x58 cm)

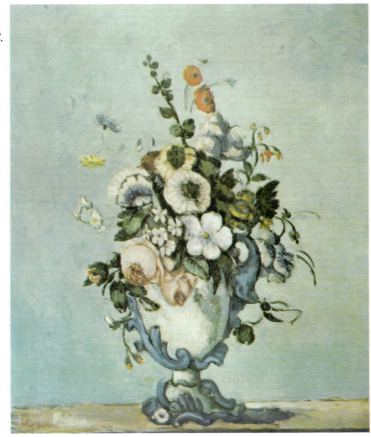

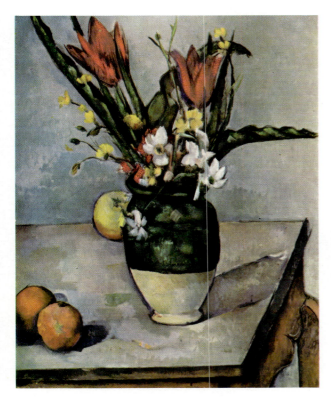

Paul Cézanne
VASE OF TULIPS, c.1890-94
The Art Institute of Chicago
613 - 22¼"x16" (56x40 cm)

Paul Cézanne
VASE OF FLOWERS, 1874
Durand-Ruel Collection, New York
630 - 20½"x16½" (52x42 cm)

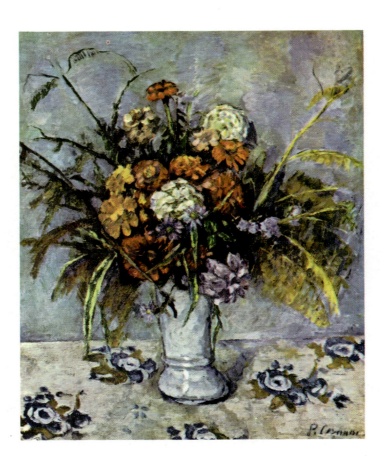

167

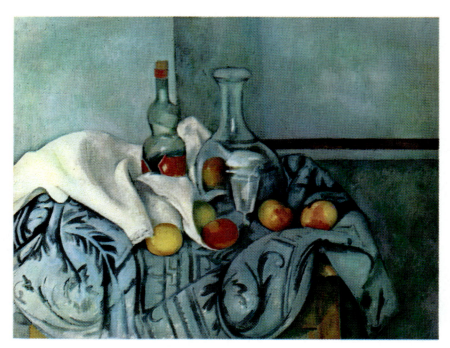

Paul Cézanne
STILL LIFE, 1890
National Gallery of Art, Washington, D.C.
Chester Dale Collection
7488 - 24"x30" (61x76 cm)

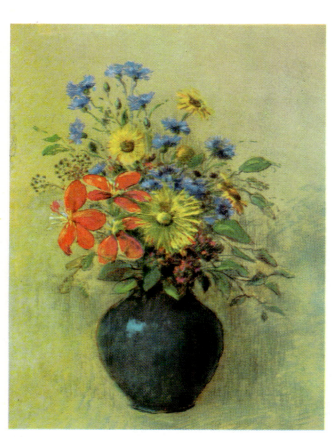

Odilon Redon *(French, 1840-1916)*
WILDFLOWERS, *c.1905*
National Gallery of Art, Washington, D.C.
6394 - 24"x18" (61x46 cm)
5530 - 18"x13" (46x33 cm)

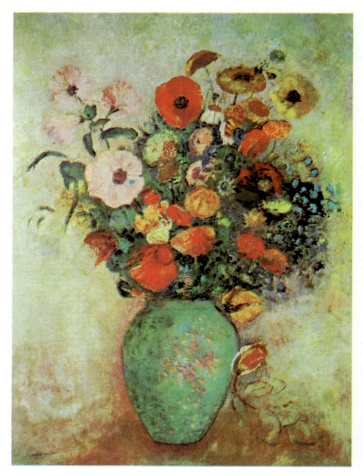

Odilon Redon
BOUQUET OF FLOWERS IN A GREEN VASE, *c.1906*
Wadsworth Atheneum, Hartford, Conn.
7097 - 28"x20¼" (71x51 cm)

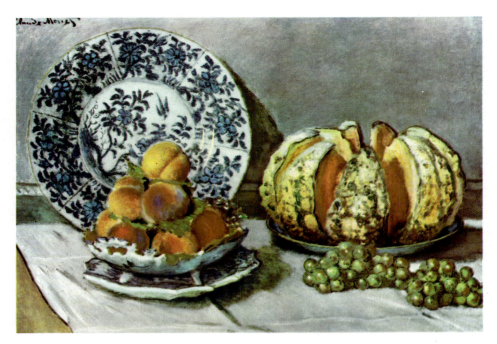

Claude Monet (French, 1840-1926)
STILL LIFE, c.1876
Gulbenkian Collection
718 - 20"x28" (51x71 cm)

Claude Monet
SPRING FLOWERS, 1864
The Cleveland Museum of Art
Gift of Hanna Fund
8285 - 32"x24½" (81x62 cm)

Claude Monet
SUNFLOWERS, 1881
The Metropolitan Museum of Art, New York
The H. O. Havemeyer Collection, 1929
7284 - 30"x24" (76x61 cm)

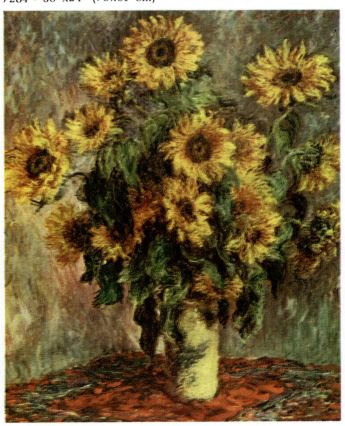

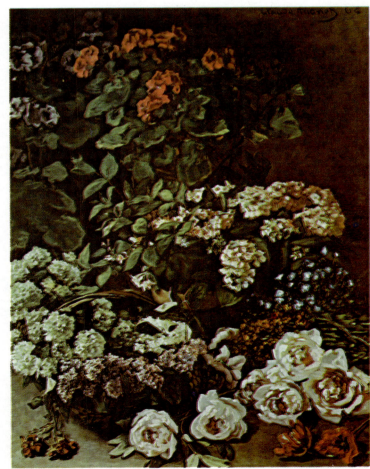

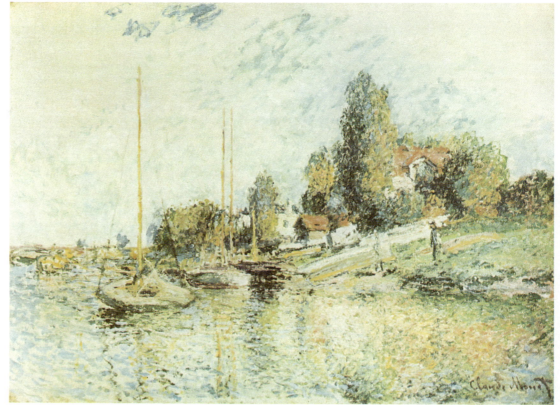

Claude Monet
BOATS AT ARGENTEUIL, 1875
Private Collection
803 - 24"x31" (61x79 cm)

Claude Monet
ARGENTEUIL, *c.1875*
Musée de l'Orangerie, Paris
7573 - 21¾"x25½" (55x64 cm)

Claude Monet
BANKS OF THE SEINE, VETHEUIL, *1880*
National Gallery of Art, Washington, D.C.
Chester Dale Collection
775 - 22"x30" (55x77 cm)

Claude Monet
BASSIN D'ARGENTEUIL, *c.1874*
Rhode Island School of Design
Museum of Art, Providence
7836 - 22"x29½" (55x75 cm)

Claude Monet
THE RED BOATS, *1875*
Private Collection
817 - 22"x30" (56x76 cm)
5523 - 13"x18" (33x46 cm)

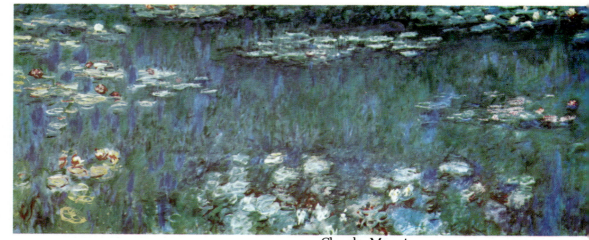

Claude Monet
WATER LILIES (detail, left side), 1914-18
Musée de l'Orangerie, Paris
8268 - 12½"x30" (32x76 cm)

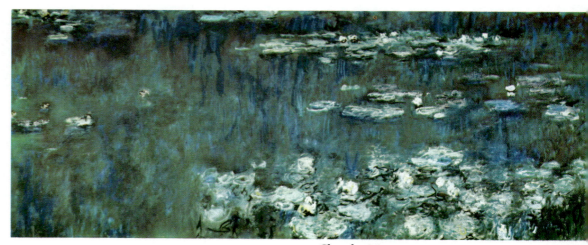

Claude Monet
WATER LILIES (detail, right side), 1914-1
Musée de l'Orangerie, Paris
8269 - 12½"x30" (32x76 cm)

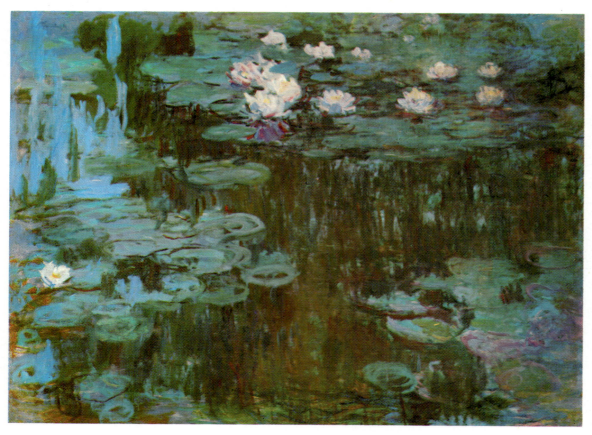

Claude Monet
WHITE AND PURPLE WATER LILIES, 1918
Larry Aldrich Collection, New York
9809 - 27"x36" (68x91 cm)

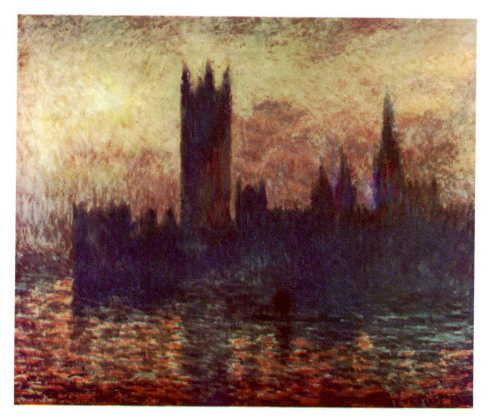

Claude Monet
THE HOUSES OF PARLIAMENT, SUNSET, 1903
National Gallery of Art, Washington, D.C.
Chester Dale Collection
8282 - 29"x33" (74x84 cm)

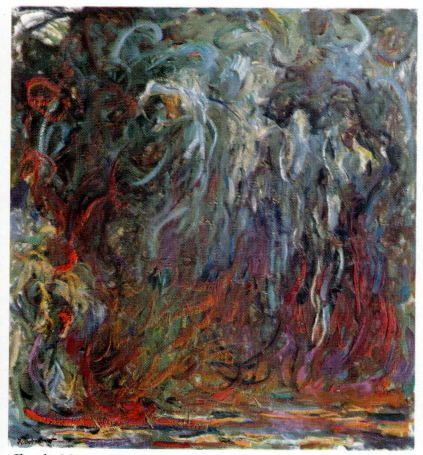

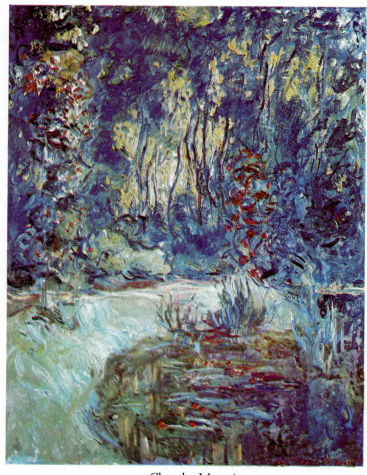

Claude Monet
WEEPING WILLOW, 1920-22
Beyeler Gallery, Basel
7336 - 26¾"x23¾" (68x60 cm)

Claude Monet
JARDIN DE GIVERNY, 1917
Musée de Grenoble
8966 - 36"x27¼" (91x69 cm)

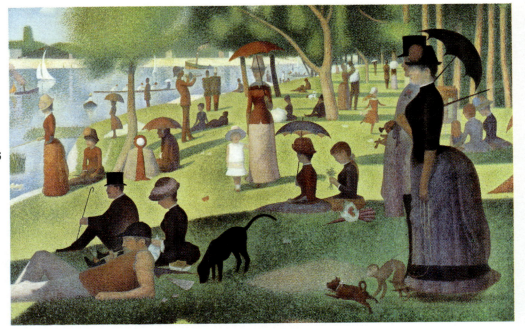

Georges Seurat
A SUNDAY AFTERNOON ON THE
ISLAND OF LA GRANDE JATTE, 1884-86
The Art Institute of Chicago
7734 - 19″x28″ (48x71 cm)

Georges Seurat *(French, 1859-1891)*
THE SIDE SHOW, 1889
The Stephen C. Clark Collection, New York
7051 - 22″x33¼″ (56x84 cm)

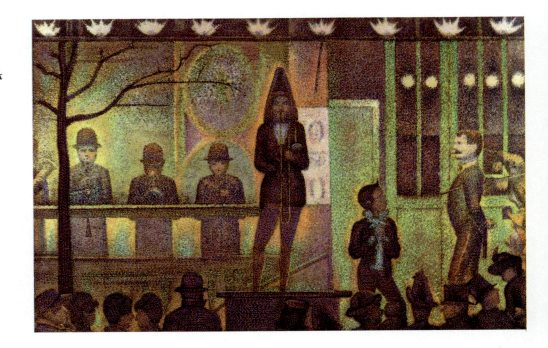

Alfred Sisley *(French, 1839-1899)*
THE ROAD AT LOUVECIENNES, 1875
Musée de l'Orangerie, Paris
6399 - 18″x24″ (45x61 cm)

Georges Seurat
LADY WITH A MUFF, *c.1884*
The Art Institute of Chicago
3084 - 12″x9¼″ (30x23 cm)

Pierre Auguste Renoir
THE ESTEREL MOUNTAINS
The Corcoran Gallery of Art, Washington, D.C.
7499 - 22⅝″x28″ (57½x71 cm)

Pierre Auguste Renoir *(French, 1841-1919)*
LA SOURCE, *1910*
Art Associates Partnership
Hamilton, Bermuda
7714 - 30″x24″ (76x61 cm)

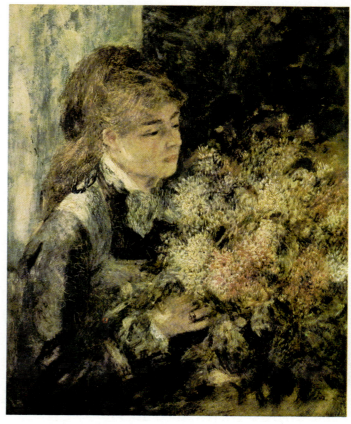

Pierre Auguste Renoir
WOMAN WITH LILACS, *1877*
Private Collection
603 - 22¾″x18¼″ (58x46 cm)

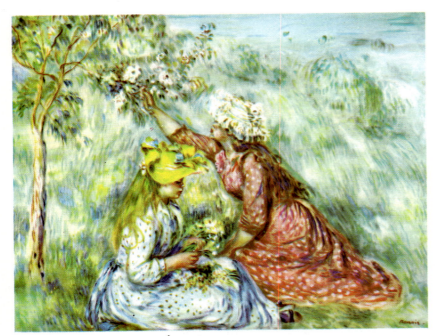

Pierre Auguste Renoir
GIRLS PICKING FLOWERS, c.1889
Museum of Fine Arts, Boston
604 - 16½"x21" (42x53 cm)

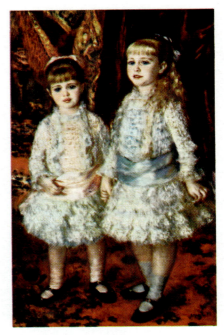

Pierre Auguste Renoir
ROSE AND BLUE, 1881
Museum of Art, São Paulo
4445 - 14"x9" (35x22 cm)

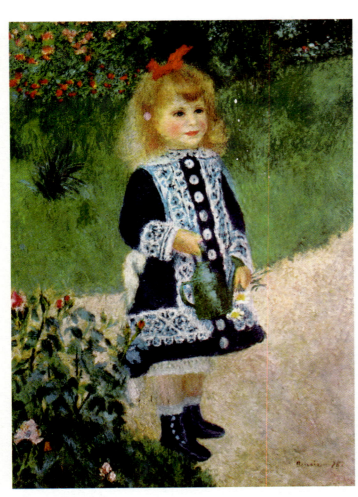

Pierre Auguste Renoir
A GIRL WITH A WATERING CAN, 1876
National Gallery of Art, Washington, D.C.
Chester Dale Collection

6099 - 22"x16" (55x41 cm)
4020 - 14"x11" (35x28 cm)

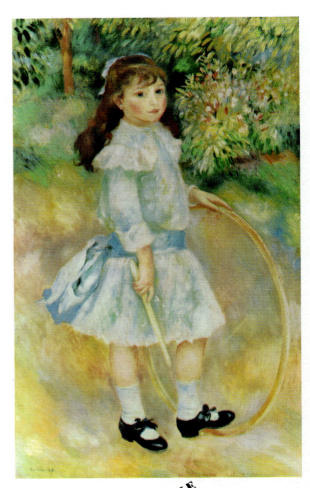

Pierre Auguste Renoir
GIRL WITH A HOOP, 1885
National Gallery of Art, Washington, D.C.
Chester Dale Collection
7487 - 29½"x17½" (75x44 cm)

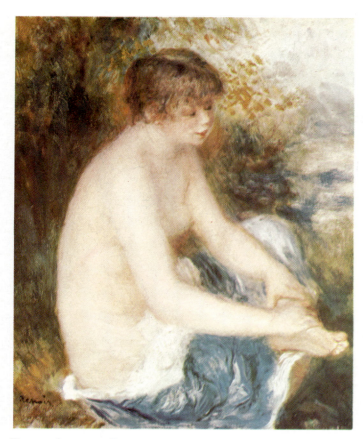

Pierre Auguste Renoir
LITTLE NUDE IN BLUE, 1880
Albright-Knox Art Gallery, Buffalo
5778 - 20″x16″ (50x40 cm)
4075 - 15½″x12″ (39x30 cm)

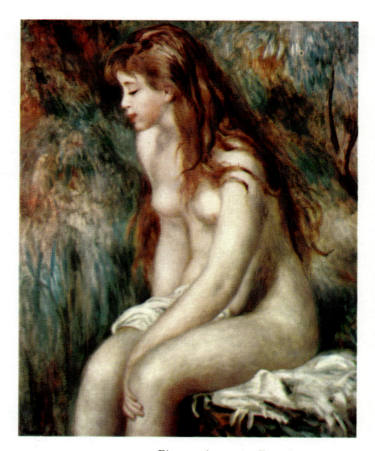

Pierre Auguste Renoir
YOUNG BATHER, 1892
Private Collection
4076 - 15″x11¾″ (38x30 cm)

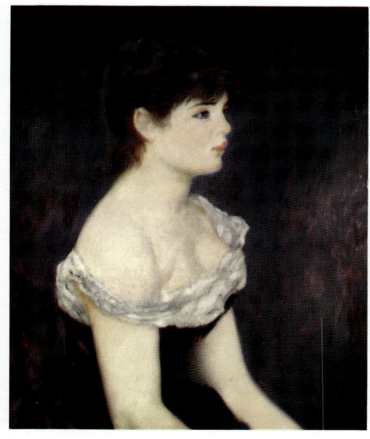

Pierre Auguste Renoir
PORTRAIT OF A YOUNG GIRL, 1884
Private Collection
4078 - 15″x12″ (38x30 cm)

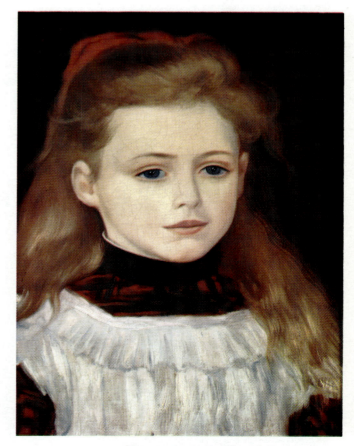

Pierre Auguste Renoir
PORTRAIT OF LUCIE BERARD
Private Collection
4077 - 15¼″x11¼″ (39x28 cm)

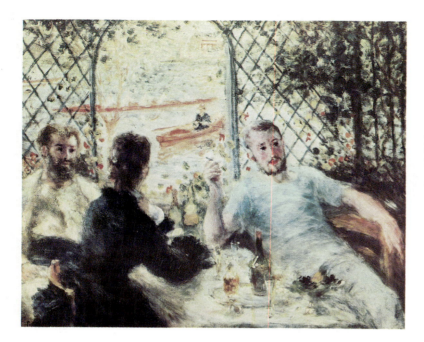

Pierre Auguste Renoir
ROWERS' LUNCH, *c. 1879-80*
The Art Institute of Chicago
Potter Palmer Collection
6770 - 20″x24″ (51x61 cm)

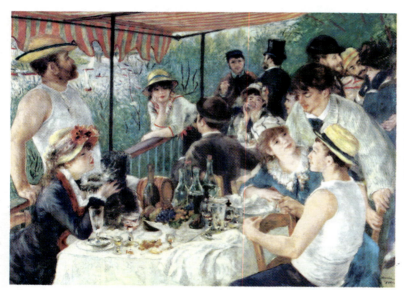

Pierre Auguste Renoir
LUNCHEON OF THE BOATING PARTY, *1881*
The Phillips Collection, Washington, D.C.
7735 - 20½″x28″ (52x71 cm)
5531 - 13¼″x18″ (34x46 cm)

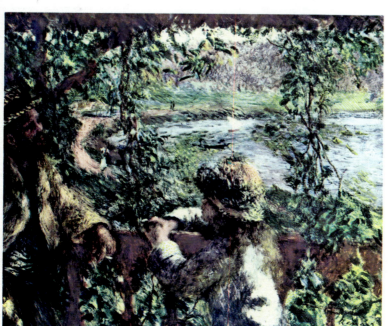

Pierre Auguste Renoir
NEAR THE LAKE, *c.1880*
The Art Institute of Chicago
6769 - 20″x24″ (51x61 cm)

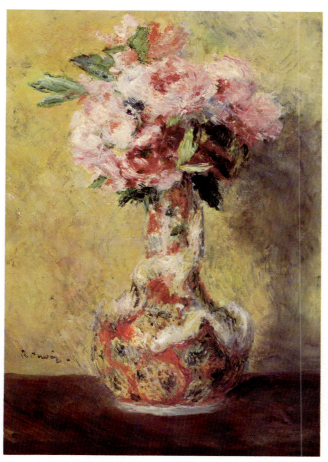

Pierre Auguste Renoir
BOUQUET DANS UN VASE, 1878
Indianapolis Museum of Art
The Lockton Collection
5065 - 20¼″x14″ (51x35 cm)

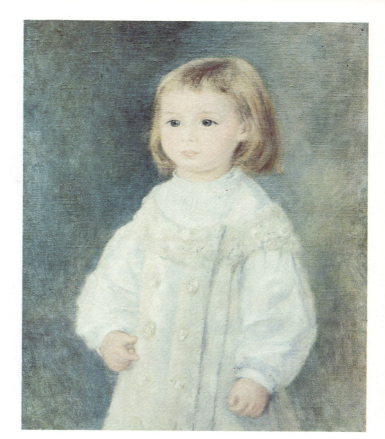

Pierre Auguste Renoir
CHILD IN WHITE, 1883
The Art Institute of Chicago

4444 - *(Detail)* 16″x12½″ (40x31 cm)

Pierre Auguste Renoir
MADEMOISELLE LACAUX, 1864
Cleveland Museum of Art
6777 - 22″x17½″ (55x44 cm)

Pierre Auguste Renoir
ROSES, 1879
Private Collection
547 - 20½″x17″ (52x43 cm)

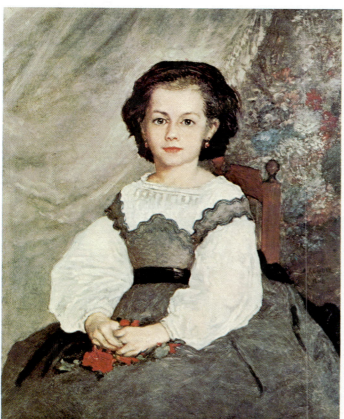

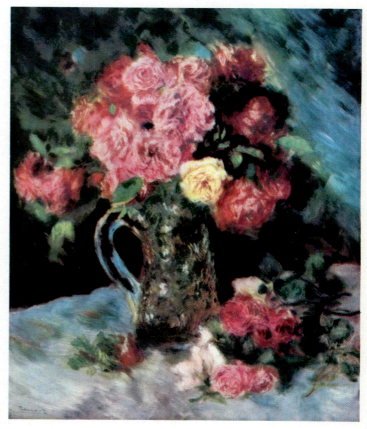

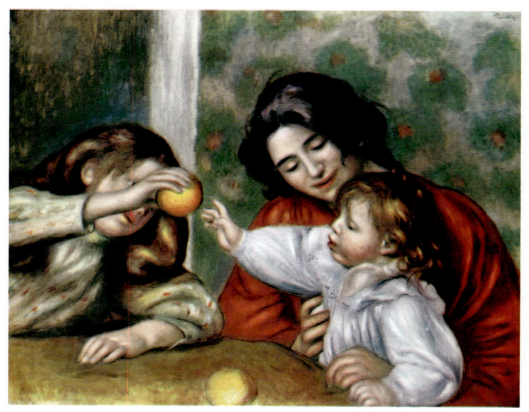

Pierre Auguste Renoir
IN THE NURSERY, 1895
Private Collection
710 - 24"x30" (61x76 cm)

Pierre Auguste Renoir
TWO GIRLS AT THE PIANO, *c.1883*
Joslyn Art Museum, Omaha, Nebraska
6322 - 21¾"x18" (55x46 cm)
4603 - 14"x11½" (35x29 cm)

Pierre Auguste Renoir
LADY AT THE PIANO, *c.1875*
The Art Institute of Chicago
4334 - 14"x11" (36x29 cm)

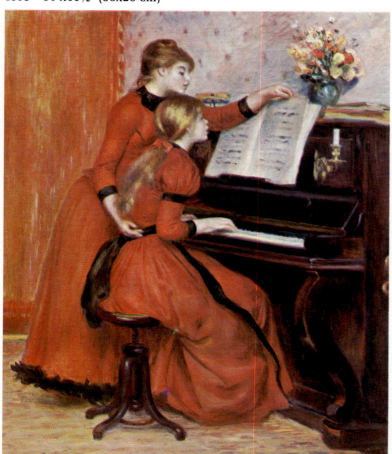

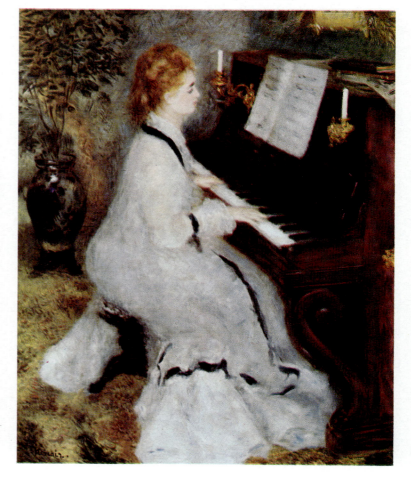

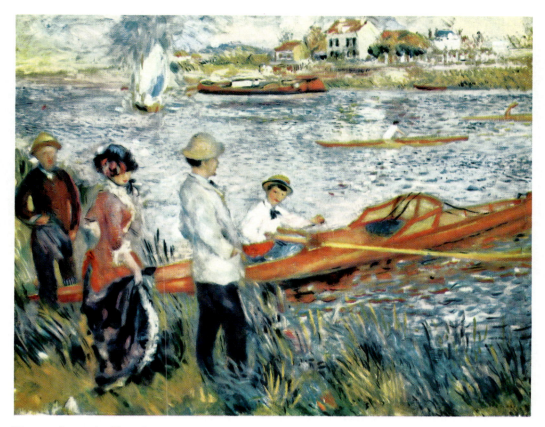

Pierre Auguste Renoir
OARSMEN AT CHATOU, 1879
National Gallery of Art, Washington, D.C.
901 - 28¾"x35½" (73x90 cm)

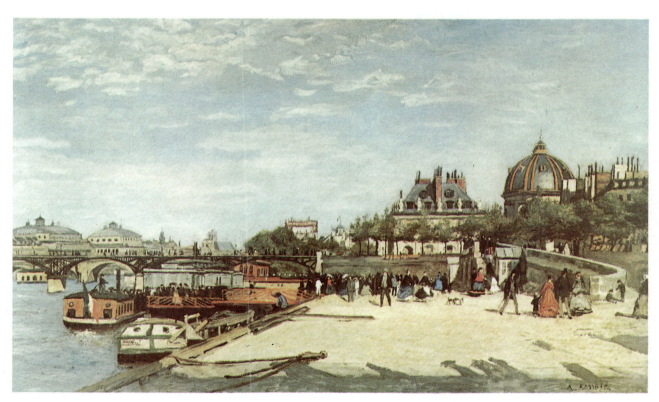

Pierre Auguste Renoir
LE PONT DES ARTS, c.1868
The Norton Simon Foundation
9302 - 24"x40" (61x101 cm)

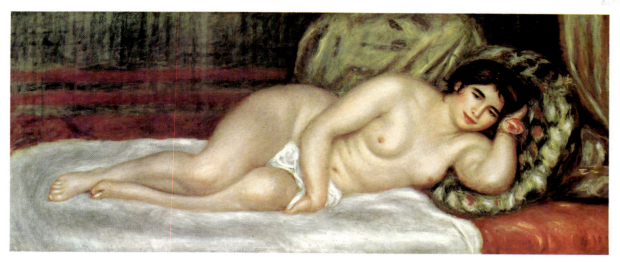

Pierre Auguste Renoir
THE NUDE GABRIELLE, 1908
Musée de l'Orangerie, Paris
9574 - 15"x36" (38x91 cm)

Pierre Auguste Renoir
BAL A BOUGIVAL, 1883
Museum of Fine Arts, Boston
885 - 32"x17" (81x43 cm)

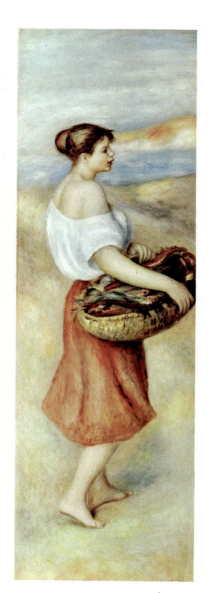

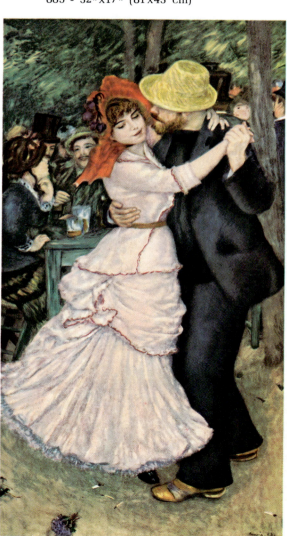

Pierre Auguste Renoir
GIRL WITH BASKET OF FISH, 1889
National Gallery of Art, Washington, D.C.
8682 - 31" (79x25 cm)

Pierre Auguste Renoir
GIRL WITH BASKET OF ORANGES, 1889
National Gallery of Art, Washington, D.C.
8681 - 31" (79x25 cm)

Pierre Auguste Renoir
LADY WITH A MUFF, *undated*
The Metropolitan Museum of Art, New York
5794 - 15″x10½″ (39x26 cm)

Pierre Auguste Renoir
ON THE TERRACE, *1881*
The Art Institute of Chicago
7684 - 27½″x22″ (70x56 cm)
5532 - 18″x14″ (46x35 cm)

Pierre Auguste Renoir
MADAME CHARPENTIER AND HER CHILDREN, *1878*
The Metropolitan Museum of Art, New York
7823 - 24″x30″ (61x76 cm)

Pierre Auguste Renoir
PORTRAIT OF A YOUNG GIRL, *1888*
Museum of Art, São Paulo
7895 - 25½"x21" (64x54 cm)

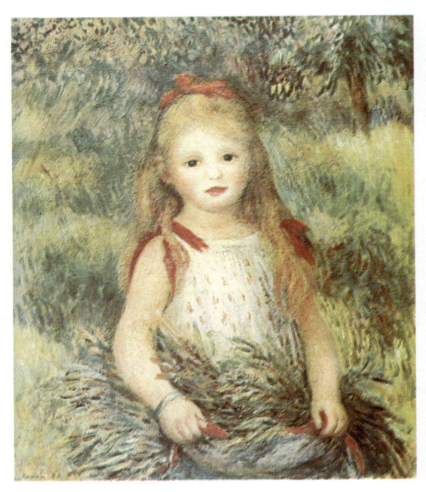

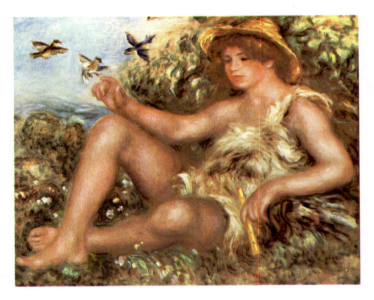

Pierre Auguste Renoir
THE YOUNG SHEPHERD, *1911*
Rhode Island School of Design
Museum of Art, Providence
6251 - 20"x24½" (50x62 cm)

Pierre Auguste Renoir
GABRIELLE AND JEAN, *1895*
Musée de l'Orangerie, Paris
7571 - 25½"x21¼" (65x54 cm)

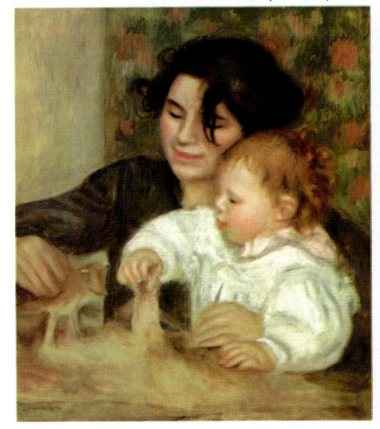

Pierre Auguste Renoir
TWO LITTLE CIRCUS GIRLS, *1879*
The Art Institute of Chicago
7824 - 28"x21" (71x53 cm)

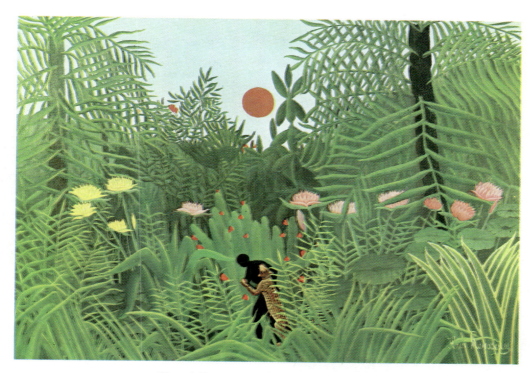

Henri Rousseau (French, 1844-1910)
VIRGIN FOREST AT SUNSET, 1907
Kunstmuseum, Basel
7256 - 19½"x27½" (49x70 cm)

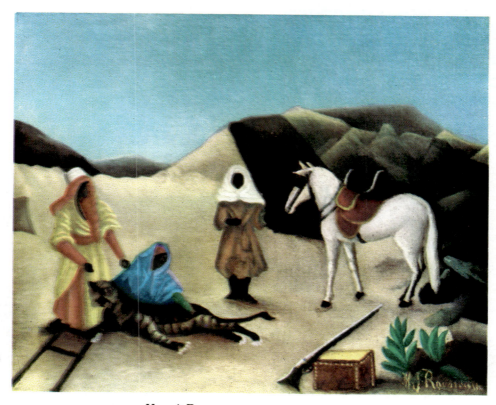

Henri Rousseau
TIGER HUNT, 1895
Columbus Gallery of Fine Arts
Columbus, Ohio
5724 - 16½"x20" (42x50 cm)

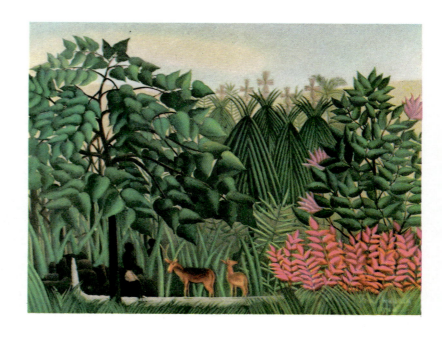

Henri Rousseau
THE WATERFALL, *1910*
The Art Institute of Chicago
8825 - 24"x31" (61x79 cm)

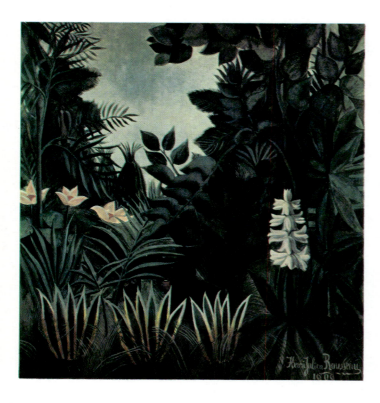

Henri Rousseau
THE EQUATORIAL JUNGLE, *1909*
National Gallery of Art, Washington, D.C.
Chester Dale Collection
7254 - 26"x23½" (65x60 cm)

Henri Rousseau
THE CART OF PERE JUNIET, *1908*
Musée de l'Orangerie, Paris
8286 - 23½"x31¾" (60x80 cm)

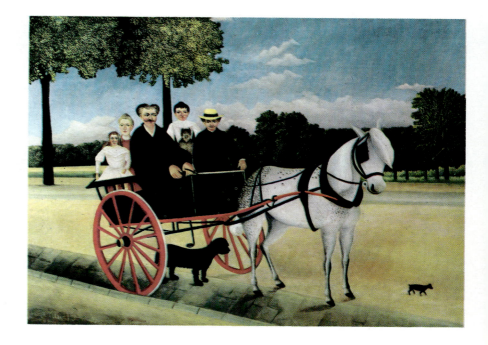

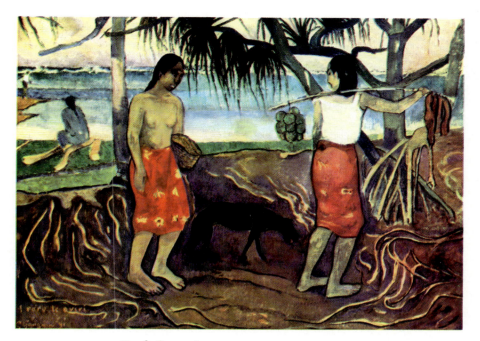

Paul Gauguin
I RARO TE OVIRI, 1891
Private Collection

4659 - 11″x14″ (27x35 cm)

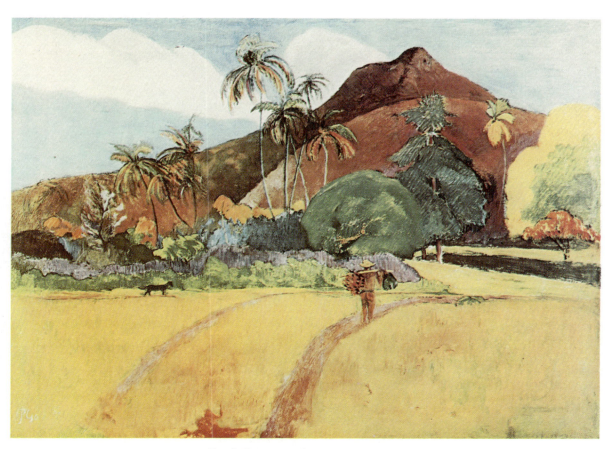

Paul Gauguin *(French, 1848-1903)*
TAHITIAN MOUNTAINS, 1891-93
The Minneapolis Institute of Arts

5290 - 14½″x20″ (37x50 cm)

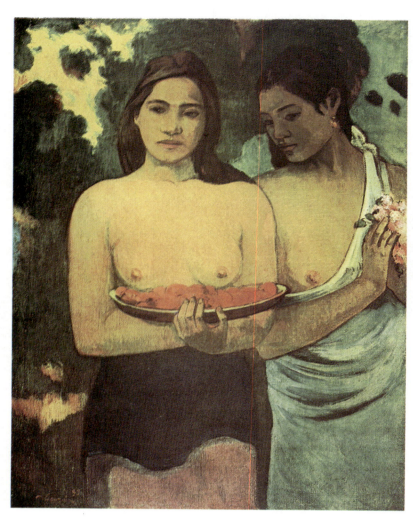

Paul Gauguin
TWO TAHITIAN WOMEN WITH MANGOES, *1899*
The Metropolitan Museum of Art, New York
660 - 23″x18″ (59x45 cm)
4602 - 14″x11¼″ (35x29 cm)

Paul Gauguin
FATATA TE MITI, *1892*
National Gallery of Art, Washington, D.C.
Chester Dale Collection
4256 - 11″x14″ (27x35 cm)

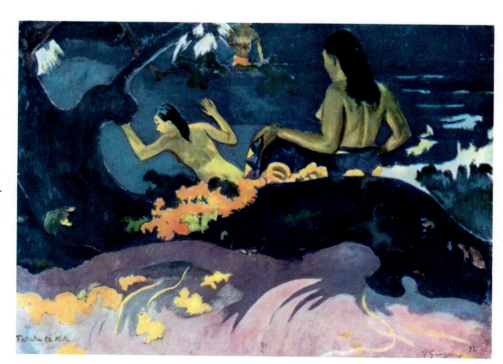

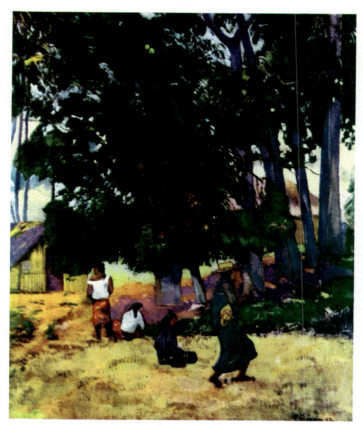

Paul Gauguin
TAHITIAN LANDSCAPE, 1892
Ny Carlsberg Glyptoteket, Copenhagen
7196 - 26¼"x21" (67x54 cm)

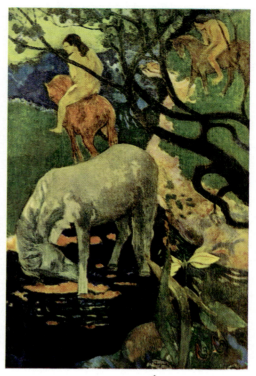

Paul Gauguin
THE WHITE HORSE, 1898
Louvre Museum, Paris
6268 - 22"x14" (56x36 cm)

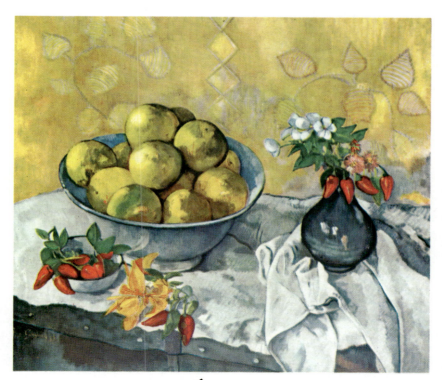

Paul Gauguin
STILL LIFE WITH APPLES, 1901
Private Collection
7193 - 25½"x29½" (65x75 cm)

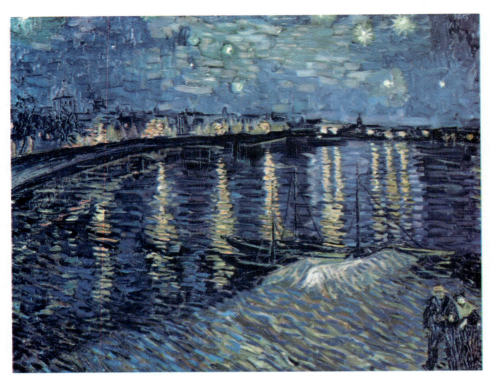

Vincent van Gogh *(Dutch, 1853-1890)*
STARLIGHT OVER THE RHONE, *1888*
Collection of Mr. F. Moch, Paris
7387 - 20"x25" (50x63 cm)

Vincent van Gogh
A SIDEWALK CAFE AT NIGHT, *1888*
Rijksmuseum Kröller-Müller, Holland
5428 - 20"x15½" (50x40 cm)
5543 - 14½"x11" (37x28 cm)

Vincent van Gogh
THE DRAWBRIDGE AT ARLES, *1888*
Private Collection
5288 - 15"x15" (38x38 cm)

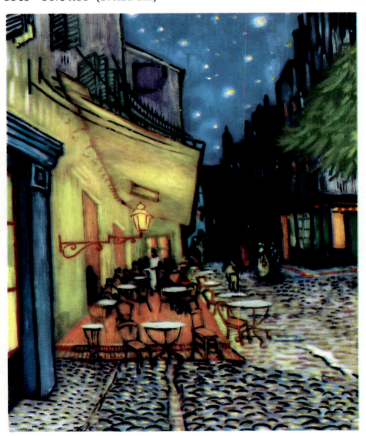

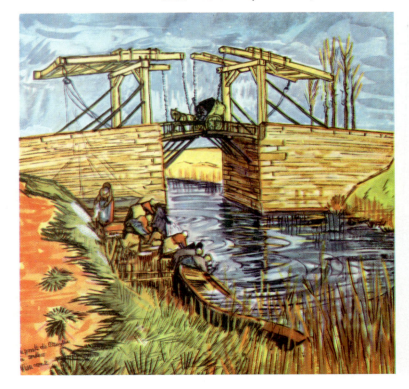

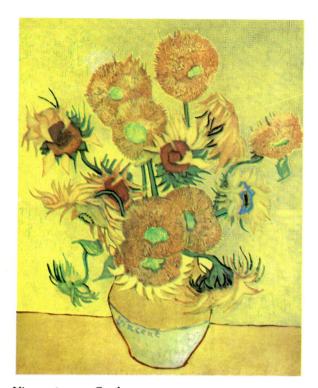

Vincent van Gogh
SUNFLOWERS WITH YELLOW BACKGROUND, *1888*
Stedelijk Museum, Amsterdam
Collection of V. W. van Gogh
6385 - 20½″x15½″ (52x39 cm)
5540 - 14½″x10¾″ (37x27 cm)

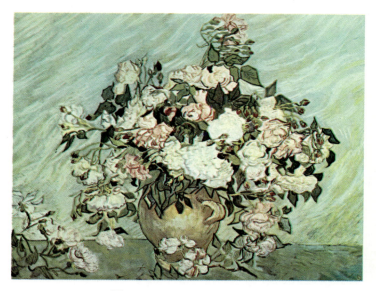

Vincent van Gogh
PINK AND WHITE ROSES, *1890*
Private Collection
5286 - 16″x20″ (41x50 cm)

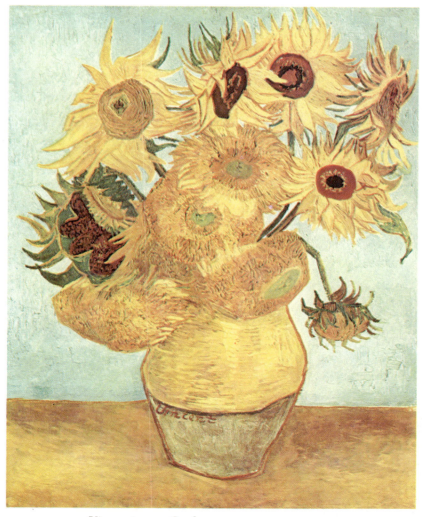

Vincent van Gogh
SUNFLOWERS, *1888*
Philadelphia Museum of Art
756 - 30″x23½″ (76x59 cm)
6386 - 20½″x16″ (52x40 cm)
5544 - 14½″ x11¼″ (37x29 cm)

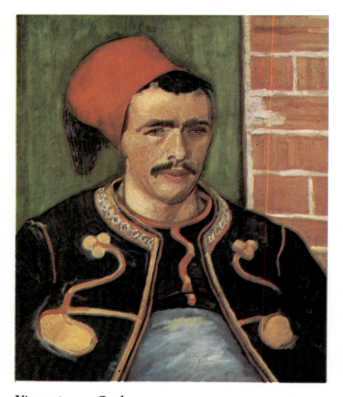

Vincent van Gogh
ZOUAVE, *1888*
Stedelijk Museum, Amsterdam
Collection of V. W. van Gogh
4321 - 14½"x12" (37x30 cm)

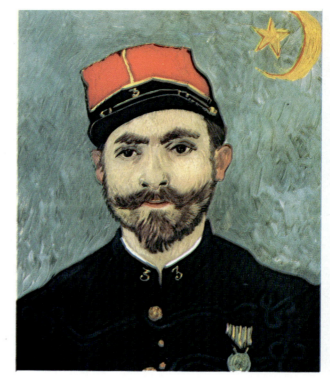

Vincent van Gogh
THE ZOUAVE OFFICER MILLIET, *1888*
Rijksmuseum Kröller-Müller, Holland
4322 - 14½"x12" (36x30 cm)

Vincent van Gogh
THE POSTMAN ROULIN, *1888*
Museum of Fine Arts, Boston
7074 - 28"x22" (71x56 cm)

Vincent van Gogh
PORTRAIT OF ARMAND ROULIN, *1888*
Folkwang Museum, Essen
5283 - 20"x16" (50x40 cm)

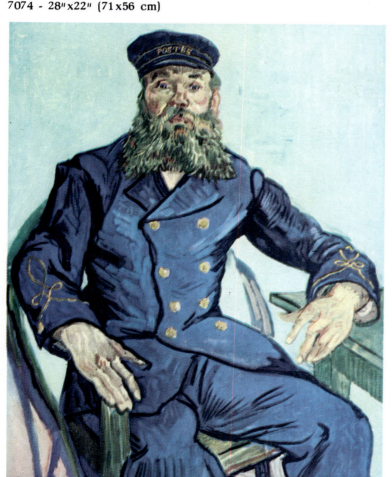

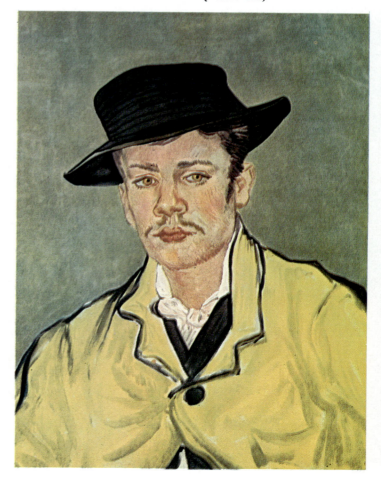

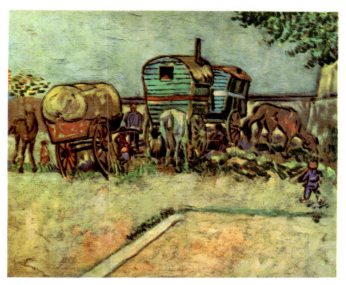

Vincent van Gogh
GYPSY CAMP, *1888*
Louvre Museum, Paris
5893 - 16½″x19″ (42x49 cm)

Vincent van Gogh
LA MOUSME, *1888*
National Gallery of Art, Washington, D.C.
Chester Dale Collection
5493 - 20″x16½″ (50x41 cm)

Vincent van Gogh
LA BERCEUSE, *1889*
The Art Institute of Chicago
5867 - 20½″x16″ (52x40 cm)

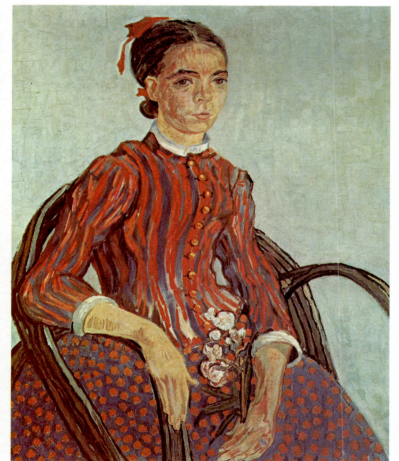

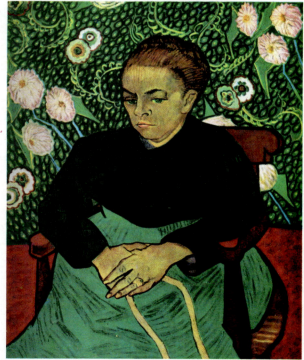

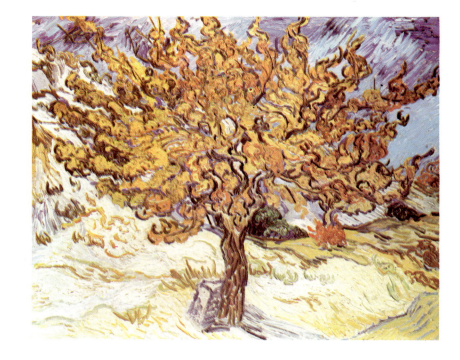

Vincent van Gogh
THE MULBERRY TREE, 1885
Mr. Norton Simon, Los Angeles
7228 - 21¾"x25¼" (55x64 cm)

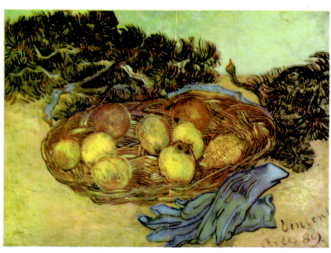

Vincent van Gogh
STILL LIFE WITH GLOVES, 1889
Private Collection
4319 - 12"x16" (30x40 cm)

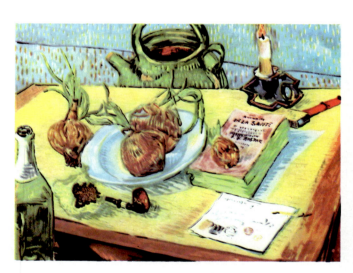

Vincent van Gogh
STILL LIFE WITH ONIONS, 1889
Rijksmuseum Kröller-Müller, Holland
4320 - 12"x16" (30x40 cm)

Vincent van Gogh
STREET IN AUVERS, 1890
Athenaeum, Gallery of Art, Helsinki
5873 - 16"x20" (40x50 cm)

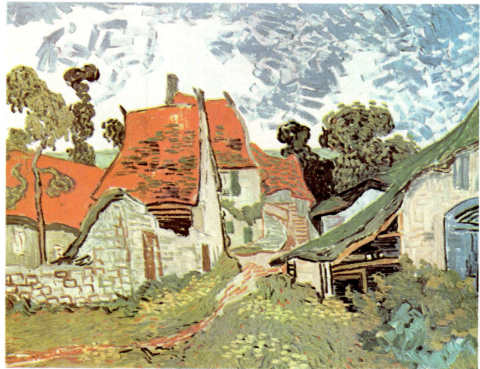

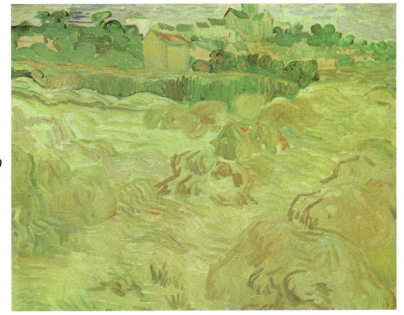

Vincent van Gogh
AUVERS, VUE DE VILLAGE, 1890
Private Collection
6338 - 17½"x20¾" (44x53 cm)

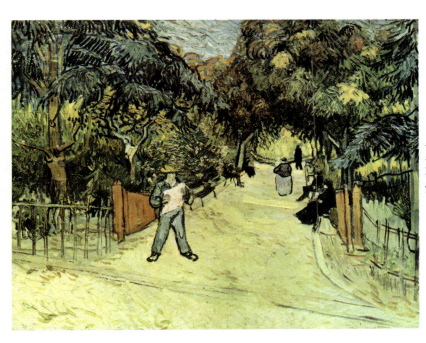

Vincent van Gogh
ENTRANCE TO THE PUBLIC GARDEN AT ARLES, 1888
The Phillips Collection - Washington, D.C.
724 - 23½"x30" (60x76 cm)

Vincent van Gogh
VEGETABLE GARDENS, 1888
Stedelijk Museum, Amsterdam
Collection of V. W. van Gogh
7287 - 22"x28¼" (56x72 cm)
5287 - 16"x20" (40x51 cm)

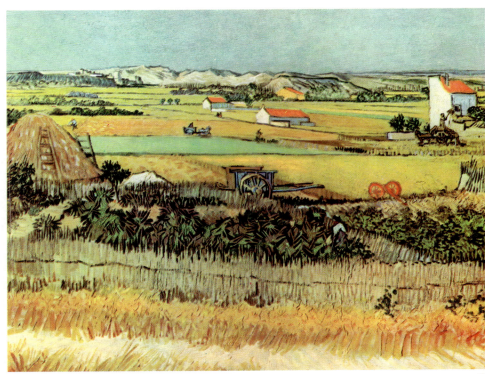

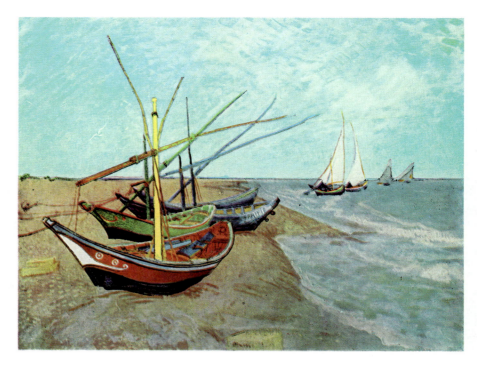

Vincent van Gogh
BOATS OF SAINTES-MARIES, *1888*
Stedelijk Museum, Amsterdam
Collection of V. W. van Gogh
7627 - 22"x28" (55x71 cm)
5284 - 16"x20" (41x51 cm)
5541 - 11½"x14½" (29x37 cm)

Paul Signac *(French, 1863-1935)*
THE HARBOR, *1907*
Museum Boymans-Van Beuningen, Rotterdam
6380 - 18"x24" (45x61 cm)

Vincent van Gogh
THE BRIDGE, *1888*
Rijksmuseum Kröller-Müller, Holland

5542 - 11½"x14½" (29x37 cm)

Jean Louis Forain *(French, 1852-1931)*
COURT SCENE: INTERIOR, *undated*
The Corcoran Gallery of Art, Washington, D.C.
6341 - 20"x24" (50x61 cm)

Othon Friesz *(French, 1879-1949)*
STILL LIFE WITH BRIGANTINE, *1930*
Private Collection
6798 - 20½"x25½" (52x65 cm)

Pierre Bonnard
VUE CANNES—1931
Collection of Mr. and Mrs. David Lloyd Kreeger
7512 - 16¼"x30" (41x76 cm)

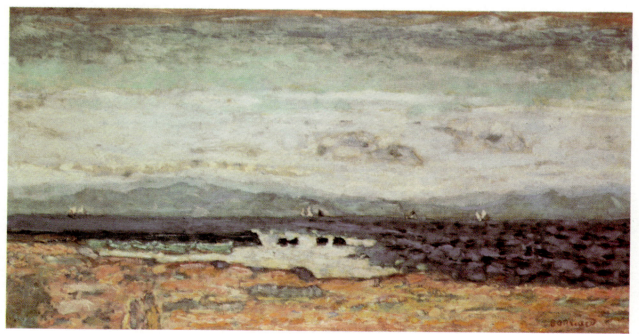

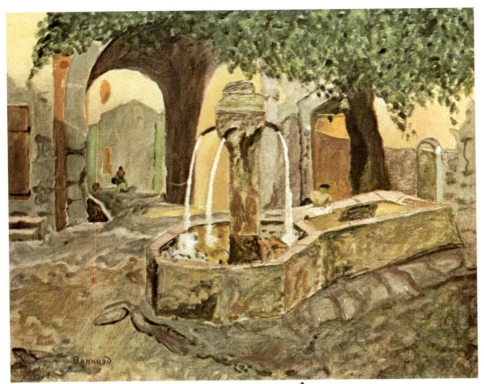

Pierre Bonnard
THE VILLAGE FOUNTAIN
(Bayols-Var, France)
Private Collection
6086 - 18"x22" (46x55 cm)

Pierre Bonnard
PORT OF CANNES, 1923
Private Collection
7710 - 28"x23½" (71x59 cm)

Henri Matisse (French, 1869-1954)
NARCISSI AND FRUIT, 1941
Private Collection
6255 - 24"x19½" (61x50 cm)

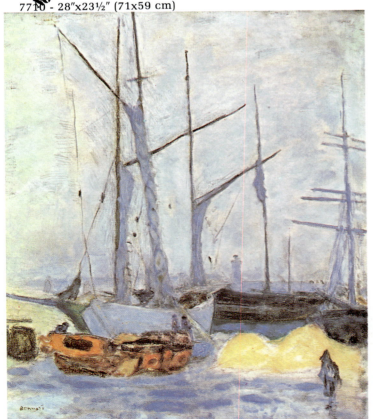

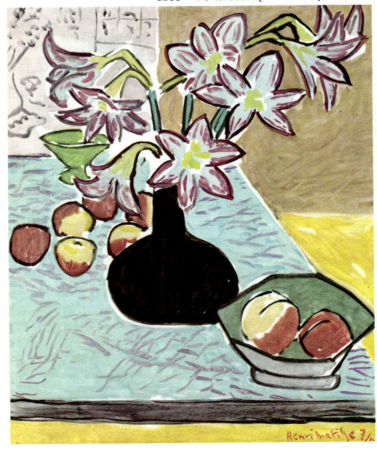

Henri Matisse
LA DANSE
Grenoble Museum
7337 - 18"x23¾" (45x60 cm)

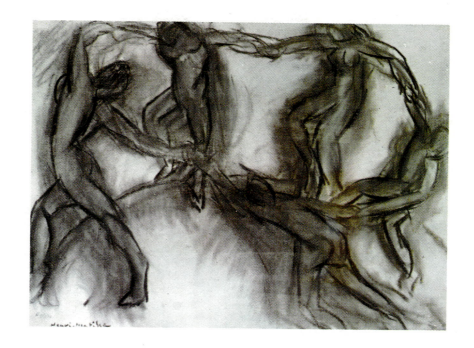

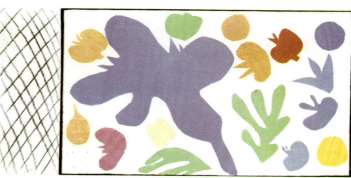

Henri Matisse
FLOWER PETALS
9085 - 11"x47" (28x120 cm)
5545 - 10½"x18" (27x46 cm)

Henri Matisse
STILL LIFE: APPLES ON PINK TABLECLOTH, c.1922
National Gallery of Art, Washington, D.C.
Chester Dale Collection
7828 - 23"x28" (58x71 cm)

Henri Matisse
STILL LIFE WITH LEMONS, *1927*
Collection of Mr. and Mrs. Nathan Cummings
518 - 16"x19" (40x48 cm)

Tivadar Csontváry Kosztka *(Hungarian, 1853-1919)*
DRIVE AT NEW MOON IN ATHENS, *1904*
Private Collection
5361 - 24″x18¼″ (61x46 cm)

Aristide Maillol *(French, 1861-1944)*
HEAD OF A YOUNG GIRL
Musée Rigaud, Perpignan
6850 - 17¼″x24″ (44x61 cm)

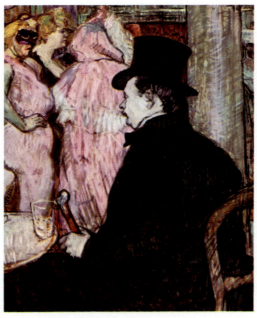

Henri de Toulouse-Lautrec
MAXIME DETHOMAS, 1896
National Gallery of Art, Washington, D.C.
Chester Dale Collection
4345 - 14"x11" (35x28 cm)

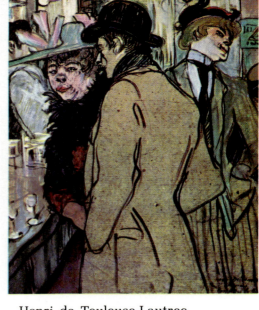

Henri de Toulouse-Lautrec
ALFRED LA GUIGNE, 1894
National Gallery of Art, Washington, D.C.
Chester Dale Collection
4344 - 14"x11" (35x28 cm)

Henri de Toulouse-Lautrec
FOLLETTE, 1890
Philadelphia Museum of Art
Bequest of Lisa Norris Elkins
5131 - 21½"x11¼" (54x28 cm)

Henri de Toulouse-Lautrec *(French, 1864-1901)*
DANSEUSE, *undated*
Stedelijk Museum, Amsterdam
W. O. Koenigs Collection
6295 - 23"x18½" (58x47 cm)

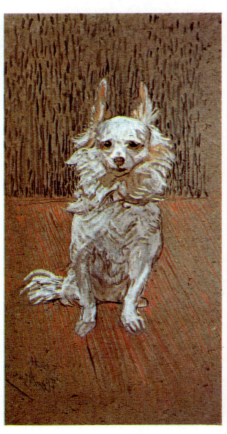

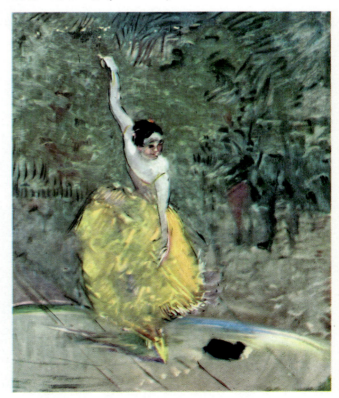

Maurice Utrillo *(French, 1883-1955)*
COURTYARD, 1936
Municipal Museum, Agen
6552 - 19¾"x24" (50x61 cm)

Maurice Utrillo
CHRISTMAS IN MONTMARTRE
Private Collection
4033 - 11"x14" (28x35 cm)
2033 - 6"x7½" (15x19 cm)

Maurice Utrillo
RUE ORDENER, MONTMARTRE, *1916*
Private Collection
7673 - 21½"x29" (55x73 cm)

202

Maurice Utrillo
RURAL FRANCE
Private Collection
6031 - 18″x22″ (45x56 cm)
4031 - 11″x14″ (28x35 cm)
2031 - 6″x7½″ (15x19 cm)

Maurice Utrillo
SUBURBAN STREET, *1950*
Private Collection
4032 - 11″x14″ (28x35 cm)

Maurice Utrillo
MONTMARTRE, *1931*
Private Collection
4034 - 11″x14″ (28x35 cm)
2034 - 6″x7½″ (15x19 cm)

Maurice Utrillo
RESTAURANT AU MONT-CENIS
Private Collection
4018 - 11″x14″ (28x35 cm)

Maurice Utrillo
EGLISE DE BOURGOGNE
Private Collection
6551 - 22"x18½" (56x46 cm)

Maurice Utrillo
MONTMARTRE, MOULIN DE LA GALETTE, *1938*
Isaac Delgado Museum of Art, New Orleans
9291 - 20¾"x39¾" (52x100 cm)

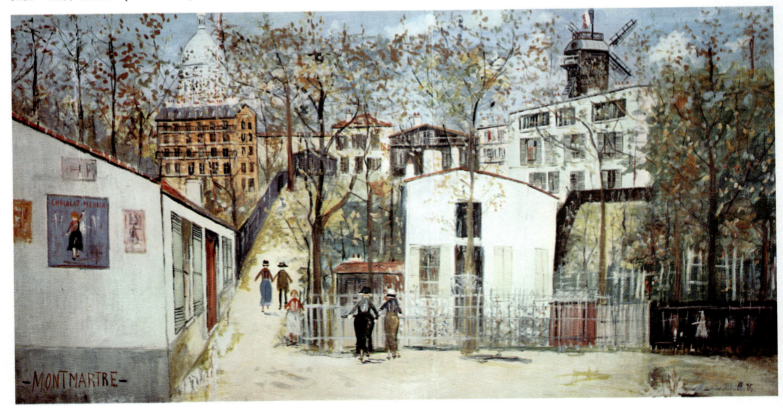

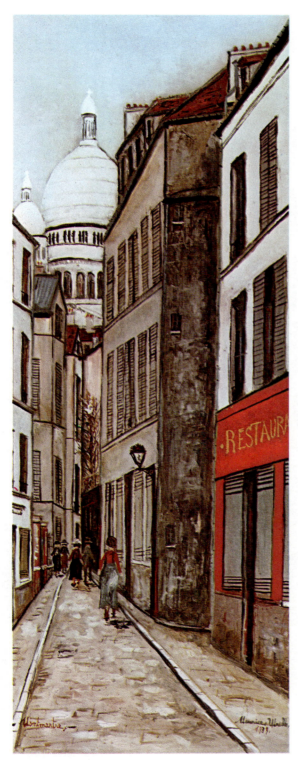

Maurice Utrillo
RUE SAINT-RUSTIQUE A MONTMARTRE, *1939*
Private Collection

5316 - 20″x7½″ (48x19 cm)

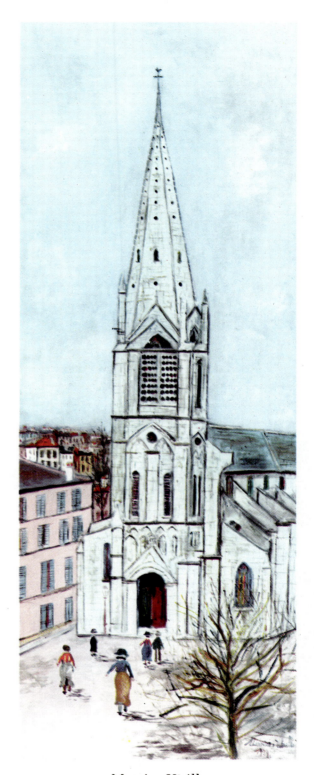

Maurice Utrillo
EGLISE DE ROYAN, *1939*
Private Collection
5315 - 20″x7½″ (48x19 cm)

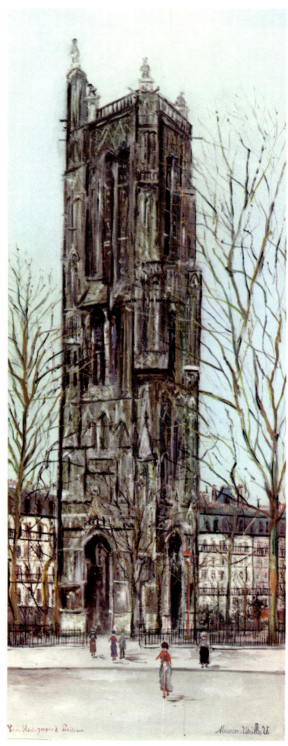

Maurice Utrillo
LA TOUR SAINT-JACQUES, *1939*
Private Collection
8017 - 31″x11½″ (78x29 cm)
5317 - 20″x7½″ (48x19 cm)

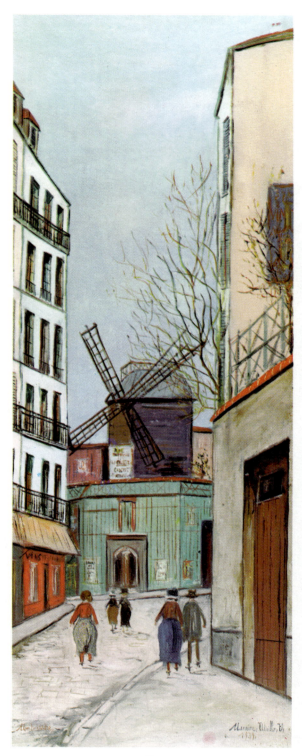

Maurice Utrillo
RUE LEPIC A MONTMARTRE, *1939*
Private Collection
5318 - 20″x7½″ (48x19 cm)

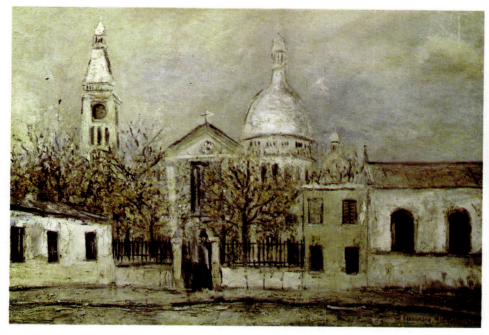

Maurice Utrillo
EGLISE ST.-PIERRE, 1914
Musée de l'Orangerie, Paris
9573 - 25½"x36" (64x91 cm)

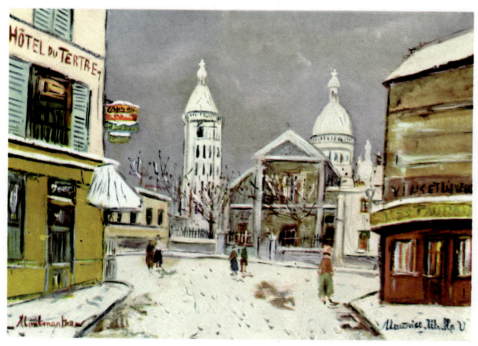

Maurice Utrillo
SNOW ON MONTMARTRE
Private Collection
6088 - 17½"x23½" (45x60 cm)

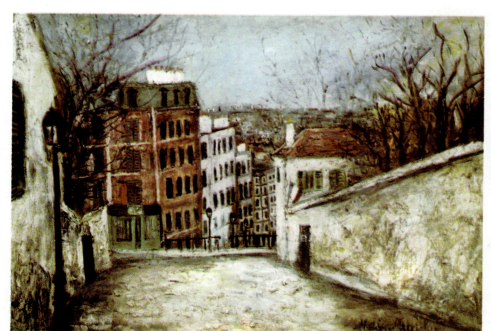

Maurice Utrillo
RUE DU MONT-CENIS, 1914
Musée de l'Orangerie, Paris
9572 - 25"x36" (63x91 cm)

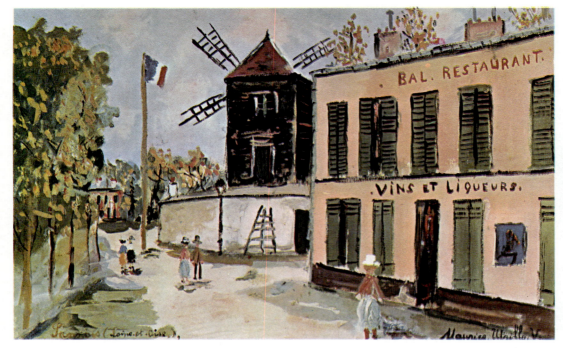

Maurice Utrillo
RUE A SANNOIS
Private Collection
5281 - 13″x20″ (32x50 cm)
4281 - 11″x14″ (28x35 cm)

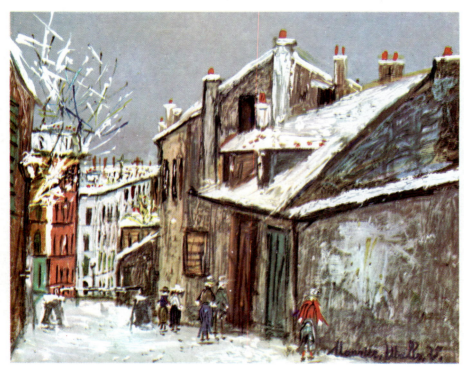

Maurice Utrillo
MAISON MIMI, *1936*
Private Collection
6030 - 19½″x24″ (50x60 cm)
4030 - 11″x14″ (28x35 cm)
2030 - 6″x7½″ (15x19 cm)

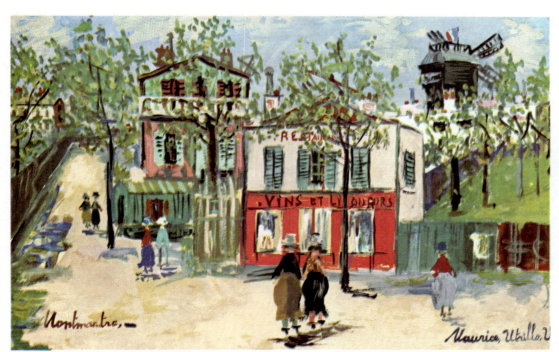

Maurice Utrillo
PETIT CAFE, MONTMARTRE
Private Collection
5282 - 13″x20″ (32x50 cm)
4282 - 11″x14″ (28x35 cm)

Maurice de Vlaminck *(French, 1876-1958)*
THE RIVER, *1910*
National Gallery of Art, Washington, D.C.
Chester Dale Collection
7077 - 23¼"x28½" (59x72 cm)

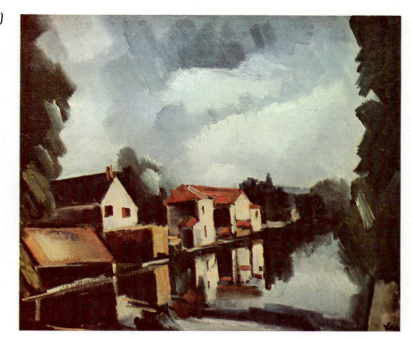

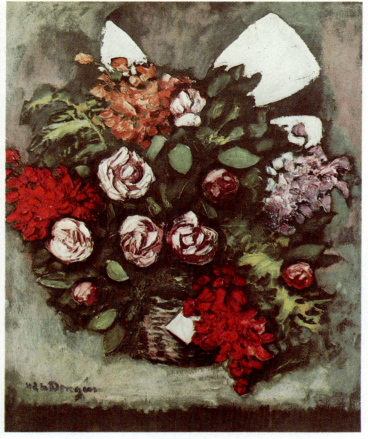

Kees van Dongen *(Dutch, 1877-1968)*
FLOWER BASKET, *1938-41*
Stedelijk Museum, Amsterdam
On loan from the Rijksmuseum
6917 - 23"x18" (58x46 cm)

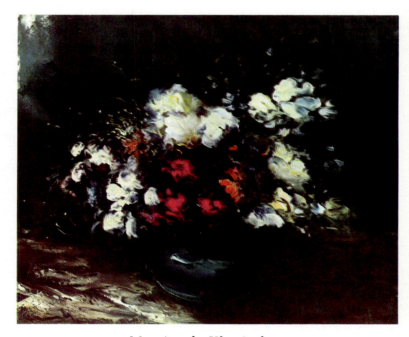

Maurice de Vlaminck
THE BLUE VASE
Private Collection
7044 - 21"x25" (53x64 cm)

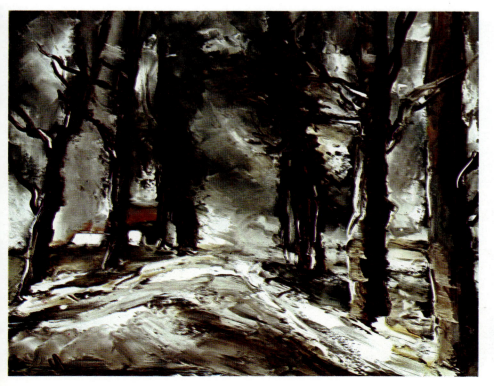

Maurice de Vlaminck
WINTER LANDSCAPE, *undated*
Private Collection
7043 - 22"x28" (56x71 cm)

209

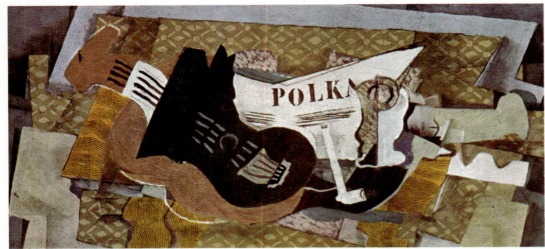

Georges Braque
VIOLIN AND PIPE
(with the word POLKA), 1920-21
Philadelphia Museum of Art
The Louise and Walter Arensberg Collection
9286 - 17"x36" (43x91 cm)

Georges Braque (French, 1882-1963)
PEONIES, 1926
National Gallery of Art, Washington, D.C.
Chester Dale Collection
7896 - 20"x24" (50x60 cm)

Georges Braque
STILL LIFE: LE JOUR, 1929
National Gallery of Art, Washington, D.C.
Chester Dale Collection
713 - 22"x27½" (55x71 cm)

Georges Braque
STILL LIFE WITH GRAPES, 1927
The Phillips Collection, Washington, D.C.
741 - 20¾"x28½" (53x72 cm)

Jean Lurcat *(French, 1892-1966)*
THE BIG CLOUD, 1929
National Gallery of Art, Washington, D.C.
Chester Dale Collection
618 - 16"x24" (40x60 cm)

Albert Marquet *(French, 1875-1947)*
LE PONT ST. MICHEL, 1908
Grenoble Museum
6334 - 20"x24" (51x61 cm)

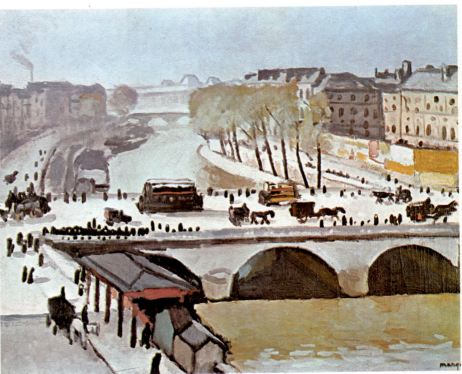

Marie Laurencin
IN THE PARK, 1924
National Gallery of Art, Washington, D.C.
Chester Dale Collection
7683 - 26½"x19" (68x48 cm)
5721 - 20"x14" (50x36 cm)

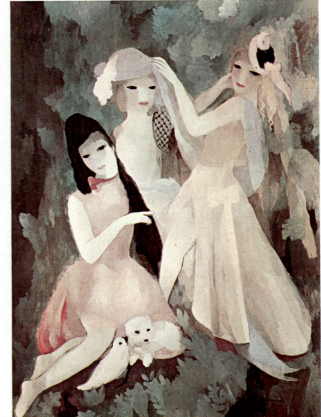

Marcel Duchamp (French, 1887-1968)
NUDE DESCENDING A STAIRCASE, Number 2, 1912
Philadelphia Museum of Art
7047 - 30"x18" (76x45 cm)

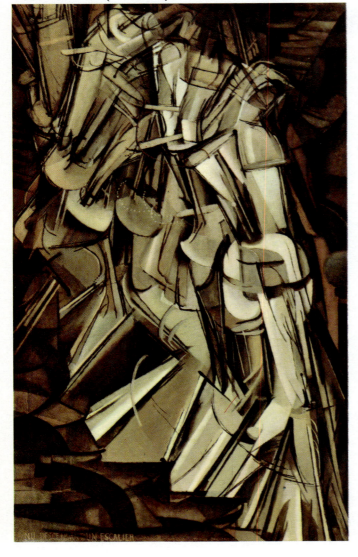

Marcel Duchamp
CHOCOLATE GRINDER NO. 2, 1914
Philadelphia Museum of Art
7523 - 24"x20" (60x50 cm)

Charles Dufresne (French, 1876-1938)
STILL LIFE, 1927-28
National Gallery of Art, Washington, D.C.
Chester Dale Collection
7222 - 24¼"x30" (62x76 cm)

André Derain
THE OLD BRIDGE, 1910
National Gallery of Art, Washington, D.C.
Chester Dale Collection
8505 - 25"x31" (63x78 cm)

André Derain (French, 1880-1954)
LANDSCAPE, THE BLUE OAK
Private Collection
5289 - 16"x20" (40x50 cm)

Georges Rouault (French, 1871-1958)
CHRIST AND THE FISHERMEN
Private Collection
799 - 20½"x29¼" (52x74 cm)

Georges Rouault
CHRIST AND THE HIGH PRIEST, *1937*
The Phillips Collection, Washington, D.C.
563 - 18¾"x12¾" (47x32 cm)

Georges Rouault
THE CLOWN, *1920*
Stedelijk Museum, Amsterdam
P. A. Regnault Collection
6918 - 23"x16½" (58x42 cm)

Georges Rouault
BOUQUET NUMBER ONE, *c.1938*
The Phillips Collection, Washington, D.C.
4000 - 14"x9½" (35x24 cm)

Georges Rouault
BOUQUET NUMBER TWO, *c.1938*
The Phillips Collection, Washington, D.C.
4005 - 14"x9½" (35x24 cm)

Raoul Dufy (French, 1877-1953)
POLO
The Phillips Collection, Washington, D.C.
602 - 18"x24" (45x60 cm)

215

Raoul Dufy
THE VILLAGE GARDEN
Private Collection
7290 - 9½"x26½" (50x65 cm)

Raoul Dufy
MARSEILLES, THE OLD PORT, *1925*
Private Collection
6289 - 18½"x24" (46x61 cm)

Raoul Dufy
DEAUVILLE, *1935*
Private Collection
7893 - 17½"x25½" (44x65 cm)

Raoul Dufy
HORAS DU PIN, 1932
The Baltimore Museum of Art
Saidie A. May Collection
7273 - 21½"x28" (55x71 cm)

Raoul Dufy
REGATTA AT HENLEY, 1930
Private Collection
7291 - 19½"x26" (49x66 cm)

Raoul Dufy
CHATEAU AND HORSES, 1930
The Phillips Collection, Washington, D.C.
7268 - 23"x28" (58x71 cm)

217

Jean Dufy
THE THREE QUARTER COACH (detail)
Private Collection
5259 - 14″x18″ (35x45 cm)

Jean Dufy
THE PHAETON (detail)
Private Collection
5258 - 14″x18″ (35x45 cm)

Jean Dufy
CIRCUS BAND
Private Collection
6237 - 23½″x18″ (60x45 cm)

Jean Dufy
GUITAR CLOWN
Private Collection
6236 - 23½″x18″ (60x45 cm)

Raoul Dufy
BOUQUET, 1942
Private Collection
6663 - 24″x18½″ (61x47 cm)

Raoul Dufy
GLADIOLI, 1942
Private Collection
6664 - 24″x18½″ (61x47 cm)

Raoul Dufy
HOMAGE TO MOZART, 1915
Albright-Knox Art Gallery, Buffalo, N.Y.
601 - 25½″x20″ (64x50 cm)

Raoul Dufy
SQUARE, ST. CLOUD
Grenoble Museum
6333 - 24″x19¼″ (61x49 cm)

Jean Carzou (French, 1907-)
FISHING BOATS, 1960
Private Collection
6308 - 18¾"x24" (47 x 61 cm)

Jean Dufy *(French, 1888-1964)*
SUNDAY AFTERNOON
Private Collection
6288 - 19"x24" (48x60 cm)

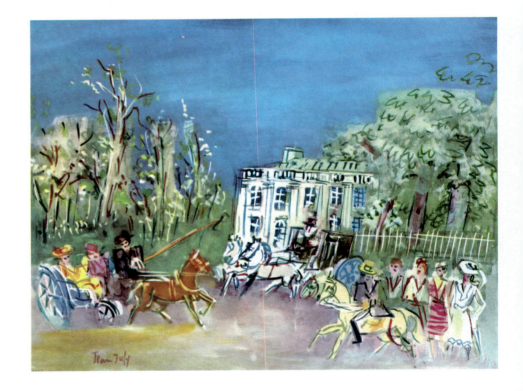

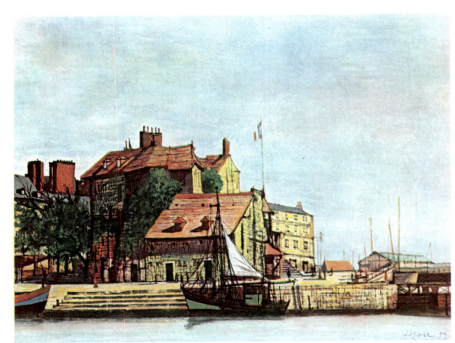

Jean Carzou
HONFLEUR, 1959
Private Collection
6309 - 18¾"x24" (47 x 61 cm)

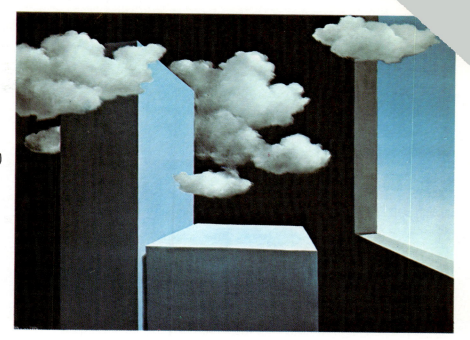

René Magritte (*Belgian, 1898-1967*)
THE TEMPEST, undated
Wadsworth Atheneum, Hartford
6356 - 19¼"x25½" (48x64 cm)

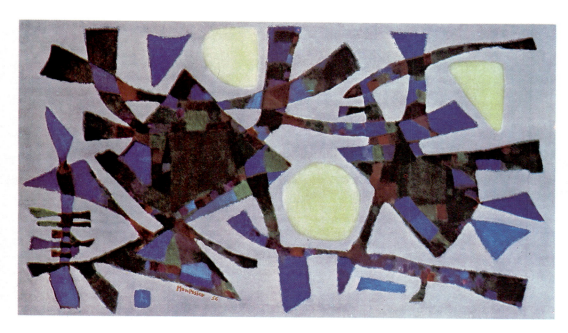

Alfred Manessier (*French, 1911- *)
FEBRUARY IN HAARLEM
*Staatliche Museum, Preussischer Kulturbesitz
National-Galerie, Berlin (West)*
7905 - 19"x31¾" (45x78 cm)

NO LONGER AVAILABLE

Jean Metzinger (*French, 1883-1957*)
THE PORT, 1912
Collection of Mr. and Mrs. Nathan Cummings
8545 - 28"x34" (71x86 cm)

Bernard Lorjou *(French, 1908-)*
FLOWERS AND PINEAPPLE, 1958
Private Collection
7039 - 22"x27½" (56x69 cm)

Marc Chagall
THE OPEN WINDOW
(Finestra Aperta)
Private Collection
6521 - 17¾"x22" (45x52 cm)

Zao Wou-ki *(Chinese, 1920-)*
STILL LIFE WITH FLOWERS, 1953
The Aldrich Museum of Contemporary Art
Ridgefield, Connecticut
8291 - 24"x30" (61x76 cm)

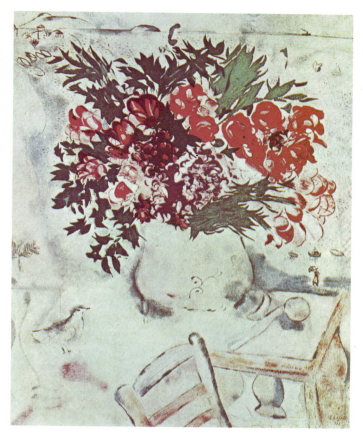

Marc Chagall
STILL LIFE WITH FLOWERS
Private Collection
6461 - 22¼"×17¾" (56×45 cm)

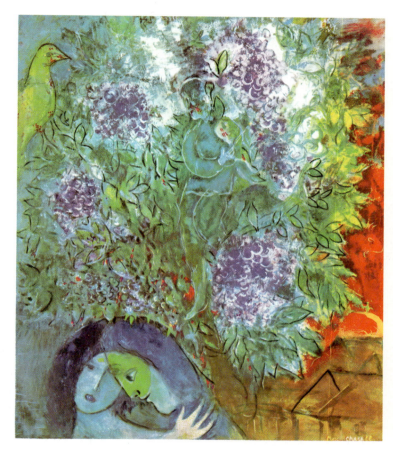

Marc Chagall
EVENING ENCHANTMENT, *1948*
Private Collection
6269 - 24"x20" (61x50 cm)

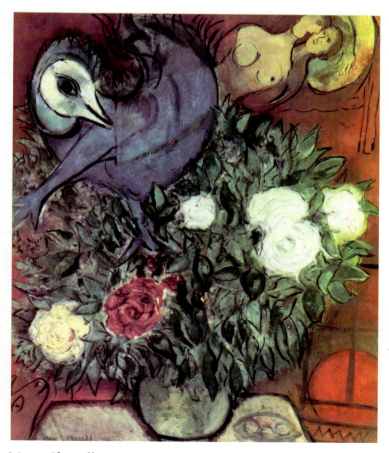

Marc Chagall
MORNING MYSTERY, *1948*
Private Collection
6270 - 23½"x19½" (60x50 cm)

223

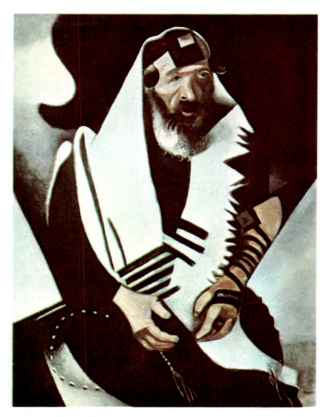

Marc Chagall
THE RABBI OF VITEBSK, 1914
The Art Institute of Chicago
Joseph Winterbotham Collection

4279 - 14″x11″ (35x27 cm)

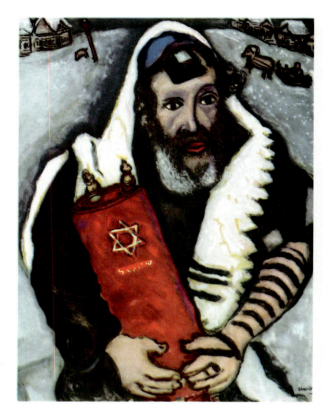

Marc Chagall
RABBI WITH TORAH, c.1930
Stedelijk Museum, Amsterdam
6292 - 23½″x18″ (60x45 cm)

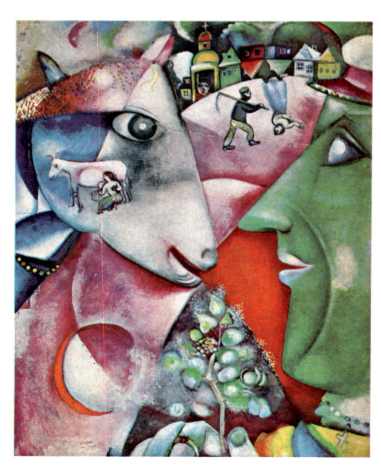

Marc Chagall
I AND THE VILLAGE, 1911
The Museum of Modern Art, New York
7037 - 28″x22″ (71x55 cm)
3512 - 7½″x6″ (19x15 cm)

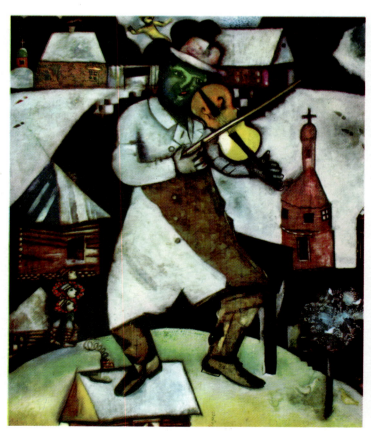

Marc Chagall
THE VIOLINIST, 1912-13
Stedelijk Museum, Amsterdam
6238 - 23½″x20″ (60x50 cm)

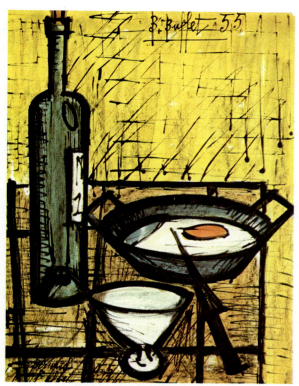

Bernard Buffet (French, 1928-)
THE BREAKFAST, 1955
Private Collection
7023 - 25½"x19½" (65x49 cm)

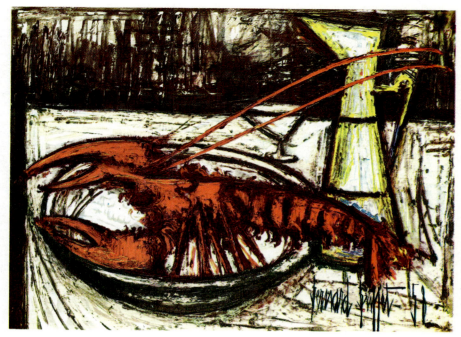

Bernard Buffet
STILL LIFE: THE LOBSTER, 1958
Private Collection
7038 - 20½"x27½" (52x70 cm)

Fernand Léger (French, 1881-1955)
THE BLUE BASKET, 1949
Private Collection
7289 - 24½"x19" (63x48 cm)

Bernard Buffet
BEFORE DINNER, 1955
Private Collection
7035 - 25½"x19½" (64x49 cm)

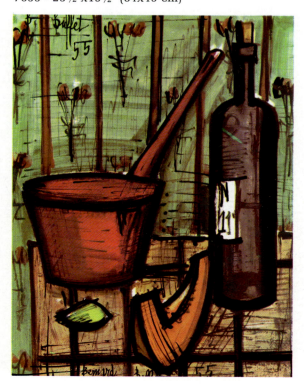

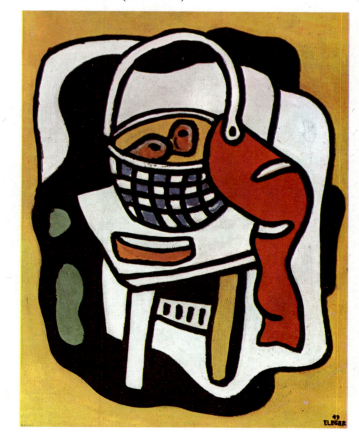

Bernard Buffet
THE YACHT, *1963*
Private Collection
8299 - 31½"x24" (80x61 cm)

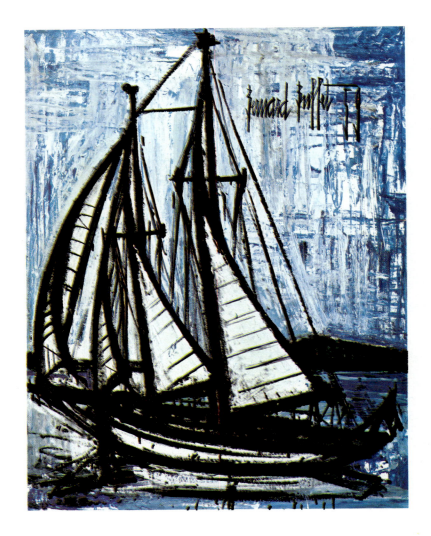

Bernard Buffet
SOMME RIVER LOCK, *1962*
Private Collection
8023 - 25½"x34" (65x86 cm)

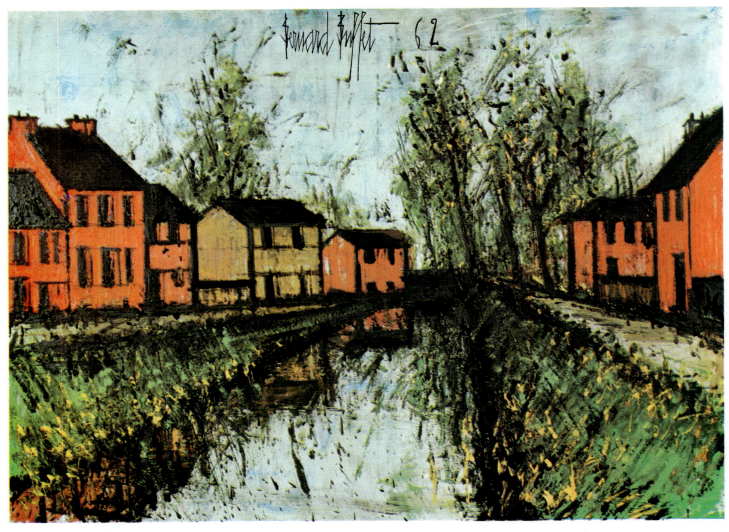

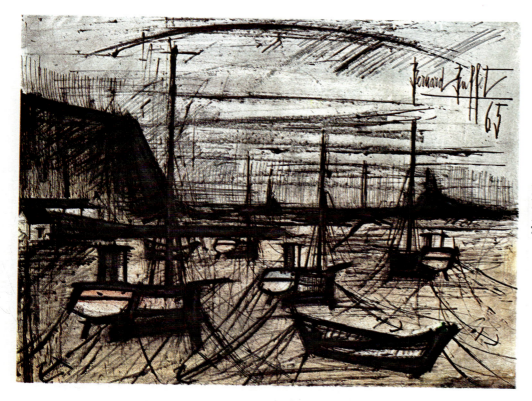

Bernard Buffet
HARBOR IN BRITTANY, 1965
Private Collection
7335 - 19"x25" (48x63 cm)

Bernard Buffet
TOREADOR, 1958
Private Collection
8010 - 31"x9½" (79x24 cm)

Bernard Buffet
MATADOR, 1958
Private Collection
8011 - 31"x9½" (79x24 cm)

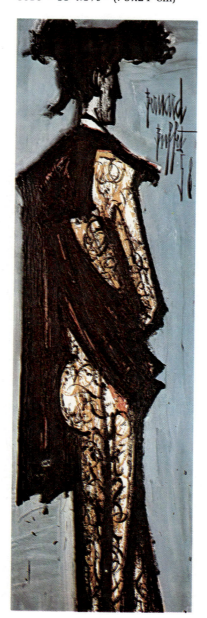 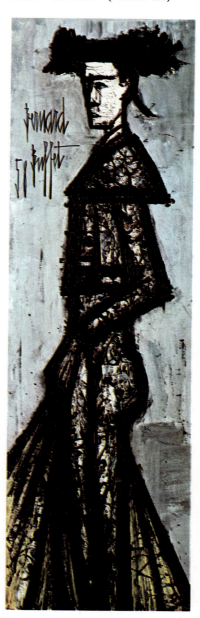

Bernard Buffet
THE BULLFIGHTER, *1960*
Private Collection
7067 - 25¾"x19" (65x48 cm)

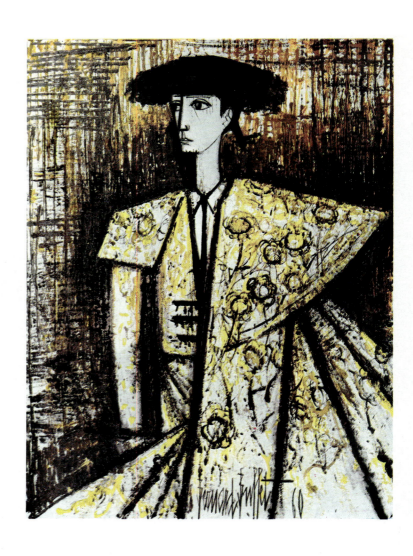

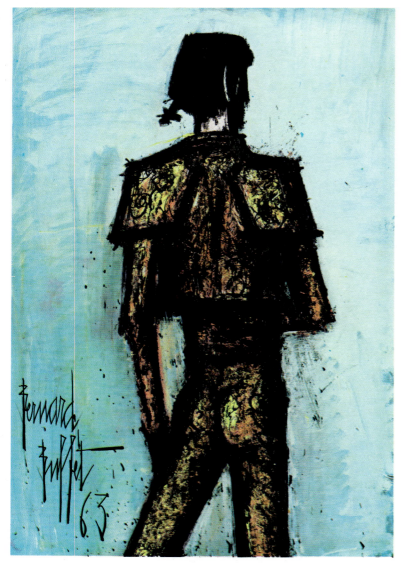

Bernard Buffet
TORERO, *1963*
Private Collection
8300 - 31"x21" (78x53 cm)

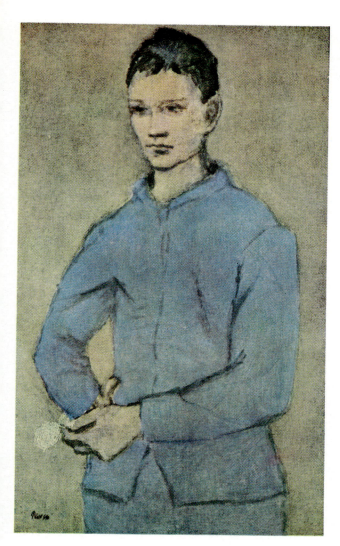

Pablo Picasso (*Spanish, 1881-1973*)
BLUE BOY, *1905*
Collection Mr. and Mrs. M. M. Warburg, New York
6807 - 24"x13¼" (61x33 cm)
4807 - *(bust detail)* 14"x11" (35x28 cm)

Pablo Picasso
THE OLD GUITARIST, *1903*
The Art Institute of Chicago
7341 - 30"x20" (76x51 cm)
4601 - 16¾"x11¼" (42x28 cm)

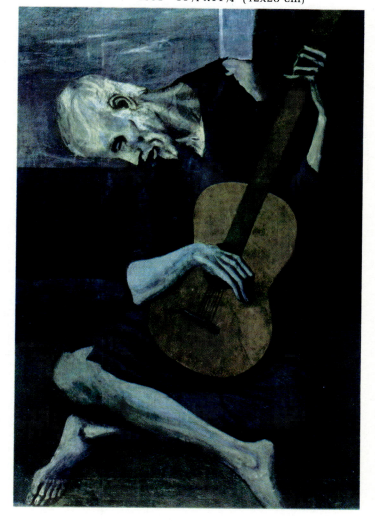

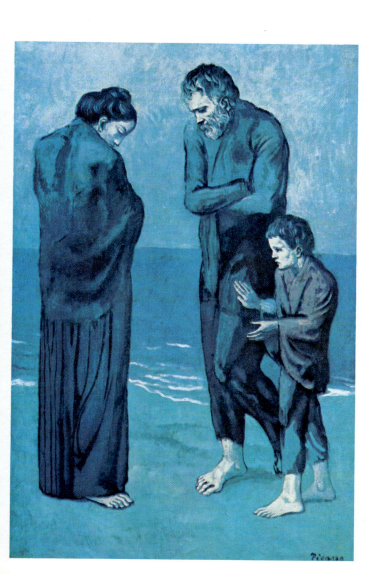

Pablo Picasso
THE TRAGEDY, *1903*
National Gallery of Art, Washington, D.C.
Chester Dale Collection
6851 - 24"x15½" (61x39 cm)

229

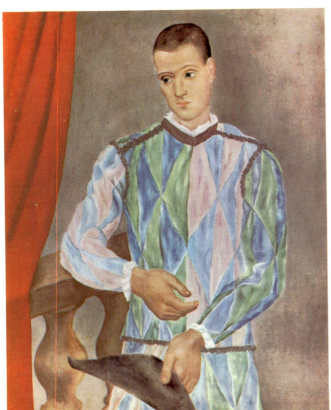

Pablo Picasso
HARLEQUIN, 1917
Picasso Museum, Barcelona
728 - 28½"x22" (73x55 cm)

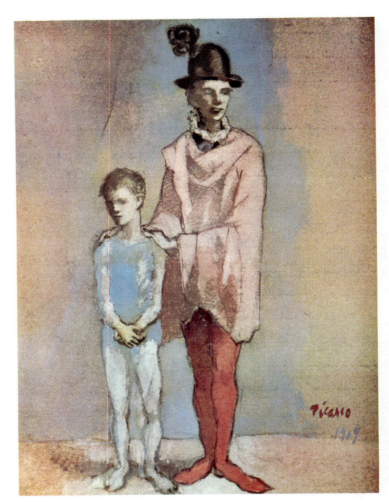

Pablo Picasso
TWO HARLEQUINS, 1905
The Stephen C. Clark Collection, New York

4006 - 14"x9¾" (35x25 cm)

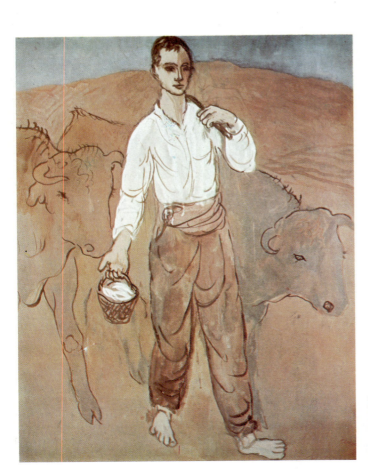

Pablo Picasso
BOY WITH CATTLE, 1906
The Columbus Gallery of Fine Arts
Howald Collection
6358 - 23½"x18½" (59x47 cm)

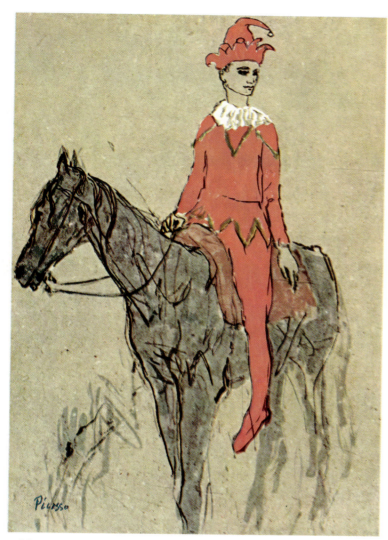

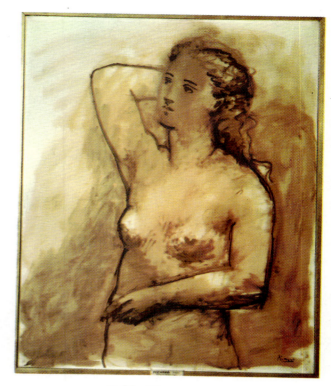

Pablo Picasso
NUDE—HALF LENGTH
Museum of Modern Art, Paris
7079 - 24"x19" (61x48 cm)
4079 - 14"x11" (35x27 cm)

Pablo Picasso
HARLEQUIN ON HORSEBACK, 1905
Collection Mr. and Mrs. Paul Mellon
6854 - 24"x16½" (61x42 cm)

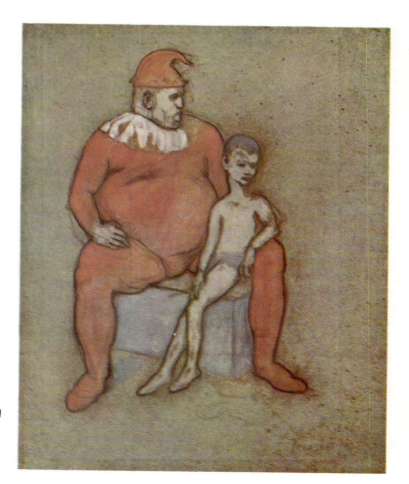

Pablo Picasso
HARLEQUIN AND BOY, 1905
(Study for "Family of Saltimbanques")
The Baltimore Museum of Art
Cone Collection
682 - 23¼ "x18½ " (59x47 cm)

Pablo Picasso
THE GOURMET, 1901
National Gallery of Art, Washington, D.C.
Chester Dale Collection
7685 - 28"x20½" (71x52 cm)

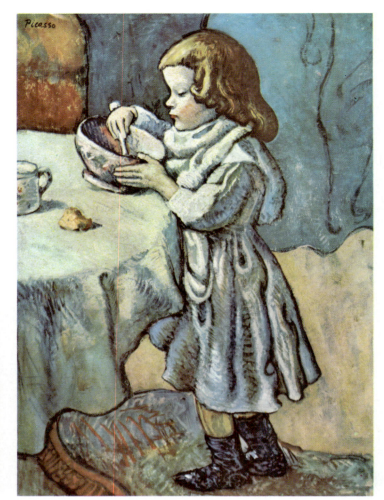

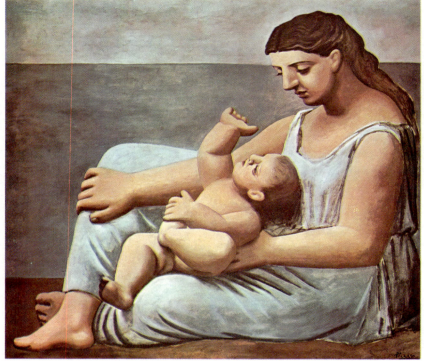

Pablo Picasso
MOTHER AND CHILD, 1921
The Art Institute of Chicago
7109 - 24¾"x28" (63x71 cm)

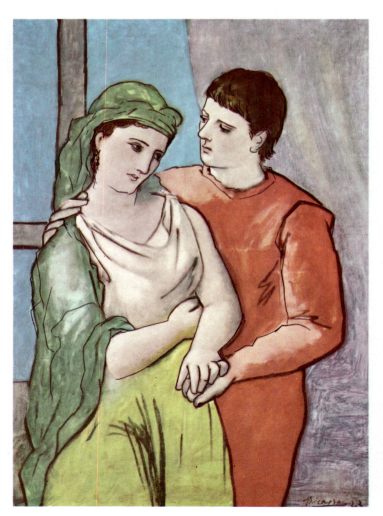

Pablo Picasso
THE LOVERS, 1923
National Gallery of Art, Washington, D.C.
Chester Dale Collection
7682 - 27"x20" (68x51 cm)
5720 - 20"x14½" (50x37 cm)

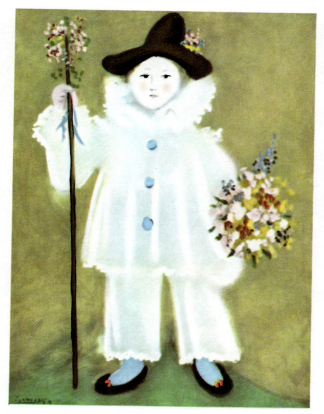

Pablo Picasso
PIERROT WITH FLOWERS, *1929*
Collection of the Artist
7326 - 21"x15½" (53x39 cm)
4326 - 15½"x11½" (39x29 cm)

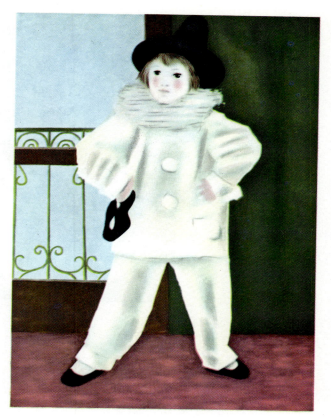

Pablo Picasso
PIERROT WITH MASK, *1925*
Collection of the Artist
7325 - 21"x15½" (53x39 cm)
4325 - 15½"x11½" (39x29 cm)

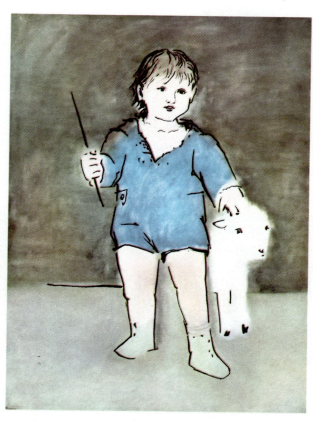

Pablo Picasso
THE LITTLE SHEPHERD, *1923*
Collection of the Artist
6323 - 21"x15½" (53x39 cm)
4323 - 15½"x11½" (39x29 cm)

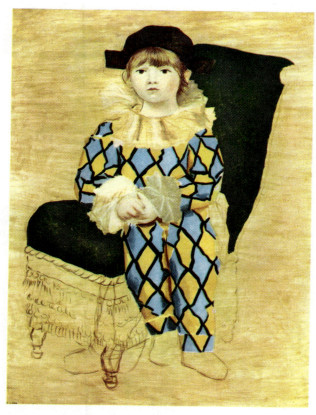

Pablo Picasso
THE ARTIST'S SON, *1924*
Collection of the Artist
7324 - 21"x15½" (53x39 cm)
4324 - 15½"x11½" (39x29 cm)

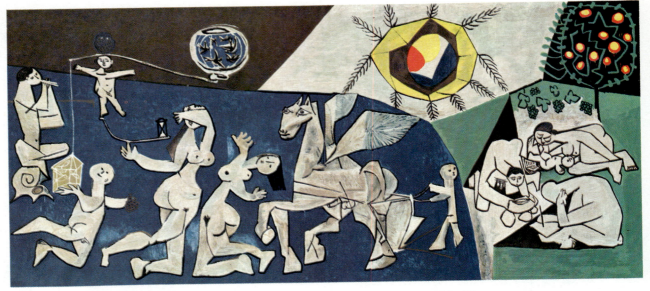

Pablo Picasso
PEACE, 1952
Temple of Peace, Vallauris
9575 - 16¼"x35¾" (41x90 cm)

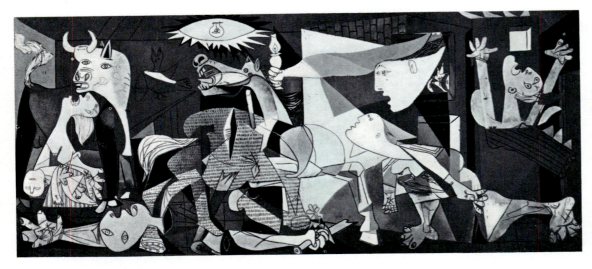

Pablo Picasso
GUERNICA, 1937
The Museum of Modern Art, New York
9728 - 16"x35½" (40x90 cm)
5728 - 8½"x19" (22x49 cm)

Pablo Picasso
WAR, 1952
Temple of Peace, Vallauris
9576 - 16¼"x35¾" (41x90 cm)

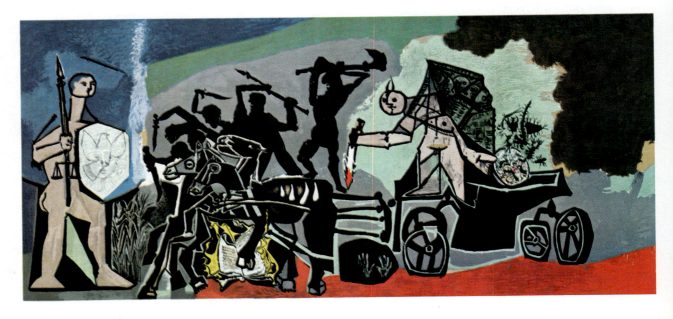

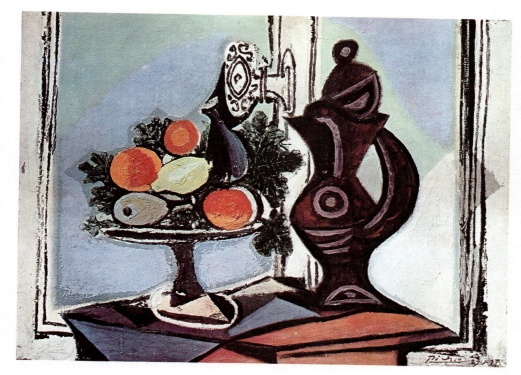

Pablo Picasso (Spanish, 1881-1973)
COMPOTE DISH AND PITCHER
BY THE WINDOW, 1937
Private Collection
712 - 21"x28½" (54x72 cm)

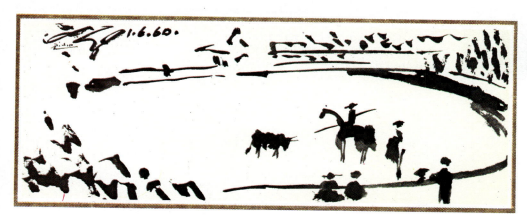

Pablo Picasso
CORRIDA, 1960
Galerie Louise Leiris
9089 - 12¼"x32" (31x81 cm)

Juan Gris
LE COMPOTIER, 1920
The Columbus Gallery of Fine Arts
Ferdinand Howald Collection
6613 - 24½"x20" (62x50 cm)

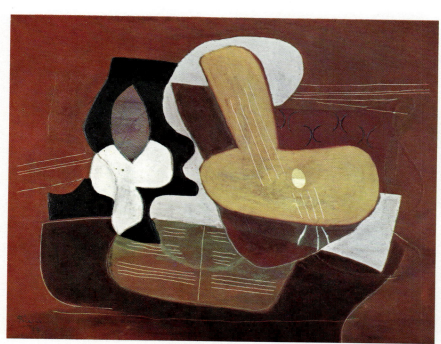

Pablo Picasso
STILL LIFE WITH MANDOLIN, 1923
Private Collection
7075 - 20½"x28" (52x71 cm)

Juan Gris (Spanish, 1887-1927)
STILL LIFE WITH OPEN BOOK 1925
Private Collection
508 - 16"x20" (40x50 cm)

Joan Miró
RED SUN, 1948
The Phillips Collection, Washington, D.C.
7572 - 28"x22" (71x56 cm)

Joan Miró (Spanish, 1893-)
MAN, WOMAN AND CHILD, 1931
Philadelphia Museum of Art
The Louise and Walter Arensberg Collection
7327 - 23"x30" (58x76 cm)

Salvador Dalí (*Spanish, 1904-*)
DRAWING FOR "CHRIST OF ST. JOHN
 OF THE CROSS," *1950*
Collection of Mr. and Mrs. A. Reynolds Morse
7666 - 21"x28" (53x71 cm)
4666 - 11½"x14" (29x35 cm)

Salvador Dalí
CHRIST OF ST. JOHN OF THE CROSS, *1951*
The Glasgow Art Gallery
7963999 - 28"x15½" (71x39 cm)
126 - 14"x8" (35x20 cm)
(For sale in U.S. and Canada only)

Salvador Dalí
CRUCIFIXION (*Corpus Hypercubus*), *1954*
The Metropolitan Museum of Art, New York
Chester Dale Collection
7691 - 28"x17¾" (71x45 cm)
4691 - 14"x9" (35x23 cm)

Salvador Dalí
COMPOSITION, *1942*
Private Collection
6087 - 22"x25½" (56x65 cm)

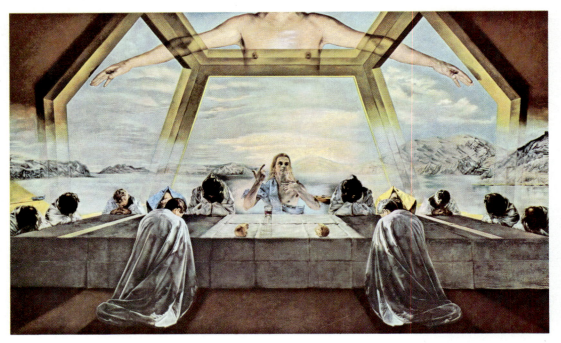

Salvador Dalí
THE SACRAMENT OF THE LAST SUPPER, 1955
National Gallery of Art, Washington, D.C., Chester Dale Collection
9923 - 27¾"x44" (70x112 cm)
7923 - 18¾"x29¾" (47x75 cm)
4923 - 8¾"x14" (22x35 cm)

Salvador Dalí
THE MADONNA OF PORT LLIGAT, 1950
Private Collection
7280 - 28"x21" (71x53 cm)
4505 - 14"x10½" (35x26 cm)

Salvador Dalí
DISCOVERY OF AMERICA BY
CHRISTOPHER COLUMBUS, 1959
Collection Mr. and Mrs. A. Reynolds Morse
Loaned to the Dali Museum, Cleveland, Ohio
7692 - 28"x21" (71x53 cm)

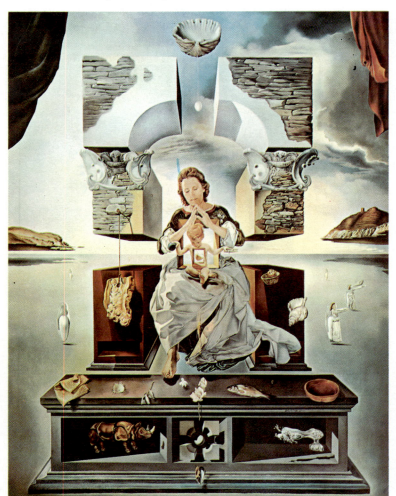

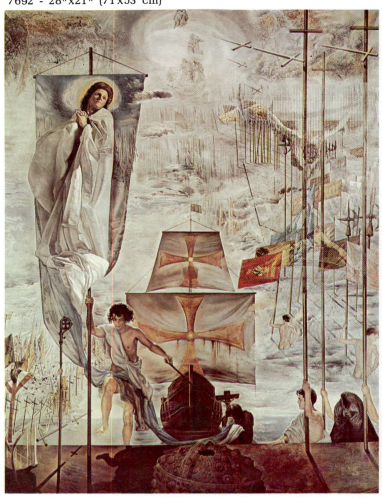

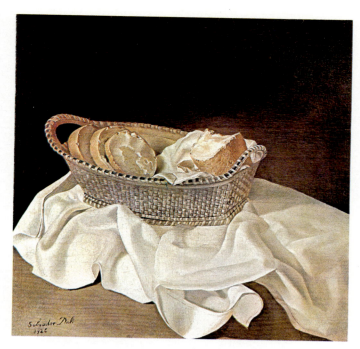

Salvador Dalí
BASKET OF BREAD, 1926
Collection of Mr. and Mrs. A. Reynolds Morse
4164 - 12½"x12½" (32x32 cm)

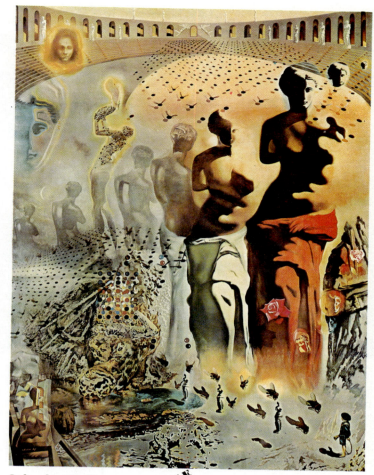

Salvador Dalí
HALLUCINOGENIC TOREADOR, 1970
Collection of Mr. and Mrs. A. Reynolds Morse
Loaned to the Dalí Museum, Cleveland, Ohio
7950 - 32"x(81 x 60 cm)

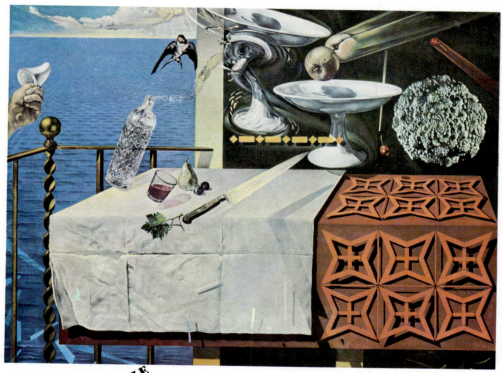

Salvador Dalí
NATURE MORTE VIVANTE, 1956
Collection of Mr. and Mrs. A. Reynolds Morse
Salvador Dalí Museum, Cleveland, Ohio
7278 - 21½"x28" (54x71 cm)

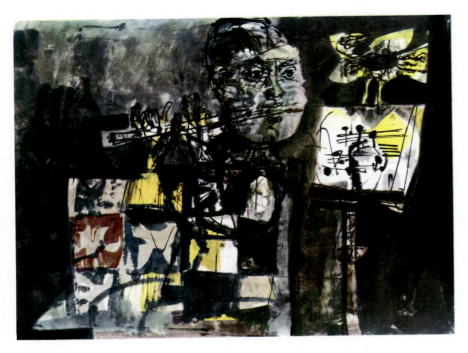

Antoni Clavé
THE MUSICIAN
Private Collection
7275 - 19½"x26" (50x65 cm)

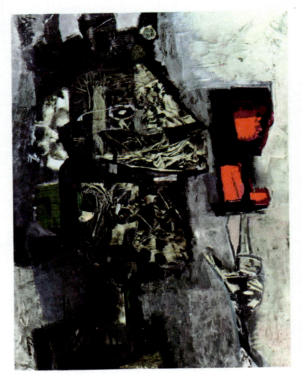

Antoni Clavé
KING BACCHUS
Private Collection
7041 - 26"x19" (66x50 cm)

Antoni Clavé (Spanish, 1913-)
TWILIGHT
Private Collection
8021 - 22½"x31½" (57x79 cm)

Montserrat Gudiol (*Spanish, 1933- *)
MOTHERHOOD, 1964
Private Collection
7148 - 25¾"x19¼" (65x49 cm)

Manuel H. Mompó (*Spanish, 1927- *)
ANSIA DE VIVIR, 1968
Selected by an International Jury
by arrangement with UNESCO
6867 - 27½"x18½" (69x47 cm)

Antonio Tapies (*Spanish, 1923- *)
PINTURA, 1958
Selected by an International Jury at the
XIXth Biennale of Venice, 1958
7992 - 22"x26½" (56x67 cm)

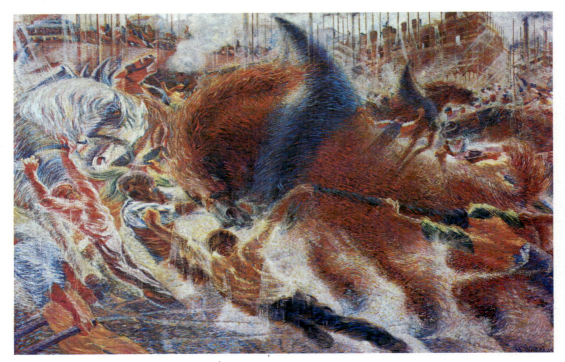

Umberto Boccioni *(Italian, 1882-1916)*
THE CITY RISES, *1910*
Museum of Modern Art, New York
Mrs. Simon Guggenheim Fund
7307 - 20"x30" (51x76 cm)

Giorgio de Chirico *(Italian, 1888-1978)*
JUAN-LES-PINS, *1930*
Private Collection
7479 - 28"x21" (71x53 cm)

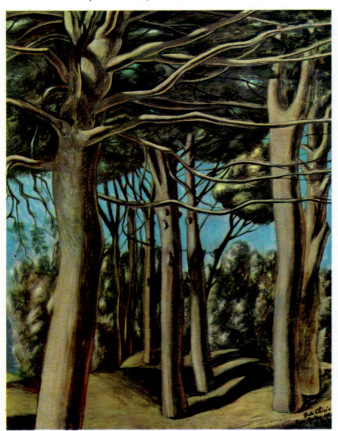

Giacomo Balla *(Italian, 1874-1958)*
DOG ON A LEASH, *1912*
George F. Goodyear and
The Buffalo Fine Arts Academy
7306 - 23"x28" (58x71 cm)

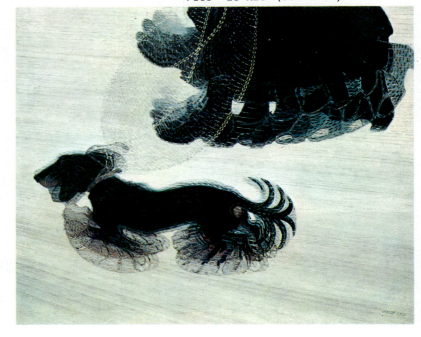

Amedeo Modigliani *(Italian, 1884-1920)*
PORTRAIT OF MADAME ZBOROWSKA, 1917-18
Rhode Island School of Design
Museum of Art, Providence
5344 - 21"x16" (53x40 cm)

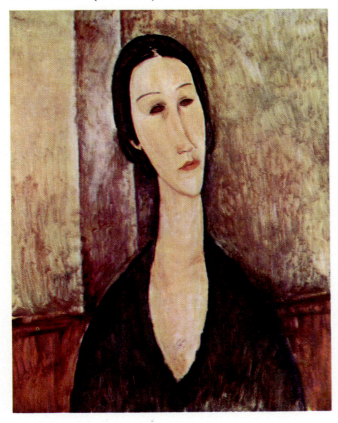

Amedeo Modigliani
GYPSY WOMAN WITH BABY, 1919
National Gallery of Art, Washington, D.C.
Chester Dale Collection
6256 - 24"x15" (60x38 cm)

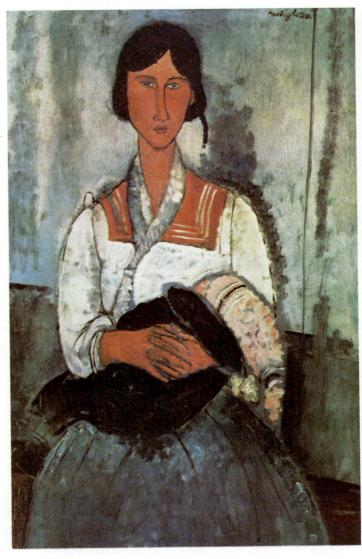

Marino Marini *(Italian, 1901-)*
THE DEPARTURE, 1957
Private Collection
6247 - 24"x16½" (61x42 cm)

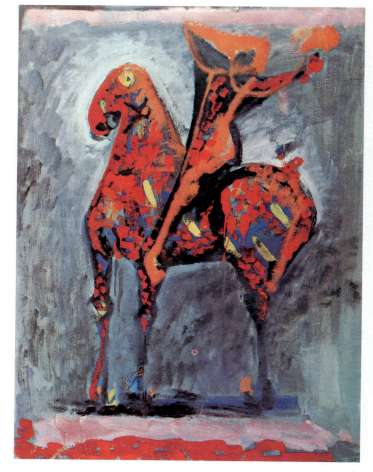

Marino Marini
RED HORSE, 1952
*Hirshhorn Museum and Sculpture Garden,
Smithsonian Institution*
7667 - 30"x22" (76x56 cm)

Marino Marini
THE HORSEMAN, 1956
Private Collection
6248 - 24"x18" (61x46 cm)

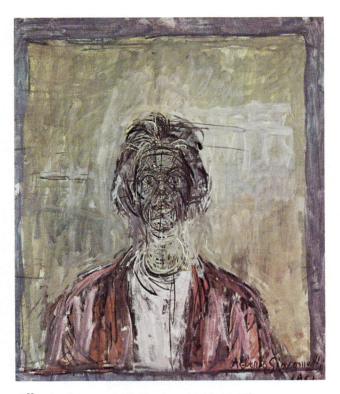

Alberto Giacometti *(Swiss, 1901-1966)*
ANNETTE
Joseph H. Hirshhorn Museum, Washington, D.C.
6395 - 21½″×18″ (55×46 cm)

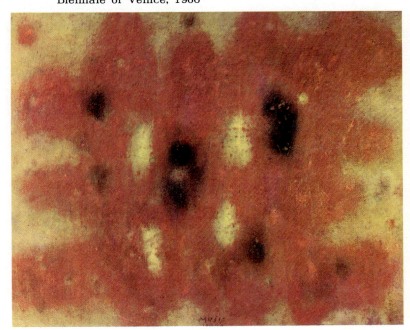

Antonio Zoran Music *(Italian, 1909-)*
SUITE BYZANTINE, 1960
7798 - 23½″x28½″ (59x73 cm)
Selected by an International Jury at the XXXth
Biennale of Venice, 1960

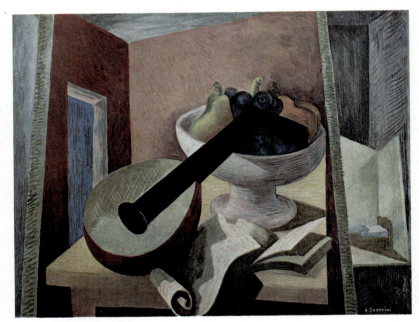

Gino Severini
STILL LIFE WITH MANDOLIN AND FRUIT, 1920-25
Stedelijk Museum, Amsterdam
On loan from the State Collection
6694 - 17″x21″ (43x53 cm)

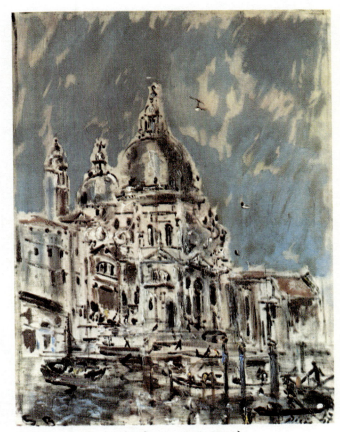

Filippo de Pisis *(Italian, 1896-1956)*
CHIESA DELLA SALUTE, 1947
Private Collection
6244 - 30″x23″ (77x58 cm)

Mario Sironi *(Italian, 1893-1961)*
THE RETURN OF MYTHE, 1956
Private Collection
6253 - 20½"x24" (52x61 cm)

Alfredo Volpi *(Italian, 1895-)*
CASAS
Private Collection
6695 - 25"x12½" (63x32 cm)
Selected by an International Jury at the IInd Biennale of the
Museum of Modern Art, São Paulo, on the occasion of the
Fourth Centennial Celebration of the City of São Paulo

Paul Klee *(Swiss, 1879-1940)*
TRAVELING CIRCUS, 1937
The Sadie A. May Collection, Baltimore Museum of Art
6274 - 26"x20" (66x51 cm)

Paul Klee
DEMON AS PIRATE, 1926
Philadelphia Museum of Art
The Louise and Walter Arensberg Collection
5133 - 11¾"x17¼" (29x43 cm)

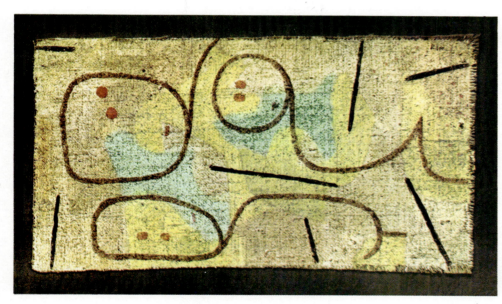

Paul Klee
LYING DOWN, *undated*
The Detroit Institute of Arts
7285 - 16½"x27" (41x68 cm)

Paul Klee
GLANCE OF A LANDSCAPE, *c.1927*
Philadelphia Museum of Art
The Louise and Walter Arensberg Collection
5134 - 11¾"x18" (29x45 cm)

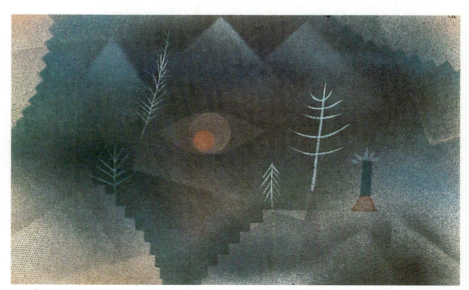

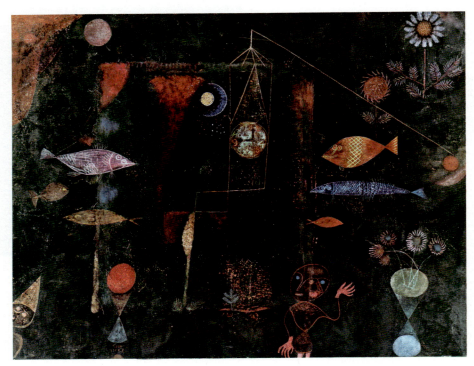

Paul Klee *(Swiss, 1879-1940)*
FISH MAGIC, c.1925
Philadelphia Museum of Art
The Louise and Walter Arensberg Collection
7046 - 23½"x30" (59x76 cm)

Paul Klee
PICTURE ALBUM, 1937
The Phillips Collection, Washington, D.C.
610 - 24"x22½" (60x57 cm)

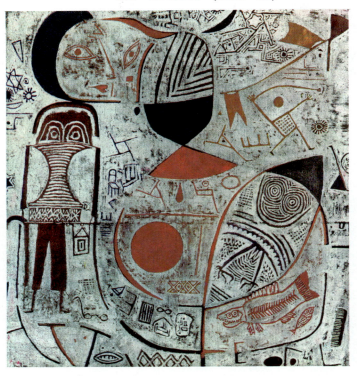

Paul Klee
ARAB SONG, 1932
The Phillips Collection, Washington, D.C.
7874 - 26"x18" (66x46 cm)

Ferdinand Hodler *(Swiss, 1853-1918)*
MEDITATION, 1886
Geneva Museum
6687 - 22½"x16" (57x40 cm)

Wolfgang Hutter *(Austrian, 1928-)*
THE LOVERS, 1950
7328 - 18½"x26" (47x66 cm)
Selected by an International Jury
at the XXVIIth Biennale, Venice, 1954

Emil Nolde *(German, 1867-1956)*
HEAVY SEAS AT SUNSET
The Minneapolis Institute of Arts
Gift of Mr. and Mrs. Bruce B. Dayton
5684 - 13½"x18" (34x46 cm)
(For sale in U.S.A. only)

Friedrich Hundertwasser *(Austrian, 1928-)*
YELLOW SHIPS, 1951
J. J. and J. J. Aberbach Collection, New York
7142 - 28"x18" (71x46 cm)

RED, YELLOW AND BLUE FLOWERS
3769 - 9¼"×6¾" (23×17 cm)

RED DAHLIAS
3767 - 9"×11" (23×28 cm)

YELLOW SUNFLOWERS AND RED POPPIES
3770 - 10¾"×12¾" (27×32 cm)

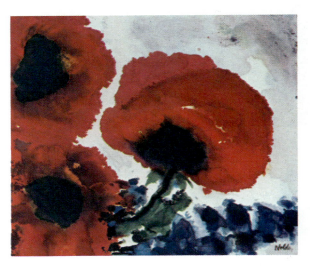

RED POPPIES AND LARKSPUR
3768 - 9"×10¼" (23×26 cm)

Four Watercolors by Emil Nolde (*German, 1867-1956*)
Norton Simon Foundation
Series 3767-3770

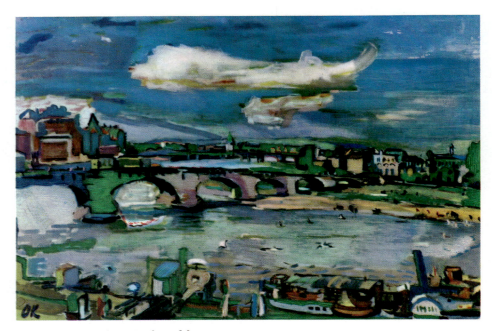

Oskar Kokoschka
VIEW OF DRESDEN, 1923
Van Abbe Museum, Eindhoven
6804 - 16"x23" (40x59 cm)

250

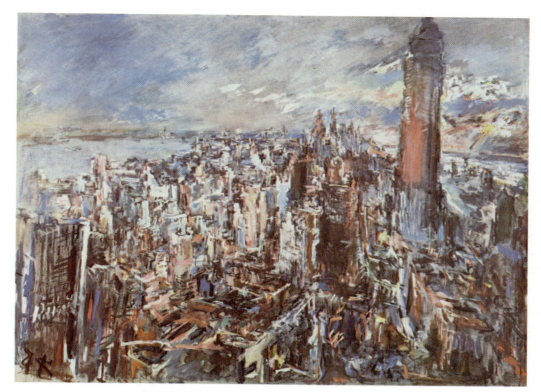

Oskar Kokoschka *(Austrian, 1886-1980)*
NEW YORK, *1966*
Collection of Mr. and Mrs. John Mosler, New York
9644 - 26¾"x36" (68x91 cm)

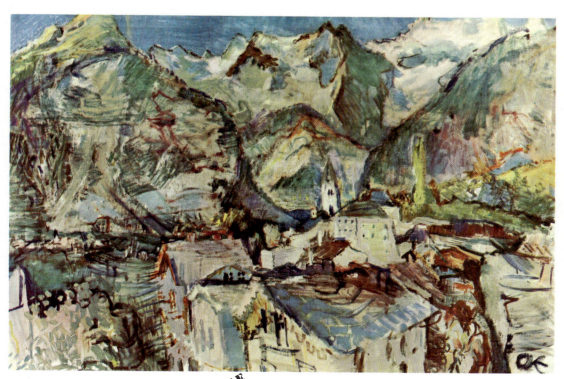

Oskar Kokoschka
COURMAYEUR, *1927*
The Phillips Collection, Washington, D.C.
959 - 24½"x36" (62x91 cm)

Max Ernst *(German, 1891-1976)*
COLOMBES BLEUES ET ROSES, *1926*
Kunstmuseum der Stadt, Düsseldorf
7975 - 22"x28" (55x71 cm)

Victor Pasmore *(British, 1908-)*
SQUARE MOTIF, BLUE AND GOLD:
THE ECLIPSE, 1950
Tate Gallery, London
6766 - 17¾"x23¾" (45x60 cm)

Willi Baumeister (German, 1889-1955)
FLOATING WORLD ON BLUE, 1950
Israel Museum, Jerusalem
On permanent loan from Mrs. Margaret Baumeister, Stuttgart
7669 - 23¼"x28¾" (59x73 cm)

Karl Hofer
STILL LIFE WITH FRUIT, 1943
Private Collection
6615 - 16"x23¾" (40x60 cm)

Roger Hilton (British, 1911-)
MARCH 1960 (GREY AND WHITE WITH OCHRE)
Waddington Galleries, London
7099 - 18½"x28" (47x71 cm)
Selected by an International Jury at the
XXXIInd Biennale of Venice, 1964

Henry Moore (British, 1898-)
STANDING FIGURES, 1940
Private Collection
6692 - 18½"x10½" (47x27 cm)

Horst Antes (German, 1936-)
INTERIOR IV (The Geometrician), 1963
Private Collection
7567 - 25½"x23" (64x58 cm)
Selected by an International Jury at the
XXXIIIrd Biennale of Venice, 1966

Karel Appel *(Dutch, 1921-)*
CHILD WITH HOOP, *1961*
7705 - 25″x19″ (63x48 cm)

Karel Appel
COMPOSITION IN RED, *1961*
Private Collection
7706 - 19″x25″ (48x63 cm)

Corneille (Cornelis van Beverloo) *(Dutch, 1922-)*
BLUE, SUMMER, CLOSED BLINDS, *1964*
Israel Museum, Jerusalem
7921 - 21¼″x28¾″ (51x72 cm)

Piet Mondrian
BLUE ROSE, c.1922
4989 - 10¾"x7¾" (27x19 cm)

Piet Mondrian
BLUE CHRYSANTHEMUM, c.1922
4988 - 11"x9½" (27x24 cm)

Piet Mondrian (Dutch, 1872-1944)
ROSE IN A TUMBLER, c.1922
4991 - 9½"x7½" (23x19 cm)

Piet Mondrian
LARGE CHRYSANTHEMUM, c.1908
4990 - 16"x9¾" (40x24 cm)

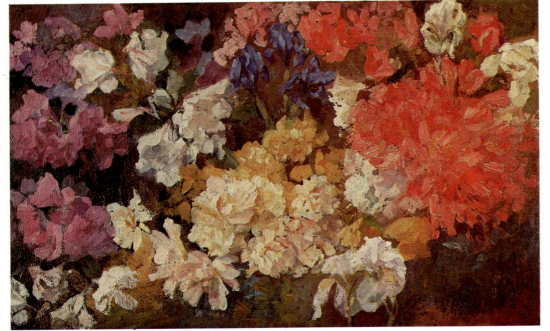

Piet Mondrian
RHODODENDRON, c. 1905
Santa Barbara Museum of Art
7017 - 18"x28½" (46x72 cm)

256

Nicholas de Staël (Russian, 1914-1955)
ROCKS ON BEACH, 1954
Hirshhorn Museum and Sculpture Garden,
Smithsonian Institution
8972 - 23¾"x32" (60x81 cm)

Wassily Kandinsky (Russian, 1866-1944)
COMPOSITION, 1934
Stedelijk Museum, Amsterdam
6920 - 17½"x23" (44x58 cm)

Seymour Fogel (Contemporary American)
COMPLEX WITH RED, 1978
Collection of the Artist
8118 - 22½"x30" (57x76 cm)

257

Jannis Spyropoulos (Greek, 1912-)
THE ORACLE, 1960
Private Collection
9084 - 35½"x23½" (90x60 cm)
Selected by an International Jury at the XXXth
Biennale of Venice, 1960

Chaim Soutine (Lithuanian, 1894-1943)
PORTRAIT OF A BOY, 1928
National Gallery of Art, Washington, D.C.
Chester Dale Collection
6257 - 24"x16½" (61x42 cm)

Tadeusz Kulisiewicz (Polish, 1899-)
PORTRAIT, 1954
4016 - 14"x12" (35x30 cm)
Selected by an International Jury at the XXVIIth
Biennale of Venice, 1954

James Ensor
EFFECT OF LIGHT
Tate Gallery, London
6765 - 19"x22¾" (50x69 cm)

James Ensor *(Belgian, 1860-1949)*
CARNIVAL, *c.1920*
Stedelijk Museum, Amsterdam
7750 - 20½"x28" (52x71 cm)

Victor Vasarely *(Hungarian, 1908-)*
KIU SIU, *1964*
Philadelphia Museum of Art
Given by the Friends of the Philadelphia Museum of Art
9978 - 19"x38" (48x96 cm)

Victor Vasarely
ARCTURUS II, 1966
*Hirshhorn Museum and Sculpture Garden,
Smithsonian Institution*
7694 - 28"x28" (71x71 cm)

Piet Mondrian
OPPOSITION OF LINES, RED AND YELLOW, 1937
*Philadelphia Museum of Art
A. E. Gallatin Collection*
5098 - 21"x17¼" (43x33 cm)

Justin Daraniyagala *(Ceylon, 1903-)*
THE FISH, 1949
Private Collection
7034 - 26"x18½" (66x47 cm)
*Selected by an International Jury at the
XXVIIIth Biennale of Venice, 1956*

Hans Hartung (French, 1904-)
COMPOSITION, 1955
Collection of Larry Aldrich, New York
9633 - 35"x26" (89x66 cm)

Pierre Doutreleau (Contemporary French)
AFTER THE STORM
Private Collection
8343 - 28"x28" (71x71 cm)

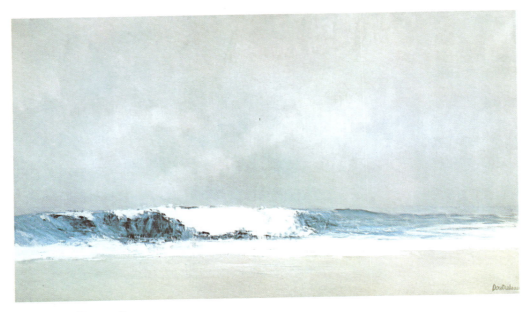

Pierre Doutreleau
THE WAVE
Private Collection
7914 - 17½"x30½" (44x66 cm)

Mordecai Ardon *(Israeli, 1896-)*
EIN KAREM, 1944
Israel Museum, Jerusalem
8648 - 32"x24¾" (81x63 cm)

Jean Paul Riopelle *(Canadian, 1923-)*
DU NOIR QUI SE LEVE, 1962
Private Collection
6922 - 24"x19¼" (61x49 cm)
Selected by an International Jury
at the XXXIst Biennale of Venice, 1962

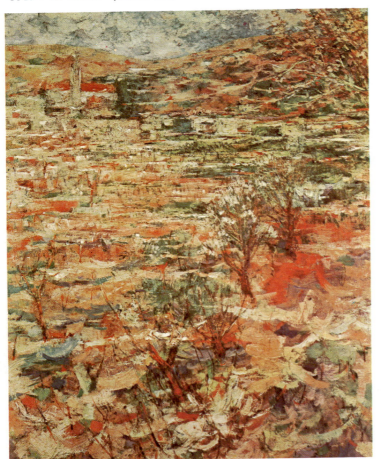

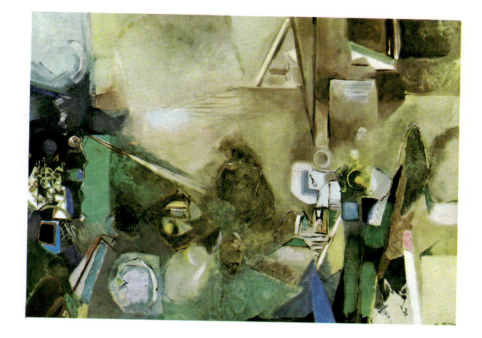

Avigdor Arikha (Israeli, 1929-)
LATENT ANTAGONISM, 1957
Israel Museum, Jerusalem
7920 - 21¼"x28" (54x71 cm)

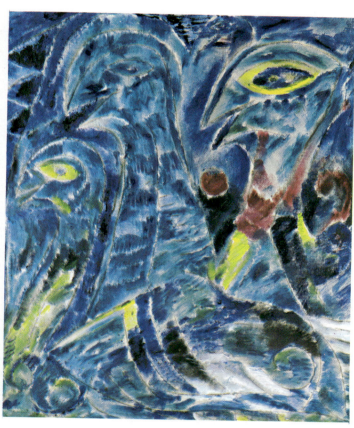

Carl-Henning Pedersen (Dutch, 1913-)
THE BLUE BIRDS, 1962
Private Collection
8546 - 31½"x26¼" (80x67 cm)
Selected by an International Jury
at the XXXIst Biennale of Venice, 1962

Mordecai Ardon
THE STORY OF A CANDLE, 1954
Private Collection
7703 - 20"x25¼" (51x65 cm) $18.00
Selected by an International Jury at the
XXVIIth Biennale of Venice, 1954

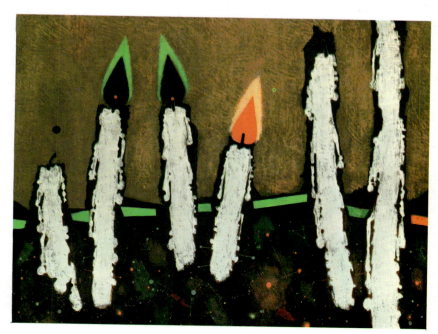

Reuven Rubin *(Israeli, 1893-1974)*
MOTHER AND CHILD, 1961
Private Collection
7150 - 25½"x19¼" (65x49 cm)

Reuven Rubin
WOMEN OF GALILEE, 1961
Private Collection
7149 - 25½"x19¼" (65x49 cm)

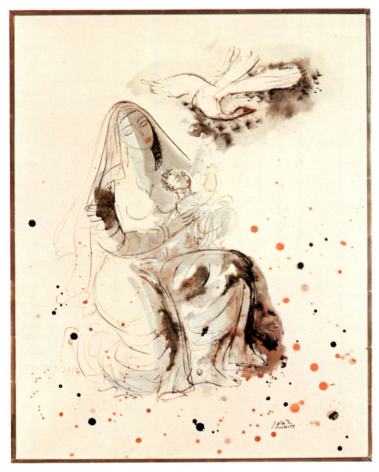

Roberto Matta *(Chilean, 1911-)*
WHO'S WHO, 1955
Private Collection
7330 - 23"x29¼" (58x75 cm)
Selected by an International Jury at the IIIrd Biennale of the
Museum of Modern Art, São Paulo

Leonor Fini
MELITA, 1961
Private Collection
7559 - 31″x10″ (80x25 cm)

Nissan Engel *(Contemporary American)*
MUSICAL FLIGHT, 1979
Collection of the Artist
7329 - 21″x31¾″ (53x80 cm)

Paul Wunderlich *(German, 1927-)*
ZU A.D.
Private Collection
6526 - 26″×20½″ (66×52 cm)

Leonor Fini *(Argentinian, 1918-)*
LOSANGE, 1960
Private Collection
7796 - 28″x18″ (71x48 cm)

Diego Rivera
FLOWER VENDOR, 1935
San Francisco Museum of Art
7555 - 28"x28" (71x71 cm)
5555 - 17¾"x17¾" (45x45 cm)

Diego Rivera
OAXACA
Brooklyn Museum, Brooklyn, N.Y.
4782 - 10½"x15½" (26x39 cm)

Diego Rivera
INDIAN GIRL
Private Collection
478? - 16"x12" (40x30 cm)

Diego Rivera
MOTHER'S HELPER, 1950
Private Collection
5788 - 13½"x18" (33x46 cm)

José Clemente Orozco *(Mexican, 1883-1949)*
ZAPATISTAS, 1931
The Museum of Modern Art, New York
7002 - 24½"x30" (62x76 cm)

Miguel Covarrubias *(Mexican, 1902-1957)*
FLOWER FIESTA
Private Collection
727 - x22½" (71x57 cm) NO LONGER AVAILABLE

Carlos Merida *(Guatemalan, 1893-)*
EL PAJARO HERIDO
Museo de Arte Moderno, Mexico City
6306 - 28"×2 (71×50 cm) NO LONGER AVAILABLE

Luis Martínez Pedro *(Cuban, 1910-)*
ESPACIO AZUL, 1952
Private Collection
7556 - 25"x30" (63x76 cm)
Selected by an International Jury at the
IInd Biennale of the Museum of Modern Art, São Paulo

John Hesselius *(American, 1728-1778)*
CHARLES CALVERT, *1761*
The Baltimore Museum of Art
6291 - 24"x19" (61x48 cm)

Unknown Colonial Artist
MRS. FREAKE AND BABY MARY, *c.1674*
Worcester Art Museum
6674 - 21"x18" (53x46 cm)

After: John Singleton Copley
ELIZABETH, THE ARTIST'S DAUGHTER, *1776-77*
National Gallery of Art, Washington, D.C.
Andrew Mellon Fund
6312 - 24"x13" (61x33 cm)

Edward Savage (American, 1761-1817)
THE WASHINGTON FAMILY, 1796
National Gallery of Art, Washington, D.C.
Mellon Collection
7059 - 21"x28" (53x71 cm)

John Singleton Copley
PORTRAIT OF PAUL REVERE, c.1765-70
Museum of Fine Arts, Boston
7073 - 26"x21" (66x53 cm)

Gilbert Stuart (American, 1755-1828)
MRS. RICHARD YATES, 1793
National Gallery of Art, Washington, D.C.
Mellon Collection
625 - 22"x18" (56x46 cm)

Unknown American Artist (*mid-Nineteenth Century*)
LEAPING DEER
Abby Aldrich Rockefeller Folk Art Center,
Williamsburg, Virginia
6503 - 20"x26⅞" (51x68 cm)

Edward Hicks
THE RESIDENCE OF DAVID TWINING, 1845-1848
Abby Aldrich Rockefeller Folk Art Center,
Williamsburg, Virginia
6505 - 20¼"x24⅛" (51x61 cm)

18th Century Copperplate Textile
THE AVIARY
Private Collection
7987 - 22″×25¼″ (56×64 cm)

Mary Slatter *(Active 1792)*
SAMPLER, *1792*
Worcester Art Museum
Gift of Mrs. J. Templeman Coolidge
6228 - 17¼″x24″ (44x61 cm)

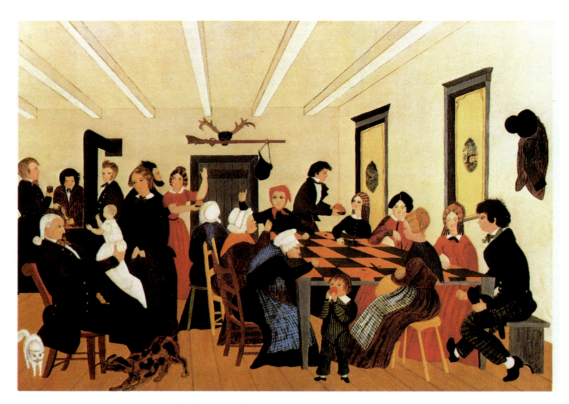

Unknown American Artist
THE QUILTING PARTY
Abby Aldrich Rockefeller Folk Art Center,
Williamsburg, Virginia
6504 - 20"x27¼" (50x69 cm)

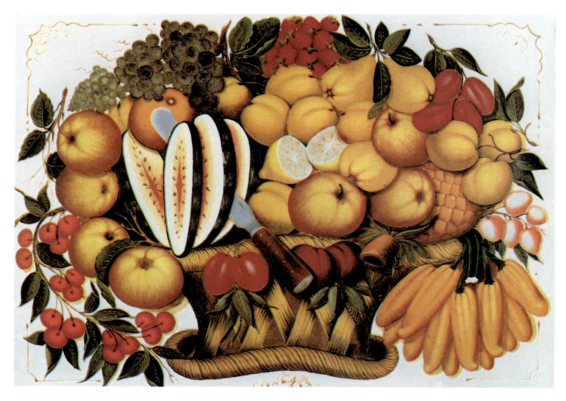

Unknown American Artist
FRUIT IN WICKER BASKET, 1870
Abby Aldrich Rockefeller Folk Art Center,
Williamsburg, Virginia
7283 - 22⅛"x30½" (56x77 cm)

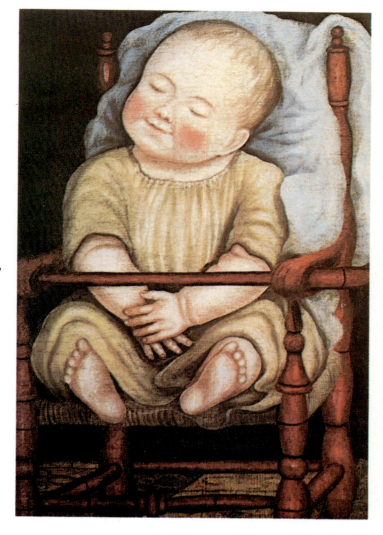

Unknown American Artist
BABY IN RED CHAIR
Abby Aldrich Rockefeller Folk Art Center,
Williamsburg, Virginia
5736 - 21½"x14½" (56x38 cm)

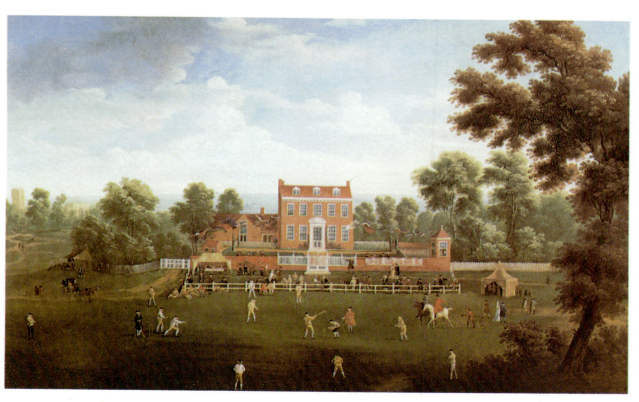

Unknown English Artist *(Early 19th Century)*
CRICKET MATCH AT KENFIELD HALL
The Marlyebone Cricket Club, London
7385 - 20"x30½" (51x77.4 cm)

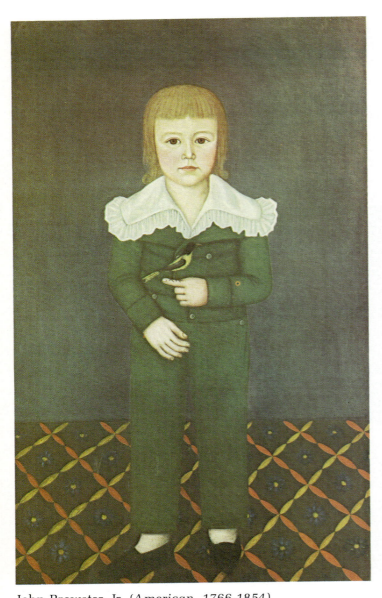

John Brewster, Jr. (*American, 1766-1854*)
BOY WITH FINCH
Abby Aldrich Rockefeller Collection, Williamsburg, Va.
6861 - 28″ × 17″ (71 × 43 cm)
5548 - 19″ × 11½″ (48 × 29 cm)

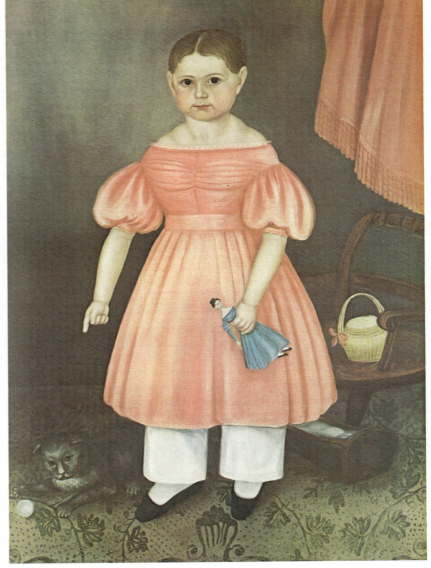

Joseph Whiting Stock (*American, 1815-1855*)
MARY JANE SMITH
Abby Aldrich Rockefeller Collection, Williamsburg, Va.
6860 - 28″ × 20″ (71 × 51 cm)
5547 - 19¼″ × 13¾″ (49 × 35 cm)

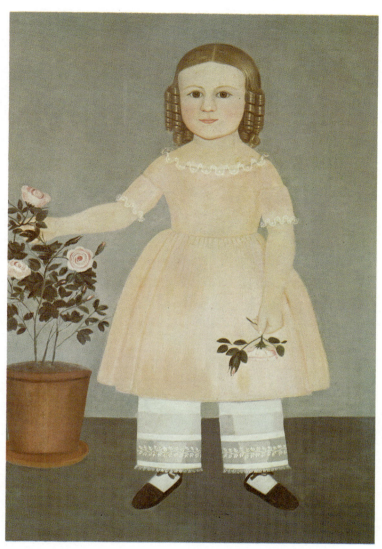

Unknown Artist *(American, 19th Century)*
PORTRAIT OF A YOUNG GIRL WITH FLOWERS
M. H. de Young Memorial Museum
6801 - 28"x19" (71x48 cm)

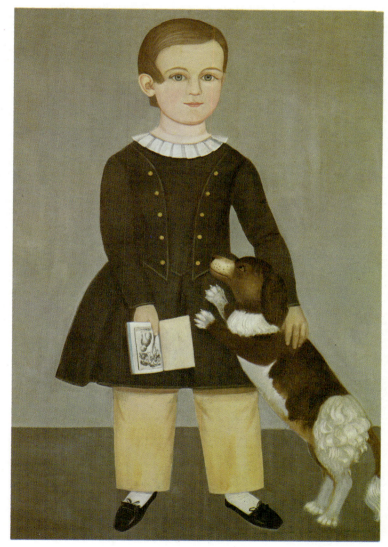

Unknown Artist *(American, 19th Century)*
A YOUNG BOY WITH DOG
M. H. de Young Memorial Museum
6802 - 28"x19" (71x48 cm)

Gilbert Stuart *(American 1755-1828)*
GENERAL JOHN R. FENWICK *(Circa 1804)*
Gibbes Art Gallery, Charleston, S.C.
6463 - 24"x20" (61x51 cm)

Ralph Earl *(American 1751-1801)*
WILLIAM CARPENTER, 1779
Worcester Art Museum
6678 - 23½"x17½" (60x44 cm)

Samuel F. B. Morse *(American, 1791-1872)*
GENERAL LAFAYETTE, 1826
Brooklyn Museum, Brooklyn, N.Y.
626 - 24"x16½" (61x42 cm)

John Trumbull
ALEXANDER HAMILTON, 1792
National Gallery of Art, Washington, D.C.
Gift of the Avalon Foundation
5439 - 18"x14½" (46x37 cm)

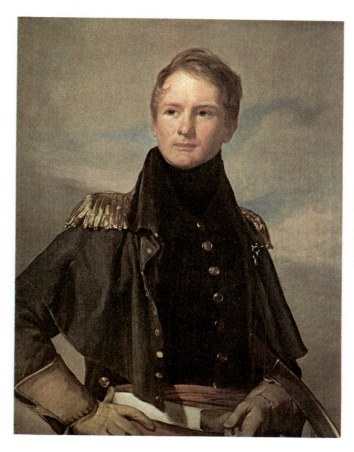

Thomas Sully (American, 1783-1872) and
Thomas Wilcocks Sully (American, 1811-1847)
MAJOR THOMAS BIDDLE, 1832
National Gallery of Art, Washington, D.C.
Mellon Collection
5365 - 20"x16" (50x40 cm)

John A. Elder (American, 1833-1895)
GENERAL ROBERT E. LEE, undated
The Corcoran Gallery of Art, Washington, D.C.
5654 - 20"x14½" (51x37 cm)
3654 - 14"x10" (35x25 cm)
2654 - 8"x6" (20x15 cm)

John A. Elder
GENERAL T. J. JACKSON, undated
The Corcoran Gallery of Art, Washington, D.C.
7653 - 30"x22" (76x56 cm)
5653 - 20"x14½" (50x37 cm)

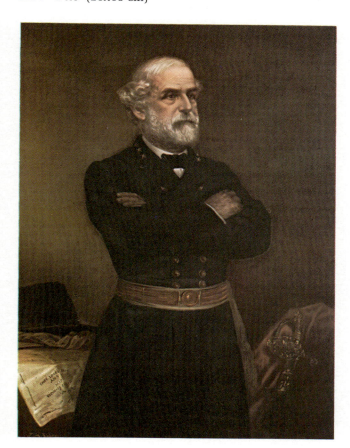

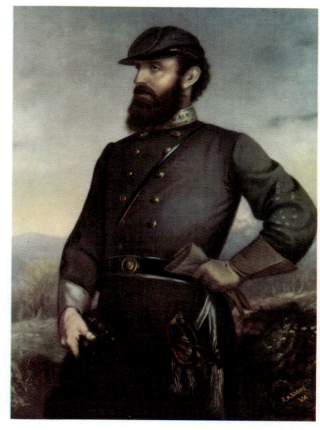

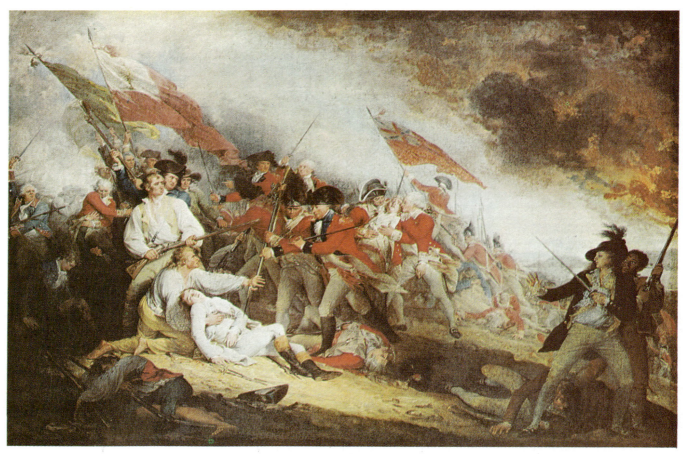

John Trumbull (American, 1756-1843)
BATTLE OF BUNKER'S HILL
Yale University Art Gallery, New Haven
7303 - 22"x30" (56x76 cm)
4276 - 9½"x14" (24x36 cm)

John Trumbull
DECLARATION OF INDEPENDENCE, *1786-1794*
Yale University Art Gallery, New Haven
7277 - 20"x30" (51x76 cm)
4277 - 9"x13¾" (23x35 cm)

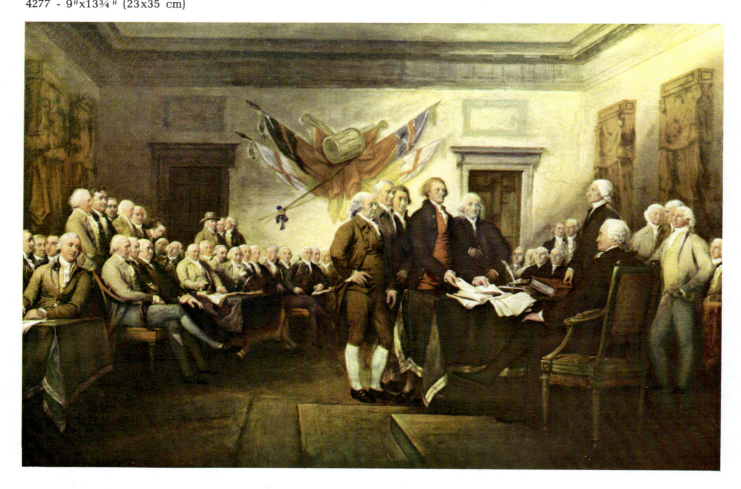

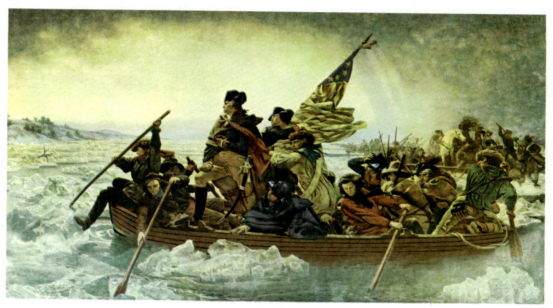

Emanuel Leutze *(American, 1816-1868)*
WASHINGTON CROSSING
THE DELAWARE, *1851*
The Metropolitan Museum of Art, New York
Gift of John S. Kennedy, 1897
7030 - 18"x30" (46x76 cm)
4275 - 7½"x13¾" (19x35 cm)

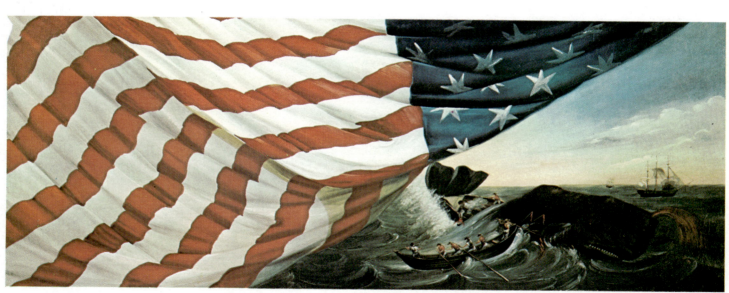

Unknown Artist
THE WHALER'S FLAG, *c.1845*
Donaldson, Lufkin & Jenrette, Inc., New York
9053 - 16"x39" (40x99 cm)

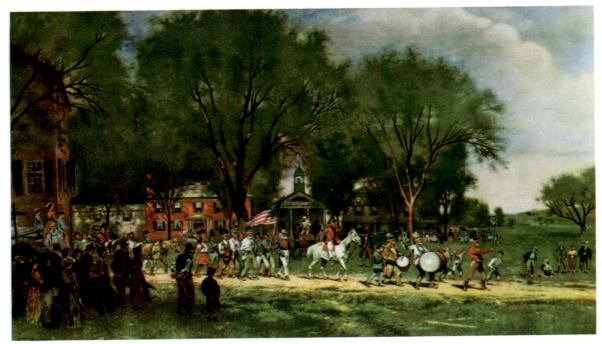

Alfred C. Howland *(American, 1838-1909)*
FOURTH OF JULY PARADE
Private Collection
9000 - 24"x40" (61 x101 cm)

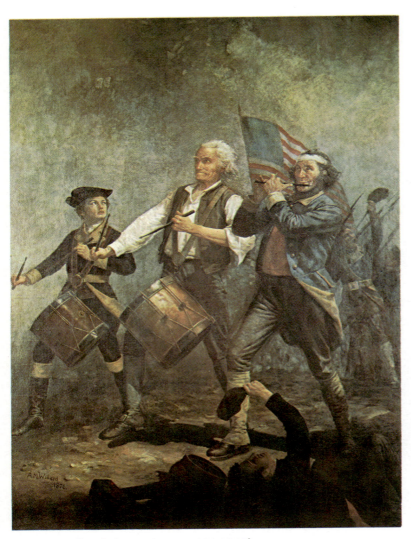

A. M. Willard *(American, 1836-1918)*
THE SPIRIT OF '76, *c.1880*
Abbott Hall, Marblehead, Massachusetts
7715 - 28"x21" (71x53 cm)
4715 - 14"x10½" (35x26 cm)

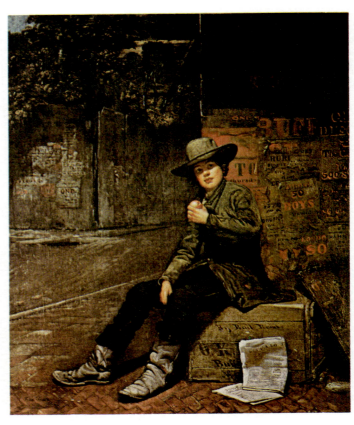

Thomas LeClear *(American, 1818-1882)*
BUFFALO NEWSBOY, 1853
Albright-Knox Art Gallery, Buffalo
6869 - 24"x20" (61x50 cm)

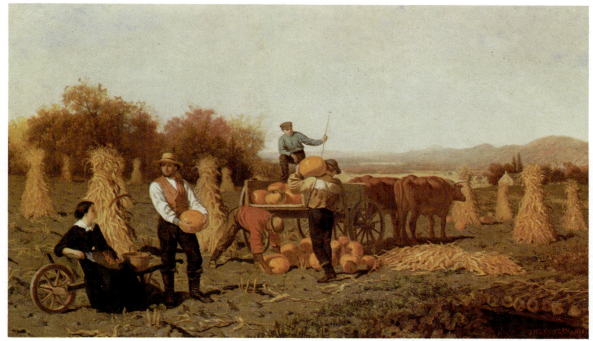

John Whetton Ehninger *(American, 1827-1889)*
OCTOBER, 1867
National Collection of Fine Arts
Smithsonian Institution
8104 - 18"x30" (46x76 cm)

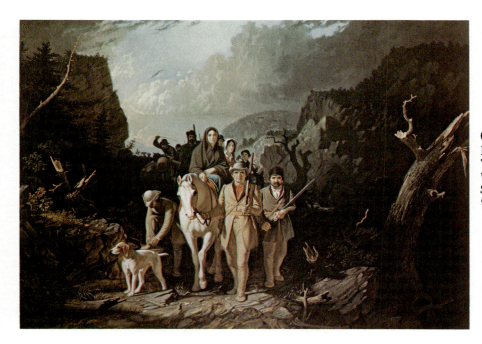

George Caleb Bingham *(American, 1811-1879)*
DANIEL BOONE ESCORTING SETTLERS
THROUGH THE CUMBERLAND GAP, *1851-52*
Washington University Gallery of Art
Steinberg Hall, St. Louis
9300 - 21½"x30" (54x76 cm)

Richard C. Woodville *(American, 1825-1855)*
THE FIRST STEP, *1847*
The New York Historical Society
7542 - 25"x27½" (64x70 cm)

Gilbert Stuart
GEORGE WASHINGTON, 1795
National Gallery of Art, Washington, D.C.
Mellon Collection
6443 - 24"x19" (61x48 cm)
4443 - 14"x11" (35x28 cm)

Gilbert Stuart
GEORGE WASHINGTON
Wadsworth Athenaeum, Hartford, Conn.
8670 - 28"x22" (71x56 cm)

Douglas Volk *(American, 1856-1935)*
ABRAHAM LINCOLN, 1908
National Gallery of Art, Washington, D.C.
Mellon Collection
4440 - 14"x11" (35x28 cm)
2440 - 8"x6½" (20x16 cm)

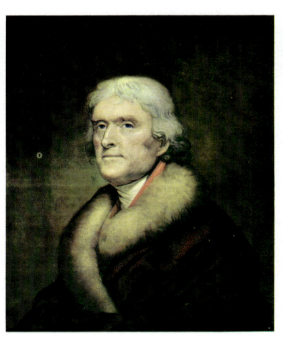

Rembrandt Peale *(American, 1778-1860)*
THOMAS JEFFERSON
A. D. Whiteside Collection
5435 - 18"x15" (46x39 cm)
3435 - 9"x7½" (23x19 cm)

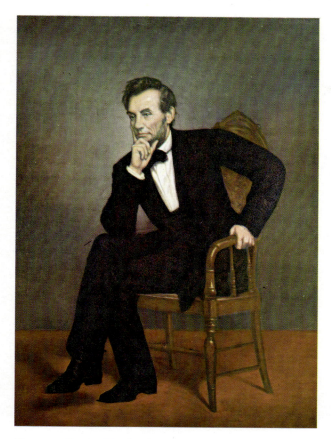

George P. A. Healy (American, 1813-1894)
ABRAHAM LINCOLN, 1887
National Gallery of Art, Washington, D.C.
Mellon Collection
7655 - 27½"x20 " (70x51 cm)

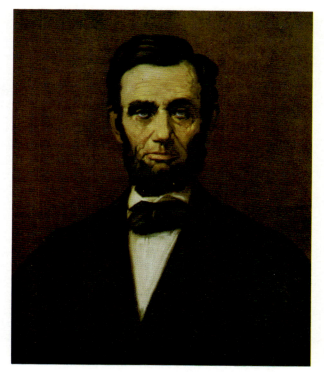

J. Redding Kelly (American, dates unknown)
ABRAHAM LINCOLN
A. D. Whiteside Collection
5434 - 18"x15" (46x38 cm)
3434 - 9"x7½" (23x19 cm)

Louis Lupas
JOHN F. KENNEDY, 1962
The John F. Kennedy Collection
7140 - 28"x20¼" (71x51 cm)
4140 - 13½"x10" (34x25 cm)

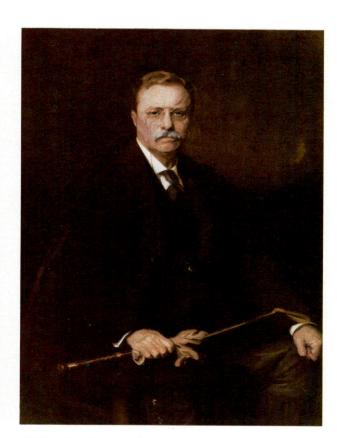

Philip Alexius de Laszlo (Hungarian, 1869-1940)
THEODORE ROOSEVELT, 1908
The New York State Theodore Roosevelt Memorial
Committee of The American Museum of Natural
History, New York, 1938
6241 - 23½"x18" (60x45 cm)

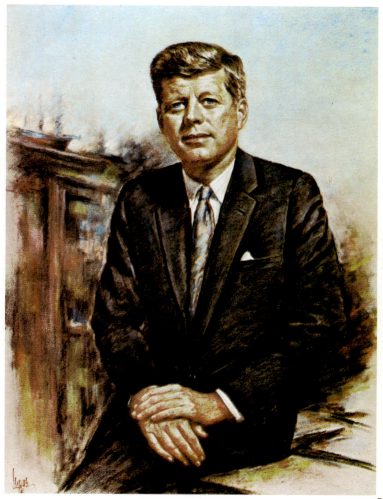

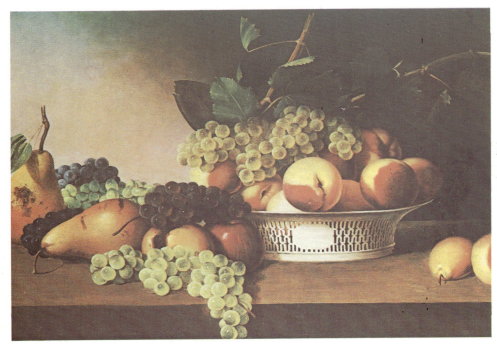

James Peale (*American, 1749-1831*)
STILL LIFE WITH FRUIT
M.H.de Young Memorial Museum, San Francisco, Calif.
6524 - 18¼″ × 25¼″ (46 × 64 cm)

James Peale
FRUIT, *c.1820*
The Corcoran Gallery of Art, Washington, D.C.
7826 - 17″x27″ (43x68 cm)

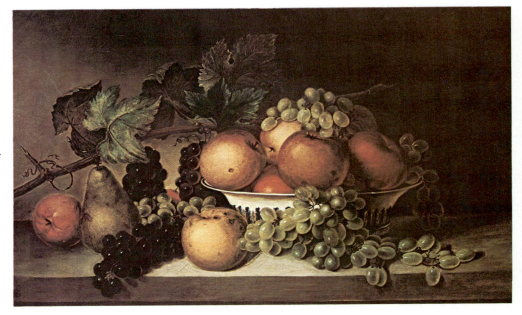

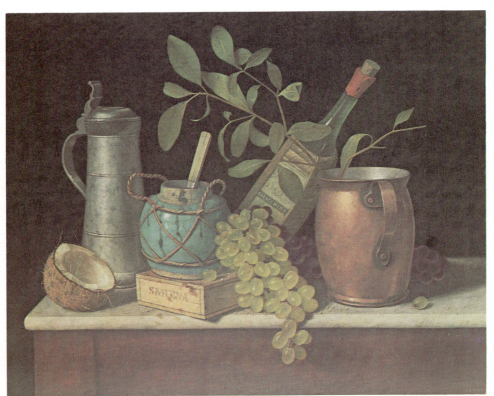

William M. Harnett (*American, 1848-1892*)
JUST DESSERT
The Art Institute of Chicago
6631 - 21″x25¼″ (53x64 cm)

William Harnett
MUSIC AND LITERATURE, *1878*
Albright-Knox Art Gallery, Buffalo
8631 - 23½"x31½" (59x79 cm)
4631 - 11"x14" (28x35 cm)

John Frederick Peto
BASKET, UMBRELLA AND HAT
Private Collection
5245 - 10"x16" (25x40 cm)

John Frederick Peto (American, 1854-1907)
OLD COMPANIONS, *1904*
Collection of Helen Peto Smiley
8633 - 23"x31" (58x78 cm)

John Frederick Peto
LETTER RACK
Private Collection
6981 - 25"x21" (63x53 cm)

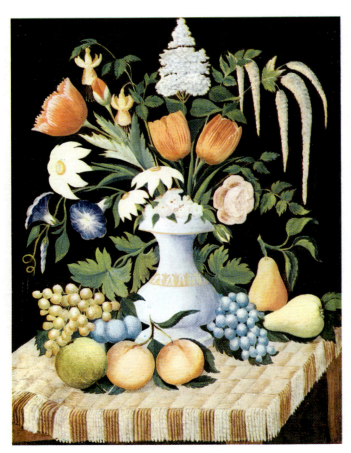

Unknown American Artist
FLOWERS AND FRUIT, *c.1830*
National Gallery of Art, Washington, D.C.
7733 - 26"x19½" (66x49 cm)

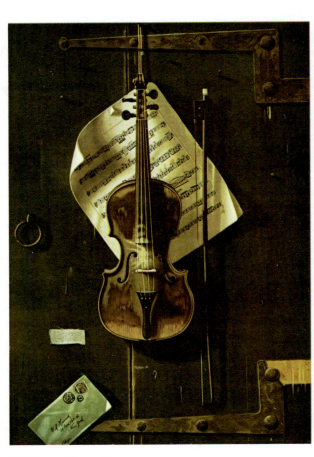

William Harnett
THE OLD REFRAIN, *1886*
Private Collection
6630 - 22½"x15½" (57x39 cm)

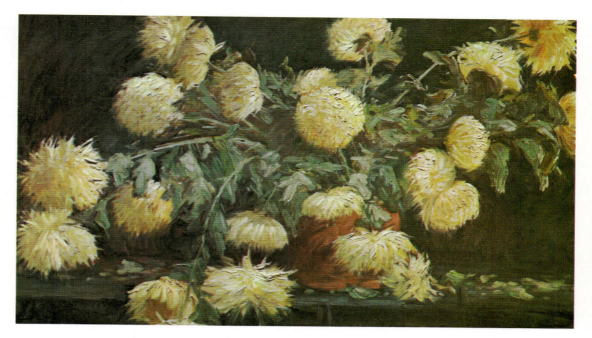

William M. Chase *(American, 1849-1916)*
CHRYSANTHEMUMS, *c.1878*
National Gallery of Art, Washington, D.C.
Chester Dale Collection
9288 - 21¾"x36" (55x91 cm)

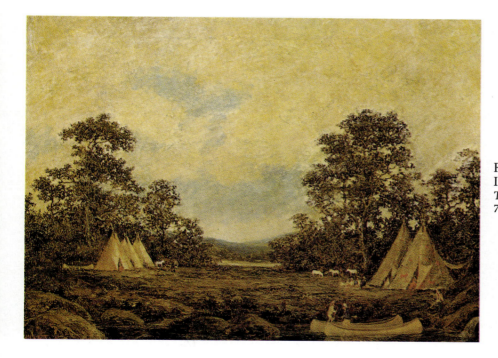

Ralph Albert Blakelock *(American, 1847-1919)*
INDIAN ENCAMPMENT
The University of Arizona, Museum of Art, Gift of Raymond Burr
7540 - 22"x30" (56x76 cm)

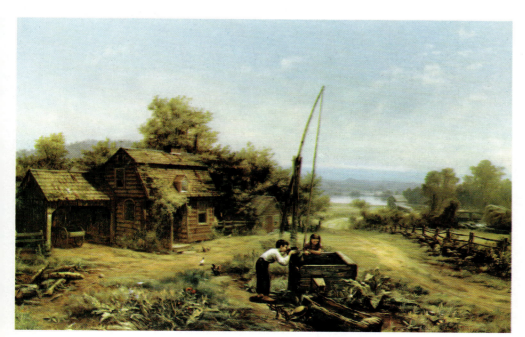

Jerome B. Thompson *(American, 1814-1886)*
THE OLD OAKEN BUCKET
7040 - 18"x28" (45x71 cm)

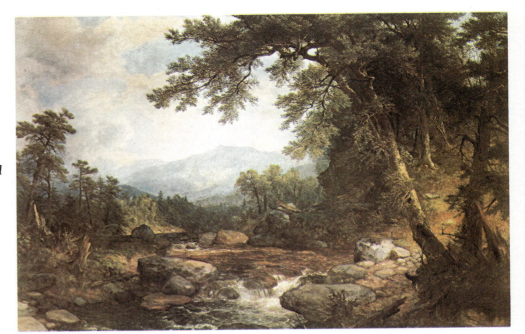

Asher B. Durand *(American, 1796-1886)*
MONUMENT MOUNTAIN, BERKSHIRES, *undated*
The Detroit Institute of Arts
9903 - 24"x36" (61x91 cm)

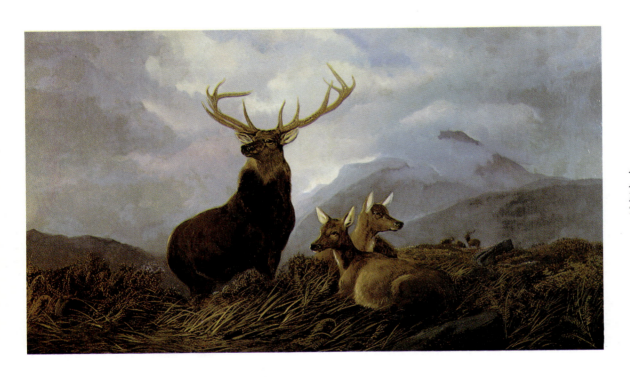

Arthur F. Tait *(American, 1819-19*
ALERT
Brigham Young University
7538 - 18"x30" (46x76 cm)

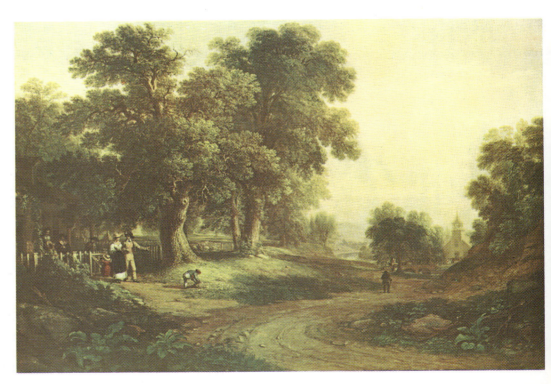

Asher B. Durand
SUNDAY MORNING, *1839*
The New York Historical Society
9537 - 24½"x36" (62x91 cm)
7644 - 17½"x26" (45x66 cm)

288

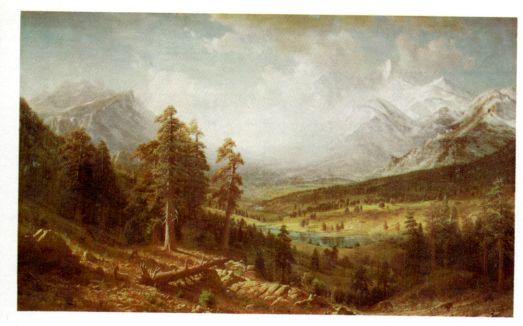

Alfred Bierstadt (*American, 1830-1902*)
ESTES PARK
Denver Public Library
9060 - 21"×36" (53×91 cm)

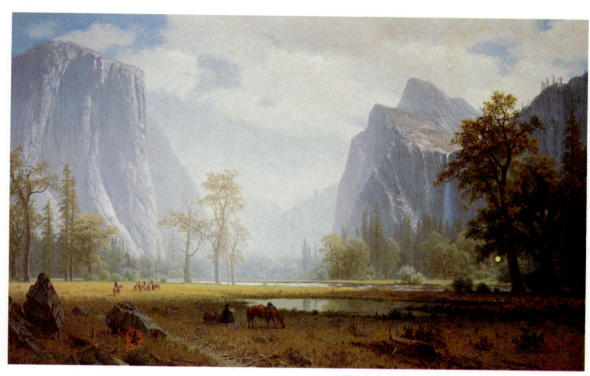

Albert Bierstadt
LOOKING UP THE YOSEMITE VALLEY
Pioneer Museum & Haggin Galleries
9979 - 22¼"x36" (56x91 cm)

Thomas Hill (*American, 1829-1908*)
MILL CREEK CANYON
E. B. Crocker Art Gallery
Sacramento, California
9659 - 22"x38" (56x96 cm)

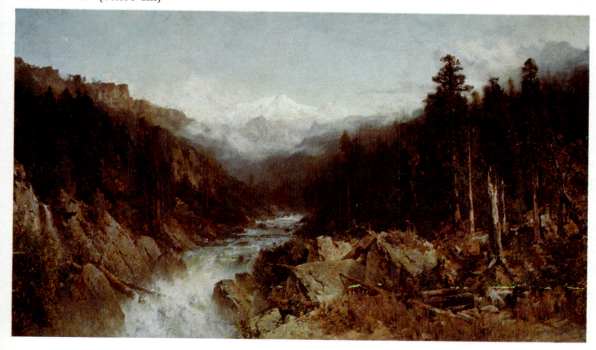

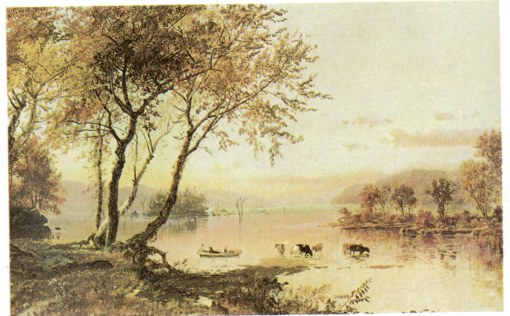

Jasper F. Cropsey (*American, 1823–1900*)
MOUNTAIN LAKES, 1871
Private Collection
9851 - 24"x36" (61x91 cm)

Jasper F. Cropsey
AUTUMN ON THE HUDSON RIVER, 1860
National Gallery of Art, Washington, D.C.
9046 - 22¼"x40" (56x101 cm)

William Sonntag (*American, 1822-1900*)
MOUNTAIN LAKE NEAR PIEDMONT, MARYLAND, 1860
National Collection of Fine Arts
Smithsonian Institution, Washington, D.C.
9299 - 25¾"x40" (65x101 cm)

George Inness *(American, 1825-1894)*
THE WOOD CHOPPER, *1849*
The Cleveland Museum of Art
Mr. and Mrs. William H. Marlatt Fund
6325 - 20″x24″ (50x61 cm)

Alfred Jacob Miller *(American, 1810-1874)*
INDIAN SCOUT, *1851*
Denver Public Library
6016 - 18″x24¼″ (46x61 cm)

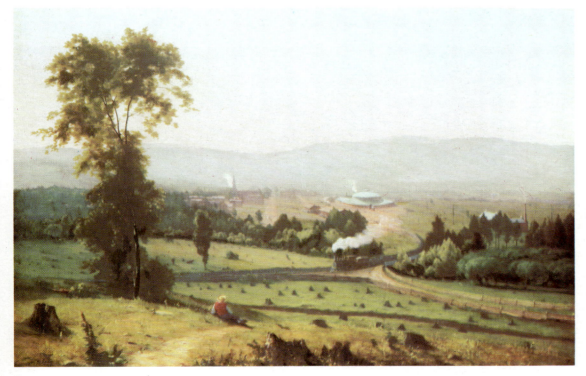

George Inness
THE LACKAWANNA VALLEY, *1855*
National Gallery of Art
Washington, D.C.
Gift of Mrs. Huttleston Rogers
9011 - 24¼″x36″ (61x91 cm)

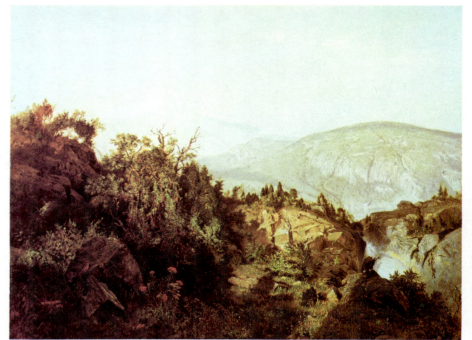

William T. Richards (*American, 1833-1905*)
IN THE ADIRONDACK MOUNTAINS
St. Louis Art Museum
9063 - 24"x32" (61x81 cm)

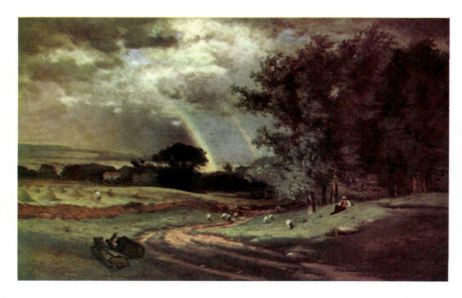

George Inness
A PASSING SHOWER
Private Collection
5078 - 12"x19" (31x48 cm)

George Inness
PEACE AND PLENTY, 1865
The Metropolitan Museum of Art, New York
7608 - 20½"x30" (52x76 cm)

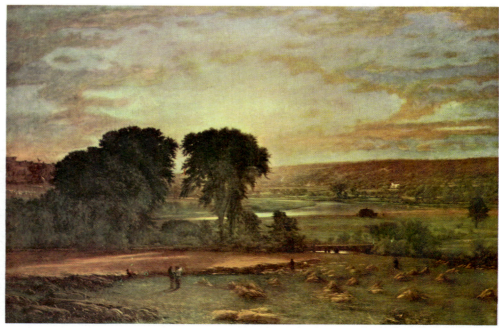

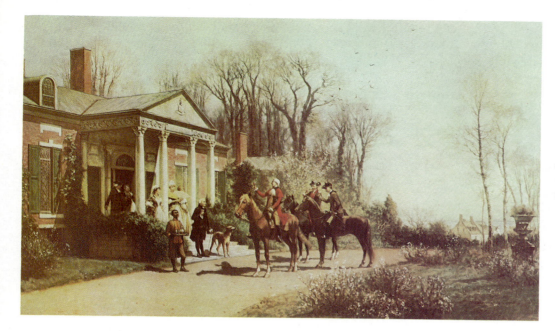

Wordsworth Thompson
(American, 1840-1896)
THE DEPARTING GUESTS, *1889*
The New York Historical Society
9538 - 21½"x36" (55x91 cm)

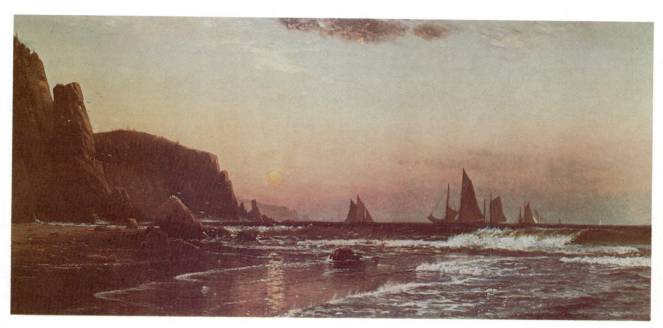

Alfred Thompson Bricher (American, 1837-1908)
SUNSET CAPE ELIZABETH, MAINE , *1878*
Indianapolis Museum of Art, Martha Delzell Memorial Fund
9973 - 18¾"x37¾" (47x95 cm)

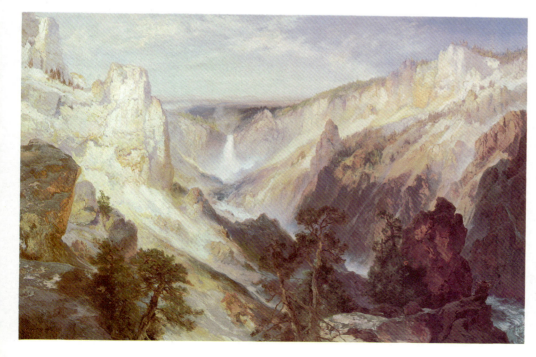

Thomas Moran
GRAND CANYON OF THE YELLOWSTONE,
WYOMING, *1906*
Private Collection
8674 - 20"x30" (51x76 cm)

293

NATHANIEL CURRIER AND JAMES MERRITT IVES *(American, Mid 19th Century)*
Plate size approx. 9½"x14½" (24x36 cm)

4879 - THE ROCKY MOUNTAINS

4880 - MIDNIGHT RACE ON THE MISSISSIPPI

4883 - WOODCOCK SHOOTING

4884 - "TROTTING CRACKS" AT THE FORGE

4881 - CLIPPER SHIP "DREADNOUGHT"

4882 - THE GREAT OCEAN YACHT RACE

Currier & Ives
ACROSS THE CONTINENT
The Harry T. Peters Collection, Museum of the City of New York
7054 - 17½"x27" (44x69 cm)

294

NATHANIEL CURRIER AND JAMES MERRITT IVES
Plate size approx. 9½"x14½" (24x36 cm)

4885 - PEYTONA AND FASHION

4886 - AMERICAN NATIONAL GAME
OF BASEBALL

4887 - THE "LIGHTNING EXPRESS" TRAINS

4888 - AMERICAN HUNTING SCENE

4889 - CENTRAL PARK, WINTER

4890 - THE ROAD, WINTER

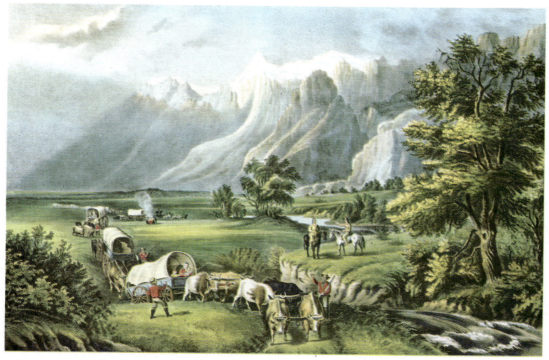

Currier & Ives
THE ROCKY MOUNTAINS
The Harry T. Peters Collection, Museum of the City of New York
7053 - 17½"x25½" (44x65 cm)
4879 - 9½"x14½" (24x36 cm)

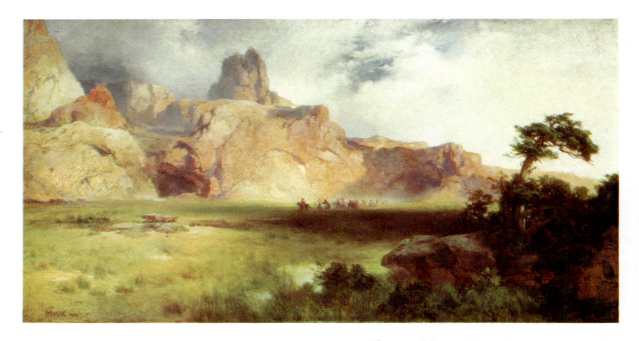

Thomas Moran (*American, 1837-1926*)
SEEKING NEW HUNTING GROUNDS
Kimball Art Foundation, Fort Worth, Texas
9061 - 19″×36″ (48×91 cm)

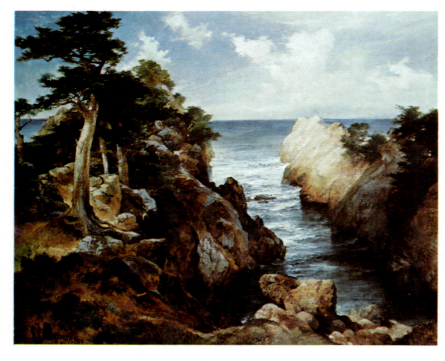

Thomas Moran (*American, 1837-1926*)
MONTEREY, CALIFORNIA, 1919
Private Collection
7890 - 24½″x30″ (62x76 cm)

Edmund Darch Lewis
(*American, 1835-1910*)
LANDSCAPE, 1860
*The Reading Public Museum
and Art Gallery, Pennsylvania*
9065 - 23″x36″ (58x91 cm)

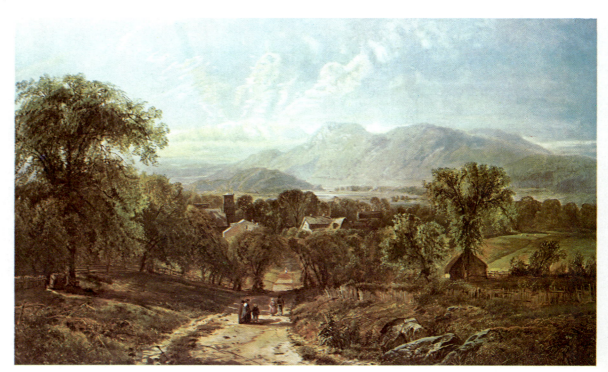

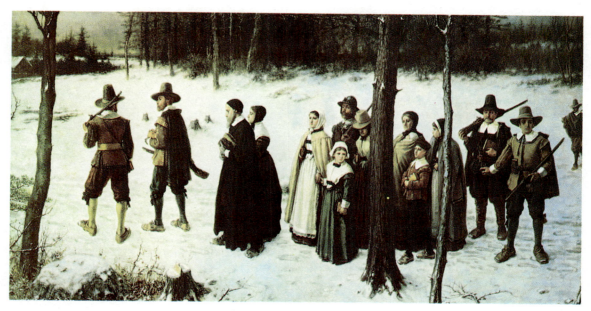

George H. Boughton *(American, b. England, 1833-1905)*
PILGRIMS GOING TO CHURCH, *undated*
The New York Historical Society
8294 - 17½"x32" (44x81 cm)

Enoch W. Perry, Jr. *(American, 1831-1915)*
THE PEMIGEWASSET COACH, *c.1899*
Shelburne Museum, Shelburne, Vermont
9096 - 22"x35¾" (56x91 cm)
5517 - 11¼"x18" (29x46 cm)

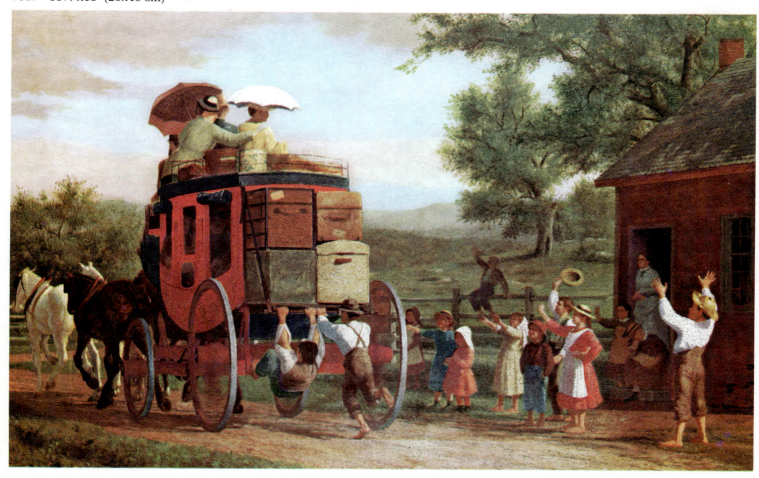

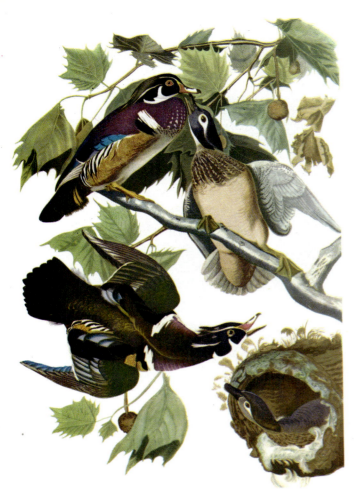

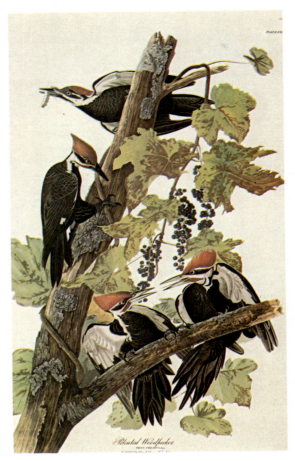

John James Audubon
SUMMER OR WOOD DUCK, 1825
From Birds of America, folio edition
7650 - 30"x19½" (76x50 cm)

John James Audubon
PILEATED WOODPECKER, 1825
From Birds of America, folio edition
7648 - 30"x19½" (76x50 cm)

6369
RUBY-THROATED
HUMMING-BIRD

6370
CAROLINA TURTLE-DOVE

John James Audubon (*American, 1785-1851*)
AUDUBON BIRD SERIES
21"x17" (53x43 cm)

6368
YELLOW-BREASTED CHAT

6367
COMMON GROSSBILL

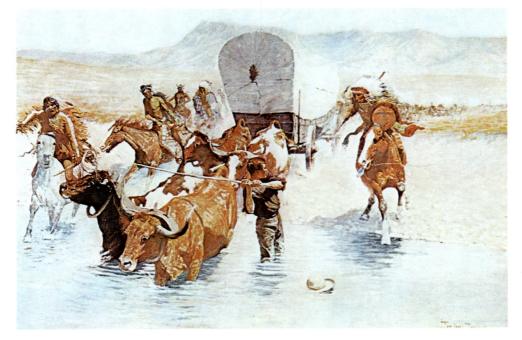

Frederic Remington (American, 1861-1909)
THE EMIGRANTS, 1904
Museum of Fine Arts of Houston
7252 - 17½"x26" (44x66 cm)
3414 - 8"x12" (20x30 cm)

Frederic Remington
WESTERN SCENES
3412-17 - each 8"x12" (20x30 cm)

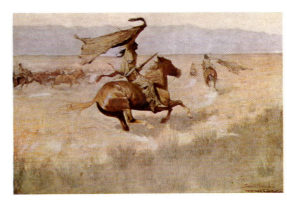

3412 - AIDING A COMRADE

3413 - CHANGE OF OWNERSHIP

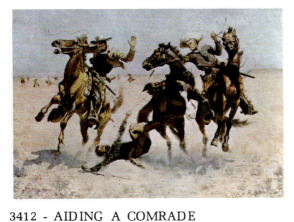

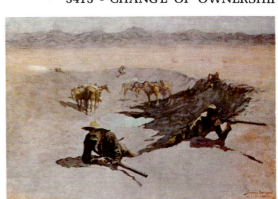

3414 - THE EMIGRANTS

3415 - THE FIGHT FOR THE WATER HOLE

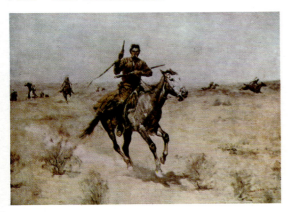

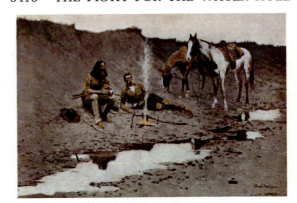

3416 - THE FLIGHT

3417 - NEW YEAR ON THE CIMARRON

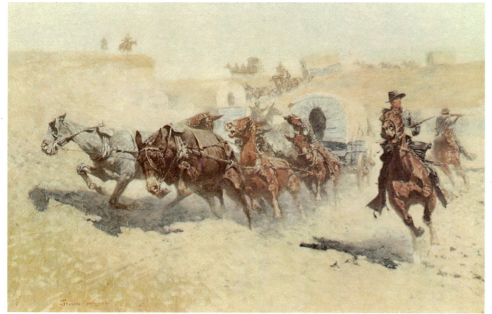

Frederic Remington
ATTACK ON THE SUPPLY WAGONS
Private Collection
5357 - 16"x24" (40x61 cm)

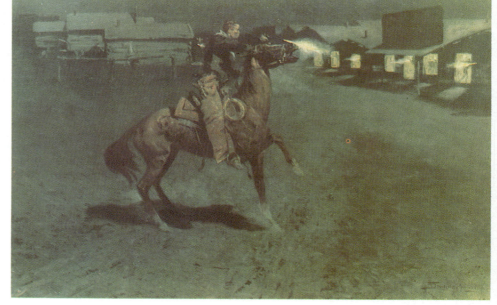

Frederic Remington
ARGUMENT WITH THE TOWN MARSHAL
Private Collection
5356 - 16"x24" (40x61 cm)

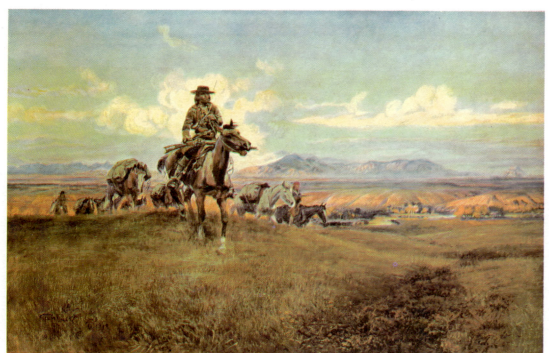

Charles Marion Russell
(American, 1865-1926)
THE WORLD WAS ALL BEFORE THEM
C. R. Smith Collection, New York City
9098 - 24"x36" (61x91 cm)
6522 - 18¾"x28" (47x71 cm)

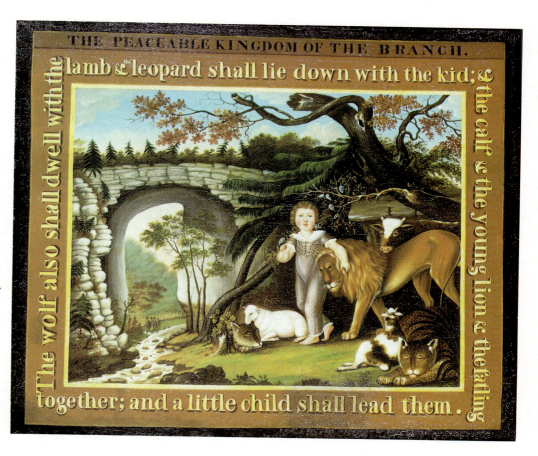

Edward Hicks
THE PEACEABLE KINGDOM OF THE
BRANCH, 1830-40

Abby Aldrich Rockefeller Folk Art Center,
Williamsburg, Virginia
6096 - 22½"x26½" (57x67 cm)
 16" x 20¼" (41x51½ cm) without border

Edward Hicks
THE FALLS OF NIAGARA, 1825
The Metropolitan Museum of Art, New York
Gift of William and Bernice Chrysler Garbisch, 1962
8654 - 26¾ "x32" (68x81 cm)
 18"x23" (46x60 cm) without border

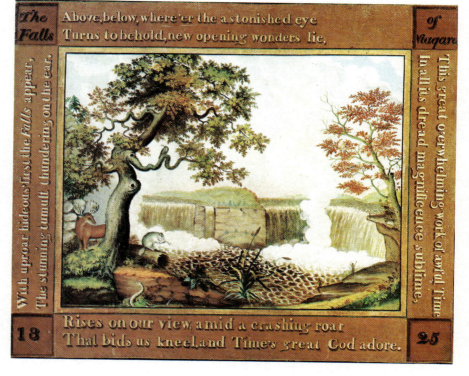

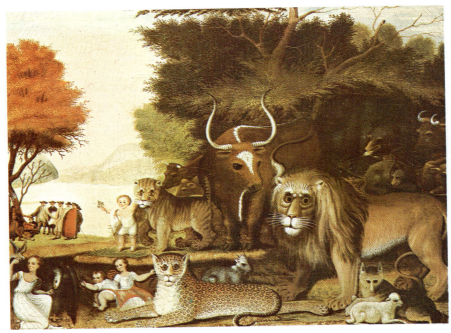

Edward Hicks
THE PEACEABLE KINGDOM, 1845
Private Collection
6010 - 17"x23" (43x58 cm)
5533 - 13¼"x18" (34x46 cm)

Edward Hicks *(American, 1780-1849)*
NOAH'S ARK, 1846
Philadelphia Museum of Art
Bequest of Lisa Norris Elkins
8699 - 24¼"x28" (61x71 cm)

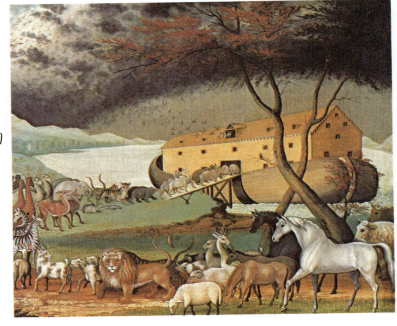

Leila T. Bauman *(American, dates unknown)*
UNITED STATES MAIL BOAT, c.1860
National Gallery of Art, Washington, D.C.
Garbisch Collection
7060 - 20"x26" (51x66 cm)

Fitz Hugh Lane (American, 1804-1865)
BOSTON HARBOR, 1853
The Bostonian Society, Boston, Massachusetts
7240 - 20″ x30¾″ (51x78 cm)

James Bard (American, 1815-1897)
THE ALIDA, 1848
The New York Historical Society
8364 - 18″x32″ (46x81 cm)

E. Opper *(American, active 1815)*
THE FIRE ENGINE
(Main Street, Elizabeth, New Jersey)
Rhode Island School of Design
Museum of Art, Providence
8365 - 23"x30½" (58x77 cm)
4898 - 11"x14" (28x35 cm)

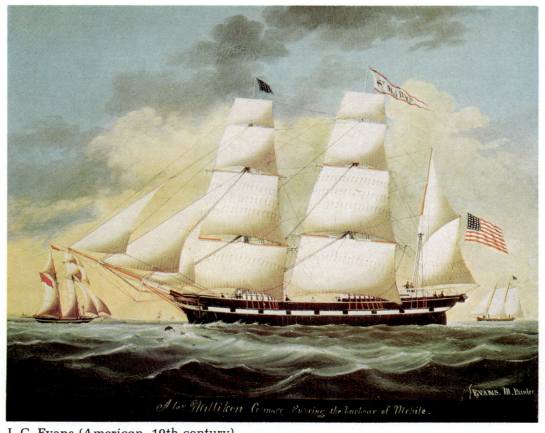

J. G. Evans *(American, 19th century)*
THE SHIP ST. MARY'S ENTERING HARBOR AT MOBILE
Hirschl and Adler Galleries
7959 - 24"×30" (61×76 cm)
5501 - 14¼"x18" (36×46 cm)

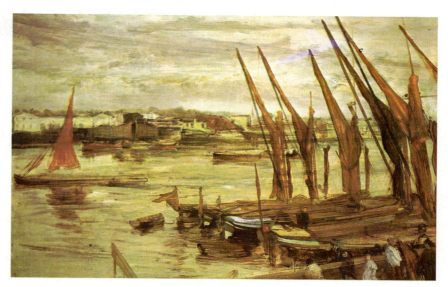

James McNeill Whistler
BATTERSEA REACH, c.1865
The Corcoran Gallery of Art, Washington, D.C.
Bequest of James Parmelee
8288 - 20"x30" (50x76 cm)

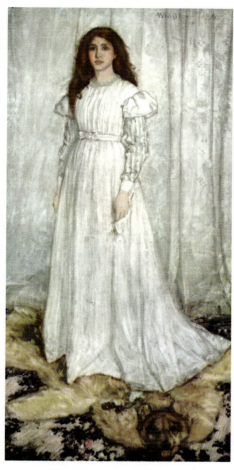

James McNeill Whistler
THE WHITE GIRL, 1862
National Gallery of Art, Washington, D.C.
Harris Whittemore Collection
624 - 24"x12" (61x30 cm)

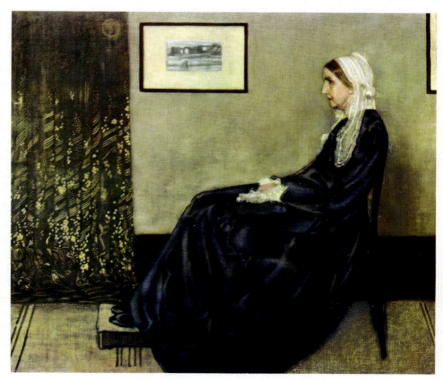

James McNeill Whistler
MOTHER OF THE ARTIST, 1872
Louvre Museum, Paris
6500 - 20"x24" (50x61 cm)
4500 - 11"x14" (28x35 cm)

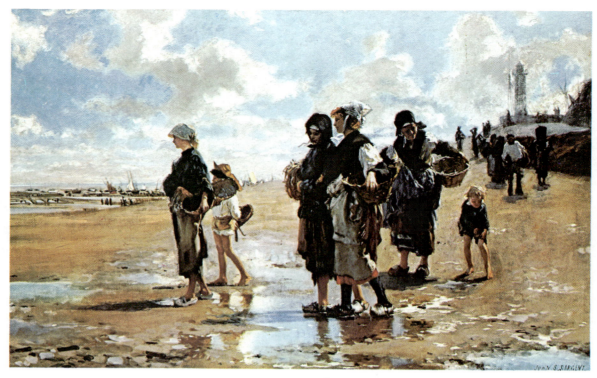

John Singer Sargent *(American, 1856-1925)*
OYSTER GATHERERS OF CANCALE, *1878*
The Corcoran Gallery of Art, Washington, D.C.
8279 - 21¾"x34" (55x86 cm)

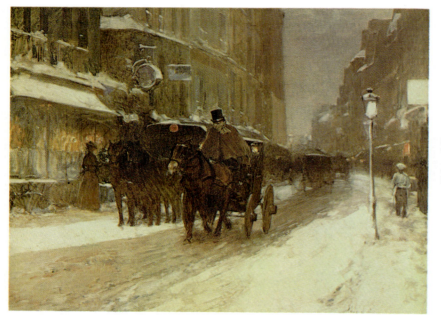

Childe Hassam *(American, 1859-1935)*
WINTER NIGHTFALL IN THE CITY, *1889*
Private Collection
5079 - 14½"x19" (37x48 cm)

John Singer Sargent
EL JALEO, *1882*
Isabella Stewart Gardner Museum, Boston
988 - 23½"x36" (60x91 cm)

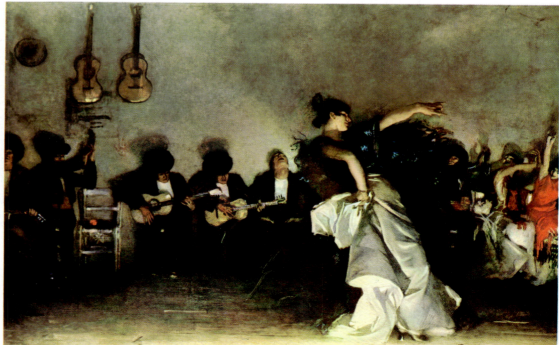

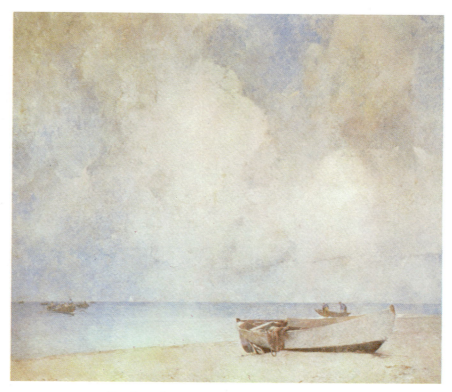

Emil Carlsen (*American, 1853-1932*)
THE SOUTH STRAND
National Collection of Fine Arts
Smithsonian Institution
7957 - 25″x28″ (63x71 cm)

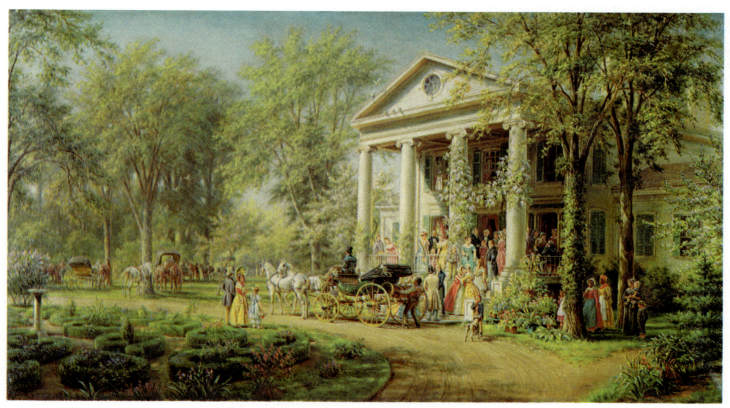

Edward Lamson Henry (*American, 1841-1919*)
THE WEDDING
The Fitchburg Art Museum
8863 - 18″×32″ (46×81 cm)

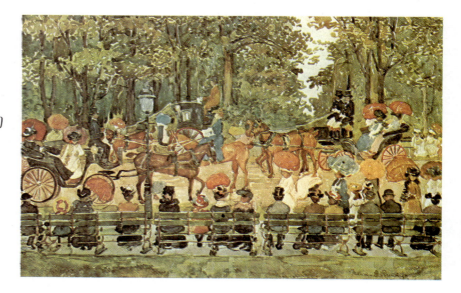

Maurice Prendergast *(American, 1859-1924)*
CENTRAL PARK, *1901*
Whitney Museum of American Art, New York
6675 - 14"x21½" (36x55 cm)

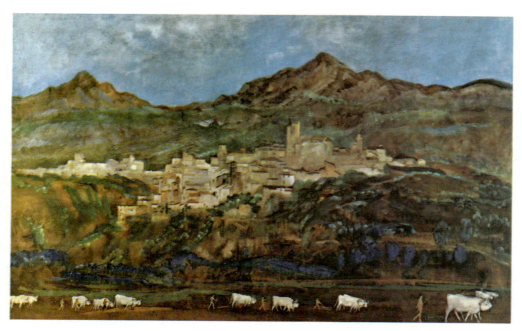

Arthur B. Davies *(American, 1862-1928)*
ITALIAN LANDSCAPE,
THE APENNINES, *1925*
Private Collection
9001 - 27¾"x43" (70x109 cm)

Homer Martin *(American, 1836-1897)*
HARP OF THE WINDS, *1895*
The Metropolitan Museum of Art, New York
8293 - 22"x31" (56x79 cm)
6293 - 15½"x22" (39x56 cm)

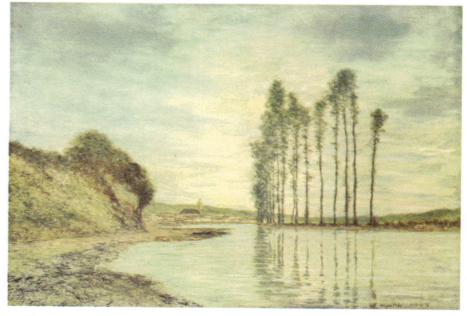

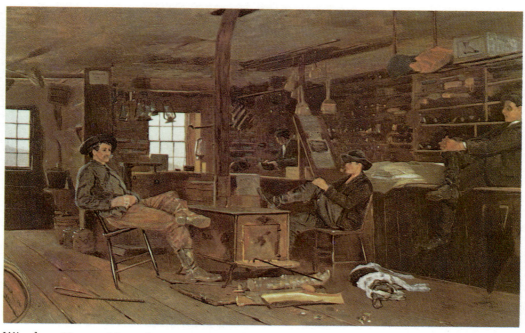

Winslow Homer *(American, 1836-1910)*
COUNTRY STORE
Hirshhorn Museum and Sculpture Garden,
Smithsonian Institution
5783 - 11½"x18" (29x46 cm)

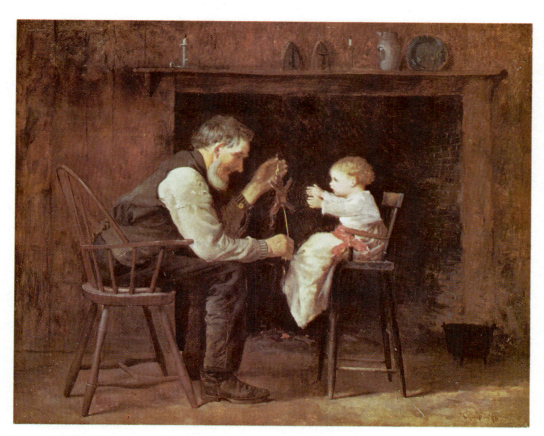

James Wells Champney *(American, 1843-1903)*
BOON COMPANIONS, 1879
Smith College Museum of Art
6388 - 17"×21" (43×53 cm)

Winslow Homer
IN THE MOWING, 1874
Wichita Art Museum
Roland P. Murdock Collection
5278 - 15¼"x22½" (38x57 cm)

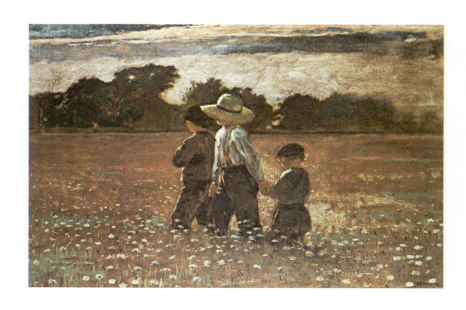

Winslow Homer
BREEZING UP, 1876
National Gallery of Art, Washington, D.C.
Mellon Collection
833 - 19½"x31" (49x78 cm)
5509 - 11¼"x18" (29x46 cm)

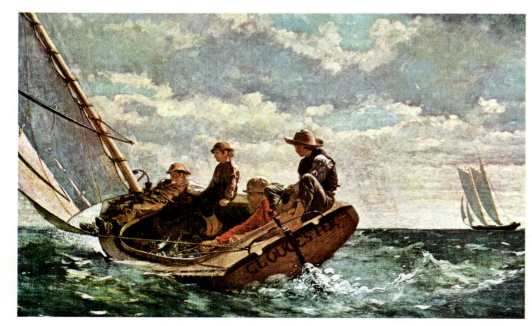

Winslow Homer
WEANING THE CALF, 1875
The North Carolina Museum of Art, Raleigh
8009 - 19"x30" (48x76 cm)

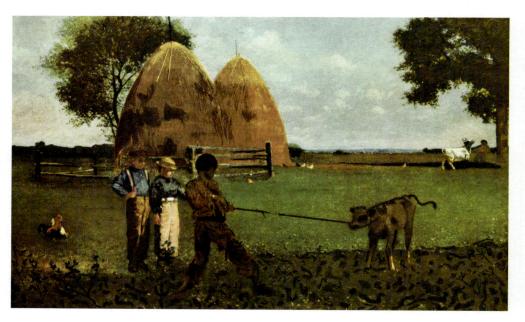

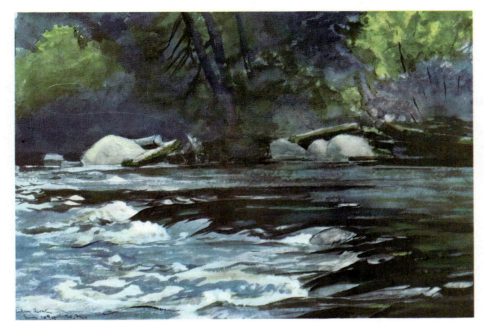

Winslow Homer
THE RAPIDS, HUDSON RIVER, 1894
The Art Institute of Chicago
5819 - 15"x21½" (38x54 cm)

Winslow Homer
THE MINK POND, 1891
Fogg Art Museum, Harvard University
5209 - 13¾"x20" (35x51 cm)

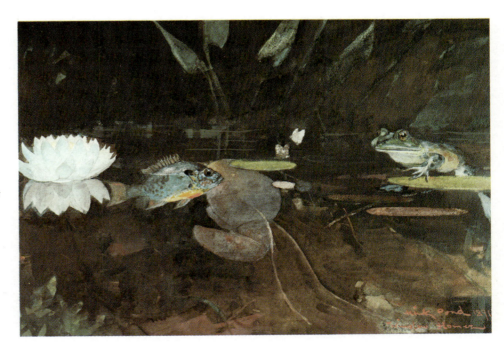

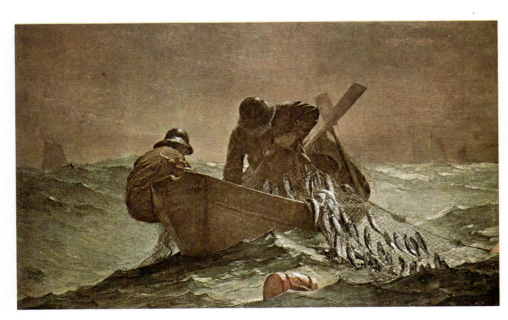

Winslow Homer
THE HERRING NET, 1885
The Art Institute of Chicago
7827 - 18½"x30" (47x76 cm)

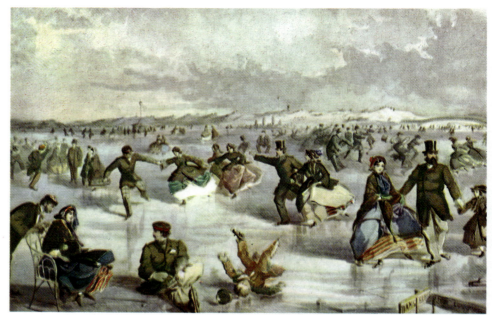

Winslow Homer
SKATING AT THE CENTRAL PARK
Winslow Homer Museum, Prout's Neck, Maine
5073 - 12½"x19" (32x48 cm)

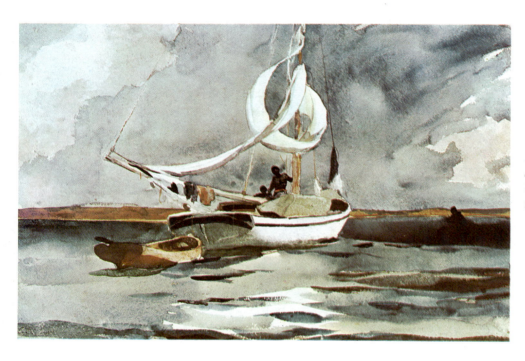

Winslow Homer
THE SLOOP - BERMUDA, *1899*
The Metropolitan Museum of Art, New York
5103 - 13½"x19½" (34x49 cm)

Winslow Homer
SPONGE FISHING, BAHAMAS
Winslow Homer Museum, Prout's Neck, Maine
5074 - 14"x18½" (35x47 cm)

NO LONGER AVAILABLE

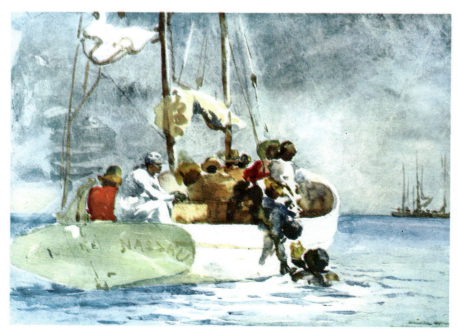

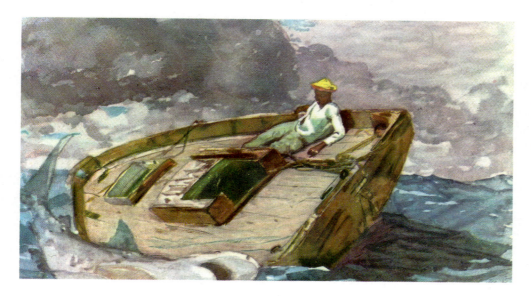

Winslow Homer
THE GULF STREAM, *1899*
The Art Institute of Chicago
5820 - 11"x20" (28x51 cm)

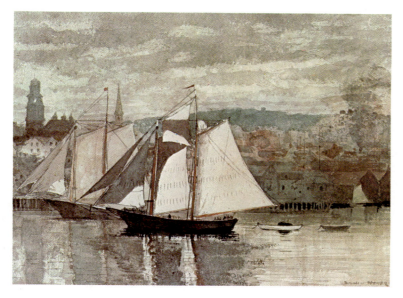

Winslow Homer
GLOUCESTER SCHOONERS AND SLOOP
Philadelphia Museum of Art
Gift of Dr. and Mrs. George Woodward
5132 - 13¼"x19¼" (33x48 cm)

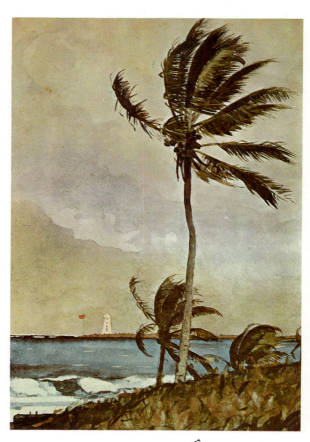

Winslow Homer
PALM TREE—NASSAU, *1898*
The Metropolitan Museum of Art, New York
5102 - 19½"x13½" (49x34 cm)

313

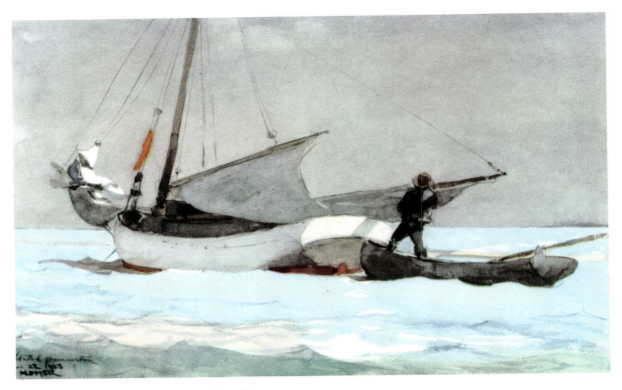

Winslow Homer
STOWING THE SAIL, BAHAMAS, *1903*
The Art Institute of Chicago
5818 - 14"x21½" (35x54 cm)

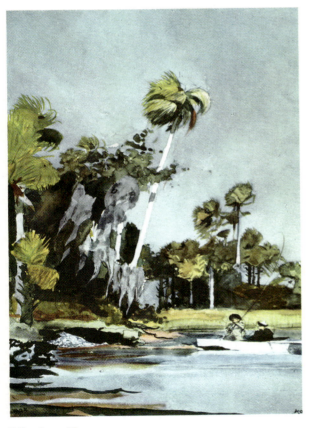

Winslow Homer
THE SHELL HEAP, *1904*
Private Collection
5780 - 18"x12½" (45x32 cm)

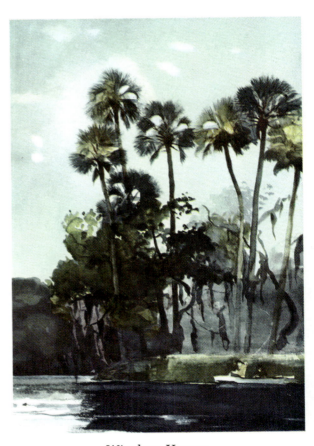

Winslow Homer
HOMOSASSA RIVER, *1904*
Brooklyn Museum, New York
5779 - 18"x12½" (45x32 cm)

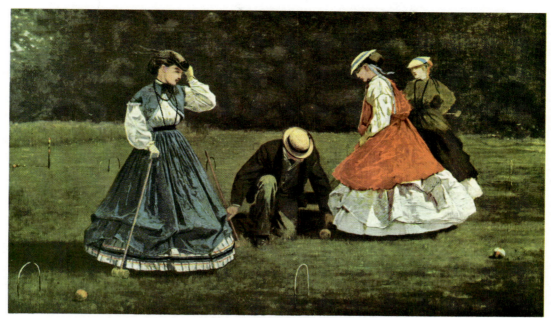

Winslow Homer
CROQUET SCENE, 1866
The Art Institute of Chicago
755 - 16"x25" (38x63 cm)

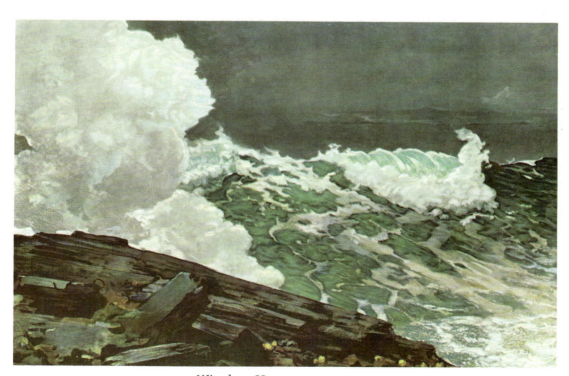

Winslow Homer
NORTHEASTER, 1895
The Metropolitan Museum of Art, New York
9829 - 25½"x37½" (65x95 cm)

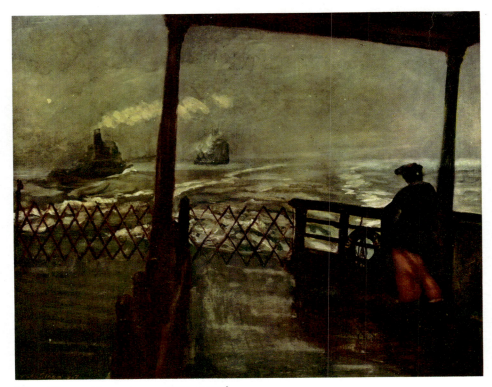

John Sloan *(American, 1871-1951)*
THE WAKE OF THE FERRY BOAT II, *1907*
The Phillips Collection, Washington, D.C.
6680 - 18"x22" (45x56 cm)

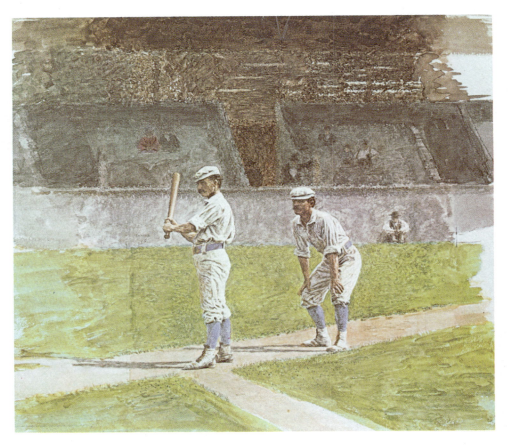

Thomas Eakins *(American, 1844-1916)*
BASEBALL PLAYERS PRACTICING, 1875
Museum of Art
Rhode Island Museum of Design
3800 - 10¼"x11¾" (26x30 cm)

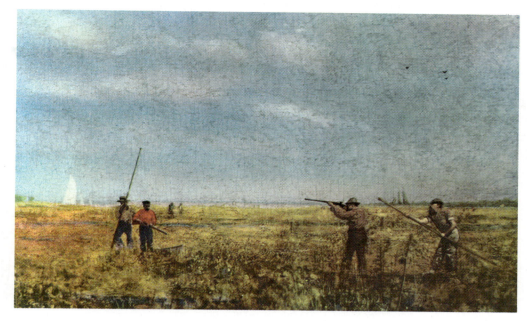

Thomas Eakins
PUSHING FOR RAIL, 1874
The Metropolitan Museum of Art, New York
6006 - 14"x21½" (35x54 cm)

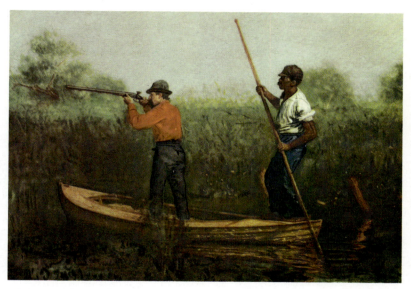

Thomas Eakins
WILL SCHUSTER AND BLACKMAN GOING SHOOTING, 1876
Yale University Art Gallery, New Haven

3171 - 7"x9½" (17x24 cm)

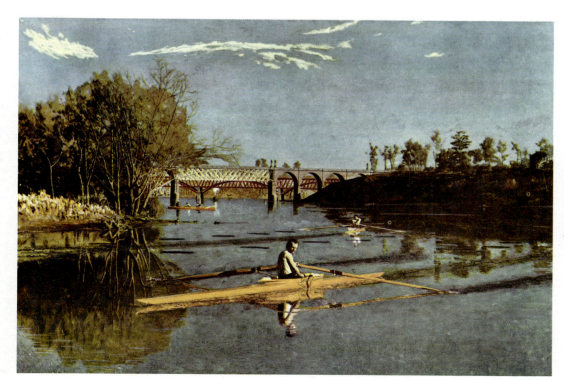

Thomas Eakins
MAX SCHMITT
IN A SINGLE SCULL, 1871
*The Metropolitan Museum of Art,
New York*
6097 - 20½"x30" (52x76 cm)

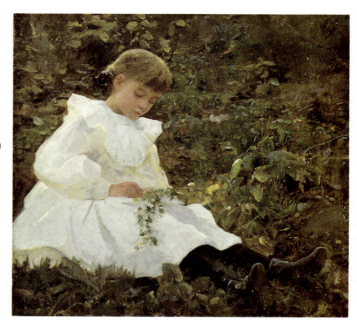

Douglas Volk *(American, 1856-1935)*
LITTLE MARION (Little Maid in White), c. 1889
National Academy of Design
5678 - 14¾"x15½" (37x39 cm)

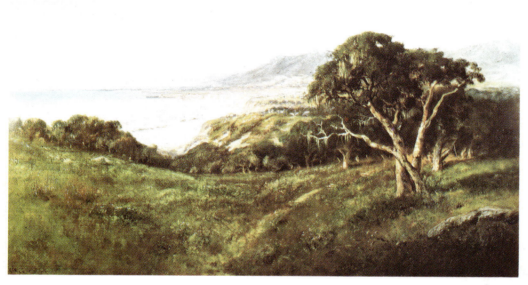

William Keith
SAN FRANCISCO SHORELINE
Private Collection
9057 - 24"×36" (61×91 cm)

William Keith *(American, 1839-1911)*
CYPRESS POINT, *1890*
William Keith Memorial Art Gallery
Oakland Art Museum
9010 · 17"x40" (43x101 cm)
7010 - 11¼"x26" (28x66 cm)

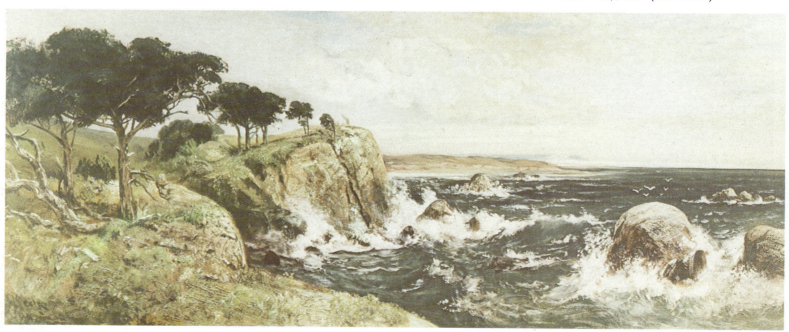

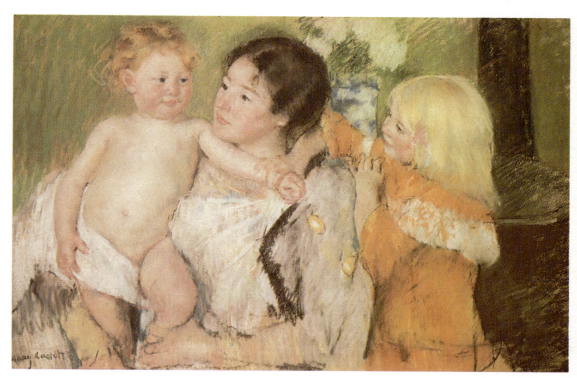

Louis C. Tiffany *(American, 1848-1933)*
AT IRVINGTON-ON-HUDSON
Nelle Cochrane Woods Collection, Nebraska Art Association,
Courtesy of the Sheldon Memorial Art Gallery, Lincoln
6393 - 18″x24″ (45x60 cm)

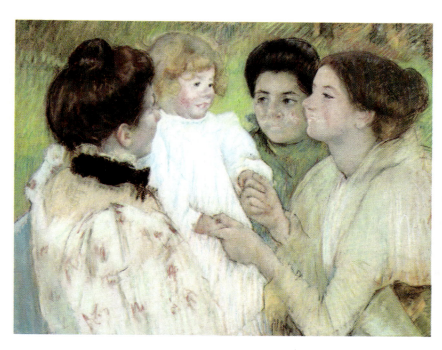

Mary Cassatt *(American, 1845-1926)*
WOMEN ADMIRING A CHILD, undated
Detroit Institute of Arts
7565 - 22¾″x28″ (58x71 cm)

Mary Cassatt
AFTER THE BATH, 1901
The Cleveland Museum of Art
6775 - 16½″x26″ (42x66 cm)

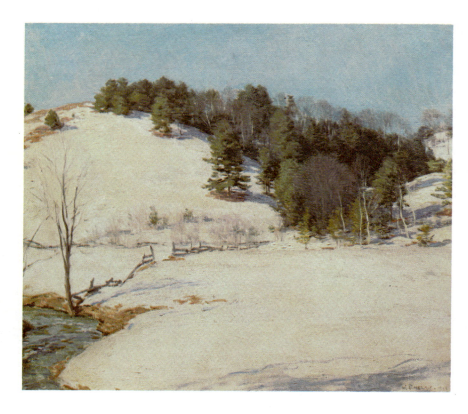

Willard L. Metcalf (*American, 1858-1925*)
THE LAST SNOW
Private Collection
7960 - 26¾"x30" (68x76 cm)

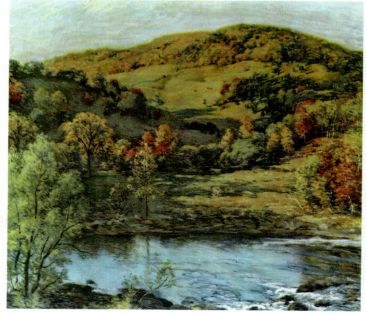

Willard L. Metcalf
GOLDEN CARNIVAL, 1910
Rochester Memorial Art Gallery
University of Rochester, New York
8603 - 28"x31" (71x78 cm)

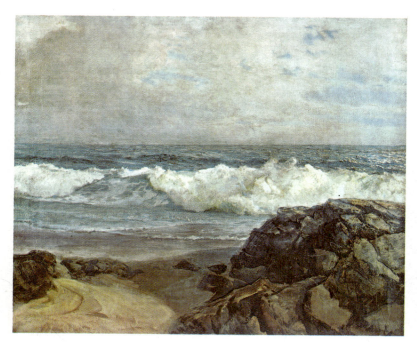

Frederick J. Waugh
A BIT OF THE CAPE
Private Collection
9850 - 30"x36" (76x91 cm)

Frederick J. Waugh (American, 1861-1940)
OPEN SEA
9535 - 27"x36" (68x91 cm)

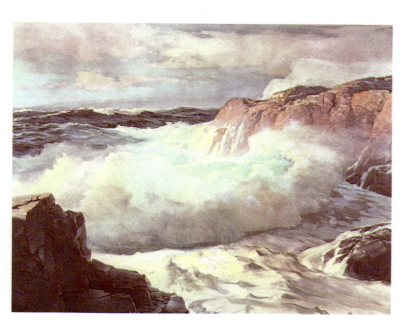

Frederick J. Waugh
POUNDING SURF
Edwin A. Ulrich Gallery, Hyde Park, N.Y.
7787 - 22"x28" (56x71 cm)
6787 - 17"x21" (43x53 cm)
4311 - 11"x14" (28x35 cm)

Jack Wilkinson Smith (American, 1873-1949)
ROCKY SHORE
Wilmot E. Forbes Collection
9304 - 27"x36" (68x91 cm)

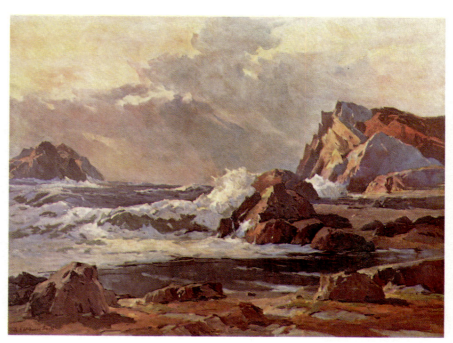

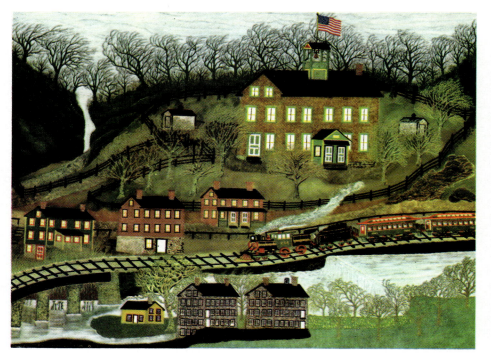

Joseph Pickett *(American, 1848-1918)*
MANCHESTER VALLEY, *1914-18*
The Museum of Modern Art, New York
7251 - 22¼"x29¾" (56x75 cm)

Bernard Karfiol *(American, 1866-1952)*
THE LAURENT PONY CART
5024 - 16"x20" (40x51 cm)

Patsy Santo *(American, 1893-1975)*
WINTER STILLNESS
Collection of the Artist
7792 - 22"x30" (56x76 cm)

322

Robert Henry Logan (American, 1874-1942)
THE YELLOW HOUSE, 1908
From the Collection 9,
The Artists Guild and Gallery, Charlestown, R.I.
6392 - 20"x24" (50x61 cm)

Edward Henry Potthast (American, 1857-1927)
CHILDREN BY THE SEA
Hirshhorn Museum and Sculpture Garden,
Smithsonian Institution
4271 - 12"x16" (30x41 cm)

William J. Glackens (American, 1870-1938)
THE BEACH AT ANNISQUAM
Private Collection
5005 - 16½"x20" (42x50 cm)

George O. Hart (American, 1868-1933)
THE BAHAMAS, 1918
Whitney Museum of American Art, New York
5054 - 12″x19″ (30x48 cm)

Malvin Marr Albright (American, 1897-)
PEACEFUL HARBOR
8003 - 15½″x33″ (39x84 cm)

William Zorach (American, 1887-1966)
THE COVE, 1927
The Art Institute of Chicago
6821 - 15″x22″ (38x56 cm)

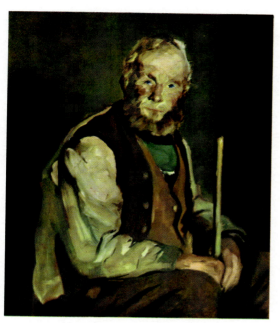

Robert Henri (American, 1865-1929)
HIMSELF, 1913
The Art Institute of Chicago
6763 - 20½"x17" (52x43 cm)

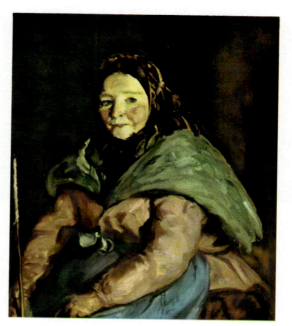

Robert Henri
HERSELF, 1913
The Art Institute of Chicago
6764 - 20½"x17" (52x43 cm)

William J. Glackens
THE DREAM RIDE
Private Collection
5081 - 15"x17" (38x43 cm)

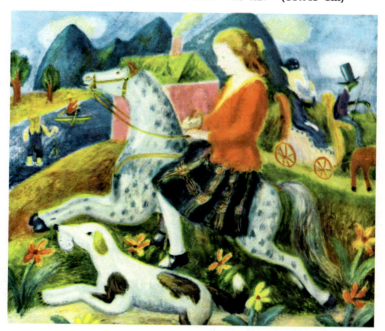

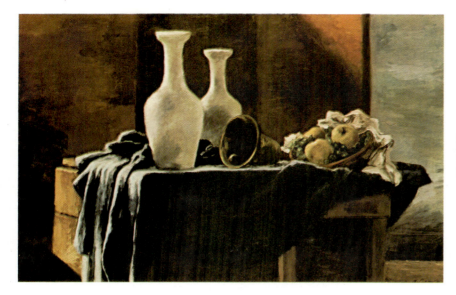

Alexander Brook (American, 1898-)
THE SENTINELS, 1934
Whitney Museum of American Art, New York
5057 - 12½"x19" (32x48 cm)

Georgia O'Keeffe (American, 1887-)
WHITE CANADIAN BARN, NO. 2, 1932
The Metropolitan Museum of Art, New York
Alfred Stieglitz Collection
8271 - 12"x30" (30x76 cm)

Georgia O'Keeffe
RAM'S HEAD, WHITE HOLLYHOCK
AND LITTLE HILLS, 1935
Edith and Milton Lowenthal Collection, New York
7025 - 25"x30" (63x76 cm)

Charles Demuth
FLOWER STUDY NUMBER ONE, *1923*
The Art Institute of Chicago
5816 - 18"x12" (46x30 cm)

Charles Demuth *(American, 1883-1935)*
FLOWER STUDY NUMBER FOUR, *1925*
The Art Institute of Chicago
5817 - 18"x12" (46x30 cm)

Charles Demuth
PAQUEBOT PARIS, 1921-2
Columbus Gallery of Fine Arts
6389 - 25¼"x20¼" (64x51 cm)

Arthur Dove (American, 1880-1946)
ABSTRACT, THE FLOUR MILL, 1938
The Phillips Collection, Washington, D.C.
7272 - 26"x15¾" (66x40 cm)

Arthur Dove
MARS, ORANGE AND GREEN, 1935
Private Collection
5031 - 13"x20" (33x51 cm)

Henry Lee McFee (American, 1886-1953)
STILL LIFE: APPLES
5048 - 20"x15" (50x38 cm)

Alfred H. Maurer (American, 1868-1932)
STILL LIFE WITH DOILY, 1930
The Phillips Collection, Washington, D.C.
608 - 17½"x21" (45x53 cm)

Marsden Hartley (American, 1877-1943)
STILL LIFE NO. 9
University of Minnesota Gallery, Minneapolis
6665 - 25"x20¾" (63x53 cm)

Marsden Hartley
WILD ROSES, 1942
The Phillips Collection, Washington, D.C.
7906 - 22"x28" (55x71 cm)

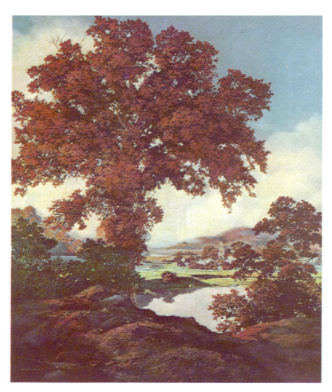

Maxfield Parrish
TRANQUILITY
Maxfield Parrish Estate Collection
7946 - 29½″×24″ (75×61 cm)

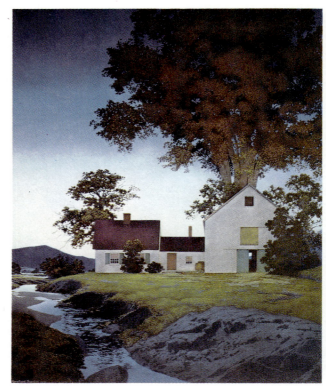

Maxfield Parrish (*American, 1870-1966*)
TWILIGHT
Private Collection
7945 - 22½″x18″ (57x46 cm)
5535 - 14¾″x11¾″ (37x30 cm)

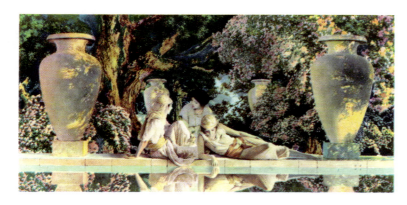

Maxfield Parrish
GARDEN OF ALLAH
5943 - 9″x18″ (23x45 cm)

Maxfield Parrish
DAYBREAK
7977 - 17¾″x29¾″ (45x75 cm)
5534 - 10½″x18″ (27x46 cm)

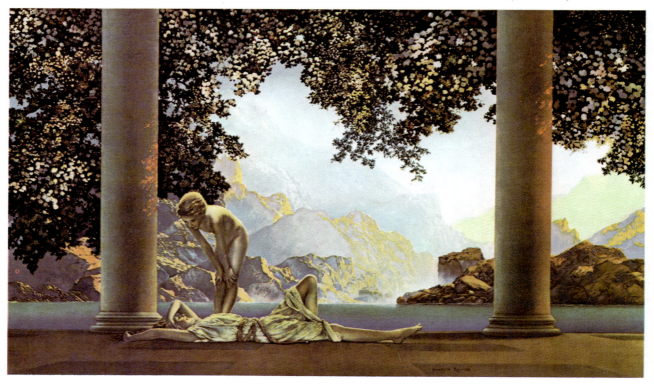

John Marin (American, 1870-1953)
MOVEMENT: BOATS AND OBJECTS, BLUE GRAY SEA, 1947
The Art Institute of Chicago
7386 - 22¼"x28" (56x71 cm)

John Marin
SUNSET, 1914
Whitney Museum of American Art, New York
5069 - 15"x17½" (38x44 cm)

John Marin
LOWER MANHATTAN FROM THE RIVER, 1921
The Metropolitan Museum of Art, New York
753 - 21½"x26" (54x66 cm)

John Marin
DEER ISLE ISLETS, MAINE, *1922*
Private Collection
5034 - 17"x20" (43x51 cm)
4091 - 12"x14" (30x35 cm)

John Marin Average size 5"x7"
SKYSCRAPERS
One of a series of 24 pencil drawings
List of titles available on request

John Marin
MAINE ISLANDS, *1922*
The Phillips Collection, Washington, D.C.
5043 - 16½"x19½" (42x49 cm)
4092 - 12"x14" (30x35 cm)

John Marin
TUNK MOUNTAINS, AUTUMN, MAINE, *1945*
The Phillips Collection, Washington, D.C.
7286 - 25"x30" (63x76 cm)

John Marin
CAPE SPLIT, MAINE, *1941*
The Art Institute of Chicago
5823 - 15"x20½" (39x52 cm)

John Marin
CIRCUS ELEPHANTS, *1941*
The Art Institute of Chicago
787 - 19"x24" (48x61 cm)

Charles Sheeler (American, 1883-1965)
BUCKS COUNTY BARN, 1923
Whitney Museum of American Art, New York
6677 - 18½"x24" (47x60 cm)

Edward Hopper (American, 1882-1967)
THE GROUND SWELL, 1939
The Corcoran Gallery of Art, Washington, D.C.
6004 - 15"x21"(38x53 cm)

Charles Sheeler
PERTAINING TO YACHTS AND YACHTING, 1922
Philadelphia Museum of Art
6259 - 20"x24" (50x60 cm)

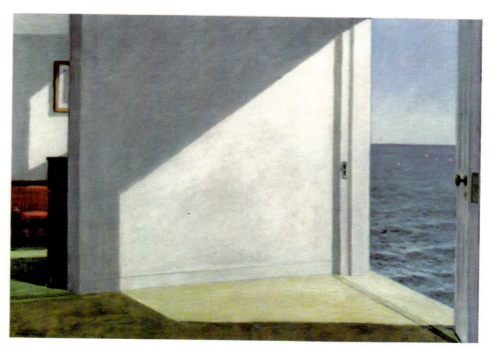

Edward Hopper
ROOMS BY THE SEA, *1951*
Yale University Art Gallery
Bequest of Stephen Carleton Clark
7670 - 21¾"x30" (55x76 cm)

Max Weber
STILL LIFE WITH FLOWERS
Collection Rosenberg Gallery
6831 - 22½"x17¾" (57x45 cm)

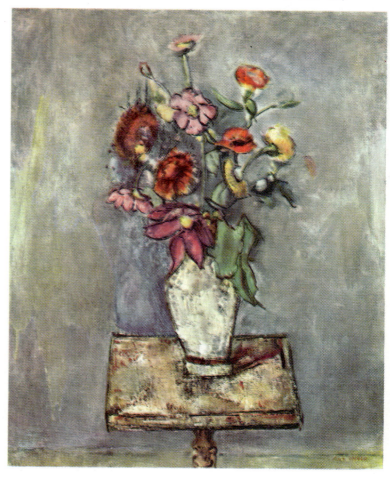

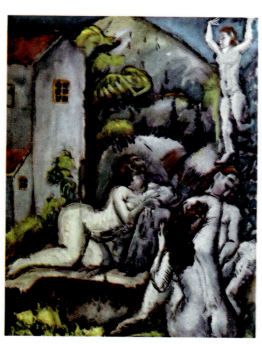

Max Weber *(American, 1881-1961)*
SUMMER, *1911*
Whitney Museum of American Art, New York
5062 - 19"x14½" (48x36 cm)

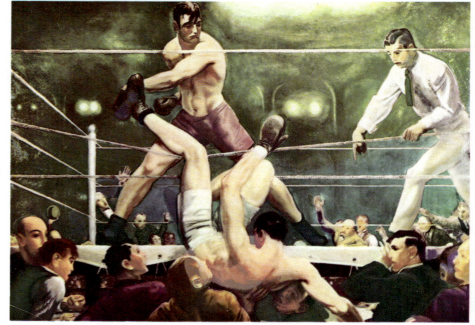

George Bellows *(American, 1882-1925)*
THE DEMPSEY-FIRPO FIGHT, 1924
Whitney Museum of American Art, New York
6002 - 15"x21" (38x53 cm)

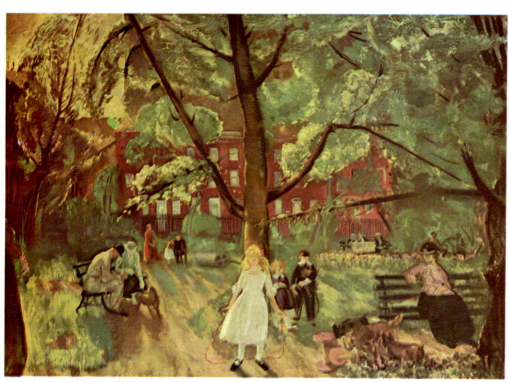

George Bellows
GRAMERCY PARK, 1920
Private Collection
6079 - 18"x24" (45x60 cm)

George Bellows
BOTH MEMBERS OF THIS CLUB, 1909
National Gallery of Art, Washington, D.C.
Chester Dale Collection
6282 - 17"x24" (43x60 cm)

George Bellows
THE SANDCART, 1917
Brooklyn Museum, New York
5076 - 12½"x19" (32x48 cm)

George Bellows
LADY JEAN, 1924
Yale University Art Gallery
5075 - 19"x9¼" (48x23 cm)

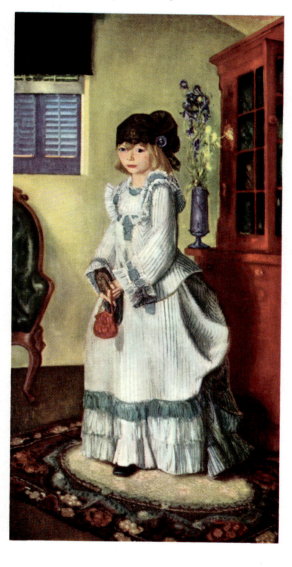

Thomas Hart Benton
SPRING TRYOUT, 1944
Charles A. MacNider Museum
Mason City, Iowa
6669 - 18"x24" (45x61 cm)

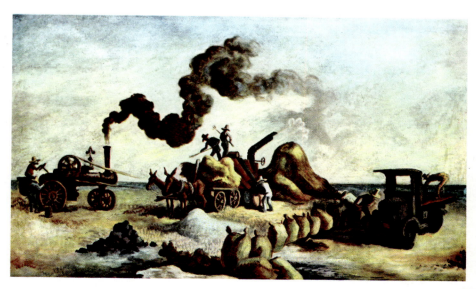

Thomas Hart Benton *(American, 1889-1975)*
LOUISIANA RICE FIELDS, 1928
Brooklyn Museum, New York
5083 - 11"x19" (19x48 cm)

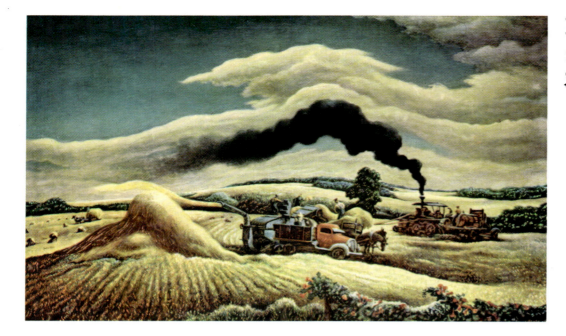

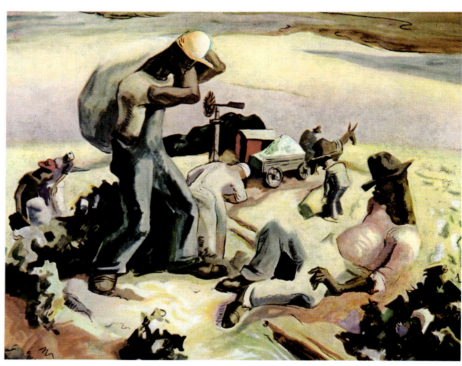

Rockwell Kent (American, 1882-1971)
WINTER, A VIEW OF MONHEGAN, MAINE, 1907
The Metropolitan Museum of Art, New York
9830 - 28"x35½" (71x90 cm)
6830 - 16½"x22" (42x56 cm)

Thomas Hart Benton
COTTON PICKERS, GEORGIA
Private Collection
5683 - 16"x20" (40x50 cm)

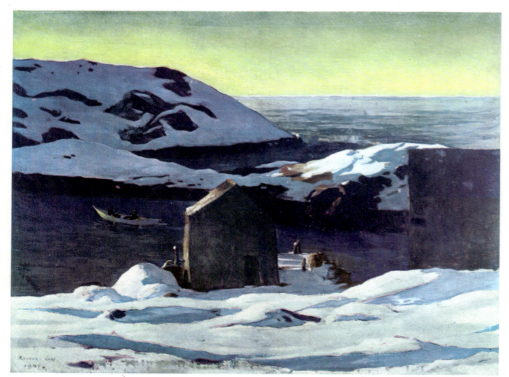

338

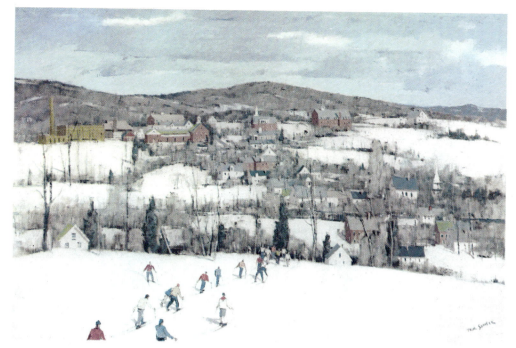

Paul Sample *(American, 1896-1974)*
BOYS' SKI OUTING, *1963*
Kimball Union Academy, Meriden, New Hampshire
9285 - 25¾"x35¾" (65x91 cm)

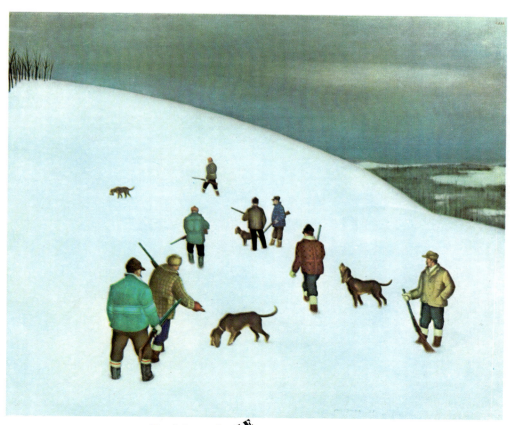

Paul Sample
THE HUNTERS
6070 - 17½"x21" (44x53 cm)

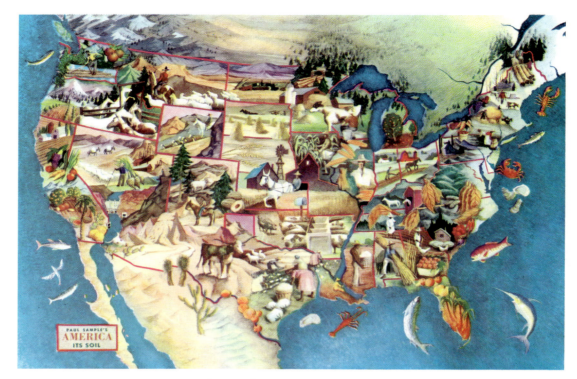

Paul Sample (*American, 1896-1974*)
AMERICA—ITS SOIL
8005 - 22″x32½″ (56x82 cm)

William Gropper (*American, 1897-1976*)
AMERICA—ITS FOLKLORE
8004 - 22″x32½″ (56x82 cm)

Aaron Bohrod (*American, 1907- *)
AMERICA—ITS HISTORY
8006 - 22"x32½" (56x82 cm)

Lottie and Moshe Davis, illustrated by Charles Harper
LAND OF OUR FATHERS
Private Collection
8007 - 22"x32½" (56x82 cm)

John Steuart Curry *(American, 1897-1946)*
THE LINE STORM, 1934
Private Collection
6055 - 15½"x24" (40x61 cm)

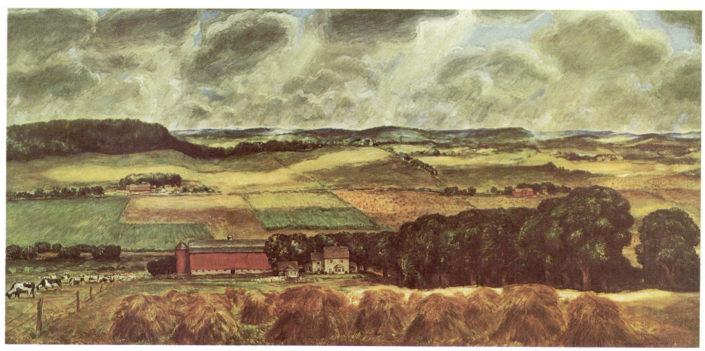

John Steuart Curry
WISCONSIN LANDSCAPE
The Metropolitan Museum of Art
9905 - 17½"x35¼" (44x89 cm)

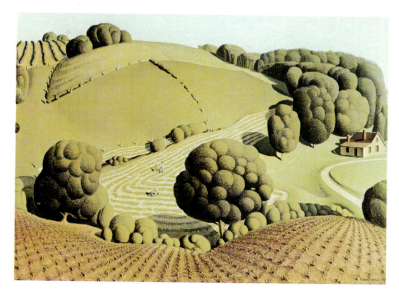

Grant Wood
YOUNG CORN, *1931*
Collection of Wilson High School
Cedar Rapids, Iowa
4058 - 12"x16" (30x40 cm)

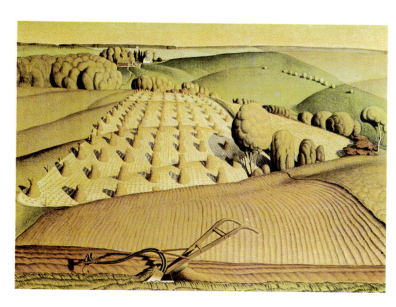

Grant Wood
FALL PLOWING, *1931*
Private Collection
4057 - 12"x16" (30x40 cm)

Orris Moe *(Contemporary American)*
RIDE AT SUNRISE
Private Collection
8113 - 19½"x32" (49x81 cm)

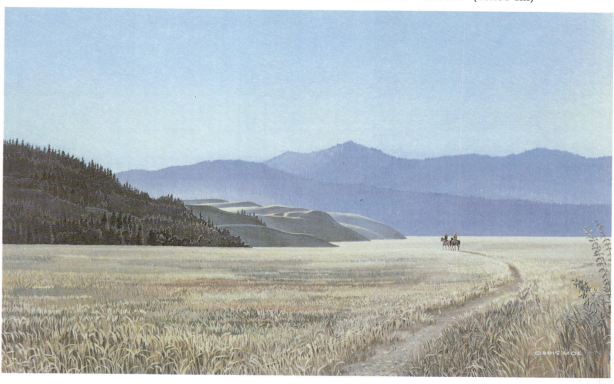

Grant Wood
MIDNIGHT RIDE OF PAUL REVERE, 1931
The Metropolitan Museum of Art, New York
6063 - 22½"x29¾" (57x76 cm)

Rico Lebrun (American, 1900-1964)
ANNA
5001 - 20"x9¾" (51x25 cm)

Grant Wood (American, 1892-1942)
AMERICAN GOTHIC, 1930
The Art Institute of Chicago
6792 - 20½"x17" (52x43 cm)
3488 - 9½"x7½" (24x19 cm)

John Steuart Curry
THE FLYING CODONAS, 1932
Whitney Museum of American Art, New York
5059 - 18"x15" (46x38 cm)

Charles Burchfield (*American, 1893-1967*)
CHILDHOOD'S GARDEN, 1917
Munson-Williams-Proctor Institute, Utica, New York
6921 - 27″×19″ (69×48 cm)

Robert Henri (*Robert Henry Cozad*)
WEST COAST OF IRELAND, 1913
Everson Museum of Art, Syracuse, New York
8100 - 26″×32″ (66×81 cm)

George Grosz (*American, 1893-1959*)
MANHATTAN HARBOR
Private Collection
6068 - 22″x16½″ (56x42 cm)

Charles Burchfield
ICE GLARE, 1933
Whitney Museum of American Art, New York
5063 - 18½″x15″ (48x38 cm)

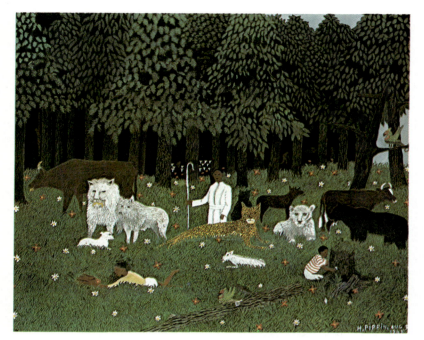

Horace Pippin (American, 1888-1946)
HOLY MOUNTAIN III, 1945
Joseph H. Hirshhorn Collection
7302 - 23½"x28" (60x71 cm)

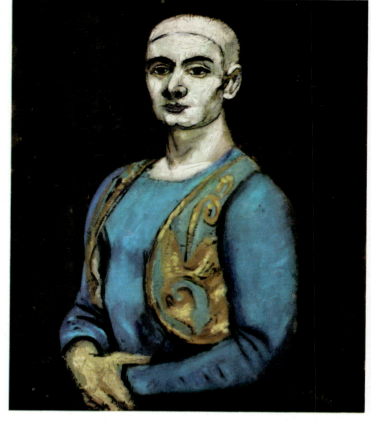

Walt Kuhn (American, 1880-1949)
THE BLUE CLOWN, 1931
Whitney Museum of American Art, New York
629 - 24"x20" (61x50 cm)

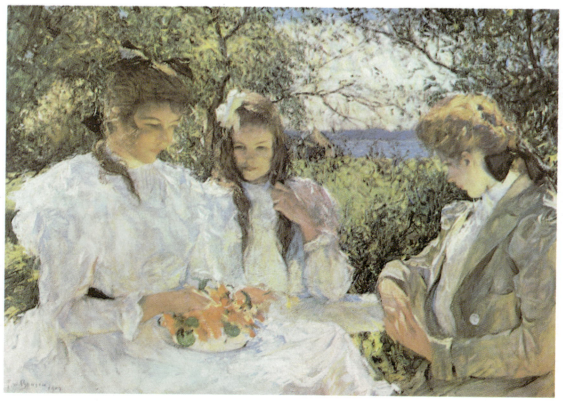

Frank W. Benson (American, 1862-1951)
PORTRAIT OF MY DAUGHTERS
Worcester Art Museum
6056 - 20¼"×28" (51×71 cm)

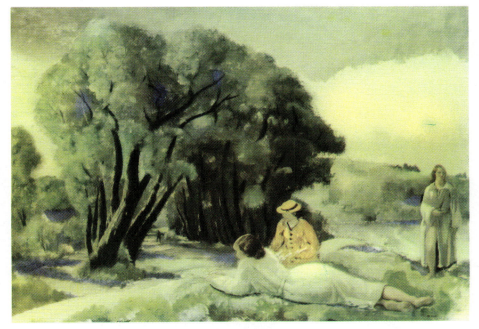

Leon Kroll *(American, 1884-1974)*
THE WILLOWS
5665 - 14"x20" (36x50 cm)

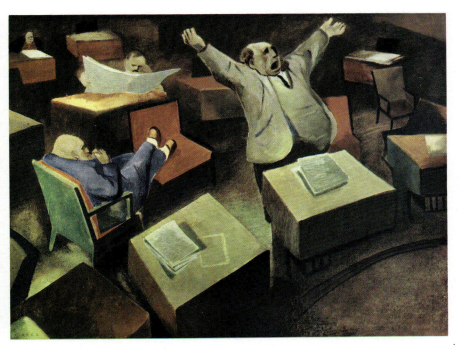

William Gropper *(American, 1897-1976)*
THE SENATE, 19
The Museum of Modern Art, New York
Gift of A. Conger Goodyear
5002 - 15"x20" (38x50 cm)

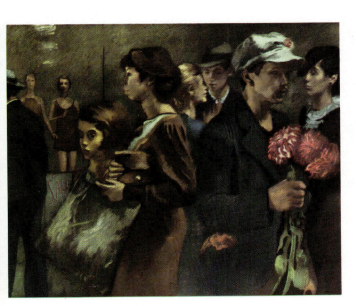

Raphael Soyer *(American, 1899-)*
THE FLOWER VENDOR
5009 - 16½"x20" (42x50 cm)

Peggy Bacon *(American, 1895-)*
THE NOSEGAY
5016 - 15"x20" (38x51 cm)

Yasuo Kuniyoshi (American, 1893-1953)
I'M TIRED, 1938
Whitney Museum of American Art, New York
5058 - 19"x14½" (48x37 cm)

Yasuo Kuniyoshi
JAPANESE TOY TIGER AND ODD OBJECTS, 1932
Private Collection
5011 - 13½"x19½" (34x50 cm)

Eugene Speicher (American, 1883-1962)
NUDE BACK
5047 - 16"x20" (41x50 cm)

Robert Brackman (American, 1896-)
STUDY: MORNING INTERLUDE
5279 - 20"x15" (51x38 cm)

Dale Nichols (American, 1904-)
END OF THE HUNT, 1934
The Metropolitan Museum of Art, New York
7634 - 19"x26" (49x66 cm)

John Rogers Cox (American, 1915-)
GRAY AND GOLD, 1942
Cleveland Museum of Art
7870 - 20"x28" (51x71 cm)

Dale Nichols
COMPANY FOR SUPPER
7558 - 19"x26" (49x66 cm)

Georges Schreiber
HAYING
Private Collection
4062 - 12"x16" (30x40 cm)

Georges Schreiber *(American, 1904-1977)*
IN TENNESSEE
Private Collection
4061 - 12"x16" (30x40 cm)

Doris Lee *(American 905-)*
THANKSGIVING 935
The Art Institute of Chicago
4240 - 9"x1 (23x33 cm)
3239 - 8 11" (20x28 cm)

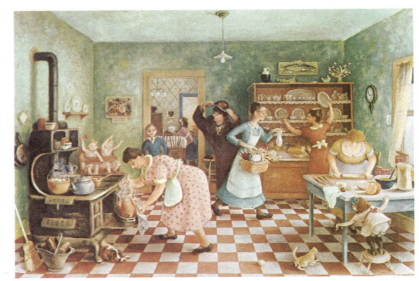

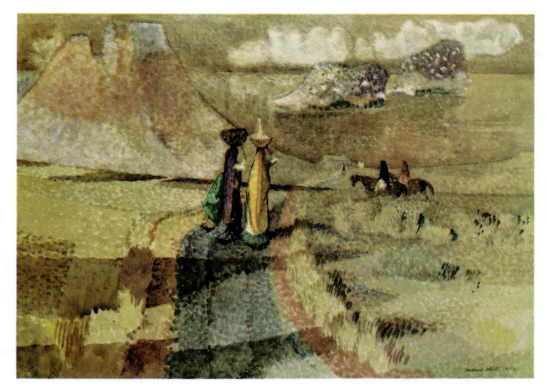

Millard Sheets (American, 1907-)
ROAD TO THE SEA, 1952
Private Collection
7721 - 21½"x29½" (55x75 cm)

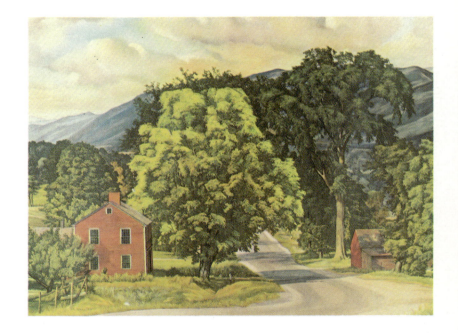

Luigi Lucioni
ROUTE SEVEN
6053 - 16"x21" (40x53 cm)

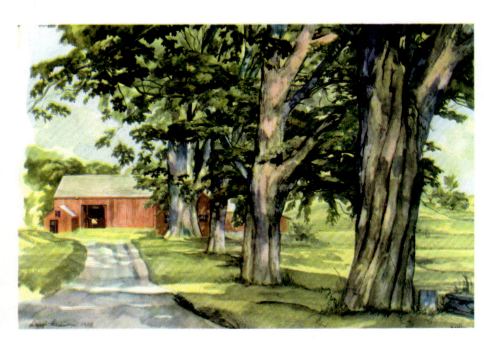

Luigi Lucioni
SUNLIT PATTERNS
5666 - 14"x20" (35x50 cm)

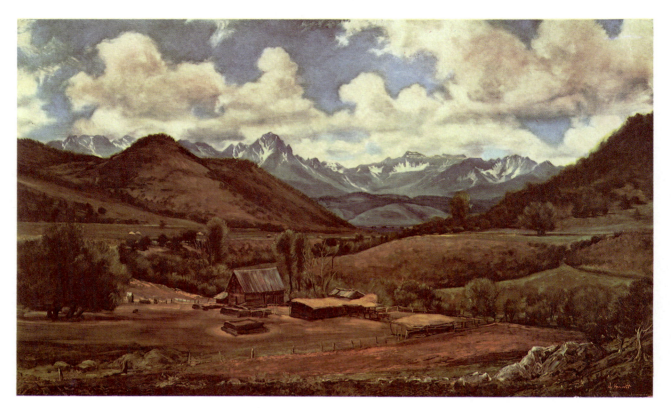

Dean Fausett (Contemporary American)
COLORADO RANCH
Private Collection
9110 - 23¾"x38¾" (60x98 cm)

Luigi Lucioni (American, 1900-)
VERMONT PASTORAL
Carnegie Institute, Pittsburgh, Pa.
9008 - 19½"x33" (49x84 cm)

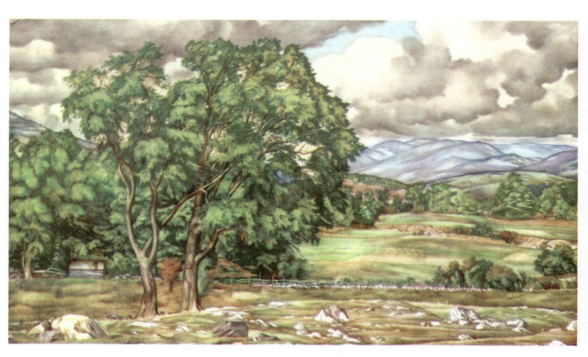

Joe Jones (*American, 1909-1963*)
SETTING SAIL
Private Collection
9022 - 17½"x36" (44x91 cm)

Joe Jones
ROCKPORT, *undated*
William Rockhill Nelson Gallery of Art and
Mary Atkins Museum of Fine Arts
Kansas City, Missouri
9009 - 23¾"x35¾" (60x91 cm)

William Thon
TWILIGHT IN ROME, *1961*
National Collection of Fine Arts
S. C. Johnson Collection
Smithsonian Institution, Washington, D.C.
9565 - 24"x40" (61x101 cm)

William Thon
SEPTEMBER WOODS
Private Collection
6847 - 20½″x27″ (52x69 cm)

William Thon
COASTAL AUTUMN
Private Collection
7892 - 20½″x27″ (52x68 cm)

William Thon *(American, 1906-)*
OVERGROWN QUARRY
Private Collection
7891 - 20½″x27″ (52x68 cm)

Bruce Mitchell *(American, 1908-1963)*
FIRE ISLAND LANDING, *1938*
The Metropolitan Museum of Art, New York
5053 - 12½"x19" (32x48 cm)

John Wheat *(American, 1920-)*
DREAMS AND SHADOWS, *1970*
Private Collection
9974 - 18¾"x37¾" (47x95 cm)

Arthur Okamura *(American, 1932-)*
STRAY CUR, EUCALYPTUS GROVE, *1961*
National Collection of Fine Arts
S. C. Johnson Collection
Smithsonian Institution, Washington, D.C.
9628 - 21½"x40" (54x101 cm)

Peter Blume (American, 1906-)
THE BOAT, 1929
The Museum of Modern Art, New York
5033 - 16½"x20" (42x51 cm)

Xavier Gonzalez (American, 1898-)
HONG KONG
Milwaukee Art Center, Milwaukee, Wis.
8663 - 21"x31¾" (53x80 cm)

Lyonel Feininger
BLUE MARINE, *1924*
Munson-Williams-Proctor Institute, Utica
8000 - 18"x32" (46x81 cm)

Lyonel Feininger
BLUE SAILS, *1940*
Collection of Dr. Sidney Tamarin
8095 - 18"x25" (46x63 cm)

Lyonel Feininger *(American, 1871-1956)*
BIRD CLOUD, *1926*
Busch-Reisinger Museum
of Germanic Culture
Harvard University
7928 - 17¼"x28" (44x71 cm)

Richard Mayhew (*American, 1924-*)
MEZZO FORTE
Private Collection
8968 - 34"x31" (86x78 cm)

Richard Mayhew
NUANCES
Private Collection
9977 - 28"x34" (71x86 cm)

Arthur Secunda
CHROMATIC SQUARE
Private Collection
5354 - 23"×24" (59×61 cm)

Arthur Secunda
DISTANT MOUNTAIN, 1976
Private Collection
6315 - 24"x18" (61x46 cm)

Lyonel Feininger
GOTHIC GABLES
The Joseph H. Hirshhorn Collection
6225 - 14¾"x24" (37 x61 cm)

3044 - KING DAVID
Collection of Mr. and Mrs. James S. Plaut

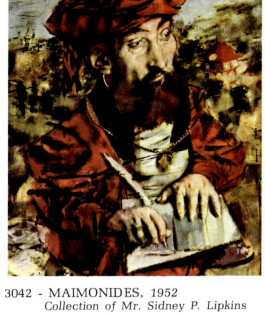

3042 - MAIMONIDES, 1952
Collection of Mr. Sidney P. Lipkins

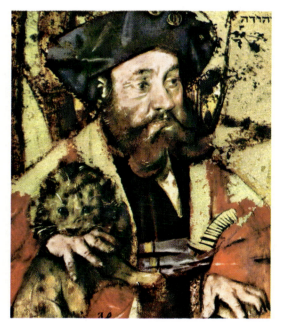

3045 - YEHUDAH, 1955
Collection of Mr. Kurt Delbanco

JACK LEVINE
(American, 1915-)
Plate Size 10″x8″
(25x20 cm)

Series: 3041-46

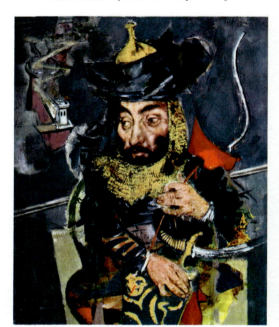

3041 - KING SAUL, 1952
Collection of Dr. Abram Kanof

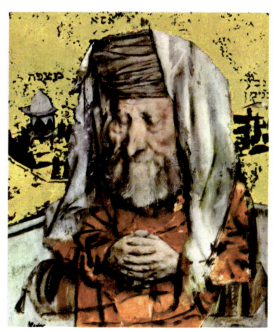

3043 - KING ASA, 1953
Fogg Art Museum, Harvard University
Meta and Paul J. Sachs Collection

3046 - HILLEL, 1955
Collection of Mr. Nate Spingold

360

A. Taylor (*American, 1941-*)
UMBER MIST
Private Collection
9056 - 30″x30″ (76x76 cm)

Eugene Berman (*American, b. Russia 1899-*)
HAT SELLER
Wadsworth Atheneum
6622 - 25″x19½″ (63x49 cm)

Eugene Berman (*American, b. Russia 1899-1972*)
NIKE, *1943*
The Joseph H. Hirshhorn Collection
9672 - 36½″x24″ (92x61 cm)

Willem De Kooning (*Dutch, 1904-*)
QUEEN OF HEARTS, 1943-46
The Joseph H. Hirshhorn Foundation
7720 - 31¾″x19″ (80x48 cm)

Ben Shahn (*American, 1898-1969*)
ALLEGORY, 1948
Fort Worth Art Museum
6051 - 21″×28″ (53×71 cm)

Conrad Marca-Relli (*American, 1913- *)
STEEL GREY, 1959-61
National Collection of Fine Arts
S. C. Johnson Collection
Smithsonian Institution, Washington, D.C.
7712 - 30″x26″ (76x66 cm)

Ben Shahn
BROTHERS
Joseph H. Hirshhorn Museum, Washington, D.C.
6067 - 25¾″×17″ (66×43 cm)

Stuart Davis (*American, 1894-1964*)
TOURNOS, 1954
Munson-Williams-Proctor Institute, Utica, New York
7566 - 30″×23¼″ (76×59 cm)

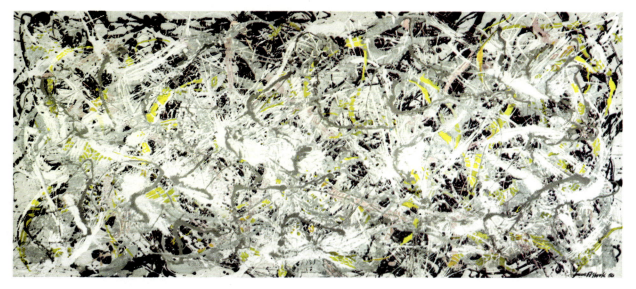

Jackson Pollock *(American, 1912-1956)*
NUMBER 27, *1950*
Whitney Museum of American Art, New York
7057 - 13½″x29½″ (34x75 cm)

Karl Knaths *(American, 1891-1971)*
CIN-ZIN, *1945*
The Phillips Collection, Washington, D.C.
607 - 20″x24″ (50x60 cm)

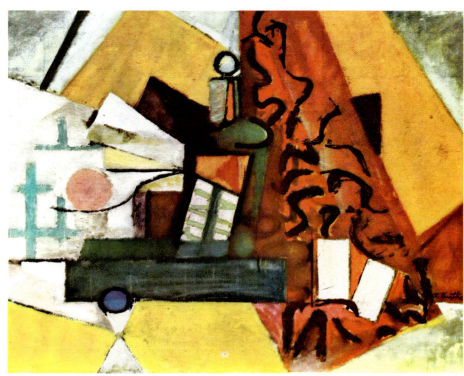

Jackson Pollock
THE WATER BEAST, *1945*
Stedelijk Museum, Amsterdam
9028 - 13½ ″x39½ ″ (35x100 cm)

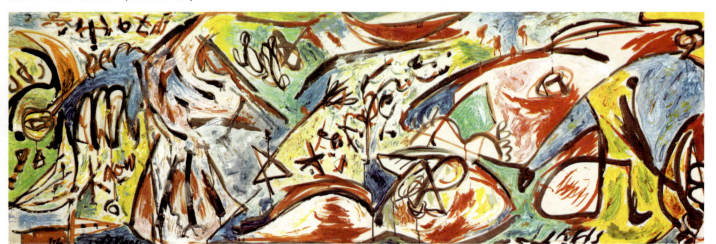

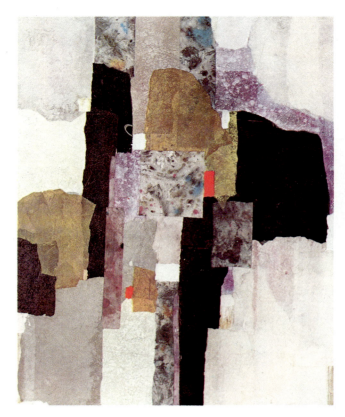

Michael Rossi (*Contemporary American*)
REVERIE
Private Collection
8606 - 32″×24¾″ (81×63 cm)
5506 - 18″x14″ (46x35 cm)

Mark Tobey (*American, 1890-1976*)
EARTH CIRCUS, *undated*
Seligmann Gallery, Seattle
7091 - 25¼″x18¾″ (64x47 cm)

Helen Strùven (*Contemporary American*)
MINGLED FORMS
Collection of the Artist
7844 - 28″x22″ (71x56 cm)

Adolph Gottlieb (American, 1903-1974)
THRUST, 1959
The Metropolitan Museum of Art, New York
George A. Hearn Fund, 1959
7314 - 28"x23¼" (71x59 cm)

Adolph Gottlieb
BLACK BLACK
University Art Museum, Berkeley, Calif.
7236 - 28"×23¼" (71×59 cm)

William Baziotes (American, 1912-1963)
DRAGON, 1950
The Metropolitan Museum of Art, New York
Arthur H. Hearn Fund, 1950
7309 - 28"x22¾" (71x58 cm)

Gregorio Prestopino (American, 1907-)
FALL LANDSCAPE WITH FOUR TREES
National Collection of Fine Arts
Smithsonian Institution, Washington, D.C.
9632 - 32¾"x28" (83x71 cm)

Kenneth Noland *(American, 1924-)*
DESERT SOUND, *1963*
Hirshhorn Museum and Sculpture Garden, Smithsonian Institution
7144 - 28"x28" (71x71 cm)

Robert Motherwell *(American, 1915-)*
CAMBRIDGE COLLAGE, *1963*
Private Collection
7257 - 28"x19" (71x48 cm)

Franz Kline *(American 1910-1962)*
BLACK, WHITE AND GRAY, *1959*
The Metropolitan Museum of Art, New York
George A. Hearn Fund, 1959
7312 - 30"x22¼" (76x56 cm)

Hans Hofmann *(American, 1881-1966)*
VELUTI IN SPECULUM, *1962*
The Metropolitan Museum of Art, New York
Gift of Mr. and Mrs. Richard Rogers
and Francis Lathrop Fund, 1963
7313 - 28"x24" (71x61 cm)

Larry Rivers (*American, 1923-*)
FLOWERS IN A VASE, 1955
Hirshhorn Museum and Sculpture Garden, Smithsonian Institution
7866 - 30"x26½" (76x67 cm)

Morris Graves
BIRD SEARCHING, 1944
The Art Institute of Chicago
7342 - 30"x15" (75x38 cm)

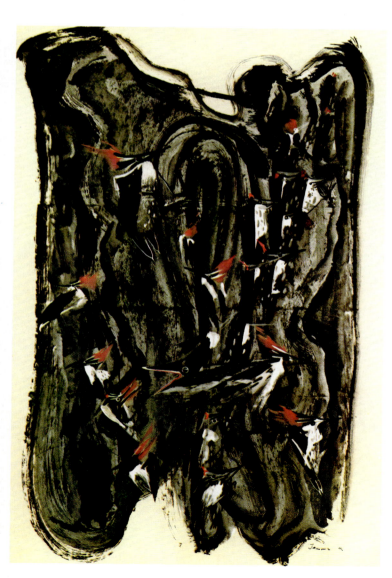

Morris Graves (*American, 1910-*)
WOODPECKERS, 1940
Seattle Art Museum
8008 - 30½"x21" (77x53 cm)

Paul Jenkins
PROMISED RITE, 1969
Private Collection
4618 - 14"x10" (35x25 cm)

Paul Jenkins
VEIL BEFORE, 1969
Private Collection
4620 - 14"x10" (35x25 cm)

Paul Jenkins
PHENOMENA: SUN OVER THE HOURGLASS, 1966
National Collection of Fine Arts
Smithsonian Institution, Washington, D.C.
9547 - 21"x40" (53x101 cm)

Paul Jenkins
INVOCATION ORB, 1969
Private Collection
4619 - 14"x10" (35x25 cm)

Paul Jenkins (American, 1923-)
SOLSTICE NEAR, 1969
Private Collection
4617 - 14"x10" (35x25 cm)

Paul Jenkins
PHENOMENA: FORCING A PASSAGE
AT THE MARK 1979
Private Collection
7974 - 28″x26¾″ (71x68 cm)

Paul Jenkins
PHENOMENA: CONTINENTAL SHELF 1979
Private Collection
8399 - 24″x30¾″ (61x78 cm)

Milton Avery (American, 1893-1965)
SPRING ORCHARD, 1919
National Collection of Fine Arts
S. C. Johnson Collection
Smithsonian Institution, Washington, D.C.
76680 22¾"x30" (58x76 cm)

Milton Avery
FRENCH PIGEONS
Private Collection, New York
7201 - 21"×28" (53×71 cm)

Ralph Hertle (American, 1937-)
UNTIL NOW
Private Collection
9062 - 24"×32" (61×81 cm)

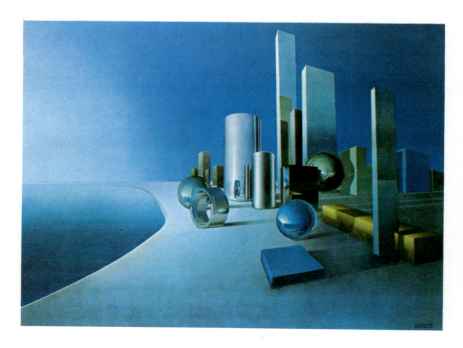

Philip Guston *(American, 1913-1980)*
NATIVE'S RETURN
The Phillips Collection, Washington, D.C.
8290 - 28"x33" (71x83 cm)

Sam Francis *(American, 1923-)*
BLUE OUT OF WHITE, 1958
Hirshhorn Museum and Sculpture Garden, Smithsonian Institution
8853 - 26¼"x30¼" (66x76 cm)

Ralph Hertle
DYNAMIS
Collection of Mr. Gary Steen, Los Angeles, Calif.
9070 - 21½"x36" (54x91 cm)

Morris Louis (American, 1912-1962)
COLOR LINE, 1961
Hirshhorn Museum and Sculpture Garden,
Smithsonian Institution
8852 -34¼"x20" (86x50 cm)

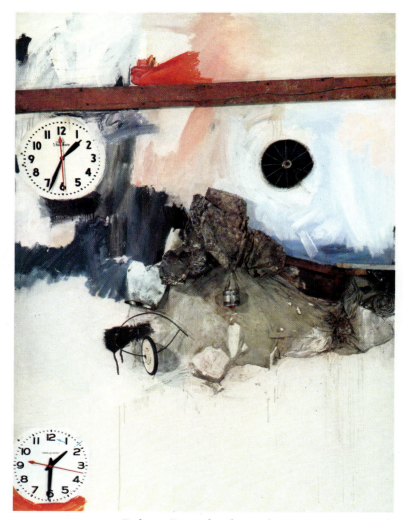

Man Ray (American, 1890-1976)
AS YOU LIKE IT, 1948
Hirshhorn Museum and Sculpture Garden,
Smithsonian Institution
6387 - 28"x23¾" (71x60 cm)

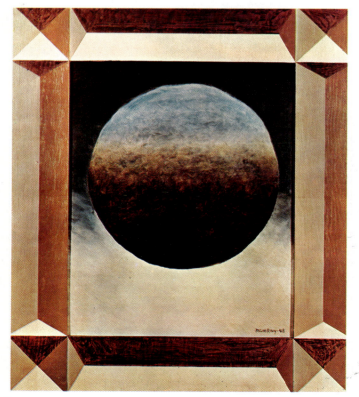

Robert Rauschenberg (American, 1925-)
RESERVOIR, 1961
National Collection of Fine Arts
S. C. Johnson Collection
Smithsonian Institution, Washington, D.C.
7713 - 30"x21½" (76x54 cm)

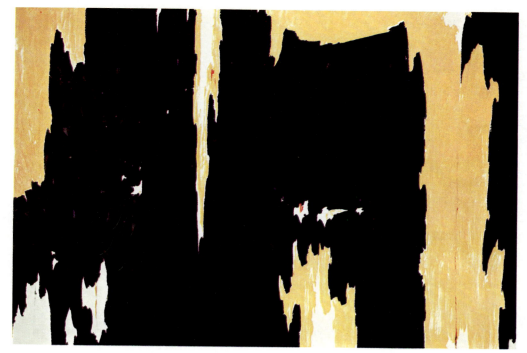

Clyfford Still (American, 1904-1980)
1957-D, No. 1, 1957
Albright-Knox Art Gallery, Buffalo, New York
Gift of Seymour H. Knox
8970 - 23¾"x33¾" (60x85 cm)

Jasper Johns (American, 1930-)
LAND'S END, 1963
Collection Edwin Janss, Jr., Los Angeles
8971 - 33¾"x23¾" (85x60 cm)

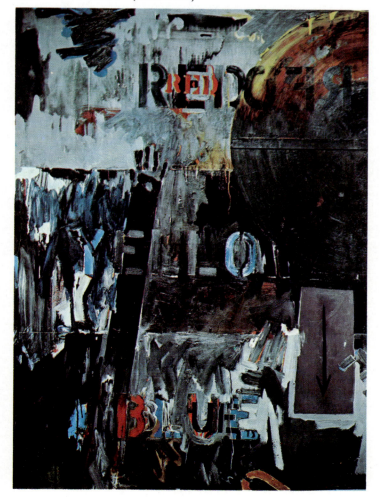

Stanton Macdonald-Wright (American, 1890-1973)
CANON SYNCHRONY, c. 1919
University Gallery, University of Minnesota, Minneapolis
7382 - 25"x25" (63x63 cm)

Roland Chenard (Contemporary Canadi[an])
FULL FLIGHT, 1979
Collection of the Artist
6943 - 18"x28⅛" (46x71 cm)

Alexander Calder *(American, 1898-1976)*
HOVERING BOWTIES, *1963*
Norton Simon, Inc., New York
8974 - 23"x30¼" (58x76 cm)

Ad Reinhardt *(American, 1913-1967)*
RED PAINTING, *1952*
Private Collection
9653 - 26"x36" (66x91 cm)

Wayne Thiebaud (Contemporary American)
YO-YOS, 1963
Albright—Knox Gallery, Buffalo, N.Y.
Gift of Seymour H. Knox, 1953
6026 - 24"x24" (61x61 cm)

Roy Lichtenstein (American, 1923-)
MODERN PAINTING OF SUN RAYS, 1967
The Joseph H. Hirshhorn Collection
9671 - 25½"x36" (64x91 cm)

Will Barnet (American, 1911-)
STAIRWAY, 1970
Private Collection
8517 - 24"x33" (60x83 cm)

Fairfield Porter (American, 1907-1975)
VIEW OF BARRED ISLAND, 1970
*The Herbert W. Plimpton Collection on extended loan
to the Rose Art Museum, Brandeis University*
8115 - 24"x30" (61x76 cm)

Andrew Wyeth (*American, 1917-)*
THE SLIP, *1958*
Private Collection
6528 - 18¼″x26″ (46x66 cm)

Andrew Wyeth
SEA ANCHOR, *1971*
Private Collection
6527 - 18¾″x26″ (48x66 cm)

Andrew Wyeth
FARAWAY, *1952*
Private Collection
6507 - 13½"x21¼" (34x51 cm)

Andrew Wyeth
GERANIUMS, *1960*
Private Collection
6115 - 20½"x15¼" (52x39 cm)

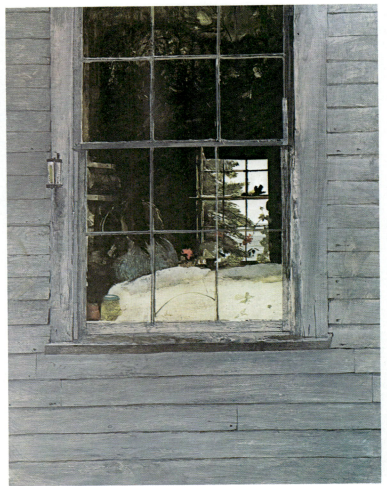

Andrew Wyeth
WOLF RIVERS, *1959*
Private Collection
5561 - 13¼"x12¾" (34x32 cm)

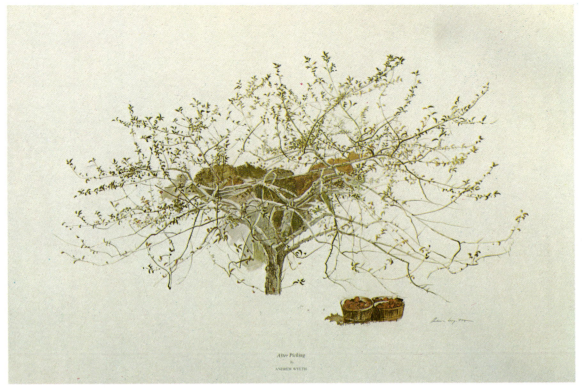

Andrew Wyeth
AFTER PICKING, *1942*
Private Collection
6506 - 18″x26″ (46x66 cm)

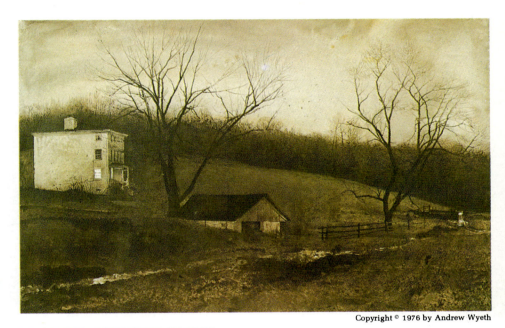

Andrew Wyeth
EVENING AT KUERNERS, *1970*
Private Collection
7241 - 18½″x28¾″ (47x73 cm)

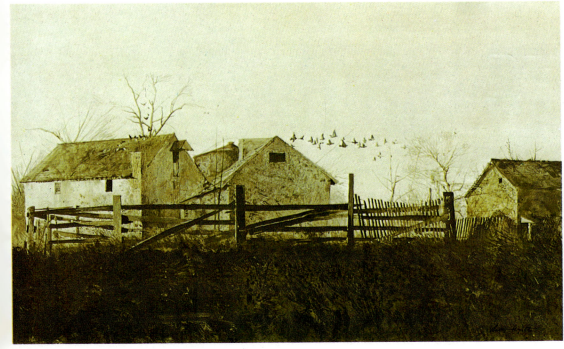

Andrew Wyeth
THE MILL, *1959*
Private Collection
5560 - 14″x22½″ (36x57 cm)

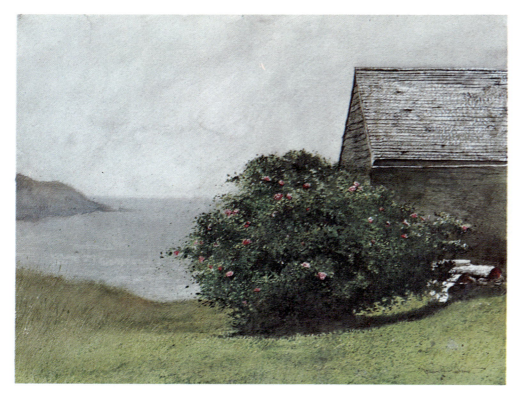

James Wyeth *(Contemporary American)*
ISLAND ROSES, *1968*
Private Collection
6272 - 18½″x23¾″ (47x60 cm)

Peter Hurd *(American, 1904-)*
RIO HONDO
Private Collection
7288 - 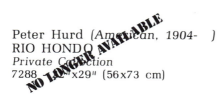″x29″ (56x73 cm)

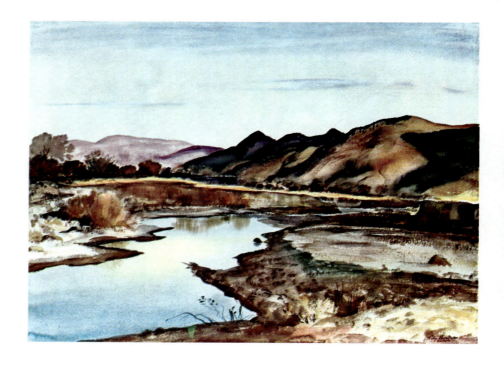

Peter Hurd
RANCHERIA, *1938*
The Metropolitan Museum of Art, New York
6242 - 12″x22″ (30x56 cm)

380

Hans Moller (American, 1905-)
PINE LEDGE, 1979
Midtown Galleries, New York
6668 - 18"x24" (46x61 cm)

Philip Jamison
ISLAND SHORE
Hirschl and Adler Galleries, New York
7345 - 21⅜"x30" (54x76 cm)

Martha Margulis (Contemporary American)
PRIMAVERA
Private Collection
7574 - 18"x30" (45x76 cm)

Philip Aziz (Canadian, 1923-)
LIFE CYCLE OF PINE TREE NO. 9, 1968
Private Collection
9006 - 36"x24" (91x60 cm)

Jane V. Chenoweth (American, 1910-)
FLOWERING QUINCE, 1970
Private Collection
8959 - 28¼"x22½" (71x57 cm)
5549 - 18"x14¼" (46.6x36.2 cm)

Dianne Nelson Tullis (Contemporary American)
EARLY FALL, 1970
Collection of William F. Buckley, Jr.
9976 - 36"x26¾" (91x67 cm)

Philip Aziz
APOTHEOSIS OF A PINE TREE
Private Collection
7947 - 30"×20" (76×51 cm)

Malcolm Thompson
SANCTUARY
Private Collection
7322 - 28″x22″ (71x56 cm)

John Weiss *(Contemporary American)*
BRICK SHED, 1977
Private Collection
6931 - 18″x24″ (45x61 cm)

Gary Barsumian *(Armenian, 1923-1978)*
THE NEIGHBORS
Collection of Mrs. Gary Barsumian
9071 - 18″ x36″ (45x91 cm)

Malcolm Thompson (*American, 1916-*)
ANOTHER MORNING
Private Collection
7998 - 28″x28″ (71x71 cm)

Malcolm Thompson
MISTY MORNING
Private Collection
7933 - 25″x34″ (63x86 cm)
5505 - 13¼″x18″ (34x46 cm)

Malcolm Thompson
MORNING FLIGHT
Collection of Mr. and Mrs. Walter S. Hennig
8114 - 30"x26⅜" (76x67 cm)

Malcolm Thompson
A BREEZE OF DAISIES, 1978
Collection of Mr. and Mrs. Gordon H. Anderson
7321 - 28"x24¾" (71x62 cm)

Mark Adams *(Contemporary American)*
RANUNCULAS
Collection of Elizabeth Banning, A.I.D.
7391 - 28"×25" (71×63 cm)

Sidney Loeb *(American, 1904-1972)*
MOONFLOWERS, 1960
Collection of Mrs. Sidney Loeb
7804 - 31"x24" (78x61 cm)

Thesis Newer
STILL LIFE WITH BASKET, 1976
Private Collection
7929 - 30"x24" (76x61 cm)

Lydia Kemeny
GERANIUMS
Private Collection
8292 - 32"x20" (81x50 cm)
5520 - 18"x11" (46x28 cm)

Lydia Kemeny
IN A COURTYARD

5519 - 18"x13¼" (46x29 cm)

Lydia Kemeny
THE RED CHAIR
Collection Neville S. Conrad
8289 - 32"x19¾" (81x50 cm)
4099 - 18"x12" (45x30 cm)

Barbara Falk
NORWALK REVISITED
Private Collection
8949 - 25¼"x30" (64x76 cm)

Barbara Bustetter Falk *(American, 1928-)*
MY GARDEN, *1976*
Private Collection
6893 - 26"x22½" (66x57 cm)

Lydia Kemeny
BLUE SHUTTERS, *1969*
Private Collection

4098 - 18"x12" (45x30 cm)

Carol Auer (Contemporary American)
SUMMER FRAGRANCE, 1970
Private Collection
7814 - 22"x28" (55x71 cm)

Marcella Maltais (b. Quebec, 1933-)
THROUGH LOVING EYES
Private Collection
8510 - 32"x25¼" (81x64 cm)

Carol Auer
FLOWER SHOP
Private Collection
8858 - 31½"x23¾" (80x61 cm)

Carol Auer
APRIL FLOWERS, 1971
Private Collection
8953 - 28"x23¼" (71x59 cm)

Russ Elliott (*Contemporary American*)
GARDEN CHAIR
Collection of the Artist
9064 - 24″×32″ (61×81 cm)
5500 - 13½″x18″ (34x46 cm)

Arthur Cady (*American 1920-*)
THE COUNTRY BOUQUET
Private Collection
7797 - 28″x22″ (71x56 cm)
5525 - 18″x14½″ (46x37 cm)

Piero Aversa (*Contemporary Italian*)
FLOWERS OF MYKONOS
Private Collection
8390 - 31″×24″ (79×61 cm)

Kamil Kubik (*b. Czechoslovakia, 1930-)
SUMMER ABUNDANCE
Private Collection
7496 - 24″x26″ (61x66 cm)

Anders Gisson (*Contemporary American*)
ALONG THE SEINE
Private Collection
7997 - 24″x30″ (61x76 cm)

Ida Pellei
YELLOW TULIPS
Private Collection
7505 - 31¾"x24" (81x61 cm)

Ida Pellei
FERNS WITH MIXED BASKET
Private Collection
7504 - 31¾"x24" (81x61 cm)

Ida Pellei (*Contemporary American*)
JOYS OF SUMMER
Private Collection
7956 - 28"x28" (71x71 cm)

Ida Pellei
THE LEOPARDS
Private Collection
8950 - 24"x29¾" (61x76 cm)

Ida Pellei
DAISIES AND STRAWBERRIES, *1976*
Private Collection
7915 - 24"x24" (61x61 cm)

Ida Pellei
SUMMER AFTERNOON
Private Collection
9065 - 24"×36" (61×91 cm)

Ida Pellei
PRIMAVERA
Private Collection
7930 - 24"x30" (61x76 cm)

Ida Pellei
BASKET BOUQUET WITH ANEMONES
Private Collection
5550 - 16"x12" (41x30 cm)

Ida Pellei
FIELD FLOWERS AND FERN
Private Collection
5551 - 16"x12" (41x30 cm)

Ida Pellei
YELLOW DAISIES AND MARGUERITES
Private Collection
5553 - 12"x16" (30x41 cm)

Ida Pellei
ORANGE ZINNIAS AND GREENERY
Private Collection
5552 - 12"x16" (30x41 cm)

Harold McIntosh
MOVING DAY FOR THE MARSH MARIGOLDS
Private Collection
6450 - 21¼"x26¼" (54x67 cm)

Harold McIntosh
BY A WOODLAND STREAM, 1979
Collection of Beverly A. McIntosh
7570 - 28⅜"x22" (72x55 cm)

Ida Pellei
SUNFLOWERS, *1976*
Private Collection
8826 - 24"x32" (61x81 cm)

Philip Jamison
LAST SUMMER
Hirschl and Adler Gallery, New York
7944 - 21″×28¾″ (53×73 cm)

Susan J. Detjens (*Contemporary American*)
GLOXINIAS II, *1974*
Private Collection
7917 - 30″x30″ (76x76 cm)

Ronald Ekholm (*American, 1942-*)
FLOWER POT
Private Collection
6445 - 19″×25″ (48×63 cm)

Bernard Cathelin *(French, 1919-)*
AUTUMN, *1963*
Private Collection
4614 - 14"x9" (35x22 cm)

Bernard Cathelin
YELLOW DAHLIAS, *1960*
Private Collection
7072 - 28"x19½" (71x49 cm)
4616 - 14"x9" (35x22 cm)

Bernard Cathelin
WINTER, *1963*
Private Collection
7491 - 28"x18" (71x46 cm)
4613 - 14"x9" (35x22 cm)

Huldah *(Contemporary American)*
WHITE ROSES
Private Collection
7771 - 25″x30″ (63x76 cm)

Bernard Cathelin
SPRING, *1963*
Private Collection
7493 - 28″x18″ (71x46 cm)

Bernard Cathelin
LE VASE BLANC, *1962*
Private Collection
7495 - 28″x21¼″ (71x54 cm)
4615 - 14″x9″ (35x22 cm)

Bernard Cathelin
SUMMER, *1963*
Private Collection
7492 - 28″x18″ (71x46 cm)

John Haymson (*American, 1914- *)
SUMMER BLUSH
Private Collection
5601 - 20"x15¾" (51x40 cm)

John Haymson
FLORAL FANCY
Private Collection
5602 - 20"x15¾" (51x40 cm)

Mimi Conkling (*Contemporary American*)
PENSIVE
Private Collection
6618 - 24"x20" (61x51 cm)

Mimi Conkling
CURIOSITY
Private Collection
6617 - 24"x20" (61x51 cm)

Mimi Conkling
FLORAL FANTASY
Private Collection
7657 - 22″x30″ (56x76 cm)

Mimi Conkling
A WOODLAND GLEN
Private Collection
6620 - 20″x24″ (51x61 cm)

Mimi Conkling
A MEADOW CORNER
Private Collection
6619 - 20″x24″ (51x61 cm)

Frans Oerder (German, 1876-1942)
MAGNOLIAS
8393 - 25½"x32" (65x81 cm)
6539 - 17"x20½" (43x52 cm)

Paul de Longpré (American, 1855-1911)
FLORALS
4358-4363 - each 14"x11" (35x28 cm)

4360 - FAIRY LUSTRE

4359 - ENCHANTING

4361 - GENTLE WAKING

4363 - FLEURS DE LOUIS

4362 · THE WHITE PRINCE

Scarlett *(Contemporary American)*
CORN SNOW, *1968*
Collection of Albert G. Chase
Portland, Maine
4646 - 11½ "x16" (29x40 cm)

Scarlett
HARBINGER, *1971*
Private Collection
4647 - 11½ "x16" (29x40 cm)

Series: 4646-49

Scarlett
REBIRTH, *1971*
Private Collection
4649 - 11½ "x16" (29x40 cm)

Scarlett
LOW BRANCH, *1968*
Collection of Albert G. Chase
Portland, Maine
4648 - 11½ "x16" (29x40 cm)

Anton Doring
GARDEN GLORY
5764 - 20"x15½" (50x39 cm)
4768 - 14"x11" (35x28 cm)

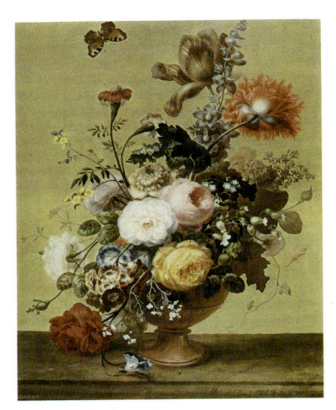

Michael Janch
GARDEN FLOWERS
5763 - 20"x15½" (50x39 cm)
4767 - 14"x11" (35x28 cm)

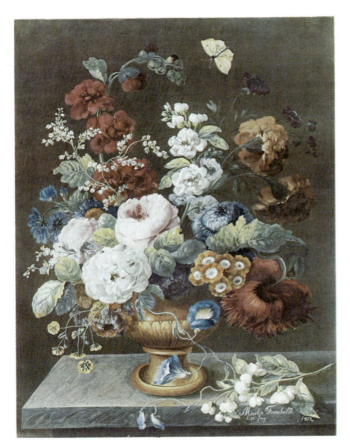

Martin Fromhold
SUMMER BOUQUET, *1802*
6706 - 22"x16" (56x41 cm)

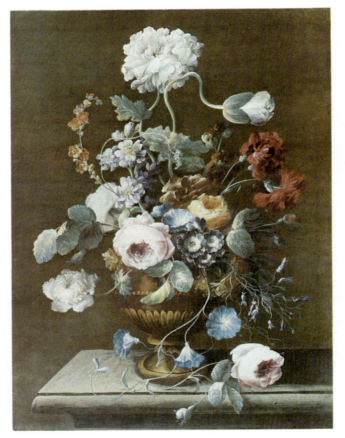

Josef Bittner
JUNE FLOWERS
6708 - 22"x16" (56x41 cm)

Rose Gaynor Barrett (American, 1884-1954)
SEA TREASURE, c.1940
6090 - 19½"x26" (50x66 cm)

Bernard Burroughs (American, 1912-)
STILL LIFE WITH JUGS
Private Collection
7401 - 22"x28" (56x71 cm)

Armando Miravalls Bové (Spanish, 1916-)
STILL LIFE: SOUVENIRS
Private Collection
9082 - 17"x39½" (43x100 cm)

Armando Miravalls Bové
BOUNTIFUL HARVEST, *1957*
6080 - 7½"x24" (19x60 cm)

Ryszard Ploskonka *(Contemporary Polish)*
FLORAL STILL LIFE, *1976*
Private Collection
7093 - 28"x22" (71x56 cm)

Armando Miravalls Bové
ROSES, *1963*
Private Collection
9093 - 12¾"x39¼" (32x99 cm)

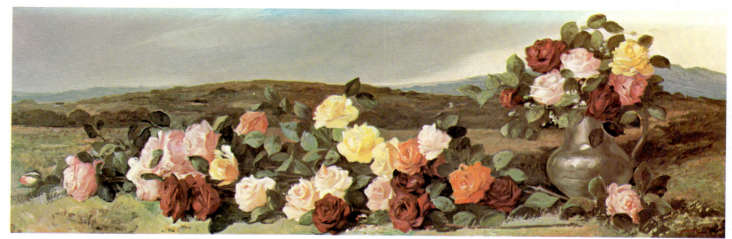

4009 - MISTY CLOVER

4010 - CLOVER

4007 - DAISY AND SUNLIGHT

Carlo Carrà (Italian, 1881-1966)
STILL LIFE, 1957
Dr. Antonio Mazzotta Collection, Milan
6659 - 23½"x19¾" (60x50 cm)

Miguel Ibarz Roca (Spanish, 1920-)
BLUE VASE
Private Collection
7317 - 28"x22" (71x56 cm)

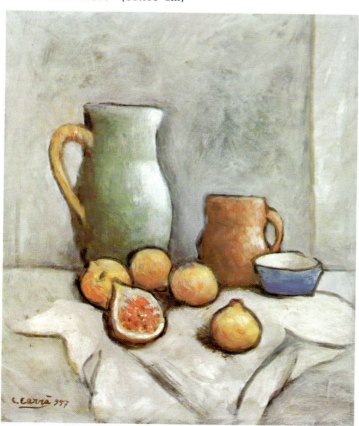

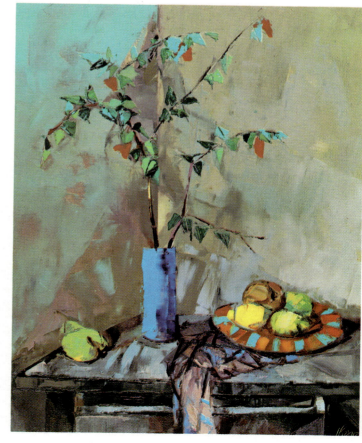

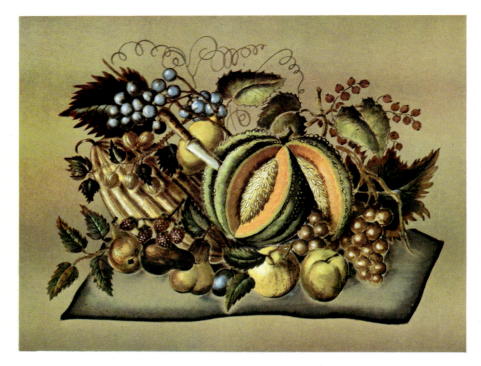

Unknown American artist
THANKSGIVING FRUIT
4029 - 11"x14" (28x35 cm)
2029 - 6"x7½" (15x19 cm)

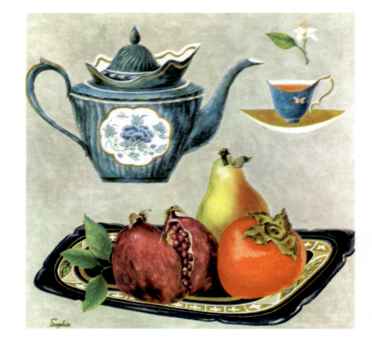

Sophie Porter
THE TEA POT
5113 - 15"x15" (38x38 cm)

Unknown American artist
GRANDMOTHER'S FRUIT

2026 - 6"x7½" (15x19 cm)

Unknown American artist
BOUNTIFUL HARVEST
4027 - 11"x14" (28x35 cm)
2027 - 6"x7½" (15x19 cm)

Sophie Porter
THE COFFEE POT
5114 - 15"x15" (38x38 cm)

Unknown American artist
FARMER'S PRIDE
4028 - 11"x14" (28x35 cm)
2028 - 6"x7½" (15x19 cm)

Alexandru Ciucurencu *(Rumanian, 1903-)*
CYCLAMEN, 1944
Art Museum of the Rumanian People's Republic, Bucharest
6311 - 19"x23½" (48x59 cm)

Arnold Blanch *(American, 1896-1968)*
FLORAL MAGIC
5675 - 16½"x11" (42x27 cm)

Joan Paley *(Contemporary American)*
SPRING
Private Collection
8345 - 25"x30" (63x76 cm)

John Haymson *(American, 1914-)*
STILL LIFE WITH BOTTLE AND FRUIT, *1967*
Private Collection
9639 - 31"x36" (78x91 cm)

Bernardo Sanjuan *(Spanish, 1915-)*
STILL LIFE, *1964*
Private Collection
7811 - 22¼"x30" (56x76 cm)

Carl Broemel (*American, 1891-*)
RIPE QUINCES AND PEARS
New Britain Museum of American Art, New Britain, Conn.
5118 - 20½″x26¼″ (52x67 cm)

Carl Broemel
GERANIUM AND GREEN QUINCES
Private Collection
5444 - 15¾″×22″ (40×56 cm)

Carl Broemel
GREEN QUINCES
Private Collection
5250 - 18¾″×24″ (48×61 cm)

Alberto Salietti *(Italian, 1892-)*
STILL LIFE WITH FRUIT
Series 2962-66 - each 7½"x6½" (19x16 cm)

2962 - STILL LIFE: CHERRIES

2963 - STILL LIFE: GRAPES

2964 - STILL LIFE: ORANGES

2965 - STILL LIFE: PLUMS

2966 - STILL LIFE: STRAWBERRIES

NO LONGER AVAILABLE

Ryszard Ploskonka
FRUIT, FLOWERS AND WATER JUG
Private Collection
7610 - 22¼"x28" (56x71 cm)

3244 - AUTUMN GEMS

3242 - THE RED CABBAGE LEAF

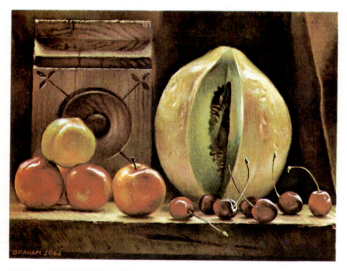

3243 - HONEYDEW, PLUMS AND CHERRIES

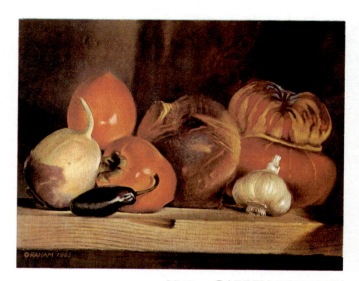

3246 - GARDEN BOUQUET

Robert MacD. Graham *(Contemporary American)*
STILL LIFES
Private Collection
Series 3241-46 - each 8"x10" (20x25 cm)

3245 - OCTOBER PEARS

3241 - MELANGE

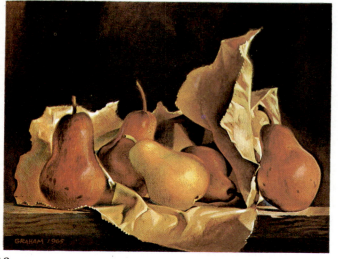

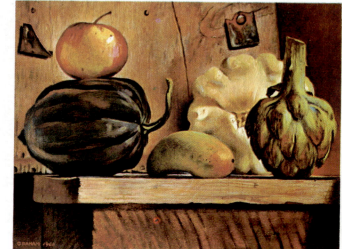

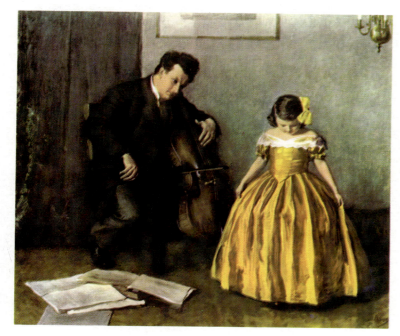

John Quincy Adams *(Austrian, 1874-1933)*
HER FIRST RECITAL
4301 - 11"x13" (28x33 cm)

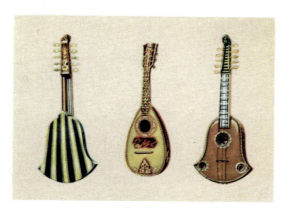

4409 - MANDOLINE AND QUINTERNA

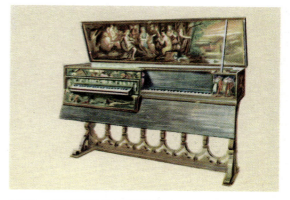

4405 - DOUBLE SPINET

William Gibb *(English, active 1850)*
MUSICAL INSTRUMENTS
4405-4407, 4409 - each 9"x13" (23x33 cm)

4406 - CLAVICHORD

4407 - UPRIGHT SPINET

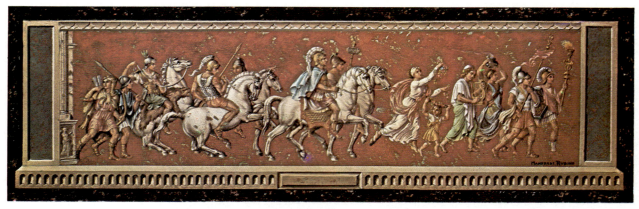

ROMAN PARADE - 9077 - 12″x36″ (30x91 cm)

Manfredi Rubino
(American, 1895-1975)
POMPEIIAN DESIGNS

TERPSICHORE
8634 - 31¼″x10¼″
(80x26 cm)

CERES
8635 - 31¼″x10¼″
(80x26 cm)

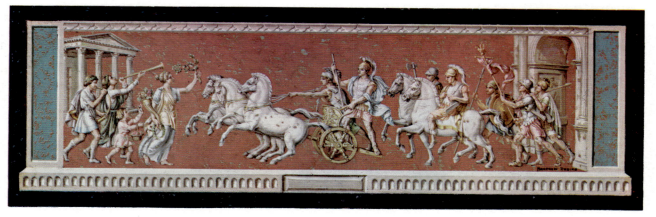

RETURNING VICTOR - 9078 - 12″x36″ (30x91 cm)

Gustav C.L. Richter *(German, 1823-1884)*
THE ARTIST'S SISTER
National Gallery, Berlin
7507 - 27½"x22" (70x56 cm)
3137 - 11"x9" (28x23 cm)

Joseph B. Kahill *(American, 1882-)*
THE COLLECTOR
6701 - 20"x24" (51x61 cm)
4701 - 11"x14" (28x35 cm)

Nicolae Grigorescu *(Rumanian, 1838-1907)*
THE GYPSY
Museum of Jassy, Rumania
7071 - 27½"x14½" (70x37 cm)

Luke S. Fildes *(British, 1844-1927)*
THE DOCTOR
Tate Gallery, London
7525 - 17½"x26" (44x66 cm)

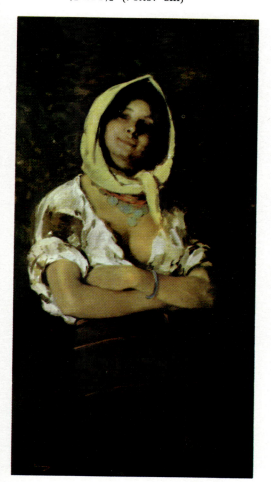

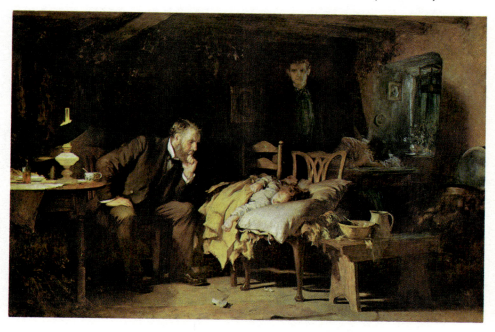

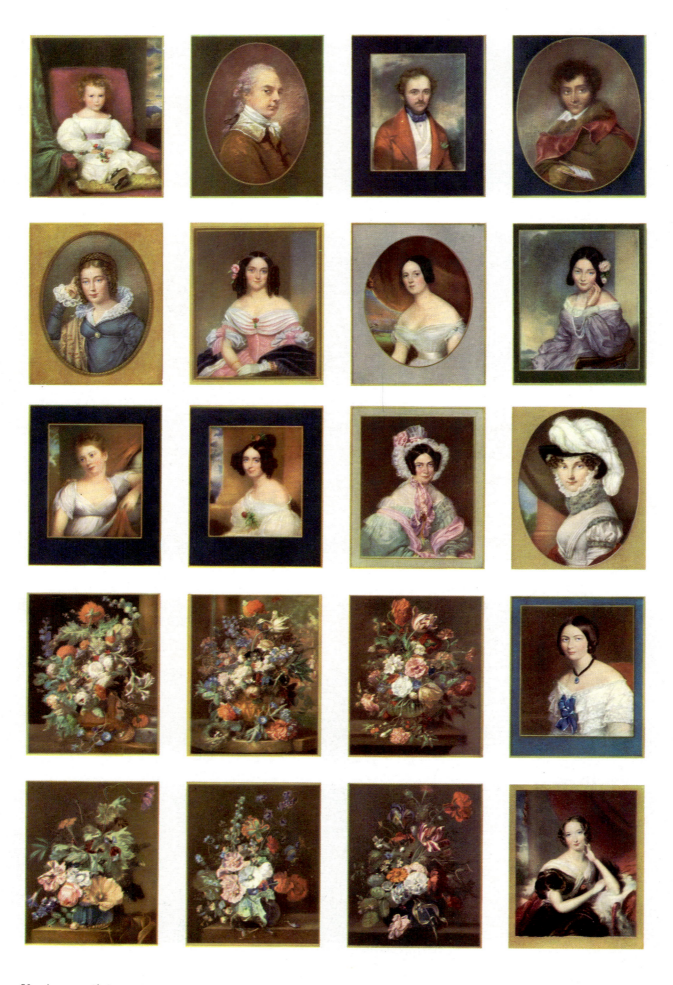

Various artists
JEWELS OF MINIATURE PAINTING
7200 - 5"x4" (12x10 cm) Sheet of 20

3121 - Daffinger
AGE OF INNOCENCE

Average plate size
11"x9" (28x22 cm)

PORTRAITS

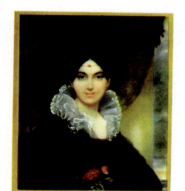

3109 - Daffinger
MADAME DAFFINGER

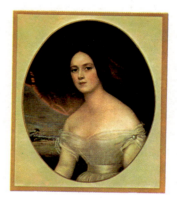

3116 - Kobel
COMTESSE D'ORSAY

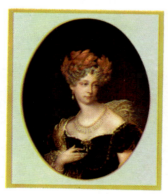

3117 - Lequeutre
FRENCH PRINCESS

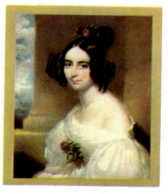

3111 - Peter
HUNGARIAN COUNTESS

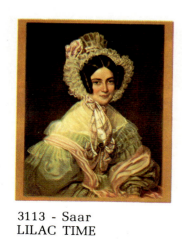

3113 - Saar
LILAC TIME

3114 - Unknown Artist
GIRL IN BLUE

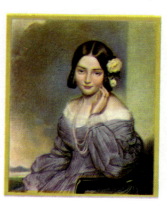

3115 - Saar
LADY IN ORCHID

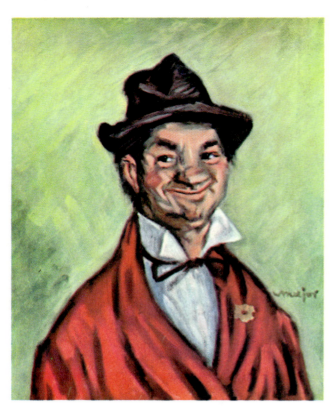

Henry Major *(?-1948)*
THE GAY PHILOSOPHER - WHY WORRY
5810 - 20"x16" (50x40 cm)

Joseph Hirsch *(American, 1910-)*
THE PHILOSOPHER
6047 - 24½"x18½" (63x47 cm)

Juan Giralt Lerin
BACKSTAGE
Private Collection
7320 - 22½"x29¾" (57x75 cm)

Henry Major
END OF A PERFECT DAY
5905 - 20"x16" (50x40 cm)

Cydney Grossman
TWO CLOWNS
Private Collection
5355 - 22″x18½″ (55x46 cm)

Cydney Grossman *(American, 1910-)*
CIRCUS FAMILY
Collection of Dr. and Mrs. B. Bergman
4083 - 17¼″x11½″ (43x29 cm)

Iver Rose
SHOW'S ON
6071 - 22″x16″ (56x41 cm)

Sheldon Clyde Schoneberg
DIANE, 1969
Private Collection
8969 - 30"x25½" (76x64 cm)
4994 - 17"x13¼" (43x33 cm)

Sheldon Clyde Schoneberg *(American, 1926-)*
TAMBOURINES, 1968
Private Collection
8525 - 27¼"x36" (69x91 cm)
4993 - 13¼"x17" (33x43 cm)

Sheldon Clyde Schoneberg
ANGEL OF BLEEKER STREET, 1967
Private Collection
8273 - 34"x25" (86x63 cm)
4992 - 17"x13¼" (43x33 cm)

Sheldon Clyde Schoneberg
DEBORAH DREAMING, 1970
Private Collection
8960 - 40"x30" (101x76 cm)
4995 - 17"x13¼" (43x33 cm)

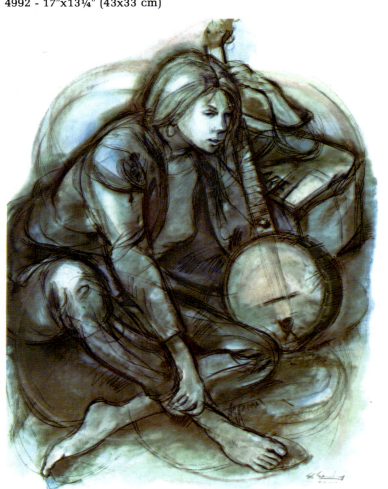

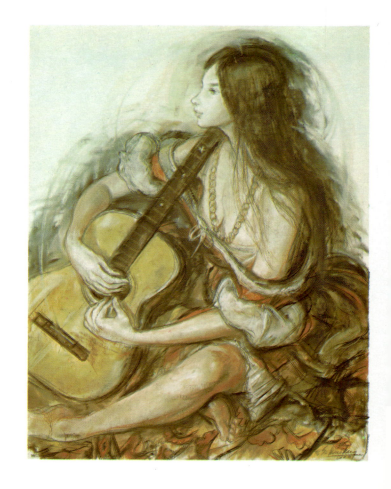

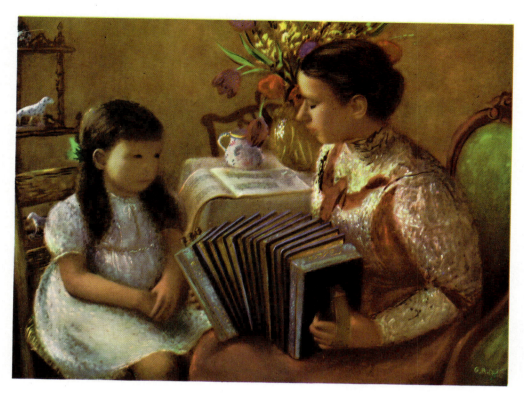

Gladys Rockmore Davis (*American, 1901-1967*)
THE MUSIC LESSON
6705 - 16½"x22" (42x56 cm)

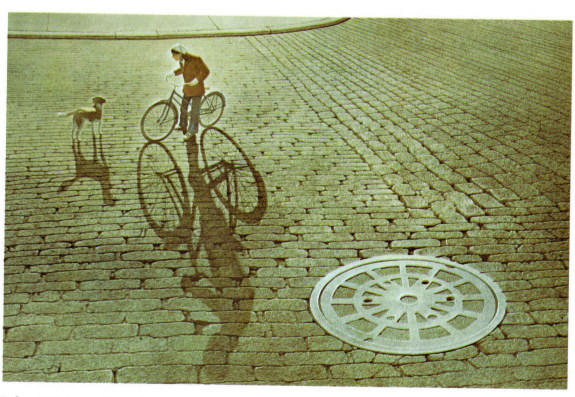

Robert Vickrey (*American, 1926- *)
CARRIE AND COCOA, 1970 (*detail*)
Private Collection
8848 - 22"x32" (55x81 cm)

Akseli Gallen-Kallela *(Finnish, 1865-1931)*
BOY WITH CROW, 1884
Collection of the Ateneum, Helsinki
Reproduced by permission of Pirkko Gallen-Kallela
6354 - 24"x20" (61x51 cm)

Robert Vickrey
PARAKEET, 1971
Private Collection
8849 - 30"x20¼" (76x51 cm)

James Chapin *(American, 1887-1975)*
MOTHERHOOD
Private Collection
6049 - 21½ " x17½ " (54x45 cm)

422

Huldah (*Contemporary American*)
IN CENTRAL PARK
6909 - 25"x20" (63x51 cm)
4806 - 14"x11" (35x28 cm)
2806 - 7½"x6" (19x15 cm)

Harrison Rucker (*American, 1930- *)
THE PINK GOWN
Private Collection
6525 - 24"×18" (61×46 cm)

Huldah
TAVERN-ON-THE-GREEN
6908 - 25"x20" (63x51 cm)
4805 - 14"x11" (35x28 cm)
2805 - 7½"x6" (19x15 cm)

Huldah
HIS ROSE
5835 - 20″x16″ (50x40 cm)
4835 - 14″x11″ (35x28 cm)
2835 - 7½″x6″ (19x15 cm)

Huldah
MAY BUD
5836 - 20″x16″ (50x40 cm)
4836 - 14″x11″ (35x28 cm)
2836 - 7½″x6″ (19x15 cm)

Huldah
LES DEUX CAMARADES
4779 - 14″x11″ (35x28 cm)

Huldah
PREMIERE AU RENDEZ-VOUS
4778 - 14″x11″ (35x28 cm)

Raymond Kanelba (American, 1900-1961)
THE LITTLE MUSICIAN
5669 - 14"x11" (36x30 cm)

Huldah
BIG BROTHER
5834 - 20"x16" (50x40 cm)
4834 - 14"x11" (35x28 cm)

Huldah
LITTLE SISTER
5833 - 20"x16" (50x40 cm)

August von Munchhausen *(American, 1908-)*
INTERLUDE
5790 - 16"x20" (40x50 cm)

Huldah
PRINTEMPS
7752 - 31¼"x9¾" (79x25 cm)
5752 - 19¾"x6¼" (50x16 cm)

August von Munchhausen
FINALE
5791 - 16"x20" (40x50 cm)
4351 - 13"x16" (33x40 cm)

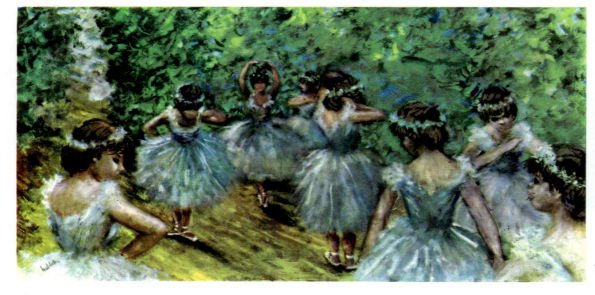

Huldah
CURTAIN TIME
7913 - 15"x29¾" (38x75 cm)

Huldah
MOIS DE MAI
7753 - 31¼"x9¾" (79x25 cm)
5753 - 19¾"x6¼" (50x16 cm)

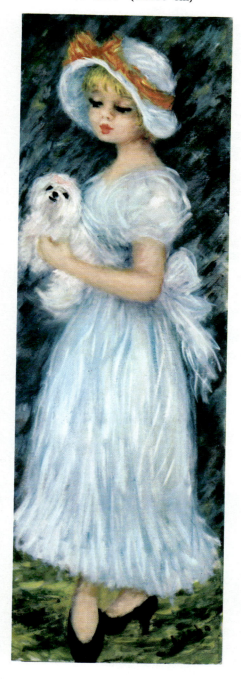

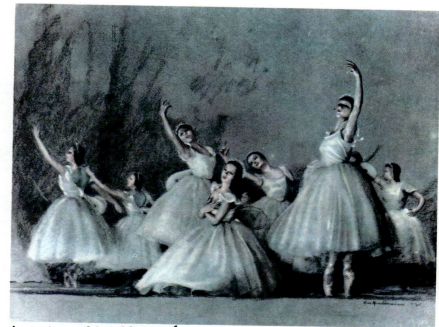

August von Munchhausen
CORPS DU BALLET RUSSE
4349 - 13"x16" (33x40 cm)

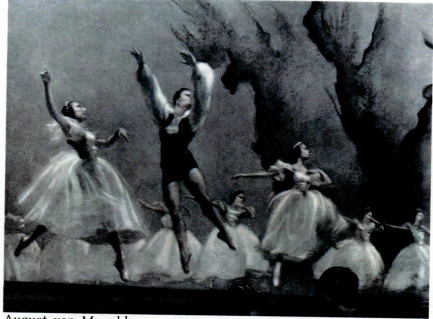

August von Munchhausen
PAS DE TROIS
4348 - 13"x16" (33x40 cm)

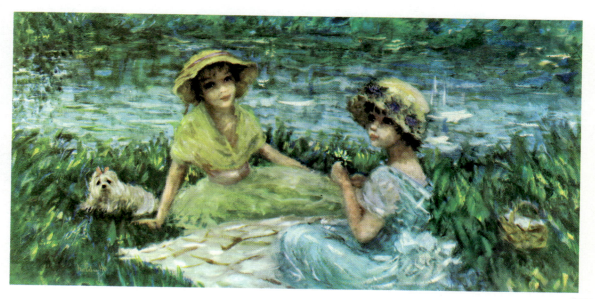

Huldah
MAYTIME
7912 - 15"x29¾" (38x75 cm)

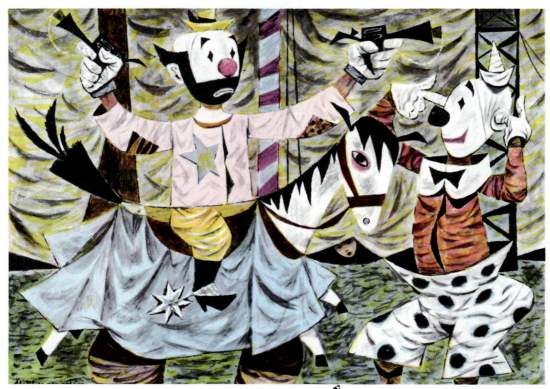

Fletcher Martin (American, 1904-1979)
CLOWN ACT
5671 - 11½"x15" (30x40 cm) NO LONGER AVAILABLE

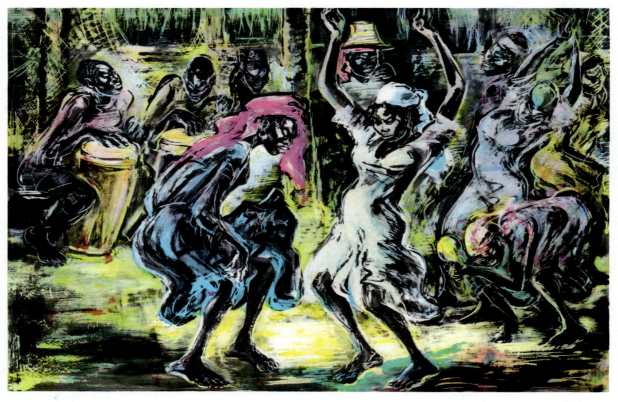

Marion Greenwood (American, 1909-1970)
HAITIAN DANCERS
5672 - 12"x18" (30x45 cm)

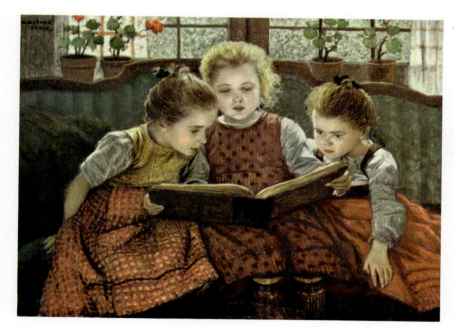

Walter Firle *(German, 1859-1929)*
THE FAIRY TALE
6702 - 18"x24" (46x61 cm)
4702 - 11"x14" (28x35 cm)

James Chapin *(American, 1887-1975)*
RUBY GREEN SINGING, 1928
Norton Gallery and School of Art
West Palm Beach, Florida
6868 - 27¾"x22" (70x55 cm)

August von Munchhausen
POSE CLASSIQUE
5760 - 20"x16" (60x40 cm)
4380 - 16"x13" (40x33 cm)

Carol Sideman (Contemporary American)
YOUNG ARTISTS, 1967
Private Collection
6866 - 19"x26" (48x66 cm)

James Chapin
THE PICTURE BOOK, 1945-46
Private Collection
7340 - 27"x18" (68x45 cm)
5340 - 16½"x11" (42x28 cm)

James Chapin
BOY WITH A BOOK, 1945
Private Collection
6062 - 21"x18" (54x45 cm)

Lawrence Beall Smith (*American, 1902- *)
THE MUSEUM VISITOR
6050 - 24½"x18½" (63x47 cm)

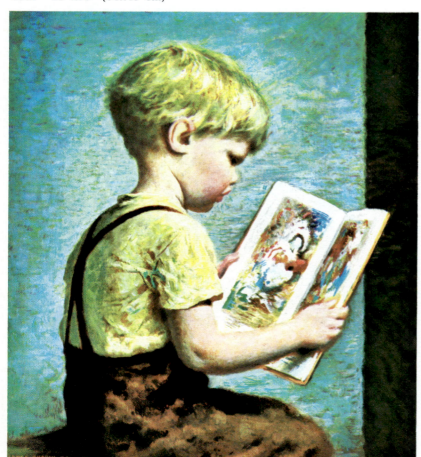

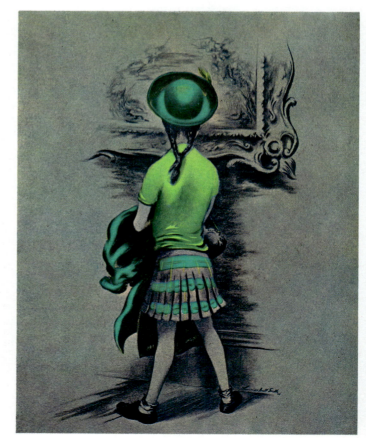

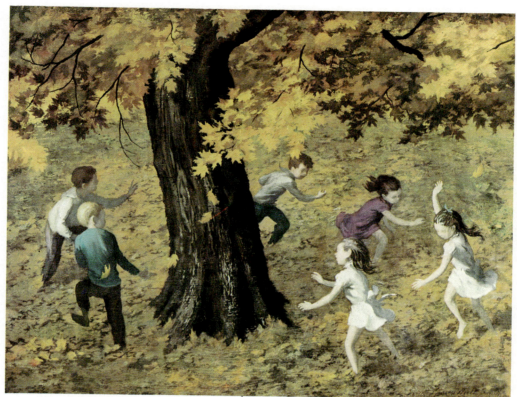

Lawrence Beall Smith
FROLIC
Private Collection
669 - 17"x22" (43x56 cm)

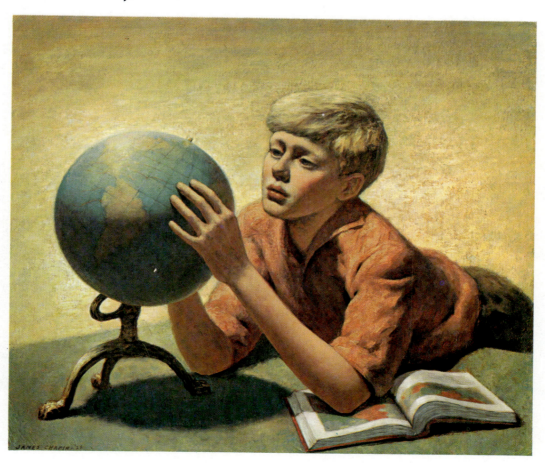

James Chapin
BOY WITH A GLOBE, 1927-28
Collection of the Artist
7339 - 21½"x26" (54x66 cm)

W. V. Kaulbach (*German, 1805-1874*)
GRETEL
3999 - 12"x9" (30x23 cm)
2999 - 7½"x6" (19x15 cm)

HANSEL
3998 - 12"x9" (30x23 cm)
2998 - 7½"x6" (19x15 cm)

Emile Renouf (*French, 1845-1894*)
THE HELPING HAND, 1881
The Corcoran Gallery of Art
Washington, D.C.
8638 - 22"x32" (56x81 cm)
4638 - 11"x14" (28x35 cm)

Willem Maris *(Dutch, 1844-1910)*
CHILDREN ON A BEACH, 1876
Wilmot E. Forbes Collection
6864 - 17"x25½" (43x64 cm)

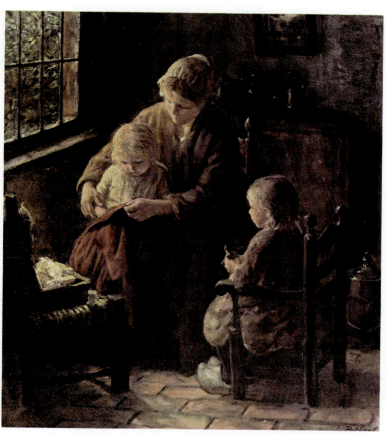

Bernard Pothast
THE FIRST FITTING
Private Collection
7033 - 26"x23" (66x58 cm)
5536 - 14½"x12⅝" (37x32 cm)

Bernard Pothast *(Dutch, 1882-)*
HER FIRST LESSON
Fort Worth Art Center
7026 - 21"x25½" (53x65 cm)
5537 - 11¼"x14½" (29x37 cm)

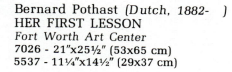

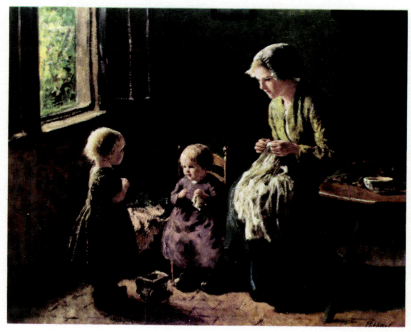

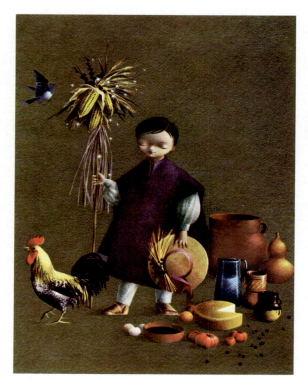

Alejandro Rangel Hidalgo *(Mexican, 1923-)*
GOING TO MARKET
4119 - 15¾"x12" (40x30 cm)
2019 - 7¾"x6" (19x15 cm)

Alejandro Rangel Hidalgo
THE LITTLE BIRD VENDOR
4120 - 15¾"x12" (40x30 cm)
2020 - 8"x6" (20x15 cm)

Alejandro Rangel Hidalgo
THE LITTLE FRUIT VENDOR
4141 - 15½"x12½" (39x32 cm)
2041 - 7¾"x6¼" (19x16 cm)

Alejandro Rangel Hidalgo
THE LITTLE FLOWER VENDOR
4142 - 15½"x12½" (39x32 cm)
2042 - 7¾"x6¼" (19x16 cm)

Alejandro Rangel Hidalgo
LA MADONA DE GUADALUPE, 1962
Private Collection
7143 - 20"x27½" (51x70 cm)
4143 - 11"x15¼" (28x39 cm)
2143 - 7¾"x11¼" (19x28 cm)

Juan Ferrandiz Castells *(Spanish, 1917-)*
HOLY NIGHT, 1963
4503 - 14"x10¼" (35x26 cm)

Juan Ferrandiz Castells
ADORATION, 1963
Private Collection
4502 - 14"x10¼" (35x26 cm)

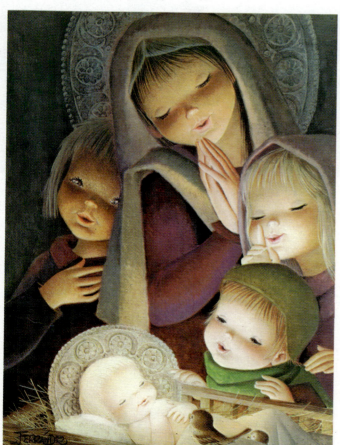

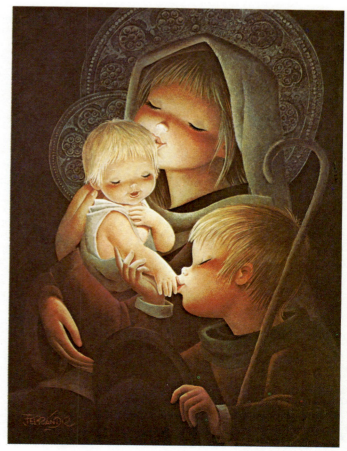

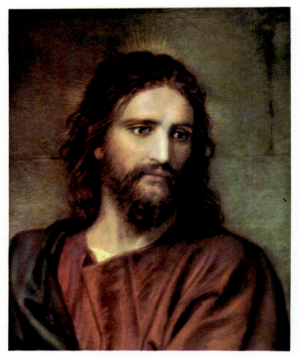

Heinrich Hofmann (German, 1824-1911)
CHRIST AT THIRTY THREE (Detail from
"Christ and the Rich Young Ruler")
The Riverside Church, New York
5718 - 20"x16" (50x40 cm)

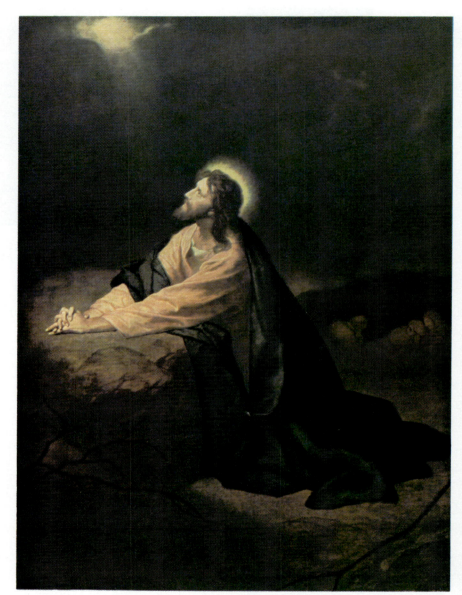

Heinrich Hofmann
CHRIST IN THE GARDEN OF GETHSEMANE
The Riverside Church, New York
6716 - 24"x17½" (61x44 cm)
5719 - 20"x14½" (51x36 cm)

Heinrich Hofmann
CHRIST AT TWELVE
(Detail from "Christ in the Temple")
The Riverside Church, New York
5738 - 20"x16" (50x40 cm)

Heinrich Hofmann
CHRIST AND THE RICH YOUNG RULER
The Riverside Church, New York
9717 - 27"x36" (68x91 cm)
6717 - 19"x24" (48x61 cm)

Heinrich Hofmann
CHRIST IN THE TEMPLE, *1871*
The Riverside Church, New York
9736 - 27"x36" (68x91 cm)
3095 - 7"x9½" (17x24 cm)

Henry Lerolle (French, 1848-1929)
THE ARRIVAL OF THE SHEPHERDS
5392 - 15¾"x20" (40x51 cm)
3133 - 8½"x10½" (21x26 cm)

Karl Hermann Fritz von Uhde (German, 1848-1911)
HIS OMNIPRESENCE
6720 - 18¾"x23½" (47x59 cm)

Roberto Ferruzzi (Italian, 1853-1934)
MADONNINA
3166 - 10"x7¾" (25x19 cm)

Edouard Brandon (French, 1831-1897)
HEDER
Israel Museum, Jerusalem
5300 - 13¾"x18" (35x45 cm)

438

Lauren Ford *(American, 1891-1973)*
THE GUARDIAN ANGEL
7192 - 26″x19½″ (66x49 cm)
3192 - 11¾″x9¼″ (30x23 cm)

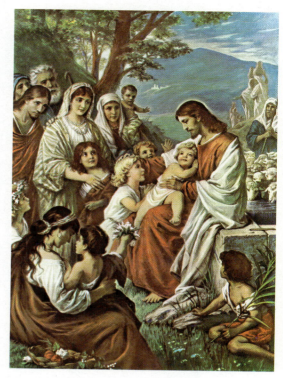

Bernhard Plockhorst *(German, 1825-1907)*
JESUS BLESSING THE CHILDREN
5390 - 20″x14¼″ (51x36 cm)
3132 - 10½″x7½″ (26x19 cm)

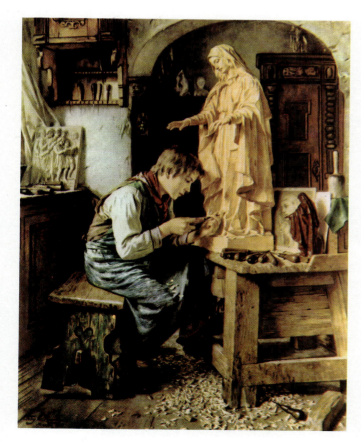

Toby Edward Rosenthal *(American, 1848-1917)*
HIS MADONNA, *1908*
California Palace of the Legion of Honor, San Francisco
6842 - 24½″x19″ (62x48 cm)
4842 - 13½″x10½″ (34x26 cm)

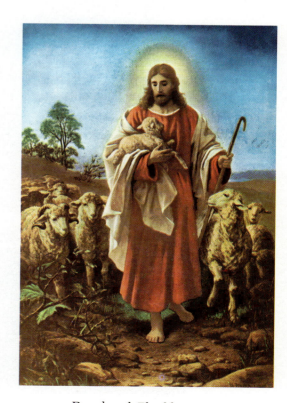

Bernhard Plockhorst
THE GOOD SHEPHERD
3130 - 10″x7″ (25x17 cm)

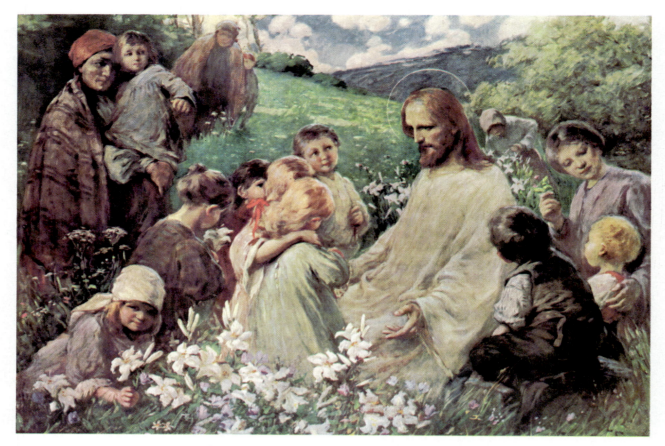

Endre Komaromi-Kacz *(Hungarian, 1880-1948)*
CHRIST AND THE LITTLE CHILDREN, *1917*
National Gallery, Budapest

4004 - 9¾"x14" (24x35 cm)

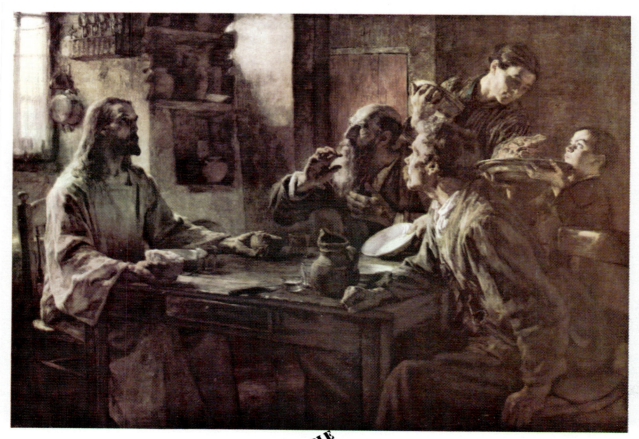

Léon Augustin L'Hermitte *(French, 1844-1925)*
THE SUPPER AT EMMAUS, *1892*
Museum of Fine Arts, Boston
8020 - 23¼"x33¾" (58x86 cm)

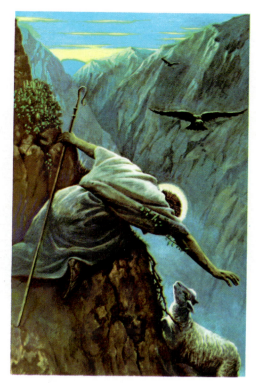

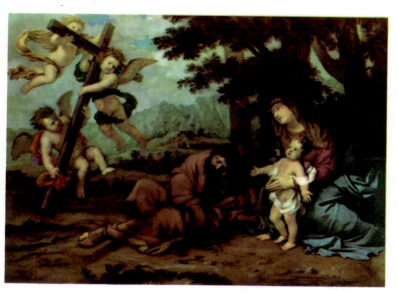

Alfred Soord (English, 1869-1915)
THE LOST SHEEP
5391 - 20"x12½" (51x31 cm)

Anton Raphael Mengs (German, 1728-1799)
REST ON THE FLIGHT INTO EGYPT, undated
Private Collection
7027 - 19"x25¾" (48x65 cm)

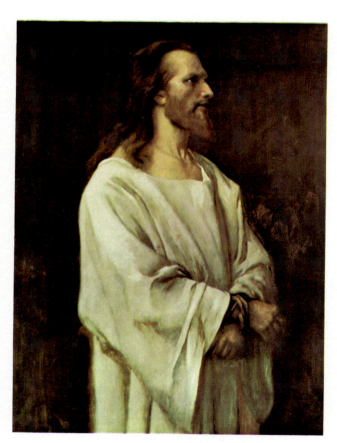

Mihály Munkácsy (Hungarian, 1844-1900)
THE SAVIOUR, 1880
Museum of Fine Arts, Budapest
8671 - 31¾"x23½" (80x59 cm)
6671 - 24"x17¾" (61x45 cm)
4671 - 14"x10¼" (35x26 cm)

Léon Augustin L'Hermitte
HEAD OF CHRIST (Detail from "Supper at Emmaus")
Museum of Fine Arts, Boston
5150 - 20"x16" (51x40 cm)
3150 - 10"x8" (25x20 cm)

441

Heinrich Hofmann
CHRIST PREACHING BY THE SEA
9738 - 22½"x35½" (57x91 cm)

George Hitchcock (American, 1850-1913)
THE FLIGHT INTO EGYPT
Private Collection
9015 - 24"x36" (61x91 cm)

After: Leonardo da Vinci (Italian, 1452-1519)
THE LAST SUPPER, 1497
Santa Maria delle Grazie, Milan
9737 - 20¾"x40" (52x101 cm)
7737 - 15½"x30" (39x76 cm)
5737 - 10¼"x20" (26x50 cm)

John Wheat (American, 1920-)
SUMMER WINDS
9718 - 20"x36" (51x91 cm)

Frank K. M. Rehn, N.A. (American, 1848-1914)
IN THE GLITTERING MOONLIGHT, undated
The Corcoran Gallery of Art, Washington, D.C.
9654 - 24"x36" (61x91 cm)

Walter Andrews (American, 1907-1969)
INCOMING COMBERS
7855 - 16"x30" (40x76 cm) (detail)

443

Walter Andrews
BREAKING SURF, *1939*

7693 - 16″x30″ (40x76 cm) *(detail)*

Walter Andrews
BLUE GULF STREAM

7854 - 16″x30″ (40x76 cm) *(detail)*

Dalhart Windberg *(American, 1933-)*
SAND DUNES, *1978*
Private Collection
9051 - 24"x36" (60x91 cm)

Benjamin Williams Leader
THE SANDY MARGIN OF THE SEA, *1890*
The Forbes Magazine Collection, New York
9666 - 24"x36" (61x91 cm)
5504 - 12"x18" (30x46 cm)

Suzy Aalund
WINDSWEPT DUNES
Private Collection
8261 - 9¾″×35¾″ (24×91 cm)

Suzy Aalund *(Contemporary American)*
SUMMER BREEZES
Private Collection
7931 - 23¾″×23¾″ (60×60 cm)
5512 - 14½″x14½″ (37x37 cm)

Suzy Aalund
SUNSWEPT DUNES
Private Collection
9067 - 23½″x35½″ (60x90 cm)
5513 - 11¾″x18″ (30x46 cm)

Stephen Hustvedt (*American, 1925- *)
I REMEMBER—IT WAS MARCH . . .
Private Collection
9055 - 22″×36″ (56×91 cm)

Dana Noble (*American, 1915- *)
AFTERNOON AT FALMOUTH
Private Collection
7943 - 20″x30″ (51x76 cm)

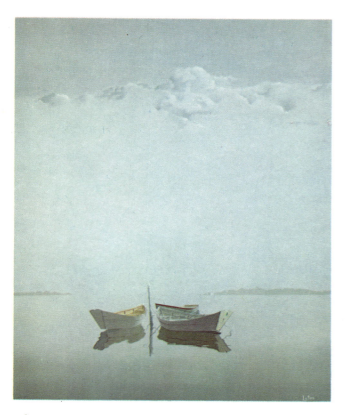

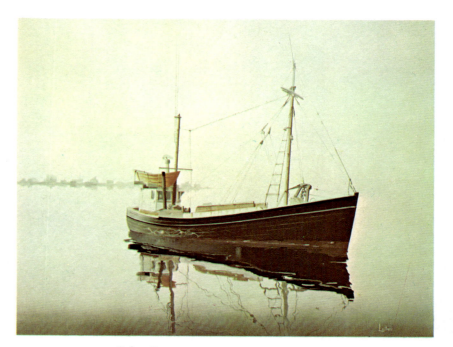

John Lutes (*American, 1926- *)
THREE DORIES
Artists Guild and Gallery, Charlestown, R.I.
8859 - 30″x24″ (76x61 cm)
5502 - 18″x14¼″ (46x36 cm)

John Lutes
JERRY JIMMY
Private Collection
7390 - 24″x30″ (60x76 cm)

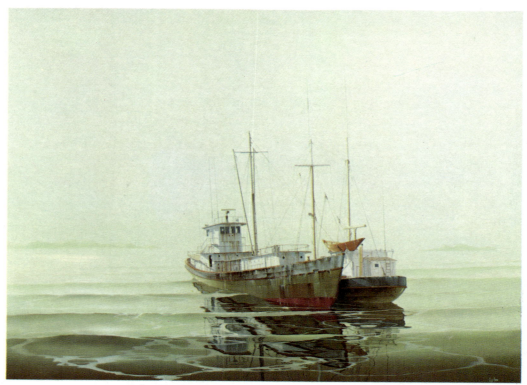

John D. Lutes
EBB TIDE
Private Collection
7971 - 22″x30″ (56x76 cm)

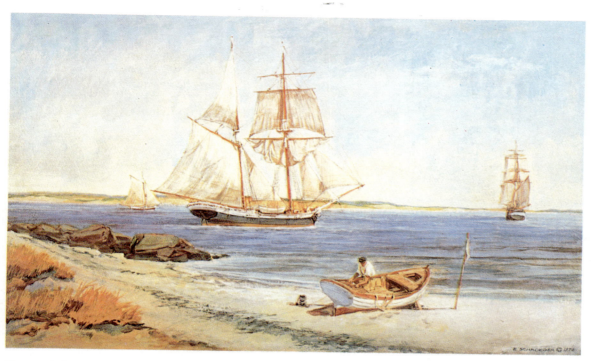

Ernest Schroeder (Contemporary American)
TOPSAIL SCHOONER, 1978
Collection of the Artist
8397 - 18"x30" (46x76 cm)

Howard Connolly (Contemporary American)
GULLS AT SEA
Private Collection
6661 - 20¼"x24¼" (51x61 cm)

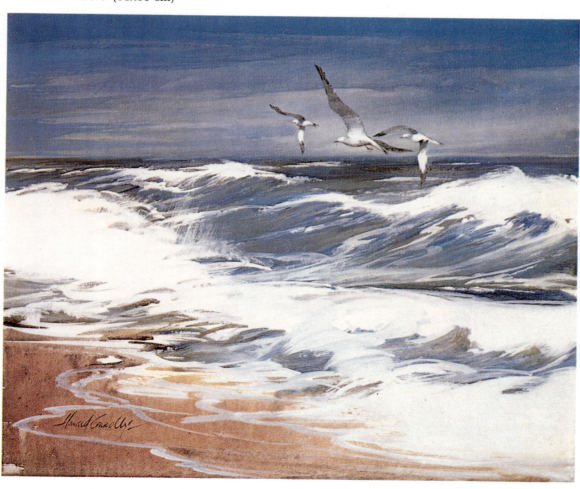

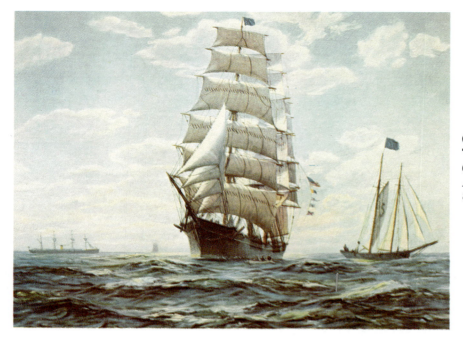

Charles Robert Patterson *(American, 1878-1958)*
THE "HENRY B. HYDE"
Collection of Columbian Rope Company
Auburn, N.Y.
8856 - 24"x32" (61x81 cm)

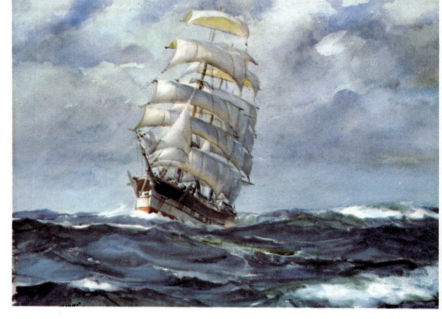

James Sessions *(American, 1882-1962)*
ROUNDING THE HORN
Private Collection
6865 - 20"x25" (50x63 cm)

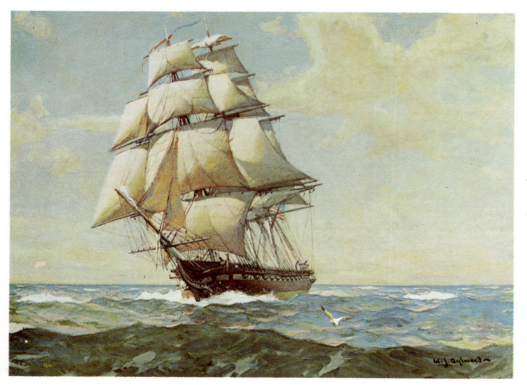

William James Aylward *(American, 1875-1956*
U.S.S. "CONSTITUTION"
8678 - 24"x32" (61x81 cm)

Vern Broe *(Contemporary American)*
THE DORY
Private Collection
7919 - 15¼"x30" (39x76 cm)

Paule Stetson Loring *(American, 1899-1968)*
A GLOUCESTER SWORDFISHERMAN
Private Collection
7815 - 22"x30" (55x76 cm)

Robert Wesley Amick *(American, 1879-1969)*
THE BOUNDING MAIN
7139 - 22½"x30" (57x76 cm)

James M. Sessions
FISHERMAN'S WHARF
Private Collection
7561 - 22"x28" (56x71 cm)

James M. Sessions
READY TO SAIL
Private Collection
7563 - 22"x28" (56x71 cm)

James Sessions
MISTY MORNING
7063 - 20″x26½″ (51x67 cm)
5510 - 13½″x18″ (34x46 cm)

James Sessions
OUTWARD BOUND
7062 - 20″x26½″ (51x67 cm)
5511 - 13½″x18″ (34x46 cm)

James Sessions
A GOOD BREEZE
7064 - 20″x26½″ (51x67 cm)

Pierre Jaques (Swiss, 1913-)
YACHT BASIN, GENEVA
Private Collection
7066 - 21"x26½" (53x67 cm)

Raymond Wintz (French, 1884-1956)
FISHING BOATS
6492 - 21½"x17½" (55x44 cm)

Raymond Wintz
THE BLUE DOOR
7999 - 30"x24" (76x61 cm)

Lt. Mitchell Jamieson, U.S.N.R. *(American, 1915-)*
GRAY MORNING
5085 - 12"x18" (30x46 cm)

Lt. Mitchell Jamieson, U.S.N.R.
CONVOY ENTERING MERS-EL-KEBIR
5086 - 12"x18" (30x46 cm)

Lt. Dwight Shepler, U.S.N.R. *(American, 1905-)*
UNLOADING OPERATIONS
5087 - 12"x18" (30x46 cm)

Lt. Albert K. Murray, U.S.N.R. *(American, 1906-)*
GEORGETOWN, GREAT EXUMA, B.W.I.
5088 - 12"x18" (30x46 cm)

Lt. Dwight Shepler, U.S.N.R.
TULAGI SECURED
6044 - 16"x24" (41x61 cm)

Lt. Dwight Shepler, U.S.N.R.
TASK FORCE OF TWO NAVIES
6039 - 16"x24" (41x61 cm)

Lt. Dwight Shepler, U.S.N.R.
NIGHT ACTION OFF SAVO
(Battle of Guadalcanal, Nov. 13-15, 1942)
6043 - 16"x24" (41x61 cm)

Lt. Albert K. Murray, U.S.N.R.
ALIGNING
6089 - 14"x21" (35x53 cm)

BERMUDA SCENES
by Adolph Treidler *(Contemporary American)*
4000 Series - 10"x14" (25x35 cm)

4051 - SNUG HARBOR

4052 - POINSETTIA TERRACE

4053 - VILLAGE LANE

4055 - COUNTRY INN

4056 - BLUE BAY

4054 - SUNNY MORNING

W. Lee Hankey *(British, 1869-1952)*
FISHERMAN'S COVE
8639 - 26"x31" (66x79 cm)

Louis Rosan (French, 1926-)
LITTLE HARBOR IN BRITTANY
Private Collection
7224 - 21"x28½" (53x72 cm)

Louis Rosan
LA ROCHELLE
Private Collection
7225 - 21"x28½" (53x72 cm)

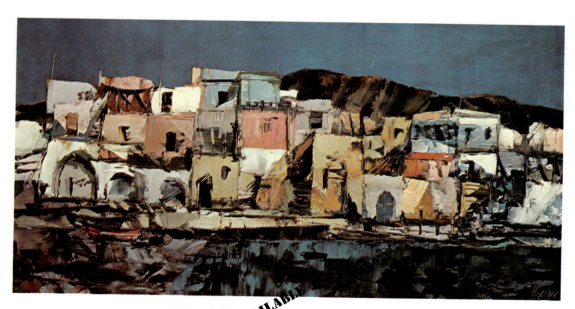

Miguel Ibarra Roca
LITTLE HARBOR *(Ibiza)*
9076 - 20½"x39¼" (52x99 cm)

457

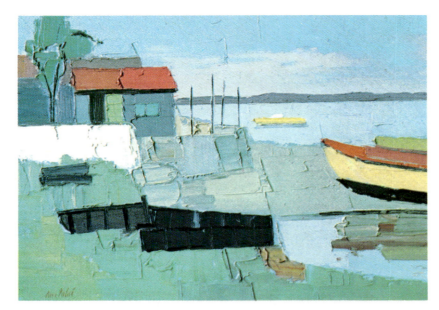

Pierre Palué (French, 1920-)
COASTLINE AT ARCACHON
Private Collection
7489 - 22x30" (56x76 cm)

Pierre Palué
APPROACHING TWILIGHT, ARCACHON
Private Collection
7490 - 22x30" (56x76 cm)

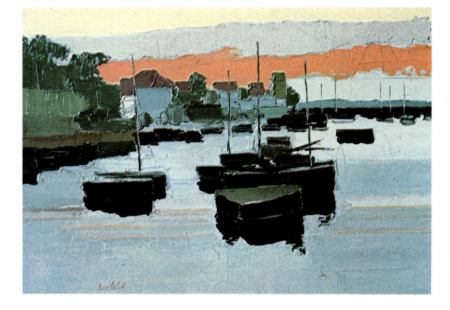

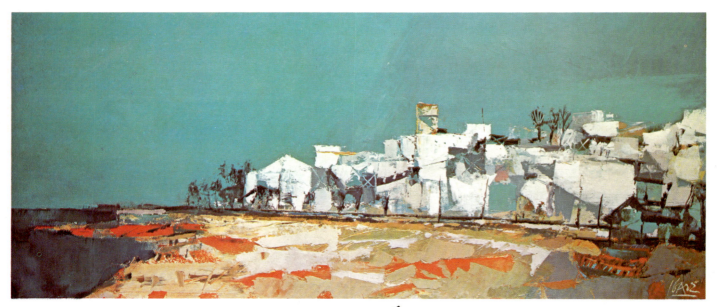

Miguel Ibarz Roca (Spanish, 1920-)
COSTA CATALANA, S. POL., 1962
Private Collection
9075 - 17¼x39¼" (44x99 cm)

John Haymson (*American, 1914-*)
POROS HARBOR, GREECE, *1967*
Private Collection
9543 - 31¼″x36″ (79x91 cm)

John Haymson
MEDITERRANEAN VILLAGE, *1968*
Private Collection
9629 - 30″x36″ (76x91 cm)

Frans Van Lamsweerde
RUSTIC GLEN, *1969*
Private Collection
9668 - 27½"x36" (69x91 cm)

Frans Van Lamsweerde
MEDITERRANEAN FANTASY, *1969*
Private Collection
9667 - 36"x27½" (91x69 cm)
5246 - 20"x15¼" (58x38 cm)

Frans Van Lamsweerde
THE TOURNAMENT, *1969*
Private Collection
9669 - 36"x27½" (91x69 cm)
5248 - 20"x15¼" (50x38 cm)

Frans Van Lamsweerde *(Dutch, 1924-1969)*
WATERFRONT, *1968*
Private Collection
9649 - 28"x36¾" (71x93 cm)
5249 - 15¼"x20" (38x50 cm)

Frans Van Lamsweerde
PORT O'CALL, *1967*
Private Collection
9648 - 25¾"x37¾" (65x95 cm)
5247 - 15¼"x20" (38x50 cm)

Nissan Engel (*Israeli, 1931-*)
EL PICADOR, *1961*
Alfred Reyn Galleries, New York
7799 - 21"x29¾" (53x75 cm)

Nissan Engel
DON QUIXOTE
Private Collection
7801 - 28"x21" (71x53 cm)

Nissan Engel
HORSEMAN, *1970*
Private Collection
7716 - 28"x21¾" (71x55 cm)

Pedro Clapera (Spanish, 1906 -)
BUFFALO
Private Collection
6328 - 19"x24" (48x61 cm)

Pedro Clapera
THE BLACK BULL
Private Collection
6329 - 19"x24" (48x61 cm)

Juan Giralt Lerin (Spanish, 1909-)
GYPSY DANCE, 1962
Private Collection
6336 - 24"x19½" (61x49 cm)

Juan Giralt Lerin
SPANISH DANCE, 1962
Private Collection
6335 - 24"x19½" (61x49 cm)

Armando Miravalls Bové (Spanish, 1916-)
STREET DANCING, SEVILLE, 1962
Private Collection
7661 - 16½"x30" (42x76 cm)

R. Riera Rojas *(Spanish, 1913-)*
PICADOR Y BANDERILLEROS, *1960*
Private Collection
6352 - 23¼"x24" (59x61 cm)
(Includes 2½" border)

R. Riera Rojas
EL MATADOR, *1960*
Private Collection
6353 - 23¼"x24" (59x61 cm)
(Includes 2½" border)

R. Riera Rojas
LA CUADRILLA, *1960*
Private Collection
6350 - 23¼"x24" (59x61 cm)
(Includes 2½" border)

Armando Miravalls Bove
FLAMENCO, *1962*
Private Collection
7659 - 16½"x30" (42x76 cm)

Raymond de Botton
BLUE FRAGMENTS (Alhambra, Granada, Spain), 1969
Collection of William F. Buckley, Jr., New York
8847 - 30"x23¾" (76x60 cm)

Raymond de Botton (Spanish, 1925-)
LA MER A CARREAUX, 1967
Collection of William F. Buckley, Jr., New York
9658 - 28¼"x36" (71x91 cm)

Nissan Engel
LANCERS, 1970
Private Collection
7705 - 20"x30" (50x76 cm)

Raymond de Botton *(Spanish, 1925-)*
THE BLUE CAVALIER, 1965
Collection of William F. Buckley, Jr., New York
9657 - 36"x19" (91x48 cm)

Raymond de Botton
THE WHITE HORSE
Collection of William F. Buckley, Jr., New York
8973 - 36"x22½" (91x57 cm)

Raymond de Botton *(Spanish, 1925-)*
THE BLUE SAIL
Private Collection
8952 - 25½"x32¼" (64x82 cm)

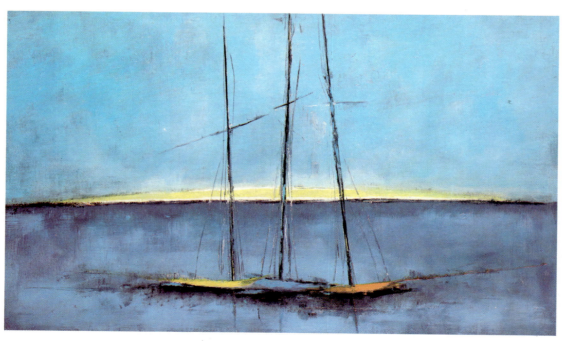

Raymond de Botton
PAINTING NO. 1: GREEK ISLAND, *1966*
Collection of Mr. and Mrs. Nathan Cummings
9636 - 24"x40" (61x101 cm)

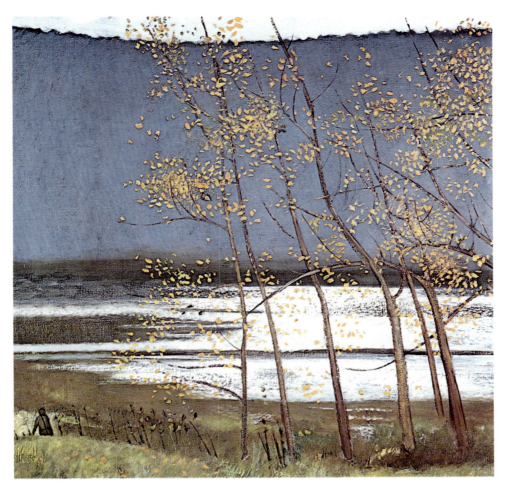

René Genis *(French, 1922-)*
LUMIERE SUR LE LAC
From The Bolger Collection
8117 - 28″x28″ (71x71 cm)

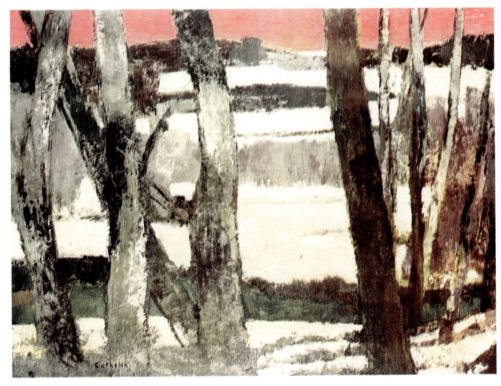

Bernard Cathelin *(French, 1919-)*
MORIN VALLEY IN THE SNOW, *1969*
David B. Findlay Galleries, New York
9972 - 27½″x35″ (69x88 cm)

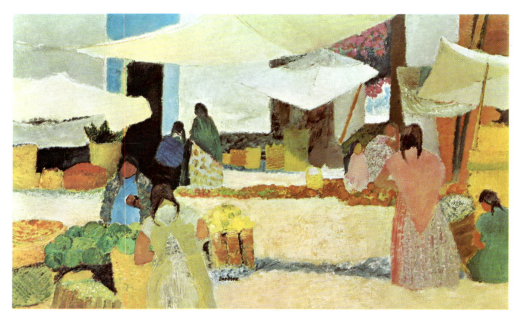

Guy Bardone
FLOWER MARKET
Private Collection
9665 - 25½"x41" (65x104 cm)

Dan Poole *(Contemporary American)*
RAINBOW BEACH, 1977
Collection of Dr. John C. Bess
8116 - 26¼"x30" (66x76 cm)

Marcella Maltais (b. Quebec, 1933-)
HYDRA EN ROSE, 1969-1972
Private Collection
6316 - 28"x21¼" (71x54 cm)

Bernard Cathelin
WINTER LANDSCAPE NEAR DAMMARTIN, 1965
Private Collection
8281 - 34"x22½" (86x57 cm)

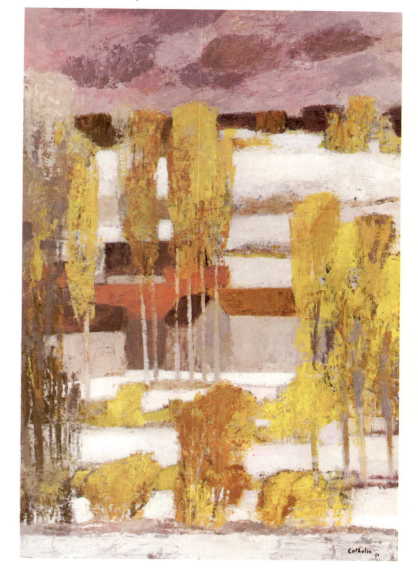

Guy Bardone
LA LOIRE A CHAUMONT, 1970
David B. Findlay Galleries, New York
7631 - 28"x22½" (71x57 cm)

J. R. Hervé (French, 1887-)
ALSATIAN LANDSCAPE (THANN)
Private Collection
8297 - 25¼"x32" (64x81 cm)

Louis Berthommé-Saint-André (French 1905-)
LES BORDS DU LEZ A CASTELNAU, 1964
Private Collection
9673 - 30"x37½" (76x95 cm)

Armando Miravalls Bové (Spanish, 1916-
MIRROR LAKE, 1966
Private Collection
9283 - 22½"x36" (57x91 cm)

J. R. Hervé
MOUNTAIN IDYLL
Private Collection
8298 - 25¼"x32" (64x81 cm)

Bernardo Sanjuan (*Spanish, 1915- *)
OLIVE TREES, MALLORCA
Private Collection
8274 - 26"x33" (66x83 cm)

Bernardo Sanjuan
LITTLE SPANISH TOWN, *1963-64*
Private Collection
9557 - 25"x35¾" (63x91 cm)

Albert Sandecki (American, 1935-)
BATEMAN'S HILL, undated
The Joseph Hirshhorn Collection
9971 - 24"x36½" (60x92 cm)

Arthur Cady (American, 1920-)
OCTOBER SKY, 1969
Private Collection
7995 - 21¾"x29¾" (55x75 cm)

Herbert Lucas (American, 1941-)
AWAITING SPRING, 1975
Private Collection
8547 - 24"x30" (61x76 cm)

Gene Pelham (*American, 1915- *)
THE COVERED BRIDGE
2510 - 6"x7½" (15x19 cm)

Gene Pelham
GREEN PASTURES
4511 - 11"x14" (28x35 cm)
2511 - 6"x7½" (15x19 cm)

Gene Pelham
TWIN PINES
4513 - 11"x14" (28x35 cm)
2513 - 6"x7½" (15x19 cm)

Gene Pelham
WAYSIDE BARN
4514 - 11"x14" (28x35 cm)
2514 - 6"x7½" (15x19 cm)

Gene Pelham
WILLOW POND
4515 - 11"x14" (28x35 cm)
2515 - 6"x7½" (15x19 cm)

Gene Pelham
HILLSIDE STREAM
4512 - 11"x15" (28x35 cm)
2512 - 6"x7½" (15x19 cm)

Pierre Jaques
SWISS VILLAGE
Private Collection
9094 - 14¾"x39¼" (37x99 cm)

Gene Pelham
VALLEY STREAM
6566 - 17"x21" (43x53 cm)

Gene Pelham
SUNNY VALLEY
9533 - 24"x36" (61x91 cm)

Gene Pelham
PEACEFUL WATERS
8534 - 25″x31″ (63x79 cm)
6534 - 17″x21″ (43x53 cm)
3534 - 9″x12″ (23x30 cm)

2010 - HORSE TROLLEY

2011 - MORNING DRIVE

2012 - NEW-FANGLED ENGINE

2013 - QUEEN OF RAILS

E. Melvin Bolstad
Series of 8
6″x8″ (15x20 cm)

2014 - RAPID TRANSIT

2015 - RIDE ON WAGON

2016 - SUNDAY RIDE

2017 - THE EXPRESS

3005 - ARRIVAL AT THE INN

3006 - COUNTRY LAWN PARTY

3007 - THE 9 O'CLOCK EXPRESS

3008 - SCHOOL'S OUT

E. Melvin Bolstad
Series of 8 - 8"x10" (20x25 cm)

3009 - SHOPPING ON MAIN STREET

3010 - THE THREE ALARMER

3017 - COUNTY FAIR

3018 - FALSE ALARM

478

Barbara Bustetter Falk
HEIDI, *1970*
Private Collection
6892 - 20"x25" (51x63 cm)

Gertrude Harbart (American, 1917-)
THE NICKEL PLATE ROAD
9016 - 17"x39½" (43x100 cm)

Melvin Bolstad
SUNDAY VISITORS
7860 - 20"x25" (50x63 cm)

John Wheat
SEPTEMBER HARVEST
9664 - 13½"x35¼" (34x89 cm)

Ken Davies
GISLER MALLARD
Private Collection
7969 - 18½"x30" (47x77 cm)

E. Melvin Bolstad
HOLIDAY PARADE
7859 - 20x25" (50x63 cm)

Jon S. Legere (American, 1944-)
WAY INSIDE
Walter von Egidy Collection
7333 - 21¼"x28" (54x71 cm)

Ken Davies *(Contemporary American)*
ANTIQUE SALE, CANADIAN GOOSE DECOY
Collection of General Mills, Inc.
6046 - 22"×28" (56×71 cm)
5538 - 14½"x18" (37x46 cm)

Jon S. Legere
NICE AND WARM
Walter von Egidy Collection
7486 - 21¼"x28" (54x71 cm)

Hubert Shuptrine (*American, 1936- *)
APPLE PLENTY, 1970
Private Collection
6013 - 19½ "x27½ " (49x69 cm)

Ronald Ekholm (*American, 1942- *)
TORN SAIL
Private Collection
7970 - 28″×28″ (71×71 cm)

Hubert Shuptrine
SEA OF SNOW, 1970
Private Collection
6014 - 19¾ "x27½ " (50x69 cm)

John Wheat (American, 1920-)
THE RED BRIDGE, 1953
9716 - 13½"x35" (34x89 cm)

Streeter Blair (American, 1888-)
MARYLAND AND PENNSYLVANIA
Collection of Mr. and Mrs. Vincent Price, Los Angeles
9688 - 25"x36" (63x91 cm)

Ethel P. Margolies (American, 1907-)
VERMONT BARN, 1969
Private Collection
9970 - 18¾"x46½" (47x118 cm)

Thomas Lloyd Ramsier *(American, 1927-)*
MAKAHA VALLEY, HAWAII
Private Collection
9660 - 30"x40" (76x101 cm)

Norma B. Green *(Contemporary American)*
SUNSET, *1971*
Private Collection
5313 - 14½"x20¼" (36x51 cm)

Norma B. Green
TROPICAL LEAVES, *1971*
Private Collection
5314 - 14½"x20¼" (36x51 cm)

Norma B. Green
NIGHTFALL, *1971*
Private Collection
5311 - 14½"x20¼" (36x51 cm)

Norma B. Green
REEDS, *1971*
Private Collection
5312 - 14½"x20¼" (36x51 cm)

484

Frederick J. Waugh
MOUNTAIN LANDSCAPE
Edwin A. Ulrich Museum of Art
Wichita State University
8110 - 20½"x30" (52x76 cm)

Paul Wenck *(American, 1892-)*
ROCKIES FROM BEAR LAKE
(Rocky Mountain National Park)
9859 - 27" x36" (68x91 cm)

Robert Wesley Amick
(American, 1879-1969)
THE INDIAN SCOUT
Private Collection
9097 - 23½"x35½" (59x90 cm)

A. Taylor (*American, 1941- *)
MARY'S MESAS, *1976*
Private Collection
9694 - 25″x36″ (63x91 cm)

A. Taylor
LINGERING BELOW
Collection of Ned and Linda Corman
8400 - 30″x30″ (76x76 cm)

Maynard Dixon (*American*)
MESAS IN SHADOWS
Collection of Brigham Young University
7539 - 22⅜″x30″ (56x76 cm)

Edgar Payne (*American, 1882-1947*)
MESA IN THE DESERT
Private Collection
8106 - 25½″x32″ (65x81 cm)

Porfirio Salinas, Jr. (*American, 1910-*)
BLUE BONNET TRAIL
8626 - 25½″x31½″ (65x80 cm)
3626 - 9″x11″ (23x28 cm)

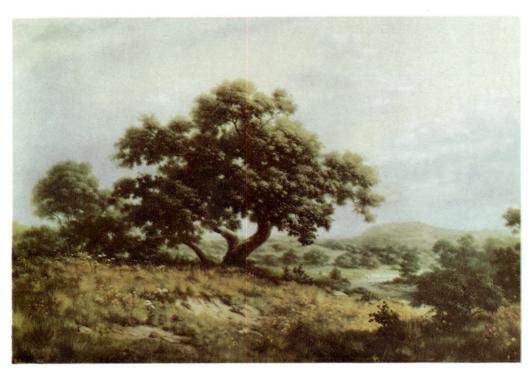

Dalhart Windberg (*American, 1933-*)
BIG TREE, *1971*
Private Collection
9050 - 24″x36″ (60x91 cm)
5522 - 12″x18″ (30x46 cm)

Porfirio Salinas, Jr.
BLUE BONNET TIME
8627 - 25½″x31½″ (65x80 cm)
3627 - 9″x11″ (23x28 cm)

Ray Strang
WESTERN SCENES
Series 3011-16 - each 7½"x10" (19x25 cm)

3011 - WILD HORSE RANCH

3012 - POPPIES AND MOMMIES

3013 - DEER AT WATER HOLE

3014 - LOST AND FOUND

3015 - SILVER CREEK

3016 - SUMMER STORM

Ray Strang *(American, 1893-1954)*
PLAYMATES
4574 - 14"x11" (35x28 cm)
2574 - 7½"x6" (19x15 cm)

Ray Strang
CURIOSITY
4575 - 14"x11" (35x28 cm)
2575 - 7½"x6" (19x15 cm)

489

Augustus V. Tack (American 1870-1949)
CANYON
The Phillips Collection, Washington, D.C.
7973 - 22"x30½" (56x76 cm)

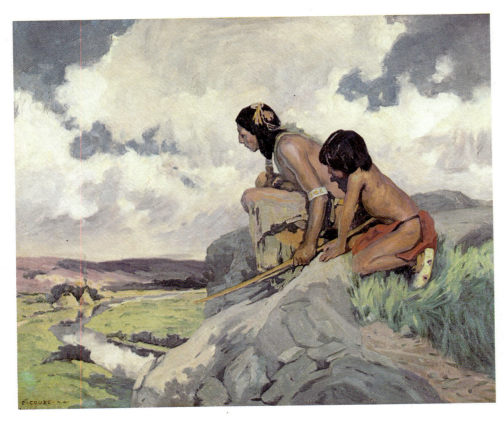

E. Irving Couse (American)
WATCHING FOR GAME
Collection of the Phoenix Art Museum
6100 - 22"x26½" (56x67 cm)

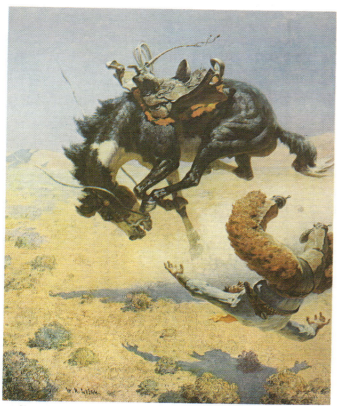

William R. Leigh (*American, 1866-1955*)
DOUBLE CROSSER
6723 - 22″x18″ (56x46 cm)

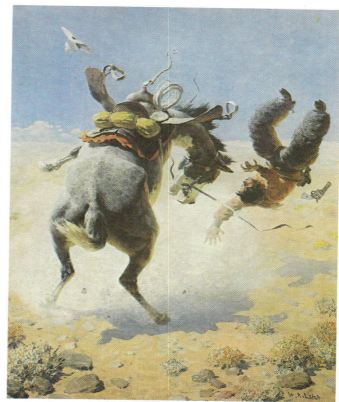

William R. Leigh
GREASED LIGHTNING
6724 - 22″x18″ (56x46 cm)

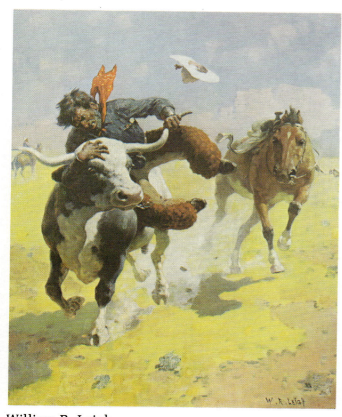

William R. Leigh
BULL DIVING
6721 - 22″x18″ (56x46 cm)

William R. Leigh
BULL DOGGING
6722 - 22″x18″ (56x46 cm)

Velino Shije Herrera *(American)*
BUFFALO HUNT
The University of Arizona Museum of Art Collection
7676 - 18"x25¼" (46x65 cm)

Blackbear Bosin *(American, 1921-)*
PRAIRIE FIRE
Philbrook Art Center, Tulsa, Okla.
7948 - 18½"x30" (47x76 cm)

Lon Megargee *(American, dates unknown)*
HOME ON THE RANCH
5932 - 16"x20" (40x51 cm)

Lon Megargee
SATURDAY NIGHT ON THE RANCH
5933 - 16"x20" (40x51 cm)
4933 - 12"x15" (30x38 cm)

Ricardo Arenys (Spanish, 1914-)
THOROUGHBREDS, 1964
Private Collection
7141 - 21"x30" (53x76 cm)

Robert Wesley Amick (American, 1879-1969)
BLACK STALLION, undated
Wilmot E. Forbes Collection
7904 - 22½"x30" (57x76 cm)

Ricardo Arenys
AUTUMN ADORN, 1963
Private Collection
9047 23"x46" (58x116 cm)

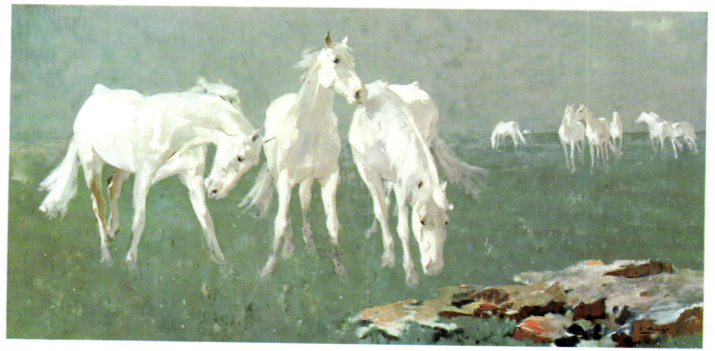

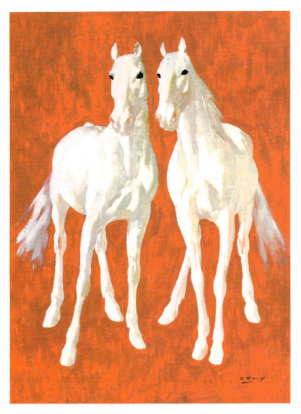

Ricardo Arenys
WHITE THOROUGHBREDS, 1965
Private Collection
8046 - 31½"x23" (80x58 cm)
4605 - 14"x10¼" (35x26 cm)

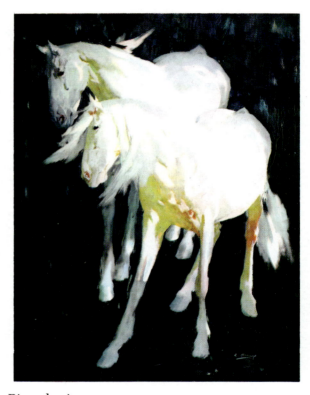

Ricardo Arenys
WHITE HORSES, 1962
Private Collection
8047 - 31½"x23" (80x58 cm)
4604 - 14"x10¼" (35x26 cm)

Ricardo Arenys
HORSES AGAINST A BLUE BACKGROUND, 1966
Private Collection
8272 - 31½"x23½" (78x59 cm)

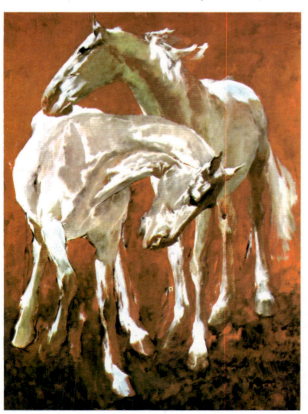

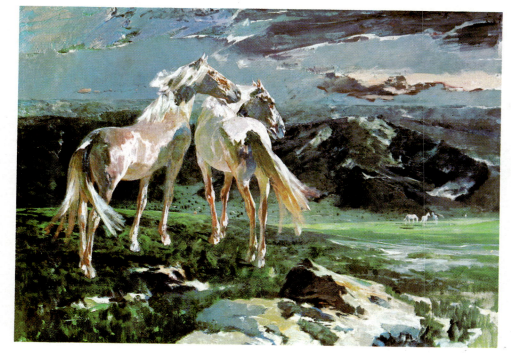

Ricardo Arenys
HORSES IN THE FOOTHILLS
Private Collection
7137 - 22¾"x30" (57x76 cm)

Ricardo Arenys
IN THE PASTURE, *1963*
Private Collection
9048 - 16¼"x39¾" (41x101 cm)

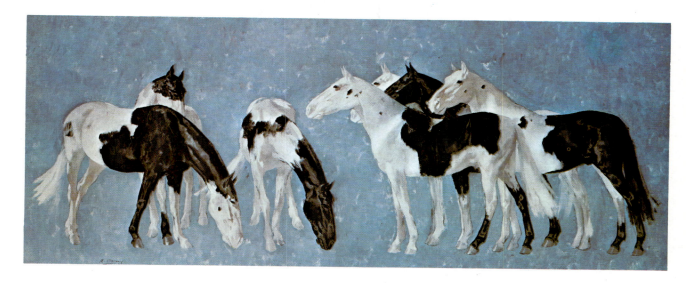

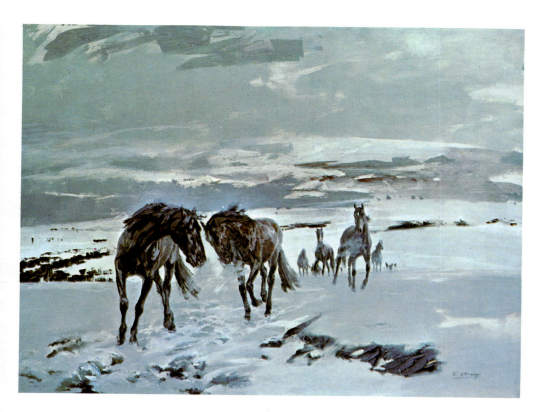

Ricardo Arenys
SNOW ON THE RANGE
Private Collection
7138 - 25¼"x30" (64x76 cm)

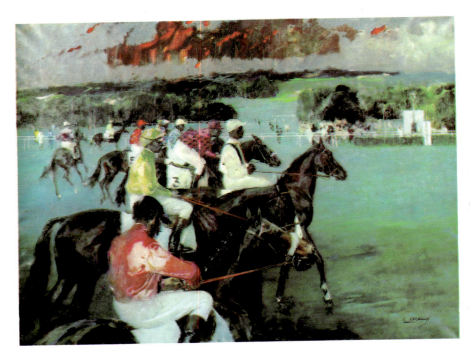

Ricardo Arenys
AT THE START, *1966*
Private Collection
7709 - 23¾"x30" (60x76 cm)

Ricardo Arenys
ON THE RANGE
Private Collection
9049 - 16¼"×39¾" (41×101 cm)

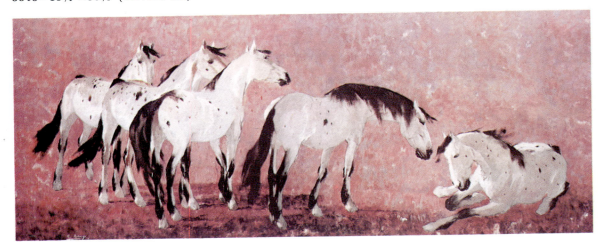

George Ford Morris *(American, 1877-1961)*
MAN O'WAR (A Study)
5371 - 17"x13" (43x33 cm)

George Ford Morris
WHIRLAWAY (A Study)
5372 - 17"x13" (43x33 cm)

Bernard Burroughs (American, 1912-)
THE HOBBY HORSE
Private Collection
7400 - 22"x28" (56x71 cm)

Sam Savitt (Contemporary American)
MALACCA, 1969
Collection of Mrs. Oliver D. Appleton
6870 - 19¾"x25½" (50x69 cm)

George Ford Morris
WHIRLAWAY
4340 - 9½"x12½" (24x31 cm)

Robert Wesley Amick
MAN O'WAR
7700 - 19¾"x26" (50x66 cm)
4700 - 11"x14" (27x35 cm)

F. J. N. Windisch-Graetz
SPANISH RIDING SCHOOL

5603 - PAS DE DEUX 1

5604 - PAS DE DEUX 2

Each reproduction 12"x18" (30x46 cm)

5605 - PAS DE TROIS 1

5606 - PAS DE TROIS 2

3608 - PASSAGE

3609 - PIROUETTE

3607 - PIAFFE

Each reproduction 12"x8½" (30x21 cm)

3611 - CAPRIOLE

3612 - VOLTE

3610 - CROUPADE

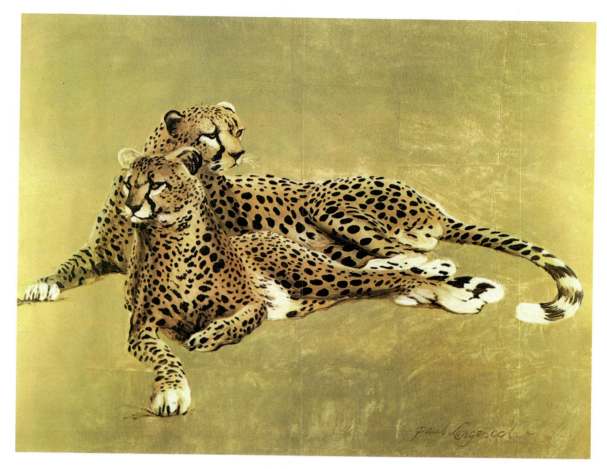

Paul O. Longenecker *(Contemporary American)*
PAIR OF CHEETAHS
Private Collection
7847 - 22"x28" (56x70 cm)

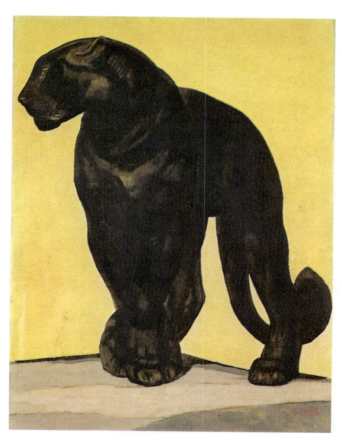

Paul Jouve *(French, 1880-1973)*
BLACK PANTHER
Private Collection
7323 - 30"x22"(76x56 cm)

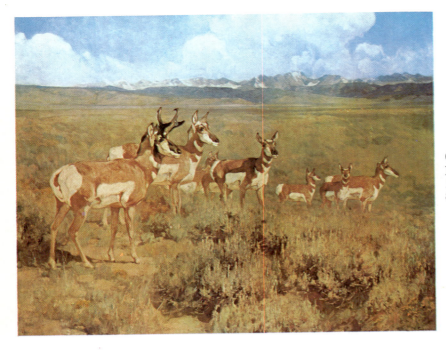

Carl Clemens Moritz Rungius *(German, 1869-1959)*
PRANGHORN ANTELOPE
New York Zoological Society
8845 - 24"x30" (60x76 cm)

A. Radclyffe Dugmore *(British, 1870-?)*
WATERHOLE NORTHERN KENYA, 1925
New York Zoological Society
9052 - 24"x36" (60x91 cm)

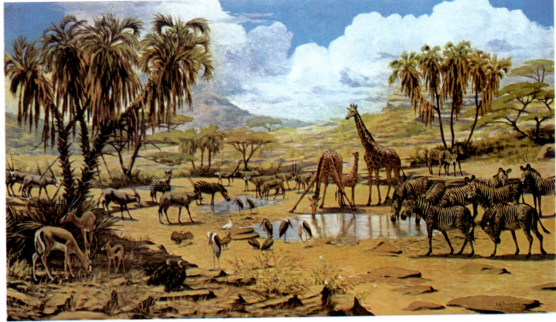

Carl Clemens Moritz Rungius
PUMA
New York Zoological Society
8846 - 24"x30" (60x76 cm)

Nan Lee (*American, 1920-*)
THE PEACEABLE KINGDOM
Private Collection
6515 - 24"x24" (61x61 cm)
5518 - 14½"x14½" (37x37 cm)

Nan Lee
THEY SHALL DWELL TOGETHER
Private Collection
7679 - 22"x26" (56x66 cm)

Robert Ravelle *(German, 1918-)*
FRIEND OR FOE?, *1970*
Private Collection
6401 - 20″x24″ (50x60 cm)

Robert Ravelle
UP A TREE, *1970*
Private Collection
6400 - 20″x24″ (50x60 cm)

Cynthia Augeri *(American, 1946-)*
GRAY SQUIRREL
Private Collection
6938 - 26″x20″ (66x51 cm)

Cynthia Augeri
SPRING FLORAL WITH SONG SPARROW
Private Collection
6915 - 26″x20″ (66x51 cm)

Cynthia Augeri
AUTUMN FLORAL WITH GOLDEN CROWN KINGLET
Private Collection
6914 - 26″x20″ (66x51 cm)

Shirley Howe *(Contemporary American)*
RED SQUIRREL WITH YELLOW PRIMROSES
Private Collection
2761 - 5″x7″ (13x18 cm)

Shirley Howe
CHIPMUNK WITH BLUEBERRIES
Private Collection
2760 - 5″x7″ (13x18 cm)

Shirley Howe
RABBIT WITH NASTURTIUMS
Private Collection
3750 - 8″x10″ (20x26 cm)

Gene Pelham (American, 1915-)
NOI, 1967
Private Collection
7343 - 28″x26″ (71x66 cm)
5546 - 14½″x13½″ (37x34 cm)

Ramon Llovet (Spanish, 1917-)
FLOWERS AND PIGEONS
Private Collection
9542 - 19½″x39¼″ (49x100 cm)

Miguel Ibarz Roca *(Spanish, 1920-)*
SPRING SONG, 1965
Private Collection
7316 - 23½"x30" (59x76 cm)

Bruce Lattig *(American, 1933-)*
GREAT HORNED OWL, 1970
Private Collection
6520 - 28"x20" (71x51 cm)
5539 - 18"x12¾" (46x32 cm)

Jessie Arms Botke *(American, 1883-)*
TROPICAL POOL
8340 - 24"x32" (61x83 cm)

Dan Poole (*American, 1942-*)
ZEBRA
Private Collection
7996 - 26″×17″ (66×43 cm)

Mara Abboud (*Contemporary American*)
THREE ZEBRAS
Private Collection
8864 - 30¼″x24″ (77x61 cm)

Hannibal Lee (*Contemporary American*)
ORPHEUS AND THE ANIMALS
Private Collection
6464 - 22″x28″ (56x71 cm)

Cecil Golding
BIRD SERIES

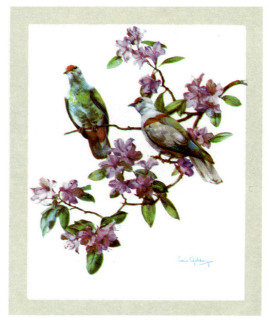

BLUE-JAY
6954 - 24½"x19½" (62x49 cm)
4954 - 16" x12" (40x30 cm)

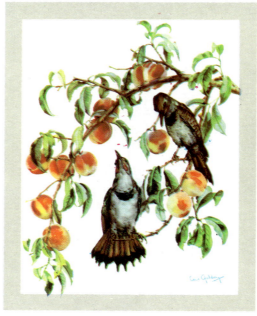

RED-SHAFTED FLICKER
4951 - 16"x12" (40x30 cm)

RED-CAPPED FRUIT DOVE
6960 - 24½"x19½" (62x49 cm)
4960 - 16"x12" (40x30 cm)

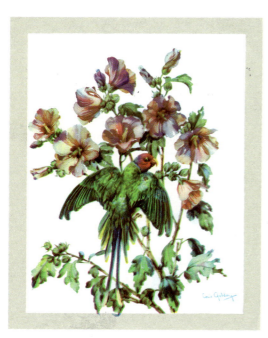

BLOSSOM-HEADED PARAKEET
6955 - 24½"x19½" (62x49 cm)
4955 - 16"x12" (40x30 cm)

YELLOW-BILLED CUCKOO
6952 - 24½"x19½" (62x49 cm)

ROSE-BREASTED GROSBEAK
6953 - 24½"x19½" (62x49 cm)

Cecil Golding *(Contemporary American)*
BALTIMORE ORIOLE
4958 - 16"x12" (40x30 cm)

Anthony La Paglia *(American, active 1952)*
BLUE-JAY
6366 - 22½"x18½" (57x47 cm)

Anthony La Paglia
CARDINAL
6365 - 22½"x18½" (57x47 cm)

Travis Keese (*American, 1932-*)
WILD TURKEY
Private Collection
7941 - 20″x30″ (51x76 cm)

Travis Keese
WHITE TAIL DEER
Private Collection
7942 - 20″x30″ (51x76 cm)

Ernest Hart *(American, 1910-)*
DOG SERIES
6382-84 - each 16″x22″ (40x56 cm)

Bruce Lattig
PHEASANT HOLDING, 1969
Private Collection
6519 - 20½″x29″ (52x73 cm)

6384 - COCKER SPANIELS

6382 - ENGLISH SETTERS

6383 - POINTERS

Bruce Lattig
PHEASANT JUMPING, 1969
Private Collection
6518 - 29″x21″ (73x53 cm)

511

Bruce Lattig
MALLARDS STRAIGHT ON, *1969*
Private Collection
6517 - 21"x29" (53x73 cm)

James Sessions *(American, 1882-1962)*
PHEASANT HUNTING
Collection Mr. and Mrs. Richard Maitzen
8843 - 24"x36" (61x91 cm)

James M. Sessions
GROUSE SHOOTING
Private Collection
7562 - 20"x26" (51x66 cm)

James M. Sessions
TROUT STREAM
Private Collection
7564 - 20"x26" (51x66 cm)

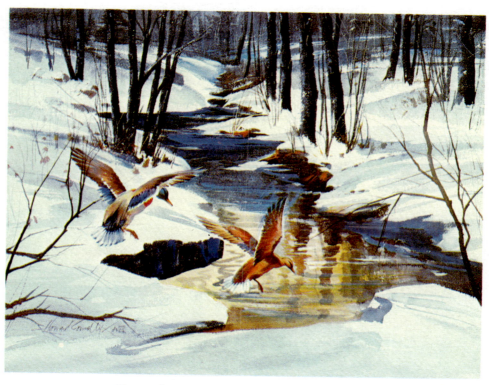

Howard Connolly
DUCKS LANDING
Private Collection
7622 - 22¼"x28¼" (56x71 cm)

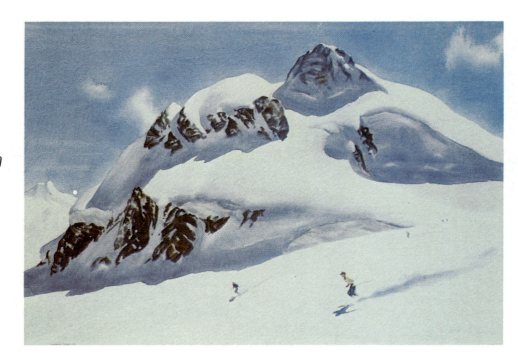

Dwight Shepler *(American, 1905-)*
ON THE GLACIER
5432 - 14″x20″ (35x51 cm)

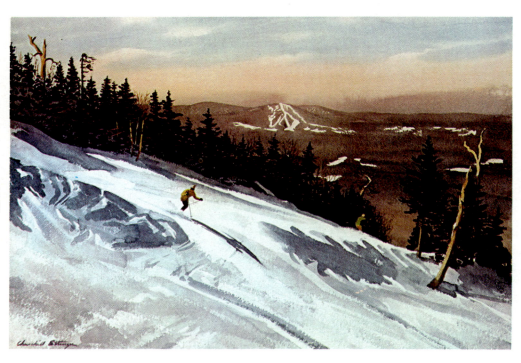

Churchill Ettinger *(American, 1903-)*
THE CHOICE, 1970
Private Collection
7308 - 20½″x28½″ (52x72 cm)

Dwight Shepler
POWDER SNOW
5433 - 14″x20″ (35x51 cm)

Hervé Baille (French, 1896-)
PLACE DE LA CONCORDE
Private Collection
4090 - 9¼″x14″ (23x35 cm)

Hervé Baille
BOOKSELLERS AT NOTRE DAME
Private Collection
4089 - 9¼″x14″ (23x35 cm)

André Panet *(Contemporary French)*
SOUVENIR DE PARIS
9017 - 15¾″x36″ (40x91 cm)

Henry Dentith *(British, 1931-)*
JERUSALEM
Private Collection
9303 - 25½″x39¼″ (64x99 cm)

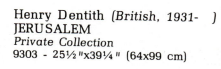

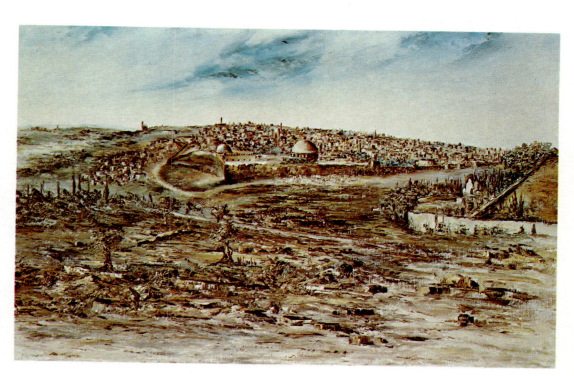

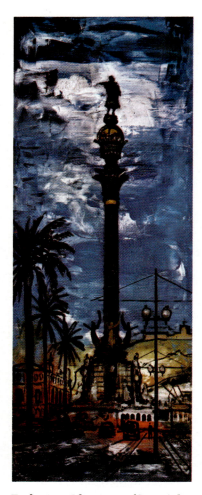

Federico Lloveras
CASTEL S. ANGELO, ROME
8537 - 25¼"x33¾" (64x86 cm)
4537 - 12"x16" (30x40 cm)

Federico Lloveras *(Spanish, 1912-)*
COLUMBUS MONUMENT, BARCELONA
8643 - 31½"x12¼" (80x31 cm)

Federico Lloveras
GIRALDA, SEVILLA
8645 - 31½"x12¼" (80x31 cm)

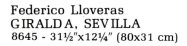

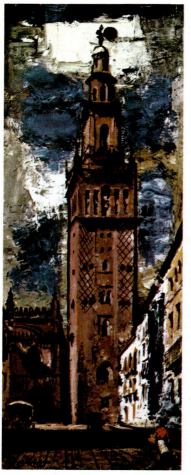

Dean Ellis *(American, 1920-)*
EVENING, SPAIN, *undated*
The Columbus Gallery of Fine Arts
Columbus, Ohio
7800 - 20"x30¼" (51x77 cm)

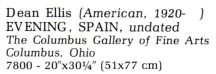

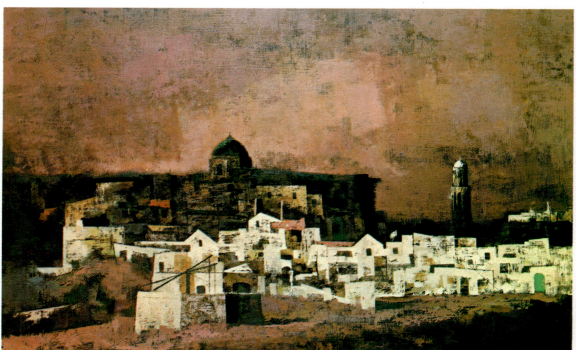

Federico Lloveras
ST. PETER'S SQUARE, ROME
8538 - 25¼"x33¾" (64x86 cm)
4538 - 12"x16" (30x40 cm)

Federico Lloveras
LA TOUR EIFFEL
8646 - 31½"x12¼"
(31 cm)

Federico Lloveras
SAN MARCO, VENEZIA
8644 - 31½"x12¼"
(80x31 cm)

Federico Lloveras
THE BAY OF NAPLES
8533 - 25"x33¾" (64x86 cm)

Federico Lloveras
SORRENTO
9042 - 17¼"x39¾" (44x101 cm)

Federico Lloveras
VENICE
9083 - 13½"x39¼" (34x99 cm)

Federico Lloveras
PARIS, ILE DE LA CITE, 1963
Private Collection
9037 - 17¼"x39¼" (44x99 cm)

518

Federico Lloveras
BAY OF PALMA DE MALLORCA
8539 - 25¼"x33¾" (64x86 cm)
4539 - 12"x16" (30x40 cm)

Federico Lloveras
PARTHENON, ATHENS
8540 - 25¼"x33¾" (64x86 cm)
4540 - 12"x16" (30x40 cm)

Federico Lloveras
LOIRE: CHATEAU D'AMBOISE
9025 - 13½" x39" (34x99 cm)

Federico Lloveras
PARIS, LE PONT NEUF, 1963
Private Collection
9036 - 17¼" x39¼" (44x99 cm)

Federico Lloveras
WINDSOR CASTLE, 1963
Private Collection
9039 - 17¼" x39¼" (44x99 cm)

Federico Lloveras
SAN FRANCISCO-OAKLAND BRIDGE, *1962*
Private Collection
9030 - 17¼"x39½" (44x100 cm)

Federico Lloveras
LONDON, HOUSES OF PARLIAMENT, *1963*
Private Collection
9038 - 17¼"x39¼" (44x99 cm)

Federico Lloveras
NEW ORLEANS, *1962*
Private Collection
9029 - 14¾"x39½" (37x100 cm)

Federico Lloveras
CHICAGO SKYLINE, *1962*
Private Collection
9033 - 13¼"x39½" (33x100 cm)

Federico Lloveras
WASHINGTON, D.C., *1962*
Private Collection
9034 - 17¼"x39½" (44x100 cm)

Federico Lloveras
NEW YORK, LOWER MANHATTAN, *1962*
Private Collection
9031 - 17¼"x39½" (44x100 cm)

Frederick Franck
DOWNTOWN RHYTHMS. NEW YORK
5298 - 14"x20" (35x51 cm)

Federico Lloveras
NEW YORK, WALL STREET, 1962
Private Collection
8628 - 31½"x12½" (80x32 cm)

Federico Lloveras
CHICAGO, FINANCIAL DISTRICT, 1962
Private Collection
8629 - 31½"x12½" (80x32 cm)

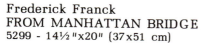

Frederick Franck
FROM MANHATTAN BRIDGE
5299 - 14½"x20" (37x51 cm)

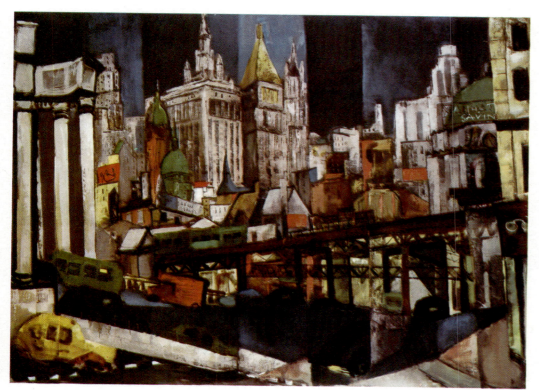

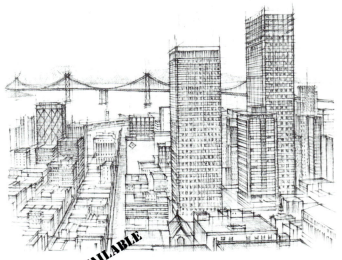

7902 - SAN FRANCISCO

Eric Nivelle (French, 1940-)
Pencil sketch reproductions
Signed by the artist
Limited to 300 copies
Average size 30¼"x24"

8839 - NEW YORK EAST RIVER DRIVE

7903 - SAN FRANCISCO BAY BRIDGE

8837 - NEW YORK EAST RIVER FRONT

Vernon Howe Bailey *(American, 1874-1953)*
METROPOLIS
6811 - 20″x24″ (50x60 cm)

Vernon Howe Bailey
MAGIC CITY
6812 - 20″x24″ (51x61 cm)

Ferruccio Steffanutti
PARIS: PONT NEUF, *1960*
Private Collection
9964 - 24"x36" (61x91 cm)
4645 - 10½"x16" (26x40 cm)

Ferruccio Steffanutti
ROME: FONTANA DEL MORO, *1965*
Private Collection
9965 - 24"x36" (61x91 cm)
4643 - 10½"x16" (26x40 cm)

Ferruccio Steffanutti
ROME: TEMPLE OF ROMULUS, *1964*
Private Collection
9967 - 24"x36" (61x91 cm)
4644 - 10½"x16" (26x40 cm)

Ferruccio Steffanutti (Italian, 1928-1969)
VENICE: VECCHIO SQUERO, 1965
Private Collection
9969 - 36"x24" (91x61 cm)
4642 - 16"x10½" (40x26 cm)

Ferruccio Steffanutti
ROME: FORO ROMANO, 1964
Private Collection
9966 - 36"x24" (91x61 cm)
4640 - 16"x10½" (40x26 cm)

Ferruccio Steffanutti
VENICE: VECCHIO RIO, 1966
Private Collection
9968 - 36"x24" (91x61 cm)
4641 - 16"x10½" (40x26 cm)

John Haymson *(American, 1914-)*
Watercolor reproductions
Signed by the Artist
Limited to 350 copies
Average size 18"x22" Each

5306 - VIEW OF THE PALACE IN THE
SCHONBRUNN PARK, AUSTRIA

5307 - OLD PART OF COPENHAGEN,
MOORING PLACE FOR FISH-
MONGERS, DENMARK

5305 - FORO DI AUGUSTO, ROME

John Haymson
THE PUBLIC LIBRARY
5293 - 15"x18½" (38x47 cm)

John Haymson
ROCKEFELLER PLAZA
5294 - 15"x18½" (38x47 cm)

REPRODUCTIONS OF BLACK AND WHITE PHOTOGRAPHS

REDWOOD FOREST
Photography by N. R. Farbman
BW7002 - 30" x 24"

SNOWBERRIES
Photography by Carl Iwasaky
BW5007 - 14" x 18"

JULY 1960
Photography by Frank Walker
BW5006 - NO LONGER AVAILABLE 14"

MONTANA RIDER
Photography by Robert W. Kelley
BW5005 - 14" x 18"

SAN JOAQUIN HILLS
Photography by Otto Hagel
BW7003 - 24" x 30"

SNOWY OWL
Photography by Howard Sochurek
BW6002 - 20" x 16"
BW5002 - 18" x 14"

OLYMPIC PENINSULA
Photography by Loomis Dean
BW7000 - 24" x 30"
BW5000 - 18" x 14" *(vertical detail)*

SOLITARY REEDS
Photography by Carl Iwasaky
BW7001 - 24" x 30"

FEATHER RIVER FISHERMAN
Photography by Otto Hagel
BW6004 - 20" x 16"
BW5004 - 18" x 14"

DRIFTWOOD AT NEAH BAY
Photography by Loomis Dean
BW6003 - 20" x 16"
BW5003 - 18" x 14"

SEA WITCH
Photography by Loomis Dean
BW6001 - 20" x 16"
BW5001 - 18" x 14"

NEW YORK GRAPHIC SOCIETY
LIMITED EDITIONS

In addition to being the world's largest and most respected publisher of fine art reproductions, the New York Graphic Society has a continuing program of limited editions, returning in the 1970's to the original purpose of the company's founding in 1925 . . . as a publisher and distributor of original graphic limited editions in the traditional media of engravings, etchings, serigraphy and lithography. (During the 30's, this program was terminated to launch the formation of what is now the largest, most respected publisher of fine art reproductions in the world.) Continuing again in its original intention, the New York Graphic Society maintains an editorial policy dedicated to presenting the work of gifted printmakers. These artists represent the finest criteria of their craft . . . the internationally known, as well as many young artists who may not yet enjoy a wide reputation.

Obviously the prints illustrated here in no way represent the depth and variety of this constantly changing collection. These can be seen in the permanent showroom galleries in New York, Chicago, Dallas and High Point, or through one of our sales representatives. You may contact the Customer Service Department in our Greenwich office for further information.

Each original graphic work is accompanied by a certificate of authenticity bearing an authorized signature and stating the medium, printer, the number of authorized prints in the edition, artist's proofs, publisher's proofs, unsigned proofs and whether or not the plate was cancelled after the edition was completed.

The prints shown here are subject to prior sale.

Virgil Thrasher
CRYSTAL WATER
Serigraph in 8 colors
Ed. 250
GR6687 - 22½"x28½" paper size
18"x25" image size

NO LONGER AVAILABLE

Victor Vasarely
VEGA FEU Vert/Rouge
Serigraph in 22 colors
Ed. 267
GR6148 - 30½"x26½" paper size
23 "x23" image size

Louis Vuillermoz
LES CASIERS
Lithograph in 11 colors
ED. 150 on arches paper
GR6277 - 22"x30" paper size
19½"x25½" image size

SELECTIVE LIST OF ARTIST BIOGRAPHIES

Albright, Malvin Marr (1897-), Chicago-born, studied architecture at the University of Illinois and at the Ecole des Beaux-Arts in Nantes. Albright's paintings are traditional and strictly objective in style. He is most noted for his sculpture for which he has won several awards.

Angelico, Fra (Giovanni da Fiesole) (c. 1387-1455) was a Dominican monk who made a significant contribution to the Early Renaissance in Florence, where he was born. In 1407 he entered the monastery at Fiesole with his brother. There he began to paint, making generous use of brilliant colors and gold, and became a skillful draughtsman. In 1436 the Fiesole monks moved to Florence, to the monastery of San Marco, whose cells Fra Angelico decorated with frescoes during the years 1437 through 1452. Although his art preserved many Renaissance innovations— breadth of forms of the figures and realistic use of space—he remains much closer to the Gothic tradition; his figures never attain the sculptural quality of Masaccio and Piero della Francesca.

Antes, Horst (1937-), born in Kassel, the son of a Hessian farmer, is regarded as Germany's most powerful postwar artist, a natural link and continuer of the German Expressionist tradition. He studied at the Karlsruhe Art School and was awarded the Grand Prix of Hanover. At the age of 24 he held his first one-man show and, in 1966, won the UNESCO prize at the Venice Biennale. In three years Antes has held fourteen one-man shows, one of which took place in New York in 1967. Recently he worked in bronze, ceramics and watercolor.

Appel, Karel (1921-) is a self-taught Dutch painter who spent his formative years in Holland and in 1950 moved to Paris. His style is basically abstract, developed from a figurative expressionism which was practiced in Holland in the 1930's. In form and color he resembles the American Abstract Expressionists. His paintings are rich in bright, swirling colors.

Ardon, Mordecai (1896-) was born in Poland, studied in Germany under Kandinsky, Feininger and Klee, and now lives and works in Israel. He is currently the Artistic Advisor to the Israeli Ministry of Education and Culture. His works are expressionist in nature, vivid in color, and they reflect a deep emotion inspired by the biblical lands.

Arellano, Juan de (1614-1676), born in Santorcas, was the pupil of Juan de Solis. He became famous as a copyist of the flower paintings of Mario di Fiori and later became even better known for his nature studies of fruit and birds. He decorated the Sacristy for the Church of St. Jerome in Madrid, the city where he died. Arellano's paintings are highly esteemed in Spain, six of which are in the Prado.

Arikha, Avigdor (1929-) first became known for his book illustrations, lithographs and drawings. He studied with Mordecai Ardon at the Bezalel School and then in Paris where he devoted himself completely to painting. He is the first young Israeli artist to develop a genre style derived from a world of abstract imagery. The combination of static, clearly-defined forms with dynamic surfaces creates a rhythm which draws the viewer's attention, not only to the completed work but also to the manner in which it was painted. The colors, in their shaded nuances, evoke an association with an actual world.

Audubon, John James (1785-1851) was born in Haiti and raised in revolutionary France where he evidently studied briefly with David. In 1804 he came to the United States. After many unsuccessful business ventures he turned to ornithology, the study of birds, and from 1827 to 1838 his great series of engravings of birds was issued under the title *The Birds of America.* Though not an artist by profession, his engravings show a meticulous draftsmanship that gives a unique sense of life to his subjects.

Avery, Milton (1893-1965) was born in Altman, New York, and grew up in Hartford where he briefly attended the Connecticut Art Students League. Avery's landscapes are quite often compared to the style of Matisse. He applies his paint sparingly in a flat manner, handling his oil in a fashion similar to watercolor. The sensitive use of pigment causes the forms to merge, which creates, in turn, either a glowing or a subdued effect. Although Avery has never taught, younger painters such as Mark Rothko and Adolph Gottlieb have painted with him. Since 1928 his work has been regularly exhibited in museums and galleries. Among the many awards he has been given, the retrospective show circulated by the American Federation of Arts remains as an outstanding tribute to this influential American artist.

Aziz, Philip (1923-) Canadian, of Lebanese descent, Philip Aziz received both his Bachelors and Masters degrees in Fine Art from Yale University. His painstaking technique of egg tempura with specially-made pigments and carefully applied gold leaf is particularly suited to his two main themes: portraiture and religious subjects. His liturgical works are in many important churches in the United States and Canada. Meticulous draughtsmanship is combined with a strong Mannerist approach to form and space, in the 16th Century tradition. An exquisite sense of detail is shown in the two treatments of the metaphysical aspects of the pine tree shown in this catalog, elegantly combining recognizable images with abstract design. Aziz has achieved international recognition and has exhibited in England at the Royal Society of Portrait Painters, London in 1966, 1967 and 1968. In Canada, he has had a one-man retrospective exhibit at the University of Waterloo in 1967. He has exhibited at EXPO '67, the Museum of Fine Arts in Montreal and the National Gallery in Ottawa as well as a one-man show at the Gallery of Modern Art, New York, and several other major exhibitions in the United States.

Balla, Giacomo (1871/4-1958) was an Italian Futurist painter and the teacher of Boccioni and Severini. In 1910 he signed the Futurist Manifesto which set down their principles—the glorification of movement, machines, and war in modern society. Balla himself was concerned with the problem of representing movement on a flat surface.

Bardone, Guy (1927-), born in Saint-Claude, in the Franche-Comté of France, studied under Brianchon at the Ecole des Arts Decoratifs in Paris. Since 1952 he has exhibited widely, especially in Paris at the Salon d'Automne, the Salons des Jeune Peintres, and at the Galerie Marcel Guiot. His robust figurative style and strong, boldly handled color has attracted many collectors, and his works are in museums of Besancon, Poitiers, and Grenoble, among others.

Barnet, Will (1911-) is one of America's best-known painter/teachers. He was born in Beverly,

Massachusetts, studied at the Boston Museum School and the Art Students League, New York, and has taught at both institutions as well as at Cooper Union, the Pennsylvania Academy, and Yale University. In both his art and in his teaching of painting he emphasizes the formal elements of drawing and composition, and he demonstrates a clear understanding of the continuing tradition of Western art, from the Old Masters through the modern abstractionists. His first one-man show was held in New York in 1939, and he has been the subject of several retrospective exhibitions.

Baumeister, Willi (1889-1955) was a German abstract painter who, although not directly associated with the Bauhaus, developed along similar lines. In Paris, from 1912 through 1914, he was influenced by Toulouse-Lautrec, Gauguin and Cézanne, and later by Leger. In 1933, during the Nazi period, he was dismissed from his teaching post but, remaining in Germany, he was later reinstated. A sensitive artist of wide range, he painted loose, plastic compositions whose organic forms with their dark symbols resemble rubbings from old inscriptions. His richness of form and breadth of content have influenced many young painters.

Baziotes, William (1912-1963) was born in Pittsburgh, grew up in Reading, and came to New York in 1933 to study at the National Academy of Design and he himself then became a teacher in the WPA Federal Arts Project at various art centers and finally at Hunter College. His paintings were, at first, naturalistic, but by 1941 he became deeply interested in the processes of abstraction and painted in a style which had much in common with his New York contemporaries. His work of the late 1940's and the 50's, tinged with bold Surrealism, is based on a bold, abstract imagery which attains the quality of a symbol.

Bellini, Giovanni (c. 1430-1516), considered the greatest Venetian painter of the fifteenth century, was the illegitimate son of the painter Jacopo Bellini. His first works date from 1462, but he was slow to develop, and some of his finest paintings date from the late fifteenth century and even from the early years of the sixteenth century. His early style is similar to that of Mantegna, his brother-in-law, but it reveals a greater emphasis on color and light. As his style evolved he came closer to the monumental and poetic feeling of the High Renaissance in such works as *St. Francis in Ecstasy.* In 1506 Albrecht Dürer wrote that Giovanni Bellini was very old but still the greatest painter in Venice.

Bellotto, Bernardo (1720-1780) was a Venetian landscape painter, the nephew and pupil of Canaletto. For much of his life he worked abroad, in Dresden, Warsaw and Vienna, painting luminous city views in a meticulous style, very reminiscent of his uncle's. In his later years he turned to religious and historical subjects.

Bellows, George Wesley (1882-1925) was a prominent American painter who studied painting with William Chase and Robert Henri. Bellows himself taught at the Art Students League and the Art Institute of Chicago, and was one of the youngest members elected to the National Academy of Design. He was associated with the Ashcan school, known for their realistic studies of urban life, and Bellows also chose to paint the activities of the city; he is especially famous for his prizefight subjects. His later work

is more rigid. confined to landscapes and portraits.

Benson, Frank W. (1862-1951) Born in Salem, Massachusetts, he studied at the School of the Museum of Fine Arts in Boston and with Boulanger and Lefebvre in Paris. Although famous for his etchings of wild ducks, his was a diversified talent, utilizing both watercolor and oil in painting portraits, landscapes and interiors. Benson is represented in many important American museums (among them, the Corcoran Gallery, Washington, D.C.) and private collections. He has won numerous awards and medals, including the Temple Gold Medal, Pennsylvania Academy of Fine Arts and Harris Silver Medal, Art Institute of Chicago. He was elected an Associate of the National Academy in 1897 and an Academician in 1905.

Benton, Thomas Hart (1889-1975) is an American landscape and genre painter—a leader of the American regionalist painters. He was born in Missouri, the son of a senator, and he studied at the Art Institute of Chicago. He went to Paris in 1908 and was influenced for a time by Cubism. However, he developed a personal manner that was representational but strongly stylized in broad rhythms. Benton was active as a muralist (his work in the New School for Social Research is well-known). Romantic scenes of rural life in the Midwest, rich in color, but rigid and stylized, are his most characteristic works.

Berman, Eugene (1899-1972) is a Russian-born American painter. He went to Paris in the early twenties, studying for a time at the Académie Ranson. With his brother Léonide and with Berard, Tchelitchew, and others, he believed that art should revive the humanist concern with man, that it should be sensory rather than cerebral. These painters were opposed to the precepts of Cubism, but they were greatly affected by Picasso's Blue and Rose periods and—Berman in particular—by the work done by Chirico between 1908 and 1917. The group was given the name "Neo-Romantics"; these artists exemplified the naturalistic side of a romantic movement that included Surrealism. Berman came to the United States in 1935 and soon thereafter became involved in stage design. His work has retained its classical, representational, and symbolic qualities.

Bierstadt, Albert (1830-1902) Born in Germany, Bierstadt and his family moved to New Bedford, Massachusetts when he was a child. He began painting in 1851 and studied in Rome and Düsseldorf, with Lessing and Achenback. He returned to the United States again in 1857, toured the Rocky Mountains gathering material for his work. After this, he confined his attention to landscapes. He became wholly identified with American art, in particular frontier and historical scenes, using the meticulous technique and somber colorations learned in his European studies. He became the most prominent member of the 19th Century school of heroic landscapes, painting and exhibiting canvases of titanic American scenery. These breathtaking scenes enjoyed a great vogue in their day and sold for huge amounts. He was elected to the National Academy in 1860 and Legion of Honor in 1867. In addition, he received medals in Austria, Germany, Bavaria and Belgium. His works appear in the Metropolitan Museum, Corcoran Art Gallery and many others. He has the honor of having one of his works in the Capitol in Washington, D.C.

Bingham, George Caleb (1811-1879) was a painter of the American frontier, born in Virginia and raised in Missouri. After attempts at careers in cabinetmaking, law and theology, he turned to portrait painting in 1830. He pursued this until 1844 when he began to paint genre scenes of American life, glorifying the west with paintings of fur trappers, hunters, and river-boatmen.

Blakelock, Ralph (1847-1919) was born in New York City and studied art there briefly at the Free Academy but ceased his classroom studies in 1869 when he travelled to the Far West. There he documented the landscape and activities of the Indian tribes and began to develop an extremely personal style. Unable to bear the stress of poverty he suffered a nervous breakdown and was confined in later years. Subsequently critical reaction to his paintings improved and he was elected to the National Academy of Design. From this point on his work was often forged and he was never to profit from the sale of his works, dying in poverty at the age of 72.

Blume, Peter (1906-) is an American artist born in Russia. He emigrated with his parents when he was very young and began to paint at the age of 12. Despite this very early start, which brought recognition at the age of 21, he has produced very few paintings. His work, which has surrealist overtones, is in an extremely meticulous style, requiring up to three years for completion of a canvas.

Boccioni, Umberto (1882-1916) was an Italian painter and sculptor who studied in Rome. He was one of the first signers of the Futurist Manifesto, and followed this creed in his concern with action in his painting and the incorporation of machine parts in his sculpture. His fluid, broken forms are very effective in giving a feeling of intense action to his paintings, as can be seen in his famous work, *The City Rises.*

Bohrod, Aaron (1907-), an American artist, was born in Chicago and studied at the Art Institute of Chicago under John Sloan. He is primarily a painter of landscape and the American scene, at his best in watercolor or gouache. During World War II he was a military artist for news magazines.

Bonheur, Rosa (1822-1899) was a French painter of animals, trained by her father, a landscape painter. She learned quickly and won immediate recognition for her animal paintings, based on a scientific study of anatomy. Although her enormous reputation has suffered a sharp decline, her most famous work, *The Horse Fair,* reveals her great feeling for the movement and vitality of animals.

Bonnard, Pierre (1867-1947), an outstanding French painter, studied for law, but soon left to work at the Ecole des Beaux-Arts. He was linked with Vuillard and Maurice Denis, and in 1891 exhibited for the first time with the Nabis. Bonnard's early style was decorative with quiet, subtle colors. Then he developed a more Impressionist technique and his later work became bolder, as he infused his still lifes, nudes and landscapes with vivid, cheerful color. His brilliant, luminous paintings seem to reflect his happy life.

Bosch, Hieronymus (active 1488-1516). Little is known about the life of this major Flemish painter. He was born in Hertogenbosch, a town in Flanders, and probably came from a family of painters. He apparently had a broad international reputation during his time for he is mentioned by several contemporary art critics. Bosch was an extraordinary artist who painted hallucinatory images in a precise technique. Such paintings as *The Garden of Delights* presents a wild array of mystical, religious and supernatural figures, blending reality and unreality in a wild pageant. Bosch appears to have had an influence on Brueghel.

Bosin, Blackbear (1921-) Born in Anadarko, Oklahoma, American Indian Blackbear Bosin was influenced in his technique by Kiowa Indian artists and by extensive research into Indian lore and museums. He utilizes watercolor, gouache and

acrylics in a flat two-dimensional Indian style. His subject matter includes birds and animals as well as Indian lore and mores. Bosin has exhibited widely in the United States and has received numerous awards, as well as a Certificate of Appreciation from the U.S. Department of the Interior in 1965. His paintings are in the collections of the Heard Museum, Philbrook Art Center, Wichita Art Museum, Department of Interior, Denver Art Museum and The Whitney Museum of American Art.

Botticelli, Sandro (1444/5-1510) was one of the most important artists of the early Renaissance in Florence. He was probably a pupil of Fra Filippo Lippi and was influenced by Pollaiuolo. After completing his apprenticeship, Botticelli became associated with the Medici family and the humanist culture soon began to have an influence on his work, particularly in his allegorical subjects. In the 1480's and 90's his charming, gentle *Madonna* subjects brought him a wide reputation and financial success. In his last years, however, his lyrical style was opposed to the current of the High Renaissance, and he also seems to have suffered a spiritual crisis. His late works are austere, but his earlier graceful style was continued by his pupil Filippino Lippi.

Botton, Raymond de (1925-), a self-taught painter, was born in Toledo, Spain, and now lives in Switzerland. He travels widely, finding inspiration for his paintings in the color and life of new surroundings and in the sea itself. His work is semi-abstract, painted with glowing color and a rich impasto.

Boucher, François (1703-1770) was the embodiment of the decorative Rococo style of 18th-century France. In canvases, drawings, and tapestry designs, he captured the elegant, fragile style of this world. Boucher studied first with his father, and his training as an engraver and the experience he gained when assisting in the publication of Watteau's work also influenced his style. He studied abroad briefly, but in 1731 settled in Paris and became the most popular painter of his time, the favorite of Madame de Pompadour. He painted many pastoral and mythological subjects with a gay elegance and confusion, and many of his designs were translated into tapestries. He was perhaps the first artist to consider the drawing as a finished work of art.

Boudin, Eugène (1824-1898) was a French marine painter, born in Honfleur in Normandy. He lived most of his life in the port city of Le Havre, and most of his paintings represent the coasts of Normandy and Brittany. His muted views are dominated by the skies, which are filled with the luminosity and dampness of the seacoast.

Braque, Georges (1882-1963) was an outstanding French painter of the 20th century and one of the innovators of modern art. Although he disclaimed any function as a revolutionary, Braque, along with Picasso, created many of the major styles of the modern period. He was born in Argenteuil, the son of a house painter, and studied at the Ecole des Beaux-Arts in Le Havre and later in Paris. His early work was done in the Fauve manner, but through his friendship with Picasso, whom he met in 1906, he turned toward Cubism. In 1912 Braque experimented with the use of collage, the assemblage of scraps of paper or other materials on a ground, using this technique in conjunction with his Cubist style. About 1919 he began to paint in great flat areas; this has been called his neo-classic period. In later years Braque turned to sculpture, plaster relief and graphic media. Until his death he continued to be a significant influence.

Breton, Jules (1827-1906) was born in Calais, studied painting in Ghent and Antwerp, then

spent most of the rest of his life in Paris. His landscapes rapidly brought him recognition and financial success. If rather contrived in sentiment, they were painted in an impeccable, studied technique which produced an effect of graceful harmony.

Bronzino, Agnolo (1503-1572) was a Florentine Mannerist painter, the pupil of Pontormo. Bronzino later worked in Urbino and Rome where he came under the influence of Michelangelo. He is particularly known for his portraits, such as those of the Medici family, which exhibit a strong Mannerist style—elongated, linear figures rendered in an enamel-like color. In his later life he painted some allegorical scenes, but it is his elegant Mannerist portraits which make him one of the most important artists of that period.

Brook, Alexander (1898-) is an American still-life and portrait painter. He studied at the Art Students League in New York and later taught there. His style, influenced by Jules Pascin, is rich in color, especially his nude and semi-nude figures. One of the leading young American painters during the depression era, he executed several works for the Federal Government.

Brueghel, Jan (1568-1625), called "Velvet Brueghel," was the son of the famous artist Pieter Brueghel. Jan became known for his small pictures of flowers and animals, although he also painted larger works with religious and genre subjects. He was born in Brussels and lived there his whole life except for a short visit to Italy and Prague. Because of his great ability in rendering detail he collaborated with many great contemporary painters, including Rubens. He was a prolific artist, wealthy and successful in his day. His son, Jan Brueghel II, was also painter.

Brueghel, Pieter (c. 1525/30-1569) was one of the greatest of the Netherlandish painters. In 1551 he journeyed to Italy and was deeply impressed with the art of the High Renaissance and the dynamic landscape of Italy. His earliest works reveal in their symbolic content the influence of Bosch, and allegories appear throughout Brueghel's work; even *The Peasant Wedding* makes a comment on gluttony. But Brueghel did not merely comment on the vices of the common man; he also glorified the simple life of the country. In paintings such as *Winter-Hunters in the Snow* and *The Harvesters* the power and control of nature becomes the subject of the painting.

Buffet, Bernard (1928-), a highly popular contemporary French artist, was born in Paris and studied at the Ecole des Beaux-Arts. He has exhibited widely since his first one-man show in 1947. His representational style is based on flat, attenuated forms within heavy lines, sparsely filled with color. This angular style is combined with simple subject matter—city views, figure studies, still lifes.

Burchfield, Charles (1893-1967) was an American landscape painter. He first worked as an accountant but soon turned to the study of art at the Cleveland Museum School. His earliest works were simple landscapes in a romantic mood. Later paintings have a stronger symbolic quality and more stylized approach. Throughout his life he has painted the American scene sympathetically and with a touch of grandeur.

Calder, Alexander (1898-1976) is an American sculptor and designer, probably best known for his mobiles. He was born in Philadelphia and studied at the Stevens Institute and the Art Students League, New York. He went to Paris in 1926, returning frequently until 1934, and became a member of the Abstraction-Creation group there. His first one-man show was held in New York in 1928, and he exhibited his first mobiles and abstract constructions in the early thirties. He was involved in stage design in the

thirties and forties, and was himself the subject of three films. His work has been exhibited worldwide, and is in major museums and collections throughout Europe and the United States.

Canale, Antonio (1697-1768), called Canaletto, born in Venice in 1697, is famous for his precise, luminous renderings of city views. He learned his trade from his father, a theatrical scene painter. These meticulous, but evocative views of Venice, such as *The Square of St. Mark* and *The Grand Canal*, caught the eye of Joseph Smith, the British consul who became Canaletto's patron. As a result, Canaletto made a tour of England where he was one of the most sought-after artists of the time.

Carrà, Carlo (1881-1966) was one of the leading Italian Futurists, and a very active propagandist for this cause. His early work showed the influence of Medieval and Renaissance painting, especially the works of Giotto and Piero della Francesca. For a time he was also associated with the Metaphysical Painters, the mood-surrealism of Chirico, but he then returned to a more naturalistic expression. His paintings are primarily still lifes in which he represents a large variety of objects in a soft pleasing manner.

Carzou, Jean (1907-) is a contemporary French artist, born in Paris. He originally studied architecture, but in 1939 he exhibited his paintings for the first time. Since then he has won several European prizes and has exhibited in some of the major museums in Europe and America. He paints scenic views and still lifes, employing a firm linear style infused with rich, powerful colors.

Cassatt, Mary (1845-1926) could be considered America's most famous woman painter. She was born into a rich Pennsylvania family, but lived most of her life in Paris. Her early work there was rejected by the conservative Salons, but in 1877 she was invited by Degas to exhibit with the Impressionists. Although she was close to Renoir, Manet and Cézanne, Degas remained the strongest influence on her art. Her oils, especially the warm, appealing studies of mother and child, reveal this influence. Her most creative contribution was in the field of etchings and colored graphics.

Cathelin, Bernard (1919-) was born in Paris where he studied at the National School of Design. His still-life paintings of flowers, in rich, vital colors, have won him prizes, and he has exhibited in numerous one-man shows and salons.

Cézanne, Paul (1839-1906), perhaps the most important artist of Post-Impressionism, has been a leading influence on 20th-century art. He was born in Aix-en-Provence and began to paint despite his father's objections. His early painting, influenced by Delacroix and Courbet, was characterized by the use of dark, intense color. Then through his association with Monet, Renoir and especially Pissarro, he adopted an Impressionist technique and he participated in the first Impressionist exhibition in 1874. Cézanne sought to make something solid of the Impressionist vision. He was not content with the rendering of superficial outer reality and his painting became a quest to reveal the inner structure of nature. His much quoted remark that all forms in nature are based on the cone, the sphere and the cylinder, suggests the geometrical orientation that was reflected first in his still lifes and later in portraits and landscapes. This approach had its successors in the Cubist style of Picasso and Braque. Yet within this geometrical view of reality there is tremendous vitality in the painting of Cézanne, and in his originality he goes far beyond any set theories.

Chagall, Marc (1887-) is a highly popular and influential contemporary artist. Born in Russia, the son of a Jewish merchant, he has spent most of his life in Paris. Both Paris and his Russian-Jewish background provided a lasting influence on his art. Chagall's early work was influenced by Cubism, and during this period he was closely associated with Delaunay and Modigliani. Then his personal style developed, characterized by poetic subject matter, fantasy and rich color. The influence of his Jewish heritage wove a spiritual, mystical pattern through his art that, along with his fanciful juxtapositions, has led some critics to call him a forerunner of the Surrealists. Recently Chagall has employed his religious motifs in graphic arts, designs for opera and ballet, ceramics and stained-glass windows. These works have brought him a vast international following, exceeded only by Picasso's.

Chapin, James (1887-1975) is an American portrait painter who sees a significant dignity in the way a human being carries his head and body. Combining his drafting ability with a brilliant use of color, gestures become symbolic in his harmonious, sympathetic portraits. Chapin has received prizes for his work; especially notable is a high honor bestowed on him by the Pennsylvania Academy of Fine Arts.

Chardin, Jean-Baptiste-Simeon (1699-1779). The quiet, subtle genre painting of Chardin stands in pleasant opposition to the courtly decorative art of the 18th century, the works of Boucher and Pater. Chardin was born in Paris in 1699 and lived and painted there until his death in 1779. The little we know of his private life appears to be melancholy. Both Chardin's genre scenes and still lifes reveal a deep feeling for the importance of the commonplace and, in their ordered space, an understanding of the Dutch painters who preceded him. In his rendering of a maid cooking, a small copper pot or merely two eggs, he gives dignity to the common man.

Chase, William (1849-1916) was an important figure in American art, both for his painting and his teaching. He was born in Indiana and first studied art in Indianapolis. In 1870 he went to New York. He then went to Germany where he was strongly influenced by the resident artists. His early works were dark, but later he painted in a more lively manner, similar to that of Manet, Sargent, and Whistler. He painted portraits, landscapes and still lifes, and was an influential teacher in New York and Philadelphia.

Chirico, Giorgio de (1888-1978) was a Greek-born Italian painter. The son of a railroad worker, he developed an early interest in art. He studied first in Athens but upon the death of his father moved with his mother to Munich. In Germany he came under the influence of the romanticism of the artist Böcklin and the moody literary style of Nietzsche, influences which helped produce the haunted silence of his urban scenes. Chirico can be considered a forerunner of Surrealism, especially in the faceless human forms that came to dominate his work at the time of the First World War. Along with Carlo Carrà he formulated a doctrine of metaphysical painting that sought to give life to inanimate objects. Chirico must be considered one of the most important Italian artists of the 20th century despite his having abandoned "metaphysical painting" in the 1930's for imitative works.

Clavé, Antoni (1913-) is a Spanish artist who began his career as a house painter, but he soon progressed from kitchen walls to book illustrations. He attended the School of Fine Arts in Barcelona for six years and later moved to Paris. There he illustrated several important books and created many praiseworthy set designs for theater and ballet. In 1954 he had his first one-man show as a painter and won a prize for his graphics at the Venice Biennale. His

moody, dark canvases and his graphics have brought him a wide reputation.

Cleve, Joos van (c. 1485-1540) was a Flemish artist born perhaps in Cleves. There are few records of his life: in 1511 he joined the painters' guild in Antwerp; he probably traveled in Italy and evidently was painter at the court of Francis I of France. Van Cleve, an adroit colorist, is primarily known for his portraits, and a number of religious paintings are also attributed to him. His few extant works hang in important museums throughout the world.

Clouet, François (c. 1522-1572) succeeded his father, Jean Clouet, as court painter to Francis I of France, and later served kings Henry II and Charles IX. François' style is more precise than his father's and it reveals a strong influence of Florentine Mannerism, suggesting a trip to Italy. Most of Clouet's surviving paintings are portraits of the king and his court.

Constable, John (1776-1837), the great English landscape painter, was born in Suffolk and studied at the Royal Academy of Art. Landscape painting became his chief interest and Ruisdael and Claude Lorraine his models. The sky and the atmosphere were of primary importance in his paintings, and land sometimes became a mere foil. His fresh vision and technique had an important influence on French painting, particularly on Delacroix and the Barbizon School.

Copley, John Singleton (1737/8-1815) was an outstanding American portrait painter of the colonial period. He was born in Boston and studied with his stepfather, an engraver, Peter Pelham. Copley began to paint portraits at the age of 16. As he grew older he grew more adept at representation, and by 1760 was by far the outstanding artist in America. A Tory, he left America at the start of the Revolution to paint in England and on the Continent. There he received the praise of Reynolds and Benjamin West as his style turned closer to the English portrait tradition. However, his greatest paintings are from the pre-revolutionary period in America.

Corneille (Cornelis Guillaume van Beverloo) (1922-) was born in Liège, Belgium. He enrolled in Amsterdam's Ecole des Beaux-Arts in 1940, and held his first exhibition two years later in Groningen. While visiting Paris in 1947 he met some of France's young abstract artists. Established in Paris, Corneille helped found the international "Cobra" group with, among others, Karel Appel. He has also been an illustrator and has worked with pottery. In his most recent work he begins by making circles from which his compositions develop and take shape in vivid colors. Corneille has had exhibitions in France and, in 1956, was awarded the Guggenheim Prize for the Netherlands.

Corot, Jean-Baptiste-Camille (1796-1875) was a major French artist in the period of transition between Romanticism and Realism. Corot began to paint late in life after rejecting a business career. In 1825 he went to Italy where he painted out-of-doors, classically ordered views of the Roman campagna bathed in light. He also traveled in France, painting scenes in Brittany and Normandy. In the 1850's his style changed as he began to paint the misty romanticized landscapes which for a time were his most popular works. During this period he was close to the Barbizon School, although not actually a member. His early landscapes, reminiscent of the ordered art of Poussin and Claude, and his figure studies, mark the high point of his career.

Courbet, Gustave (1819-1877) was a very important French painter who influenced the rise of Realism. Rejecting the imaginativeness of the Romantic movement, Courbet felt that the subject

of a painting should be an object "visible and tangible to the painter," that is, the painting should be an historical record of what the artist sees. Courbet was essentially a self-taught artist, although he did spend some time in the studios of Steuben and Hesse. His early style was quite romantic but by 1848 he had become increasingly realistic. This change can, in part, be attributed to his social consciousness and his active participation in the uprising of 1848. Throughout his life social problems remained his concern, and are reflected in paintings such as The Stonebreakers. Courbet painted portraits, still lifes, figure studies, seascapes, and hunting scenes, and his deep feeling for nature is suggested by the landscapes of his native Jura region.

Covarrubias, Miguel (1904-) is a contemporary Mexican painter who has worked in Mexico, the United States and Europe. In addition to painting, he is an active illustrator, writer and caricaturist. He is currently a professor of Art History in National School of Anthropology in Mexico.

Cox, John Rogers (1915-) was a bank clerk and then the director of the Terre Haute (Indiana) Art Gallery before beginning to paint in 1941. Since then his feeling for color and design, as seen in his lyrical landscapes, have brought him recognition as a leading contemporary American artist. He has exhibited his work in Chicago, Cleveland and Toledo. The Metropolitan Museum of Art gave him a distinguished award for his painting, Gray and Gold.

Cranach, Lucas (1472-1553) was a German painter and graphic artist. He was born in Franconia, lived in Vienna, and in 1505 went to Wittenberg, the birthplace of the Reformation. In Wittenberg Cranach was active in civic life and served as a court painter for the rulers of that small German state. His paintings, which utilize a jewel-like technique and highly stylized line, are among the most delightful creations of the period. He was important as a portraitist, and is credited with the development of the full-length portrait. Much of his work, especially his graphics, shows the influence of Dürer. Cranach met Martin Luther in Wittenberg and, along with Dürer, actively supported his reforms; through his painting Cranach made a significant contribution to the development of a Protestant art.

Creti, Donato (1671-1749), a Baroque artist from Cremona, spent most of his life in Bologna. His style was like that of his master, Pasivelli, and he was influenced by the brush technique of Guido Reni's pupil, Cantarini. Creti painted altarpieces in Bologna as well as religious works for churches in Rimini, Bergamo, and Palermo. His atmospheric drawings, often in delicate penhatchings, have a Rococo charm.

Cropsey, Jasper F. (1823-1900) was an American landscape painter closely associated with the Hudson River School. He was born in New York and studied art there. Cropsey's richly colored autumn scenes of the Berkshire and Catskill mountains are especially admired.

Currier and Ives (19th century). Nathaniel Currier was an important publisher of colored prints of popular subjects. James M. Ives joined his firm in 1852. The prints, derived from original subjects by artists employed in the firm, were hand-colored lithographs of sporting events, frontier scenes, views, landscapes, and disasters. Several new scenes appeared weekly for a period of fifty years, and Currier and Ives prints became the most popular form of art in 19th century America.

Curry, John Steuart (1897-1946) was an American landscape painter who, along with Thomas Hart Benton and Grant Wood, painted rural life in the

Middle West. Curry was born and raised on a farm in Kansas and studied art at the Art Institute of Chicago. He began as an illustrator but in 1928 his realistic portrayal of an American scene, The Baptism in Kansas, earned him a wide reputation and he turned to painting, becoming one of the outstanding Regionalist painters of the 1930's.

Cuyp, Aelbert (1620-91) was a Dutch landscape painter born in Dordrecht, the son of a painter who was his teacher. Cuyp is known for his broad sweeping landscapes dominated by the sea, as is life in Holland. Figures of men and domestic animals are prominent in his landscapes which are bathed in a poetic golden light which seems to have been influenced by Claude Lorrain of France.

Dali, Salvador (1904-) is a Spanish artist whose eccentric personality and combination of Surrealist subject matter and fastidious technique have caught wide public attention. Born in Figueras, Spain, he studied at the Madrid School of Fine Arts. He had his first one-man show in Barcelona in 1925. For a while his art was based in Cubism, but by 1928 he rejected this for a highly-finished technique and subject matter that makes use of subconscious fantasies and dream material. In evaluating Dali one must distinguish between his flamboyant life and his art, which has influenced the development of Surrealism.

Daraniyagala, Justin (1903-) was born in Colombo, Ceylon, and educated at Cambridge University in England, after which he studied art in London at the Slade School. In 1943 he returned to Ceylon and is a prominent artist there today. His noted painting, The Fish, expresses the miserable plight of human poverty, mitigated by a universal faith in God.

Daumier, Honoré (1808-1897) was famous in his lifetime as a caricaturist rather than as a painter. He began work as a lithographer for the French periodical La Caricature. For this magazine he produced a series of political and social satires, brilliantly executed and deeply biting; he was, in fact, jailed for his caricature of King Louis Phillipe. In the 1840's he turned to painting, using strong shadow and fluid, thick colors that give an inner power. His social criticism was carried into painting in such brilliant works as The Third Class Carriage and The Uprising, biting commentaries that yet give dignity and worth to the humblest of men.

David, Gerard (c. 1460-1524) was a Flemish painter, born in Oudewater, and active in Bruges. The first records of David indicate that he was admitted to the Guild of St. Luke in 1483, and from then on he painted in Bruges and Antwerp except for a brief trip to Italy. His gentle style, detailed and rather rigid, was influenced by van Eyck. David employed vivid color and often strongly symmetrical compositions. A considerable number of religious paintings now hanging in the major museums of the world are attributed to him.

David, Jacques-Louis (1748-1825) was the chief exponent of the Neoclassical style in France, a political supporter of the French Revolution and painter to Napoleon. Such early works as the Oath of the Horatii are characteristic of his Neoclassical style—a severe, frontal composition, static gestures, emphatic definition of the muscular structure of the figures, all combined with a subject drawn from ancient Rome. David was active politically during the Revolution and, in fact, voted for the execution of the king. His painting, The Death of Marat, is his most brilliant work from this period. The painter became a fervent Bonapartist, heralding Napoleon's success in many paintings including one of his coronation as Emperor. In 1815 after the return

of the Bourbons, David fled from France to live in Brussels and almost entirely ceased painting.

Davies, Arthur B. (1862-1928) was an American Romantic painter born in upper New York State. He studied art at the Chicago Academy of Design and at the Art Students League. Davies began his career as a magazine illustrator but soon turned to painting. In 1893, under the patronage of Benjamin Altman, he went to Europe and came under the influence of French and German Romantic painters. With this background Davies produced idyllic pastoral scenes, peopled by pale nymphs. Later, after a trip to California, his paintings became more powerful as he tried to capture the grandeur of the American West. Davies was president of the Armory Show of 1913 which introduced advanced European trends to America.

Davis, Gladys Rockmore (1901-1967) was born in New York and studied at the Art Institute of Chicago. She began her career as an illustrator and worked for a time with George Grosz. In 1932 Davis went to Europe where Renoir's work greatly influenced both her style and subject matter.

Degas, Edgar (1834-1917) was a major figure in 19th century painting, associated with the Impressionist movement, but not strictly a part of it. Degas, from a wealthy French family, turned from the study of law to painting, enrolling at the Ecole des Beaux-Arts. During the early years of Impressionism Degas was a strong force behind the exhibitions, but he soon disagreed with the theories of the Impressionists. Influenced by Ingres and Manet, Degas did not sacrifice line to color, and remained a studio painter, resisting the Impressionists' desire to capture outdoor light. His only outdoor scenes were of the race track; while his ballet dancers are probably his most famous works, both themes provide studies in movement. Degas concentrated on the portrayal of the human form but traditional ideas of beauty are subordinated to the compositions based on the odd vantage points he selected.

Dehn, Adolf (1895-1968) was an American watercolor artist and lithographer. He was born in Minnesota and studied art in New York at the Art Students League. His early work was mainly social satire, influenced by George Grosz and Boardman Robinson. His later watercolors are beautiful studies of the American Southwest.

Demuth, Charles (1883-1935) greatly influenced the development of modern art in America. He studied art in his native Philadelphia and in 1907 went to Paris where he came under the influence of Cézanne. Demuth's early paintings were primarily still lifes, similar in style to the watercolors of Cézanne and John Marin. Shortly, however, he turned to Cubism, one of the first American artists to do so, and he developed a personal Cubist expression. He rendered architectural and industrial subjects in geometricized forms. These subjects contributed to the development of the urban and realist school in America.

Derain, André (1880-1954) was a leading French artist and a founder of the Fauve movement. He studied art in Paris, where he became associated with Matisse and Vlaminck in the early stages of the Fauve movement, using violent color and distortions. After World War I he turned to a more rational and ordered art. Cubism and his revived interest in Cézanne led Derain to paint more formal, traditional landscapes, still rich in color. Later he experimented with collage, and pursued his interest in form through sculpture. Throughout his life he remained one of the more traditional artists and avoided the extreme experimentation of the 20th century.

Dongen, Kees van (1877-1968) was a Dutch painter who worked mainly in Paris. He met Matisse and soon joined the Fauves whose wild, vibrant colors were very appealing to him, and he continued to paint in this manner for most of his life. He was also associated with the German Expressionist painters of *Die Brücke*, who, like the Fauves, used violent color and powerful distortions.

Dossi, Dosso (c. 1480-1542) was an Italian artist of the Ferrarese school, influenced by Giorgione and Titian. He is recorded in Mantua and seems to have been in Venice. Dossi is known for his lush, romantic landscapes full of fantasy, and especially for the frescoes he executed for the ruling family of Ferrara.

Dove, Arthur (1880-1946) was one of the first American painters to experiment with abstract art. He was born in New York and began to paint in a realist style. About 1912 he employed an abstract style although he never totally rejected nature. His semi-abstract style employs a broad range of color, and reveals a soft poetic feeling for nature.

Duchamp, Marcel (1887-1968), a French artist, was one of the founders of the Dada movement. He is the brother of the sculptor Raymond Duchamp-Villon and the painter Jacques Villon. Duchamp's early works were influenced by Cubism and Futurism; his notorious *Nude Descending a Staircase* is a product of this period. He became fascinated with the aesthetic qualities of machines and made use of mechanical forms in his Dada works. This movement, which originated during World War I, responded with cynicism and disillusionment to the failure of idealism demonstrated by the war. As preached by Duchamp, Max Ernst, and others, Dada rejected the standard values in art and became a nihilistic movement. Duchamp's use of common objects, weirdly juxtaposed in his Dada works, recently revived his reputation because of parallels in Pop Art, although he himself abandoned expression through art years ago.

Dufresne, Charles (1876-1938) studied sculpture and pastel at the Ecole des Beaux-Arts until 1910 when he went to Algeria. There he spent two important years painting romantically exotic scenes, atypical of his academic background. Upon his return to France Dufresne accepted the post of professor at the Scandinavian Academy. He also executed decorative murals and scenery designs and continued painting. A prolific artist, Dufresne's work has been exhibited at the Venice Biennale and in Pittsburgh; he was one of the precursors of modern art.

Dufy, Raoul (1877-1953), a French painter, was born in the port city of Le Havre; his early environment probably stimulated his interest in harbor scenes and seascapes. Dufy was associated with the Fauves and adapted their brilliant colors and free forms into gay, sketchy treatments of popular subjects. As a result of his friendship with a prominent fashion designer, Dufy designed textiles, tapestries, and ceramics. His decorative work, and the easy-going, decorative style of his painting gained him great popularity, yet it is possible to distinguish the early artist from the later decorator.

Durand, Asher Brown (1796-1886) was an American landscape painter of the Hudson River school. He began his career as a commercial engraver, but abandoned this in 1835 to pursue painting. In the 1840's he spent several years in Paris where he discovered the landscapes of the 17th century French painter Claude Lorrain. Durand was one of the first of the American artists to work out-of-doors and this direct contact with nature is reflected in his sensitive romantic landscapes.

Dürer, Albrecht (1471-1528) was one of the greatest German artists of the Renaissance. He was born in Nuremberg and studied art with his father, a goldsmith, and Michael Wohlgemut, a local painter and printmaker. In 1494 he journeyed to Italy and came under the influence of Mantegna and Jacopo de'Barbari. In 1495 he returned to Nuremberg and began an extremely productive career which included painting, woodcuts, and copper engravings. More than any German artist, Dürer adopted the Renaissance ideals of humanism. He sought to become not only an artist but a gentleman and scholar; he made scientific studies of perspective and wrote treatises on proportion and theory. Dürer was most influential as a printmaker; his very numerous engravings and woodcuts are created with a tremendous degree of dexterity, vitality, and originality. Dürer's art became increasingly didactic and such engravings as *Melancholia* and *Knight, Death and Devil* have complex levels of meaning. After 1517 he supported the principles of Luther and his great panels of the Apostles, Peter, Paul, Mark, and John, are Dürer's personal testament to the new Protestant faith.

Durrie, George H. (1820-1863), an American landscape painter, was born in New Haven, Connecticut, and studied with Nathaniel Jocelyn. He began work as a portrait artist, but soon turned to genre subjects and landscapes, especially farm scenes. His most famous works are the winter scenes reproduced by Currier and Ives.

Dyck, Anthony van (1599-1641) was a major Flemish painter of portraits and religious subjects during the Baroque era. Born in Antwerp, he was the favorite pupil and chief assistant to Rubens; van Dyck was already an accomplished painter and in many cases it is difficult to separate the work of the teacher from that of the pupil. The work of van Dyck contains a greater use of chiaroscuro, the balance of light and shadow. In 1620 van Dyck went to England to paint for King James I, a trip that gave impetus to his career as a portrait artist, and in 1621 he went to Italy. There he studied the portraits of Titian and the Venetian school, and developed a portrait style of great elegance, sensitivity and restraint. In 1632 he returned to England to become court painter to Charles I, receiving a knighthood and achieving great personal success.

Eakins, Thomas (1844-1916) was one of the most important realist painters in America. Born in Philadelphia, he studied art at the Academy of Fine Arts there, and the Ecole des Beaux-Arts in Paris. Although he came in contact with the end of the French Romantic movement, he remained a realist throughout his life. Upon his return to America in 1870 he taught painting and anatomy at the Pennsylvania Academy. His early works often represented outdoor sporting activities, sculling, shooting, and sailing. Later he painted indoor scenes, genre subjects and portraits with a powerful realism and dark, moody palette. He was an outstanding portraitist, combining penetrating analyses of his sitters with solid technique.

Earl, Ralph (1751-1801) was a self-taught American artist, born in Massachusetts. At the start of the American Revolution he went to Concord and Lexington to depict the early battlefields of the war. In 1778 he left America for England, perhaps to study with Benjamin West, a Loyalist, and soon exhibited at the Royal Academy. He returned to America in 1785. His finest works date from his first American period, such as his fine portraits of Roger Sherman and William Carpenter.

Engel, Nissan (1931-) was born in Haifa, Israel, and studied at the Bezalel Art School. Since

1956 he has lived in Paris and New York, and shown in Israel, France, Switzerland, Italy, Sweden and Germany, as well as New York and California. He participates by invitation in various International Art Fairs, and many Salons in Paris. Already represented in some of the finest private collections, his paintings have recently been acquired by several important museums. Engel's style blends the lyric, intellectual and mystic with a superb sense of color and sensitivity of nuance, while never neglecting craftsmanship and clear mastery of his media, be it acrylic, oil, mixed media and collage, stained glass, etching or lithography. His earlier work was figurative; while in New York he was influenced by bold modern forms. Engel's current work is delicately semi-abstract, growing from such themes as chess, music, scrolls, and the rooftops of Paris.

Ensor, James (1860-1949) was a very creative Belgian artist who foreshadowed many modern art movements of the 20th century. He was born in Ostend and spent most of his life there. His early paintings were dark naturalistic landscapes and seascapes. Later he turned to mystical and psychological subject matter, often highly macabre. His moody, silent figures are often masked, and a high-keyed palette contributed to their disturbing effect. As high colors became lighter and thinner, his figures gained a more fanciful quality. In addition to fantasy he produced works of sharp social satire, such as the *Entry of Christ into Brussels in 1889.* Ensor's emotion and symbolism make him a precursor to both Surrealism and German Expressionism.

Ernst, Max (1891-1976) is a German artist born near Cologne who, with Arp, was a principal founder of the Dadaist movement in Germany, about 1920. A self-taught painter, he first exhibited in Berlin in 1913. He went to Paris in 1922, where he showed his work at the first Surrealist exhibition in 1926. He published *Beyond Painting* in 1948. Ernst's Surrealist style depends upon the world of real things seen in bizarre perspective or strange isolation, creating a dream world, an artificial nightmare environment. His art has more in common with Dali's than with the work of abstract Surrealists like Miró.

Eyck, Jan van (c. 1385-c. 1441) was born in Flanders and traveled widely as court painter to the Duke of Burgundy before settling in Bruges. Van Eyck's major work, the Ghent Altar, is one of the monuments of Flemish art. Probably begun in 1425 by his brother, Hubert, it was completed by Jan himself in 1432. It is an iconographically complex polyptych, powerfully somber in its realism. The luminous tones of skin and robes, with the solidly rendered figures, produce a unified effect of static beauty in a crystalline atmosphere. Van Eyck's early *Madonnas* are intellectually conceived, classically balanced and rich in symbolic detail. The *Rolin Madonna* of 1433-34 is a quiet symmetrical scene which opens out onto an exuberantly picturesque landscape. The *Madonna van der Paele* of 1436 is more remote and sculptural in its rendering. The famous *Arnolfini Wedding Portrait* represents the sacrament of marriage in which each carefully painted object takes on symbolic significance. Van Eyck's portraits, like the figures of the religious paintings, are descriptive rather than interpretive in style. Despite the absence of definable qualities, they reveal the personality of the sitter, thus creating an image which is enigmatic but, at the same time, mysteriously real.

Feininger, Lyonel (1871-1956) was an American artist who spent most of his life in Germany. There he was associated with the German Expressionists of the Blue Rider and the Bauhaus, later forming the Blue Four with Klee, Kandinsky and Jawlensky. His early works, landscapes, still lifes and political caricatures, were softly painted in a fancifully poetic manner. Later his style crystallized in a cubistic delineation of planes and spaces. His architectural compositions of New York are rendered in shadows cast by the glaring sun on the surface of buildings. Whether sea or city scapes, these geometric paintings reflect Feininger's world vision of beauty and pure order.

Feti, Domenico (1589-1624), born in Rome, was influenced both by current local admiration of Elsheimer and the realistic style of Caravaggio's followers. In 1613 he went to Mantua as court painter to Cardinal Gonzaga. The last three years of Feti's life were spent in Venice where he was impressed by Rubens and the Venetian school. His small religious genre scenes are colorfully painted in a broad style.

Fini, Leonor (1918-) was born in Argentina and grew up in Tricote where she began her painting career. In 1935 she and her family moved to Paris. A year later she exhibited several of her large works and soon became associated with the Surrealists and other noted artists and writers, among them Jean Cocteau, Benjamin Britten, Albert Camus and Jean Genet. Her figure studies are both sensual and ethereal in feeling.

Forain, Jean-Lous (1852-1931) was a French painter and lithographer of social, political and theatrical subjects. His style combines the biting social comment of Daumier with the darkly shadowed mood of Rembrandt.

Fragonard, Jean-Honoré (1732-1806) was a brilliant French decorative artist and portraitist of the Rococo period. Fragonard's art exemplified the gay courtly life of this era. He learned painting from Chardin and Boucher, especially the latter, a leader of the Rococo style. At the age of 21 Fragonard won a prize which enabled him to study in Rome. There the works of Pietro Cortona, Tiepolo and other artists influenced his development. Fragonard's work is more reminiscent of Rubens than any of his contemporaries, painting with a fluidity and spontaneity similar to Rubens' oil sketches. This style is seen in his extremely decorative work of lovers, cupids, and boudoir scenes. However, his greatest works have a restraint and softness of color as seen in *The Swing* and *A Young Girl Reading.* The French Revolution ruined his career and only the protection of Jacques Louis David enabled him to survive.

Francis, Sam (1923-) was born in San Mateo, California, and studied medicine and psychology until, while hospitalized for a spinal injury, he took up painting for recreation. He then studied at the California School of Fine Arts, and returned to the University of California at Berkeley where he earned degrees in art. He went to Paris in 1950, studied briefly at the Académie Fernand Léger, and held his first one-man show there in 1952. He traveled around the world in 1957, and was particularly affected by his long stay in Japan. He made his first lithographs in Zurich in 1960. Francis paints in an extremely abstract style, creating effects with dark and light or with color contrasts. His paintings of the early nineteen-fifties depended on heavily textured surfaces, but by 1956-57 the Japanese influence became apparent, lending a new delicacy and grace to his compositions.

Friesz, Othon (1879-1949), born in Le Havre, first painted landscapes of Brittany and Normandy, as well as portraits. In Paris he studied briefly at the Ecole des Beaux-Arts where he met Raoul Dufy and Georges Braque. As a pupil of Thullier his drawing grew more disciplined and he gained an admiration of Delacroix, Géricault and Corot. Friesz painted in the Impressionist style but, attracted to the brilliant colors of Matisse and Marquet, became associated with the Fauve movement. Besides painting, Friesz illustrated books, designed scenery and, with Dufy, decorated the Palais de Chaillot. Later he ran his own studio and was an excellent teacher.

Gainsborough, Thomas (1727-1788) was one of 18th century England's outstanding landscape and portrait painters. Born in Suffolk, he studied in London where he evidently saw and was influenced by the work of Francis Hayman, Watteau, and Dutch 17th century landscapists. Gainsborough's virtuosity in handling paint gave his scenes a soft atmospheric quality. Temporarily neglecting his real passion—for landscape—he moved to Bath, then a flourishing spa, and painted fashionable people in elegant settings. In 1774 Gainsborough, now well-known, went to London and became much sought after as a portraitist and rival of Reynolds. In his later landscapes, which reflect the influence of Rubens, he continued to perfect his original technique.

Gauguin, Paul (1848-1903) was born in Paris, spent his childhood in Peru, and then six years at sea. Once again in Paris he became a stockbroker and painted as a hobby. As his interest and ability grew, he made friends with Pissarro and exhibited with the Impressionists. In 1883 his growing passion for painting led him to abandon both wife and career in restless search for a primitive, "unspoiled" civilization. After years of wandering he went to Tahiti, finding there the simplicity of life he was seeking. His style of painting in broad flat areas of color outlined in black influenced not only the Fauves and Nabis but also non-representational painters of the 20th century.

Gentileschi, Orazio (1563-1638) was a Tuscan Mannerist who studied with Bronzino before going to Rome. There he spent 25 years carrying out commissions for the papacy. During this time he became a close friend of Caravaggio, whose influence is evident in Gentileschi's religious scenes. When he was 41 he went to Genoa where he met van Dyck. After a year in Paris as court painter to Marie de Medici he settled in London, as the court painter to Charles I. Gentileschi is important for having brought Caravaggio's dramatically realistic style to England.

Géricault, Théodore (1791-1824) showed an early talent for drawing. Despite his wealthy family's disapproval, he studied painting, first with Carle Vernet and then with Guérin. The influence of Gros and Delacroix is evident in his powerful rendering of horses. In 1812 Géricault sent his first painting to the Salon, a dramatic battle scene which, in its original technique and subject, pointed toward the Romantic movement. After several years spent studying the old masters in Italy, Géricault returned to France to produce his most important work, *The Raft of the Medusa.* Based on an historical event, this dramatic composition of sculptural figures aroused great political and artistic criticism. Géricault exhibited the painting in England and remained there for several years executing many lithographs of horses and racetrack scenes. Although his production was small and his brilliant career was brief (he died at 33 following a hunting accident), Géricault is very significant as one of the primary innovators of Romanticism.

Gérôme, Jean-Léon (1824-1904) studied under Delaroche and Gleyre in Paris. Well-known for his painstakingly researched paintings of classical antiquity, Gérôme also painted genre and portraits in a clear linear style often combined with sentimentality. Large canvases of desert scenes and oriental subjects were inspired by his frequent travels through Egypt and the Near East. In later life, Gérôme forsook painting for sculpture.

Ghirlandaio, Domenico (1449-1494) was the most successful fresco painter of his time in Florence.

He studied with Baldovinetti and Verrocchio and later himself maintained a large active workshop: Michelangelo was one of his apprentices. Among Ghirlandaio's major frescoes are the scenes from the life of St. John the Baptist in Sta. Maria Novella and the painting in the Sistine Chapel.

Giacometti, Alberto (1901-1966) Born in Stampa, Switzerland, the son of Impressionist painter, Giovanni Giacometti, he studied sculpture at the Ecole des Arts et Métiers in Geneva, and his paintings show the influence of this background. His work was first exhibited in the Salon des Tuileries, Paris in 1925. With his brother Diego, he designed chandeliers, lamps and other furnishings for interior decorator Jean-Michel Franck in the early 1930's. In 1930, he exhibited with Miro and Arp at the Galerie Pierre in Paris. Giacometti joined with the Surrealists in 1930 and was closely associated with their activities until his expulsion from the group in 1935. The angularity and attenuation of his sculpture is translated into a linear tracery in his paintings, adding a quality of intensity and unrest to these works very much a part of the quality of contemporary life and its human condition. His works have been shown at numerous exhibitions and retrospectives throughout the world, including the Solomon R. Guggenheim Museum and the Museum of Modern Art, New York; Galerie Maeght, Paris; the Tate Gallery, London; Kunstmuseum, Zurich; and Humbelbaek, Denmark.

Giorgione (Giorgio da Castelfranco) (c. 1478-1510) was one of the most influential artists of the Venetian Renaissance. Facts about his life and career are as mysterious as his work itself. Giorgione's original genius is evident in the few extant works which are generally attributed to him. Born near Venice, it is probable that he worked in the studio of Giovanni Bellini and certain that in 1508 he painted, with Titian, the fresco decorations of the German merchants' building in Venice. An enigmatic, spiritual mood pervades both his religious and profane subjects. Giorgione's figures, in complicated positions, are placed in a rhythmic unity within the carefully designed scenes. His limpid landscapes simultaneously complement the casual figures and arouse feeling of deep psychological penetration. This lyrical combination of dreamy melancholy and psychic tension, executed with the fineness of Venetian color and shadows, did much to influence such 17th century artists as Rembrandt and Poussin, and later, the French Impressionists.

Glackens, William James (1870-1938) was born in Philadelphia where he began his career as a newspaper illustrator while studying at the Philadelphia Academy of Art. In 1895 he went to Paris where he was influenced by the Impressionists' use of swift brushstrokes and gay colors. While there he painted with Robert Henri, George Luks and John Sloan, American painters whom he had known in Philadelphia. Together they developed an independent regionalist type of painting, a distinctly American style in reaction to the watered-down estheticism of the 1890's. Upon his return to the United States Glackens showed his work in the 1908 exhibition of "The Eight." His deep-toned, realistic scenes of American skyscrapers and city crowds gave new pictorial and poetic significance to the representation of urban life.

Gogh, Vincent van (1853-1890) grew up in an educated Dutch family; his father was a minister and his uncle an art dealer. Great energy and an inquiring mind led van Gogh to try various careers as a teacher, art dealer, and missionary preacher. His generosity, compassion, and deep desire to understand his fellow men were misunderstood by the Belgian coal-miners with whom he lived and to whom he preached until his dismissal in 1880. Around this time he began to

sketch copies of Millet's somber peasants and later to take anatomy and perspective lessons in Brussels. Van Gogh's early self-training showed intense visual perception which developed into a sinuous, flame-like style with brilliant colors. At the age of 33 he went to Paris to stay with his brother Theo. There he was influenced by the Impressionists, Pointillists, and the flat planes and vigorous outlines of Japanese prints. In 1888 poor health and mental disorders forced him to leave Paris for Arles where, in the striking sunlight of Provence, he spent his last two years producing many of the most memorable works. In St. Rémy and in Auvers, where van Gogh died, he painted vivid, passionate works, expressive of his tormented life. The impelling power of van Gogh's painting was also expressed in his genuinely moving letters to his brother Theo.

Gonzalez, Xavier (1898-) received his formal training at the Art Institute of Chicago. He has won many important prizes, among which are the Award of the American Academy of Arts and Letters, a Guggenheim Fellowship, and a Ford Foundation Grant. His work is widely represented in leading American museums as well as private collections here and abroad. He has taught at many of the leading art schools throughout the United States. Recently Gonzalez has worked in steel, bronze and silver as well as experimenting with sculptured murals.

Gottlieb, Adolph (1903-1974) is a contemporary American artist who was born in New York. He studied briefly at the Art Students League but found his greatest inspiration in the works of Klee and Miró. During the 1930's he worked with various W.P.A. art projects, and in the early 1940's went to Arizona to paint scenes of the desert and the American Indians. Gottlieb's work became progressively abstract as he experimented with accidental forms, strong color, and powerful simple images which take on the quality of signs.

Goya, Francisco de (1746-1828) was born in Aragon and painted in Saragossa before working in Madrid and finishing his studies in Rome. Although Goya's early life is sparsely documented there are numerous legends of love affairs and violent adventures which coincide with the physical power and courageous, abrupt temper he displayed in later life. In Madrid during the 1770's, besides designing tapestry cartoons and preparing mural decorations, he began to etch and paint portraits. In 1785 Goya became president of the royal Spanish Academy of San Fernando and began working for the Duke of Osuna. He designed tapestries for the Escorial and painted portraits of the king and queen. Despite illness in 1792, followed by deafness, he carried on with the decorations of San Antonio de la Florida, and in 1799 was appointed the first painter to the court. The same year saw the publication of *Los Caprichos.* The power and subtlety of this set of aquatinted etchings soon brought him international fame. With the war-torn era which came with the Napoleonic Wars and Restoration in Spain, Goya's introspection and humanitarian response found expression in the set of engravings entitled *Los Desastres de la Guerra.* His imaginative depiction of mankind from its dignified heights to its bestial depths left a satirical yet compassionate vision for the succeeding century and, in fact, for the entire history of art.

Graves, Morris (1910-) is an American artist who grew up in the Pacific Northwest. There he studied under Mark Tobey, whose paintings have a subjective, lyrical quality based on European abstractionism and Oriental art. Graves was also directly influenced by Oriental art when, as a young man, he traveled in Japan. His haunted images of birds are transformed into linear, subdued symbols suggesting the mystical imagination of the East.

Greco, El (Domenico Theotocopuli) (1541-1614). El Greco is considered Spain's greatest 16th century artist. The fact that he was born into the Byzantine tradition of Crete and, in Italy, assimilated the Renaissance and Mannerist styles, is evident in his works of Toledo where he lived from 1577 until his death. Besides historical and religious scenes, he painted royal portraits and landscapes in a highly expressionistic manner. El Greco employed strong contrasts of color and composition to heighten the intensity of each particular painting. Whether it be a frenzied mystical experience or a moody landscape, his enlongated forms, painted in flame-like brushstrokes profoundly influenced the Romantic artists and the 20th century Expressionists.

Greuze, Jean-Baptiste (1725-1805) was a French painter of narrative, moralistic scenes. His painting of 1755, *Grandfather Reading the Bible to his Family,* brought him immediate recognition from the Salon. For a time his work enjoyed immense popularity but his arrogant personality resulted in his ostracism from the salons. His privately exhibited works were most successful during the 1770's but with the misfortunes of the Revolution and an unhappy marriage, his work degenerated into trite sentimentality. He died impoverished and neglected.

Gris, Juan (1887-1927) was a Spanish artist who studied at the School of Arts in Madrid. He went to Paris in 1906 and there met Picasso, and Braque and, in 1912, became associated with Cubism. He first exhibited in 1912. His early works employ transparent Cubist planes, often combined with Braque's collage techniques. His later paintings, less transparent and more colorful, are marked by rigorous structure of planes. In the 1920's Gris designed sets for the ballet and the theater.

Gropper, William (1897-1976) is a contemporary American realist. Born in New York, he studied at the National Academy of Design and at the Ferrer School with Robert Henri and George Bellows. Gropper's drawing ability and feeling for dramatic exaggeration were best expressed in his political cartoons for newspapers and magazines. He also painted murals for federal buildings in Washington as well as expressive oil paintings which make social comments.

Grosz, George (1893-1959) was born in Berlin and studied at the Dresden Academy. He served in World War I but was courtmartialed and nearly shot for his antipatriotic views. As Berlin's founder of the Dada movement, Grosz expressed his horror of war in a wildly fantastic style. The savagely satirical pictures caused him to be driven out of Germany, and he settled in the United States where his paintings and illustrations became milder in tone. Grosz's work has been widely exhibited and represented in museums both here and abroad.

Grünewald, Matthias (c. 1475-1528). Little is known about the early life of this great German artist. He spent several years in Mainz as court painter to the Archbishop-Elector and was also active in Strasbourg and then in Colmar where he studied under Martin Schongauer. Although he met Dürer in Basel, Grünewald's painting took a different direction, as seen in his magnificent Isenheim altarpiece (1513-1515). This powerfully expressionistic work shows, in the central panel of the *Crucifixion,* Christ as a decomposing, distorted body, painted in greenish tones; the *Resurrection* panel emphasizes the expressive juxtaposition of earthly ugliness and heavenly beauty; here Christ rises weightlessly, a mystical vision bathed in diffused light. Grünewald's masterfully original handling of color and composition combines to express in plastic terms his profoundly emotional message.

Guardi, Francesco (1712-1793), a member of a family of painters, was one of the greatest Venetian artists of the 18th century. He is best-known as a brilliant painter of *vedute*, views of his native Venice. These sparkling scenes evoke the light and mood of the city through dashing, abbreviated strokes. Guardi, with his characteristic shorthand, captured transient effects of lights, the sun striking intricate architectural carvings, or the rapid movement of figures hurrying across a piazza.

Guercino (Giovanni Francesco Barbieri) (1591-1666) was a leading Italian Baroque artist. He began his career decorating houses and churches in Ferrara and then worked for several years in Bologna. His early works, in their strong shadows and modeling, show the influence of Michelangelo, the Carracci, and Caravaggio. But later, when Guercino traveled to Venice and Rome, he developed a softer, more delicate touch. His individual style reached its height in the famous illusionistic ceiling decoration of the Villa Ludovisi in Rome where Guercino painted for Pope Gregory XV. When the Pope died in 1623 Guercino moved back to his native Cento, and then to Bologna where he spent the rest of his life painting religious works. He was a draughtsman of great virtuosity.

Guston, Philip (1913-1980) an American abstractionist painter, was born in Montreal but came to the United States in 1916. He studied briefly at the Otis Art Institute, Los Angeles, and has taught at numerous institutions, including New York University, Yale University, and the Pratt Institute. He received first prize at the Carnegie International in 1945 and his first one-man show was held in New York that year. His painting style in the nineteen-forties was representational, but in the fifties he turned to abstraction, and since the late fifties his work has been increasingly aggressive, with strong surface rhythms and a dramatic use of color.

Hals, Frans (1580-1666), one of the greatest painters of northern Baroque period, was born in Antwerp and lived primarily in Haarlem. He was a brilliant and successful portraitist, painting dashing studies of individuals or lively, informal group portraits of prosperous Dutch burghers. His flickering brushstrokes, which caught the sitters' fleeting expressions and gestures, influenced Manet and the Impressionists; however, Hals works are more subdued in handling and show greater perception in characterization.

Hamen, Juan van der (1596-1631) studied first with his father who was a Flemish archer in the royal guard and a competent flower painter. Young van der Hamen failed to win the post of painter to the Spanish Court but became famous for his paintings of flowers and fruit. His *Scenes from the Childhood of Christ* are in the Convent of St. Trinity in Madrid.

Harnett, William (1848-1892) was born in Ireland and grew up in Philadelphia where he practiced drawing in night classes at the Academy of Art. He first worked as a silver engraver but soon began painting still lifes. He spent several years studying art in Munich, then a great center, and after that settled in New York City. The silent intensity and extraordinarily realistic depiction of commonplace objects brought him great popularity. Since his death and a period of obscurity his works are receiving new attention.

Harpignies, Henri (1819-1916) was a French landscape painter whose style was strongly influenced by the painting of the Barbizon School, and Corot in particular. His late landscapes have a romantic, generalized quality, possibly due in part to his failing eyesight but nevertheless appealing. During his lifetime his work was more popular in England than in his native France, and

the National Gallery in London possesses four of his paintings.

Hart, George O. ("Pop") (1868-1933) was a wandering painter of watercolors and genre scenes. Born in Illinois, he worked in his father's glue factory and painted in his spare time. He traveled widely, studying and developing his rich impressionistic landscape style.

Hartley, Marsden (1877-1943) studied art in Cleveland and, with William M. Chase, in New York City. His early landscapes were in an impressionistic style but when he went to Paris he felt the impact of the current European trends of Fauvism, Cubism and German Expressionism. During this period he painted large, colorful, abstract still lifes and portraits. When he returned to the United States in the 1920's he joined the New York circle of Alfred Stieglitz, but later moved back to his native state of Maine where he painted the land and the sea in deep, glowing colors and dense pigment—bold, strong landscapes which owe something to Cézanne.

Hartung, Hans (1904-　) was born in Leipzig. He began to paint abstractly in 1922, and from 1924 to 1928 studied in Leipzig, Dresden, and Munich. He first became familiar with Kandinsky's work in 1925, and made numerous trips to Paris until 1933. In 1935 he fled from Berlin to Paris; after several years of underground activities he served in the Foreign Legion during the war, and became a French citizen in 1945. Throughout this difficult period he did not lose sight of his artistic aim, which was to record psychic images pictorially. His painting is based upon theory rather than upon any particular artistic model, and the energy-charged color and line patterns which move on his canvases are the attempt to translate emotional experiences to an abstract visual mode.

Hassam, Childe (1859-1935) studied art in Boston. The softly luminous gray tones of his early scenes owe some debt to Whistler. When he was 27 Hassam went to Paris where he studied at the Ecole des Beaux-Arts and then at the Académie Julian. He quickly absorbed the Impressionists' style and use of color; on his return to New York his work was shown, in 1895, in an exhibition of ten American Impressionists. His naively happy scenes, freshly painted and filled with light, brought Hassam rapid recognition as well as numerous awards.

Havell, Robert (1793-1878) was born into a noted English family of engravers. He followed Audubon to America and engraved the plates of the latter's *Birds of America*. In 1857 Havell settled in Tarrytown where he employed his exact and delicate technique in aquatints and oils of the Hudson River valley.

Healy, George Peter Alexander (1813-1894) became a portrait painter at a young age in his native town of Boston. Healy went to Paris in 1834 and studied with Baron Gros from whom he learned how to achieve tonal effects. In 1855 he moved to Chicago, then still a new city on the American frontier. After twelve years there he returned to Europe and lived in Paris and Rome. Due to his mobility and his talent, Healy became both famous and successful. An energetic artist, he painted many distinguished Americans and Europeans.

Heem, Jan Davidsz de (1606-1684) was a Dutch still-life painter. Born in Utrecht, he lived in Leyden and Antwerp. His realistic representation of arrangements of flowers, food, goblets, and utensils, brilliantly painted, won recognition throughout 17th century Holland and today his works are contained in museums throughout Europe and the United States.

Henner, Jean Jacques (1829-1905) was a French artist who studied painting in Germany before entering the Ecole des Beaux-Arts in Paris in 1847. Due to his mother's poor health he was forced to return to Alsace for two years, during which time he painted many portraits. In 1858, having returned to Paris, he won the Prix de Rome and went to Italy where he was greatly influenced by Correggio. While there he also painted small landscapes reminiscent of Corot's early work. In 1863 Henner exhibited *Sleeping Bather* in his debut at the Salon. He continued to paint nudes, in the style of Prud'hon, as well as portraits and historical subjects. He was an active artist whose work brought him both financial and artistic success.

Henri, Robert (1865-1929) contributed to American art both as a teacher and a painter. Born in Cincinnati, he studied under Anshutz at the Pennsylvania Academy, then in Paris at the Ecole des Beaux-Arts and the Académie Julian. He traveled widely in Europe, continually developing his realistic style. In 1891 he returned to Philadelphia to teach and to paint. There he recognized a fresh quality in the work of George Luks, John Sloan, and William Glackens, and Henri encouraged these illustrators to turn to painting. His challenge to the current mood of imitative estheticism materialized in the New York exhibition of "The Eight." Five years later he took an active part in the famous Armory Show. His own style shows itself in his sketchy, often too hasty, portraits. He published his artistic theories in *The Art Spirit*.

Henry, Edward Lamson (1841-1919) recreated America's past in historical genre scenes. Born in South Carolina, he studied at the Philadelphia Academy and in New York. In Paris he worked with Gleyre and Courbet. Despite his exposure to Impressionism, Henry did not assimilate the French manner of using rich pigments. Instead, his execution is rather dry. His most attractive works are naturalistic, homey studies done on Long Island and in the Catskills.

Hesselius, John (1728-1778), with his father, Gustavus, was a leading portrait painter in colonial Philadelphia, Maryland and Virginia. His early work took on the dignified Baroque manner of Robert Feke's portraits. Later, around 1760, he painted in the more Rococo mood of John Wollaston. Hesselius was a competent artist whose strong colors attained luminous effects. He married well and assumed the life of a country gentleman. Thus, semi-retired in Maryland, his production dwindled during his later years.

Heyden, Jan van der (1637-1712) is remembered for his paintings of Amsterdam. At a very young age he showed remarkable talent for drawing architecturally precise houses and monuments. He softened the linear severity of the public buildings by employing aerial perspective, plays of light and fluid atmosphere. He developed this skill in oil, giving meticulous attention to the detailed rendering of brick walls and tile roofs. The finely-graded nuances of light and warm colors gave significance to the scenes known and loved by the Dutch. Van der Heyden was interested in physics as well as painting, and he worked on designs for improving the fire engine.

Hicks, Edward (1780-1849) was a Pennsylvania Quaker who painted signs and coaches for a living and later became an itinerant preacher among the Friends. When he began to paint he applied the decorative colors and flat composition of his craft to peaceful religious scenes. His best-known primitive, *The Peaceable Kingdom*, (which he painted in many versions) interprets simply, in both form and content, a naive harmony between man and beast.

Hill, Thomas (1829-1908) born in England, came to America in 1841 and studied at the Pennsylvania Academy of Fine Arts. His portraits and flower paintings were exhibited with great success during the 1850s, and in 1861 he traveled west where he began painting the landscapes for which he became noted. After a year's study in Paris, Hill returned to America and finally settled in San Francisco.

Hirsch, Joseph (1910-) is an American painter of portraits and genre scenes. He studied in Philadelphia with George Luks and later traveled through Europe and the Far East. Hirsch has won several awards for his passionate and caustic satires, thickly painted in a dramatic manner. He is particularly noted for his drawings of World War II.

Hobbema, Meindert (1638-1709) was one of Holland's greatest landscape artists. He studied under and painted with Jacob van Ruisdael but developed a style different from that of his master. Hobbema's peaceful scenes contain evidence of man and his labors, while Ruisdael's romantic landscapes emphasize nature's boundless forces. In the later part of his life Hobbema virtually retired as an artist and worked as a civil servant. His paintings influenced the 18th and 19th century English landscape artists.

Hodler, Ferdinand (1853-1918) was an eminent Swiss artist whose work is identified with Post Impressionism. His early paintings were realistic expressions of his youthful examination of science and religion. During the 1870's Hodler studied art in Madrid and Paris where he was influenced by the works of Cézanne, Seurat and van Gogh. His fine drafting ability assumed a symbolic quality and his drawings employed curvilinear lines reminiscent of Art Nouveau.

Hofer, Karl (1878-1955) was a German Expressionist from Karlsruhe. Early in his career he was influenced by Hans Thoma and Arnold Bocklin, whose romantic styles he combined with the ordered composition of Cézanne. His figure studies from World War I express the horrors of battle and the artist's own disillusionment. But Hofer's later charming figures and still lifes grew freer in handling and reveal a more positive attitude toward life.

Hofmann, Hans (1881-1966) was born in Bavaria and began his artistic career in Paris where, between 1904 and 1914, he worked closely with Matisse and Delauney, and their influence is apparent in his painting. He returned to Munich and opened his own art school. In 1931 he came to New York and conducted a year-round school and also a summer school in Provincetown, Massachusetts. It is particularly through his teaching that Hofmann has been a major force in American painting. He was the prophet and patriarch of the new American painting—and with his inexhaustible source of ideas was a primary factor in the development of Abstract Expressionism. Hofmann worked both with forms taken from nature and with abstract inventions, using pure colors of high intensity, predominantly bold simple colors such as red, green, yellow and blue. As early as 1940 he anticipated Abstract Expressionism in his use of freely-dribbled paint and sweeping brushstrokes. His work is exuberant yet controlled. Hofmann describes his own work as a constant process of "push answering pull—and pull answering push."

Holbein, Hans the Younger (1497-1543) was born in Augsburg and studied with his able artist father, Hans Holbein the Elder. Still a young boy, he continued his studies and painting in Basel, then an active center of Humanism. There he met and became a lifelong friend of Erasmus, the famous philosopher, whose portrait Holbein painted, thus gaining recognition and an in-troduction to Sir Thomas More. In London he painted many portraits; among the most famous are those of King Henry VIII and Sir Thomas More's family. Holbein painted with great technical ability in a realistic style. The penetrating intensity of his subjects' expressions rightfully earned him recognition as the north's most outstanding realistic portrait painter.

Homer, Winslow (1836-1910) was born in Boston of an old New England family. As a young man he was apprenticed to a leading lithographer and later became a free-lance illustrator for *Ballou's Pictorial and Harper's Weekly* in New York. The fresh observation of his woodcuts, in clean, energetic lines, reflect his training in graphics. During the Civil War Harper's sent Homer south to do drawings of the Union armies. During that time he first painted in oil. These simple, disciplined works are penetrating in their convincing narration. *Prisoners from the Front*, exhibited at the National Academy in 1866, brought both acclaim and criticism. From 1867 to 1868 Homer studied in Paris where he was exposed to European currents. His exploration of light took a different direction from the vibrating tones of the Impressionists. Instead, his luminosity was contained within firm outlines and broad planes. In 1873 Homer began painting watercolors and here he employed the same technique, although later examples grew more fluid and subtle. After another trip abroad in 1881 he settled in Maine where he spent the rest of his life painting subjects from outdoor life. These scenes of berrypickers, hunters and playing children show a new solidity and plastic strength. His last work was a series of powerful, lonely seascapes. Homer's objective realism had a directness and simple monumentality which made him one of the most representative of American artists.

Hooch, Pieter de (1629-1688) was a Dutch painter of genre scenes, particularly of bourgeois life in Holland. His approach was close to that of Jan Vermeer, whom he probably knew in Delft. His finest paintings, characteristically interiors of Dutch homes with views through open doors, reveal a precise attention to detail and a special ability in handling the light flooding into a room. Later in his life he moved from the small city of Delft to Amsterdam, where his work took on a grander social tone, but lacked the insight and feeling of his earlier works.

Hopper, Edward (1882-1967) was born in Nyack, New York, of mixed Dutch and English ancestry. He studied with Robert Henri in New York City and painted dark-toned, moody scenes, influenced partly by Henri's palette and by his own solitary personality. Hopper went to Paris in 1906, but instead of becoming associated with any movement of group, he drew and worked by himself. Impressed by the unique light of Paris, he developed his own quietly luminous style. Upon his return to New York his slowly maturing impressions accumulated from constant observation of everyday sights resulted in numerous city scenes—the streets, houses and people enveloped in a spirit of loneliness and the canvas itself bathed with clean, glaring light. Hopper exhibited during the '20's and, although recognition came late to him, it has endured. His individual interpretation of life communicates a sympathetic, objective love of the commonplace American scene.

Howland, Alfred C. (1838-1909), born in Boston, studied in New York and at the Royal Academy of Düsseldorf, then in Paris with Emile Lambinet, later returning to New York in the 1870's. His work was well received; he was elected to the National Academy in 1882, and continued to paint and exhibit in New York, Paris and Munich until his retirement.

Hundertwasser, Friedrich (1929-) was born in Vienna but lives in Venice today. His use of curvilinear lines derive from the Art Nouveau era. Hundertwasser employs oriental motifs in his heavily textured abstract works. He also mixed gold, silver foil, beeswax and grains of sand to enhance this textural effect.

Hurd, Peter (1904-) is a native and devoted painter of the American west. Born in New Mexico, he studied art with N. C. Wyeth and at the Pennsylvania Academy of Fine Arts. He paints in egg tempera on wood coated with white, the effect of which is a luminous and realistic representation of his dramatically spacious scenes.

Hutter, Wolfgang (1928-) is a contemporary Viennese painter who also designs tapestries and mosaics. He transforms his subject matter, usually people, animals and flowers, into colorful symbolic images. His work has been exhibited internationally and in 1954 he won the UNESCO prize at the Venice Biennale.

Huysum, Jan van (1682-1749) was a Dutch artist who studied with his father, Justus, a competent flower painter. His dramatic Baroque compositions are crowded yet precise in their manner and detail. Huysum's work is sometimes mistaken for that of his father or of his younger brother, Jacob.

Ingres, Jean Auguste Dominique (1780-1867). Ingres spent his early life in Montauban and studied at the Academy of Toulouse. In the Paris studio of David he developed his own style under the influences of John Flaxman, Raphael, and Etruscan painting. In 1806 he went to Italy, spending 14 years in Rome and four in Florence. During that time he painted historical, mythological and religious scenes as well as making fine pencil and graphite portraits of foreign visitors. Between 1820 and 1824 he executed a major commission, the *Vow of Louis XIII* for the Cathedral of Montauban. His work was well received by the Salon of 1824 so Ingres returned to Paris and concentrated on the historical paintings of the *Apotheosis of Homer* and the *Martyrdom of St. Symphorien*. From 1835 to 1841 he was again in Rome as Director of the French Academy. This period was devoted primarily to teaching and revising the curriculum but he also found time to paint *Odalisque*, bathing nudes, portraits and religious subjects. He spent the last 26 years of his long life in Paris. It was a productive time, as seen by the numerous female portraits and drawings of friends as well as religious and historical subjects. These later works indicate a freer, more robust manner of handling than that of his earlier style.

Inness, George (1825-1894) was born on the Hudson River, grew up in New Jersey and lived later in eastern Massachusetts. He worked for a map engraver before becoming a landscape artist. Inness was largely self-taught, but the influence of William Page and the Barbizon painters is evident in his early naturalistic works of scenes which are luminous and calm in their atmospheric eloquence. Inness took numerous trips to Europe and it was during his last visit, between 1871 and 1875, that he developed a new style. The landscapes painted near Rome and *The White Monk* of 1874 are typical of this change. In America again, he painted dream-like scenes bathed in soft light and color which exemplify the change in American taste which was taking place around 1875.

Jamison, Philip (1925-) Philadelphia born, Jamison graduated from Philadelphia Museum College of Art. He had originally planned to enter The Wharton School, but this was interrupted by his being drafted. On his return, he gave up plans for a financial career to study art. A skilled watercolorist, he chooses to represent the world around

him in a realistic, yet sensitive and contemplative manner. Subject matter includes flowers, landscapes and interiors, many of which are painted in his summer studio at Vinalhaven, an island off the coast of Maine. He says, "The things I paint are close to me: the hills that surround my home, the houses among the hills, the flowers that grow nearby, my children." Although his paintings are inspired by nature, they often bear little resemblance to the source of inspiration. He has exhibited in dozens of shows, winning prizes throughout the United States. He is a member of the American Watercolor Society and an elected Associate of the National Academy of Design.

Jenkins, Paul (1923-) was born in Kansas City, Missouri, and studied at the Art Students League in New York. He was influenced by the work of Klee and Kandinsky but has developed his own personal technique which involves pouring paint on unstretched canvas and moving the canvas to blend the paint. Jenkins has exhibited his acclaimed works internationally.

Johns, Jasper (1930-) is an American Pop artist. Born in South Carolina, he studied at the University of South Carolina, and his first one-man show was held in New York in 1958. A number of recurrent motifs in his work have become very well known: targets, various treatments of the American flag, the use of letters of the alphabet and numbers as subjects, the addition of real objects to his paintings, and sculptures based upon real objects. His artistic relationship to Dada is apparent, but his work is clearly in the mainstream of Pop.

Jones, Joe (1909-1963) was born in St. Louis where he worked as a house painter before the depression and then became an artist associated with the Federal Arts Project. He met Thomas Hart Benton and William Gropper during this period and they influenced both his subject matter and style. Jones expressed current social concern in realistic city scenes but, following World War II, turned to painting pastel seascapes in a linear manner.

Jongkind, Johan (1819-1891) was a Dutch precursor of Impressionism. Settling in France, he first worked with the Barbizon painters but, like Boudin, was attracted to the harbors and beaches near Le Havre. He sketched and painted watercolors out-of-doors, experimenting with the effects of light on the sea. Jongkind developed a soft, translucent style which was to influence Monet and other young Impressionists.

Kalf, Willem (c. 1622-1693) was an outstanding Dutch still-life painter who studied under Hendrick Pot and for a short time came under the guidance of Rembrandt. His sure touch and deep color also suggest the influence of Vermeer. He spent his life in Holland except for occasional trips to France and Italy.

Kandinsky, Wassily (1866-1944) was a Russian artist considered by many to be the originator of non-objective art. He went to Munich to study art and there he came under the influence of Cézanne. In 1909 he started an art school with Alexej Jawlensky and the following year painted his first completely non-objective work. His book, *The Art of Spiritual Harmony*, explains his theory of abstract art. He was one of the founders of the Blue Rider, the pioneering group of German Expressionists. As a teacher at the Bauhaus where he came in contact with Klee and Feininger, he formed the group known as the Blue Four, with them and with Jawlensky. Kandinsky's style from 1913 shows a steady development of the abstract principle. From his early lyrical work to his later geometrical forms, Kandinsky has strongly influenced the development of modern art.

Kano Tannyū (1602-1674). Upon the death of his father, Tannyū became the head of the Kano school of painting in Kyoto, Japan. His first commission was the decoration, with wall and screen paintings, of the castle in Nijo. Tannyū's painting was influenced by the Chinese style of brushwork and the Chinese concept of space.

Karfiol, Bernard (1886-1952), an American painter, was born in Budapest and studied in Paris at the Académie Julien and in the United States at Pratt Institute and the National Academy of Design. His nudes and interior scenes in a realistic style show his interest in the work of Renoir and Cézanne, and his earlier painting especially is notable for a light, warm quality. Karfiol exhibited widely and his paintings are included in major American public collections.

Keith, William (1839-1911) was born in Scotland and studied with Andreas Achenbach and Carl Marr in Germany. Settling in America, he became known for his portraits and powerful landscapes of the California coast, many of them now in the Corcoran Gallery of Art in Washington, D.C.

Kemeny, Lydia (1925-) British-born Lydia Kemeny was educated at the St. Martins School of Art and the Royal College of Art, both in London. Her great affection for the English countryside is shown in her paintings, revealing flower-filled courtyards and gardens with freshness and delicacy. She combines an acute sense of color harmony with a keen observation of the inherent charm of the gentle world around her. A meticulous craftsman, she has had numerous exhibitions including the Royal Academy in London and the Salon in Paris.

Kent, Rockwell (1882-1971) was an American painter, illustrator, engraver, writer and explorer. He began his studies at the Columbia School of Architecture, but soon turned to painting. His varied travels have determined his strong realistic style but he is best known for his illustrations.

Klee, Paul (1879-1940), born in Switzerland, went to Munich at the age of 19 to study art; there, in an early series of allegorical engravings, he expressed an introspective fantasy which was to characterize his mature style. Klee was an early associate of the Blue Rider group of German Expressionists, and later taught at the Bauhaus. He painted fanciful scenes in an objective and realistic style. This childlike, whimsical quality (despite later experimentation with geometric forms) continued to imbue the simplest line with a feeling of lively humor and movement.

Kline, Franz (1910-1962) was one of the leading innovators of American Abstract Expressionism. During the 1930's he was associated with the Ashcan School. In the late 1940's and early fifties Kline began to experiment with the abstract. His paintings are deliberately stark and powerful, executed in very broad brushstrokes on large canvases.

Knaths, Karl (1891-1971) was born in Wisconsin and studied at the Art Institute of Chicago. He was deeply impressed by the 1913 Armory Show and began to paint in a post-impressionist manner. Around 1930 he turned gradually to abstract forms, but his style never lost its representational quality.

Kokoschka, Oskar (1886-1980), one of the most imaginative of the Expressionists, was born in Vienna where he first exhibited in 1909. He taught at the Dresden Academy, traveled widely in Europe and the Near East; declared "degenerate" by the Nazis, he left Germany for Prague, then lived in London from 1938 until 1953. Kokoschka's portraits are especially noted for their sensitivity and introspective quality. Both his portraits and landscapes show a vivid use of color and a restless energy of line.

Kooning, Willem De (1904-) is a Dutch painter who studied at the Rotterdam Academy of Fine Arts and came to the United States in 1926. He has taught at Black Mountain College, North Carolina, and at the Yale University School of Fine Arts. His abstract style has never completely freed itself from organic forms and, in fact, his most famous motif is an oversized, grotesque female form used as the basis for abstract compositions and stylistic development in the "Woman" series. His retention of a painterly approach sets him apart from the pure Abstract Expressionists of modern painting.

Korin, Ogata (1658-1716) was a Japanese painter, exemplar of the Rimpa School and founder of the Korin School. Korin was greatly influenced by Sotatsu (whose work he sometimes copied) and Koetsu. By profession a designer of Kimonos, he nevertheless excelled in calligraphy and painting. His work is justly famous for its superb decorative effect, and its influence is seen throughout Japanese art of the period. Irises, one of his favorite themes, are the subject of two fabulous gold screens, one in the Metropolitan Museum of Art, New York and the other in the Nezu Art Museum, Tokyo.

His life was not as serene as his paintings, however. Growing rich by his Kimono designs, he indulged his extravagant taste to the point that he was punished under the sumptuary laws then in effect in Japan. He became bankrupt around 1700 and turned to painting, moving from Kyoto to Edo. It is our good fortune that his need for funds gave birth to the magnificent work that was the result.

Koson, Ikeda (1802-1867) Japanese painter of the Edo period, Koson was regarded as a top student of Hoitsu, briefly following his style and also echoing his teacher in writing a book on Korin. He later studied Chinese pictures of the Ming Dynasty, and his style changed from the traditional brilliant colors and bold designs of the Sotatsu-Korin school to a subdued, almost delicate technique using only subtle ink tones, varying in tone from pitch black to pearl gray. He expresses the essence of the subject with an elegant economy, achieving his effect with a quiet serene statement of line and tone. Koson's subject matter consisted entirely of trees, and he used soft vertical brush strokes to delineate the tree trunks, large and small, with a light wash of ink and small ink dots, creating a quiet, dream-like quality.

Kroll, Leon (1884-1974) was born in New York City and studied at the Art Students League. His early paintings show the influence of George Bellows and his later work the influence of Cézanne and Renoir. He is known primarily for his realistic interior scenes.

Kuhn, Walt (1880-1949), an influential American artist, was born in New York. He began his career as a cartoonist in San Francisco. In 1912, with Arthur B. Davies, he helped organize New York's historic Armory Show which introduced avant-garde European art to the U.S. Kuhn's early work was in the tradition of the Ashcan School and the "urban realists;" his later style became more powerful and vigorous as seen in his sensitive images of circus and vaudeville performers.

Kuniyoshi, Yasuo (1893-1953), a Japanese-born artist, studied extensively in Europe but has painted most of his life in America. His work, painted in free, realistic style, is full of humor and fantasy. His later surrealistic paintings are reminiscent of Chagall.

Lancret, Nicolas (1690-1743) was born in Paris and studied with Gillot, and then with Watteau whose study style strongly influenced him. Lancret became a successful artist; he was elected to the Academy and executed several commissions for Louis XV. His typical works are varied and graceful *fêtes galantes*, depicting the frivolities of society, elegantly costumed, in charming landscapes, a

kind of subject matter much in vogue in the 18th century.

Lane, Fitz Hugh (1804-1865) was born in Gloucester, Massachusetts and studied lithography under Pendleton in Boston until the late 1830's when he was employed by the Boston publishing firm of Keith & Moore. He returned to Gloucester in 1849 and spent the rest of his life painting sea and marine scapes as well as landscapes in Maine, Massachusetts and possibly Puerto Rico.

Laurencin, Marie (1885-1956) was a French painter known for her portraits in soft pastel shades. A close friend of both Picasso and Matisse, Laurencin's portraits show their influence.

Lawrence, Sir Thomas (1769-1830) was a major British portraitist. At a very early age, in Oxford, he painted crayon miniatures of nobles and military figures. When he was 18 he became a student at the Royal Academy. He soon became the most eminent portrait painter in England and, in fact, established a wide reputation throughout Europe. On Reynold's death in 1792, Lawrence was appointed Painter to the King, and in 1820 became the President of the Royal Academy.

Lebrun, Rico (1900-1964) was born in Naples where he studied art until 1924 when he came to the United States and settled in Illinois. Lebrun's early paintings make use of forms adopted from the Italian Renaissance and his drawings often have a classical purity of line. In later works he incorporated recognizable shapes in a more abstract style imbued with a powerful expressionism used to explore such themes as the Crucifixion and "Buchenwald."

LeClear, Thomas (1818-1882) was an American painter born in upper New York State. He went to New York City in 1839, studied with Henry Inman, and made several short trips abroad. A member of the American Academy, LeClear was known for his portraits and figure-painting, and he also painted a number of genre pictures. His painting is, on the surface, boldly naturalistic, but it is marked by the sentimentality so apparent in much nineteenth century American art.

Lee, Doris (1905-) is an American artist whose genre scenes such as *Thanksgiving* show her warm humor. She was born in Illinois, studied at the Kansas Art Institute, and has won several awards at the Chicago Institute of Art.

Léger, Fernand (1881-1955) was an extremely versatile French artist, having worked as a painter fabric designer, stage and set designer, and interior decorator. He studied at the Beaux-Arts in Paris under the Post-Impressionist Paul Signac and later went through a Fauve phase during his association with Matisse. But his dominant style came from Picasso, Braque, and their Cubist movement. The Cubism of Léger is more colorful than that of Picasso or Braque; in addition, Léger employs the use of mechanical forms—even his figures and city scenes have an angular, machine-like quality.

Leutze, Emanuel (1816-1868) is especially famous for his painting *George Washington Crossing the Delaware*. Leutze was born in Germany; his family moved to America when he was young, but he returned to Germany to study art. While there he painted many historical scenes. In 1860 he was commissioned to decorate a staircase of the United States Capitol with a series of murals.

Levine, Jack (1915-) was born in Boston where he studied at the Museum School. During the depression he worked for the W.P.A. and was recognized for his satirical social commentaries. His paintings are expressionistic and reveal a keen sense of observation.

L'Hermitte, Léon Augustin (1844-1925) was born in Paris where he studied art. He painted rural scenes in a precise, realistic style similar to Millet's, but strikingly different from that of his contemporaries, the Impressionists.

Liao, Shiou-Ping (1936-) was born in Taiwan and studied at Taiwan Normal University and the Tokyo University of Education. Upon arriving in Paris, he studied at the Ecole Nationale Supérieure des Beaux-Arts, joining the atelier of internationally-known printmaker Stanley William Hayter. He currently resides in New York. Liao draws on the artistic traditions of both East and West in his oil paintings, collages, and intaglio prints. Although his media are western, and his relationship to the New York school is apparent in his concern with form and his use of the framing edge. Liao's use of Buddhist symbols and Chinese calligraphy in his abstract representations strongly suggests his eastern background, as does the compositional arrangement of his canvases. He is particularly noted for the coloristic and formal variety of his graphic works.

Lichtenstein, Roy (1923-) is an American Pop artist. Born in New York, he studied at the Art Students League and Ohio State University. He has taught at the latter as well as at Rutgers University and the Oswego campus of the State University of New York. His first one-man show was held in New York in 1951. Lichtenstein, is perhaps best known for his paintings of oversize comic strip frames, and for his cartoon-like renditions of everyday objects.

Liotard, Jean Etienne (1702-1789) was born in Geneva, studied in Paris and, in 1735, went to Italy where he painted portraits of Pope Clement XII and several cardinals. He traveled to Vienna and Constantinople with two Englishmen he had met in Rome. While in Turkey he grew a beard and adopted oriental dress, thus earning the nickname of "The Turkish Painter." Later he visited England and painted a portrait of the Prince of Wales. The following year he worked in Holland. Liotard showed great versatility in his portraits and still lifes of flowers and fruits but is particularly remembered for his gracefully delicate pastel drawings.

Lorenzetti, Ambrogio (c. 1300-c. 1348) was born in Siena and worked with his older brother, Pietro. Few specific facts are known about his life, and several documented works have not survived. It is evident, however, from the extant frescoes and paintings that Ambrogio was an artist of great inventive imagination. His work of the early 1330's revealed him as a distinguished artist. To the graceful *Madonna and Child* of the Sienese tradition, he added the lively gestures and the exchange of penetrating glances appropriate to his humanising concept of the *Mother and Child*. Active through the 1330's, Ambrogio carried out numerous fresco commissions in Tuscany. Between 1337 and 1339 he painted his renowned allegorical fresco of *Good and Evil Government* in Siena's Town Hall. Once again he treated a traditional subject in a lively manner and expressed the beauties and bounties of nature within his interpretation of a universal harmony. The precision of composition and the richness of color (now faded) is enhanced by the vigorous town and country scenes. It unfolds in a large Sienese landscape which is rendered in accurate perspective and ornamental decoration.

Lorjou, Bernard (1908-) is a French Expressionist. Largely self-taught, he paints still-lifes and interior scenes in a loose powerful style with rich colors reminiscent of van Gogh and Gauguin.

Lotto, Lorenzo (1480-1556). Although this Venetian artist's paintings are enigmatic in their personal intensity, they reflect the influence of such artists as Giovanni Bellini, Giorgione and Correggio. Lotto's work bridges the transition from the High Renaissance to the Baroque. His altars in Venice and frescoes both in and near Bergamo are perhaps his most significant contributions to the history of art.

Louis, Morris (1912-1962) was born in Baltimore and studied at the Maryland Institute. His first one-man show was held in New York in 1957. He is best known for his technique of staining acrylic paints directly into unsized canvas, a method adopted by other Abstract Expressionist painters, including Kenneth Noland. Louis' famous stripe paintings are notable for their vivid clarity of color and purity of design. The effect created by the overlapping stripes of intense color against a white background is striking and compelling, and the names given to these works by the artist, such as *Pillar of Fire*, and *Pillar of Hope*, make his artistic intention clearer still.

Lurçat, Jean (1892-1966) began to paint in the style of Cézanne and later he was attracted by the work of the Fauves. Both Lurcat's paintings and his designs for tapestries reflect the influence of his travels through Spain and the Sahara. From 1920 on, he concentrated primarily on painting broad, moody landscapes.

Macdonald-Wright, Stanton (1890-1973) was born in Charlottesville, Virginia. He went to Paris in 1907 where he studied at l'Ecole des Beaux-Arts, the Académie Julien and the Sorbonne. He was exposed there to such new movements as Fauvism, Futurism and, in particular, to the early developments in color abstraction by Delaunay and Kupka in 1912 and 1913. With Morgan Russell, Macdonald-Wright became the co-founder of the Synchromists, whose style was based upon free-flowing, vivid color patterns. He exhibited at the Armory Show of 1913 and held a one-man show at Stieglitz's in New York in 1917. He has taught at the University of California at Los Angeles and is the author of *A Treatise on Color*, as well as numerous magazine articles.

Magnasco, Alessandro (1677-1749) was born in Genoa. He was influenced by the Mannerist works of Tintoretto and Bassano, while Magnasco himself influenced the style of Marco Ricci. His scenes of peasants, monks, and soldiers, set in stormy, melodramatic landscapes, reflect the transition from the Baroque to the Rococo.

Magritte, René (1898-1967), the well-known Surrealist painter, was born in Lessines, Belgium. He began to draw and paint at the age of twelve, and demonstrated an early taste for the unusual and bizarre. He attended, only intermittently, the Académie des Beaux-Arts in Brussels, and began, in about 1918, to search for a personal painting style. His earliest work showed the influence of Futurism, and by the early 1920's a form of Cubism became apparent in his painting. Magritte's first exhibition was in Brussels in 1920. As his career progressed he gradually grew away from current artistic movements, and he evolved a personal style which emphasized the meaning of his paintings, rather than subordinating meaning to an overriding aesthetic effort.

Maillol, Aristide (1861-1944). Maillol studied painting in Perpignan and in Paris before taking up tapestry and woodcarving. Around 1900 he began to work on a grand scale in clay, marble and bronze. He was first influenced by Paul Gauguin's powerful carvings, but after a trip to Greece in 1909 his work returned to the ideals of early Greek Art, an influence which distinguished his style from Rodin's disrupted emotional forms. Maillol's work is devoted almost exclusively to the female nude. In his later years

he turned to drawings and to book illustrations. He is represented in museums throughout the world.

Malevich, Kasimir (1878-1935), a Russian painter and art theoretician, began as a Fauve in Moscow but became a Cubist in the early 1900's. He is famous for his treatise *Suprematism* which advocated an absolutely pure geometrical abstract art, exemplified in his painting (of 1919) of a white square on white ground. Malevich's fame rests mainly on his theoretical work, for his paintings are coldly academic.

Manessier, Alfred (1911-) was born in France at Saint-Ouen (Somme), studied at Amiens and in 1931 went to Paris. He met and studied with Bissière at the Académie Ranson. In 1941 he exhibited in ''Young Painters in the French Tradition,'' a show which was characterized by a strongly representational style of painting. However, with a group of other young painters, including Bazaine he took up the precepts of the pre-war Abstraction-Création group and developed an almost non-objective form of expression. Manessier, a practicing Catholic with strong religious commitments, concentrated on creating spiritual stained-glass effects in paint; in 1949 he created a series of lithographs on the subject of Easter, as well as a set of church windows.

Manet, Edouard (1832-1883). Manet was born into a prosperous, well-educated Parisian family. He studied with Thomas Couture, a history and portrait painter, before breaking away from this academic tradition to develop his independent style. He painted directly from the model and gave equal importance to the breaking up of the canvas itself by means of quick brushstrokes and colors. His early work, although novel in subject (Spanish dancers and singers on tour in Paris), show his admiration of Goya and Velázquez. These dark-toned compositions are soberly analytical. In 1863 Manet's *Déjeuner sur l'Herbe,* exhibited at the Salon des Refusés, created scandalized reactions of both the critics and the public. During the 1870's his work took on the freer handling and lighter colors of the Impressionists, as seen in his daily intimate subjects such as *Children Playing in the Tuileries* and *Women at the Races.* Manet, however, refused to be linked with the Impressionist movement. Despite discouragement he continued to paint and criticism lessened as the public grew accustomed to his independent vision. But he died still unacclaimed by the academic painters whose tradition he respected and reinterpreted in his own pictorial conception. Manet was a poetic realist who provided an impetus not only for the Impressionists but also for his successors.

Mantegna, Andrea (1431-1506) of Padua was the most important Renaissance painter of northern Italy. His scientific knowledge of anatomy and perspective reveals itself in his sculpturesque figures set in archeologically detailed spaces. As court painter to Lodovico Gonzaga, the Duke of Mantua, he executed illusionistic frescoes (the Camera degli Sposi), whose subjects appear to extend beyond the wall and ceiling spaces. This example of ''trompe l'oeil'' was an innovation which reached its peak in Baroque and Rococo art.

Marc, Franz (1880-1916) was a leading German Expressionist associated with Kandinsky in the Blue Rider group. His best-known works are semi-abstract compositions of horses and other animals painted in broad lines and vital colors.

Marca-Relli, Conrad (1913-) was born in Boston and spent an artistic childhood in New York and Europe. He worked for the W.P.A. during the depression after which he began to develop a personal abstract style. His collage technique employs pieces of canvas layered one upon the other and his intensely turbulent compositions are colorfully pleasing in effect. Marca-Relli is a recognized artist whose works hang in several major museums in America and have been exhibited by the Whitney Museum.

Marin, John (1870-1953) was an American watercolorist who studied at the Pennsylvania Academy of Fine Arts before he went to Paris for six years. During that time Marin met the photographers Alfred Stieglitz and Edward Steichen, who exhibited his work. In Europe he came under the influence of the Fauves and German Expressionists. When he returned to America he lived in New York for several years before moving to the coast of Maine where he settled for the rest of his life. Marin is noted for his fresh watercolor landscapes, seascapes, and city views whose style, originally expressionistic, grew increasingly abstract in his later works.

Marini, Marino (1901-1980) was an Italian painter, engraver and sculptor. He was born in Pistoia and studied art in Florence. For many years he concentrated on painting and engraving, but since then he has turned to sculpture. Marini's subject matter, in all three media, includes horses, riders, and nudes, represented in a strongly simplified classicizing style.

Marquet, Albert (1875-1947) was born in Bordeaux and went to Paris while still a young man. There he became associated with the Fauves, particularly with Matisse who was a lifelong friend. Different from the Fauves, Marquet's style expressed itself in exuberant movement rather than vivid color. His superb draughtsmanship is evident in all of his work, including his later landscapes and town views, painted with harmonious colors in an impressionistic style.

Martin, Homer Dodge (1836-1897) was an American landscape painter who studied under J. M. Hart at the American Academy. In Paris in 1876 he met and was influenced by the work of Whistler. In America again, Martin was associated with the Hudson River School until he broke away from its rather conventional style to develop a broader manner of painting which was more romantic and impressionistic in treatment.

Masaccio (Tommaso Guidi) (1401-1428) continued Giotto's initial break from the Gothic flat picture plane to represent, anatomically and scientifically, the human form in three-dimensional space. The revolutionary concept of making figures appear to exist in an actual space, surrounded by air and light, painted on a one-dimensional surface, is one of major significance to the history of western art. Masaccio's short but brilliant career reveals his ingenious understanding of perspective and chiaroscuro. His altar paintings and Brancacci Chapel frescoes are deeply moving in their quiet grandeur. The solid figures are seen enacting their sober dramas with a magnificence which heralds the Florentine Renaissance ideal of the dignity of man.

Massys, Cornelis (c. 1508-1580) was a Flemish painter and engraver who studied art with his famous father, Quentin Massys. By 1531 Cornelis was a master in the Antwerp Guild and he also traveled to Italy where he made copies of Raphael's paintings. He is particularly acclaimed for his landscapes.

Matisse, Henri (1869-1954) was the leader of the Fauve movement and one of the most creative French artists of the 20th century. His early years in Paris were spent working in the studio of Gustave Moreau and in copying the old masters in the Louvre. The development of his style reflects the influence of contemporary artistic currents. Finding the Impressionists' and Divisionists' use of color limited, Matisse forged ahead until his independent vision reached its logical conclusion in Fauvism. The exaltation of bright color, arranged and controlled in simple flat areas, found expression in a wide range of subjects: still lifes, interior scenes, odalisques and portraits. Criticized in France, Matisse found encouragement in the patronage of Gertrude Stein and the Russian collectors, Stchonkine and Rocosoff, who helped gain recognition for his work. Matisse settled in Nice in 1917 and continued to explore the possibilities of light and color, deliberately and eloquently reduced to their essentials. Examples of his meticulous method are to be seen in his careful pen sketches whose sharp clean lines result in spontaneous purity. Bedridden after a serious operation in 1941, Matisse began to experiment with brightly-painted paper which he cut into imaginative shapes and arranged in vivacious compositions. The culmination of Matisse's creative activity is visible today in the Dominican Chapel at Vence, for which he designed everything from the stained glass windows, the liturgical objects and vestments to the tiles on the roof and the cross on the tower. The total effect of the stark white walls with black-lined drawings opposite the shimmering blue-green windows is one of a radiantly spiritual serenity.

Matta, Roberto (1911-), a Chilean, was an apprentice to the famous architect, Le Corbusier, before his eccentric, imaginative spirit led him to join a group of Surrealist artists. Matta's colorful paintings are both emotional and abstract in style.

Maurer, Alfred Henry (1868-1932) was born in New York and studied at the National Academy of Design before going to Paris where he was influenced by the Fauves. On his return to America his work seemed shockingly ''modern'' to the public. He painted dense, Fauve-influenced landscapes and still lifes which combined the discolorations of the Cubists with strong fresh colors. Some of his work seems to reflect a tormented life, which ended in suicide.

Mayhew, Richard (1924-) was born in Amityville, New York and studied at the Brooklyn Museum School. His first one-man show was held in New York in 1957, and he has taught at the Brooklyn Museum School, the Art Students League, Pratt Institute, and Smith College. His paintings have been widely acclaimed, both in general shows and, recently, in exhibitions of the work of black artists. Mayhew is best known for his quiet, low-key landscape paintings and drawings, for which he has won several important prizes and fellowships.

McFee, Henry Lee (1886-1953) was an American still-life painter from the midwest who studied in St. Louis and Pittsburgh. His early work was cubistic, probably influenced by his friend and contemporary, Andrew Dasburg. McFee's later style, however, grew more conservative and less experimental.

Melchers, Gari (1860-1932) was an American-born Impressionist who studied in Germany and France. He established studios in both Paris and Holland. As an artist he received acclaim for his genre scenes and religious paintings.

Memling, Hans (c. 1432-1494), German-born, lived in the Netherlands; in Brussels he was a pupil of Rogier van der Weyden. He later settled in Bruges where his style matured into an individual, rather lyrical expression. Memling's portraits and religious paintings, though lacking real grandeur, are precisely rendered and imbued with grace and calm dignity.

Mengs, Anton Raphael (1728-1779). The life of this German artist encompasses periods spent in Dresden, Rome, and Spain, each of which added to his technical training as well as to his eventual

fame as an exponent of Neoclassicism. In Rome he met Johann Winckelmann, the renowned German art historian, whose knowledge surely helped Mengs to develop his own treatise on Neoclassical art. As court painter to the Spanish king, Charles III, Mengs executed many outstanding portraits and, until Tiepolo's arrival, worked on the decoration of the royal palaces.

Merida, Carlos (1893-) Born in Guatemala City, Guatemala, Merida turned to painting at age 15 when his original plans to become a concert pianist and composer were frustrated by hearing problems. He lived in Paris for 9 years, studying with Modigliani and Picabia, and was a protégé of Picasso's friend and biographer, Sabartes. In 1919, Merida moved to Mexico, and joined the Muralist Movement. He was commissioned to paint a mural for the Hall of the Secretary of Public Education. His interest in his Mayan ancestry, as well as the influence of Picasso, served to change his style from representational to geometric art of extreme precision, translating this ancient heritage into the painter's language of the 20th Century with a stern quality that reflects an incredible discipline and meticulousness. Not one brush stroke is left to chance. The color areas are clearly delineated, as though cut with a knife. Advanced in years, Merida, in the tradition of Picasso, still actively pursues his art.

Metcalf, Willard L. (1858-1925) was born in Lowell, Massachusetts, and studied at Boston's Museum of Fine Arts. At the age of 29 he went to Paris where he came under the influence of the Impressionists. Upon his return to America he painted landscapes of New England. Metcalf's finest work dates from the period following his first one-man show in 1905.

Metzinger, Jean (1883-1957) was, with Picasso and Braque, an innovator of French Cubism. Born in Nantes, he studied in Paris where he was influenced by the Fauves until 1910 when he began to experiment with the newly-emerging cubistic style. In 1912 he published the first thesis on Cubism. After World War I Metzinger's style again became more representational and he continued to be influential in European art.

Michelangelo Buonnaroti (1475-1564), the archetype of artistic genius, was a brilliant sculptor, painter, architect, and poet. His early Florentine years were spent learning fresco techniques from Ghirlandaio and sculpting with Bertoldo under the patronage of the Medici. With Lorenzo's death in 1492 and the Medici's expulsion from Florence, Michelangelo worked in Bologna and Rome where he studied the depiction of anatomy and drapery and the works of his predecessors. Giotto and Masaccio. His consuming passion was to represent the power and beauty of the human figure. The effect of such works as *Bacchus, David,* and several *Madonnas,* is one of physical grandeur as well as deep emotional feeling. Michelangelo's fresco commission for the Vatican's Sistine ceiling took four years to complete. The awesome result is a monumental series of scenes depicting the *Creation* and the *Story of Noah. The Last Judgment,* painted 24 years after on the chapel's altar wall, is manneristic in style. It might be said to represent the changing religious and political atmosphere as much as it reveals the intensification of the artist's personal crisis. Michelangelo's poetry elaborates the religious anxieties of a troubled genius. During the later part of life he was an active architect, designing the Medici family church of S. Lorenzo in Florence and the dome of St. Peter's in Rome. Michelangelo's incomparable contribution to the Italian Renaissance transcends his time and deeply influenced the history of western art.

Miller, Alfred Jacob (1810-1874) Born in Baltimore, Maryland, he studied with Thomas Sully in that city, as well as at the Ecole de Beaux Arts in Paris and the English Life School in Rome. Known chiefly as a painter of the American West, his work is represented in numerous museum collections throughout the United States, including the Baltimore Museum of Art; the Museum of Fine Arts, Boston; the Denver Art Museum; the Yale University Library and the New York Historical Society. Miller was engaged as artist with an expedition into the West led by Captain William Drummond Stewart in 1837. "Indian Scout" resulted from a sketch made during this expedition. He obviously felt deeply the romantic notion of the noble Indian in harmony with his environment and in control of his destiny.

Millet, Jean François (1814-1875) was the son of a French peasant. For a brief time he trained under a local Cherbourg artist and then under Delaroche in Paris where he was also influenced by Daumier. In 1849 he settled in Barbizon and painted genre subjects of peasants at work and prayer. *The Gleaners* and *The Angelus* are among his most representative works. Both are sentimental scenes executed in a realistic style.

Miró, Joan (1893-) was born in Spain and studied art there before he went to Paris where, in 1925, he took part in the First Surrealist Exhibition. He was, with Salvador Dali, recognized as a leading Spanish Surrealist. Although his work is abstract, it is not completely nonobjective. He distorts and exaggerates his colorful forms to achieve an effect of humorous fantasy.

Modigliani, Amedeo (1884-1920) had his first artistic training in Italy before going to Paris at the age of 12. There he was deeply impressed by the smooth oval faces of primitive African masks (recently rediscovered by Picasso). Modigliani's meticulous draftsmanship underlies the varied facial expressions seen in his sensuous, pensive portraits. Modigliani's fragile constitution was further undermined by his gaily dissipated habits, and he died at the young age of 36.

Mompó, Manuel (1927-) is a Spanish abstract artist. At the 1968 Venice Biennale a special room in the Spanish pavilion was dedicated to his work, and his painting *Ansia de Vivir* was selected by the International Art Critics Association to be included in the UNESCO Art Popularization Series. His painting has a spare, fantastic quality somewhat reminiscent of the work of Miró and of early synthetic Cubism.

Mondrian, Piet (1872-1944) was a Dutch artist who went to Paris. There he painted Cubistic landscapes until he concentrated solely on the strictly horizontal-vertical shapes and primary colors of Neo-Plasticism. This rigorous form of abstraction, promoted by the Dutch magazine *De Stijl,* was to exert a great influence on commercial art, as seen in printing and poster design, and on modern architecture, as seen in the work of Gropius, Le Corbusier and Mies van der Rohe.

Monet, Claude (1840-1926) might be called the most important French Impressionist. From his earliest encounters with artists, such as Boudin, Pissarro and Jongkind, through the time of later contacts with such influential contemporaries as Sisley and Renoir, Monet continued to explore the optical effects of changing light and color. Monet painted directly from the object in order to record visual sensation more accurately. His late studies were a series of *Haystacks* and *Rouen Cathedral* which examine how light at different times of the day changes the subject it illuminates. Monet's famous *Water Lilies* in their shimmering formlessness have recently been related to Abstract art, more specifically to Abstract Impressionism.

Monnoyer, Jean-Baptiste (1634-1699) was a French still-life painter, a member of the Academy of Painting and Sculpture during the reign of Louis XIV. He was born in Lille and worked in France until he went to London in 1690. A specialist in the painting of flowers and fruit, Monnoyer did extensive decorations at Montagu House at Holyrood. He died in London. Five of his paintings are in the collections of the Louvre.

Moore, Henry (1898-) was born in Yorkshire, the son of an English coalminer. He served in World War I, after which he taught school, then studied at the Leeds School of Art and the Royal College of Art. A traveling scholarship allowed Moore to visit Italy and France. Upon his return he was appointed to a teaching post at the Royal College. Moore is considered primarily a sculptor but his sketches from World War II's bomb shelters give an authentic account of the tragedy of war and reveal Moore's freedom of expression in watercolor. He feels that inspiration comes from two sources: nature and the work of art itself. He has won the International Prize for Sculpture both in Venice and São Paulo and is recognized as the greatest sculptor of his generation.

Moran, Thomas (1837-1926), American landscape painter, was born in Ireland and came to the United States with his family in 1844. In Philadelphia he was apprenticed to a wood-engraving firm where his ability as a draftsman first became apparent. He worked in painting with his brother Edward, and studied for a time with James Hamilton. Moran took up etching in 1856 and lithography in 1858, and exhibited his first painting in 1858. He first visited Europe in 1861 where he was much influenced by the works of Turner and Claude Lorrain. Traveling in the western part of the United States, he began the most important phase of his career, painting and sketching the rugged landscape. In his later life he lived in East Hampton and in Santa Barbara, and his paintings sensitively reflect the surroundings wherever he traveled or lived.

Morisot, Berthe (1841-1895) was a French painter and, with Mary Cassatt, one of the two successful female Impressionists. She was early exposed to the style and philosophy of numerous artists since her father's home was a gathering place for painters in the mid-nineteenth century. Her earliest works were strongly influenced by Corot, but she was one of the first painters to turn to Impressionist techniques. In 1868 she met Manet (later her brother-in-law), occasionally posed for him, and it is believed that she was the force behind his adoption of the Impressionist palette. She participated in all but one of the Impressionist exhibitions, and her style after 1885 was most strongly affected by the work of Renoir.

Morland, George (1763-1804) painted rustic genre scenes of the English countryside which reflect the 17th century Dutch manner of Brouwer and Ostade. Morland, instead of working for individual patrons (as was customary in 18th century England) sold his work through an agent. This new practice greatly affected the tradition of patronage in England. Morland's personal life was dramatically full of debts and trouble with creditors; he, in fact, died in prison.

Moroni, Giovanni Battista (c. 1525-1578) was the pupil of Moretto. The influence of Titian and Lotto is evident in Moroni's quiet, realistic family portraits which represent the intimate style of Lombard portraiture.

Morse, Samuel F. B. (1791-1872) is best remembered for his invention of the telegraph (Morse code) but he was also a competent portrait painter. He studied under Washington Allston and Benjamin West in London where he

also knew Turner, Lawrence, Coleridge and Wordsworth. Back in America, Morse was the founder and first president of the National Academy. His most famous paintings are the *House of Representatives* and *Lafayette*.

Motherwell, Robert (1915-) was born in Aberdeen, Washington, studied at Stanford University, Harvard's Graduate School of Philosophy and the Graduate School of Architecture and Art at Columbia University. During this period he also traveled to Europe and taught at the University of Oregon. The European trip introduced him to Surrealism; then, when in New York, Motherwell experimented with collages and automatism with Jackson Pollock and William Baziotes, also with Roberto Matta with whom he went to Mexico. Motherwell's first one-man show occurred in 1944 and he has continued to exhibit and teach, including a retrospective exhibition of his work held at the São Paulo Biennale. Motherwell paints large canvases, restricting his palette to black and white with muted ochers and blues. Irregular shapes converge on flat planes in a kind of plastic phantasy. As one of the foremost American Abstract Expressionists, he is a major influence on contemporary art.

Murillo, Bartolomé Esteban (1617-1682) was a Spanish Baroque artist whose "beggar boys" and religious paintings enjoyed tremendous popularity. As Murillo's style developed, it revealed his knowledge of Rubens, van Dyck, Titian, Velázquez and Ribera. His religious paintings evolved from coolly detached, unidealized figures to fervent devotional images, the last of which culminate in a softness and sweetness of sentimental emotion. His large decorations in the Hospital de la Cáridad in Seville (despite their unresolved composition and mixture of the idealized and the naturalistic) are rich in Baroque expression.

Music, Antonio Zoran (1909-) is an Italian painter, designer, engraver and lithographer. He studied art in Florence and, before World War II, worked in Spain, Yugoslavia and in Venice. He was put into the Dachau concentration camp in 1943 but escaped at the end of the war. Music creates a roughly textured effect to his abstract works painted on burlap.

Nichols, Dale (1904-) was born in Nebraska and studied at the Art Institute of Chicago. He is active as a designer, commercial artist and teacher, and his pleasant landscapes have brought him recognition.

Noland, Kenneth (1924-) was born in North Carolina and studied at Black Mountain College in 1946 and at the Zadkine School of Sculpture in Paris in 1948-49. His first one-man show was held in Paris in 1949. In the 1950's Noland was much influenced by the work of Morris Louis, especially his technique of staining acrylic paint into unsized canvas. His chevron paintings of the late fifties and early sixties, as well as his more recent work, are characterized by the juxtaposition of clear, brilliant colors in highly formalized patterns, on oversize canvases which in recent years have frequently been cut to match the predominant pattern.

Nolde, Emil (1867-1956) stands out from his fellow German Expressionists of the Brücke group in that his work has a particularly violent, tormented quality. Nolde achieved this demoniac effect by distorting the forms and by applying vivid colors, as seen in his graphics as well as in his religious paintings.

Ochtervelt, Jacob (1634-1708) was a Dutch genre and portrait painter much influenced by Pieter de Hooch and, through him, by Vermeer. Although success came slowly to Ochtervelt, by the age of 40 he was the head of the painting guild in his native Rotterdam.

Okada, Kenzo (1902-) is a Japanese artist who was born in Yokohama, studied in Tokyo, and lived for a time in Paris before returning to Tokyo in 1929. Since then he has divided his time between Japan and America and has held important exhibitions in both countries. Okada's work is primarily abstract in style, employing strong, vivid colors.

Okamura, Arthur (1932-) was born in California and studied at the Art Institute of Chicago. His style was first influenced by the works of Klee, Picasso and De Kooning, but his landscapes of California blend color and forms in a richly lyrical style reminiscent of his Japanese heritage. Okamura has won several prizes for his work and he has also taught painting in various California schools of art.

O'Keeffe, Georgia (1887-) is particularly famous for her starkly simple shapes which seem to speak of the universality of nature and, more specifically, of the vast, powerful spaces in the Southwestern United States where O'Keeffe lives and paints today. Many of her subjects are skulls and animal bones in desert landscapes.

Orozco, José (1883-1949). As a prolific Mexican painter of murals, Orozco was highly honored for his contribution to Mexican culture. His first series (1910) commemorates the Mexican Revolution. By the 1920's his subdued colors had become vivid and his composition less rigid. During the 1930's he traveled and painted murals throughout the United States. In 1934 he began his major work, a series of murals at the Palace of Fine Arts and at the Governor's Palace in Mexico City. Here one can see a new use of political symbolism and a more Expressionist style. Orozco's last works were painted in a geometric, abstract manner.

Pang, Tseng-Ying (1916-) is a Chinese artist who was born in Tokyo. His first one-man show in the United States was held in New York in 1954, and in 1965 a grant from the Asia Foundation brought him to this country to work. Since then he has earned over one hundred awards for his watercolors. His style contains elements of both eastern and western artistic traditions, with emphasis on form, design and tonal rhythms. Pang's work includes both strongly calligraphic abstractions and meticulous renditions of subjects from nature.

Panini, Giovanni Paolo (1692-c. 1765) was born in Piacenza but worked in Rome most of his life. He studied art and architecture and was influenced by Salvator Rosa and Locatelli. Panini eventually specialized in painting Roman architectural ruins in a formal manner, using light and shadow to dramatize his strong linear perspective. He also made "vedute" (views) of contemporary Rome which were very popular among tourists of the time.

Parrish, Maxfield (1870-1966) Born in Philadelphia, Parrish attended Haverford College and the Philadelphia Academy of Fine Arts. He also studied under the celebrated illustrator, Howard Pyle, at the Drexel Institute. Parrish's unique combination of artistic and mechanical ability produced his distinctive classical and romantic style, which made him the best known and most popular American artist of the early 20th Century. His work took various forms: murals, prints, book plates and illustrations, calendars and even advertising. In 1885 he visited Paris, where he learned the glazing effect typical of his work. He followed this with a visit to Italy where he studied the formal gardens and villas often seen in his later work. His works of historical as well as aesthetic interest created a new vocabulary in American art, and his contributions in each of his areas was immense. The intense azure color of the sky in many of his paintings became known as "Maxfield Parrish Blue." Parrish died in 1966 at his Plainfield, New Hampshire home.

His awards were as varied as his media. Among them were admission to the Society of American Artists, Honorable Mention at the 1901 Paris Exposition, and the Gold Medal of the Architectural League, as well as an honorary Doctor of Letters degree granted him in 1914 by Haverford College.

Pater, Jean-Baptiste (1695-1736) was a French Rococo artist, the pupil and imitator of Watteau. Pater's numerous *fêtes galantes* are amorous scenes whose quality lessened as their quantity increased.

Peale, James (1749-1831) came from a family of American artists. He lived most of his life in Philadelphia where he became known particularly for his miniatures. Peale also painted still lifes, portraits and historical subjects.

Peale, Rembrandt (1778-1860) was the second son of Charles Willson Peale, the father of the Peale family of painters. Rembrandt trained under his father and later studied in England under Benjamin West. He is especially noted for his portraits of George Washington.

Pedro, Luis Martinez (1910-) was born in Havana and studied architecture at its University before working as a painter in New Orleans and Florida. Upon his return to Cuba in the early 1940's he became the central figure in the local modern art movement. His abstract paintings have won him acclaim as one of the most outstanding artists in Cuba today.

Pellei, Ida (American Contemporary) Born in New York, she studied at the Jamisine Franklin School of Professional Arts and the Accademia di Bella Arte in Rome, where she had her first exhibition. As vivacious as her pictures, her bold and vibrant approach to the painting of flowers and greenery has earned her enormous popularity and acclaim. She has exhibited at the Saggitarius Gallery in London and Los Angeles, the Galerie Juarez in Palm Beach and the Wally Findley Gallery in New York and Paris. Born under the sign of Leo, her paintings are often "peopled" with felines—leopards and house cats. She presently lives in a flower-filled house in Pleasantville, New York.

Perugino, Pietro (c. 1445-1523) was an important Umbrian artist of the Italian Renaissance, most famous as the teacher of Raphael. His background is obscure but historians believe he studied with Piero della Francesca. The first record of Perugino is that of a young painter working in Florence, later in Rome, painting frescoes in the Sistine Chapel and the dome of St. Peter's. His greatest work was executed in 1480 to 1500 which included those in Rome and the fresco at the Church of Santa Maddalena dei Pazzi in Florence. Perugino's art is simple and clear, sometimes almost sentimental. After 1500 he could not compete with the rising monumentality of the High Renaissance; however, he advanced the knowledge of linear perspective and influenced the young Raphael.

Peto, John Frederick (1854-1907) was born in Philadelphia where he studied at the Academy of Art. His paintings are "illusionistic," i.e., so carefully rendered that they lead the viewer to interpret the subject as an existing three-dimensional object. This "trompe l'oeil" technique was made particularly famous by William Harnett, a lifelong friend of Peto.

Picasso, Pablo (1881-1973) was the instigator of or a contributor to nearly every important artistic movement in the 20th century. He was born in Malaga and lived in Barcelona where his remarkable talent was evident at an early age. In 1900 he went to Paris, and was attracted to the subject matter and color of late Impressionism. He painted the squalid but fascinating world of beggars and circus performers, first in predominantly blue tones, then in rose. The broken forms and planes of his 1907 *Demoiselles d'Avignon* reveal the influence of

Negro sculpture which led him, with Braque, to Cubism. Before World War I Picasso produced still-life collages of everyday objects. The years of the thirties saw nudes flattened into patterns of intense movement. Around this time Picasso remembering Spain, painted a famous series of bullfight scenes. In 1937 he finished *Guernica*, a personal statement on the brutality of war. It refers particularly to the Spanish Civil War but the complex symbolic images transcend time and place. A painter of universal vision, Picasso's work runs the gamut of subject and mood, expressed in varied media with the verve and spontaneity of innate genius.

Pippin, Horace (1888-1946) was an outstanding, self-taught American Negro artist from a poor Pennsylvania family. He began to paint while recuperating from wounds received in World War I, depicting the American scene in a primitive style. In his oils he created a world sometimes somber and terrifying but more often vibrant in texture with ringing colors. First exhibited in Philadelphia in 1940, Pippin's work has since been hung in the Museum of Modern Art in New York and other American galleries and exhibited at the Whitechapel Art Gallery in London.

Pisis, Filippo de (1896-1956) was an Italian painter and writer, and in his writings paralleled the ideas of the "metaphysical painters," Chirico and Carrà. De Pisis' paintings are outdoor scenes, painted impressionistically in soft colors and dominated by the light.

Pissarro, Camille (1831-1903) was the oldest member of the French Impressionist movement. He was born on the island of St. Thomas in the West Indies and came to Paris as a young man. First, while associated with Barbizon School he came under the influence of Millet and Corot. In 1863 he joined the Impressionist group and, in many respects, was its leader. Pissarro became a close friend of Monet and also of van Gogh. Later when he met Cézanne and they painted landscapes together in Pontoise, Pissaro's style grew more structured. A further influence was Neo-Impressionism, for Pissarro was deeply interested in the so-called optical mixture theories of Seurat. Increasing eye trouble forced Pissarro to stop painting out-of-doors, and his last scenes are views of Paris seen from a window.

Pollock, Jackson (1912-1956) was one of the originators of the American Abstract Expressionist movement. Born in Wyoming, he studied with Thomas Hart Benton at the Art Students League in New York. During the depression he worked for the Federal Arts Project, a branch of the W.P.A. In the early 1940's he, with Robert Motherwell, Mark Rothko and Willem De Kooning, began to develop the Abstract Expressionist style. The application of apparently arbitrary color emphasized the artist's "subconscious." The spontaneity of this physical action (the artist dribbling paint on canvas) was meant to express the pure emotion of the artist himself. Abstract Expressionism was the first specifically American contribution to modern art and was instrumental in shifting the center of painting from Paris to New City.

Pontormo, Jacopo (1494-1556) was, with Parmigianino and Rosso Fiorentino, one of the leading Mannerists. A native Tuscan, he went to Florence and there was impressed by the works of Leonardo da Vinci and Piero di Cosimo. Pontormo worked with Andrea del Sarto, whose influence remained visible under the increasingly agitated forms of early Mannerist pictures. In addition to many religious paintings in Florence itself, Pontormo executed several groups of frescoes outside Florence, such as the lively decorations for a Medici villa at Poggia a Caiano and the Passion scenes for the Carthusian monastery near Florence. In paintings such as the *Deposition* (1525), the asymmetrical composition of juxtaposed angular forms create disturbing emotional undertones. Often Pontormo's use of light colors heightens this agitation. In the later works one can trace the growing influence of Michelangelo and the transition from the High Renaissance to Mannerism is even more evident.

Porter, Fairfield (1907-1975) was born in Winnetka, Illinois. He studied at Harvard and at the Art Students League. After his first one-man show in 1939 he exhibited widely throughout the United States. His early works are social commentary and the everyday scenes in his later work, both interior and exterior, abound in light but rich colors.

Potthast, Edward Henry (1857-1927) studied art in his native Cincinnati before continuing to paint in Munich and Paris. In 1906 he was elected to the National Academy of New York. His genre scenes hang in museums in Chicago, Brooklyn and Buffalo.

Poussin, Nicholas (1594-1665). As a young art student from Normandy Poussin worked briefly in Paris before going to Rome for the rest of his life. He did return to Paris in 1640 for an unhappy 18 months as court painter to Louis XIII. Once again in Rome, Poussin experimented widely with color technique and subject matter. An intellectual painter, Poussin's elevated moral themes in classical settings appealed to his cultured patrons. His ordered but evocative landscapes were influential on later Dutch and English landscape painting. He is indeed one of France's greatest painters.

Prendergast, Maurice (1859-1924) grew up in Boston where he began painting as a hobby. His interest grew, and in 1886 he and his brother went to Paris to study. After two return trips to Europe he settled in New York City. Prendergast's early works are impressionistic watercolors but his later paintings are in a Post-Impressionist style. When bad health kept him indoors he turned from watercolors to oil and produced some of his most successful work in that medium.

Prestopino, Gregorio (1907-) was born in New York and studied at the National Academy of Design with C. W. Hawthorne. He has traveled in Europe, Mexico, and the southwestern United States, and has taught at the New School for Social Research and the Brooklyn Museum School. His first one-man show was held in New York in 1943. He is best known for his female nude compositions, freely designed and exuberantly colored. In 1958 he won a First Prize at the Cannes Film Festival for the film "Harlem Wednesday."

Raeburn, Sir Henry (1756-1823) was an eminent Scottish portrait artist who painted two generations of Edinburgh's leading citizens. As his prominence grew, Raeburn went to London where he met and was greatly influenced by Sir Joshua Reynolds. The Scot painted in quick, spare brushstrokes, the effect of which added immediacy to his penetrating portraits. Recognized during his lifetime, Raeburn became a member of the Royal Academy in 1815 and was knighted by George IV in 1822.

Raphael (Raffaello Sanzio) (1483-1520). As one of the greatest Italian painters of the High Renaissance, Raphael combined Leonardo's dynamic lyricism with Michelangelo's physical power. Born in Perugia, he studied with his painter father before becoming the pupil of Perugino. Around 1505 Raphael was active in Florence during which time he painted softly tender Madonnas reminiscent of the styles of both Leonardo and Perugino. In 1508 he went to Rome where he became associated with the active group of writers, designers and artists who were working for the pope. Raphael's *School of Athens*, a fresco in the Vatican library, is a perfect rendering of Renaissance ideals reflecting the contemporary concern with Platonic learning and the direct influence of Michelangelo. Raphael also painted mythological subjects such as *Galatea* and designed tapestries for the Sistine Chapel. His late *Sistine Madonna* reflects the change in concept and style from his earlier Madonnas and his last works point the way toward Mannerism.

Rauschenberg, Robert (1925-) is one of the younger artists of the New York School. He was born in Texas and studied at the Academie Julian in Paris. Often compared to Marcel Duchamp, Rauschenberg is considered one of the neo-Dadists, a group that today includes the artists of "sculpture painting." He gathers objects from daily life, such as clocks, paper and wire, and unites these with media such as paint drippings, pencil tracings and strips of canvas. These he molds together to form a collage or a "combine-painting," one of the many forms of neo-Dadism which some art critics call the art of the future. Rauschenberg first exhibited in New York in 1951 and then in cities throughout Europe. In 1964 he won first prize at the Venice Biennale.

Ray, Man (1890-1976) is an American artist of many talents. He was born in Philadelphia and in 1912 studied life drawing in New York. He attended the Armory Show of 1913 and was profoundly influenced by the avant-garde European paintings he saw there. His first one-man show was held in New York in 1915, and in 1916 he was cofounder of the Society of Independent Artists, Inc. With Marcel Duchamp and others he founded the Société Anonyme in 1920, and in 1921 published *New York Dada*. He had taken up photography in 1915, and in 1921 he developed the "rayograph" technique. Ray went to Paris and became involved with Dadaists there in the early twenties, making his first films and exhibiting at the first Surrealist show in 1926. After that he continued his filmmaking, and his work in photography, Surrealist painting and sculpture.

Redon, Odilon (1840-1916) was one of the leading artists of the French Symbolist movement. Although he was a contemporary of the Impressionists, Redon did not experiment with light and color. Instead, his charcoal drawings run the tonal gamut of blacks and grays to penetrate a phantasmagoric world of subconscious dreams. His softly lyrical pastels of flowers are rich in color and imagination. Not only did Redon express in plastic forms such universal feelings as love, hate and fear, but he was subtle as a draughtsman in charcoal, pastel and oil.

Reinhardt, Ad (1913-1967) was born in Buffalo, New York. He studied at Columbia University, the National Academy of Design, New York, and the Institute of Fine Arts, New York University. His first one-man show was held at Columbia University in 1943, and he was the subject of a retrospective exhibition at the Jewish Museum, New York, in 1966. Reinhardt was a pioneer of "quietistic" painting. His works achieved their effects through subtle variations in tone over the whole picture surface. His is an extremely pure abstract style, and his search for total artistic purity was documented in his many magazine articles and other writings.

Rembrandt van Rijn (1606-1669) was such a brilliant and prolific artist that his engravings and paintings have influenced the course of western art. Born in Leyden, Rembrandt worked with Pieter Lastman until he settled, at the age of 25, in Amsterdam. There he met and married Saskia van Uylenborch, a young heiress, who bore him a son named Titus. Both wife and son were the subjects of many beautiful portraits. Saskia died eight years later and Rembrandt.

who had grown accustomed to living extravagantly, soon went bankrupt. Henrikje Stoffels came as housekeeper and nurse to live with Rembrandt for the rest of his arduous impoverished life. During these later years Rembrandt's work changed from the richly-colored portraits of prosperous burghers of his early period to sober, deeply-felt works. *The Night Watch*, as well as many religious paintings, are seen through a diffused light. These changes indicated a growing depth of introspection, especially evident in Rembrandt's emotionally penetrating self-portraits.

Remington, Frederick (1861-1909) was an American painter, sculptor and illustrator. He was born in Canton, New York, and studied at Yale and the Art Students League. After his training he went west to capture the adventurous spirit of America in the last years of the 19th century. His bronze sculptures of cowboys and his illustrations of the Indian wars were immensely popular during the 1890's and, in fact, today his work is enjoying renewed recognition.

Renoir, Pierre Auguste (1841-1919) painted porcelain in his native Limoges before moving to Paris, where he was greatly influenced by the works of Courbet, Watteau and Raphael in the Louvre. Painting out-of-doors with Monet helped to lighten his colors and loosen his brushstroke. During this period Renoir painted many gay café and boating scenes, some of which he exhibited at the Salon, and he exhibited in the first Impressionist exhibitions. Later Renoir traveled widely through Europe. After studying Raphael's work in Rome Renoir's drawings grew tighter and more linear in style. The late period of Renoir's work was almost solely concerned with the female nude; among them, the *Bathers* assumes solid, simple forms softened by warm tones of pink and red. Arthritis crippled Renoir's hands so severely that he could paint only by having the brush taped to his wrist. Despite this handicap, Renoir continued to exalt joyfully the simple beauty of nature which he felt so strongly in flowers and the human form.

Reynolds, Sir Joshua (1723-1792). Born and raised in an intellectual atmosphere, Reynolds' portraits quickly gained fame in his native Devon as well as in London. During travels in Italy, and later in the Netherlands, he was influenced not only by the Antique but also by such Old Masters as Raphael, Titian and Rubens. Reynolds' portraits, in their classical allusions, appealed to the intellectuals and aristocrats of 18th century England. As first president of the Royal Academy he was instrumental in gaining the public's respect for the artistic profession.

Ribera, Jusepe de (c. 1588-1652) was a Spanish painter who probably studied under Francisco de Ribalta before traveling through Italy and settling in Naples. The influence of Caravaggio's strong chiaroscuro is evident in Ribera's early work. Eventually his shading and technique softened, as seen in his religious paintings. He gained international acclaim, particularly in Spain during the period of the Counter-Reformation.

Richards, William Trost (1833-1905) Philadelphia born, he excelled in both oil and watercolor. He received awards in United States and European exhibitions, among which were medals from the Philadelphia Centennial Exposition (1876) and Paris Exposition of 1889. "In the Adirondacks" reflects the meticulous attention to detail and the enormous sweep of romantic landscape typical of paintings of this genre in mid-nineteenth century America.

Riopelle, Jean-Paul (1923-) was born in Montreal where he studied at the Polytechnic School. His early representational Canadian landscapes were exhibited in various salons. Around 1945 Riopelle abandoned his earlier methods and went to Paris in 1947 where he was influenced by the abstract styles of Kandinsky, Miró and Jackson Pollock. He exhibited his work in various Parisian salons as well as in the Biennale of São Paulo in 1951 and in Venice in 1954.

Rivera, Diego (1886-1957) was one of the greatest modern Mexican artists. Rivera studied at the Academy of San Carlos and traveled in Europe from 1907 to 1921, during which time he met Picasso, Braque and Derain, whose Cubist style influenced him. Upon his return to Mexico he executed many murals in Mexico City. During the 1930's he worked in the United States, painting murals in San Francisco and New York (Rockefeller Center). For the last 20 years of his life Rivera worked exclusively in Mexico, where he used his colorful narrative style to express dynamically his socialistic political views.

Rivers, Larry (1923-) was born in New York City where he studied music at the Julliard School before beginning to paint. In 1947 he worked in Hans Hofmann's studio and later held his first one-man show. Rivers paints in a realistic style, choosing everyday subjects from American life. He has been identified with the Pop Art movement and his original experiments with different media, such as plastic, metal and neon lights, have contributed greatly to contemporary American art. In addition to receiving awards from the Corcoran Gallery of Art, the Newport Arts Festival and Spoleto, Rivers has had many one-man shows in New York, Paris and London, as well as having taken part in group exhibitions all over the world.

Robbia, Luca della (1400-1482) was an important sculptor in Renaissance Florence. His greatest work was a marble *Singing Gallery* executed for the Cathedral of Florence. A band of *putti* in a frenzied, rhythmic dance exemplified the successful adaptation of antique motifs to this Renaissance relief. Della Robbia did not continue to work in marble; instead, he founded a flourishing family business which was devoted to the production of decoratively-colored terracottas.

Robert, Hubert (1733-1808) was a French painter whose lengthy stay in Rome, where he sketched ruins and genre subjects, brought him immediate acclaim upon his return to Paris. He continued to paint such subjects, especially views of an imaginary, romantic Ancient Rome, and later decorated French hotels and gardens. As an architect, he drew plans for the Louvre but they were not executed.

Roberti, Ercole (c. 1456-1496) was a minor Renaissance artist who worked in Bologna before settling in Ferrara. There he became the painter to the Este family. A pupil of Cosimo Tura, Roberti painted agitated, eccentric religious works which reflect the court's atmosphere. He was also influenced by Giovanni Bellini, although it is doubtful that Roberti painted in Venice.

Roland de la Porte, Henri-Horace (1724-1793), French painter, was born in Paris and exhibited frequently at the Academy between 1761 and 1789. A rival of Chardin, Roland de la Porte was noted particularly for his still-life studies which were in the tradition of Dutch painting of the previous century and yet manifested a profoundly original creative style.

Romney, George (1734-1802) was a British artist who, at the age of 28, moved from the north country to London where he joined Reynolds and Gainsborough in painting portraits of the aristocracy. Two intermediate years in Rome produced many sketches for large historical paintings. In England once again, Romney met Lady Hamilton, whose portrait he painted in various costumes and poses. He was considered to be Reynolds' rival and, like him, was a great artistic and financial success during his lifetime.

Roshū, Fukaye (1699-1757) was a Japanese artist of the Tokugawa period. Noted for his fine screens, Roshu painted landscapes in a flat, decorative style, emphasizing shape, color, and pattern rather than attempting a realistic rendition. His handling of the human form reduced it to its ornamental, linear aspect. Roshu's style can be traced directly to that of the great painter Sōtatsu, who was active a century earlier.

Rouault, Georges (1871-1958) worked first in stained glass before turning to the media of oil, watercolor, and the graphic arts. His early, darkly-outlined religious paintings, with their rich, somber colors, reflect the influence of his early craft. At the Ecole des Beaux-Arts Rouault worked with Gustave Moreau and Henri Matisse and thus became associated with the Fauves, executing many paintings of clowns and judges. Although Rouault exhibited with the Fauves in 1905, he continued to develop, in subsequent religious and social paintings, his own very personal expressionism.

Rousseau, Henri (1844-1910) was a French customs officer who taught himself to paint by copying the masters in the Louvre. Later he exhibited at the Salon des Independants. Rousseau's tranquil jungle settings have a dreamlike quality and the forms of staring, hypnotic animals are rendered in a bold, naive style.

Rubens, Peter Paul (1577-1640) worked under various local painters in Antwerp before going to Italy in 1600 to be court painter to the Duke of Mantua. During his eight-year stay he studied the works of Michelangelo, Titian, Tintoretto and Caravaggio, assimilating their styles while developing his own. In 1608 he returned to Antwerp to settle there and manage an active workshop, hiring able assistants to help execute his numerous commissions, among which were the decoration of churches and palaces in Antwerp, Paris, London and Madrid. Rubens' wide range of subjects included religious and historical scenes, portraits, and even book illustrations and designs for courtly processions and tapestries. His dramatic forms show an Italian feeling for volume and plasticity and, in their diagonal composition, wind into swirls of dynamic vitality. These flowing rhythms produce an effect of exuberant abundance and make Rubens the greatest northern artist of the Baroque.

Rubin, Reuven (1893-1974) was an Israeli painter born in Rumania and went to Jerusalem at the age of 18. In 1912 he left to study in Paris, but the outbreak of World War I forced him to return to Israel, then Palestine. Rubin is noted for the personal paintings of his people and homeland, dramatically expressive and, at the same time, objective in approach.

Ruisdael, Jacob van (1629-1682) was a Dutch painter of realistic landscapes who, with his pupil Hobbema, greatly influenced the development of landscape painting in 19th century England. Jacob studied with his uncle, Salomon van Ruysdael, an established landscape artist. Jacob's early works are primarily Haarlem street scenes and coastal scenes of sand dunes. Later he traveled to the eastern part of Holland and began to paint low mountains and large shade trees. When he was about 26 he settled in Amsterdam. His style grew increasingly romantic; a dramatic device he frequently used was the sun spotlighting lush fields through breaks in the clouds. The effect of these paintings is one of quiet melancholy.

Russell, Charles Marion (1865-1926) left his native St. Louis when he was 16 and went west to Montana where he became a trapper and then a cowboy. In his spare time he sketched what he saw around him—cowboys, mountains, Indians—with a spontaneous self-taught talent which was to bring him recognition as one of the best illustrators of the American west.

Saito, Yoshishige (1905-) is a contemporary Japanese artist who was born in Tokyo and lives there today. He has exhibited widely, and at the Venice Biennale his painting, E. was selected by the International Critics Association to be included among the UNESCO Art Popularization Series.

Sakai, Hoitsu (1761-1828) was a Japanese artist of the Tokugawa Period (1614-1868). Born of a noble family in Edo, he studied for the priesthood in Kyoto. He was a distinguished poet, musician, calligrapher, horseman and archer, and his home was the center of an active literary circle. In keeping with a Chinese, and later a Japanese tradition, painting was the province of the intellectual. Sakai revived the Korin's style of painting in a delicate brush technique, but he eventually developed his own more realistic style. His screen paintings and fine hand scrolls have justly brought him fame.

Sample, Paul (1896-1974) was an American landscape painter from Louisville, Kentucky. He studied at Dartmouth College before spending two years in France and Italy. Sample was a hunter and explorer, and his paintings reflect his love for the rugged outdoor life. He won numerous awards, including the Temple Gold Medal from the Pennsylvania Academy.

Sargent, John Singer (1856-1925) was an American who lived and painted in Europe for most of his life. Born in Florence, Sargent studied art in Paris. He made brief trips to Spain and the United States before opening a studio in 1881 in Paris. There he painted elegant portraits of internationally prominent people. Despite his success, he was disturbed by criticism and in 1884 moved his studio to London. Later Sargent painted murals, of which two good examples are in the Museum of Fine Arts and the library in Boston. Sargent's most brilliant work, however, is seen in his watercolors and sketches.

Sassetta, Stefano di Giovanni (c. 1392-1450). Born into the tradition of the Sienese School, Sassetta incorporated the hierarchical composition of Byzantium with the glorification of the Virgin. That he was aware of contemporary trends, however, is evident in his St. Francis altarpiece. Here the courtly elegance of the International Style is softened into a sweet mysticism and the Florentine concern with scientific concepts is used to create a spatial reality, as evident in the landscape of the *Procession of the Magi.* The effect of Sassetta's work is one of great mystic fervor.

Savage, Edward (1761-1817), an American painter of landscapes and portraits, was born in Massachusetts. First employed as an engraver, he turned to painting in 1789. A portrait of George Washington, commissioned by Harvard College, was his earliest recorded work. In 1791 Savage went to England where he studied with Benjamin West, returning three years later with several panoramic views of London. He is noted for his life-sized painting of *The Washington Family,* executed in 1796 from life sketches made in 1789. Savage painted portraits of many other prominent Americans.

Schoneberg, Sheldon Clyde (1926-) was born in Chicago, and his education included the Chouinard Art Institute, Los Angeles, the University of Southern California, and the Ac-

cademia di Belle Arti, Rome. His first one-man show was held in Rome in 1949 and his works have since been exhibited throughout Europe and the United States. He draws and paints in a classical, representational style, with emphasis on the human figure.

Secunda, Arthur (1927-) was born in New Jersey and studied at New York University, the Art Students League, the Académie de la Grande Chaumière and the Académie Julian in Paris. His first one-man show was held in Detroit in 1951, and he has exhibited widely in the western United States, France, Belgium, and Sweden. Secunda's works are included in several important collections, including those of the National Museum in Stockholm and the Museum of Modern Art, New York.

Seurat, Georges (1859-1891) was the youthful founder of Neo-Impressionism. Born in Paris, he studied the current theories of color and aesthetics and was also impressed by the abstract harmonies of Delacroix. The subtle gray tones of his early conté crayon drawings show his sensitivity to the quality of light. As Seurat evolved a method of systematic painting he also developed a theory of composition based on the Golden Section. Meanwhile, Seurat studied the paintings of his contemporaries, the Impressionists. Like them, he sought to fill his paintings with color and light, but using a painstaking, scientifically-based technique and imposing on his subjects a strong formal order. In 1886 Seurat finished *La Grande Jatte.* In this peaceful Sunday afternoon scene "Pointillism" attains complete purity of classical form and poetic content.

Severini, Gino (1883-1966), an Italian artist and writer, was one of the original signers of the Futurist Manifesto. His paintings of Parisian night life, however, show that he was influenced most by Neo-Impressionism and Cubism as well as by Futurism. After World War II he painted murals for several Swiss churches and, later he began to write about his theories of art.

Shahn, Ben (1898-1969) Born in Russia, Shahn spent most of his life in the United States. He began by working as a industrial lithographer. In the twenties, he studied in Paris, but revolted against what he felt was mere aestheticism. Shahn's journalistic paintings of the Sacco and Vanzetti case resulted in his first artistic success and the recognition of Diego Rivera, who employed him to assist in painting the controversial Rockefeller Center murals, considered politically objectionable at the time. The theme of social injustice in its many forms permeates Shahn's work, but later paintings deal with the bittersweet but still powerful portrayal of people who stand alone, lost and sad in the isolation of today's world. Internationally acclaimed, Shahn represented the United States in the famous Venice Biennale Exhibition of International Art, where he was awarded one of three top prizes.

Sheeler, Charles (1883-1965) studied art at the Pennsylvania Academy of Fine Arts in his native Philadelphia, later with William Merritt Chase in New York. The influence of modern American architecture is evident in his industrial scenes, painted in a cool geometric style derived from Cubism. His landscapes are also starkly realistic, in the same style, portraying in minute detail natural and man-made objects revealed by a strong, cold light.

Sheets, Millard (1907-) was born in Pomona, California, and studied art at the Chouinard School in Los Angeles, after which he held his first one-man show at the Hatfield Gallery in that city. The success of this show brought Sheets national fame. He paints subjects as diversified as the Manhattan skyline and lush Hawaiian

tropics. He is also an architect and designer, and recently has been active as a museum consultant and art teacher.

Signac, Paul (1863-1935) began painting in the style of the Impressionists but soon adopted Seurat's pointillist technique. His faithful interpretation of Neo-Impressionist formalism never equalled the brilliance of Seurat's work but his numerous seascapes are memorable examples of careful observation and execution.

Sironi, Mario (1885-1961) was an Italian artist who was closely associated with the Futurist movement. With the rise of Fascism, Sironi was forced to find expression in traditional subjects such as baroque revivals which evoked the Italian past. Sironi also painted frescoes and worked in mosaic.

Sisley, Alfred (1839-1899) was born in Paris of prosperous middle-class British parents. As a young man he was sent to England to learn the language and to study business. Unsuited to these pursuits, he returned to Paris and entered the studio of Gleyre where he met the founders of Impressionism, Monet, Renoir and Bazille, and the four formed their own independent group. From 1870 on, it was necessary for Sisley to make a living from what had been a carefree hobby. Sisley exhibited with the Impressionists, sharing their notoriety, and it was not until twenty years later that his shimmering, lucid landscapes received public acclaim.

Sloan, John (1871-1951) was born in Lock Haven, Pennsylvania. He studied at the Philadelphia Academy of Fine Arts and became, with William Glackens, George Luks, and Everett Shinn, a member of Robert Henri's circle. When he moved to New York he illustrated magazines and later taught at the Art Students League. Sloan's sweetly nostalgic paintings of New York, particularly Greenwich Village, reveal a sensitive eye and mind which penetrated mere visual reality. He was a witty, talkative, rather temperamental person, whose independent spirit was typically American. Later he painted nudes, working directly from the model, which are slightly reminiscent of Renoir.

Soutine, Chaim (1894-1943) was born in a small Lithuanian town not far from Minsk where he went to study art at the age of 13. Four years later he went to Paris where he met Lipchitz, Chagall and Modigliani. Soutine was greatly influenced by the Expressionists, evident in his rich, turbulently-colored landscapes and still-lifes. By means of distorting the sitters' features, Soutine's portraits are sensitive and penetrating in effect. In 1923 Dr. Barnes of Merion, Pennsylvania, bought 100 of his paintings which were exhibited throughout the U.S., thus bringing recognition to this expressive artist.

Soyer, Raphael (1899-) was born in Russia and came to America in 1912. He studied at the National Academy of Design and the Art Students League in New York. Soyer paints sensitive ghetto scenes in a simple, mildly expressionistic style. He has a twin brother, Moses, who is also an artist.

Speicher, Eugene (1883-1962) was born in Pawtucket and studied at the Rhode Island School of Design in Providence, then at the Art Students League where he met George Bellows and other members of the Ashcan School. Speicher is known for his portraits of women. An able draughtsman, he uses generous color and paints in a traditional style.

Spyropoulos, Jannis (1912-) is considered the most distinguished living Greek abstract painter, internationally exhibited with many one-man shows and winner of many prizes. He first studied in Athens, then spent two years in Paris

before returning to Athens at the outbreak of World War II. His early work was descriptive and illustrative, strongly reflective of Greek cultural traditions as well as of the physical environment he portrayed. By 1950 his style had become more disciplined and eventually grew highly abstract though still reminiscent of his attachment to his native soil in the use of rich, deep color flashed through with light as if touched by the sun. An exciting tension is created with the juxtaposition of earth-warm and vivid colors with a dark palette, yet his compositions are contained and harmonious.

Staël, Nicolas de (1914-1955) was born in St. Petersburg, Russia, and his family emigrated to Poland in 1919. He moved to Brussels in 1922 and studied at the Académie Royale des Beaux-Arts in 1932 and 1933. By 1940 he had settled in Nice, but he visited Paris frequently. Some of de Staël's paintings may be classified as pure abstraction, but his most powerful works use color and structure to create visible reality.

Still, Clyfford (1904-1980) an American painter who was born in North Dakota and attended Spokane University and Washington State College. He has taught at Washington State University, the California School of Fine Arts, Hunter College and Brooklyn College. His first one-man show was held at the San Francisco Museum of Art in 1941. His early paintings, abstraction touched with surrealism, show the influence of Kandinsky and Arp. His later work, like Rothko's, is pure and rather formal, evidence of a continuing search for the absolute in painting.

Stuart, Gilbert (1755-1828), the leading portrait artist of the Federalist period, established the American classical portrait style. He was born in Rhode Island and began painting at an early age. The migrant Scottish artist, Cosmo Alexander, recognized Stuart's talent and took him to Edinburgh. Later Stuart went to England where he spent 12 years, part of the time painting with his compatriot, Benjamin West. Having gained success, Stuart led an extravagant life, fell into debt, and was forced to flee to Dublin. In America again, he painted three portrait types of George Washington, numerous copies of which are to be found in collections throughout the United States. By eliminating extraneous descriptive details, Stuart's portraits take on the timeless, motionless aspect of statues.

Sully, Thomas (1783-1872) was a prolific, successful portrait painter and miniaturist. He was, for a time, the pupil of Gilbert Stuart but went to England to study with C. B. King and Benjamin West. Upon his return he settled in Philadelphia. Wealth and fame came quickly to Sully, who dramatized and idealized his sitters' appearances. His large portraits are romantically refined and graceful in their elegance.

Tait, Arthur Fitzwilliam (1819-1905) was born in England and emigrated to New York in 1850. Summering in the Adirondacks he painted a great many sporting scenes, many of which were lithographed by Currier & Ives. He was elected to the National Academy in 1858.

Tao-chi (1641-ca. 1720) in his treatise, Hua-yü-lu, stressed the spiritual as well as the technical aspects of art. One of the great "eccentrics" of Chinese painting, he drew inspiration directly from nature. In his paintings and calligraphy, Tao-chi used a variety of styles from the bold "single stroke" to detailed, refined brushwork. All his work is characterized by a free, expressive quality.

Tapies, Antonio (1923-) was born in Barcelona, studied law, then devoted himself to painting. A self-taught artist, Tapies paints in a heavily-textured style. First working in Spain, he won a scholarship to study in France and the Netherlands. He has exhibited his work in galleries throughout the world and been awarded numerous prizes for his paintings.

Taylor, A. (1941-) Born in Rochester, New York, Miss Taylor began painting professionally while attending the New School for Social Research where she received her B.A. in 1962. Primarily a landscape painter, she uses cool, quiet colors reminiscent of Japanese watercolors, with a hazy, romantic quality. A still and foggy veil envelops all. Hers is a dreamer's realm. It reflects a spiritual attitude toward the silent ethereal work of nature. She has had one-woman shows at the Flair Gallery, Cincinnati; the York Gallery, New York; and the Schuman Gallery, Rochester, N.Y. Her work is seen in many prominent museums and private collections.

Thiebaud, Wayne (1920-) was born in Mesa, Arizona and studied at San Jose and Sacramento State Colleges. He worked in New York and Hollywood as a cartoonist, designer and advertising director and produced several educational motion pictures. His work is exhibited widely, with many one-man shows, the first in Sacramento in 1951. He is best known for his paintings of food. Among his favorite subjects are hot-dogs, ice cream, lipsticks and yo-yos. He is currently Professor of Art at the University of California, Davis.

Thon, William (1906-) was born in Manhattan, leaving school at the end of the eighth grade to develop his artistic talent. Encouraged by an artist neighbor, he sketched whatever he saw around him, particularly waterfront scenes near his home. Thon studied briefly at the Art Students League but is really self-taught. His early works reflect his preference for the moody, lonely scenery of Maine. These seascapes were composed over an underlying abstract pattern, similar to that of Ryder's paintings. A period spent painting in Mediterranean Europe helped to brighten Thon's palette and led him closer to the abstract. While his style has become increasingly simplified in design, his poetic responses have become more profound. In his work the air seems to sparkle around each fragile object whose delicate outlines are worked into a lattice of richly-textured rectangles. Thon has won several outstanding prizes and, in 1956, was the artist-in-residence at the American Academy in Rome.

Tiepolo, Giovanni Battista (1696-1770) was the greatest artist of 18th century Venice and perhaps the most outstanding exponent of the Italian Rococo. In Italy he executed many murals in fresco and large altarpieces in oil, as well as the monumental fresco decorations of the fine palaces in Würzburg and Madrid. Tiepolo's handling of dramatic perspective and his use of pale color created splendid effects of flamboyant virtuosity. While in Madrid Tiepolo's career was hindered by controversy with the neoclassicist Anton Mengs, and cut short by his sudden death. Hundreds of energetically sketched drawings survive to attest to the spontaneous genius of this vital artist.

Tiffany, Louis C. (1848-1933), the son of Charles Lewis Tiffany, renowned U.S. Jeweler, was born in New York, where, for some time, he was the pupil of George Inness, and subsequently in Paris where he studied under Leon Belly. He contributed to American art both as a painter and decorator, especially of glass. He excelled in watercolor and oil and his extensive travels are reflected in his work.

Tintoretto, Jacopo (1518-1594) was one of the greatest Venetian artists of the Italian Renaissance. He probably studied with Titian and later worked under Schiavone and Bordone. Attempting to combine as models Titian's color and Michelangelo's sculptural drawing, Tintoretto developed his own individual Mannerist style. He carried out commissions for the State, and between 1564-1588 worked on the decoration of the School of S. Rocco. Using strong brushstrokes and bold colors Tintoretto achieved dramatic effects of movement and perspective. These religious scenes, permeated by luminescent light, create unforgettable impressions on the viewer's mind.

Titian (Tiziano Vecelli) (1477-1576) was one of the most brilliant Venetians and among the greatest artists of Italian history. His early style was largely determined by Giorgione and Giovanni Bellini. Upon the latter's death, in 1516, Titian, so to speak, inherited Bellini's position as Painter to the Republic of Venice. His original, dramatic style developed quickly and heralded the grand manner of the High Renaissance, evident in his early religious paintings of the Assumption and the Pesaro Altar. In the 1530's Titian turned to painting portraits of European kings and emperors. Precise in their restrained dynamism and impressive in their "official" poses, they are also penetrating in their portrayal. In his later years Titian continued to explore the possibilities of oil, which he handled more freely, applying the paint in "impressionistic" strokes of color.

Tobey, Mark (1890-1976) was born in Wisconsin and went to Chicago where he first designed layouts for a fashion magazine. He studied briefly at the Art Institute there, but was really self-taught. After ten years in New York Tobey moved to Seattle, then traveled through Europe to the Far East. In Shanghai he was greatly impressed by Chinese brush drawings which he assimilated and reinterpreted in "white writing"—abstract series of lines surrounded by dark areas of color. These squiggles, not legible as letters, numbers or objects, are Tobey's attempt to synthesize East and West and to transcend the bounds of the real world.

Tokusai, Tesshū (c. 1342-1366) Born in Shimotsuke (Tochigi) Province, Japan. Important in the early development of suiboku-ga (Japanese ink monochrome painting), he spent a contemplative life as a Zen priest, a disciple of the Priest Mugoku. He studied in China under Nan-su Shih-shuo. He was revered in China, as well as Japan, where he was awarded the honorary title of "Great Master of Universal Wisdom." He returned to China and held abbotship in leading Zen temples. Tesshu excelled in landscapes, flowers and birds, as well as calligraphy, and his experiences while visiting China apparently influenced him in his attempt to break through Japanese convention and broaden the subject matter of Zen art. The realism of his latter works (such as Reeds & Geese from the collection of Baron Inagaki) is indicative of his influence.

Tosa Mitsuoki (1617-1691) was the last important artist of the Japanese Tosa School which, with the decline of the Japanese nobility, lost its important position. He is remembered for his paintings of birds and flowers, executed with delicate brushwork and subtle precision.

Toulouse-Lautrec, Henri de (1864-1901) was born in Albi, France of an aristocratic family. A congenital bone disease, aggravated by two childhood accidents, left Lautrec stunted in growth and deformed in appearance. With this handicap, he decided to devote himself to recording the current life in Paris. Living in Montmarte, he met other artists such as van Gogh, Pissarro, Gauguin and Seurat, but the linear technique and nudes of Degas exerted the strongest influence on Lautrec. His outstanding draughtmanship and eye for design caught and immortalized the fleeting gestures of actresses, dancers and habitués of Parisian cabarets. These unposed, vivacious scenes were executed in post-

ers, lithographs and oil, and survive as objective records of an era now gone. The last several years of his life were plagued with illness, made worse by alcoholism. During this time Toulouse-Lautrec painted his circus series, still exquisite examples of the artist's ability to portray form and movement.

Tour, Georges de la (1593-1652). Few specific details are known about the life of la Tour. Born in Lorraine, he rose from humble origins to execute commissions for the Duke of Lorraine and the King of France. His religious and genre themes are simple in construction and calm in mood. The indirect influence of Caravaggio is evident in la Tour's use of lighting. Out of sharply contrasting light and dark areas, the forms emerge, dramatically illuminated by a hidden source or more often by candlelight.

Trumbull, John (1756-1843) was born in Connecticut and studied at Harvard College. He fought in the Revolutionary War and served briefly as an aide to George Washington. Later Trumbull studied in England with Benjamin West and in Paris with David. When he returned to America in 1789 he painted portraits and historical subjects. Among his most famous works are the *Signing of the Declaration of Independence* and the *Surrender of Cornwallis.* Trumbull never reached great artistic heights and he died a disappointed man.

Turner, Joseph M. W. (1775-1851) was born into a simple family in London's Covent Garden. At an early age he was admitted to the Royal Academy where he showed great talent and practical intelligence. By the time he was 15 the Royal Academy exhibited his work, and three years later he had his own studio. The first period of his career was spent painting watercolors with Thomas Girtin and learning topographical drawing from Dr. Munro, resulting in new effects of free handling and bright colors. Although Turner exhibited his first oil painting around 1796, his mature style did not reveal itself until he visited Italy in 1819 and in the years following. These oils and watercolor sketches, which emphasize the atmospheric effects of light, are romantic in style and "incomplete" in appearance. They created criticism at the time but have since proved, in their coloristic innovations, to be a revolutionary influence on modern art, particularly on the development of Impressionism.

Utrillo, Maurice (1883-1955) is remembered for his paintings of French provincial streets. Born in Paris, he was the son of Suzanne Valadon, herself a painter and model who posed for the Impressionists. Utrillo was encouraged to begin painting at an early age. He became associated with the Montmartre artists and was influenced by the Impressionists' colorful style. His later works are less vivid and more strongly linear, the paint being applied with a palette knife in broad areas.

Vasarely, Victor (1908-) was born in Hungary and studied at the Padolini-Volkmann Academy and at Bortnyik's in Budapest. He settled in Paris in 1930 and engaged in graphic studies in commercial art and decoration there until 1944. He then turned to the study of "concrete art" and exhibited, in Paris and abroad, his "kinetic plastic art," most recently associated with the Op Art movement. He is noted for his paintings and his graphic works, and has received many international awards, including the Prix de la Critique in Brussels and the Gold Medal of the Triennale of Milan.

Vasi, Giuseppe (1710-1782). Sicilian-born Vasi was first a pupil of painters Conca, Ghezzi and Juvara before going to Rome where he turned to engraving and designing. He received commissions for en-

gravings from the Pope, Ferdinand of Naples, and Charles III. His ability and growing reputation won him the post of engraver to the Court of Naples. Hundreds of plates of Roman buildings, among them the Farnese and Caprarola Palaces, were executed by Vasi, who is also remembered as the teacher of Piranesi.

Velázquez, Diego Rodrigues de Silva (1599-1660) was one of the major artists of the Baroque era in Spain. Born in Seville, he studied art at the academy of Pacheco who, with Caravaggio, influenced Velázquez's early work. In 1623, as court painter in Madrid, he executed numerous royal portraits using sober colors and a linear technique. It was probably due to Rubens' Spanish sojourn and his friendship with Velázquez that the latter was encouraged to visit Italy in 1629. Two years later he returned to Madrid with a style which had matured. His technique had become freer and his interest in the effects of light was even greater. The magnificent treatment of color and landscape in *The Surrender of Breda (1625)* attests to Velázquez's originality, as do the penetrating portraits of the following decades. Especially significant is the atmospheric handling of light in *Las Meninas* which, in itself, makes a revolutionary statement about the artist's relationship to the world he sees and paints.

Velde, Willem van de (The Younger) (1633-1707) Dutch born, his ability to capture light and space places him among the masters of 17th Century painting. Using oils, van de Velde limited himself to seascapes, blending precision with sensitivity to capture the vast expanses of sky and clouds and the quiet, reflection-filled waters of his homeland. His technical skill shows the influence of his father, a talented Naval draughtsman, with whom he worked on commission from Charles II of England. His paintings are in numerous private collections and have been exhibited with the Old Masters Exhibition, Royal Academy, London; Burlington Fine Arts Club, London; Duveen Galleries, New York; Art Association of Montreal and Fogg Art Museum, Harvard University.

Vermeer, Jan (1632-1675). Although little is known about his life, which lay in undeserved obscurity until the late 19th century, Vermeer's domestic genre portraits stand out and apart from the 17th century Dutch naturalistic tradition. They include quiet familiar scenes of a courtly lady writing a letter or having a music lesson in an immediately understandable space. The infused light (its source usually an unseen door or window), glowing upon rich textures, achieves an equilibrium of tone and shape by the glittering application of separate brushstrokes. The shadows seem to deny the lines and at the same time evoke a perfectly convincing representation of each particular object. The subtle but intense absorption in the air creates a depth of mood secretly personal in its very detachment. Vermeer's oeuvre consists of only about 40 paintings, but they are small jewel-like masterpieces which have brought him deserved fame.

Verspronk, Johannes (1597-1662) was born in Haarlem and was a pupil of his father before studying with Frans Hals. He entered the Guild in 1632. Verspronk painted portraits and hunting scenes which are to be seen in Dutch, German, and French museums.

Vickrey, Robert (1926-) was born in New York and studied at New York University, Wesleyan University, the Yale School of Fine Arts, and the Art Students League, where he was a student of Kenneth Hayes Miller and Reginald Marsh. He is known for his watercolors and his egg tempera paintings, carried out in an extremely precise realistic technique, and he has painted numerous commissioned portraits. Vickrey's work has been exhibited widely, and his paintings are in important collections throughout the United States. The prizes he has been awarded for his work

include the Audubon Artists Award and the American Watercolor Society Award.

Vigée-Lebrun, Louise Elizabeth (1755-1842) was a successful French portrait painter who was trained at a young age by her father. She was painting professionally at the age of 15 and, in 1783, became a member of the Academy. The years between 1779 and 1789 were actively and successfully spent at Versailles. As the favorite artist of Marie Antoinette, she painted many portraits of the Queen and ladies of the Court. When the Revolution broke out, Vigée-Lebrun left France to travel widely through Italy, visiting Vienna, Prague, Dresden and Berlin. She spent six years in St. Petersburg painting the Russian nobility, followed by two years in Berlin and several in London. Her portraits were pleasantly decorative and in later years, as her style became outmoded, her fame diminished.

Vinci, Leonardo da (1452-1519). In his inventive and artistic genius, Leonardo embodied the ideals of the period in which he lived. Born in the Tuscan town of Vinci, he showed innate ability in drawing natural history and mathematics at a young age. In Florence he was admitted to the studio of Verrocchio. It seems that, in the late 1470's, Leonardo painted several Madonnas; those which have survived reveal a unique play of light over the figures and background and indicate a significant break from the Renaissance mood. By 1480 Leonardo was executing independent commissions for Lorenzo de Medici who sent him to Milan where he worked for the prominent Szforza family. While in Milan he painted the *Madonna of the Rocks* and, in 1495, began the famous fresco, the *Last Super,* in Santa Maria delle Grazie. In 1499 the French army entered Milan and Leonardo left to return , via Mantua and Venice, to Florence. There, in 1500, he finished the cartoon of the *The Virgin, Child and St. Anne* and painted the *Mona Lisa.* Between 1508 and 1513 he divided his time between Milan and Florence, painting, studying anatomy, and working as a hydraulic engineer. In 1513 he was called to Rome by the Pope; unfortunately, little work from those years has survived. Leonardo was in the service of King Francis I of France from 1515 until his death in 1519 in Amboise. He is remembered today for his painting more than for his other achievements as a military engineer, architect, costume designer and writer and his *Notebook* and *Treatise on Painting* have proved significant contributions to western civilization.

Vlaminck, Maurice de (1876-1958) was a French landscape artist of Belgian heritage. A talented, independent person, he was a musician, writer, and racing cyclist as well as artist. Vlaminck's inquiring mind and varied interests led him to Paris where he shared a studio with Derain. Together with Matisse they became the leaders of the Fauve movement and during this period Vlaminck's work was characterized by strong, bright colors and broken brushstrokes. Around 1908 his landscapes grew more somber and romantically stormy. His abiding fascination with the power of nature is evident in his later paintings for which he is best remembered today.

Vlieger, Simon de (c. 1600/1605-1653) was a Dutch painter of landscape and marine subjects. Born in Rotterdam, he lived in Amsterdam between 1638 and 1648, and then in the provincial town of Weesp until his death. Influenced primarily by the work of Jan Porcellis, he in turn affected the style of Jan van de Cappelle, probably the greatest Dutch marine painter. De Vlieger's paintings are characterized by a silvery-grey tonality, an increasingly classical composition, and, in his later years, a marvelous serenity. His subjects include numerous marine and beach scenes, as well as river, forest and night scenes.

Volpi, Alfredo (1895-) was born in Lucca, Italy, and was brought to São Paulo, Brazil, at the age of four. He is self-taught and his large abstract paintings have developed from the use of broad flat areas of color to the introduction of more complex colors and lines. Volpi first exhibited his work in 1924 and was awarded first prize at the 1953 São Paulo Biennale.

Watanabe, Shiko (1683-1755) Japanese painter known for his suiboku (ink-wash) paintings, Watanabe was trained in the Kano style by Korin. He was influenced by Naonobu, and his works often possess a realism which sets them apart from the more formal Rimpa School and anticipate the Maruyama and Shijo Schools. He was widely praised and copied after his death, as was often the case among Japanese painters of note. Some of his work was copied by the painter Okyo, just as his teacher, Korin, was copied by others.

Watteau, Jean Antoine (1684-1721) was the most important French artist of the Rococo era. Born in Valenciennes, a town near Flanders, he undoubtedly saw and was impressed by Rubens' work. When he went to Paris he worked as an art dealer's copyist and then, between 1704 and 1705, painted scenery for a theater company. He was admitted to the Academy in 1712 and presented the *Embarkation for the Island of Cythera* five years later. This masterpiece exemplifies the gay, frivolous courtly life, the description of which was to build Watteau's reputation. He painted *fêtes galantes*, richly decorative scenes of an elegant and amorous fantasy world with such sensitivity that a tender melancholy underlies his work and enhances the exquisite delicacy of both form and content. Toward the end of his career Watteau seemed to be developing a new genre style but its realization was thwarted by the artist's premature death from tuberculosis.

Waugh, Frederick Judd (1861-1940) was one of America's great marine artists who came from a New Jersey family of painters and studied at the Pennsylvania Academy of Fine Arts. Waugh moved to Paris to study at the Académie Julian and lived in Europe at intervals during his long painting career. He is justly remembered for his polished technique in depicting water and rocks in seascapes undisturbed by ships or man. Waugh was also an able illustrator of English weeklies and children's books. In 1909 he was elected to Associate Member of the National Academy and an Academician in 1911. A prolific painter, he produced about 75 seascapes annually for nearly 25 years. His work has been exhibited in London, Paris and the United States, examples of which hang in museums and private collections throughout the world.

Weber, Max (1881-1961) was born in Russia, the son of a tailor who immigrated to New York in 1891. Raised in Brooklyn, Weber studied at the Pratt Institute, taught art and carpentry, then went to Paris in 1905. There he studied at the Académie Julian, later working with Matisse, Picasso and Henri Rousseau.

He was significantly impressed by the Cubists' use of perspective and the Fauves' use of color. At the end of four years he returned to the United States, held his first one-man show and worked on painting urban scenes of New York in a semi-abstract style. In the 1920's his work grew more representational, only to revert, in the 1930's, to total abstractionism. Weber's last works are strongly expressionistic, emphasizing linear pattern and intense color.

Weyden, Rogier van der (1399/1400-1464) was, with Jan van Eyck, the greatest Flemish painter of the 15th century. He was born in Tournai and trained with his father before working under Robert Campin between 1427 and 1432. His works include religious subjects and several portraits. The *Descent from the Cross,* an important work, reveals a new dramatic content not previously expressed in the orderly composition of the Gothic tradition. Such harmony between the mystical and humble daily lives, seen in *The Seven Sacraments,* was heretofore unknown, as was the poignant intimacy of the later Brussels *Pietà.* Van der Weyden's originality lies in the emotional drama with which he imbues his figures, whether to express the desolation of the mourning Virgin or the sensuous immediacy of a secular portrait subject.

Whistler, James Abbott McNeill (1834-1903) was born in Lowell, Massachusetts, but, as the son of an army officer, spent his early life in Russia, Connecticut and New York. In 1855, after leaving West Point Military Academy, he went to Europe. In Paris, he first studied with Gleyre and became associated with the early Impressionist movement. Whistler was impressed by Courbet's deep-toned palette and his use of thick impasto. He added a softness to his own handling of paint and adopted Velázquez's early method of painting against a plain background in cool, silvery-gray colors. These influences, together with Whistler's keen sense of observation, helped to create an objective realist whose painting style was neither American nor entirely European. In 1859 Whistler left Paris for England where he lived for the rest of his life. Japanese prints were receiving much attention in London and Whistler was influenced by their two-dimensional quality and the subtle arrangement of form and color. As an interest in creating a harmonious decoration grew, his refined style became increasingly elusive and exotic. The period during the 1870's includes his *Nocturnes,* landscapes painted at twilight or at night. These works were criticized by John Ruskin and resulted in Whistler's loss of popularity. But, between 1879 and 1880, he produced an etching series of Venice which, with the presentation of many fine portraits, regained the reputation his work enjoys today.

Wood, Grant (1892-1942) was an American regionalist painter from the midwest. He spent several years in Europe where, in Paris, he admired the Impressionists and, in Munich, he learned much from studying the skillful execution of the Flemish old masters. When he returned to his native town of Cedar Rapids, Iowa, he taught

art and received a commission for a local stained glass window. He painted scenes of simple, hardworking farm life and in 1930 received national recognition for his portrait, *American Gothic,* after which he continued to paint and teach at Iowa State University.

Woodville, Richard Caton (1825-1855) was an American painter of genre scenes. Born in Baltimore, he saw the Dutch genre paintings in the Robert Gilmor Collection and decided to go to Düsseldorf. There he studied art and developed his expressive drawing ability. He settled in Germany and sent his clear colorful scenes back to the United States where they were sold. He died at the young age of 30.

Wyeth, Andrew (1917-) was born in Chadd's Ford, Pennsylvania and studied with his father, N.C. Wyeth, painter and illustrator of children's classics. Portraying the people and surroundings of Chadd's Ford and Cushing, Maine, he developed a realistic style based on subdued colors, simplicity of line and contemplative vision of objects. His paintings, though dealing with apparently commonplace experiences, investigate the loneliness of people and things.

Zao-Wou-Ki (1921-) was born in Peking and studied at the National Art School in Hangchow, later teaching there until 1947. In 1948 he left China for Paris where his first one-man show was held in 1949. In 1957 and 1958 he traveled in America, Japan, Thailand, and Greece. His works are characterized by an electric linear motif against subtly colored, fluid backgrounds. The style of Zao-Wou-Ki's paintings and graphics includes both pure abstraction and a semi-abstraction based upon real objects and organic forms.

Zorach, William (1887-1966) came to America from Lithuania when four years old. His family settled in Ohio and Zorach later left school in the eighth grade to work for a lithographer in Cleveland. He studied drawing and painting at the Cleveland School of Art, then went to live and study in New York for two years. In 1910 he traveled to Paris where he was impressed by the Cubists' and Fauvists' color and form. He returned to New York where he continued to paint, eventually abandoning oil for watercolor.

Numerical Index

559

NOTES

NOTES

NOTES

FINE ART REPRODUCTIONS
SUPPLEMENT

NEW
YORK
GRAPHIC
SOCIETY
LTD.

NEW YORK GRAPHIC SOCIETY, LTD.
FINE ART REPRODUCTIONS OF OLD AND MODERN MASTERS
CATALOG SUPPLEMENT

A NOTE FROM THE PUBLISHER:

The current edition of the New York Graphic Society master catalog, FINE ART REPRODUCTIONS: OLD AND MODERN MASTERS, published in 1980, continues to represent the world's largest collection of high quality fine art reproductions. Not only is it an invaluable source book for retailers and their customers, but it also is widely utilized as a reference by art historians, students and all interested in the world of fine art.

This supplement includes over 70 new fine art reproductions which have been published since the master catalog was issued and serves as an addendum to that catalog.

The selections illustrated here affirm our on-going commitment to the publication of superlative reproductions for residential and corporate decor and to bring beautiful images within the reach of everyone who appreciates fine art.

We are proud of this collection, the representation of significant artists and the wide scope of our program. And we are grateful to the owners and artists who placed their trust in the New York Graphic Society to publish their art with meticulous attention to quality and fidelity of the reproductions.

Orders for our fine art reproductions may be placed through the mail or by phone:

New York Graphic Society Ltd.
P.O. Box 1469
Greenwich, Connecticut 06830
(203) 661-2400

Please see our price sheet for details.

Unknown American Artist
ALPHABET SAMPLER
Paragon Needlecraft, New York
5261 - 16" x 22" (41 x 56 cm)

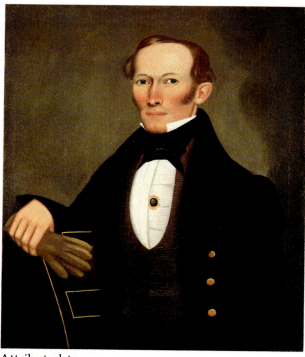

Attributed to
ERASTUS SALISBURY FIELD (American, 19th Century)
Mr. Pearce (c. 1835)
Abby Aldrich Rockefeller Folk Art Center, Williamsburg
7237 - 26" x 22" (66 x 56 cm.)

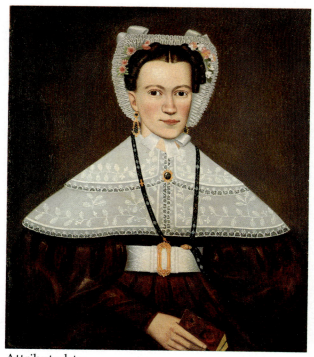

Attributed to
ERASTUS SALISBURY FIELD (American, 19th Century)
Mrs. Pearce (C. 1835)
Abby Aldrich Rockefeller Folk Art Center, Williamsburg
7238 - 26" x 22" (66 x 56 cm.)

1

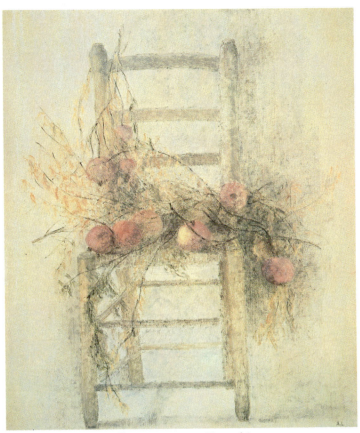

Anne La Bouriau (Contemporary French)
AUTUMN
Private Collection
8134 - 30" x 24¼" (76 x 61.5 cm)

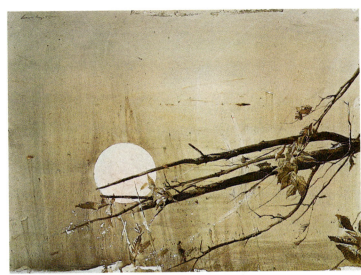

Andrew Wyeth (Contemporary American)
FULL MOON
5125 - 17" x 22" (43 x 56 cm)

Charles Themmen (American, 19th Century)
BARNYARD SCENE, c. 1860
Collection of Mr. and Mrs. Henry B. Holt
8124 - 20" x 29¾" (50.5 x 75.5 cm)

Andrew Wyeth (Contemporary American)
THE WRITING CHAIR
5233 - 20¾" x 13" (53 x 33 cm)

Unknown Chinese Artist (20th Century)
TREE PEONIES
Private Collection
9297 - 13½″ x 38″ (34.5 x 96.5 cm)

Unknown Chinese Artist (Early 19th Century)
MANDARIN DUCKS IN LANDSCAPE
Collection of Toynbee-Clarke Interiors, London
7557 - 18¾″ x 30″ (47.5 x 76 cm)

Unknown Chinese Artist (Contemporary)
WISTERIA AND CHICKS
Private Collection
7825 - 24″ x 28″ (61 x 71 cm)

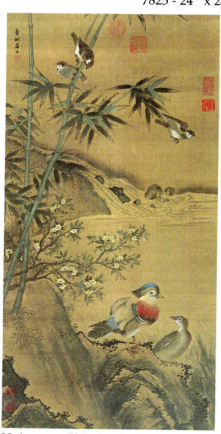

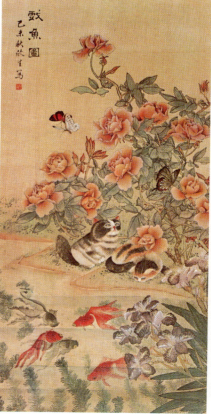

Unknown Chinese Artist (Early 19th Century)
ANCESTOR PORTRAIT
Collection of Toynbee-Clarke Interiors, London
7907 - 30″ x 22¾″ (76 x 58 cm)

Unknown Chinese Artist
MANDARIN DUCKS BY A STREAM
Private Collection
9073 - 33¾″ x 17″ (86 x 43 cm)

Unknown Chinese Artist
TWO KITTENS BY A POOL
Private Collection
8518 - 33¾″ x 17″ (86 x 43 cm)

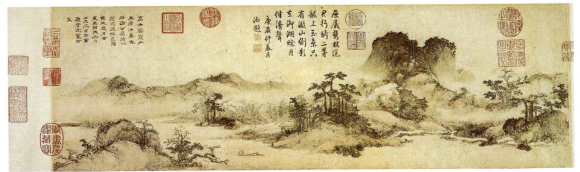

Li Sheng (Chinese, 1271-1368)
SAYING FAREWELL BY THE LAKE DIANSHAN, 1346
Shanghai Museum
7900 - 9" x 29¾" (23 x 75.5 cm)

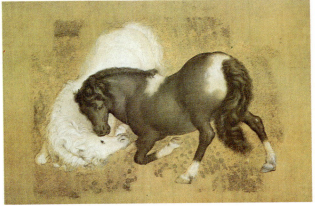

Lang Shih-Ning (Giuseppe Castiglione)
(Born: Milan, Italy, 1688: Died: Peking, China 1766)
PONIES AT PLAY
Shanghai Museum
6782 - 15" x 22" (38 x 56 cm)

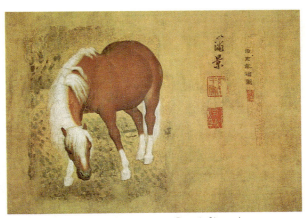

Lang Shih-Ning (Giuseppe Castiglione)
(Born: Milan, Italy, 1688: Died: Peking, China 1766)
AT PASTURE
Shanghai Museum
6781 - 15" x 22" (38 x 56 cm)

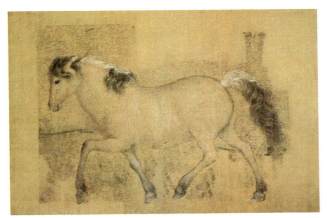

Lang Shih-Ning (Giuseppe Castiglione)
(Born: Milan, Italy, 1688: Died: Peking, China 1766)
TROTTING
Shanghai Museum
6783 - 15" x 22" (38 x 56 cm)

Fan Chi (Chinese 1616-1694)
SIX ALBUM LEAVES
Collection of John M. Crawford, Jr.
7646 - 18" x 28½" (45.5 x 72.5 cm)

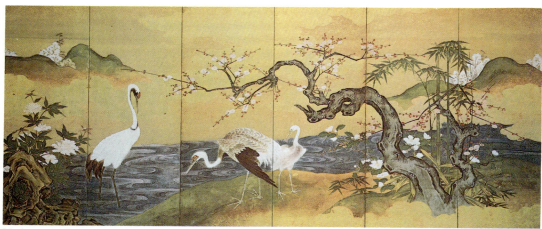

Unknown Japanese Artist (19th Century)
CRANES ALONG A RIVER
Ariane Faye, Paris
9645 - 16″ x 38″ (41 x 96.5 cm)

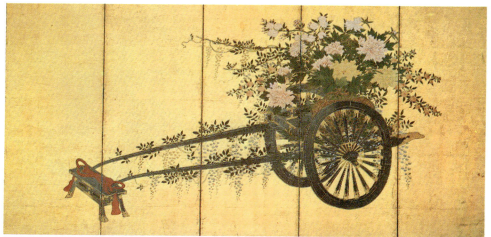

Unknown Japanese Artist (18th Century)
A FLOWER CART
Milne Henderson Collection, London
9981 - 17″ x 33¾″ (43 x 86 cm)

Yamamoto Baiitsu
(Japanese, 1783-1856)
HERON AND LOTUS
Milne Henderson Collection, London
8122 - 34″ x 12″ (86 x 31 cm)

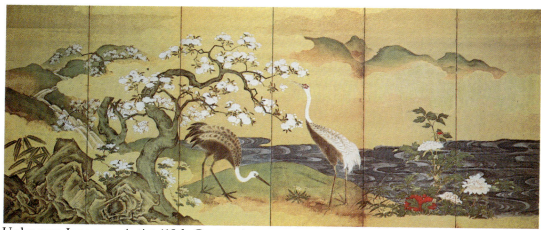

Unknown Japanese Artist (19th Century)
CRANES AND BLOSSOMING TREES
Ariane Faye, Paris
9646 - 16″ x 38″ (41 x 96.5 cm)

5

Unknown Japanese Artist (Late 18th Century)
FANS
Collection of Spink and Son Ltd., London
7036 - 30" x 22" (76 x 56 cm)

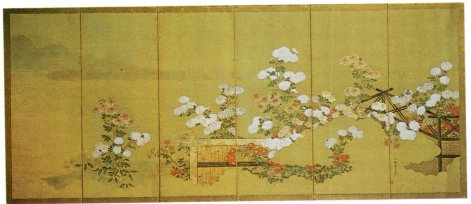

Unknown Japanese Artist (18th Century)
CHRYSANTHEMUMS
Collection of Ciancimino Limited, London
9552 - 16¾" x 37¾" (43 x 95.5 cm)

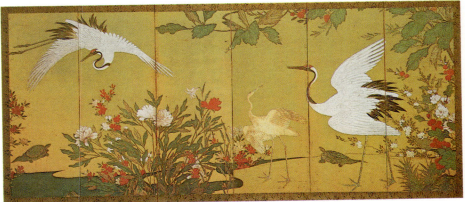

Unknown Japanese Artist (Late 16th-Early 17th Century)
CRANES AND FLOWERS
Collection of Ciancimino Limited, London
9553 - 16¾" x 37¾" (43 x 95.5 cm)

6

Barbara Nechis (Contemporary American)
HOLIDAY, 1981
Private Collection
6859 - 22¼″ x 15″ (56.5 x 38 cm)

Barbara Nechis (Contemporary American)
FESTIVAL, 1981
Private Collection
6858 - 22¼″ x 15″ (56.5 x 38 cm)

M.H. Hurlimann Armstrong (Contemporary American)
MY FRIEND'S GARDEN, 1979
Collection of the Artist
6816 - 18″ x 24″ (46 x 61 cm)

Henri Fantin-Latour (French, 1836-1904)
BOUQUET DE JULIENNE ET FRUITS
The Fine Arts Museums of San Francisco
6704 - 22″ x 21″ (56 x 53.5 cm)

M. H. Hurlimann Armstrong (Contemporary American)
ESTHER'S FLOWERS
Collection of the Artist
6268 - 20¼″ x 26″ (51.5 x 66 cm)

Bill Stark (Contemporary American)
LAS FLORES MEJICANAS, 1967
Private Collection
7229 - 23¾″ x 27½″ (60.5 x 70 cm)

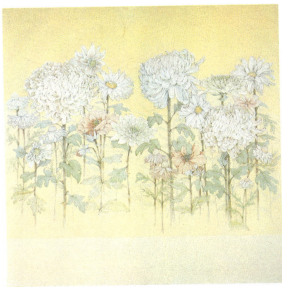

Virginia Greenleaf (Contemporary American)
CHRYSANTHEMUMS AND DAISIES, 1982
The Main Street Gallery Nantucket Inc.
8133 - 30″ x 30″ (76 x 76 cm)

Julia Lopez (Contemporary Mexican)
STILL LIFE WITH DOVE, 1967
Private Collection
6239 - 20″ x 24″ (51 x 61 cm)

Leonard Brooks (Contemporary Canadian)
AMARYLLIS AND CAT
Collection of the Artist
8126 - 28″ x 24¾″ (71 x 63 cm)

Leonard Brooks (Contemporary Canadian)
IRIS AND POND
Collection of the Artist
8127 - 30″ x 19″ (76 x 48 cm)

8

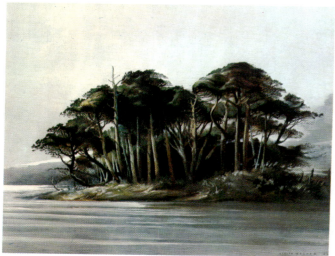

Marlon Malcom (Contemporary American)
RUSSIAN RIVER V, 1979
The John Pence Gallery, San Francisco
8652 - 24" x 32" (61 x 81 cm)

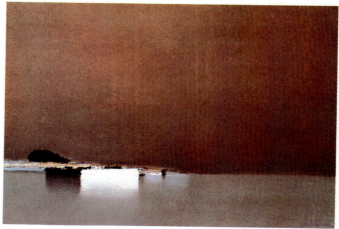

Pierre Doutreleau (Contemporary French)
DISTANT HARBOR
Private Collection
7233 - 20½" x 30" (52 x 76 cm)

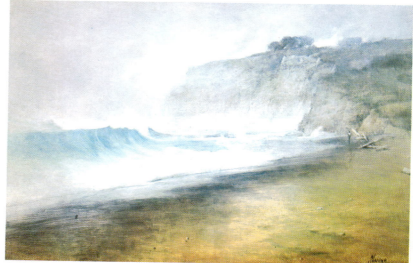

Robert Maione (Contemporary American)
CLIFFS AND SURF, CALIFORNIA, 1977
The John Pence Gallery, San Francisco
9072 - 24" x 36¼" (61 x 92 cm)

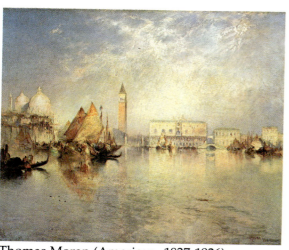

Thomas Moran (American, 1837-1926)
SPLENDOR OF VENICE, 1889
Philbrook Art Center, Tulsa
8948 - 25¾" x 30" (65.5 x 76 cm)

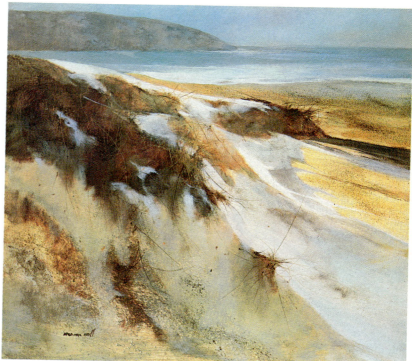

Fred D. MacNeill (Contemporary American)
SHORE PATTERNS
Private Collection
8130 - 25½" x 28" (64.5 x 71 cm)

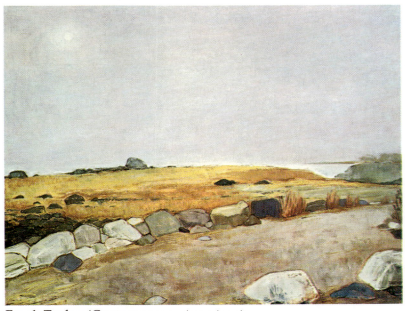

Frank Trefny (Contemporary American)
TOD'S POINT - NOVEMBER, 1980
Private Collection
8951 - 25″ x 32″ (63.5 x 81 cm)

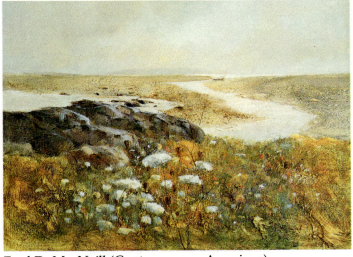

Fred D. MacNeill (Contemporary American)
TIDAL FLOW
Private Collection
8131 - 24″ x 32 (61 x 81.5 cm)

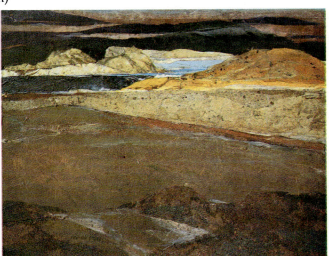

Leonard Brooks (Contemporary Canadian)
MORNING BEACH, BAJA, CALIFORNIA
Collection of the Artist
8128 - 24¾″ x 29¾″ (63 x 76 cm)

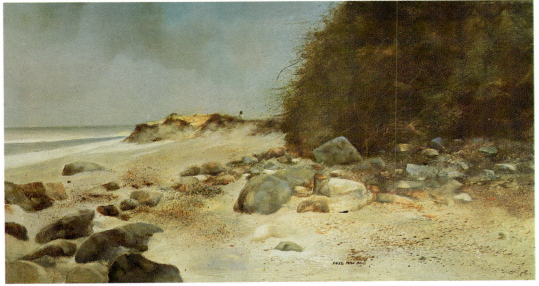

Fred D. MacNeill (Contemporary American)
FAR END
Private Collection
9074 - 20″ x 36½″ (51 x 93 cm)

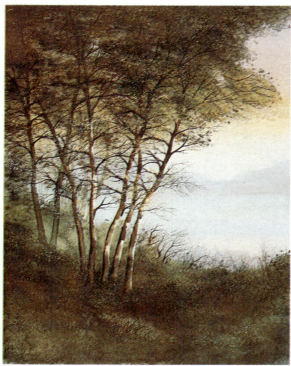

Trevyh (Contemporary French)
SEVEN BIRCHES
Private Collection
6344 - 26" x 20" (66 x 51 cm)

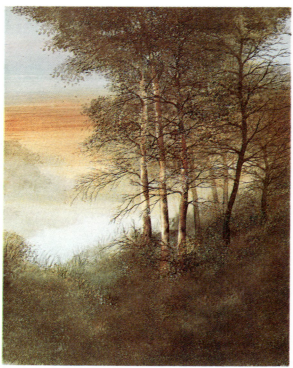

Trevyh (Contemporary French)
BIRCH COVE
Private Collection
6345 - 26" x 20" (66 x 51 cm)

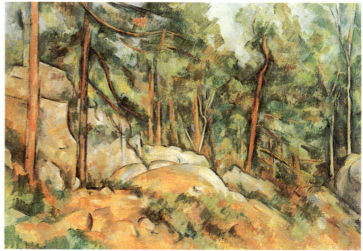

Paul Cezanne (French, 1839-1906)
ROCKS IN THE PARK OF CHATEAU NOIR, 1900
The Fine Arts Museums of San Francisco
Mildred Anna Williams Fund
7028 - 22" x 30" (56 x 76 cm)

Trevyh (Contemporary French)
GLEN MIST
Private Collection
6346 - 22" x 28¼" (56 x 72 cm)

Lee Hochberg (Contemporary American)
BESIDE THE STILL WATERS, 1981
Collection of the Artist
8120 - 26½" x 32" (67 x 81 cm)

Marianne Hornbuckle (Contemporary American)
JEMEZ SERIES, 1981
Collection of the Artist
9719 - 24″ x 35¾″ (61 x 90.5 cm)

Nicholas Roerich (Russian, 1874-1947)
THE MOUNTAIN SCHITROVAYA, 1925
The Nicholas Roerich Museum, New York
8121 - 18″ x 30″ (46 x 76 cm)

Sidney F. Willis (Contemporary American)
AWAKENING, 1981
Harris Peel Gallery, Danby, Vermont
8132 - 25″ x 32″ (64 x 81 cm)

Vilnis Strazdins (Contemporary American)
MOUNTAIN TWILIGHT, 1981
Private Collection
7633 - 26½″ x 29¾″ (67.5 x 75.5 cm)

Claude Monet (French, 1840-1926)
WATERLILIES AND JAPANESE BRIDGE, 1899
The Art Museum, Princeton University
7632 - 28″ x 28″ (71 x 71 cm)

Kyohei Inukai (Contemporary American)
THE RED HOSE, 1981
Collection of Mrs. Nancy Goodenow
6945 - 24″ x 19″ (61 x 48.5 cm)

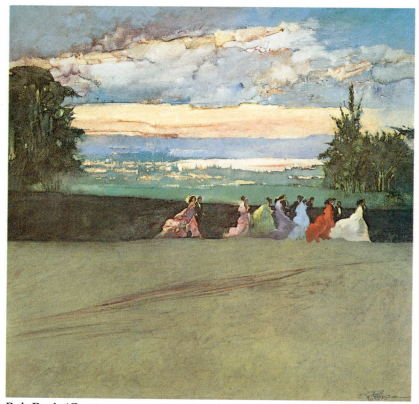

Bob Peak (Contemporary American)
NIGHT MUSIC
Private Collection
8123 - 28″ x 28″ (71 x 71 cm)

13

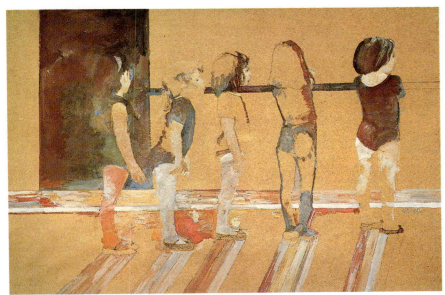

Robert A. Heindel (Contemporary American)
CORPS DES ENFANTS, 1980
Collection of Mr. and Mrs. John B. Hipp
8129 - 20½″ x 29¾″ (52 x 75.5 cm)

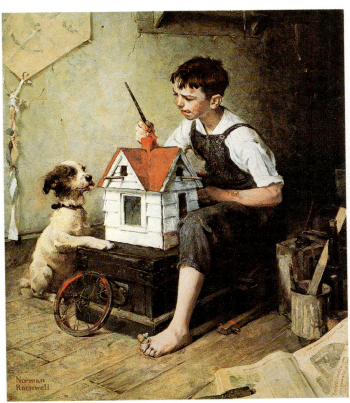

Norman Rockwell (American, 1894-1978)
PAINTING THE LITTLE HOUSE, 1921
Collection of Mr. and Mrs. Henry B. Holt
8125 - 27¾″ x 24″ (71 x 61 cm)

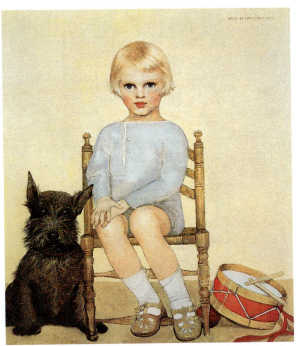

Maria DeKammerer (Contemporary American)
BOY WITH DOG, 1933
Collection of Mr. and Mrs. Henry B. Holt
6240 - 24″ x 20″ (61 x 51 cm)

Mady Daens (Contemporary Belgian)
CARNIVAL, 1980
Private Collection
7146 - 29¾″ x 24½″ (75.5 x 62 cm)

Mady Daens (Contemporary Belgian)
GIANT'S CAUSEWAY, 1980
Collection of the Artist
7147 - 29¾″ x 24½″ (75.5 x 62 cm)

Marjorie Price (Contemporary American)
STRUCTURE IV, 1976
Private Collection
7980 - 30″ x 22″ (76 x 56 cm)

Leonard Brooks (Contemporary Canadian)
TIME PENDULUM
Collection of the Artist
9980 - 32″ x 23½″ (81 x 60 cm)

Henri Matisse (French, 1869-1954)
L'ESCARGOT, 1952
The Tate Gallery, London
6523 - 21¼" x 21½" (54 x 54.5 cm)

Wassily Kandinsky (Russian, 1866-1944)
HEAVY CIRCLES, 1927
The Blue Four Galka Scheyer Collection
Norton Simon Museum, Pasadena
6529 - 24" x 22" (61 x 55.5 cm)

Toby Eric Joysmith (Contemporary British)
PALENQUE, 1967
Collection of Mrs. Carolyn Sammet, Mexico
7877 - 25½" x 28" (64.5 x 71 cm)

Max Ernst (German, 1891-1976)
LE VENT SE REPOSE JAUNE, 1952
Acquavella Galleries, Inc., New York
6442 - 25½" x 21" (65 x 53.5 cm)

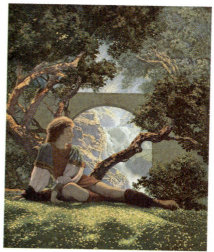

Maxfield Parrish (American, 1870-1966)
THE PRINCE
3975 - 12″ x 10″ (30.5 x 25.5 cm)

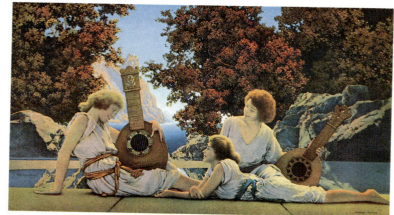

Maxfield Parrish (American, 1870-1966)
THE LUTE PLAYERS
5930 - 10½″ x 18″ (27 x 46 cm)

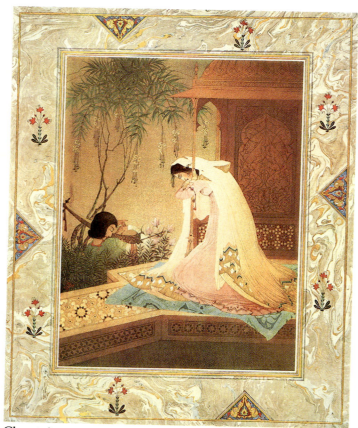

Chugtai
FOR A SONG
7195 - 30″ x 24″ (76 x 61 cm)

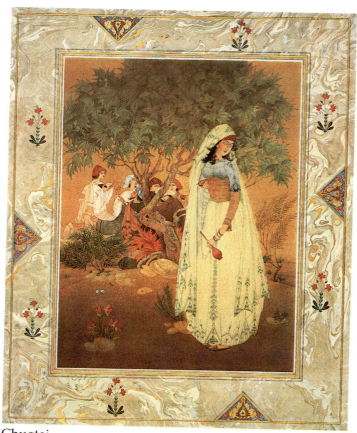

Chugtai
COME FILL THE CUP
7194 - 30″ x 24″ (76 x 61 cm)

Brooks, Leonard (1911–) was born in London. In 1914 his family moved to Canada where he received his education. He has been active as painter, art and music teacher in Mexico since 1951. In his early years in Mexico he traveled widely throughout the country studying its people, its colors and forms. At intervals he returned to Canada to paint and exhibit his work. Further travels in France, Greece and Italy also enriched his artistic expression. His paintings are represented in collections in Canada, the United States, Mexico and Europe. Brooks has, in recent years, been translating his paintings into woven tapestries. He is also well known as a lecturer and art critic. His wife, Reva, is an outstanding photographer.

Daens, Mady (Contemporary Belgian) is considered to be representative of the Modern School of Flemish Art. She has held several one-woman shows throughout Europe and Australia. She has twice represented Australia, where she lived for 15 years, in international exhibitions of Naive paintings. Her colorful paintings possess a childlike simplicity which critics have called romantic, primitive, happy and idyllic. Paintings by Ms. Daens are found in private collections in Belgium, England, the United States, Canada and all the major cities in Australia.

Doutreleau, Pierre (1938–) is a native of Arles, France. He studied law at the University of Grenoble and in the late 1950's he moved to Paris and took up painting rather than the practice of law. He had his first one-man show in Marseilles in 1960 followed by a series of solo shows in Paris. During this period he was best known for his still-lifes and his still water seascapes painted in a style expressing calm, serenity and silence. In 1968 he toured America and became infatuated with American sports. He likened the images of football he saw on television to "abstract painting with ever changing blocks of brilliant colors moving across the screen." In 1971 Doutreleau held his first one-man show in New York. It included paintings of basketball, hockey, auto and motorcycle racing, golf, horse racing, skiing and football.

Fan Chi, (1616–1694) is considered to be one of the Eight Masters of Nanking. He was a painter by profession during the Chi'ing Dynasty who lived and worked in the Nanking area. His landscapes often appear to be mysterious or fantastic in nature with craggy, threatening mountains, unnatural light and heavy pockets of mist. Elements in his work such as dense textures and subtle shading suggest that he may have seen western engravings brought to China by European Jesuits.

Greenleaf, Virginia (Contemporary American) attended Yale University, The Art Students League, American University and studied with Robert Brackman, Ivan Olinsky, Robert Gates and Gene Davis. Her works are found in the collection of the State Department, Washington, D.C., the Office of the Deputy Secretary of State, the Office of the Ambassador to the United Nations, The Folger Library, the Office of the Secretary of Far Eastern Affairs, The United States Embassy, and the residences of the United States Ambassadors in Italy, France and 25 other countries. Greenleaf currently lives in Old Lyme, Connecticut.

Hochberg, Lee (1921–) was born and grew up in New York City. As a young woman, Hochberg's first love was music. She won several vocal scholarships and sang professionally with a New York opera company. After raising her family, Hochberg turned to painting. Although she did study art briefly, she is primarily a self-taught painter. Her work was shown at the Hudson River Museum in Yonkers, New York, in a group show entitled "Small Oils by Five Woman Painters." Her portrait of Carl Sandburg now hangs in the Carl Sandburg Museum in Flat Rock, North Carolina. Her work is in collections throughout the United States and Europe. Hochberg maintains a studio in Yorktown Heights, New York, where she also teaches painting.

Hornbuckle, Marianne (1944–) was born in Newark, Ohio, and grew up in Texas. She graduated from the University of Texas with a B.A. in English. She is married to William Preston, also an artist, and has two children. Hornbuckle studied art for a short time, but is primarily self-taught. She held her first one-woman show in 1976 and has participated in group exhibitions throughout the Southwest United States. She has received several awards for her watercolors—most recently the Samuel Bloomingdale Award at the 120th annual exhibition of the American Watercolor Society. Her work is represented in the collections of many major corporations. She resides in Texas and Santa Fe.

Inukai, Kyohei (1913–) was born in Chicago. He studied art at the Chicago Art Institute, the National Academy of Design and The Art Students League. He held his first one-man show at the California Arts Club in 1934. He has participated in numerous exhibitions including the Corcoran Biennial, the White House Rotating Exhibition, and the USIA Print Exhibition at the Osaka World's Fair in Japan. His works are represented in major private and corporate collections and are included in the collections of the Albright-Knox Museum, Buffalo; Portland Museum of Fine Art, Oregon; and the Wichita University Museum of Fine Art, Kansas. Mr. Inukai is also a sculptor and writer of Haiku poetry. He lives in New York City.

Lang Shih-Ning, (1688–1766) was born in Milan, Italy as Giuseppe Castiglione. As a young Jesuit he traveled to Portugal where he spent four years decorating the chapel of the Jesuit Novitiate in Coimbra with Frescoes of the life of St. Ignatius Loyola. In 1715 he arrived in Peking where he received instruction in Chinese painting techniques from the local mandarin. He was presented to the Emperor and took the name Lang Shih-ning. He proceeded to create his own style of painting in which Chinese medium and technique were blended with Western naturalism and subtle shading. He was a great favorite at court where his still-lifes, portraits and handscrolls were very much admired.

Lopez, Julia (1935–) was born in Ometepec, Mexico, a small rural village south of Acapulco. She traveled to Mexico City in 1951 where she worked as an artist's model. She is a self-taught painter whose works reveal an aura of fantasy and spontaneity. Her first exhibition was held at the Galeria Artes Visuales in 1952. Lopez exhibited extensively throughout Mexico during the 60's and 70's.

MacNeill, Fred (1930–) was born in Boston. He studied painting at the Vesper George School of Art and with Arthur Saffard and Alphonse Shelton. MacNeill's work is represented in many collections throughout the northeastern United States and Europe and he is represented by several fine galleries in the United States and Canada. He maintains a studio in Concord, Massachussetts, where he resides with his wife and children.

Nechis, Barbara (Contemporary American) graduated from the University of Rochester and received her masters degree from Alfred University. She also attended Manhattanville College. She has exhibited extensively throughout the U.S. and has been the recipient of a variety of awards for her painting. Her works are included in over 500 private and corporate collections including Citicorp, Westinghouse, C.B.S., and IBM. Her watercolors vary in style and approach, but are often evocative and suggestive in nature. Ms. Nechis resides in New Rochelle, New York.

Peak, Robert (Contemporary American) was born in Colorado and attended Wichita State University as a geology major. He later changed his major to art after working part-time for a printing firm. After a tour of duty in the Army, Peak studied at the Art Center College of Design in Los Angeles. He moved to New York City in 1953 where he developed a highly successful reputation as an advertising illustrator. He is particularly noted for his movie posters. He has created illustrations for over 75 films, including "Pennies from Heaven," "Apocalypse Now," "Superman," "Westside Story," and "Camelot." Peak has also created 45 *Time* magazine covers, three of which are in the Smithsonian Institution. In addition to his advertising work, Peak enjoys painting for himself and derives great satisfaction from these personal paintings. Although he prefers working in watercolor, he is well versed in oils, pastel and airbrush. Peak currently lives and works in Los Angeles.

Rockwell, Norman (1894–1978) was born and spent his youth on Manhattan's Upper West Side. He inherited artistic talent from both his father, a cotton goods merchant and amateur sketcher, and his grandfather, Thomas Hill, an English artist who emigrated to America. Rockwell entered the National Academy of Design after his second year of high school and also studied at The Art Students League under George Bridgeman. At the age of 17 he was illustrating children's books. At age 20 Rockwell was making 50 dollars per month working for a boy's magazine. For that sum he illustrated the cover each month, acted as art director and illustrated two stories. In 1916 he presented his first illustrations to *The Saturday Evening Post* and on May 20th of that year the first of hundreds of Norman Rockwell *Post* covers appeared. Rockwell endeared himself to the American public by continuously portraying the common man—the ordinary American confronting typical everyday experiences. His illustrations have become an American institution. He was a master of detail who always painted his subjects from live models, even if they were animals. He spent hours hunting antique shops and auctions for costumes and props for his paintings. In the late thirties Rockwell moved from New Rochelle, New York, to Vermont. In 1953 he moved to Stockbridge, Massachusetts where he lived and painted until his death.

Stark, Bill (1923–) is a native of New York City. He studied Art at Yale University Art School, The Art Students League and graduated with honors from Cooper Union. He held his first one-man show in 1953 and participated in several group shows in the New York Metropolitan area. For the past ten years he has lived in San Miguel De Alende, Mexico, and has exhibited his work in a number of fine galleries in that country.

Trefny, Frank (1948–) received a B.F.S. from Syracuse University and an M.F.A. from the Hoffberger School of Painting, Maryland Institute in 1974. He also attended the Skowhegan School of Painting and Sculpture where he received a full scholarship. He has participated in exhibitions and one-man shows throughout the Northeast United States. Mr. Trefny lives in Greenwich, Connecticut. His painting of Tod's Point depicts the Greenwich shoreline along Long Island Sound.

Trevyh (1946–) was born in Lyon, France. He began painting and drawing in early childhood. He recalls spending hours, as a small boy, looking through books and art magazines with his father who also painted. As a young man, to help support his painting, Trevyh became a framer. At the age of 23 he opened a small art gallery where he exhibited his frames together with his watercolors. He attracted a following from his regional exhibitions and his reputation soon reached Paris. Trevyh's paintings have been featured in exhibitions throughout Europe.

New York Graphic Society P.O. Box 1469 Greenwich CT 06830 (203) 661-2400